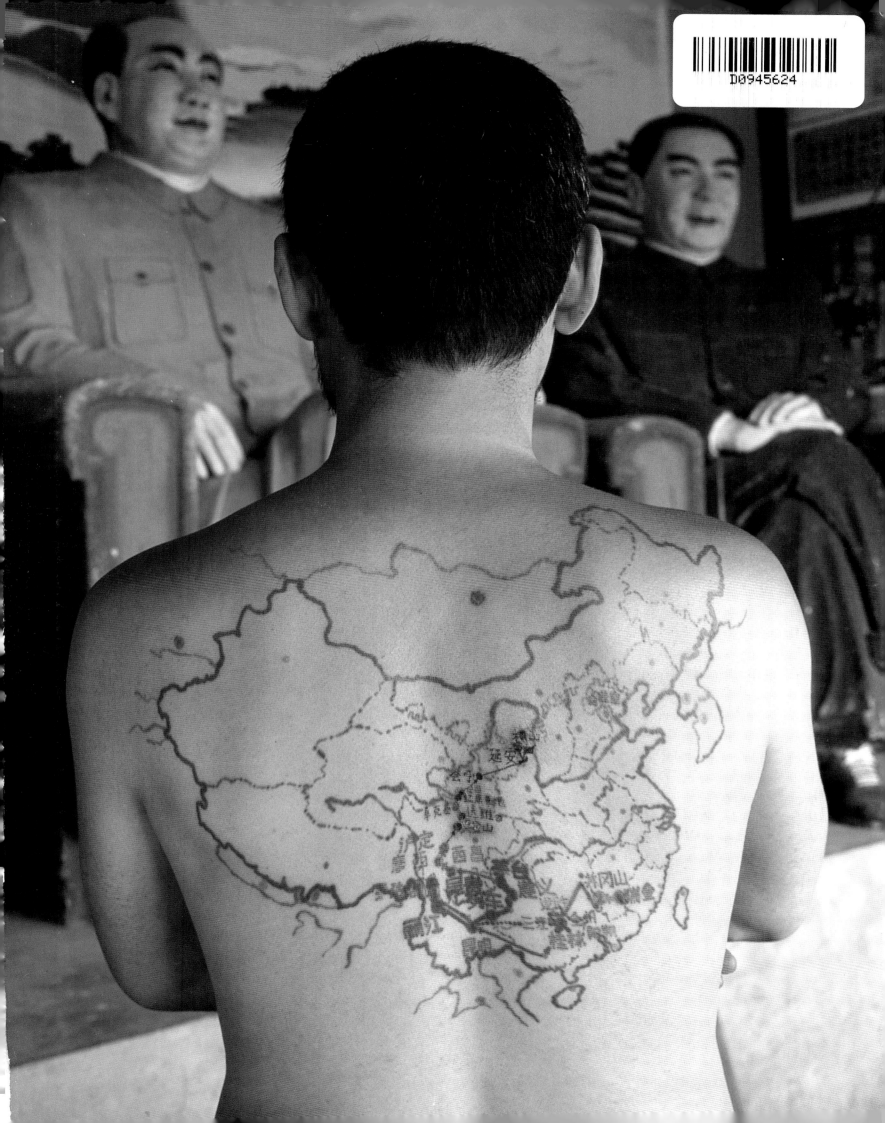

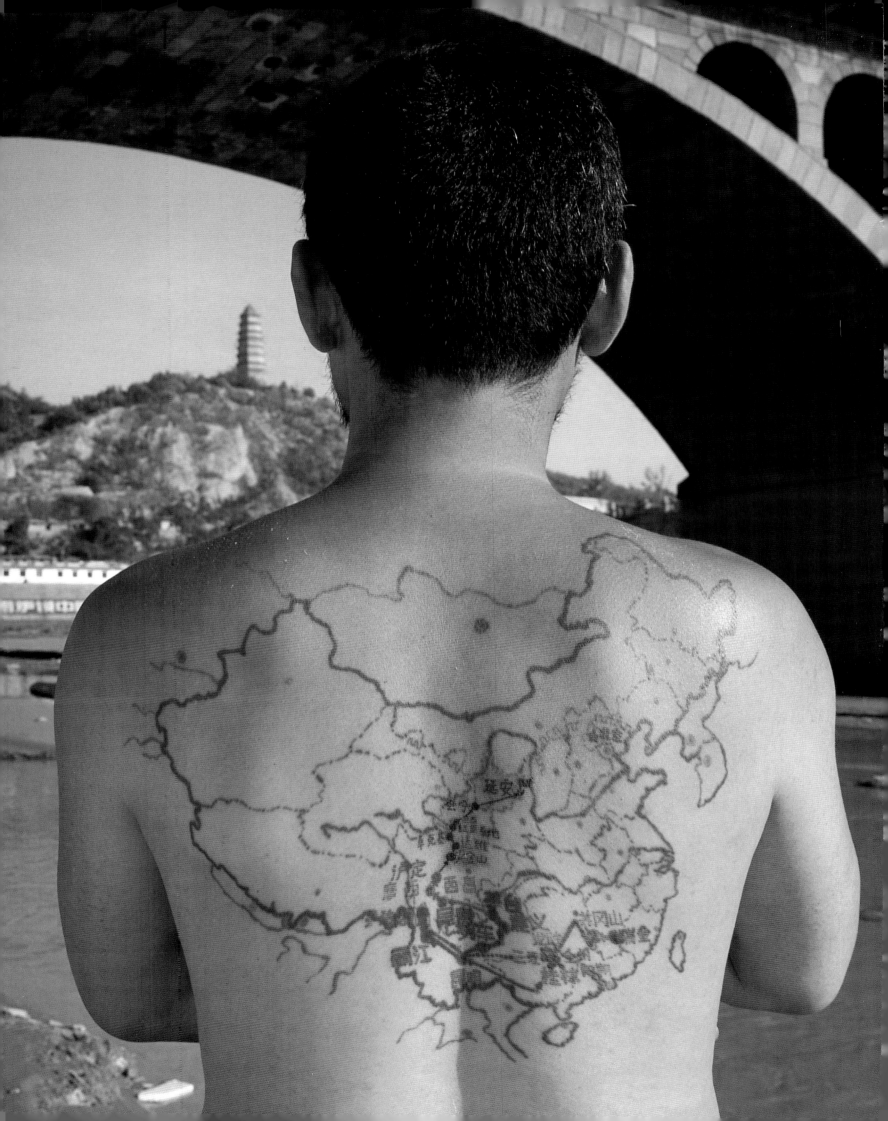

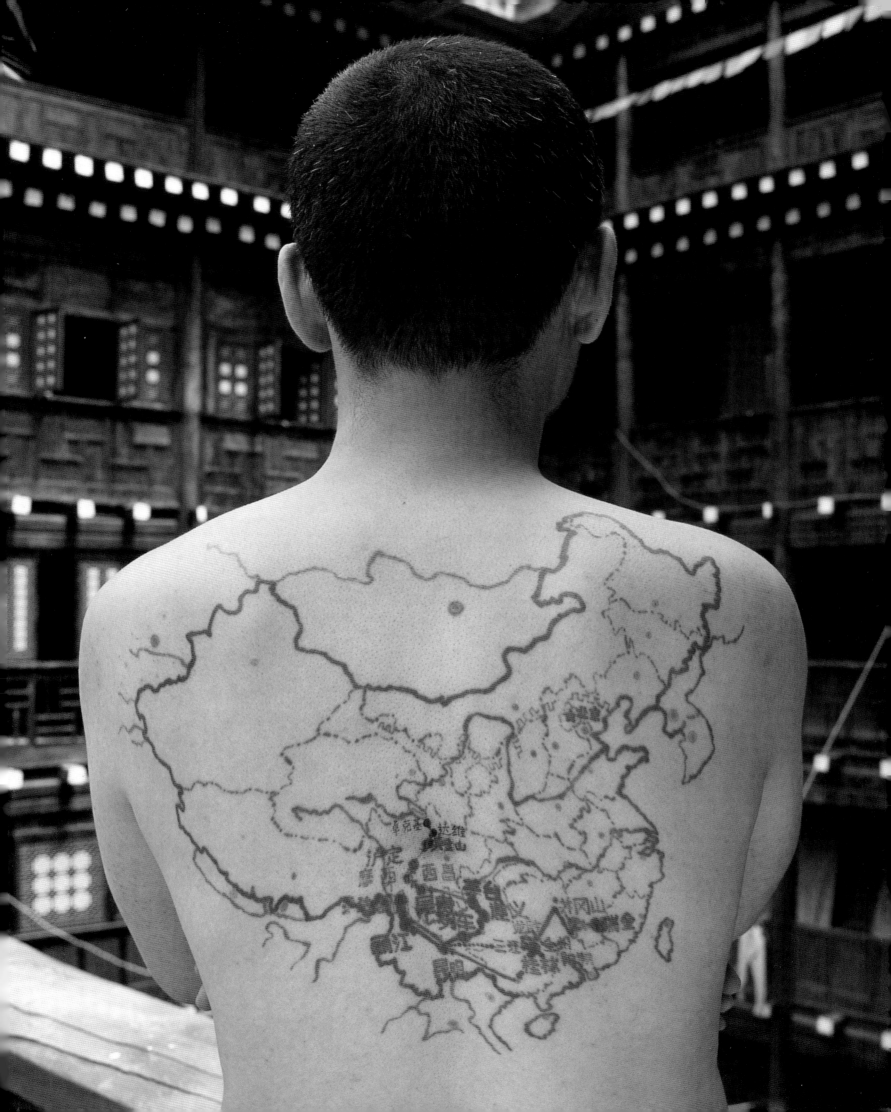

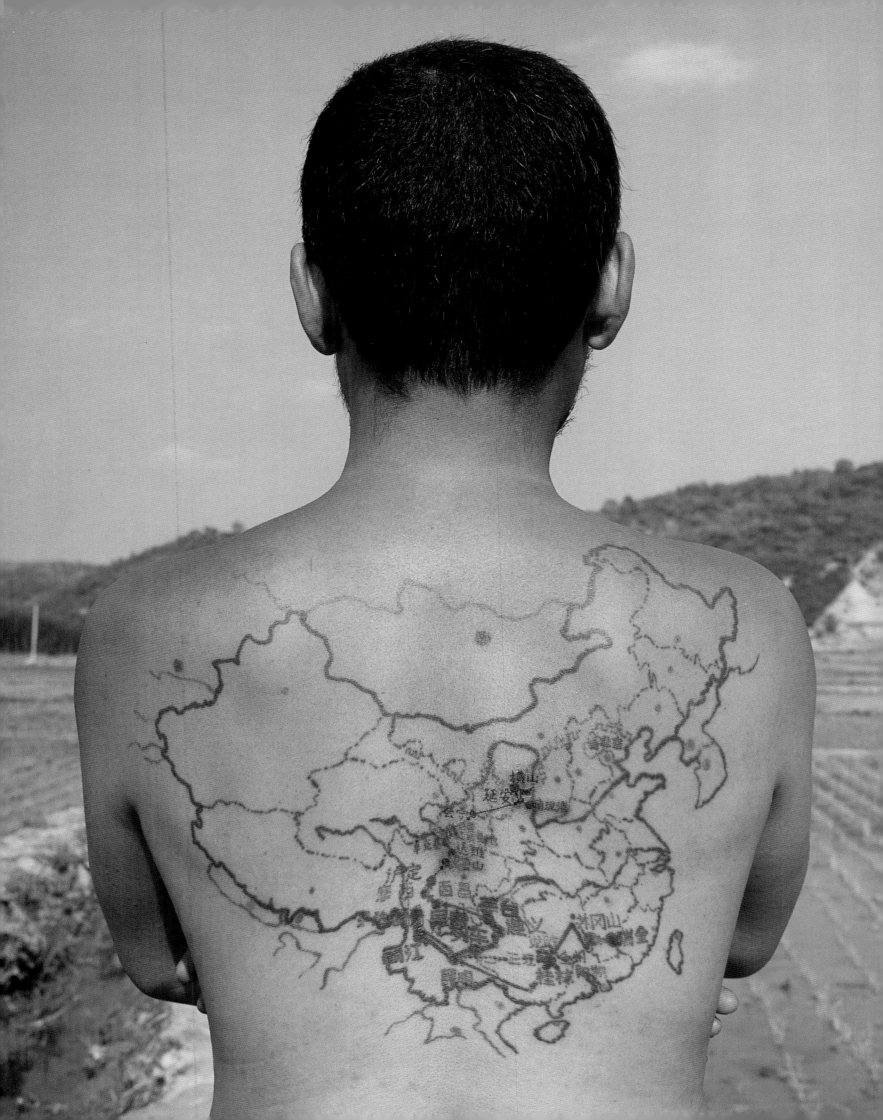

THE 5TH ASIA-PACIFIC TRIENNIAL OF CONTEMPORARY ART

EDITORS / LYNNE SEEAR & SUHANYA RAFFEL

QUEENSLAND ART GALLERY PUBLISHING 2006

PUBLISHER
Queensland Art Gallery
Stanley Place, South Bank, Brisbane
PO Box 3686, South Brisbane
Queensland 4101 Australia
www.qag.qld.gov.au

National Library of Australia Cataloguing-in-Publication
data:

 The 5th Asia-Pacific Triennial of Contemporary Art.
 ISBN 978 1 876509 38 5.

 1. Asia-Pacific Triennial of Contemporary Art (5th :
 2006 : Brisbane, Qld.). 2. Art, Modern - 21st century -
 Asia - Exhibitions. 3. Art, Modern - 21st century -
 Pacific Area - Exhibitions. 4. Art, Asian - 21st century
 - Exhibitions. I. Queensland Art Gallery. II. Title.

709.50749431

Published for 'The 5th Asia–Pacific Triennial of Contemporary
Art' held at the Queensland Art Gallery / Gallery of
Modern Art, 2 December 2006 – 27 May 2007, in
association with the Australian Centre of Asia–Pacific Art.

NOTES ON THE PUBLICATION

The order of the artists' family names and given names
varies depending on the conventions used in their
respective home countries.

 Dimensions of the works are given in centimetres (cm),
height preceding width followed by depth.

CURATORIAL TEAM

Doug Hall, AM, Director
Lynne Seear, Assistant Director, (Curatorial and
 Collection Development)
Andrew Clark, Assistant Director, Public Programs
Suhanya Raffel, Head of Asian, Pacific and
 International Art
Julie Ewington, Head of Australian Art
Kathryn Weir, Head of Cinema
Maud Page, Curator, Contemporary Pacific Art
Sarah Tiffin, Curator, Historical Asian Art
Don Heron, Head of Exhibitions and Display

PUBLICATION TEAM

Lynne Seear, Assistant Director (Curatorial and
 Collection Development)
Suhanya Raffel, Head of Asian, Pacific and
 International Art
Judy Gunning, Head of Information and
 Publishing Services
Ian Were, Senior Editor
Eric Meredith, Publications Assistant
Robyn Ziebell, Project Officer, Australian Centre
 of Asia–Pacific Art
Elliott Murray, Head of Design, Web and Multimedia
Chris Starr, Senior Designer

Thanks also go to the staff of the Gallery's Asian, Pacific
and International Art department for their assistance with
various aspects of the publication.

Photography of art works and installations for APT5,
and works in the Queensland Art Gallery Collection
by Ray Fulton and Natasha Harth. All other photography
credited as known.

Typeset in Paralucent. Stock: Raleigh Paper Novatech
and Nordset. Printed by Screen Offset Printing, Brisbane,
Australia.

FOUNDING SUPPORTER

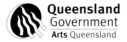

Queensland Government
Arts Queensland

Frontispiece:
Qin Ga / China b.1971
The miniature long march (details) 2002–05
Type C photographs / 23 sheets: 75.5 x 55cm
(each) / Collection: The artist / Image courtesy:
Long March Project, Beijing

Page 7:
Justine Cooper / Australia/United States b.1968
Trophies (from 'Saved by science' series)
(detail) 2005
Digital colour print on Fuji Crystal Archive Matte
paper, ed. 1/8 / 99.2 x 76.4cm / Purchased 2005 /
Collection: Queensland Art Gallery

Page 50 & 51:
Ai Weiwei / China b.1957
Boomerang (detail) 2006
Glass lustres, plated steel, electrical cables,
incandescent lamps / 700 x 860 x 290cm (irreg.) /
Site specific installation for APT5 / Collection:
The artist

Page 273–75:
Khadim Ali / Pakistan b.1978
The making of *The Bamiyan drawing
project* 2006 for Kids' APT
Photographs: Barat Ali Batoor

Page 304:
Michael Parekowhai / New Zealand b.1968
What's the time Mr Woolf 2005
Type C photograph, marker pen, ed. 5/5 / 100 x
100cm / Purchased 2006, Queensland Art Gallery
Foundation / Collection: Queensland Art Gallery

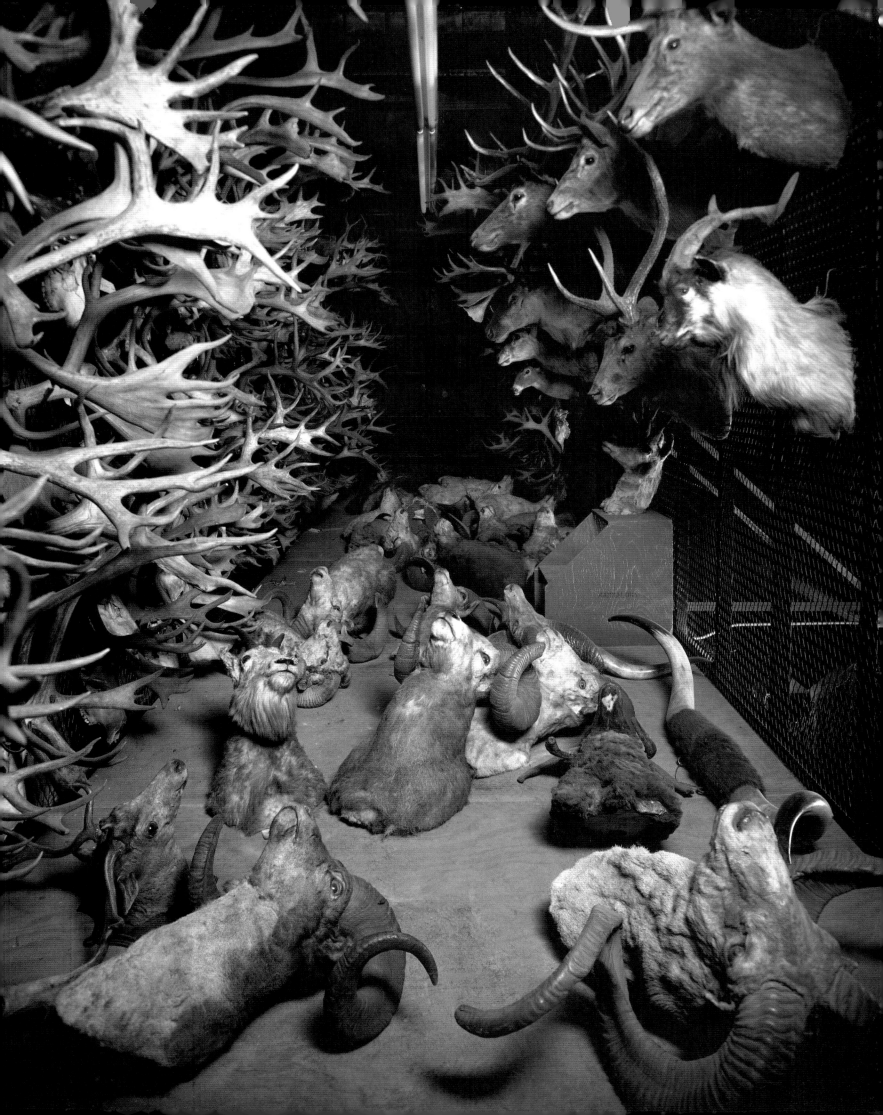

In just over a decade, the Asia—Pacific Triennial of Contemporary Art (APT) has become the defining art exhibition in the Queensland Art Gallery's repertoire. It is also one of Australia's most exciting and significant arts events, and an inseparable part of our international cultural engagement. The critical success and public acceptance of the Triennial have helped change the way Australia sees the Asia—Pacific region through its contemporary art. The APT was the first and continues to be the only major exhibition series in the world to focus exclusively on the contemporary art of Asia, Australia and the Pacific.

A lasting engagement with the Asia—Pacific region — through collecting, researching, exhibiting, publishing and interpreting recent and current art — was seen as one of the central roles for the Gallery's planned second site, the Gallery of Modern Art (GoMA). The APT series embodies the full expression of these interests, so it is fitting that the Triennial is the opening exhibition at GoMA.

Designed by Lindsay and Kerry Clare of Architectus, GoMA is a stunning building and exemplary venue for displaying contemporary art; it is Australia's largest gallery of modern and contemporary art and an important new cultural landmark for Queensland. It will house the Gallery's contemporary collections including the Asian and Pacific collections, and the Australian Centre of Asia—Pacific Art — the research and publishing arm of the Gallery's Asian and Pacific activities.

'The 5th Asia—Pacific Triennial of Contemporary Art' (APT5) is the most ambitious of the series to date — twice the scale of previous Triennials. The exhibition features more than 300 works by 37 artists, filmmakers and performers from Asia, Australia and the Pacific as well as two multi-artist projects. APT5 is presented in GoMA's spectacular new galleries, as well as in key spaces in the refurbished Queensland Art Gallery building, including the Watermall, which has been the focal point for some of the Gallery's most spectacular displays.

APT5 continues the series' groundbreaking reputation by introducing a curated cinema program — presented by the Gallery's Australian Cinémathèque in GoMA's two cinemas and media gallery. Permanent facilities for the Children's Art Centre will be introduced to audiences with several Kids' APT interactive art works, which promise to be an exhibition highlight for children and families. The performance program, premiering over the opening days of the APT5 and GoMA, is the most extensive ever staged for a Triennial.

The APT is distinguished from other recurring international art events by its collecting focus. The Gallery is one of the few public institutions in the world to collect contemporary Asian and Pacific art, made possible through significant private and Government support.

If the Queensland Art Gallery was innovative and risk-taking when it embarked on the APT series more than a decade ago, then its sponsors and partners also showed great foresight. The Queensland Government, as Founding Supporter, has provided significant support for all APT exhibitions. It has also embraced and been fully committed to the development of the Gallery of Modern Art since its inception. I acknowledge and congratulate the Government on this commitment to contemporary culture and infrastructure in Queensland.

PREFACE

WAYNE GOSS

I acknowledge the support of our Principal Sponsors, the Visual Arts and Craft Strategy, an initiative of the Australian, State and Territory Governments, and the Australian International Cultural Foundation, under the auspices of Art Exhibitions Australia. In addition, the following sponsors have made a significant contribution to this and previous Triennials: the Australia Council and the Department of Foreign Affairs and Trade, who support the project through their various programs, British Council, Creative New Zealand, Japan Foundation, Sidney Myer Fund and the Thai Ministry of Culture and Office of Contemporary Art and Culture. I extend my gratitude to our Major Sponsors: Accor Hotels and Resorts, Adshel, Brisbane City Council, *The Courier-Mail*, Fosters Group, Network Ten and Singapore Airlines.

I also warmly thank our many supporting sponsors, who are acknowledged in this publication.

The opening of GoMA and the refurbished Queensland Art Gallery with APT5 has involved an intensive contribution from all sections and staff. I congratulate them on their achievement.

As Premier in 1989, I took on the portfolio of Minister for the Arts and it was early in the piece that Doug Hall approached me with the concept of the Triennial. It was original, relevant and exciting. Some might say it was risky. But the rewards that have flowed from this initial commitment have been considerable, not only in the way in which the Gallery introduced contemporary Asian and Pacific art to a diverse local and international public, but also because of the way in which people viewed Queensland and Brisbane — where a new cultural relationship was formed with the region.

Just as the APT broke new ground in the early 1990s, we believe APT5, from its new home in the Gallery of Modern Art, will continue to challenge expectations about the contemporary art of our region.

WAYNE GOSS is Chair of the Queensland Art Gallery Board of Trustees.

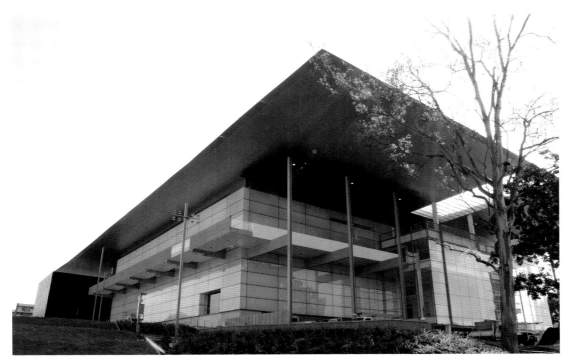

Gallery of Modern Art, September 2006
Photograph: Natasha Harth

In this fifth Asia—Pacific Triennial (APT), the hopeful reach of the Queensland Art Gallery's formative years is fully realised. This exhibition also marks the maturity of the Gallery's relationship with those who have worked with it — the participating artists, and the responsive audiences, both here in Brisbane and beyond. The fifth Triennial is occurring at a time when the risk of being overly self-congratulatory is all too possible. Nonetheless, it is true that the case for the new Gallery of Modern Art (GoMA) was strongly influenced by the Gallery's connection with Asia and the Pacific — it marked a certainty, a point of difference from other state and national institutions.

The Triennial is the opening exhibition in this major museum — an exciting new museum for Australia and the Asia—Pacific region. GoMA more than doubles the exhibition space available, and offers unprecedented opportunities for the installation of ambitious works, including those by filmmakers and performers. The Australian Cinémathèque and the Cinema department establish the Gallery's commitment to moving image and new media. These facilities will not only provide new and diverse opportunities for the exhibition of contemporary screen culture, but will also present historical works as part of a program of research and reinterpretation. GoMA's opening program will include thematic presentations ranging from Hong Kong and Shanghai: Cinema Cities to Japan Fantastic: Before and Beyond Anime, and a celebration of the career of Jackie Chan.

In a little over a decade, there has been a proliferation of exhibitions — mainly biennial events — throughout the region. Many have sought to mark a sense of civic maturity through the presentation of contemporary culture and have been directed and supported by governments; others, like the APT, continue with institutional independence. It must be emphasised, however, that to acknowledge projects that represent the idea of cultural exchange — in which art may have a function beyond its own status — is not necessarily a criticism, now that open dialogues occur and clichéd views of cultural and ideological subterfuge have been consigned to a few peripheral think tanks. The APT continues its successful model of selecting individual artists rather than taking on an approach of *national* representation; with many artists now working in places other than their country of origin — their location and the culture with which they might most closely identify, and the influences that shape their art, become less clear. The APT cannot, therefore, only represent art that is defined by national or geographical borders.

Both the Triennial and the Gallery's collections reveal the depth and diversity of individual expression within cultures that were at one time often represented as collectivist — artists were seen as working within genres and styles that reaffirmed continuity rather than engaging with innovation and change.

The evolving character of the Triennial has revealed significant shifts in practice as well as public and critical reception. On the occasion of this Triennial an emphasis has been placed on work from the Pacific — work that, in the context of the radical and ambitious internationalisation of some Asian art, might at first appear neither groundbreaking nor contemporary. It is working with (and against) these simplistic perceptions that underlines the special critical framework of the APT and its willingness

IT'S ALL ABOUT THE DESTINY!
ISN'T IT?

DOUG HALL

Gallery of Modern Art, September 2006
Image courtesy: Architectus / Photograph:
© John Gollings Photography

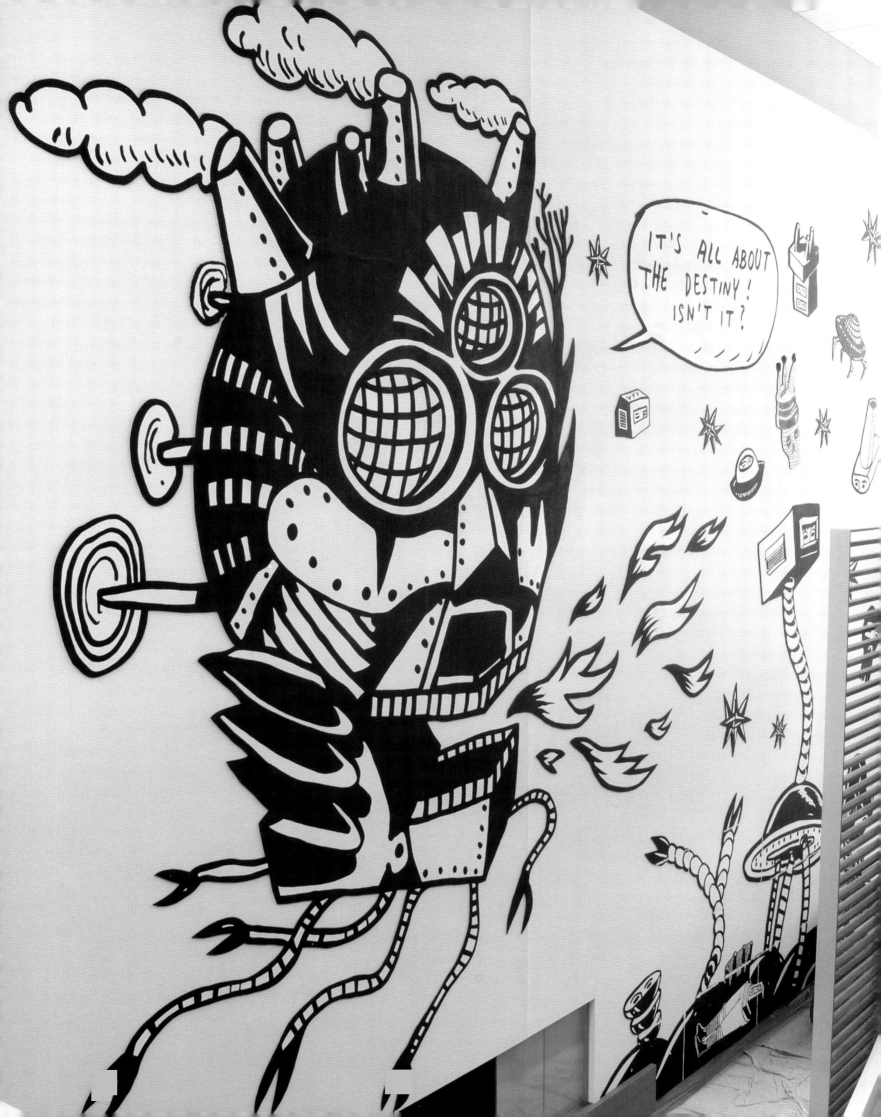

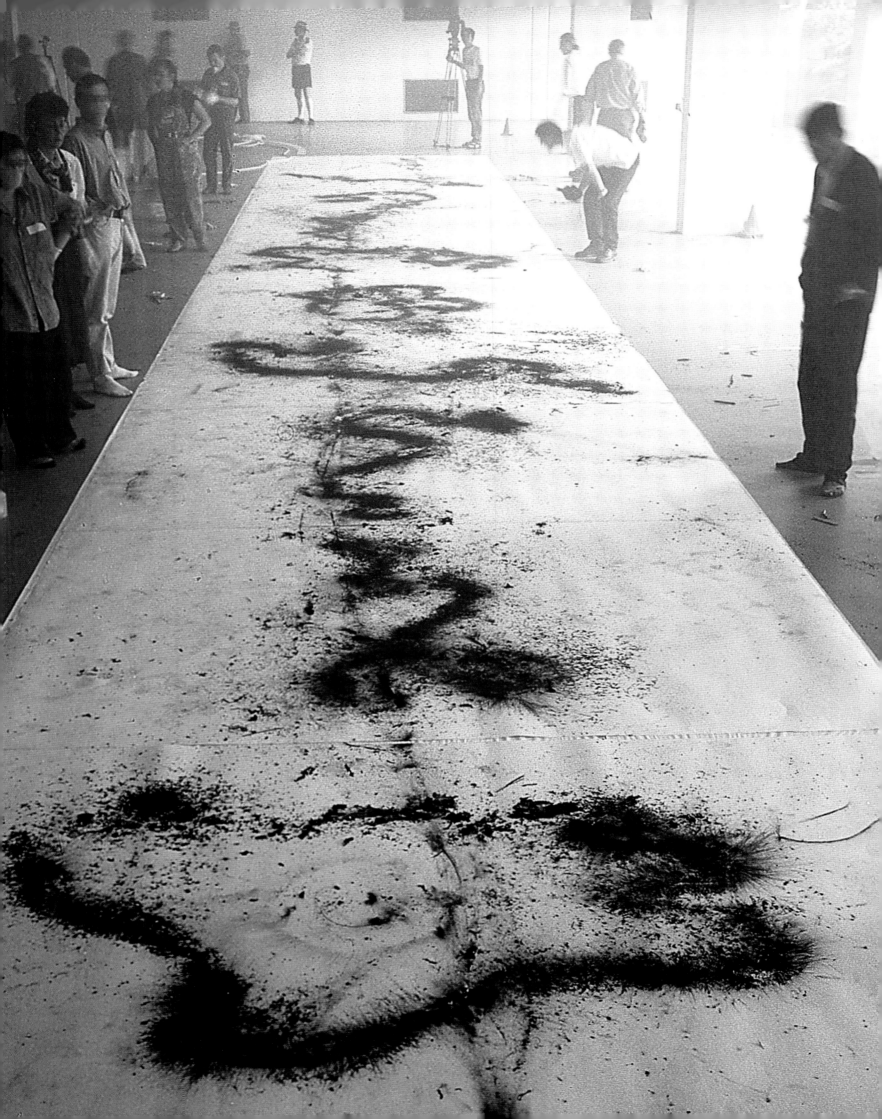

to deal with multifaceted regional practices, to place Pacific textiles in an international context and to allow them to speak as art, unconstrained from references to them as 'material culture'. In a general sense, exhibitions of works from Pacific cultures have often presented them in isolation from broader regional or international perspectives; or even excluded them completely, as though exclusion was better than miscued and misunderstood display.

The Triennials have served a curatorial role beyond the exhibition itself. Around 70 per cent of the works in this Triennial have been or will be acquired for the Collection — such has been the scope and depth of the Gallery's recent acquisitions and research program. These works undergo a somewhat protracted process of curatorial reflection, persuasion and consideration. This has meant that, while works may deal with issues and actual events that have shaped modern history, they are not consumed by overheated identity politics that quickly shifts to the next debate. Instead, they are seen as holding a presence that will carry ideas forward, metaphorically as well as literally, into realms that hold our interest. Take for example the gunpowder drawings of Cai Guo Qiang or the sparse immediate gestures of Lee Ufan in which the idea endures through the instant of how the work was brought into existence. This also extends to ideas of performance and play — wry humour and twisted narrative have embodied the work of much East Asian figurative art. There might be intense discussion in the West about the listlessness of much contemporary Western figurative art — 'Who rivals anyone of the previous generation and earlier?' is a much vaunted criticism. Yet it remains a commentary that ignores, for example, work from China, Japan, Korea, Thailand, India and Pakistan, work that has already set up new possibilities for figuration. The APT exhibitions continue to present and explore this crucial and long-established practice in the region.

GoMA and the Triennials seek to have a local and international role, encouraging and shaping visual literacy in areas that are new, relevant and genuinely exciting — where public programs will range from serious symposia to a softer and closer relationship with children, families and youth; where media and cultural overlaps can flourish. The Children's Art Centre, Australian Cinémathèque and Australian Centre of Asia–Pacific Art are investments that have been made so the public will have access to the region's modern and contemporary art on a scale and depth previously not available — where artists will continue to enjoy an association with the Gallery which brings practices, commissions, exhibitions and writing into closer contact with the public.

DOUG HALL is Director, Queensland Art Gallery / Gallery of Modern Art.

Chinese artist Cai Guo Qiang created the gunpowder drawing *Dragon or Rainbow Serpent: A myth glorified or feared: Project for extraterrestrials no. 26* 1996 for APT2 at the Queensland Art Gallery

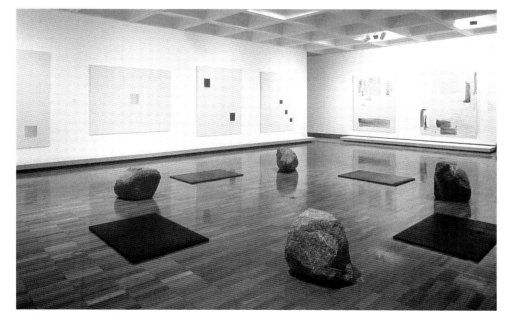

Installation view of Lee Ufan's work in APT 2002, Queensland Art Gallery

Nusra Latif Qureshi / Pakistan/Australia b.1973
Precious strings of pearls 2006
Gouache, ink and graphite on wasli paper / 34 x 26cm / Purchased 2006 / Collection: Queensland Art Gallery

This essay is a brief meditation on how art can engage with the social and political aspects of everyday experience. It's meant to help us think about some of the communitarian works in APT5, the kinds of initiatives instigated by 'catalyst' groups such as the Long March Project.

But before considering these initiatives, I'd like to start somewhat indirectly, by examining the sly politics in one of the great art works of the twentieth century, namely John Ford's film *The Searchers* 1956. This example is useful because it shows how *feelings* get activated by any truly transformative art work. It helps us understand how people are moved to act, how politics are poised in our emotions, how an art work can be a catalyst instigating change.

Set in Texas during the final phase of the American frontier, *The Searchers* opens with events that quickly change from alluring to disturbing. During the first sequence, in a quiet cabin on the edge of boundless plains, you watch with real affection as a tenderly observed family of homesteaders welcome a wanderer who's come in from the wild to be enfolded in the family's care. Feeling a wash of compassion, you identify with this interloper called Ethan, played by John Wayne. He's intriguing. You're captivated by the scale of him, by his mysteries and energies, and you accept that he'll be your guide through the entire film. Everything seems secure and bountiful.

Then a catastrophe obliterates the little world you've grown so quickly to love and want. Comanches raid the homestead and slaughter almost everyone sheltering there, with the exception of the two daughters who are abducted. This happens while Ethan is out on patrol with a young man named Martin, whom Ethan had disparaged earlier, complaining that Martin could be 'mistaken for a half-breed'. This nasty outburst brings you up short for a moment but before you can dwell on it you are taken by grief and outrage when the raid tears the ideal world apart. You are given no pause to reflect on Ethan's passing moment of vilification with Martin. Rather, you are scalded by a sudden urge for revenge and a flush of hatred for the Indians. So, without thinking it through, without wondering whether the raiders might have had a motive and what that motive might have been, you ally yourself to Ethan as he saddles up and rides out to wreak vengeance on the Comanches.

The blood lust prevails all the way into the second half of the film. It burns not just on the screen but in your glands and central nervous system. For an hour or more you have a mania inside yourself, ruling your sensibilities as you ride alongside Ethan and Martin. This ire, this *racism* (let's name it for what it is) keeps propelling you until, informed by the evermore dissenting arguments of Martin, you begin to analyse all the foregoing events, understanding at last that Ethan is insane and beast-like. You understand that you cannot ride with him anymore, that you must repudiate him and retrieve your dignity somehow.[1]

Crucially, this is not just an *intellectual* conviction. No, you *feel* the mania that has doused your sensibility and you realise, on reflection, that you are repulsed by it. You sense a yen growing in you, a need to undergo change and work yourself free of Ethan's bleakness. You hanker to partake of a world that is not governed his way. It's this factor that makes *The Searchers* as political as it is exemplary. Ford designed the film so that first

AESTHETIC POLITICS

Spanish release poster for *The Searchers (Centauros del Desierto)* 1956

Director: John Ford / 35mm, 119 minutes, colour, mono, USA, English / Image courtesy: Warner Bros Pictures

ROSS GIBSON

you feel the racism in you, then you feel disgust for it, then you crave a cleansing transformation. Rather than just espousing some sharply honed political manifesto, the film puts you palpably through a process of political change, taking you from unthinking innocent through to blood-drunk revenger until you finally become a searcher in quest of a complex but wary compassion for everyone struggling in the aftermath of so much land theft and recrimination. This *flow of feelings* occurs in your nervous system, in the patterning of your emotions, and it will remain forever accessible in your body now that the film has staged a radical transformation inside your person. As you view the film and then remember it later, you feel *The Searchers* within you vibrantly as an *aesthetic* system; you haven't received it passively as a polemical message sent to you from outside. This deliberate, dynamic re-structuring of your feelings is what makes *The Searchers* great political art.

Aesthetics and politics are not often so closely conjoined. In the dictionary definition, aesthetics are concerned with everything that's 'perceptible by the senses'.[2] Which is to say, an aesthetic experience occurs first in the nervous system. An aesthetic experience starts with sensations in the body, providing matters to be contemplated by the intellect, with the effect that your aesthetically induced *ideas* are deeply felt because you have been moved to think, moved by the sensory impact of the artistic encounter. Sensation has led to cognition. Conviction has been prompted by emotion. In this movement, there's transformation, which is the first step in political effectiveness. Moved by the aesthetics, you feel an urge to engage intensively with whatever experiences the world might offer. Let's call this politics.

This is why art continues to be so important in everyday life. It can give you more than a thesis, more than a polemical message. It can put you through directly felt changes. Indeed, if a project claims to be political art but it causes no palpable difference within your sensibility, well, it lacks the aesthetic dimension and it probably doesn't deserve to be called art.

By using the example of *The Searchers*, I've tried to conjure some understanding of the necessity of aesthetics. But as a means of advancing our knowledge of some of the *social* aspects of art, this example has its limitations, because Ford's film enacts most of its aesthetics and politics at a singularly *personal* level. It's been useful to my argument to the extent that it's helped me emphasise the potency of each viewer's feelings. But frankly, the film is not explicitly concerned with social cohesion. It has a social dimension only to the extent that each viewer feels a burgeoning fellow-feeling for characters who customarily get condemned as 'other' or 'savage'. And granted, the viewer senses this emotion moving through the little community of viewers in the darkened auditorium. But, personally political as it certainly is, *The Searchers* is not primarily concerned to direct your thinking to transformations on a *social* scale.

Which prompts us to shift focus back to the Triennial, bringing with us this awareness of the transformative power in feelings. What do we discern in an initiative like the Long March Project? Most strikingly, we discern feelings cannily propagated on a *social* scale. We see the politics in projects that generate feelings of collective custodianship at the same time as they stimulate an aesthetic excitement inside each person's private

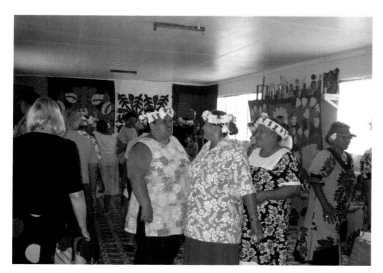

On the island of Aitutaki, Cook Islands, a one-day *tivaevae* exhibition is held annually. The 2005 exhibition showed around 100 *tivaevae* in seven halls across the island, including the Vaipeka Community Centre, where approximately 20 *tivaevae* were displayed

sensibility. We see that communally scaled art can stitch individual sensibilities into a *shared, social* consciousness.

With the Long March Project, communities are roused to work cohesively for change. Each participant's sensibility is stirred and then strengthened in a social dramaturgy. The art work burgeons within a collective setting — within the public institutions and legal systems that administer the jurisdictions where the project occurs, within the shared eco-systems and buildings scattered across their various, contentious settings, within the customs, rituals and protocols governing interpersonal cohesion all across and around the locations. As the transformations occur with each new project instigated by the Long March Project, something grows in each participant, something that is felt in common with the community hosting the action. The feeling is not contained just within each person's isolated psyche.

Compare this shared sensibility with the inwardly-focused contemplation that most art galleries afford you. Typically an art gallery prompts you to feel self-indulgent at worst or self-improving at best. Either way, the experience is usually stage-managed so that it appeals to your reflective, private sensibility. Your singular sensibility. Some of the most stridently 'political' art of the past fifty years has interrogated and sometimes discomfited this cosseting of the self in the gallery. Think of the myriad happenings and performance art interventions that have been staged in cultural institutions all round the world during this time. Challenging individualist complacency and the institutionalised tameness of connoisseurship, much 'political art' has been reactive and corrosive rather than initiatory and generative. It's been plaintive, cast negatively with grievance. At its best, such art unsettles your assumptions and challenges your private comforts. At its most useless, such art exudes a priggish sense of moral superiority.

Avoiding smugness or self-righteousness, many of the works in APT5 present a different kind of political art. Many works in the exhibition are animated by feelings that are generous and generative rather than chiding and churlish. Not merely condemnatory, such 'catalyst' projects are driven by a spirit that is preponderantly *communal* and *creative*. This is a political art that *gives* rather than *accuses*. Literally it gives you and your fellows a shared and enlivening sense of how you might create new conditions for living alongside one another.

Generative, communal art is usually impelled by 'what if' questions. What if an art work widened your concerns beyond your habitual focus on yourself? What if the art work pushed your imagination past a consideration of the value and material qualities of the *objet d'art* in front of you? What if the object was not important in itself? What if its materials were a minor concern? What if *ethereal* issues were given prominence instead so that we concentrated on the feelings and relationships shared by everyone participating in the art work? What if the label on the art work was not focused, therefore, on its materials, not on whether it is 'oil paint on canvas' or 'video projection from DVD', for example? What if the label spoke, rather, of collaborations, inventive gestures, generosity and ingenuity emerging from people's negotiated involvement in the aesthetic and semantic configurations of a collectively stimulating art work?

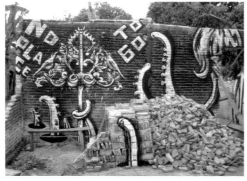 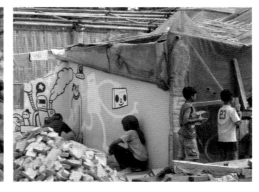

Indonesian artist Eko Nugroho worked with other young Yogyakarta artists to create *Plaosan Project* in the ruins of a house in Yogyakarta in August 2006 following a major earthquake
Image courtesy: The artist

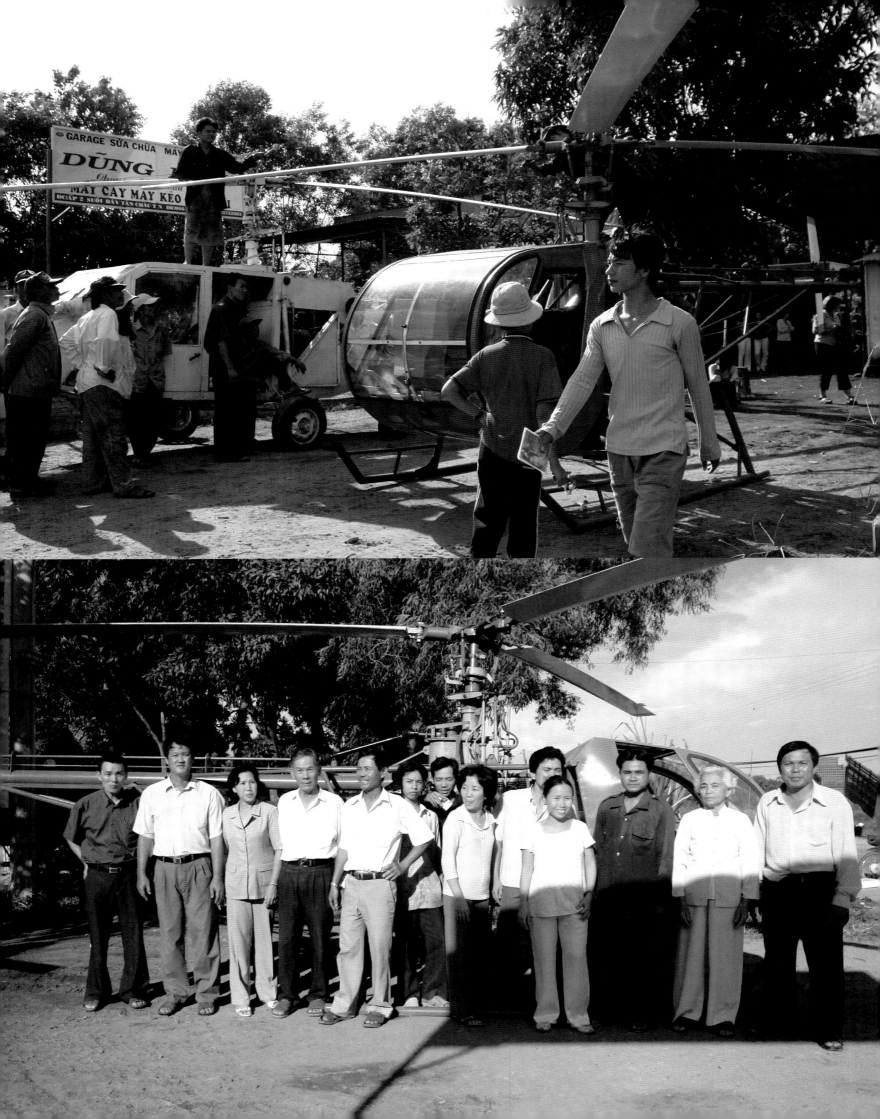

Might this be Utopian? Possibly. Might it be generative, initiatory, venturesome? Most likely. Might it be political, social and aesthetical in ways that are markedly different from most art labelled 'political' during the past fifty years? Certainly.

These ideas are not dissimilar to the propositions in Nicholas Bourriaud's influential book, *Relational Aesthetics*.[3] For Bourriaud, the value of art depends on the degree to which it can bring people and their ideas and emotions together in provocatively managed patterns that cause speculation and negotiation amongst everyone involved. Privileging not the solid matter of an art work but the potential transactions between all the art work's elements, this way of thinking about the value of art has similarities to many contemporary theories about networked creativity. Rather than residing in any one material object, the value of a network depends on the extent to which a capacity for responsiveness is distributed across an ever-shifting array of potential connections and transactions. The same goes for collaborative art works. The worth of the projects can be understood as relational rather than material.

This focus on dynamics aligns well with the theme of *emergence*, which is so preponderant now in contemporary culture. In an emergent situation, an active system or culture evolves in response to an inter-related set of stimuli, impedances and tendencies. Take the example of a gardener who plants a young eco-system, judiciously considering the tendencies of the plants, the qualities of the soil, the problems and advantages of the topography and climate. From this managed but inconclusive set of influences and possibilities, something emerges,

something that is partly built and partly grown, partly created, partly facilitated and partly just emitted as an output of the entire dynamic configuration.

Similar dynamics operate in many digital art works, for example, where the artist encourages emergence by programming conditions into the governing code of an interactive experience. And growing numbers of socially engaged artists deploy a comparable process when proffering their 'what if' postulations. Aspiring to affect the way the world might unfold, communitarian artists usually set up rituals and imaginative prompts that directly impact on everyday reality. Consider the imaginative scenarios staged by the Long March Project. Transformations occur not only in the physical environment and in peoples' social interactions but also in the participants' imaginations, in their hunches about what might be possible. Thus an aesthetic idea — an idea that is infused with feelings as well as intrigue — is set in play. For example, what if a community were to re-enact Mao's Long March, imagining how the new march might give its participants a means of re-conceiving and transforming the original Utopian dream of the Chinese Communist Party? All at once this idea is playful, dangerous, generous, critical, wishful and regretful. There's a catalytic urge in the idea that is vivacious enough to transform the way people think and feel about their everyday routines. Before long the world itself will take on different characteristics because people have begun to imagine different possibilities, because new rituals have started nudging the world in unprecedented ways.

All this speculation, aspiration and alteration can happen in collective art. Most importantly, though, the new relations and transformations will

Vietnamese artist Dinh Q Lê's **The farmers and the helicopters** 2006 explores the social significance of the helicopter in Vietnam. The United States Army mobilised over 12 000 helicopters during the Vietnam-US War. Lê tells the story of Trần Quốc Hải, a farmer and engineer who spent six years handcrafting two functioning helicopters. Trần's aspirations to fly take on a collective meaning within his community
Image courtesy: The artist

Tibetan lama preparing a *Tanka* drawing for scripture reading ceremony
Image courtesy: Long March Project, Beijing

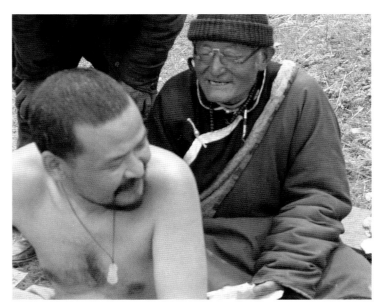

A Tibetan lama examines Qin Ga's work, *The miniature long march* 2002–05, which is tattooed on his back
Image courtesy: Long March Project, Beijing

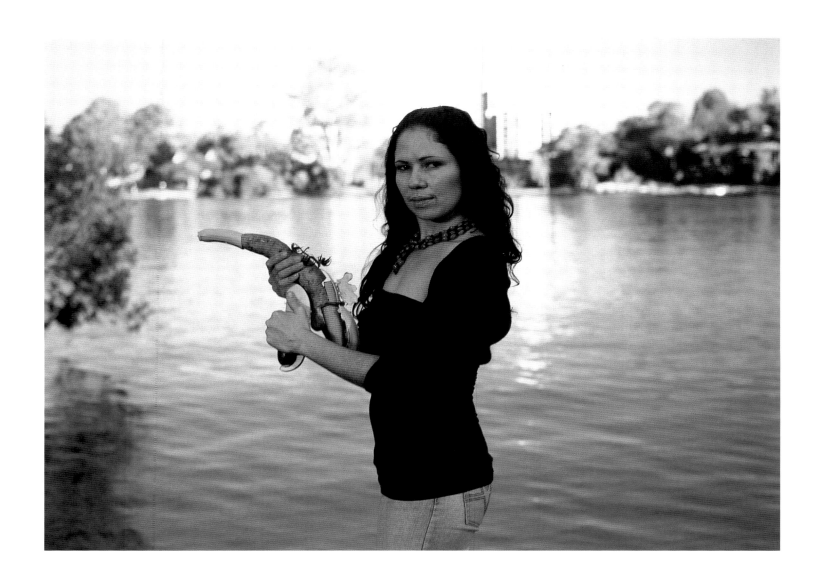

emerge only if the work is aesthetically strong. In other words, the perceivers of an idea will be moved to participate and to endorse the adventure of change only if they feel the idea move into them and through them, only if they sense its tingling potential, its wonderment and excitement. Furthermore, the dynamism implicit to an art work will be realised only if each participant is moved to act communally, to negotiate, to produce an effect that is larger than the mere sum of all the individual elements.

This last factor gives a clue to why the most affecting political art is emerging now, not in the individualist parts of the world, not in the self-indulged West, for example, but in places that have always known a more communal mentality, places where citizens customarily band together to be at home in their shared portion of the world. In times of globalisation, when the entire world is assailed evermore methodically by Western presumptions about the right way to live, the collective mentalities of the non-Westernised world become even more vital, even more compelling and politically moving.

Can I conclude with a summation delivered not as a slogan but with the hope that it has already been your slow revelation? My conclusion is this: political art does not deliver messages; political art is effective only if it is affective; it must assemble and rouse constituencies; it needs to change the world from the inside, from inside *people*. Political art works best when it changes the people encountering it so that, flush with ideas and emotions, these people find ways of negotiating and collaborating to change the world within them, around them and between them. Politically engaged art is bigger and more vital than any one of us can imagine.

ROSS GIBSON is Professor of New Media and Digital Culture, School of Humanities and Social Sciences, University of Technology, Sydney.

Tsuyoshi Ozawa / Japan b.1965
Vegetable curry/Brisbane, Australia
(from 'Vegetable weapon' series) 2005
Type C photograph / 113 x 156cm / Purchased 2005 with funds from John Potter and Roz MacAllan through the Queensland Art Gallery Foundation and the Queensland Art Gallery Foundation Grant / Collection: Queensland Art Gallery

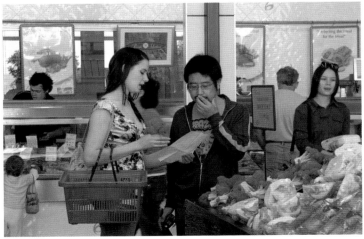

Japanese artist Tsuyoshi Ozawa creating three new 'Vegetable weapon' works in Brisbane in 2005. He worked with volunteers who provided favourite recipes, the ingredients for which are turned into 'vegetable weapons' which are photographed, cooked and shared
Photographs: Natasha Harth

REFLECTIONS ON CONTEMPORARY ART, GLOBALISATION AND HISTORY

The best exhibitions do not solve problems, but showcase them, by airing issues of value and interpretation, by putting debates on the table, by challenging audiences to come up with their own responses and judgments. The Asia–Pacific Triennials have from the start confronted one of the most basic questions in global art and culture today. Of course, any biennale or periodic temporary international exhibition that groups contemporary art from a range of international contexts together at least implicitly raises the issue of whether art from different nations, some Western, some non-Western, meaningfully belongs to the category of contemporary art. But a Triennial based in the Asia–Pacific, which incorporates a very heterogeneous mix of urbanised, utterly modern and cosmopolitan societies, and vast numbers of people whose lives are for one reason or other only superficially touched by the globalising cultures associated with the West, surely confronts this issue in a more profound way.

Do we understand by 'contemporary art' only the genres and practices that are marked by some dialogue with international avant-garde art? Are these then simply local expressions of global cultural forms, essentially all variants of the same kind, like local currencies? Or do they possess more profoundly different qualities that prejudice this commensurability? Qualities that mean that we should not, in fact, see them as new instances of something we already know? Can we, or should we, see 'contemporary art' as narrowly as this? Might it, in the end, only be legitimate to see this category as including all the art that is produced in the present? And, if that means that the category becomes hopelessly inclusive and internally heterogeneous to the extent that making comparisons or judgments

becomes problematic at best, we have at least learnt something of the true complexity of international art and culture today.

In my view, the great strength of the Asia–Pacific Triennial is the evolving sophistication of its engagement with this issue, with the real diversity of the region, and the real diversity of the art produced in the various nations that are presented. This is not merely a rich, inevitably eclectic, and compelling showcase of innovative and exciting works of art from many different nations. It is also an exhibition that presents us with the question of how we recognise and engage with cultural and artistic heterogeneity today. Grasping that question is more important than answering it, if the answers are as facile or banal as the idea that, today, everybody has mixed identities. Propositions of that sort have long exhausted their usefulness in debates about global art and culture.

The proposition that things are complex is, of course, not necessarily interesting in itself. We need a way into artistic and cultural complexity that tells us something. The argument of this essay — which is unavoidably roundabout — is that a historical perspective is critical. And this may be a surprising claim to make, not for the art of the past but that of the present. It may be surprising, also, because the very opposite of this claim — the idea that works of art might be framed in an avowedly ahistorical way, to innovative and productive effect — has recently become fashionable. So let me start by considering where and how an ahistorical turn in curatorial practice has seemed to make sense.

Famously, the opening installation of the permanent collection at Tate Modern in London in May 2000 avoided art-historical chronologies and

OUR HISTORY IS WRITTEN IN OUR MATS

NICHOLAS THOMAS

Aline Amaru / Tahiti, French Polynesia b.1941
La Famille Pomare (The Pomare Family) 1991
Tifaifai, Pa'oti-style quilt: commercial cotton cloth
and thread in appliqué and embroidered
technique / 231 x 238cm / Purchased 2004.
Queensland Art Gallery Foundation Grant /
Collection: Queensland Art Gallery

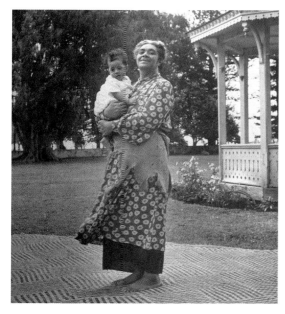

Queen Salote Tubou of Tonga, holding her grandson

Photograph: Eliot Elisofon/Time Life Pictures/Getty Images, 1949

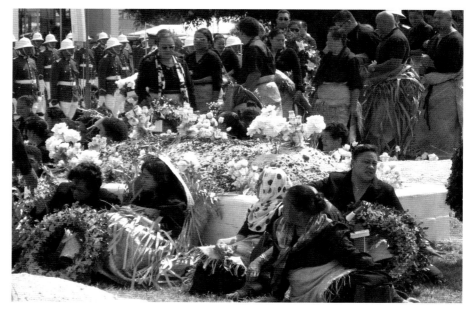

Funeral of Col. The Hon. Fetu'utolu 'Aloua Tupou, Minister of Defence, Tonga, April 2005. Woven mats serve a variety of purposes, from the ordinary to the ceremonial. For important events, the finest of these are exchanged and sometimes worn

Queensland Art Gallery Image Archive

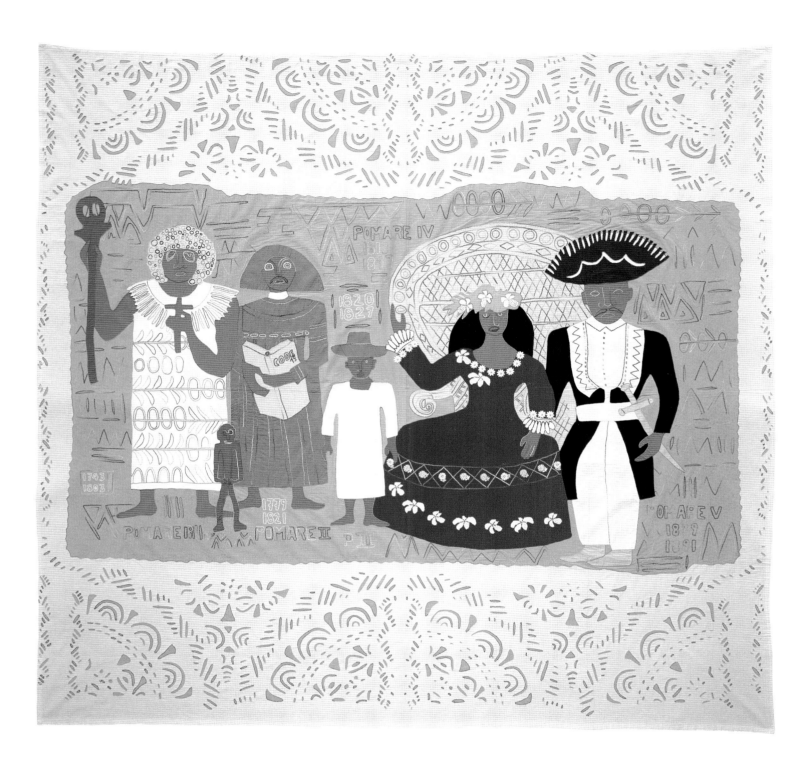

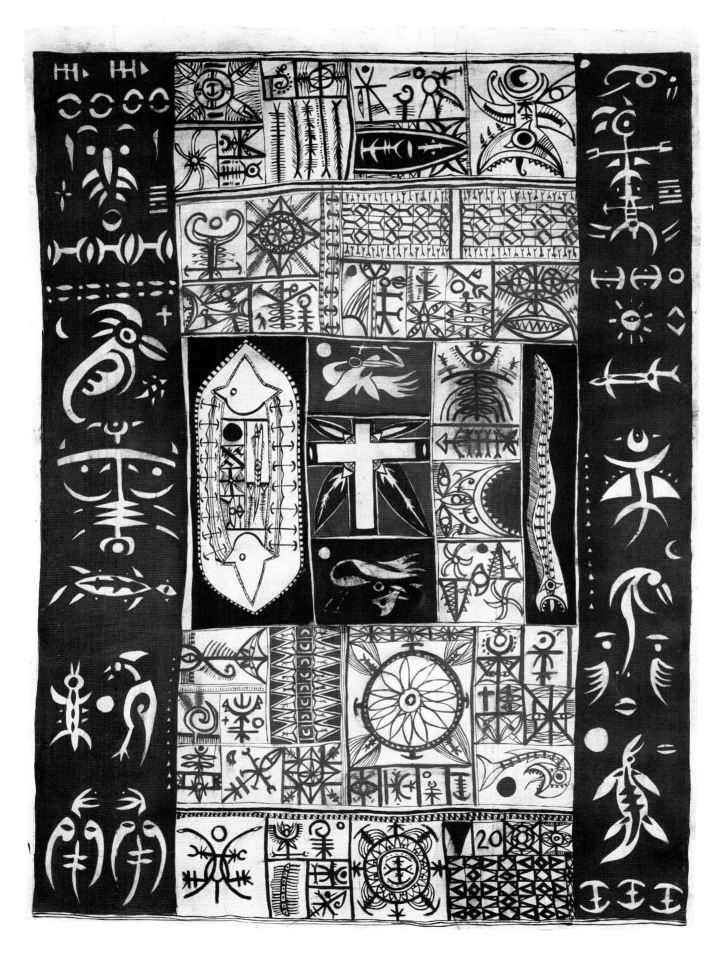

periods and instead grouped works on the basis of broad thematic rubrics.[1] Two points might be made upon this bold and much-debated gesture. The first is that the initial selection of work in the permanent modern and contemporary galleries almost completely ignored artists from outside Europe and North America. Although this unimaginative approach to what 'modern' art and culture might embrace should have been criticised more than it was, that is not my concern here.[2] The second point is that there is a link between the timidity of the Tate's engagement with any genuinely global sense of art and culture and the notion that history can and should be dispensed with. Because, of course, the primary and dominant frame of academic knowledge around modern art is the academic discipline of Art History. If that 'historical' discipline constitutes an orthodox paradigm, it may be assumed that there are gains to be made by departing from its 'historical' constitution. (Of course, what that 'history' entails has been understood in diverse ways, ranging from a narrow engagement with artists' lives and chains of influences to a social history, and is inevitably contentious; and many art historians are more interested in other approaches such as psychoanalytical ones).

The point, however, is that in the context of the canon of modern and postmodern art, history's framing status is routine; it is something to be either questioned or departed from. But this issue assumes an entirely different complexion if one is engaging, not with a well-known series of European and American modern art movements, but with cultural events and expressions from far more diverse settings — for example, with the twentieth- and twenty-first-century arts of Asia and the Pacific. These arts inevitably include both customary genres, such as woven fabrics and artefacts still categorised as works of craft rather than art by many people, and abstract paintings that evidently incorporate 'European influence' (whatever exactly that might mean). Perhaps these genres have never been embraced by a historical understanding in the first place, or their apparent histories cannot be related to those of other art movements; or they do relate to them but only in ambiguous and confusing ways. Nevertheless, it is by no means obvious, for these Asian and Pacific genres, that historicisation is a stale or dead gesture.

In reflecting on this issue, it may be productive to detour via an old argument regarding the inclusion of traditional works of indigenous art in major art museums. This has been an often repetitive debate, because of the uneven nature of the process. In north America, the tendency has long been for art museums such as the Metropolitan Museum of Art in New York to embrace Asia, Africa, etc., whereas in Europe, European art pre- and post-1900, decorative art, Asian art, and ethnographic art tend each to end up in different, vaguely complementary institutions; only in the lead-up to the opening of the Musée du Quai Branly in Paris has the Louvre exhibited tribal art, while art galleries in Australia did so from the 1970s onwards for reasons associated with the local significance and revaluation of Indigenous Australian culture. The issue that has tended to come up again and again is whether various African and Oceanic genres should be talked of as art.

What became a cliché in these discussions was the claim that there was (is) no word for 'art' in whichever local language, hence whichever African or Oceanic cultural forms did not belong in art museums because

John Pule / Niue/New Zealand b.1962
Halahala (The pathway is clear for the child to be born) 1992
Oil on canvas / 247 x 176.5cm (unstretched) / Gift of the artist 2005 / Collection: Queensland Art Gallery

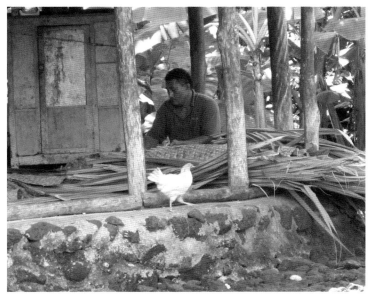

Man preparing pandanus for weaving on Manono Island. Samoa, 2005
Queensland Art Gallery Image Archive

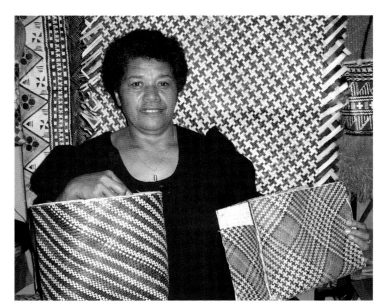

Fijian artist Finau Mara with her work. Suva, Fiji, 2005
Queensland Art Gallery Image Archive

they were not categorised as art locally. If the cliché was partially true, or sometimes true, and if there indeed needed to be a debate around the issue, the point to be made in this context is that the claim was often overstated. There may indeed have been no word for 'art' but there often were (are) words in local languages from these regions that refer to ancestral treasures, ritually charged artefacts, objects that are understood to be aesthetically and spiritually powerful, and so forth. In many cases the meanings of these terms overlap with the varied and extensive meanings of art in European languages. The issue was consistently pushed because the assumptions concerning cultural difference were essentialist.

The imputation was that Indigenous art forms emerged from a wholly alien cultural space, that anything approaching their accurate characterisation posed formidable problems of translation or interpretation. Hence, in any instance of their inclusion in a non-native context, such as a collection or an institution, the issues of decontextualisation or inappropriate recontextualisation were inescapable. Perhaps this was apt for various ritual arts but Pacific and African art traditions were always diverse. Some genres were not meaningfully obscure, they did not pose fundamental, irresolvable problems of translation, and they were and are not in an alien cultural domain unmarked by engagement with colonial, European, and globalised worlds. To insist on the untranslatability of indigenous art work is to deny the degree of mutual engagement which has in fact often been knowing and sophisticated.

I have reiterated this issue of the blindnesses associated with canonical views of indigenous art, despite it being both apparently tangential to a contemporary art exhibition and also overfamiliar for some readers, because I want to argue that it has a corollary. Just as there has been an assumption, a too routine and unexamined assumption, that 'traditional' indigenous art is incommensurable and ultimately untranslatable, it is also assumed, too routinely, that modern and contemporary art is commensurable and translatable. That is, that it is all part of one world, one system of meaning. Both these ways of seeing things are linked and both rest on an understanding of cultural exchange that is now recognised to be deficient in many ways. This understanding, expressed most simply, is that there were once diverse, different cultures that are steadily becoming Westernised and standardised. The thesis has been around for a long time but it has been aired increasingly in the context of discussions of globalisation.

While many commentators seem to take a process of cultural globalisation for granted, there are powerful objections to this understanding. First, there are many energetic global cultural circuits (for example those associated with Islamic religion and South Asian popular culture) that have nothing to do with the West or America. Second, the assumed influence of Western popular culture in many parts of the non-Western world has been wildly exaggerated. Third, in many regions (such as South Asia) where Western cultural forms are circulated locally and may be conspicuous, and where indeed links to the West via immigration are common, local cultures incorporate and deal with the foreign in complex ways. It may be facile to construe these purely as 'local appropriations', if that implies a simple reversal — the local neutralising the foreign rather

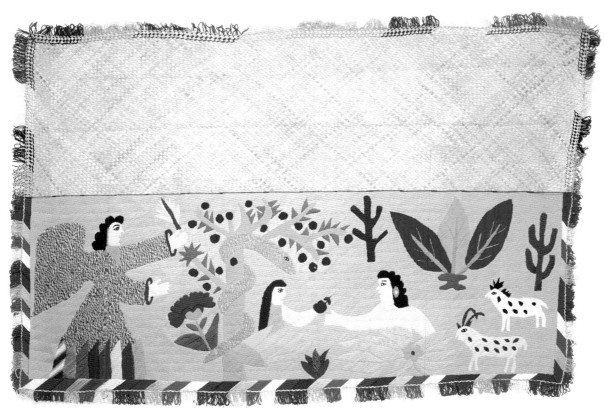

Sivaimauga Vaagi / Samoa b.1964
Fala su'i 2005
Mat: woven laufala (pandanus) and commercial wool / 148.5 x 217.3cm (irreg., including fringes) / Purchased 2005. Queensland Art Gallery Foundation / Collection: Queensland Art Gallery

than vice versa — but it cannot be doubted that global processes and cultural forms impact and are received locally in very uneven, diverse and unpredictable ways. Hence the cultures of the colonial and postcolonial world are neither purely exotic (they never were), nor have they become derivative expressions of the West (they are both less and more), nor can we see them productively as hybrids (that suggests too smooth an operation of blending).

If we need a more complex and nuanced vision of the complexity of the postcolonial world — where there may be unexpected continuities as well as losses and innovations, refusals to trade as well as energetic traffic — we need to extend this vision to the arts of the modern and postmodern epochs outside the West. The notion that on the one hand traditional practices are on the wane and, on the other, that derivative versions of modernist Western art have belatedly emerged to be succeeded by similarly second-hand postmodernist practices, will clearly no longer do. Yes, some historic genres were indeed obliterated by the obliteration of the native political and religious institutions that generated them, but other domains of indigenous life, such as those of kinship, family and genealogy, are very much alive and they continue to engender art genres associated with familial reproduction, exchange and memory. And yes, the paintings that some contemporary indigenous artists produce embrace modern, modernist, and postmodernist Western styles that are no longer of the moment, so far as artists, curators and critics in Europe and the United States are concerned.

If this is a fact, progressive art critics are prompted, almost compelled, to use a language of cultural backwardness or rather, perhaps, to avoid discussing significant bodies of non-Western modern and contemporary art because they have no terms other than these for assessing it. The right response, though, is not to ignore work that appears to invite only a paternalistic response and focus instead on the few artists who are deploying digital media, installation or other genres that sit more comfortably in biennales and similar international art fairs. The right response, surely, is to interrogate this 'fact'. Does an abstract or expressionist painting from Malaysia or the Solomon Islands, made in the first decade of the twenty-first century, really belong to the same history as abstraction or expressionism in Europe? Perhaps what we need to do is ask what these styles, genres, and practices represent locally. What salience do they possess and why might they be part of the present in one part of the world, yet not in another?

One of the most exciting features of this Asia–Pacific Triennial is the inclusion, for the first time in any major exhibition of this kind, of an important group of woven fabrics and textiles from the Pacific. These epitomise genres that are neither here nor there, so far as the longstanding, if much criticised categories of art and craft, traditional and contemporary, are concerned. Though apparently humble and utilitarian things — mats for sitting and sleeping on, decorated bedspreads — these fabrics are in fact saturated with social and cultural importance. They were exchanged in ceremonies marking key familial and political events, and the histories of their exchanges were remembered. They constituted models of exchange, genealogy, and political history.[3] They became maps of time and history. Which is why Queen Salote, the famous mid-twentieth-century Tongan

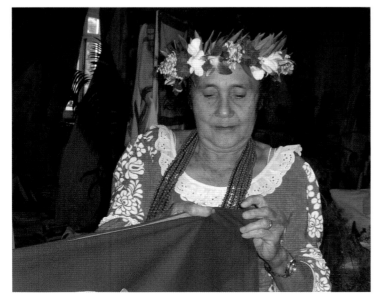

Tahitian artist Emma Tamarii folding
Couronne du Roi (The King's crown) 2003
made by the artist and her daughter and
now in the Queensland Art Gallery
Collection. Tahiti, 2005
Queensland Art Gallery Image Archive

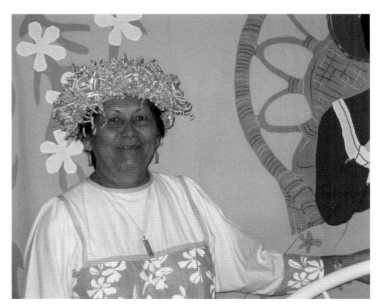

Aline Amaru. Tahiti, 2005
Queensland Art Gallery Image Archive

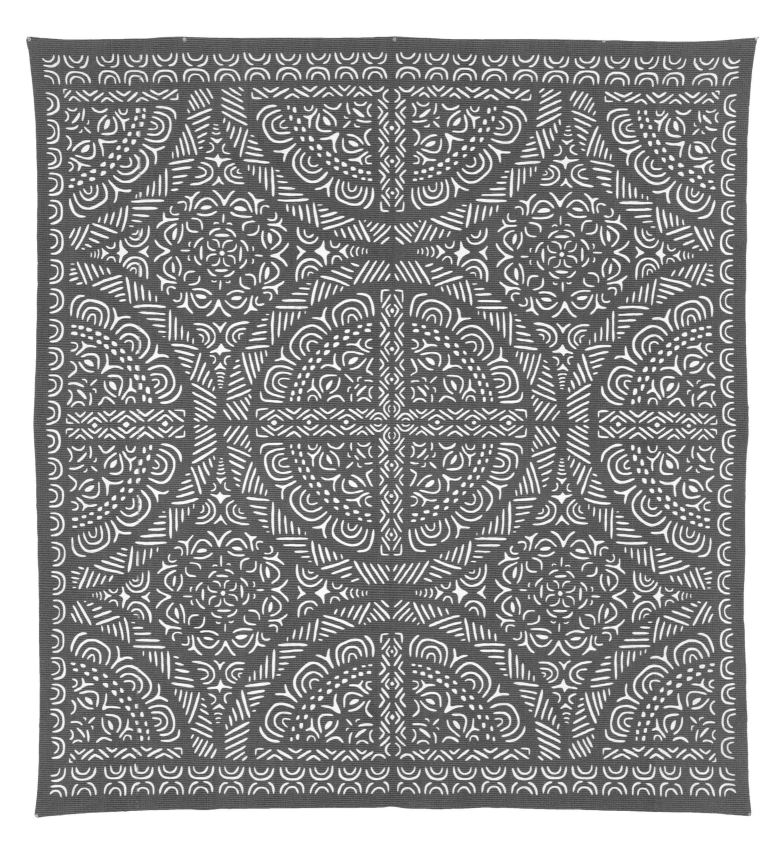

ruler, declared that 'Our history is written in our mats'.

Today, too, the *tifaifai* (appliqué quilts) of central Polynesia are assuming new forms, and imaging historical events — such as the royal family of Tahiti, who were brutally eclipsed during the second half of the nineteenth century by the French colonial administration that retains control, albeit in an increasingly contested way, in French Polynesia today. We need concepts of 'contemporary art' that make space for these remarkable works, and that prompt us to understand what they have to tell us, about place, culture, history and politics. Otherwise the loss is ours.

NICHOLAS THOMAS is a Professor and Director of the Cambridge University Museum of Archaeology and Anthropology. He is author of a number of influential books on Pacific and cross-cultural art including *Oceanic Art* (Thames and Hudson 1995) and *Possessions: Indigenous Art/Colonial Culture* (Thames and Hudson 1999).

Emma Tamarii / Marquesas Islands/Tahiti, French Polynesia b.1937
Tifaifai 2000
Marquesan style quilt: commercial cotton cloth and thread in reverse appliqué technique / 227 x 253cm / Purchased 2000. Queensland Art Gallery Foundation Grant / Collection: Queensland Art Gallery

Finau Mara / Lau Islands, Fiji b.1950
I yara yara 2005–06
Baby mat: woven voi voi (pandanus) with beach hibiscus and commercial wool / 100 x 140cm / Commissioned 2005 / Collection: Queensland Art Gallery

Introduction / The Oceania Dance Theatre, based at the Oceania Centre for Arts and Culture at the University of the South Pacific (USP) in Suva, Fiji, is creating waves in the Pacific and beyond. Its success is due to: an atmosphere that encourages the freedom of the artist to create without boundaries; a visionary leader; a talented choreographer and a cadre of multicultural dancers rooted in their own cultures, but not bound by them; and an audience hungry for original and innovative works. The success of this initiative suggests that contemporary dance in the Pacific — in contrast to traditional dance — is less concerned with the purity of dance traditions or the ethnicity or race of its dancers than with creative fusions of dance forms that reflect urban experiences and connect us to a global community.[1]

As contemporary dance groups become established and accepted widely in the Pacific, they begin to destabilise deep-seated notions that Pacific Islanders should only concern themselves with the dance forms of their specific cultures and refrain from venturing into dance traditions that are not theirs.[2] The result of this progressive ideology is that the focus is now shifting away from ethnicity or race; boundaries that have separated Pacific Islanders and other kin in the past are now crumbling. A new Oceania is emerging — one in which we are all connected — and the dance program at the Oceania Centre for Arts and Culture is at the forefront of this development.

Freedom to dance / In a moving speech by Moana Jackson of Aotearoa New Zealand at a United Nations Global Seminar at the University of Hawai'i in 2004, he reminded his audience of professors and students that the terms 'Polynesia', 'Micronesia', and 'Melanesia' are divisive categories imposed on the Pacific region by the French navigator Jules Dumont d'Urville (1790–1842). By putting the people of Oceania into three different boxes, he 'broke down, weakened and, in some cases, destroyed the long traditions and histories which had joined us together'.[3] Jackson also said that as a result of a history of colonisation in Oceania, Pacific Islanders have been preoccupied with a culture of survival as they adapted to realities imposed on them by their oppressors. The time has come, he exhorted, for Pacific Islanders to work towards a culture of freedom so they can define and represent who they are rather than have foreign powers continue to do so for them.

Epeli Hau'ofa, Director of the Oceania Centre for Arts and Culture, concurred with Jackson's assertion in his keynote address at the first academic conference on dance in Oceania, held at the Museum of New Zealand Te Papa Tongarewa, in Wellington, New Zealand, in 2005. Like Jackson, he sees the carving up of the Pacific into three different areas as responsible for severing our historical, social and cultural ties. According to Hau'ofa, the time has come for Pacific Islanders to find their lost relatives.[4] Both Jackson and Hau'ofa clearly recognise the importance of Pacific Islanders taking charge of their present as well as their future. Both also advocate the need for the peoples of Oceania to be free from the shackles of colonialism and to recognise their common history and heritage.

But free to do what? In the context of this paper, free to dance any way we want, free to produce original dances that dazzle the eye, move the heart and speak to our human experience. Free to perform each other's

DANCING OCEANIA

VILSONI HERENIKO

Performance of *Fenua* (a contemporary interpretation of Tahitian traditional dance) by Oceania Dance Theatre at the Oceania Centre for Arts and Culture, University of the South Pacific, Fiji, September 2006

Choreographer: Allan Alo / Image courtesy: Oceania Centre for Arts and Culture, University of the South Pacific, Fiji / Photograph: Ann Tarte

Oceania Centre for Arts and Culture, University of the South Pacific, Fiji, 2005
Queensland Art Gallery Image Archive

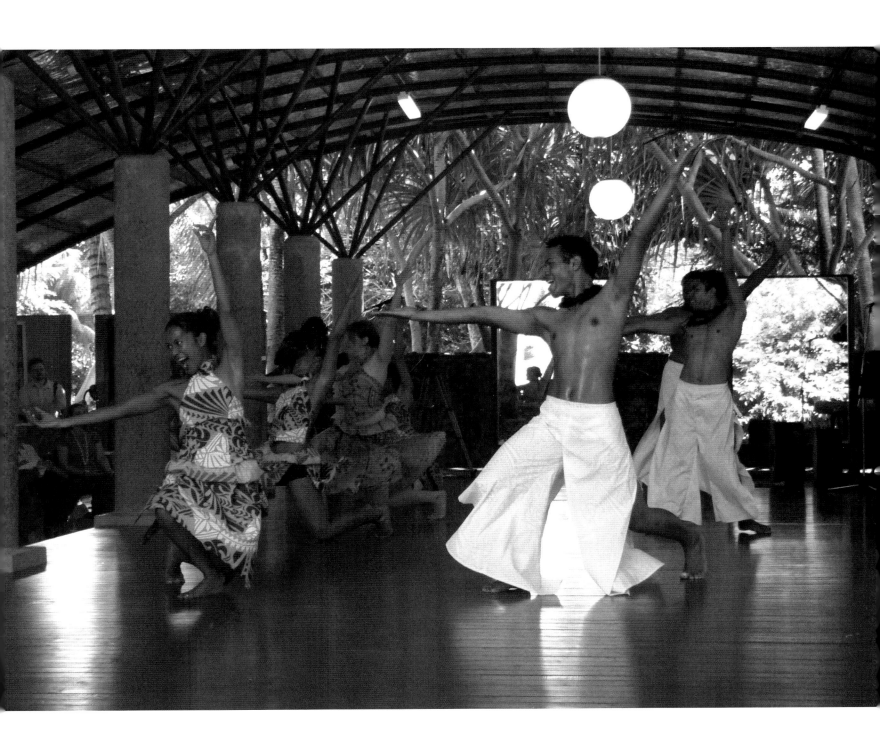

dance traditions if we wish to, as well as adapt them for present-day audiences without fear of being ridiculed or abused. Overall, however, Pacific Islanders are very protective about their traditional dances and frown upon outsiders who appropriate their dance styles or movements. The reason for this attitude is our present fear that, if we don't protect our traditional dances from foreign interests, we will lose what has taken us years to recover.

A historical overview / When missionaries entered the Pacific in the late eighteenth century, one of the first things they did was try to eradicate Pacific dance, together with other aspects of island life they regarded as heathen. The first missionaries linked dance with paganism and, in most parts of the Pacific, forbade their new converts to dance.[5] An example from Tahiti should suffice to illustrate this wide-spread practice. In 1796, the London Missionary Society sent its first missionaries to Tahiti and, in 1814, they began to meet with success. When King Pomare became a Christian — as was the case with many other parts of the Pacific when kings or chiefs converted — the rest of the inhabitants 'renounced idolatry, and destroyed their idols, or gave them up to the missionaries'.[6] About this time, the missionaries succeeded in abolishing the Arioi Society, a religious order that engaged in dance and play-acting when its members travelled from one island to another.

The missionary William Ellis had nothing positive to say about the Society and its practices. Words like 'abominable', 'unutterable' and 'debased' proliferate in his descriptions. However, Ellis was correct in his observation that the Tahitians' 'system of religion was interwoven with every pursuit of their lives'.[7] Tahitian dance, like other dances forbidden by missionaries in the Pacific, survived because of its centrality to the cultural identities of Tahitians.[8] Determined to keep dancing, practitioners passed on their knowledge of dances in secret until the public arena was safe for the re-emergence of traditional dance — in many instances, around the 1960s and 1970s.

The revival of ancient dance practices meant trying to remember, record, relearn and perpetuate dances previously forbidden. However, because of social, cultural and religious changes in the years between missionary arrival and the return of traditional dance into the public arena, what was revived was not exactly the same as what was practised on the eve of missionary intervention. The word 'traditional' has therefore become a source of contention, and is often interpreted instead to mean what is acceptable in contemporary Christian society.[9]

The Festival of Pacific Arts / The first South Pacific Festival of Arts, held in Suva, Fiji, in 1972, provided an arena for the disconnected and marginalised efforts of dance practitioners throughout the Pacific to find strength in a collective vision. This was the first regional event that gave Pacific Islanders the confidence they needed to continue practising, teaching and performing their dances and other art forms. Although its name has changed to the Festival of Pacific Arts, its original mandate has remained largely unchanged. It continues to be the premiere festival in the Pacific region for the promotion and perpetuation of traditional Pacific dances.

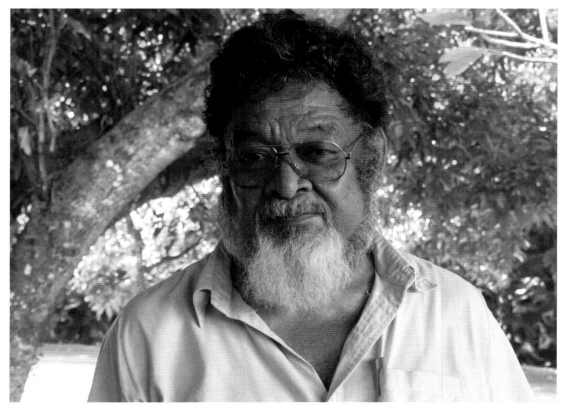

Epeli Hau'ofa, Director of the Oceania Centre for Arts and Culture, University of the South Pacific, Fiji

Image courtesy: Oceania Centre for Arts and Culture, University of the South Pacific, Fiji / Photograph: Ann Tarte

Held every four years, the festival has been hosted by the following Pacific Island countries: Fiji (1972), New Zealand (1976), Papua New Guinea (1980), French Polynesia (1985), Australia (1988), Cook Islands (1992), Samoa (1996), New Caledonia (2000) and Palau (2004).[10] The host for each festival has tended to emphasise aspects of Pacific art it deemed important and, in the case of dance, some differences in opinion on what is appropriate costuming has emerged. For those with a fundamentalist interpretation of the bible, this does not include exposed breasts or buttocks even if such was the traditional practice.

At the Cook Islands festival, where Indigenous Australian women performed topless, some spectators laughed at them; at the Samoa festival, one of the organisers slapped the bare buttocks of a male performer with a coconut frond to demonstrate his displeasure.[11] Such attempts to police what is allowable or not in what was originally intended to be an arena for the revival of 'tradition' reflect the diversity of Islanders' experiences and varying degrees of colonisation among island countries. It also underscores the importance of acknowledging that, although there are many aspects of Pacific cultures that are common throughout the Pacific, there are different colonial histories (the result of different colonial masters) and geographies (atolls versus volcanic islands, for example) that have made each island culture evolve in unique ways.

Westernisation or modernisation has had varying degrees of acceptance and importance among Pacific Island countries. The same is true of Christianity. Also, there are different phases in the decolonisation process. For example, Fiji, Samoa, the Solomon Islands and Papua New Guinea are now independent, whereas the indigenous peoples of Hawai'i, New Zealand, French Polynesia and New Caledonia are still fighting for sovereignty. Ironically, some independent nations appear the most concerned about being covered up while performing their traditional dances, especially in countries where Church and State are closely allied.[12] However, traditional Pacific dance remains an integral part of Pacific Island cultures. Each country prides itself on perpetuating its cultural dances and its indigenous population can be very territorial about who has the right to perform its dances. Having the right pedigree is often more important than talent when it comes to selecting artists to participate at the Festival of Pacific Arts.

Outside the Festival of Pacific Arts, in formal contexts, it is still the norm to expect that only Samoans should perform Samoan dances, Tongans should perform Tongan dances, Hawaiians should perform the hula, and so on. When individuals have not adhered to this unwritten rule, they have been criticised by Pacific Islanders who see themselves as 'owners' of the dance.[13] It takes a lot of courage for a Fijian, for example, to perform a hula. However, the context can influence what is allowable and what isn't. For example, an impromptu performance of the hula by a Caucasian at a wedding may be permissible but, in the present context of Hawai'i, will most likely be frowned upon by Native Hawaiians and other Pacific Islanders in the audience. It would not surprise me if some were to walk out during such a performance as a way of protesting that their dance has been appropriated by a member of the race that at one time tried to kill it. Some may even call this act of appropriation neo-colonialism.

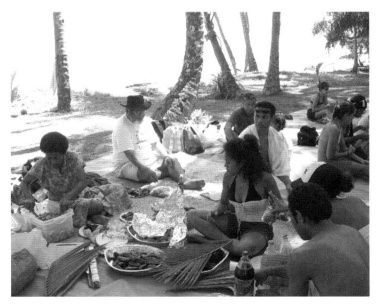

Epeli Hau'ofa and staff of the Oceania Centre for Arts and Culture sharing a meal at the University of the South Pacific, Fiji

Image courtesy: Oceania Centre for Arts and Culture, University of the South Pacific, Fiji

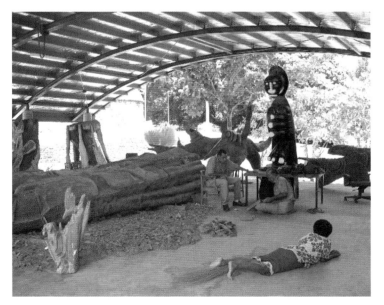

Sculptor working at the Oceania Centre for Arts and Culture, University of the South Pacific, Fiji

Image courtesy: Oceania Centre for Arts and Culture, University of the South Pacific, Fiji / Photograph: Ann Tarte

There are certain public spaces where the ethnicity of the dancer doesn't matter so much to the viewer, but these performances are usually intended for tourists or for people who don't know any better. A tourist is unlikely to be able to tell the difference between Tongans, Samoans, Tahitians or Cook Islanders. They may not even care. Thus, at the Polynesian Cultural Center, all Polynesian ethnicities are interchangeable and, although the kinds of dances performed change from one island culture to another, the ethnicities of the performers do not change accordingly. As the number one tourist attraction in Hawai'i, the Polynesian Cultural Center is a big success financially. Yet their performers have never been chosen to represent Hawai'i at any Festival of Pacific Arts. Only Native Hawaiians have been chosen; the same practice exists for the rest of the Pacific.

The nation of Fiji usually represents itself at the Festival of Pacific Arts by sending four separate dance groups: Fijian, Indian, Rotuman, and Chinese. It is telling that, since 1972, Fiji has never allowed the same delegates to perform dances drawn from these four different dance traditions. From a financial point of view (a sore point every time the festival comes up), such an ensemble would save the country a lot of money because travel and other expenses would be greatly reduced since there would be fewer performers. Also, this kind of representation would mean that all performers would have to learn each others' dance traditions, and possibly the language and the culture. In terms of moulding a nation of diverse cultures and peoples, this notion appears politically astute and necessary. Yet, the idea remains unthinkable for the vast majority of Fiji's peoples, even after more than 125 years of living together.

The only dance in which Fiji's multicultural community participates as one is in the contemporary or creative dance category. Members of this dance ensemble at the 2004 Festival of Pacific Arts in Palau consisted of Fijians, Indians, Rotumans, and Chinese. They were an ad hoc group put together specifically for the festival, rather than an established dance ensemble. After the festival, the dancers dispersed. For a multicultural representation in dance to receive wide acceptance, a sustained and more professional approach is needed. This is where the dance program at the Oceania Centre for Arts and Culture comes in.

The Oceania Centre for Arts and Culture / The Oceania Centre for Arts and Culture was established in 1997 after many years of struggle for existence. Epeli Hau'ofa was appointed its Director but was not handed a job description. Because the USP's interest in arts and culture is minimal compared to its high regard for formal academic disciplines and programs, it allocated little money for the centre's development. Hau'ofa was given a program assistant and a part-time cleaner and left alone to either flounder or flourish. Seizing this rare opportunity to do something unconventional in academia, he brought together school drop-outs, unemployed youths, and part-timers and casuals, and facilitated their desire to be artists — be it painter, sculptor, musician or dancer.

Hau'ofa is ambivalent about formal training in the arts because it is more concerned with 'international standards' and developing aspiring artists 'away from our Oceanic base'.[14] He supports Ulli and Georgina Beier — two influential catalysts in the growth or art and creative writing in

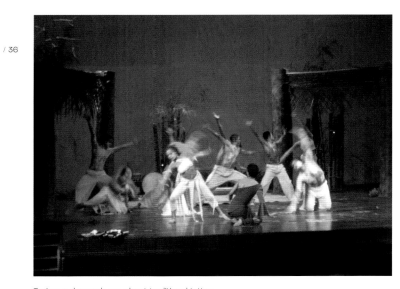

Ta-tau, a dance drama about traditional tattoo, performed by the Oceania Dance Theatre at the Oceania Centre for Arts and Culture, Fiji in 2003. The 'woman' in the photograph is the male dancer, Pelu Fatiaki

Choreographer: Allan Alo / Image courtesy: Oceania Centre for Arts and Culture, University of the South Pacific, Fiji / Photograph: Ann Tarte

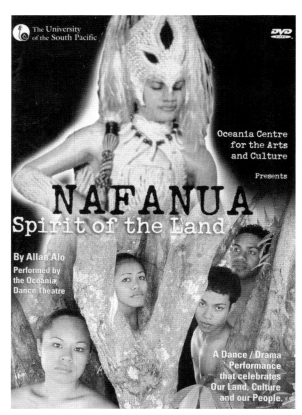

DVD cover for *Nafanua: Spirit of the Land*
Choreographed by Allan Alo and performed by Oceania Dance Theatre at the Oceania Centre for Arts and Culture, University of the South Pacific, Fiji 2005

Papua New Guinea in the 1960s and 1970s, and in the formation of a philosophical foundation for the Oceania Centre for Arts and Culture — in their view that formal Western training in the arts can stifle strong personalities and original creative talents. Thus, the Oceania Centre for Arts and Culture employs a hands-on approach to teaching and learning so that students develop at their own pace; instead of emulating Western ideas and practices, they look to contemporary Pacific cultures as well as past and present experiences for inspiration. Every now and then, the centre invites a visiting artist with a unique Pacific perspective to reinvigorate and mentor its students. The first such artist was John Pule, the New Zealand-based Niuean artist whose work is inspired by the use of earth colours as well as tapa and mat designs.[15]

A student who participated in one of the painting workshops held at the centre was Allan Alo, originally from Samoa. Alo told Hau'ofa he wanted to develop his choreographic talent and Hau'ofa hired him on a part-time basis soon afterwards. In 2000, the Oceania Centre launched the Oceania Dance Theatre, with Allan Alo, Letava Tafuna'i and Katerina Martina Teaiwa as its founders.[16] Now, Alo is a full-time lecturer at the centre, and is also its choreographer. Charismatic, talented and passionate about dance, Alo 'grew up learning traditional Samoan dance but since then has explored modern, contemporary, jazz and funk dancing'.[17] After gathering a group of young people to work with him and with each other, he began developing dances that draw from Pacific cultures as well as from modern Western and Eastern dance forms. Like another artist at the centre, Sailasa Tora, who has developed a unique style of Fijian music,

Alo has developed a contemporary dance style that is new to the Pacific region.

In December 2005, I spent two weeks as artist-in-residence with the Oceania Centre for Arts and Culture. During several conversations with the Director and through personal observation, I came away wishing that all Pacific Studies programs would have the kind of vision and atmosphere that exists at the centre. Hau'ofa is a gentle, dedicated, hardworking, generous and brilliant mentor of young people. Prior to being Director of the Oceania Centre, Hau'ofa was Head of the School of Social and Economic Development, the largest School at USP. He holds a PhD in anthropology from the Australian National University, has a long history of teaching at university level, and is one of the Pacific's most respected writers and public speakers. In short, he doesn't have to spend the best years of his life building up a centre from scratch. Yet, he has chosen to be director of one of the most poorly funded art and culture programs at any university, surrounded by young people who arrive at the centre, not through a rigorous selection process but through their own volition and a desire to create art.

In 2005, the artists involved with the Oceania Centre's programs consisted of Fijians, Indians, Rotumans, Solomon Islanders, Tongans, Samoans and Caucasians, all working harmoniously and learning with and from each other. In early December 2005, I observed members of Allan Alo's dance group rehearsing diligently, during his absence, for an upcoming performance at a hotel on another part of the island.[18] I was surprised at how difficult it was to tell who was in charge. There was no

The Oceania Dance Theatre performing 'Woman' from the production *Va, The Broken Sinnets* in 2004. From left to right: Sinu Naulumatua, Ateca Ravuvu, Ane Ester

Choreographer: Allan A'o / Image courtesy: Oceania Centre for Arts and Culture, University of the South Pacific, Fiji / Photograph: Ann Tarte

single individual shouting out commands or lording it over the others. Yet they were focused and serious, like true professionals. Later, I discovered that these dancers are paid for doing what they love to do, which partly explains their motivation for excellence. As paid dancers, they are motivated to rehearse regularly, keep fit and perfect their technique. Since the amount each dancer receives at a performance varies depending on the venue, the takings at the box office as well as the extent of participation, there is added reason for total commitment. Several of the dancers even left their academic programs at USP to dance full-time for Alo.[19]

Hau'ofa's hope for a centre that brings the diverse peoples of Oceania together is reflected in its present home, which he describes as 'conducive to creativity, an environment that people would find relaxing and welcoming'.[20] As a Tongan rooted in his culture, but who has lived in different parts of the Pacific (he also speaks several Pacific languages), Hau'ofa infuses the centre with a Pacific sensibility and world-view that motivates the artists in his care. For example, Hau'ofa correctly observes that 'In Oceanic societies, we prefer to do things with enjoyment, mixing work and pleasure shamelessly'.[21] At his centre, he practices what he preaches.

Hau'ofa's group of artists spend a lot of time together. For instance, when I was there, I joined everyone (including the Director, the program assistant, and the cleaner) for a picnic at the beach. It looked very much like a big happy family having a great time: swimming, barbequing, laughing, playing soccer, lying around and telling stories. It was an end-of-year celebration and yet there was no drunkenness, fighting or evidence that this diverse group of artists from different parts of the vast Pacific did not

get along. In previous years, the university has had bad publicity about ethnic tensions on campus that sometimes culminated in bloody brawls among the different ethnic groups. It was refreshing to see evidence to the contrary.

On one of my day-time visits, I saw seven dancers in tights, shorts and T-shirts rehearsing on a raised wooden stage in full view of the public. Nearby, two sculptors chipped away at their wood while holding a conversation with the part-time cleaner who was lying on the floor listening to and observing them. Nearby, out of sight of the dancers, the musicians and the painters were telling stories and laughing. Hau'ofa rightly views such 'noisy openness with very little privacy' as an important aspect of community life in Oceania.[22] With painters, sculptors, dancers, musicians and visitors interacting harmoniously, the centre has become a safe haven for all kinds of aspiring artists. Indeed, it is a space where 'lost relatives' can be found; on arrival, they are sometimes greeted with a welcome bowl of kava.

Unlike the vast majority of art and culture programs in the Western world that are enclosed in air-conditioned buildings, the centre is an open space where anyone can wander in at anytime, uninvited and unannounced. Again, lack of money is a blessing; had the centre been endowed with millions of dollars at its inception, one would have to make an appointment to see its Director. Instead, one can see him and his students at work and play from the main road that winds its way around the campus. The dancers also rehearse in full view of the general public and the art exhibitions enjoy the same visibility. As Hau'ofa points out, it is

Minoi 1999 was choreographed by Neil Ieremia and premiered at the Spiegel Tent, Auckland, New Zealand in 1999

Image courtesy: Black Grace Dance Company / Photograph: Scott Venning

Neil Ieremia, Artistic Director of Black Grace Dance Company

Image courtesy: Black Grace Dance Company / Photograph: John McDermott

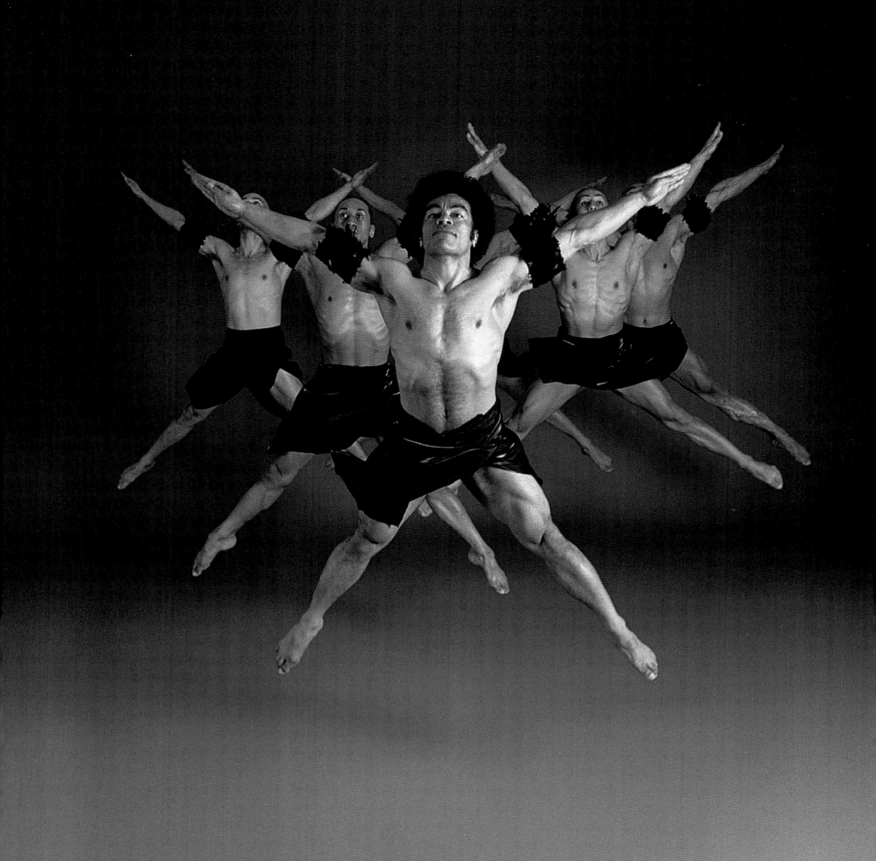

a space that is 'free in an increasingly managed and controlled world'.[23] In this kind of space, where freedom reigns and everyone is treated as equal regardless of ethnicity, race, economic status, class and sexual orientation, it becomes possible to create new dances that are free of the shackles of our past, our racial prejudices and our fears of criticism.

Dance at Te Papa / At the first academic conference on Pacific dance, held at the Museum of New Zealand Te Papa Tongarewa, more than a dozen dance groups from various parts of Oceania provided attendees with an overview of the present status of dance in Oceania. Titled 'Culture Moves! Dance in Oceania from Hiva to Hip Hop', this conference assembled dance groups that normally perform separately in different venues for different audiences. It also attracted 'choreographers, dancers, composers, curators, costume makers scholars, writers, musicians and artists to participate in a discussion on the knowledge and practice of dance in Oceania across cultural, national, academic and aesthetic boundaries'.[24] The conveners — Katerina Martina Teaiwa of the University of Hawai'i, April K Henderson of Victoria University, Wellington, and Sean Mellon of Te Papa Tongarewa — used every effort to be inclusive of all kinds of dance, and left one wishing that the Festival of Pacific Arts would do the same when it holds its next festival in American Samoa in 2008. It is important that what we see on stage reflects actual contemporary dance practices; to give the impression that all young people in the Pacific are interested only in performing their traditional dances is burying our collective heads in the sand. Hopefully, the example that has been modelled at this conference

will bring about changes in the wider community's perception of the wide-ranging nature of dance forms in the contemporary Pacific and lead to better appreciation of non-traditional dance genres.[25]

While the most internationally successful dance company, Black Grace, did not perform, its director, Neil Ieremia, was a participant at one of the panels in which he expounded on his group's philosophy. A video of this company satisfied the curiosity of conference goers who had not seen their live performances. Like the Oceania Dance Theatre, this dance ensemble is multicultural, although it consists primarily of Polynesian men. Recently, it has added some women performers who have broadened its repertoire of dances. I attended a Black Grace performance at Leeward Community College in Hawai'i in 2005, and witnessed a full house rise to their feet in adoration and to cheer for more. I left the theatre feeling awed by the brilliant choreography and the physical stamina of its dancers.

An advantage of having so many groups perform dances that ranged from traditional to contemporary to hip-hop is that the best dancers and the best dance groups become evident. Pacific audiences are not shy to express their emotions, particularly when watching their own people on stage. When there is little applause or clapping, no shouts or shrieks of delight, it means we are not impressed. The reverse means we are having a great time being entertained, and we are appreciative of the hard work that went into preparation. At Te Papa, audience reactions varied, acting as a barometer on the quality of the performers on stage. Some groups were better prepared than others; some better costumed; others better choreographed. As a dance ensemble, the Oceania Dance Theatre best

Micronesian dancers at the Festival of Pacific Arts, Palau, 2004
Queensland Art Gallery Image Archive

embodied the contemporary spirit of Oceania. As usual, Alo's choreography was inventive. It was familiar because we recognise influences from established dance traditions, yet unfamiliar in its final interpretation into dance movement. The music, costuming and storyline are contemporary, original and bold, if not defiant. For example, the performance I saw began with a Fijian woman clad in a green sari, her bellybutton and midriff showing, poised like a dancing Shiva with her arms outstretched and her eyes gleaming like jewels. By collapsing Fijian and Indian identities into one, this image challenged me to see Fiji with fresh eyes, and to hope for a future in which Fijians and Indians live together in peace and harmony.[26]

Conclusion / True artists need freedom to create, to produce something new or different, something that has never been performed before. To insist artists should only work within the narrow confines of their own ethnicity or culture is to stunt their creative talents. Although one can be creative within the tiny box we call traditional dance, for those whose experience is multicultural, this box is too limiting. So far, Hau'ofa has been successful in keeping the Centre free of institutional constraints. This freedom energises and motivates its dance director–choreographer and other artists from diverse and varied backgrounds to be innovative; they are limited only by their imagination.

Their cultural backgrounds may inform or inspire their dance movements, lyrics, music and storylines, but the dancers at the Oceania Centre are not stuck in their ethnic or racial boxes. Instead, they draw from any and all sources available to them. An Indian can perform a Fijian dance; a Fijian can perform an Indian dance; a Caucasian can perform them all.[27] Ethnicity or race is not as important as whether or not one can dance, and dance well. Moreover, the dance movements are not necessarily traditional; quite often they merely hint at their cultural origins. This melding of dance traditions and genres performed by a talented group of energetic Oceanians has become the defining characteristic of the Oceania Dance Theatre.

A culture of freedom, of the kind advocated by Jackson and Hau'ofa, exists at the Oceania Centre for Arts and Culture at USP, at least at the time of writing.[28] As the years go by and the Oceania Dance Theatre becomes more secure and innovative, its reputation for producing works of incredible beauty and power will spread beyond the Pacific to the rest of the world. And when we watch its members dancing with passion and grace, we'll be transported to other realms and other worlds we can only dream about now.

VILSONI HERENIKO is Professor of Pacific Studies, Centre of Pacific Islands Studies, University of Hawai'i. He is an award-winning playwright, filmmaker and author, and has studied in Fiji, England and the United States, leading to a PhD in literature and language from the University of the South Pacific. In 1997, he was the recipient of Hawai'i's prestigious Elliot Cades Award for literature for his 'significant body of work of exceptional quality'.

Allan Alo, Director and choreographer for the Oceania Dance Theatre, performing the dance drama *Va, The Broken Sinnets* at the Oceania Centre for Arts and Culture, Fiji in 2004. The character represented is *Aitu o le Aoa* (Guardian spirit of the forest)
Image courtesy: Oceania Centre for Arts and Culture, University of the South Pacific, Fiji / Photograph: Ann Tarte

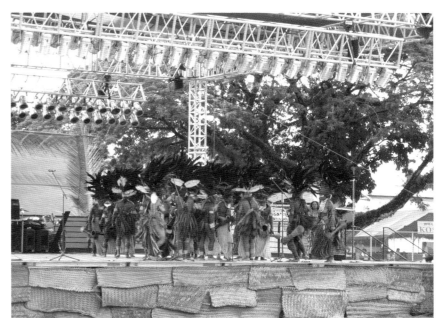

Papua New Guinean performers at the Festival of Pacific Arts, Palau, 2004
Queensland Art Gallery Image Archive

Works of art and film do not necessarily — or even very often — speak for themselves. When shown outside their local contexts of production and exhibition, such cultural objects call for intelligent translation if viewers are not to run the risk of becoming what Paul Willemen has called 'cultural ventriloquists', hearing only their own voices speaking for the work, although believing it is the work speaking to them.[1] Assertions of the existence of universal formal qualities in art production expressed in an international language of art history have often looked for similarities and essences, and tended to ignore or erase specificity, minimising the attention given to what may be lost in translation. Translation is in no way a transparent process. Walter Benjamin points to the imperative and impossibility of translation in his important 1969 essay, 'The task of the translator'.[2] Many other recent cultural theorists have also turned their attention to questions of translation; art historian Sarat Maharaj colourfully describes the stakes of the debate:

> Translation, as Derrida [says], is quite unlike buying, selling, swapping — however much it has been conventionally pictured in those terms. It is not a matter of shipping over juicy chunks of meaning from one side of the language barrier to the other — as with fast-food packs at an over-the-counter, take away outfit. Meaning is not a readymade, portable thing that can be 'carried over' the divide.[3]

The translator's challenge is to do justice to the original while maintaining something of its strangeness and unfamiliarity — to allow it, impossibly, to be itself.

Cinema is a product and symptom of modernity, but also occupies a privileged position from which to digest modernity's effects. The fifth Asia–Pacific Triennial includes a cinema program entitled Hong Kong, Shanghai: Cinema Cites. It features over 50 films produced in Hong Kong and Shanghai from the 1920s to the 1960s, and profiles the interconnected film histories of these cities. Important centres of film production, both cities have generated strong cinematic responses to their particular urban character and histories of social upheaval.[4] In this period, directors, actors and other crew moved frequently between them, often in response to major political events: the occupation of Shanghai by Japanese forces from 1937 and its attendant wave of refugees taking flight to Hong Kong; the protracted struggle between communists and nationalists for control of Republican China, culminating in the communist victory in 1949; the continued emigration of artists and intellectuals to Hong Kong throughout the 1950s. As scholar Miriam Bratu Hansen states in her elegant analysis of Shanghai silent film and 'vernacular modernism':

> Shanghai cinema must have allowed its viewers to come away from the film and imagine their own strategies of survival, performance, and sociality, to make sense of living in the interstices of radically unequal times, places and conditions.[5]

The study of locally defined modernisms — which privileges culturally specific and everyday responses to modern life — in the cosmopolitan cinemas of Hong Kong and Shanghai is useful in establishing 'the historical

SEEING WHAT IS (THERE)

Production still from *The Spring River Flows East (Yijiang Chunshui Xiang Dongliu)* (detail) 1947
Director: Cai Chusheng / 35mm, 190 minutes, b. & w., mono, Shanghai, Mandarin / Image courtesy: British Film Institute and China Film Archive

KATHRYN WEIR

The triumphant Communist Party forces parade a banner in Shanghai 27 June 1949
Image courtesy: Bettmann/CORBIS

Hong Kong in the 1940s
Image courtesy: Bettmann/CORBIS

connection or dialogue between film culture and modernity, and between cinema and other media'.[6] This allows for a more complex understanding of cinema's place in modernity than is possible through analyses of 'popular' or 'mass' culture (understood as a struggle between high and low forms). The emergence of international distribution and exhibition networks for cinema raises questions about the relationships between local, regional and antipodean conversations and forms.

The film productions of Shanghai and Hong Kong in the modern period are examples of distinct cultural forms that thrived in a local and regional context. They drew on the operatic and literary traditions of China, while also absorbing and inflecting influences from Europe and North America, particularly from the Hollywood productions that conquered cinema screens around the world. Carefully negotiating cosmopolitan, national and regional elements, films produced in Shanghai and Hong Kong were increasingly successful from the 1930s in feeding the Nanying (South-East Asia) market, notably Singapore. Cinema was integrated into the heart of these fast modernising cities, and was central to their 'mass culture of leisure, entertainment, and fashion, of cafés and tea houses, department stores, dance halls, night clubs, and brothels'.[7]

Given the broadly modulated cultural references of Hong Kong and Shanghai directors and screenwriters, it is not surprising that they created specifically located modernist cinema with overt cosmopolitan range. Alongside local influences such as that of Chinese urban fiction by the popular 'Mandarin Duck and Butterflies' school of writers, adaptations of European, American and Japanese literary and theatrical works were highly prized, and Hollywood films inspired similar screenplays with regional inflections. European literary works adapted for cinematic screenplays included for example Oscar Wilde's *Lady Windemere's Fan* 1892 — *Shao Nainai de Shanzi (The Young Mistress' Fan)*, made by Li Pingqian in Shanghai in 1939 — and 'Boule de Suif' 1879, Guy de Maupassant's short story of a self-sacrificing prostitute, set during the Franco-Prussian War of 1870–71.[8] Zhu Shilin's adaptation of Maupassant, *Hua Gu Niang (The Flower Girl)*, made in Hong Kong in 1951, transposes it to the Sino-Japanese War of 1937–1945. The enormously popular Li Lihua — like Zhu, an émigré from Shanghai to Hong Kong in the 1940s — plays Hua Fengxian who has become a prostitute after losing her father and brother in the war. She sacrifices herself to detain and kill a Japanese commander. Li Lihua was a transnational star, first across Asia, later also in the United States, where she appeared opposite Victor Mature in Frank Borzage's *China Doll* 1958. The flow of cinematic exchange between Shanghai and Hong Kong began to diminish from 1952, the year in which ten left-wing representatives of the film industry were deported back to China, and in which China closed its doors to Hong Kong film productions.

Hollywood films of the 'classical era', from the beginnings of the studio system to around 1960, are characterised by the systematisation of a cinematic language, which made pervasive use of continuity editing to give the impression of a seamless narrative, and by storytelling based on individual character's psychology and actions. It was not so much any universal qualities of the content or style that made this form of cinema internationally successful, but rather the mirror it offered audiences who

Li Lihua, June 1956, after being signed by Cecil B DeMille to make her American motion picture debut alongside Yul Brynner in **The Buccaneer** 1958. Although she did not appear in this production, she went on to star in Frank Borzage's **China Doll** 1958

Image courtesy: Bettmann/CORBIS

Li Lihua in *Flora* aka *The Flower Girl* (*Hua Gu Niang*) 1951

Director: Zhu Shilin / 16mm, 96 minutes, b. & w., mono, Hong Kong, Mandarin / Image courtesy: Marie-Claire Quiquemelle & Centre de Documentation du Cinéma Chinois

Li Lihua in *The Beauty and the Dumb* (*Yi Ming Jingren*) 1954

Director: Tang Huang / 35mm, 98 minutes, b. & w., mono, Hong Kong, Mandarin / Image courtesy: Marie-Claire Quiquemelle & Centre de Documentation du Cinéma Chinois

Li Lihua in *Spoiling the Wedding Day* aka *Should They Marry* (*Wu Jiaqi*) 1951

Director: Zhu Shilin & Bai Chen / 35mm, 98 minutes, b. & w., mono, Hong Kong, Mandarin / Image courtesy: Marie-Claire Quiquemelle & Centre de Documentation du Cinéma Chinois

were digesting a historical period of transformation. Hollywood cinema threw into question particular social identities and gender relations, suggesting new possibilities and advancing new cultural styles. As Hansen suggests:

> ... the cinema was not only part and promoter of technological, industrial–capitalist modernity; it was also the single most inclusive, *public* horizon in which both the liberating impulses and the pathologies of modernity were reflected, rejected, or disavowed, transmuted or negotiated.[9]

The experience of modern life, including technological, economic and social change was simultaneously digested in different parts of the world, and the opportunity to see how others were negotiating modern life was irresistible. Many films were in fact changed for presentation in different parts of the world: edited for particular markets, censored, differently programmed and advertised, and also dubbed and subtitled. Most interestingly, specific Hollywood genres were more popular in particular countries or regions: slapstick comedy was very popular in Europe and Africa; in India, the runaway successes were musicals and historical costume dramas, which display significant parallels with classical Indian epic theatre and dance.[10]

A privileged example of a regional creative preoccupation not valued in international modernist readings of aesthetics is that of 'melodrama'. Melodramatic forms are ubiquitous across large parts of Asia, though varied in their specific cultural manifestations. Wimal Dissanayake suggests in his introduction to the landmark study, *Melodrama and Asian Cinema*, that:

> In most Asian societies melodrama has a distinguished history considerably different from its history in the West and is intricately linked to myth, ritual, religious practices, and ceremonies.[11]

Dissanayake claims, for example, that much of classical Indian drama could be categorised as melodrama. Studies of popular cinema also suggest that a 'melodramatic mode' is widely linked to cultural transition, particularly to modernisation.[12] Melodrama is a dominant form in Chinese cinema and figures strongly in the Hong Kong, Shanghai: Cinema Cites film program. Chinese family melodrama is also a longstanding and important genre in popular literature. *Yi Jiang Chun Shui Xiong Dong Liu (The Spring River Flows East)* 1947 is an epic melodrama by directors Cai Chusheng & Zheng Junli which mirrors political events in the period between the war against the Japanese (1937–45) and the communist victory of 1949. It traces a mother and her child, who become separated from the child's father in occupied Shanghai. He escapes to a Kuomintang-dominated area and slides into decadence, taking a mistress. The mother, destitute on the city streets with her child, is a potent symbol of the suffering inherent in political conflict and social change.[13] In later mainland Chinese melodramas, the permutations in family relationships and plot lines reflect changes in Communist Party policies. Xie Jin's *Wu Tai Jie Mei (Stage Sisters)* 1964 is a melodrama in a didactic social realist mode, which dates from the final

Production still from *Everlasting Regret (Changhen Ge)* 2005
Director: Stanley Kwan / 35mm, 115 minutes, colour, Dolby, Hong Kong, Mandarin & Cantonese / Image courtesy: Golden Scene Company Limited

year of mainland Chinese cinema production before a severe period of restriction. Film historian Gina Marchetti has described the film as an aesthetic mixture of Hollywood classicism, Soviet socialist realism, Shanghai dramatic traditions, and indigenous Chinese folk opera forms.[14] An iconic sequence shows the two 'stage sisters' entering neon-lit Shanghai with superimposed images that create a metaphoric parallel between the women's lack of confidence and the mirage of city lights. The film was banned, and the director denounced for his 'bourgeois humanism'. A number of leading contemporary Hong Kong filmmakers, such as Stanley Kwan, also privilege elements of melodrama in their work, nostalgically recreating pre-communist China and cosmopolitan Shanghai of the modern era.

Parallels can be drawn to Vietnamese films which have emphasised melodrama and allegory as extensions of the social realist tradition of politically engaged cinema. Trained in Moscow at the Russian State Institute of Cinematography after editing documentary films for the Vietnamese Liberation Army, Việt Linh crafts fine-grained examinations of community and the harm wrought by social isolation. Her early black-and-white masterpiece, *Travelling Circus* 1988, uses a cast of Fellini-esque characters to construct a trenchant allegory of state indifference in the face of human suffering. *Me Thao, Once upon a Time* 2002 is an adaptation of Nguyễn Tuãn's historical novel, *Chūa Đãn (Dan Pagoda)* 1946, about a man's emotional devastation and self-destructive isolation upon the death of his fiancée in a motor accident. The modern world has destroyed the object of Nguyen's love and he tries to turn the clock back, rejecting all technological incursions into his rural domain. Việt Linh

constructs an extraordinary metaphor for his impossible struggle, filming the transplantation of an enormous blossoming tree — isolated, arrestingly beautiful and bound to die. Nguyễn's flight into the past is shown to be illusory with the arrival of the railway at his remote estate. The film features the celebrated folk music form, *ca tru*. This loving retention of popular music, circus and theatre is also characteristic, in varying ways, of Chinese and Indian melodramatic forms. Film writer and scholar E Ann Kaplan points to the literalisation in many early Asian dramatic forms of 'fixed types representing generalised emotions and situations', in makeup used for stock Chinese Opera characters for example; these theatrical conceits are retained in the character types of melodrama.[15]

The model of a geographically located Modernism is useful in turning the spotlight on the role of everyday responses to the modern and on the interrelationship of local cultural forms and languages. An attendant shift in the locus of aesthetics to the senses and perception – and away from formal principles or technical 'discoveries' – allows for a more nuanced analysis of varying artistic creation. The centrality to modern aesthetics of changes in sensory perception is identified by Walter Benjamin, who suggests that the technological, social and economic transformations definitive of modernity bring about a new *sensorial* regime.[16] Cultural theorist Geeta Kapur delineates an alternative to the international modernist ideal of aesthetic cultural transparency, achieved through a focus on formal innovation and a persistent reductionism, in order to arrive at principles that may be universally applied. She uses cinema theorist André Bazin to formulate a 'phenomenological purism' which would offer

Production still from *Wild, Wild Rose*
(Ye Mei Gui Zhi Lian) 1960

Director: Tian-lin Wang / 35mm, 124 minutes,
b. & w., mono, Hong Kong, Mandarin / Image
courtesy: Cathay-Keris Films

Production still from *Stage Sisters*
(Wu tai jie mei) 1965

Director: Xie Jin / 35mm, 120 minutes, colour,
mono, Shanghai, Cantonese & Mandarin /
Image courtesy: British Film Institute and China
Film Archive

a substantive representation of lived experience; filmmaker Jean Renoir figures as Bazin's privileged example of an oeuvre that sediments fine-grained experience to isolate what may then transcend individual experience.[17] Kapur identifies art forging contemporary *traditions-in-use* as the way forward out of the pitfall of cultural pastiche for a country like India which is distinguished by the existence of living traditions. Filmmaker Kumar Shahani, whose oeuvre unfolds a richly layered and extremely precise exposition of Indian classical arts, offers Kapur a powerful example of an avant-garde figure who can take on an almost allegorical status in relation to the national traditions mined within his artistic practice. Underlining film's potential as a vehicle for distilling experience, ideas and history, Shahani suggests that the creative forms of each culture offer 'suppressed aspirations — whether artistic, spiritual, material or intellectual'. He continues:

> 'Filmmakers carry within themselves all kinds of possibilities which can then be made available across cultures'.[18]

This distinction between a homogenous or uniform culture and types of meaning or experience that can be shared between cultures is fundamental to understanding Shahani's desire to abstract from specific experience and history. Such sharing or availability 'across cultures' does not imply direct cultural transparency, rather it calls for translation and openness to difference.

Jean Renoir was the first non-Indian to make a feature film in India for non-Indian audiences, with *The River* 1951, also Renoir's first colour film.

Shahani reflects on this film as an expression of an individual's discovery of Indian civilization. He suggests that Renoir came to India looking for the childhood of civilisation, but instead found extraordinary complexity and discipline in the classical arts. The insertion in *The River* of Indian music and dance, including giving a role to classical Indian dancer Radha, testifies to Renoir's conversion. Despite his primitivist preconceptions, Renoir recognised civilisational principles in forms that were new to him. He entered Bengal prepared to abandon fixed ideas and with great curiosity and attentiveness. Shahani says that he was embarrassed by the film when he first saw it at the Cinémathèque Française in the late 1960s, but later came to think about it differently. He responds to it now as an authentic expression of Renoir's experience in India, which was attentive to the transformations effected in him by the period he spent in Bengal.[19]

The Bengali cinema into which Renoir temporarily inserted himself (famously meeting Satyajit Ray on the set of *The River*), is the origin of an influential theory of regionally rooted cinemas. Shahani notes that while this theory, developed in the 1950s:

> . . . had a healthy contempt for a spurious internationalism which consists in producing derivative art (like much of our painting of that period) it had all the possibilities of degenerating into a narrow, medieval and decorative idea of culture.[20]

Other local, national and regional histories also offer significant critiques and analyses of internationalism. Interestingly Renoir is also known as a

Production still from *The River* 1951
Director: Jean Renoir / 35mm, 99 minutes, colour, mono, India, English and Bengali / Image courtesy: Beta film and British Film Institute

Kasba (still) 1990
Director: Kumar Shahani / 35mm, 115 minutes, colour, mono, India, Hindi, Urdu and Punjabi / Purchased 2006. The Queensland Government's Gallery of Modern Art Acquisitions Fund / Collection: Queensland Art Gallery / Image courtesy: National Film Development Corporation, India

filmmaker whose best work is rooted in a fine-grained depiction of certain sections of French society. His is a vernacular cinema that remains embedded in a particular place, aesthetics and history.

Filmmakers like Kumar Shahani, Jean Renoir and Việt Linh are representative of a visual production which creates from and for the local, while also taking part in international conversations though distribution and exhibition. Their cinema remains embedded in a particular place, aesthetics and history, and stands in opposition on the one hand to a derivative internationalism and on the other to unreflective ethnography or cultural sampling for outside audiences. Similarly, the interrelated cinema histories of Hong Kong and Shanghai in the modern era offer a privileged example of locally embedded cosmopolitan aesthetic production. The techniques and genres of film and art production in modernity are integrally entwined with the technologies, networks and social forms of modern life. These symptoms of modernity offer artists and filmmakers a range of local and culturally defined means and modes to assimilate the imbrication of local and international spheres of influence. Viewers are challenged to be ever more receptive as cultural and aesthetic translators to the traditions-in-use distilled through contemporary art and film.

KATHRYN WEIR is Head of Cinema, Queensland Art Gallery / Gallery of Modern Art.

Me Thao, Once upon a Time (Mễ Thảo, Thời Vang Bóng) (still) 2002
Director: Việt Linh / 35mm, 107 minutes, colour, stereo, Vietnam, Vietnamese / Image courtesy: Giai Phong Film Studio

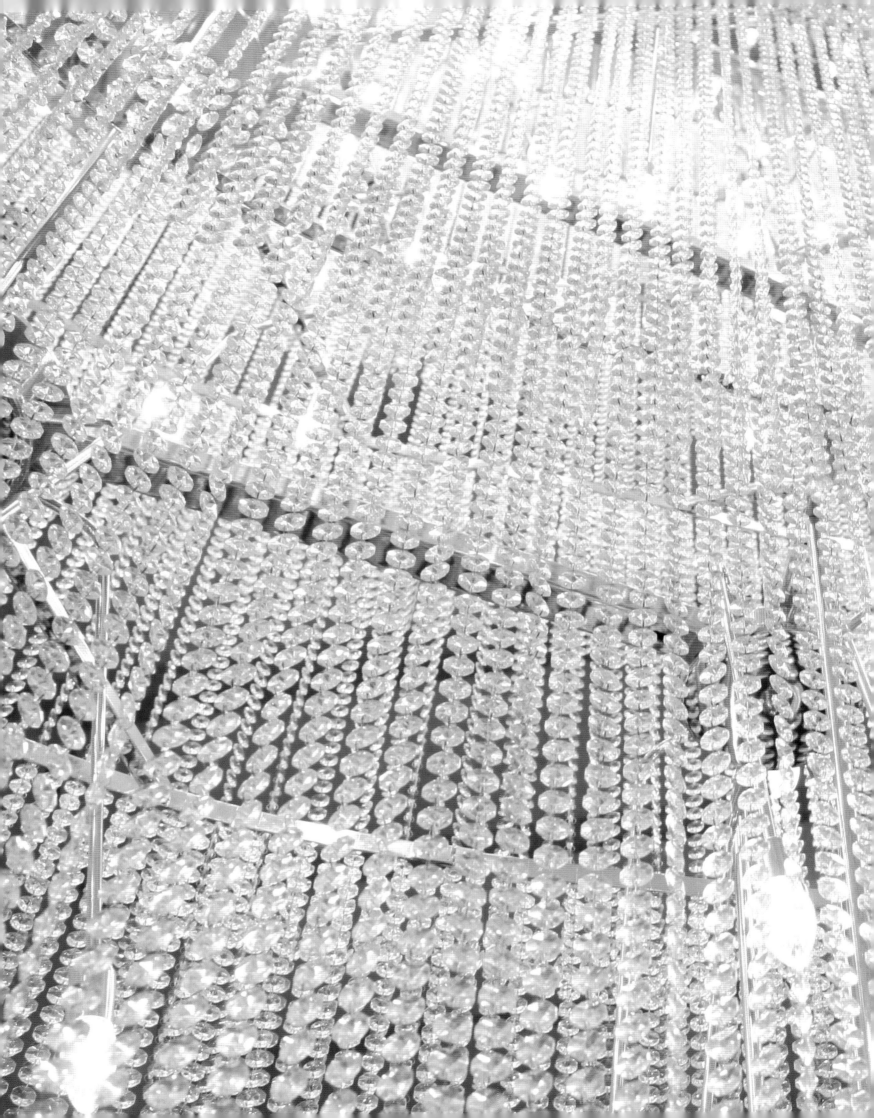

It has often been observed that Ai Weiwei's absurdist constructions reflect a dadaist sensibility. Certainly, a Duchampian wit pervades his practice, but many of the materials Ai uses are anything but the banal, everyday objects so often found in Dada readymades. A discerning connoisseur and collector of Chinese antiquities, Ai creates a very refined anarchism. He takes objects that are hallmarks of Chinese cultural excellence — Buddhist sculpture, Ming and Qing furniture, Neolithic and Han dynasty ceramics — and playfully transforms them to create works that challenge the authority of cultural value, meaning and authenticity. More than rhetorical irony, this questioning represents a genuine investigation to expose more fundamental truths. 'By changing the meaning of the object, shaking its foundation,' he suggests, 'we are also changing our own condition. We can question what we are'.[1]

One of Ai's most provocative challenges to the established canons of cultural authority is his photographic triptych *Dropping a Han dynasty urn* 1995, which documents the destruction of a genuine *hu* (wine jar). Admired for their simple, graceful forms, Han ceramics are the highly collectable material remains of a dynasty that is vested with a unique cultural authority in China's long history.[2] For modern connoisseurs the urn is a potent symbol of refined taste, cultural achievement and purchasing power, but its rarefied status is negated by Ai's seemingly wanton iconoclasm. However, this act of destruction is paradoxically and crucially constructive, creating a dialectic on the subjectivity of cultural value. For Ai, any reflection on the 'weight and gravity' attached to his gesture is not so much an exercise in semantics as an observation of the physical forces at play on the falling

mass of the urn. The action, he suggests, is 'powerful only because someone thinks it's powerful and invests value in the object'.[3] When Ai records the act of its destruction, the meaning of the urn is transformed, co-opted into a modern editioned art work that subverts prevailing value systems — cultural, aesthetic, economic — while at the same time colluding with them by its very existence as a contemporary art object.

Not all of Ai's investigations into the subjectivity of cultural worth and meaning have such devastating consequences for the objects he appropriates. In *Painted vases* 2006 the gently burnished and russet-hued surfaces of Neolithic earthenwares, some six to seven thousand years old, are obscured beneath a layer of Tupperware-bright monochrome paint. However, while masking the mellow lustre and bold decoration of their original surfaces, the acrylic paint does not destroy them. Their aesthetic and symbolic import remains intact beneath a veneer of modern, synthetic pigment and the exact contour of their patterning has become each vessel's own sly secret. The aura of enigmatic antiquity that permeates these objects has been disrupted by Ai's intervention so that our affinity with them now goes no deeper than the gaudy gaiety of their new vividly coloured exteriors.

The 13 stone fragments that comprise *Feet* 2005, all that remains of Buddhist sculptures dating from the Northern Wei (386–535 CE) and Northern Qi (550–570 CE) dynasties, reveal another strategy in Ai's arsenal of aesthetic manipulations — sculptural salvage. Treading pedestals that once elevated, both literally and metaphorically, the full body sculptures, the dismembered feet exude a ghostly poignancy. China is littered with the

AI WEIWEI

Ai Weiwei / China b.1957
Painted vases (detail) 2006
Synthetic polymer paint on ceramic (Neolithic period) / 14 components ranging from 17 x 21cm (diam.) to 33.7 x 29 x 27cm / Purchased 2006. The Queensland Government's Gallery of Modern Art Acquisitions Fund / Collection: Queensland Art Gallery

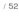

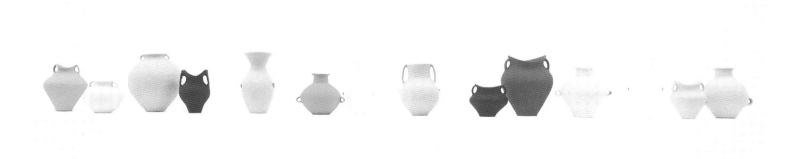

Painted vases 2006
Purchased 2006. The Queensland Government's Gallery of Modern Art Acquisitions Fund / Collection: Queensland Art Gallery

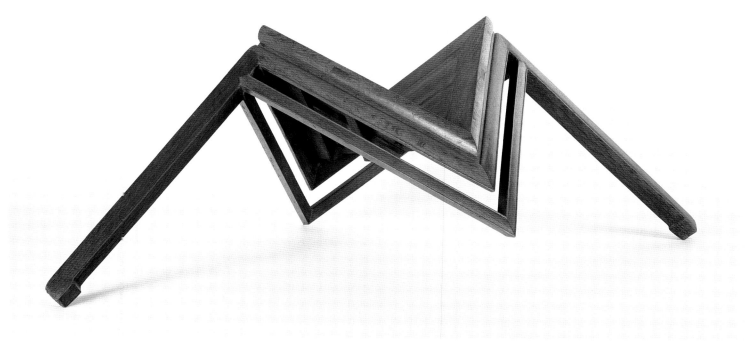

Table with two legs 2004
Reassembled wooden table (Qing dynasty
1644–1911) / 65 x 184 x 119cm / Purchased 2006.
The Queensland Government's Gallery of Modern
Art Acquisitions Fund / Collection : Queensland
Art Gallery

Reconfiguring historical furniture into
new forms. These reconstructions use
the same meticulous techniques applied
in the originals.

Table with two legs on the wall 2005
Reassembled wooden table (Qing dynasty
1644–1911) / 115.5 x 95.2 x 120cm / Purchased
2006. The Queensland Government's Gallery
of Modern Art Acquisitions Fund / Collection:
Queensland Art Gallery

wrecks of ruined statuary despoiled during disruptive periods of dynastic change, as new regimes attempted to remove all traces of the cultural and aesthetic achievements of former powers. Reduced from intact sacred objects to anonymous sculptural shards, the fragments Ai has gathered attest to the crudity of these efforts to obliterate the past. His reappropriation of the overlooked and forgotten objects, apparently not even worthy of plunder or complete destruction, leads us to question why such carefully sculpted forms have been relegated to the status of worthless debris. Rescued from the scrap heap and arranged with reverence on a simple wooden table, the fragments acquire a new relevance, dignity and significance in an act of determined and subtly nuanced preservation.

This need to call attention to what Ai has referred to as the 'nature of destruction in society and life' is also apparent in his series which marries antique Chinese furniture with time-scarred and exotically-timbered pillars and beams recovered from demolished buildings.[4] China's urban skylines, bristling with the futuristic profiles of an international architectural new order, are being transformed at phenomenal speed in a building boom bolstered by a surging economy. Ai Weiwei himself is involved in this sweeping change: as a freelance architect he has been engaged in a number of major construction projects, most notably his collaboration with Swiss architectural firm Herzog & de Meuron in developing the design of the spectacular National Stadium for the 2008 Beijing Olympics. He laments, however, the disappearance of countless beautiful old buildings as whole neighbourhoods vanish under the wrecker's ball. Disappearing, too, are the time-honoured skills of traditional Chinese carpentry and joinery. In *Pillar through round table* 2004–05, Ai Weiwei reunites these skills, quite literally. Skewering a small round table on the pillar of a demolished Qing dynasty temple, a victim of China's drive towards urban modernisation, Ai contrives a seamless and meticulous fusion that leaves both pillar and table tilted off their axes and aimlessly adrift.

Pillar through round table is part of Ai's ongoing furniture series in which he hires artisans to disassemble then reconstruct furniture of the Ming and Qing dynasties to create new unconventional forms. Ming and early Qing furniture is much admired for its appealing simplicity, quiet dignity and refined functionalism. The high values it can attract on the international market, though, have led to a preoccupation with issues of authenticity. Poor or spurious restorations abound as tables are cut down to create more marketable forms, reconfigured to become 'rarities', or largely reconstructed using recycled timbers. Ai's reconstructions, however, are unambiguously his own. Redeploying the materials, style, proportions and intricate joinery of the objects he is refashioning, Ai creates a skilfully wrought disorder in which comfort and utility are denied. Although their new symmetries are a technical tour de force, the function of his furniture can be rendered redundant (*Pillar through round table* and *Table with two legs* 2004) or made perilous (*Table with two legs on the wall* 2005).

As extravagant symbols of affluence and aspiration, chandeliers provide all the Versailles-style bling that China's increasingly affluent middle class could hope for in the adornment of their homes, hotels and shopping malls. They are a fitting vehicle for Ai's incisive observations on value and meaning and, where worth and status can be measured in crystal drops,

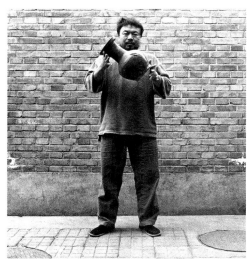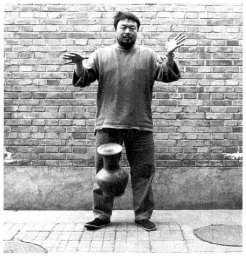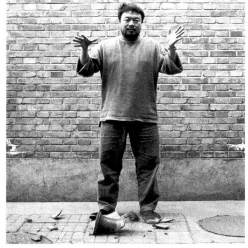

Dropping a Han Dynasty urn 1995
Gelatin silver photograph / 3 sheets: 180 x 169.5cm
(each) / Purchased 2006. The Queensland
Government's Gallery of Modern Art Acquisitions
Fund / Collection: Queensland Art Gallery

bigger is definitely better. Composed of 270 000 crystal pieces which cascade to ground level, the impressive yet delicate bulk of Ai's *Boomerang* 2006 fills the soaring space of the Gallery's Watermall, distorting our sense of scale and perspective (just as great or sudden wealth may do). It is a beguiling dreamscape of sparkling luminosity that playfully responds to its reflection and refraction in the water below, a spectacular monument to consumption and display with a finely honed sting in the tail.

DR SARAH TIFFIN is Curator, Historical Asian Art, Queensland Art Gallery / Gallery of Modern Art.

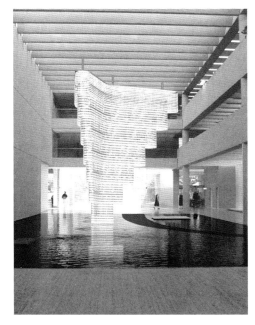

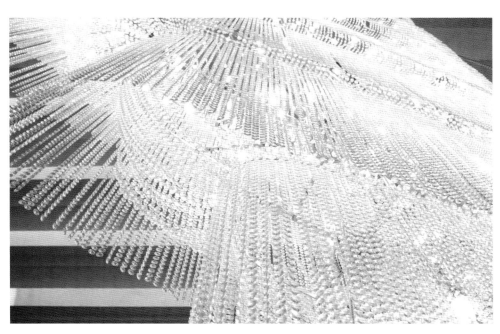

Concept drawing for *Boomerang* 2006 in the Queensland Art Gallery's Watermall, a site specific installation for APT5

Boomerang (detail) 2006
Glass lustres, plated steel, electrical cables, incandescent lamps / 700 x 860 x 290cm (irreg.) / Collection: The artist

In a recent interview on the BBC, renowned novelist Orhan Pamuk analysed the fabric of society in his country. According to him, most inhabitants of Turkey are a product of both traditional Islam and the modernity of Europe. What is true of Turkey is relevant for many other modern Muslim states, especially those situated on the rim of South Asia.

Countries, such as Iran, Pakistan and Afghanistan, at some stage of their history, had to find a balance between tradition and modernity, between their conventional cultures and the requirements of being a modern-day nation state. These two elements (relating to past and present) formulate the way people see their future and live and interact with each other. This duality, based on past and present or a blend of East and West, is now generally accepted as a natural phenomenon, with language, art, fashion and other forms of creative expression, all influenced or moulded by it.

It is only when the fine balance between the two is shaken that societies in these countries face a crisis. The most recent example was the rule of the Taliban in Afghanistan. In their zeal to revive a period from the early Muslim epoch, the Taliban desired to abolish the symbols of modernity and any signs of other cultures. Their society, which banned music, film, art, sport and even shaving blades (because they decreed that all men must grow beards to follow the custom of the holy prophet and his disciples), is rare in modern times, but not unique. A similar kind of exercise was seen in the Khmer Rouge's Kampuchea (Cambodia) in which the Khmer Rouge saw the 'others' (Vietnamese) as enemies and tried to eradicate all traces of them from their country.

During their reign, Afghani Taliban, also in a frenzy to destroy the 'others', demolished the Bamiyan Buddhas. These colossal figures from the fifth or sixth centuries, carved in the rock-faces of the Bamiyan Valley and standing from 37 to 55 metres high, were the embodiment of everything unbearable, prohibited and foreign. By blasting the statues, the Taliban purified their state of two symbols of idolatry — Buddhism and art.

However, art is strangely subversive. It takes its revenge in many ways. Whenever it is suppressed, it emerges somewhere else and in some other form. This happened with the Buddhas at Bamiyan. Once razed to the ground, they reappeared in the miniatures of Khadim Ali, who has origins in the same mountain regions of Hazarajat in Afghanistan — although his family migrated to Pakistan and he was trained in miniature painting at the National College of Arts in Lahore from 1999 to 2003.

Miniature painting, once flourishing in the court of the Mughals in India, suffered a decline in its practice and popularity during the British colonial rule in India. It was only in the early 1980s that miniature painting was revived at the ateliers of the National College of Arts, where Ali learnt the method of making images in the traditional technique, using delicate lines and flat colours and mastering the sensitive rendering of volume.

Miniature painting originally served to illustrate books, but present-day miniature painting has become an independent art form, a synthesis of tradition and modernity — subjects, images and methods of this historic art are combined with modern-day sensibilities. In the new miniatures, elements from the past are placed next to imagery from our contemporary life and immediate surroundings.

KHADIM **ALI**

Khadim Ali / Pakistan b.1978

Untitled (from 'Jushn-e-gulle surkh' (Celebration of red tulips) series) 2004–05

Gouache on wasli paper on card / 20.2 x 14.8cm / Purchased 2005 / Collection: Queensland Art Gallery

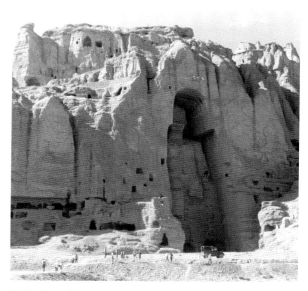

The Buddhas of Bamiyan, Hazarajat region, Afghanistan, 2001
Image courtesy: UNESCO

Children weaving rugs, Bamiyan, 2005
Photograph: Barat Ali Batoor

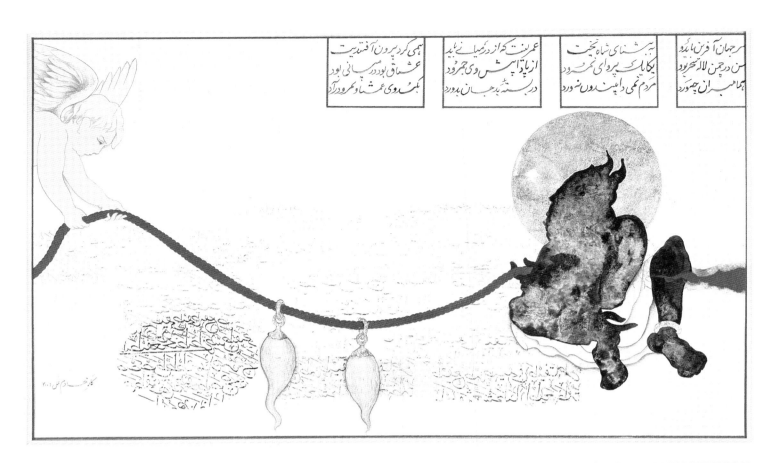

This duality is a remarkable feature of Ali's work — and of new miniature painting in general. In his paintings, paradoxes of all kinds, whether formal or conceptual, create narratives relevant to our times. In a number of miniatures, the silhouette of an absent Buddha merges into Leonardo da Vinci's *Vitruvian man*. In other works, cupids pointing their arrows are juxtaposed with canons. With these compositions, Ali constructs a pictorial multiplicity that is both a part and reflection of the structure of our (or any other) Muslim society.

Not only is the subject of heterogeneity dealt with in his paintings, Ali's work also alludes to the current political situation. On the one hand, the cute figures of cupids might symbolise love and yet, at the same time, they can be understood as carrying weapons. This reading is accentuated with the dim outlines of canons and the shapes of hand grenades. Besides these images, streaks of red paint (which might be blood) run across the page, and enhance the sense of violence.

While dealing with his chosen subject matter and imagery, Ali adapts a unique approach. The pictorial and political narratives are constructed not in a continuous space but are built up over several layers. Diverse in scale and origin, the images in each layer overlap each other in such a way that one keeps on deciphering the totality of form through the hints and glimpses of hands, flower stems, petals and contours of mechanical objects. This kind of visual complexity — appropriate to the aesthetics of the modern miniature — is an amalgamation of different world views.

Diversity is also presented in this work through poetic means: in addition to figures from the art of the West and the East, Ali renders the outlines of flowers that are associated with separate and specific parts of the globe. In his miniatures, lotuses and tulips are joined to convey a broader and shared visual experience. Somehow the depiction of these flowers signifies that, even if the world is politically, ethnically, religiously and economically divided, the classification of flowers according to nationalistic labels is an act against nature. Flowers are planted on a particular soil and grow in a certain climate but they do not belong to a specific place or state. A situation, which can be applied to Ali, too; with his origins in Afghanistan, his training in Pakistan and his travels to other places, he does not belong to one place and neither is his work confined to one school, style or tradition.

QUDDUS MIRZA is an artist, art teacher, critic and independent curator based in Lahore, Pakistan.

Untitled (from 'Rustam-e-pardar' (Rustam with wings) series) 2006
Watercolour, ink, gold and silver leaf on wasli paper / 15.8 x 27.2cm / Purchased 2006 / Collection: Queensland Art Gallery

Untitled (from 'Rustam-e-pardar' (Rustam with wings) series) 2006
Watercolour, ink and gold leaf on wasli paper / 16.5 x 25.2cm / Purchased 2006 / Collection: Queensland Art Gallery

Folio from *Shahnama of Firdawsi* / *Bahram Gur Wins the Crown, from a Shahnama (Book of Kings) by Firdawsi*
Na'imuddin Ahmad b. Mun'imuddin Muhammad / Safavid dynasty, 1518
Opaque watercolour, ink, and gold on paper / 29 x 19.4cm (overall) / Arthur M Sackler Gallery, Smithsonian Institution; Washington D.C., Purchase-Smithsonian Unrestricted Trust Funds, Smithsonian Collections Acquisition Program, and Dr Arthur M Sackler

Govardhan
Akbar with Lion and Calf / Leaf from an album made for Emperor Shah Jahan. Mughal period, 17th Century, 1630
Ink, colors and gold on paper / 38.9 x 25.7cm / The Metropolitan Museum of Art, Purchase, Rogers Fund and The Kevorkian Foundation Gift, 1955 / Photograph © 1980 the Metropolitan Museum of Art

Before leaving Hong Kong to take up his new job in Australia in 1960, Charlie Chan decided to send his seven-year-old son Chan Kong-seng to learn Peking Opera at the China Drama Academy in Hong Kong. At that moment, he would not have imagined that Kong-seng, today internationally known as Jackie Chan or Sing Lung (Cheng Long), would become a Hollywood superstar of action cinema, and achieve a worldwide reputation in filmmaking.[1] Over the next ten years, Jackie learned Peking Opera with his master Yu Zhanyuan. Living with his fellow students — among them Sammo Hung, Yuen Biao and Corey Kwai — Chan went through vigorous training in Chinese operatic art, which synthesises singing, reciting, dancing, and martial and acrobatic arts. In retrospect, such a humble and severe life at the academy paid off. The acting virtuosity and fraternity acquired during Chan's childhood studies were instrumental in paving his way to becoming a king of kung-fu cinema. However, his road to super-stardom was not easy.

Peking Opera was not very popular in 1960s' Hong Kong, a British colony populated predominantly by Cantonese-speaking people to whom Peking Opera was an 'outside' theatrical art from the north. The indigenous Cantonese opera and Cantonese movies received much more support from the local and South-East Asian audiences. During his schooling, Chan and his fellow students in the troupe 'Seven Little Fortunes', performed at amusement parks and earned a living by acting in low-budget Cantonese martial arts films such as Wu Pang's *The Eighteen Darts* 1966. Riding the craze of Mandarin swordplay and kung-fu cinema, Hong Kong film studios demanded more energetic stuntmen and creative action choreographers.

The blooming industry soon absorbed the new blood provided by the local opera academies; some of the well-known names are Sammo Hung, Jackie Chan, Yuen Biao, Tang Kai, Lam Ching-ying and Yuen Woo-ping.

After acting as a stunt player for a few years, Chan moved to Australia in 1975 to live with his parents. In the mid 1970s, Lo Wei (Luo Wei), the director of *The Big Boss* 1971 and *Fist of Fury* 1972, hand-picked Chan to act in *New Fist of Fury* 1976, a 'Bruceploitation' movie in which he is presented as an imitator of Bruce Lee. It is not until *Snake in the Eagle's Shadow* 1978, *Drunken Master* 1978 and *Fearless Hyena* 1979 that Chan reveals his personal charm, establishes his distinctive style and creates real box office success.

Snake in the Eagle's Shadow and *Drunken Master* mark the emergence of a new subgenre of martial arts film, 'kung-fu comedy', which incorporates martial arts and acrobatics with comic elements. The producer of both films, Ng See-yuen, recalls that the appearance of this innovative genre was a response to criticism, mainly from the European markets, that kung-fu movies were too bloody and violent.[2] The films' director–action choreographer Yuen Woo-ping and Ng worked together to design an alternative form, a form that demonstrates the force and vitality of Chinese martial arts yet tones down the violence and brutality by adding a humorous touch.

Remaking the popular legend of the Cantonese martial arts hero Wong Fei-hung (Huang Feihong), *Drunken Master* invents a young Wong Fei-hung who is mischievous, clever, creative and energetic but lacking the persistence to learn and always looking for a short cut. Film scholars have already pointed out that this modern image of a 'smart guy' is a reflection

JACKIE **CHAN**

Jackie Chan / Hong Kong b.1954

Production still from ***The Young Master (Shi Di Chu Ma)*** 1980

Director/Action director: Jackie Chan / 35mm, 101 minutes, colour, mono, Hong Kong, Cantonese / © 1993 STAR TV Filmed Entertainment (HK) Limited / Image courtesy: Fortune Star Entertainment (HK) Limited

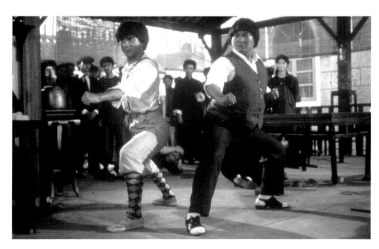

Jackie Chan (left) with Sammo Hung in a production still from ***Project A (A'gai Waak)*** 1983

Director/Action director: Jackie Chan / 35mm, 106 minutes, colour, mono, Hong Kong, Cantonese / © 1993 STAR TV Filmed Entertainment (HK) Limited / Image courtesy: Fortune Star Entertainment (HK) Limited

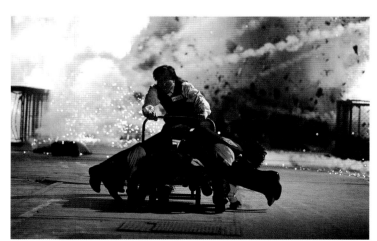

Production still from ***New Police Story (San Ging Chaat Goo Si)*** 2004

Director: Benny Chan / Action director: Jackie Chan / 35mm, 123 minutes, colour, Dolby Digital, Hong Kong, Cantonese / Image courtesy: Force Entertainment

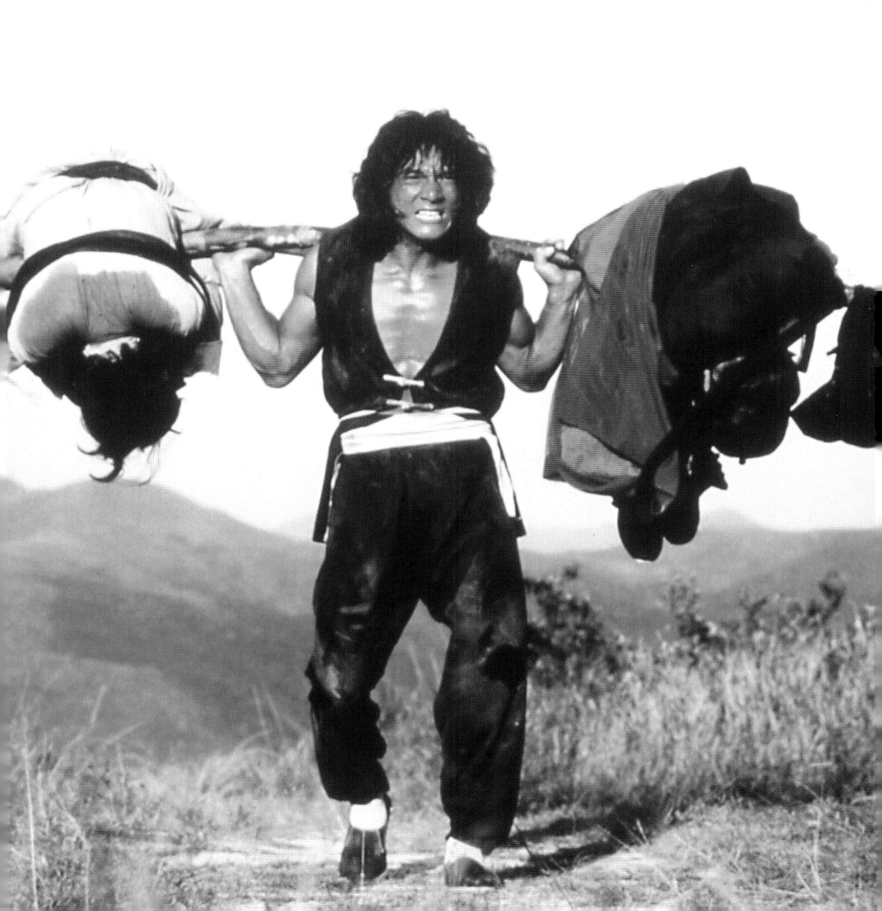

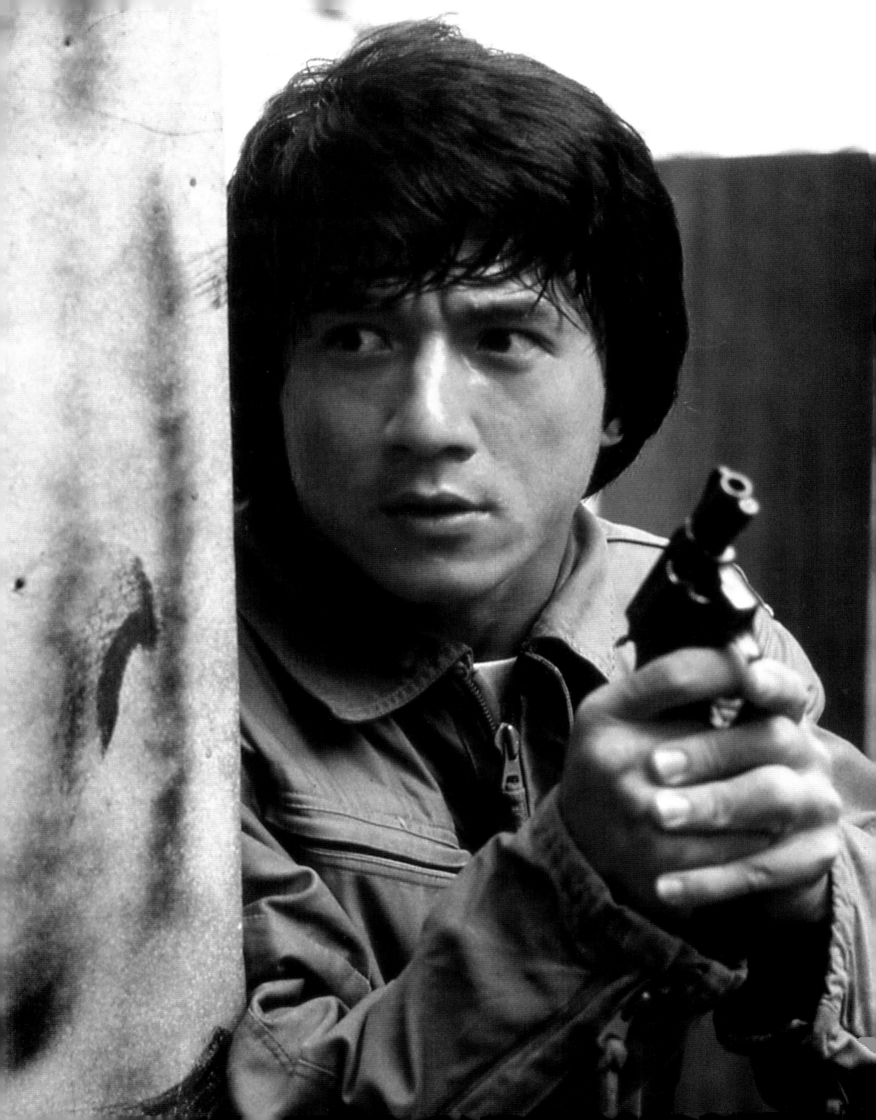

of the economic boom and social changes in Hong Kong during the 1970s. Still, the choreography and action in the movie is much indebted to traditional Chinese theatre. Besides Jackie Chan himself, Yuen Woo-ping — who is best-known to Western audiences for his action choreography of *The Matrix* 1999 and *Crouching Tiger, Hidden Dragon* 2000 — was also a Peking Opera actor during his teens, trained by his father Simon Yuen Siu-tien, who plays Beggar So in the *Drunken Master*. An obvious example of employing Chinese operatic skill in the movie is the combat scene between Wong Fei-hong (Jackie Chan) and the villain Yan Tiexin (Huang Zhengli). They start fighting in a deserted temple after Wong runs away from the harsh training imposed by Beggar So. In this fabulous scene, Chan shows his 'chair skill' developed from Peking Opera — being pulled backward and forward on the chair, lying horizontally and falling from the back, and rolling around with the chair on the ground. Similar choreography can also be found in *Project A* 1983, *Project A II* 1987 and *Miracles* 1989.

As David Bordwell postulates, Chan's indomitable urge to overcome all obstacles seems designed to project one modern image of Hong Kong.[3] Beyond the death-defying stunts and breath-taking action, a wide range of meanings can be read into his movies. While *Drunken Master* is set in an unknown village in Guangdong province, the setting of *Police Story* 1985 moves to a modern city, Hong Kong. The traditional 'chair fight' in the movie is now further elaborated to more hyperbolic stunts — for example, Chan slides down a six-storey shopping-mall pole that is wrapped in lights, bursting all the light bulbs before crashing through a glass roof below; or he jumps across moving traffic, from the top of a truck to the roof of

a bus going the opposite direction, and then through a billboard on the other side of the road.

In *Rumble in the Bronx* 1995, Jackie Chan is a Hong Kong policeman who arrives in New York and fights with gangsters in the cosmopolitan centre. It was through this movie that Chan was accepted into mainstream Hollywood, fulfilling the dream of internationalising Hong Kong cinema. Not only narrating a 'police story', the movie tells Chan's story, the story of Hong Kong cinema and of Hong Kong history as well. It is the story of striving for ultimate success — *Sing Lung* (becoming dragon).

YUNG SAI-SHING is Associate Professor, Department of Chinese Studies, Faculty of Arts and Social Sciences, National University of Singapore.

Production still from *Police Story (Ging Chaat Goo Si)* (detail) 1985
Director/Action director: Jackie Chan / 35mm, 101 minutes, colour, mono, Hong Kong, Cantonese / © 1993 STAR TV Filmed Entertainment (HK) Limited / Image courtesy: Fortune Star Entertainment (HK) Limited

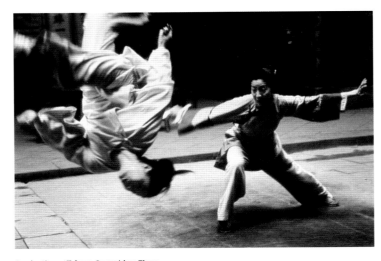

Production still from *Crouching Tiger, Hidden Dragon (Wo Hu Cang Long)* 2000
Director: Ang Lee / 35mm, 120 minutes, colour, Dolby Digital, Taiwan/Hong Kong, Mandarin / Image courtesy: Sony Pictures Classics

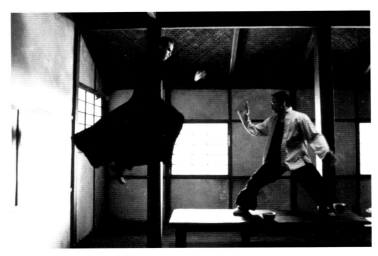

Production still from *The Matrix: Revolution* 2003
Directors: Andy Wachowski & Larry Wachowski / 35mm, 129 minutes, colour, Dolby Digital, USA, English / Image courtesy: Warner Bros. Pictures

Beck Cole is a prominent figure in the new wave of Indigenous Australian filmmaking, alongside contemporaries such as Rachel Perkins, Ivan Sen and Darlene Johnson. Cole layers her films and documentaries with broad cultural concerns, yet captures the complexity and diversity of individual Indigenous stories.

Throughout her career, Cole, a central Australian woman from the Warramungu and Luritja peoples, has been part of a strong community of Indigenous film and video producers. Born in Adelaide in 1975, she later moved to Alice Springs and, by the age of 16, she was a trainee journalist at Imparja Television in Alice Springs, part of the Central Australian Aboriginal Media Association. After studying communication and sociology at Charles Sturt University in Bathurst, Cole worked in the Indigenous unit at ABC Television, Sydney. It was during this time that she started making films.

In 2001, Cole studied documentary scriptwriting and directing at the Australian Film, Television and Radio School in Sydney, where she directed two documentaries: *The Good Fight* 2001 and *The Creepy Crawleys* 2001. Cole's talent for storytelling was already evident in *The Good Fight*, which was set in a boxing club for disadvantaged youths in the Sydney suburb of Dulwich Hill. This story about persisting despite hardship also captures Cole's ongoing interest in giving a voice to people who fall outside the mainstream.

Later, Cole returned to Alice Springs where, working with the Central Australian Aboriginal Media Association, she directed *Wirriya Small Boy* 2004, a documentary about seven-year-old Ricco Japaljari Martin.[1] Ricco is a bright, spirited child who lives in the remote community of Hidden Valley, a town camp on the outskirts of Alice Springs. The camera follows Ricco to school, swimming lessons, Warlpiri language lessons and trips to the shops to buy lollies.[2] Through interviews with Ricco and his carer, Maudie, his poignant story unfolds. Cole's camera frames Ricco lying face down on a public bench in Alice Springs while Maudie (in voice over) tells of an incident where Ricco lay on top of his mother to protect her from her lover's violent attack. In an introspective moment, Ricco later says, 'I got no story . . . about my mother'.[3] Cole says of her experience of making *Wirriya Small Boy*:

> Telling Aboriginal stories is absolutely crucial to what I do and what I set out to do. For something like *Wirriya Small Boy*, I thought that unless you live somewhere like Alice Springs or somewhere remote where you have places like town camps, you would never even know they exist. I thought a really gentle way of bringing audiences into that world would be to do it with a child, which automatically strips away the politics of it all. People can relate to that straight away, it just opens up so many doors that sort of story.[4]

With her scaled-back crew and lightweight DV camera, Cole forms close bonds of trust and complicity with her subjects, encouraging them to participate throughout the filming and editing process. For *The Lore of Love* 2005, Cole and her small crew camped at Lake Mackay, a remote salt lake, with two young Indigenous women, Lizzie and Jessie, and their grandmothers, Mijili, Nancy and Kumanjayi. In the film, Lizzie and Jessie are

BECK **COLE**

Beck Cole / Australia b.1975 / Warramungu/Luritja people
Production still from *Wirriya Small Boy* (detail) 2004
Director: Beck Cole / Digital Betacam and Mini DV, 26 minutes, colour, stereo, Australia, Warlpiri and English / Image courtesy: The artist and CAAMA Productions

Production still from *Flat* 2002
Director/Script: Beck Cole / 16mm and Mini DV, 13 minutes, colour, stereo, Australia, English / Image courtesy: The artist

taught about love and what it means to their grandmothers and ancestors. This sharing of lore and history is intimately captured by Cole as stories and events unfold in front of the camera. Jessie narrates the documentary, giving authority to her own story as she reconciles her contemporary urban lifestyle with her inherited cultural history.

Both Cole's fiction and documentary works focus on individual stories, imbuing her characters with a complexity that transcends their adversity. She writes strong fictional protagonists: young, Indigenous women historically under-represented in Australian screen culture. Isolated, whether physically in a remote mining community in *Plains Empty* 2005 or emotionally due to a lack of family support in *Flat* 2002, her characters face the reality of family relationships and responsibilities or the ghosts of a destructive colonial past. In *Plains Empty*, a young Indigenous woman and her boyfriend move to a remote mining camp in the Australian outback. While he is away working at another mine encampment, she contends with her lonely existence and a ghostly presence that starts to take form in her home. *Flat* features a teenager, Big Sis, whose father spends too much time gambling in the local TAB while she takes care of her younger sister.[5] When she is given a video camera, Big Sis gains insight into her own life by filming the local community.

The Australian landscape plays a significant role in Cole's work. In *Plains Empty*, cinematographer Warwick Thornton uses sweeping wide-angle shots of a starkly beautiful outback to create a sense of disconnection and solitude. The young woman's emotional isolation is mirrored by the remoteness of her location; her loneliness emphasised by the sense of scale of her surroundings. In *The Lore of Love*, which captures an exchange between two different generations of Indigenous women, the landscape, despite its remoteness, is a communal one, a place to connect with culture and knowledge.

A talented, emerging filmmaker, Beck Cole presents Indigenous stories in a highly personal way, acknowledging the social and cultural histories that influence individual experience. She has already made a significant contribution to Australian screen culture, which will no doubt continue into the future.

ROSIE HAYS is Curatorial Assistant, Cinema Acquisitions and Programming, Queensland Art Gallery / Gallery of Modern Art.

Production still from *Plains Empty* (detail) 2005
Director/Script: Beck Cole / 35mm, 27 minutes, colour, Dolby Digital, Australia, English / Image courtesy: Mark Rogers and Film Depot

Production still from *Plains Empty* 2005
Image courtesy: Mark Rogers and Film Depot

HOW THE LEOPARD GOT ITS SPOT:
A TAXONOMY OF THE MUSEUM

When Justine Cooper first visited the American Museum of Natural History in 2001, it was to sequence human DNA samples for *Transformers*, a project exploring markers of identity (genes, fingerprints, photographs and personal histories). She recognised then the potential for an artist's response to the hidden treasures and vast storage areas that she glimpsed. Established in 1868 and internationally renowned for its collections and displays, the museum has over two hundred staff and research laboratories covering four city blocks. Cooper returned as the museum's first artist-in-residence in 2003 and spent over 18 months completing the photographs for the 2005 series 'Saved by science' and a video work, *Sounds of science* 2005.

Ornithology: the artist pulls out a shallow metal tray to reveal a score of neatly aligned feathered breasts, like corpses lined up for identification in wartime. *Yellow honeyeaters (Lichenostomus flavus)* is a photograph of birds collected in 1898 in Queensland by AS Meek, an Englishman who travelled widely in northern Australia and New Guinea and went on to publish *A Naturalist in Cannibal Land* 1913.

'Saved by science' documents the collections and repositories of a museum whose past is entwined with the history of North American and European acquisitive expeditions. Cooper photographed what is hidden from public view — corridors, compactus, cupboards, drawers, shelves and attics, along with the objects they contain. The museum holds 32 million specimens and artefacts, only a small percentage of which are on display. She used a large format wooden Korona View camera (circa 1910) from the museum's Special Collections.[1] Cooper's photographs underline the ambition of such encyclopedic museum collections to classify and value the natural world.

In a hallway of white metal cabinets, the artist slides back a door to reveal a pride of leopard skins hanging like winter coats. *Leopards (Panthera pardus), Congo 1911* features a selection of skins sent back by the American Museum Congo Expedition (1909–15). Led by Herbert Lang, mammalogist and photographer, and budding ornithologist James P Chapin, the expedition collected everything from molluscs to giraffes: 5800 mammals, 6241 birds, 4800 reptiles and batrachians, 5400 fish and 110 000 land invertebrates (including insects — of spiders alone, 5000). Cooper captures the corridors and cabinets that struggle to contain such multitudes.[2]

Mammalogy: A stuffed trophy head in *African lion (Panthera leo)* bears witness to its final resting place. This specimen is tagged 'No data'. Framed by the cabinet, the lion's head is transformed into a museum object, though it provides scientific evidence only of the strange cultural practices of big game hunting and taxidermy. Herbert Lang photographed his scientific trophies carefully before having them skinned, propping up dead animals in lifelike positions to aid the taxidermist back at the museum. Their habitats were also documented for the diorama artists.[3]

Cooper's 'Saved by science' project unfolds along the borders of art and science. Earlier works use ultrasound imaging, scanning electron microscopy, and DNA sequencing, taking visual art to these new territories. Cooper reminds us that scientific knowledge, like art, is concerned with rendering visible that which was unseen. The artist's video self-portrait, *Rapt* 1998, uses another recent scientific technology, magnetic resonance imaging (MRI), to scan the interior of her body. With the resulting axial MRI slices, Cooper created a three-dimensional animated fly-through of grey

JUSTINE **COOPER**

Justine Cooper / Australia/United States b.1968
Yellow honeyeaters (Lichenostomus flavus)
(from 'Saved by science' series) 2005
Digital colour print on Fuji Crystal Archive Matte paper, ed. 1/8 / 99.2 x 76.3cm / Purchased 2005 / Collection: Queensland Art Gallery

Leopards (Panthera pardus), Congo 1911
(from 'Saved by science' series) 2005
Digital colour print on Fuji Crystal Archive Matte paper, ed. 1/8 / 76.3 x 99.2cm / Purchased 2005 / Collection: Queensland Art Gallery

Leopard, male, shot by a Pygmy with an arrow in the heart, Medje, Congo Belge Gamangui, 6 February 1910
Photograph: Herbert Lang / Image courtesy: American Museum of Natural History, New York

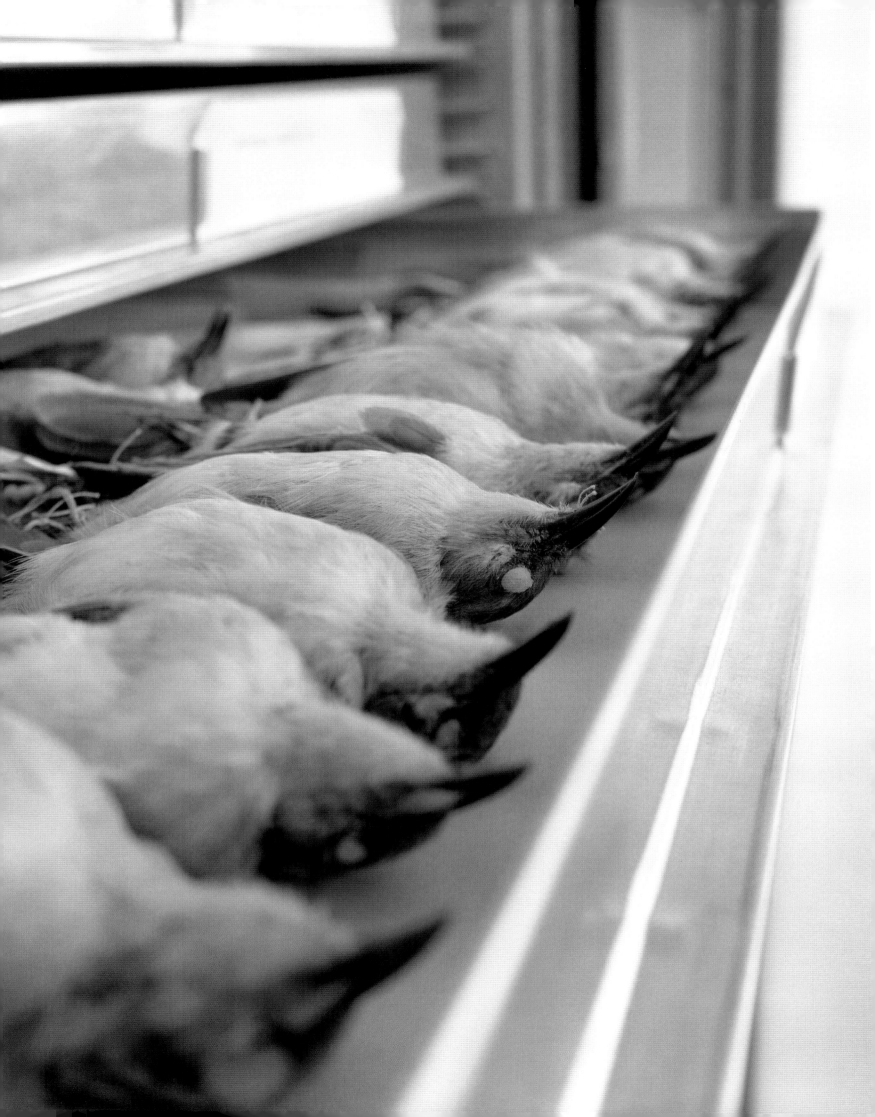

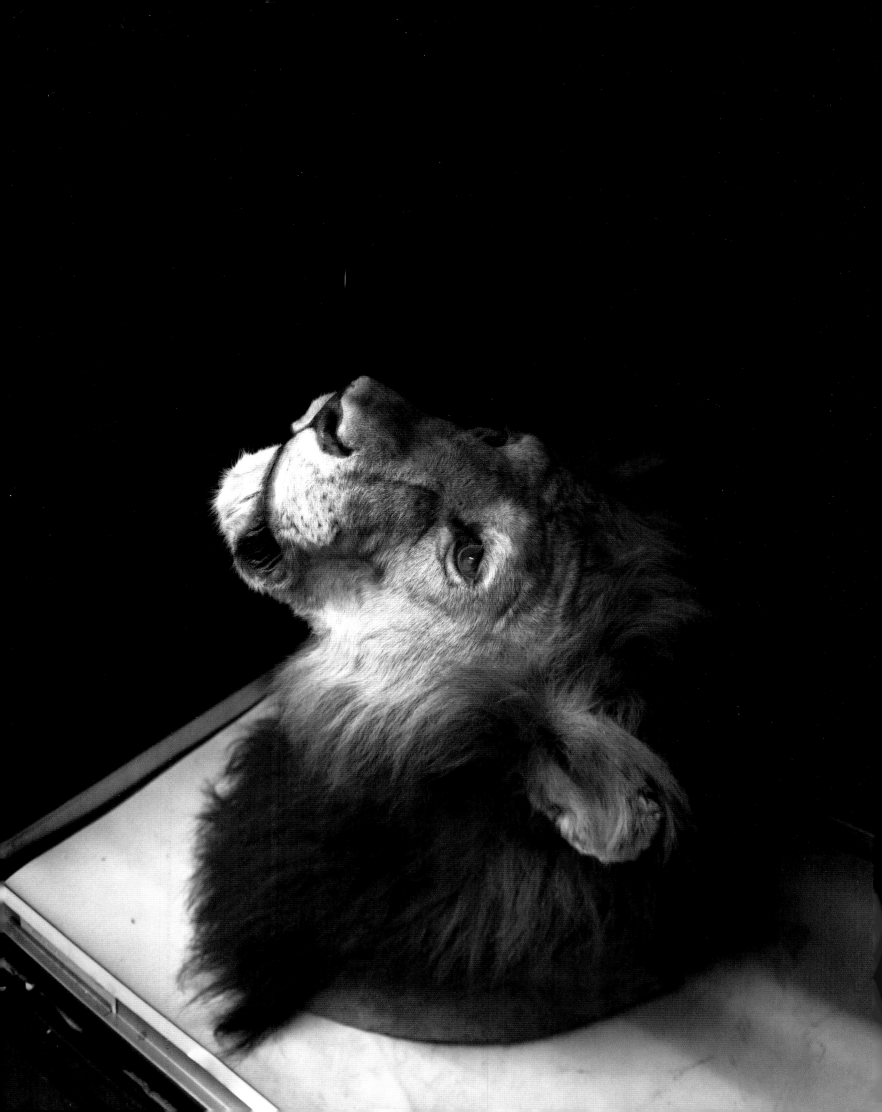

scale vivisection anatomy, accompanied by a rhythmical soundscape. She has spoken of her interest in the processes through which 'living flesh is translated into malleable data'.[4]

When Cooper photographs objects in the American Museum of Natural History framed in drawers and cabinets, she highlights their transformation into scientific information. She contrasts the quiet order of the storage spaces with the surprises they contain. In the attic, she finds a storehouse of trophies: herds of antelope and other decapitated horned quadrupeds, their antlers massed like thorny brambles. Like the lonely lion, they have no contemporary scientific or display use. They featured in the museum's original African Hall as evidence of animals seen and shot in Africa.

Anthropology: *The bustroom* 2005 shows the museum's line-up of studies of human physiognomy. In the foreground is a cast for a walking hominid couple who stride into their evolutionary future. The museum collection reflects a drive to investigate and interpret all aspects of life on earth; its anachronistic survival also links it to specific colonial histories and to the search for data to support discredited branches of evolutionary theory.

In *S.O.S (Sounds of science)* 2005, the video produced towards the end of Cooper's residency, a camera tracks through the maze of the fifth floor of the museum. It slides through corridors flanked by storage cabinets, past the signposts for collecting areas: 'Invertebrates', 'Anthropology', 'Mammalogy'. Layered natural sounds bring to life the contents of the cabinets — we cannot see the collections, but we can hear them. The wild returns in the soundtrack — bird calls, insect noises, roars and howls.[5] The transition from Mammalogy to Anthropology fades from primate chatter to

baby vocalisations to human speech, chanting and wailing. The sudden rip of a chainsaw points to humanity's paradoxical position as part of and apart from nature. *S.O.S (Sounds of science)* comes to a close in a fade to white through windows, a filmic convention suggesting death, transcendence or a realm beyond the world of objects.

Justine Cooper has commented on the destabilisation inherent in electronic art forms: 'Art is no longer embedded in the object, but evolved into an information-processing event'.[6] In 'Saved by science', she continues this exploration of objects in themselves and as information. Her photograph of grey-bound accession books speaks of a history of acquisition, classifying and information gathering. Museum collections are self-portraits, creating institutional identity and reflecting what is culturally valued. Cooper shows that every object in a collection has a story to tell. Some of these stories can be generalised to other similar objects — this is what we know as science. Others speak truths closer to art or literature.

KATHRYN WEIR is Head of Cinema, Queensland Art Gallery / Gallery of Modern Art.

African lion (Panthera leo) (from 'Saved by science' series) 2005
Digital colour print on Fuji Crystal Archive Matte paper ed. 1/8 / 99.2 x 76.3cm / Purchased 2005 / Collection: Queensland Art Gallery

The bustroom (from 'Saved by science' series) 2005
Digital colour print on Fuji Crystal Archive Matte paper, ed. 1/8 / 99.1 x 76.2cm / Purchased 2005 / Collection: Queensland Art Gallery

Leopard diorama in the Hall of African Mammals, American Museum of Natural History, New York
Photograph: Denis Finnin / Image courtesy: American Museum of Natural History, New York

EX de Medici crafts her brilliant watercolours with a poisoned brush. Her recent body of work is comprised of what she calls 'beautiful pictures for ugly people'; finding her target audience in a climate of conservative regression.[1] Throughout the various and at times anti-aesthetic art forms she has employed in her career, de Medici has remained consistent in her regard for the fragility of life and her interrogation of the power relationships which underlie contemporary visual culture. In recent years, however, the artist has borrowed from particular historic conventions to cloak and sharpen her work's polemic charge.

The 'big' paintings, as she calls them, each resemble a cabinet of curiosities — the princely precursor to the state museum — which exhibited both objects from the natural world and those which were transposed through craft into the world of art. These cabinets have a historical relationship to the task of scientific classification through Dutch still-life painting, in which realistic rendering of the natural world functioned as a pictorial catalogue of nature (recalled by the title of her 2005 work, *The theory of everything*). As art historian Norman Bryson suggests:

> . . . flowers, shells and specimens of insect or saurian life enter into the same scene (with, to our eyes, such surreal results). All are subject of the labour of classification, in an era of natural history when taxonomy is the dominant mode of producing scientific knowledge.[2]

The first of de Medici's 'big' paintings, *Blue (Bower/Bauer)* 1998–2000, refers both to the satin bowerbird, a natural collector, and to the scientific

illustrator Ferdinand Bauer, who joined Matthew Flinders's circumnavigation of Australia in 1801–03. After seeing his extraordinary work in 1998, de Medici was prompted to take up Bauer's medium of watercolour.[3] She discovered a latent interest in scientific illustration and its potential for producing images which are readily understandable to an audience unschooled in art history. Her relationship with the scientific genre subsequently deepened when, after drawing the mangled corpse of a butterfly retrieved from the grill of a friend's car, she was inspired to undertake research at the Australian National Insect Collection (ANIC).[4] She focused particularly on unclassified species of *microlepidoptera*, the infinitesimally small moths which she copied, like the Dutch still life painters, with the aid of a microscope.[5] The patterns, and particularly the texture, of these creatures' wings introduced a new vocabulary into her watercolours, which she transferred onto the guns and skulls that dominate her work.

Seventeenth-century still life painting is, of course, inseparable from *vanitas* — vanity and its futile struggle against the brevity of life and the transience of earthly pleasures and achievements. The human skull is first among the signs for this theme, but de Medici multiplies it: 'One skull is a memento mori but many skulls are mass death'.[6] The ancient inscription 'What you are, I was, and what I am, you will be', reaches a heightened pitch of foreboding in *Live the (Big Black) Dream* 2006. Here, scattered skulls, the Chernobyl nuclear power plant and 'Little Boy', the bomb dropped on Hiroshima, are set against a background of apocalyptic cloud.

As art historian Margaret Plant writes, 'to represent the present as the end of a succession of doomed sequences of the past is to represent it

EX **DE MEDICI**

eX de Medici / Australia b.1959
Live the (Big Black) Dream 2006
Watercolour / 114 x 166cm / Collection: The artist

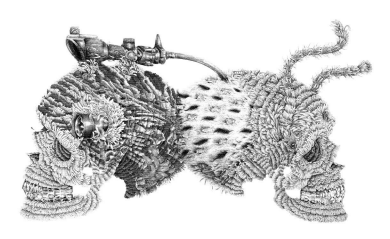

Desire overcoming duality 2006
Watercolour and metallic pigment on paper /
114 x 134cm / Collection: The artist

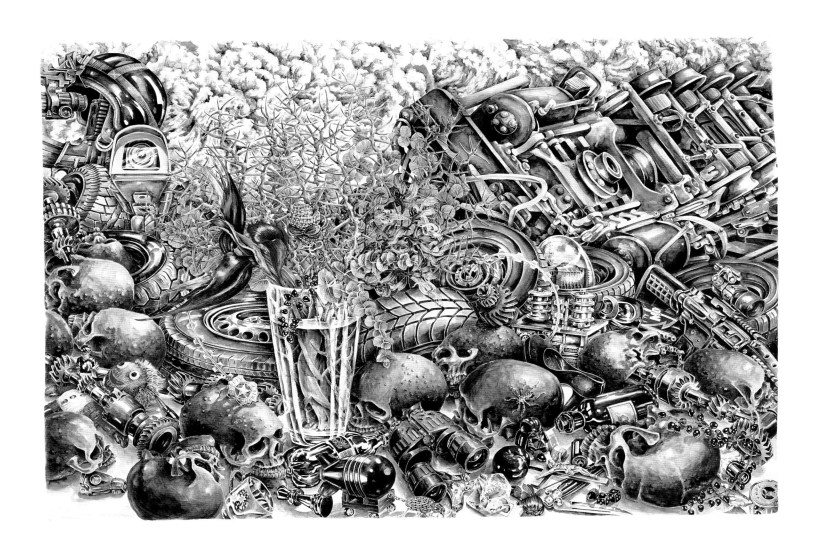

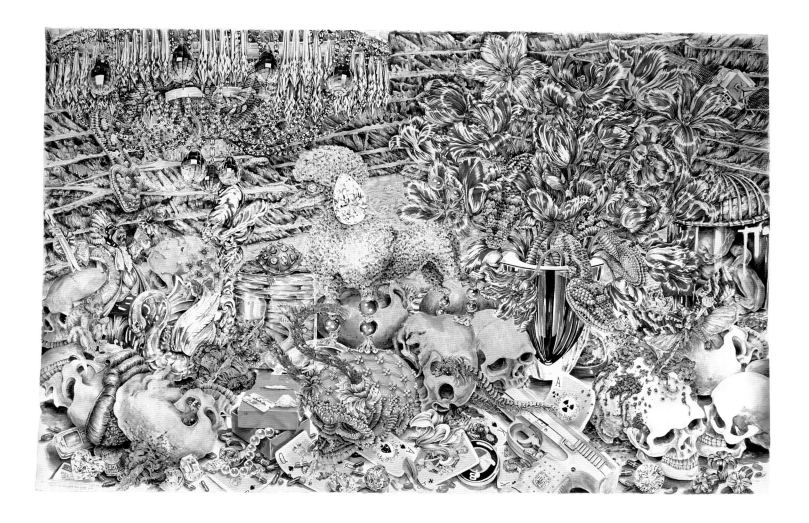

allegorically'.[7] The 'big' paintings function according to the allegorical mode because de Medici has spliced together scientific illustration and the *vanitas* tradition in order to create a new meaning within these visual styles. Her polemic depends on this process because, as described by the critic Craig Owens, '. . . allegory becomes the model of all commentary, all critique, insofar as these are involved in rewriting a primary text in terms of its figural meaning'.[8] In this day and age, an endangered species, an automatic rifle or a wrecked train can stand for the brevity and fragility of life. But, while the death's heads and overturned empty vessels remain from the historic *vanitas*, they can be also contemporary referents, respectively, for the mass graves of genocide and materialist consumption. On its own, scientific illustration such as Bauer's carries no meaning other than what it represents; in de Medici's paintings, however, its role within the Enlightenment's quest for knowledge is thrown into relief.[9] In so doing, the artist poses questions about the implications of this quest within colonisation, the exploitation of resources and the technologies of destruction. De Medici's moths from the storehouse of science are not drawn toward enlightenment but gather about the burning candle of the *vanitas*.

De Medici confounded the scientists at the ANIC by painting the old moth specimens which had been rent by crystals of verdigris as their pins corroded; paradoxically, her honest vision offended the 'good science' of objective illustration. These crystals appear in *The theory of everything* and by their magnified size upset the true perspective of historical still life. Her paintings are frank about the contrived nature of picture-making and point towards its potential for violence. She alludes to this as 'My eye, a flaying instrument'.[10] The singular eye recalls the monocular structure of Cartesian perspective, itself an analogy for the absolute monarchies of the era of its conception. De Medici draws attention to the continued significance of the all-seeing eye to contemporary power structures by including a surveillance camera and army binoculars in *Live the (Big Black) Dream* and a satellite in *The theory of everything*. Indeed, another of her watercolours, *Desire overcoming duality* 2006, refers expressly to the dependency of totalitarian power on the military; the implications of vision are made most deadly here through the highly advanced gun sights which emerge from the two skulls.

The shifts of scale within the 'big' paintings do not disrupt their smooth surfaces but, by toying with the rules of perspective in this way, de Medici foregrounds its constructed nature, its artifice. It follows that veristic art — reliant upon the structure of Cartesian perspective while appearing 'natural' — has always been, and remains, a conservative preference. Although eX de Medici's paintings are contrived to seduce such an audience, violence and death are at the end of every lure.

FRANCIS E PARKER is Curatorial Assistant, Australian Art to 1970, Queensland Art Gallery / Gallery of Modern Art.

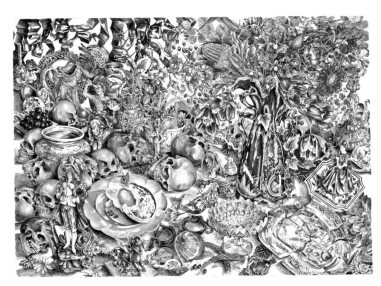

Blue (Bower/Bauer) 1998–2000
Watercolour, traces of pencil / 114 x 152.8cm / Purchased 2004 / Collection: National Gallery of Australia

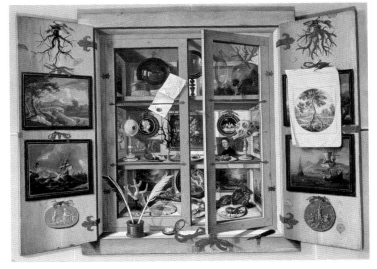

Domenico Remps / Flemish 1650–1700
Cabinet of Curiosities, second half of 17th century
Oil on canvas / 99 x 136 x 2cm / Collection: Museo dell'Opificio delle Pietre Dure, Florence / © Paolo Tosi — ARTOTHEK

The theory of everything 2005
Watercolour and metallic pigment on Arches paper / 114.3 x 176.3cm / Purchased 2005 / Collection: Queensland Art Gallery

Jitish Kallat's *Public notice* 2003 is a reflection on a passage in the history of modern India. In burnt letters on a buckled and warped acrylic mirror surface, Kallat rehearses the famous words of India's first prime minister, Jawaharlal Nehru (1889–1964), proclaiming independence from the British Empire at midnight on 14 August 1947. Nehru's 'Tryst with Destiny' speech, as it is commonly known is a remarkably Messianic text, addressed to a fledgling nation-state and to the world at large, carrying messages of predestination, hope, toil and peace. A British-educated socialist, Nehru spoke in English to a multi-ethnic, multilingual nation at the moment of independence amid the uncertainty and violence of decolonisation and partition. He spoke of a dream of a secular democracy that stood for social justice and protected the rights of the weakest. For generations of Indians, this dream has been essential to the legitimacy of the nation-state. Equally, it is these same values — secularism and social justice — that have been most conspicuously undermined since the early 1990s, with the simultaneous (and arguably, linked) advent of free-market policies and political fundamentalism. Curiously enough, at the same time that India has attracted increasing international attention as an emerging economic power, it has also seemed vulnerable to a calamitous unravelling along the fault-lines of ethnic, religious, caste and class differences.

While the text of Nehru's speech is remarkable in itself, Kallat's treatment of it is especially significant in the light of traumatic events in India's recent past. Kallat produced *Public notice* in the aftermath of the genocidal attacks on the Muslim minority in the state of Gujarat in 2002, when Hindu mobs in collusion with police and the state administration launched systematic assaults on Muslim neighbourhoods in purported retaliation against the burning of a train carrying Hindu activists.[1] Kallat's technique was deceptively simple, though it presented formidable difficulties because of the scale of the project and the materials he used. He squeezed rubber adhesive directly onto the surface of acrylic mirror sheets, enunciating the speech one letter at a time.[2] As each letter was formed, Kallat set the wet adhesive alight, burning the acrylic and causing it to melt, thus branding the impression of the letter into the surface; the accumulation of heat caused the entire surface to buckle.[3] Encountering the finished work, it seems as though the reflective surface is warped under the ideological weight of the message, and the memory of its inexorable undoing in recent years. With *Public notice*, Kallat produces a work of remarkable torsion, its momentum imparted by the opposing forces of disintegration and memorialisation. It is physically impossible to read the message without, at the same time, encountering one's own distorted image, as though in a showground spectacle gone wrong. Nehru's speech, this disembodied voice from the past, floats atop and alongside a phantasmic and equally disembodied reflection of one's own body in the act of viewing.

The vision Nehru articulated in his 'Tryst with Destiny' speech was of an independent India poised to reclaim its rightful place in a community of nations, an India bound together in peace and celebrating its diversity, an India free from deprivation, discrimination and violence. In picking up Nehru's speech as his material, Kallat is attentive to the possibilities underwritten by the forces of incineration and re-invocation. *Public notice* was not the first time that Kallat made use of a statement of national

JITISH **KALLAT**

Jitish Kallat / India b.1974
Public notice (detail) 2003
Burnt adhesive on acrylic mirror, wood and stainless steel frames / 5 panels: 198.1 x 137.1 x 15.2cm (each) / Collection: Shumita and Arani Bose, New York / Photograph: Reena Saini Kallat

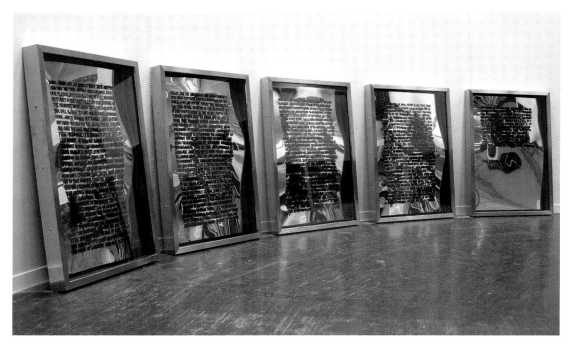

Public notice 2003
Installation view at the National Gallery of Modern Art, Mumbai, in 2003 / Collection: Shumita and Arani Bose, New York / Photograph: Reena Saini Kallat

SATO WE MADE

HE TRUE. COME

E NOT WHOL

SUBSTANTIA

GHT HOUR, WHA

WAKE TO TH

purpose — earlier works have featured the national pledge 'All Indians are my brothers and sisters' encrypted through their rendition in a 'Wingdings' font. Kallat also used a similar technique of burning letters onto acrylic in *Detergent* 2004, using the speech given by Hindu mystic Swami Vivekananda to the World's Parliament of Religions in Chicago on 11 September 1893, 108 years before the terrorist attacks on New York.

Significantly, other contemporary artists — notably Xu Bing and Savanhdary Vongpoothorn — have, in recent works, chosen to focus on statements from significant political figures associated with the birth of nations. Xu has worked with Mao Zedong's 'Talks at the Yan'an Forum on Literature and Art' transmuted into his *Square word calligraphy: Quotations from Chairman Mao* 2001.[4] Vongpoothorn has used texts from Ho Chi Minh and Kaysone Phomvihan in her *Floating words* 2006.[5]

With *Public notice*, Kallat's incinerated communiqué appears as a massive group of near-sculptural elements almost two metres high and seven metres long. Its deformed reflective surface creates an overlapping of the viewer's own image and the burnt letters that spell out a message heralding the awakening of a nation to freedom and fulfilment: 'At the stroke of the midnight hour, while the world sleeps, India will awaken to life and freedom'.[6] In Kallat's own words, Nehru's speech 'was the inspirational midwife for the birthing of the nation with many key themes inscribed in it. Reading against the grain of this text we give ourselves a report card to grade our performance as a nation'.[7]

Kallat's decision to burn the letters onto the surface of the work adds a symbolic layer. While the action of burning affords certain textural possibilities and contributes to the warping of the reflective surface, it also leaves the viewer to ponder the incinerated words — they are hard to read and time must be spent deciphering their meaning. More importantly though, the viewer is encouraged to think about the cultural implications of incineration — laying to rest as part of a cremation ceremony, or renewal through fire. Nehru's words are both burned into a memory-membrane and presented as the charred, tortured remains of what was once a great dream. The double processes of incineration and reflection make the message resonant with those momentous pronouncements of national destiny and mission, and with the reflected presence of the viewer, with his/her own sense of self and history. The viewer as witness is literally assimilated into the experience of the work. Alternately, the message is made permanent through this process, engraved for all time, to perish only with the destruction of the mirrored surface of which it is now an inseparable part.

DR CHAITANYA SAMBRANI teaches in the Art Theory Workshop at the School of Art, Australian National University, Canberra. His curatorial projects include 'Crossing Generations: diVERGE', 2003, and 'Edge of Desire: Recent Art in India', 2004–07.

Documentation of the text being burned after the application of adhesive onto the acrylic surface of Jitish Kallat's
Public notice
Photograph: Reena Saini Kallat

/ 81

Jawaharlal Nehru, India's first prime minister, delivering his famous 'Tryst with Destiny' speech at Parliament House in New Delhi, India, at midnight, 14 August 1947
Photograph: STR/AFP/Getty Images

Xu Bing / China/United States b.1955
Square word calligraphy: Quotations from Chairman Mao 2001
Ink on paper / Image courtesy: Xu Bing Studio, New York

In general, there is a lot of sculpture that refers to objects and makes them into texts of consciousness or takes pleasure in a fetishistic sensibility. There is also sculpture that joins objects to space and shows interest in a relationship with the world.

However, Anish Kapoor makes sculpture by using objects to refer to space. He cuts holes in stones, covers concave shapes with dark blue pigment, makes rectangular shapes that are empty inside, fabricates metal plates with a warped surface, and creates depressions in the floor or the wall, covering the place with dark blue pigment so that there seems to be a deeper hole that sucks you inward. When people encounter his art, the first thing they become aware of is the mystery of space — space containing nothing that seems to bend, recede or swell. These effects seem to exist as fundamental features of actual space rather than the result of the artificial deformation of space.

Kapoor uses materials like phosphorescent powder paint or makes random arrangements of objects covered with this powdered pigment. These works make viewers feel that they are in a faraway universe or a different dimension. Transcending ordinary spatiality and materiality, they have a mysterious presence that does not seem to be of this world. There is no intention here of making an object or becoming aware of a world through a relationship between it and space. Most likely, this is because perception is essential to seeing. It is important to bring out the sense of different dimensions and immateriality in space that is taken for granted as reality and let people perceive these qualities directly. Experience of the diversity and resilience of space gives people a sense of infinity.

Anish Kapoor's method is always visual and sensual. He is not influenced by the character of the times or the social system, but depends on a more fundamental, physical sense of space. That is why he gives importance to the experiential quality of lived reality. The other side of space is referred to as the quality of a particular place, the world that exists there, and something connected to everyday life. In any case, Kapoor's sculpture, even if it takes the form of a single, independent unit, is not internally autonomous or closed. He limits the existence, form, colour and structure of his sculpture, but that does not mean that it is just a visual medium. The space and atmosphere of the surroundings enter in and open up a higher sense of time and space.

Sculpture is a playground of space. Today, as modernity's attempt to realise human ideals shows signs of crumbling, Anish Kapoor has found a new way to save vision in sculpture.

ANISH **KAPOOR**

LEE UFAN is an artist and writer based in Japan.

Anish Kapoor / India/United Kingdom b.1954
Void (#13) 1991–92
Fibreglass and pigment / 161 (diam) x 120cm / Purchased 1998, Queensland Art Gallery Foundation / Collection: Queensland Art Gallery

Untitled 1995
Fibreglass and pigment / 202.5 x 202.5 x 330cm / Collection: The artist / Image courtesy: Lisson Gallery, London / Photograph: John Riddy, London

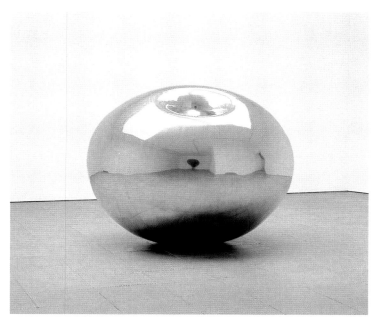

Turning the world inside out 1995
Stainless steel / 148 x 184 x 188 cm / Image courtesy: Lisson Gallery, London / Photograph: John Riddy, London

1000 Names 1981

Wood, gesso, pigment / 5 components:
122 x 183 x 183cm (installed) / Collection: The
artist / Image courtesy: Lisson Gallery, London

Untitled 1992

Sandstone and pigment / 230 x 122 x 103cm /
Installation: De Pont Foundation for Contemporary
Art, Tilburg, 1995 / Collection: The artist / Image
courtesy: Lisson Gallery, London

Bharti Kher was born and raised in London of Indian parents who migrated to the United Kingdom. She completed art school in the early 1990s, at a time when the Young British Artists (YBA) movement was just emerging.[1] The artists associated with YBA thumbed their noses at the prevailing art establishment and courted controversy. But if Kher, trained as a painter, felt isolated by these developments in contemporary art, her decision to move to and settle in India gave her the platform on which to extend and develop her art practice.

Kher's status as a return émigré to India is often noted, and indeed she assumes a unique vantage point as an observer of both Western and Indian cultures. Her work contends with the paradoxical dilemmas and moralistic conventions of contemporary society, and draws on diverse artistic methods and tactics. Her most distinctive works are two- and three-dimensional collages and sculptures covered with a textured surface of stick-on bindis.[2]

In India, the bindi is a ubiquitous item of female adornment and a distinctive marker of ethnic identity. Prepared from pure pigment and worn as a kind of 'third eye' at the centre of the forehead, the bindi is an indicator of marital status and caste in traditional Hindu society. Now mass-produced and sold in packets as fanciful vinyl embellishments, the bindi has also become an almost kitsch item of Indian glamour fashion. Yet Kher's fascination with the bindi is not simply for its symbolic or cosmetic appeal but for its possibilities as an art material.

In 1999, Kher produced her first bindi collage titled *Spit and swallow*. Created from thousands of snake-like, sperm-shaped bindis, arranged as a star-burst, the work comments on the irony of the bindi — worn as a symbol of chaste Indian femininity but produced in shapes that are apparently masculine and sexual. *Spit and swallow* derives its meaning from amusing image and word associations but is essentially conceived as an abstract pattern concerned with the process of making — a repetitive, rhythmic and meditative practice of arranging, layering and building up a surface of colours, textures and shapes. This ordered process of making acknowledges the ritualistic application of the bindi, even in its more prosaic cosmetic use. Kher speaks of her fascination with the idea that every morning thousands of Indian women adorn their foreheads with a third eye, as though with each new day they see the world with fresh eyes.[3] Guided by this idea, Kher uses the bindi to transform images and objects to make the viewer look at these images with fresh eyes.

Kher's two-dimensional bindi collages are typically produced alongside sculptures and assemblages constructed from cast fibreglass and overlaid with a skin of bindis. The earliest of these works, *You are what you see* 2002, depicts a pair of copulating dogs encrusted with a brilliant layer of sperm-shaped bindis. With this work Kher demonstrates the effectiveness of the bindi in producing a boldly coloured and tactile surface. Indeed, Kher exploits the pleasure of the surface to full effect, the scintillating quality of the bindis transforming and enlivening the robust form of the sculpture, and commanding the viewer's attention. *You are what you* see is a reflection on the nature of the sacred and the profane, the domesticated and the bestial. Taken as a metaphor for the human condition, the work is a sharp comment on the thin veneer of civilisation.

BHARTI **KHER**

Bharti Kher / United Kingdom/India b.1969
Rudolph and Bambi (detail) 2002
Bindi on painted fibreglass / Collection: Amrita Jhaveri, Mumbai

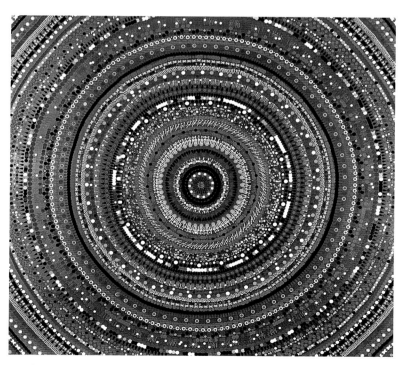

Squaring the circle 2004
Bindi on board / 152.4 x 152.4cm / Collection: Priya Paul, Delhi

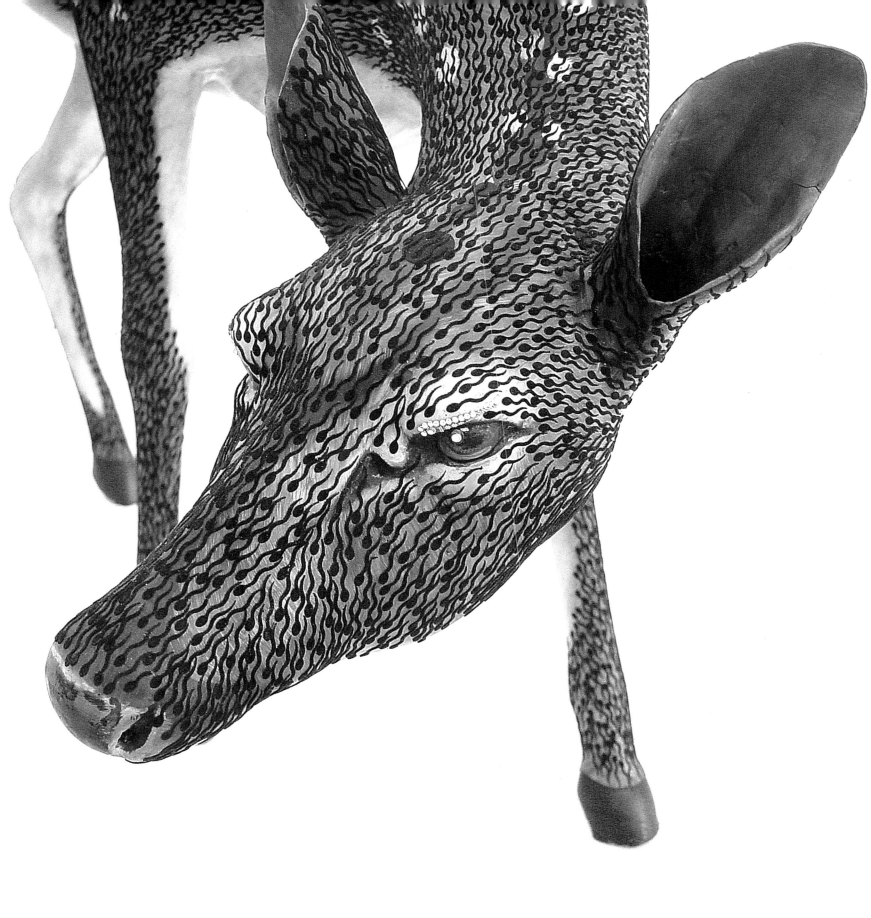

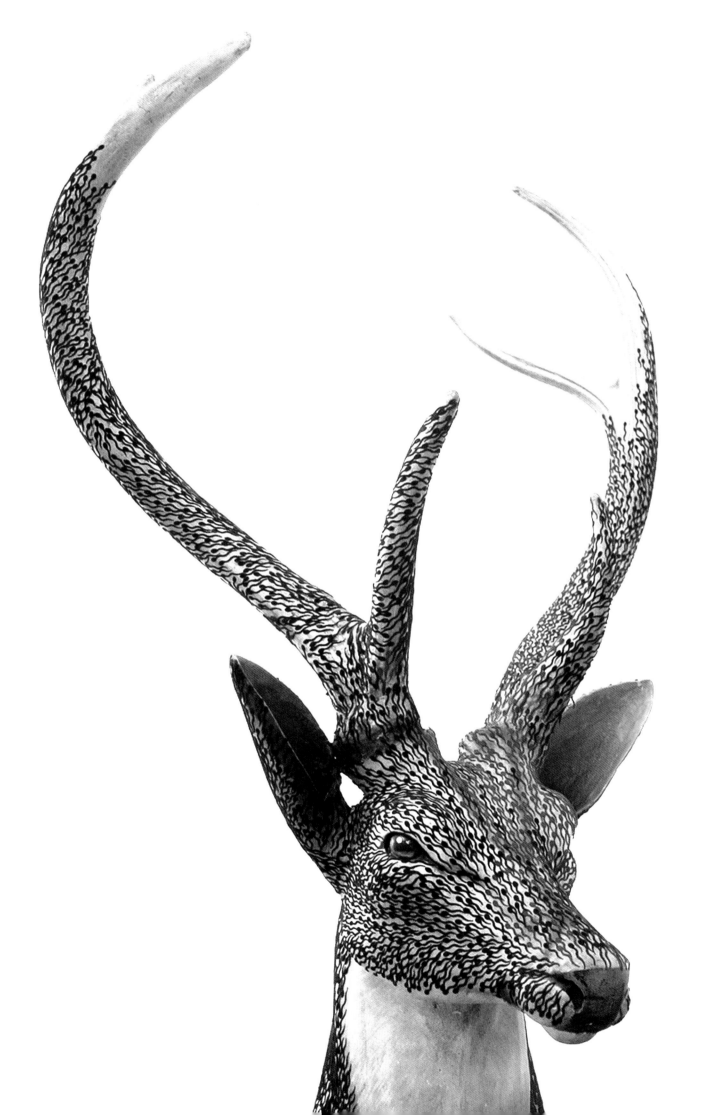

If the bindi is a marker of gendered ethnic identity, it is by no means a superficial cosmetic item but a complex symbol that can be shown to be unstable and paradoxical.[4] In Kher's work, the bindi becomes a mechanism to probe broader questions about how concepts of identity are constructed. In *I've seen an elephant fly* 2002, Kher uses thousands of sperm-shaped, white bindis to cover the surface of a grey fibreglass elephant, giving the sculpture a beguiling appearance and a quality of lightness reinforced by the elephant's graceful stance. In this work, Kher tackles the politics of colour and the concept of value through the metaphor of the white elephant. In the West, the 'white elephant' signifies something useless, redundant or expensive to maintain but, in South-East Asia, the white elephant is revered as a symbol of sovereignty.[5] This work asks if the white elephant is sacred or mundane, valuable or worthless, handsome or unsightly? What are the criteria that determine cultural worth or value? Are these criteria only skin deep?

The skin speaks a language not its own 2006 is a related work. Kher describes it as the 'mother' of the baby elephant represented in *I've seen an elephant fly*. *The skin speaks a language not its own* depicts a full-scale, reclining adult elephant. The animal is majestic, opulent and grand but, represented on the brink of death, it is also fallible, frail and vulnerable. The work appears as a meditation on suffering, incapacity and subjection; the monumental form of the elephant is at odds with its defenceless, sprawling posture. It is a work that engenders pathos and, when regarded as a partner to the baby elephant, illustrates the contrast between youth and old age, innocence and experience, the optimism and anticipation of

a life yet to be lived, and the acceptance of one's mortality. Like the other sculptures that constitute this body of work, *The skin speaks a language not its own* attempts to give form to human emotions and experiences.

HAEMA SIVANESAN is a curator and writer with expertise in the historical and contemporary art of South and South-East Asia. She is the Executive Director of the South Asian Visual Arts Collective in Toronto, Canada.

Spit and swallow (detail) 1999
Bindis on vinyl sheet / Diptych: 152.4 x 304.8cm (overall) / Collection: Lekha and Anupam Poddar, Delhi

Rudolph and Bambi (detail) 2002
Bindi on painted fibreglass / Collection: Amrita Jhaveri, Mumbai

Example of commercially produced Indian bindis

In Thailand the white elephant is a national symbol of wisdom, prowess, good luck and long life. Even as the numbers of Asian elephants decrease and the species becomes endangered, Thai images and symbols of the creature remain ubiquitous. Carvings, models and paintings of elephants adorn Buddhist temples, shrines, gates and the palace of the King of Thailand in Bangkok. A white elephant on a red ground once made up the Siamese flag (1855–1916), and the Order of the White Elephant is one of the Royal Thai Navy's highest honours, bestowed by the king.

There are of course many other familiar Thai icons: Buddhas and monks seated in the lotus position; stupas and wats (temples), figures performing the *wai* (Thai greeting with the hands held together in front of the chest), the *kanok* motif (Thai architectural curlicues), the *tuk-tuk* (three-wheeled taxi), and the lotus flower. Several symbols have ended up on Thai commercial products — Beer Chang (elephant beer), for example. Collectively they stereotype Thailand for the West.

On the face of it, Sutee Kunavichayanont's art is very Thai. Many traditional images and symbols have been incorporated and frequently reprised in his art projects over the last decade, images that are richly presented in the Grand Palace and royal compound — a block away from Bangkok's Silpakorn University, from where the artist graduated and where he now teaches. Sutee's images are, however, presented in ways commonly seen in contemporary art — through the installation of sculptural objects, sometimes kinetic and frequently requiring audience participation. 'Sutee . . . combines a variety of ideas regarding [Thai] historical, cultural, literary and religious heritage together with Western concepts and techniques', said writer Somsak Chowtadapong.[1]

For some time a number of Silpakorn University lecturers and graduates have used contemporary cultural and political issues as a basis for their art: including environmental challenges, religious hypocrisies and public injustices — such as the October 1976 student protests and its violent repression by military and paramilitary forces. Sutee was only 11 years old at the time of this event, but later, as a young graduate from Silpakorn, he began to commit to related themes in his art.

By the early 1990s, Sutee's focus was on the predicament of the Asian elephant. This theme appeared in at least ten installations from 1995 to 1997, as well as in numerous works on paper (including one remarkably like the old Siamese elephant flag). Similarly, the plight of the South-East Asian tiger, also an endangered species, was addressed in his first work involving an inflatable latex object. In *The myth of Asian tiger* 1997–98, he sought the aid of gallery visitors to (literally) breathe life into the deflated animal.[2]

In both *Elephant (breath collecting)* 1998 and *The white elephant* 1999, Sutee again used latex rubber models, with the elephants presented as lifeless, flaccid beasts.[3] Like the tiger, these creatures could be given life by the audience, inflating them by blowing through rubber hoses connected to their bodies. This 'resuscitation' was short-lived, however, as the animals soon deflated. When Sutee's inflatables were exhibited at the Liverpool Biennial of Contemporary Art in 1999, New York writer and curator Elizabeth Sussman called them 'standout works': 'These inflatables represent animals in danger of extinction and also serve as metaphors for the disappearance of native cultures with the advance of global capitalism'.[4]

SUTEE
KUNAVICHAYANONT

Sutee Kunavichayanont / Thailand b.1965
Rubbings produced from *Stereotyped Thailand* 2005–06
Teak wood and steel chairs with writing arms, wallpaper, paper and crayons; ed. 2/2 / 20 chairs; 86 x 72 x 53cm (each) / Collection: The artist

 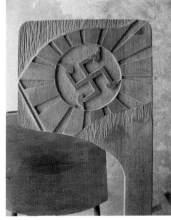

Details of carvings in *Stereotyped Thailand*
2005–06
Collection: The artist

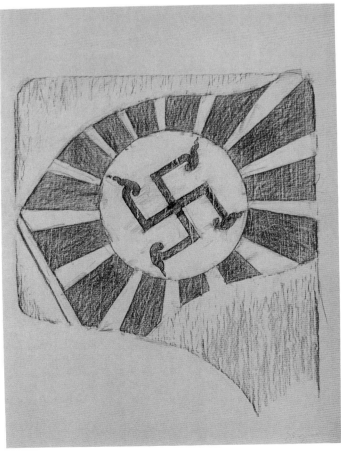

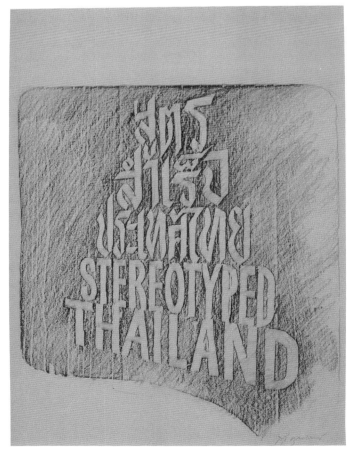

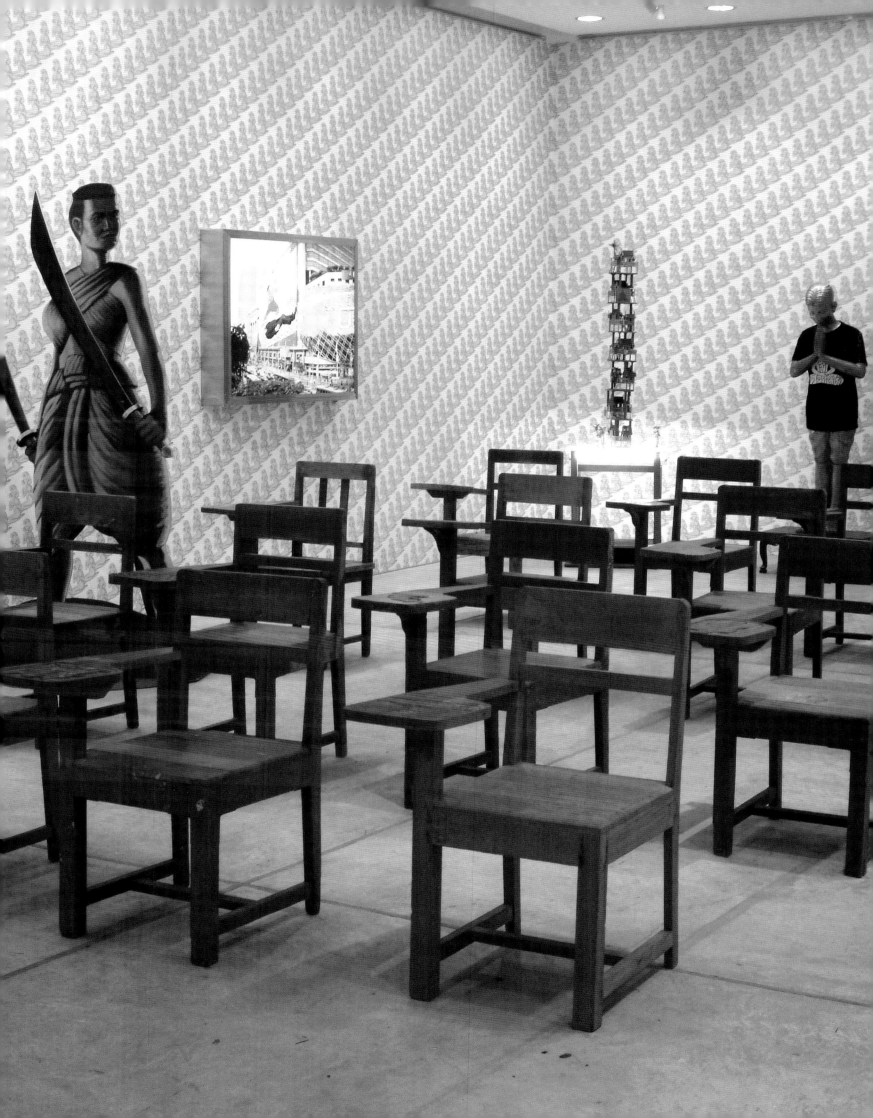

In his most overtly political works to date, *History class (white man's burden)* 2000, *History class (Thanon Ratchadamnoen)* 2000 and *History and meaning* 2001, Sutee incorporated authoritarian decrees and democratic slogans in three similar installations. For this series, the artist set up a pseudo classroom with multiples of old wooden desks and chairs, with messages engraved on each desktop. Paper and crayons were supplied to visitors, encouraging them to make (and take) rubbings from the desktops. 'Gradually I've been simplifying my work — the desktop rubbings are just the same as woodcut prints', said the artist at the time, alluding to his graduate studies in printmaking and drawing.[5] '*History class* is a straightforward no-nonsense approach of delivering the intended information.'[6]

With the *Thanon Ratchadamnoen* version, Sutee highlighted passages from historical writings including royal and government edicts beginning from the time of King Rama V (1868–1910), and incidents relating to the suppression of antigovernment sentiment. *Thanon Ratchadamnoen* refers to the name of the avenue (*thanon*) and the area around Bangkok's Democracy Monument, which was the scene of three violent upheavals in Thai society — in 1973, 1976 and 1992. Directly referencing the 1976 student repression for example, he used a poignant quote from the students: 'Mr policeman, please stop shooting us. This is a peaceful gathering, no arms. Our representatives are negotiating with the government. Please do not shed any more blood . . .'[7]

History class was the conceptual precursor to *Stereotyped Thailand* 2005, an installation also in the form of a classroom using 16 old-style school chairs with extended armrests that serve as writing surfaces.[8] For APT5, Sutee has further developed this installation using 20 chairs — each writing surface carved with a Thai icon — and wall motifs, to make up the 'classroom'. The 'wallpaper' which fills the space, is made up of multiples of small figures of a modern, bouffanted Thai woman performing the *wai* and sitting in the classic position: calves and feet tucked neatly under the buttocks. As in previous works, gallery visitors are encouraged to make rubbings of the satirical yet playful carvings, using paper, pencils and crayons.

In *Stereotyped Thailand* each chair depicts a different image dealing with contemporary perceptions of Thailand. On one, a robotic woman performs the *wai* but, as she bows forward, her head opens to reveal emptiness within (reprising an earlier kinetic sculpture series titled 'The eternal banality', 1997–98); on another, a swastika is adorned with Thai *kanok* curlicues. Here, Sutee has chosen a motif with multiple applications from prehistoric to modern times: a sacred Hindu and Buddhist symbol also used by Native American cultures and later adopted by the Nazi Party — but its title, 'The elegant fascism', confirms the artist's intention. On another chair, Mickey Mouse and Juk (a small Thai boy with a traditional topknot) are Siamese twins, melding into each other. 'We generally have stereotyped perceptions of icons like the *kanok* or Wat Pra Kaew [Temple of the Emerald Buddha], or the floating markets', says Sutee, 'They're all nostalgic images of the Kingdom'.[9]

Like many of Sutee Kunavichayanont's projects, *Stereotyped Thailand* encourages audience participation and playfully challenges the homogeneity of ideas — from concepts of Thai identity, to the consequences of Thailand's rapid social, economic and political changes, to the unquestioning acceptance of what we are taught, both in and out of school.

IAN WERE is Senior Editor, Queensland Art Gallery / Gallery of Modern Art.

Installation view of **Stereotyped Thailand**, 25 August – 2 October 2005, at 100 Tonson Gallery, Bangkok, Thailand
Photograph: Opas Chotiphantavanont / Image courtesy: The artist

Installation view of **History class (Thanon Ratchadamnoen)** 2000, in front of Bangkok's Democracy Monument, which was the scene of three violent upheavals in Thai society — in 1973, 1976 and 1992
Image courtesy: The artist

A PLAYGROUND OF INTERPRETATION

Born and based in Seoul, Kwon Ki-soo works in a wide range of media, including painting, sculpture and video. He is primarily known for his creation of Dongguri, a character that frequently appears in his work. Although human-shaped, Dongurri is an icon formed by certain marks and symbols; a by-product of modernisation in which everything is symbolised, simplified, and mechanical. Dongguri has gained wide appeal in contemporary art circles and has also been used commercially (not necessarily according to the artist's intentions). The character's popularity probably came about because it appeals to a younger generation that readily consumes and reproduces popular culture.

Because of his use of pop language and materials and Dongguri's flexible application to commercial markets, Kwon's art has often been classified as Neo-Pop.[1] This classification, however, does not seem to adequately describe Kwon's work. Instead, more emphasis should be placed on the range of meanings and emotions Dongguri conveys, forging a link between artist and audience.

Certainly, Kwon's art is not all about Dongguri and extends beyond his often used and much admired symbol. He has continuously created innovative designs, marrying ultra-modern elements with old traditions. He draws on tradition as a means of expressing modern sensibilities, a feature found in his most recent paintings. Kwon's reinvention of classical Korean motifs might be a natural extension of his study of traditional Korean art, but it is also interesting that his works contain coded messages hidden in layers beneath the surface of the art itself.

The artist's favourite motifs, such as plum blossoms, orchids, chrysanthemum and bamboo are drawn from traditional *sumi* painting.

These four plants, fundamental artistic motifs in *sumi* painting, are also symbolic representations of a scholarly life and of literati culture.[2] Each represents one of the four seasons: plum blossom for spring, orchid for summer, chrysanthemum for autumn and bamboo for winter. Like the *sumi* painters, Kwon uses these motifs as symbols, however, his paintings may be better described in terms of traditional *sansui* (landscape) painting. Rather than copying nature, *sansui* painters use form and technique to express their own concept of it. For them, the transcendent values of nature and the universe are not to be conquered but are an innate attitude, the order and reason of which should be studied and followed. *Sansui* painters express transcendence by refuting a visual imitation of what is seen as reality, seeking meanings in the unseen world. *Sansui* is, therefore, more than a technique; it is a symbol, a paradigm and a fundamental concept.

Kwon's recent paintings reflect his continuing use of Korean traditions; in particular, the symbolism of *sansui*. In *Black forest 2* 2006 and *Colour forest* 2006, numerous vertical poles represent a bamboo forest, with stem sections marked by colourful ribbons. Dongguri sits on a cube among the bamboo. The cube, in this case, represents a rock — a significant object in traditional Korean painting and literati culture, prized for its abstract qualities. With its conventional shape and colour removed, the valued symbol is given a fresh beginning in Kwon's work.

Another traditional motif is transformed in Kwon's *In the fountain* 2006. Here, the water fountains symbolise a variety of orchid shapes. Although the lines appear simple and free-flowing, they are actually positioned according to the strict conventions of the traditional *sansui* style. Rippling

KWON KI-SOO

Kwon Ki-soo / Korea b.1972
Black forest 2 2006
Synthetic polymer paint on canvas on board /
227 x 182cm / Collection: The artist

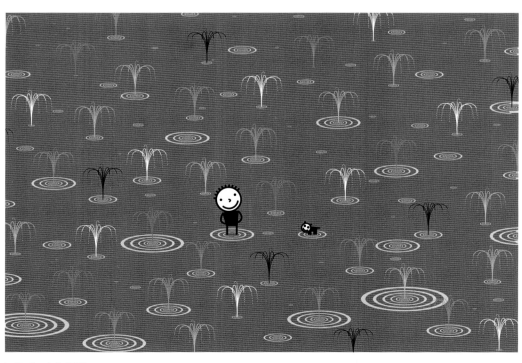

In the fountain 2006
Synthetic polymer paint on canvas on board /
130 x 190cm / Collection: The artist

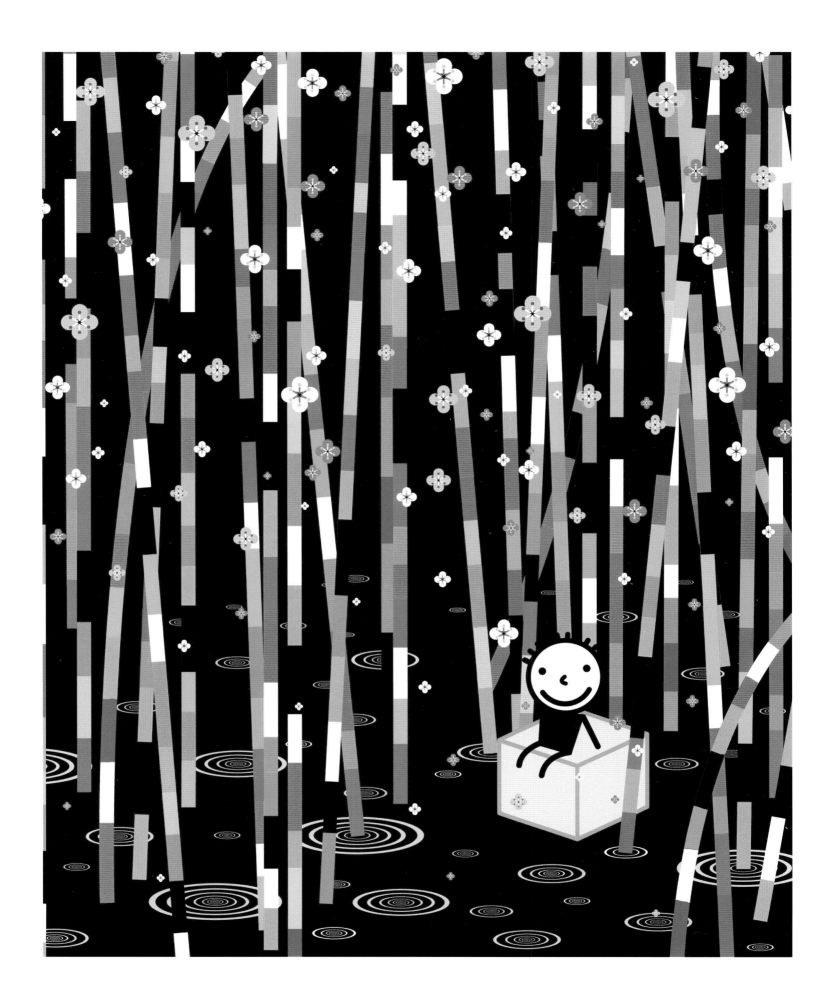

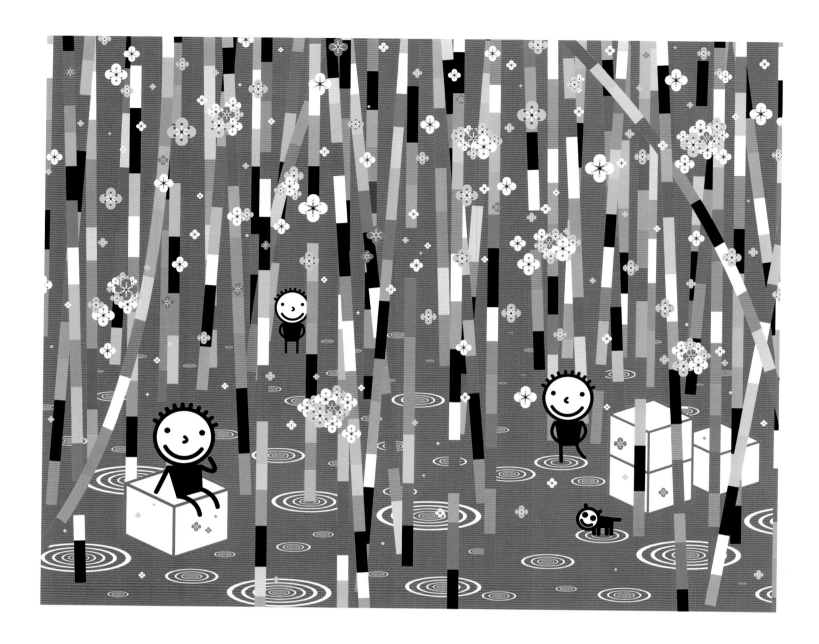

water, a recurring theme in the artist's work, also recalls a common theme in Asian culture — radiating energy.

Untitled 2005–6, is particularly interesting because Dongguri, who appears in most of Kwon's work, is gone. Only plum blossoms and ripples remain. Plum blossoms were much loved and frequently used in the literati tradition as an image of endurance — the plant bears fruit throughout winter and is the first to blossom in spring. The artist gives special meaning to this and also uses the blossom as a signifier of beauty.

The video animation, *Plum blossoms around a cottage – visiting a friend on a snowy day* 2003 tells the story of visiting a friend early in spring, when the first plum blossoms appear. The rather silly but nonetheless adorable Dongguri appears as both the host and the visitor. The painting in the background is by Goram Jeon Gi (1825–54), one of the most important artists of the late Joseon dynasty (1392–1910). The theme of this painting was conventionally used in *sansui* to display a natural harmony between seasonal changes and the poetic nature of literati culture. In his video animation, the artist converts a form of art considered traditional and highbrow into something contemporary and cheerful.

Through his work, Kwon Ki-soo continually explores traditional themes and values, which he adapts and incorporates into contemporary art forms. His art is characterised by a creative grafting of past spiritualism onto contemporary materialism, moulded into symbols and icons. Through multiple layers of symbolism and meaning, Kwon offers viewers a playful interpretation of a world where lightness and heaviness can coexist.

KIM SUN-HEE is Art Director of Zendai Himalaya Center 2009, Shanghai, and a guest curator of Mori Art Museum, Tokyo.

Colour forest 2006
Synthetic polymer paint on canvas on board / 181 x 227cm / Collection: The artist

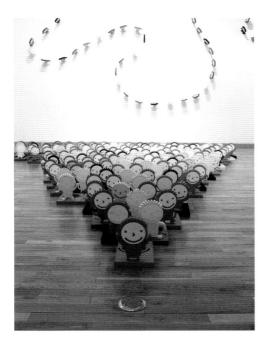

Run, run, run 2005
Foam / Dimensions variable / Installation at 'Who are you', Kumho Museum of Art, Seoul, 2006 / Collection: The artist

Plum blossoms around a cottage — visiting a friend on a snowy day (stills) 2003
Flash animation on DVD, 1.31 minutes, colour, sound / Collection: The artist

DAMAGED GENES AND THE EXPERIENCE OF MEMORY

On 1 May 1975, the North Vietnamese Army marched into Saigon (now Ho Chi Minh City) signalling the reunification of the country after almost 30 years of war. Three decades after these events the complex history of violence in Vietnam continues to be framed by photojournalism and American cinema. While these images provide an intimate view of suffering, they are often limited by editing and political rhetoric. The work of Dinh Q Lê seeks to disrupt the ways in which these mainstream and dramatic representations have informed dominant understandings of the American war in Vietnam.[1] Lê's work offers an alternative perspective and experience of the Vietnamese people whose lives have been irrevocably transformed by the effects of war.

Born in 1968, Lê's hometown of Ha-Tien on the Cambodian–Vietnamese border was invaded by the Khmer Rouge after several years of conflict.[2] Fleeing with his family to Thailand in 1977, Lê remained in a refugee camp for a year before being granted asylum in the United States. Reflecting on these experiences of violence and displacement, Lê investigates the nature of identity and memory in postwar Vietnam and how the legacies of warfare are entwined with Vietnam's ambivalent aspirations for progress. It is a strategy that allows Lê to highlight the impact of historical events on individual lives, presenting an optimistic approach to the experience of survival.

While acts of remembrance might reconcile the effects of war, for Lê they also highlight a complex exchange between the use of memories to authenticate an experience and transforming or absolving memories as a means of survival. As Lê states:

> I am interested in the way nature actively erases both physical evidence as well as our memory of the event. We cannot keep all memories because not all memories are meant for us to keep. The question then is what memories to keep and what to let go of as the way nature intended.[3]

Theorist Jill Bennett argues in her study of trauma and contemporary art that the imagery of traumatic memory deals 'not simply with a past event or with the objects of memory but with the present experience of memory'.[4] Lê describes how the sight of helicopters extinguishing fires in California reminded him of those he had seen in Vietnam. However, Lê is conscious of how his recollections were influenced by popular media:

> . . . he quickly remembered . . . that there had been no helicopters in their region of Vietnam. What Lê had remembered from life was, in fact, a scene in the film *Apocalypse Now*.[5]

In the three-channel video installation *The farmers and the helicopters* 2006, Lê edits together interviews with Vietnamese farmers and sequences from Hollywood films dramatising the war.[6] These recollections and images evoke the experience of farmers awed and terrified by helicopters raining down bullets, bombs and chemical agents, but they also provide a complex counter-narrative to the mythologies of warfare depicted in American cinema.[7] The interviews also highlight a generational shift in memories of the Vietnam–US War: older farmers remember the horror of what they witnessed while many younger Vietnamese, like Trần Quốc Hải,

Dinh Q Lê / Vietnam b.1968

In collaboration with Tuấn Andrew Nguyễn and Hà Thúc Phù Nam

Production stills from *The farmers and the helicopters* 2006

From left to right: Phạm Thị Hồng, Trần Văn Giác, Vương Văn Bang, Lê Văn Đãnh, Trần Quốc Hải and Trần Thị Đảo

3-channel video installation, High Definition Video, 15 minutes, colour, sound, ed. 1/10 / Dimensions variable / Collection: The artist

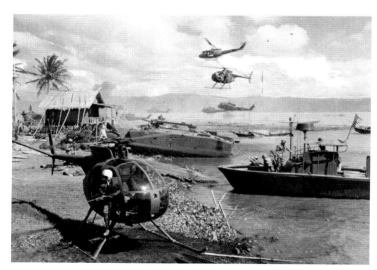

Production still from *Apocalypse Now* 1979
Director: Francis Ford Coppola / 70mm, 153 minutes, colour, sound, USA, English, Vietnamese, French, Khmer / Image courtesy: United Artists

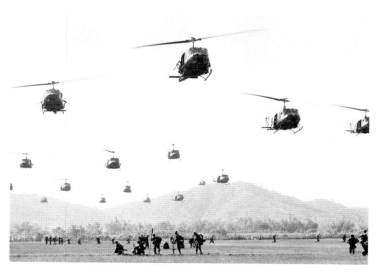

US Helicopters landing near Bong Son, South Vietnam, 16 February 1966
Image courtesy: Bettmann/CORBIS

elide the trauma of these events by re-signifying the helicopter. A self taught engineer and farmer, Tran recounts his childhood fascination with helicopters since living near an American military base during the war, and the seven years he spent designing and building a functioning helicopter. For Tran the aspiration to fly reflects a desire to assert a modernity otherwise thought not to exist in postwar Vietnam.

In *Damaged gene* 1998 and *Lotusland* 1999, Lê explores the effects of chemical defoliants used by the United States during the war.[8] Emphasising how exposure to the dioxins in these chemicals still permeates bodies, memories and land in Vietnam, Lê strategically interweaves social agency with forms of popular culture. The title of *Damaged gene* refers not only to the immediate consequences of chemical exposure but also its long-term genetic effects and the large number of conjoined twins born as a result. In Vietnam, congenital malformation has been a taboo subject, with the government's silence about the contamination of soil partly due to its economic dependency on agricultural export. *Damaged gene* reacts against this silence as well as the unwillingness of the United States government to compensate Vietnamese victims of Agent Orange.[9]

Originally staged in a small kiosk in Ho Chi Minh City for a month in 1998, *Damaged gene* displayed and sold objects illustrating the physical effects of Agent Orange.[10] A range of clothing and pacifiers custom made for conjoined twins were fabricated and presented alongside figurines of Siamese twins and T-shirts informing shoppers of the high rate of birth abnormalities in Vietnam. Lê does not shy away from the issue of accountability, branding the clothes with the names of American companies, such as Monsanto and Uniroyal Chemical, which were responsible for producing the dioxins. He also cites statistics about the extent to which American troops sprayed these chemicals across Vietnam, Cambodia and Laos.

For author and activist Susan Sontag, 'compassion is an unstable emotion, it needs to be translated into action, or it withers'.[11] If *Damaged gene* represents the transference of compassion into action, the installation *Lotusland* proposes an alternate mode of memorialisation as social action. *Lotusland* comprises a number of human-scaled fibreglass figures of Siamese twins made by the craftsmen responsible for carving temple sculptures. Lê configures their bodies to resemble deities drawn from Buddhist and Hindu iconography. Refusing to sensationalise his subjects, Lê situates the children on lotus flowers and leaves, connecting them to the Buddhist symbols of purity and enlightenment. Their defective bodies no longer constitute simply the suffering and stigma of war. They appear instead as creatures of reverence to be honoured rather than rejected for their pain and deformities.

Lotusland was inspired by Lê's experience of visiting rural towns in Vietnam, where communities often worship conjoined twins as 'special spirits', believed to possess the power to protect and bestow luck. The deification of these children reduces the distinction between mythology and the realities of congenital malformation. Often dying young as a result of insufficient medical treatment, the children are in effect memorialised in *Lotusland*.

Lê's use of deification and his emphasis on the present experience of memory takes on a contemporary political dimension. Acts of remembrance

Previous:

Lotusland 1999

Fibreglass, polymer, wood and synthetic polymer paint / 27 components ranging from 30 x 57.5 x 52.5cm to 77.5 x 55 x 45cm (installed dimensions variable) / Purchased 2006. The Queensland Government's Gallery of Modern Art Acquisitions Fund / Collection: Queensland Art Gallery

Buddhist temple sculptures in Ho Chi Minh City. Dinh Q Lê's work **Lotusland** references contemporary religious sculptures in Vietnam

Image courtesy: © iStock International Inc.

work in a local context to give a new significance to the trauma of war and encourage people to reject simple expectations of grief and tragedy. For Vietnamese communities, these acts provide an opportunity to recover what has been lost and demonstrate the capacity of cultures to move beyond the horrors of war with dignity.

JOSE DA SILVA is Curatorial Assistant, Film, Queensland Art Gallery / Gallery of Modern Art.

Damaged gene (detail) 1998
Plastic and fabric / Dimensions variable / Collection: The artist

Four US Air Force C-123s spraying Vietcong jungle near Tan Son Nhut, South Vietnam, 30 September 1965. The four specially equipped aircraft cover a swath of more than 300 metres wide on each pass over the dense jungle
Image courtesy: Bettmann/CORBIS

The Long March Project is a journey of visual creation and display. It follows the route of the historical Long March. Its aim is to allow people on this route to see contemporary art from China and abroad, and to create art in their presence. The Chinese people are currently on another 'Long March', the journey toward a socialist market economy with Chinese characteristics. Long Marcher Deng Xiaoping said that 'only development is hard reason'. The results of this reform era are evident, as the annual growth rate for the Chinese economy has hovered around 9 per cent for more than a decade. While rapid urbanisation and commercialisation have happened along the route of the Long March, such changes have also caused cultural losses and ideological voids. At the same time, a new cultural paradigm has emerged in China, whereby people regard wealth as glorious. What do people today think about communist idealism, the seeds of which were sown along the route of the Long March? What do they think about revolutionary practice, in which retreat can become victory and achievement, and which substitutes 'Chinese reality' and 'the local context' for foreign 'truth'? What do they think about the theoretical and practical implications of the transfer of power to Mao Zedong, an event which happened during the Long March? From the viewpoint of visual culture, Long March culture is missionary and metaphorical. It turns the kind of culture that derives from the people to serve the people into a valid mainstream language. It surpasses concrete authority, which is rooted in collective memory.

The biggest problem facing contemporary Chinese art is that its audience is limited to overseas organisations and markets, and to a couple of major cities like Beijing and Shanghai. The vast majority of Chinese have no opportunity for direct contact with contemporary art. Furthermore, precisely because the Long March Project travels to Chinese cities other than Beijing and Shanghai — places labelled as relatively 'backward' — the people with whom it comes into contact have virtually no experience with Western art. Therefore, there is special significance in sharing contemporary art with them. This activity looks to review the cause and effect relationships between revolutionary history and cultural ideology in the People's Republic of China — especially Mao Zedong's ideology of 'art for the people', in conjunction with ideologies that were prevalent in the West during the Mao era, including some that were inspired by Maoism. It aims to analyse how Western thought and art have influenced the creation and reception of art in China in the past and present. It will re-examine how our reading and rewriting of things Western and the Western reading and rewriting of things Chinese have affected personal and mutual understandings. Just like other simplifications and misreadings of Chinese culture, Western Maoists also set out to reinterpret Chinese history based on their own power. We must raise a new inquiry, seeing misreading as misreading, and acknowledging the creative power implied therein. Thus, the entire Long March Project also includes art works from other countries, just as the historical Long March involved contemplation of foreign thought and the integration of 'sinicized' readings of such thought into Mao's guerilla warfare tactics. The Long March will examine the influence of these shifts in thought on history, along with that of the processes of national migration, capital flows, cultural changes, and the engagements, intersections, exchanges and connections

LONG MARCH PROJECT

One interest of the Long March is to investigate history and linkages between China and abroad. The Long March team is pointing at the Tatlin-style tower in downtown Kunming. Site 4
Image courtesy: Long March Project, Beijing

The logo for the Long March: A Walking Visual Display
Image courtesy: Long March Project, Beijing

The journey of the Long March Project
Image courtesy: Long March Project, Beijing

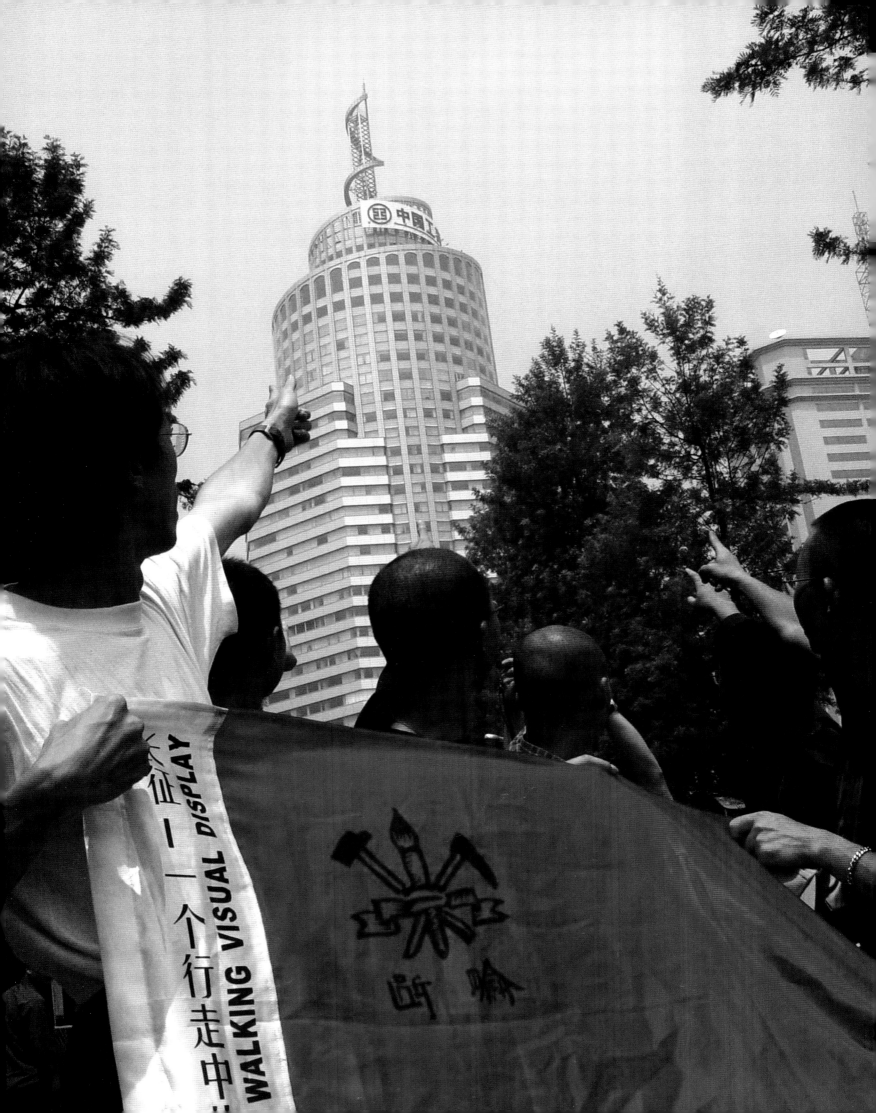

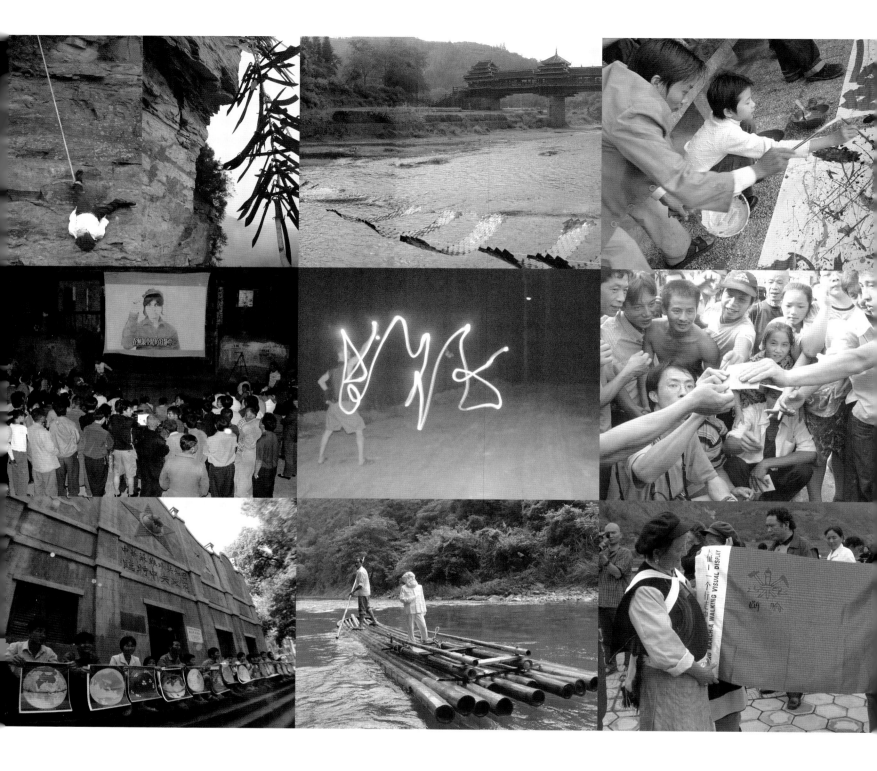

Left column:

Wang Jin, *Hanging Swords on the Cliff with Swords Hung Upside Down*, Jingangshan, Huangyangjie, Jiangxi province. Site 2

Screening of Jean-Luc Godard's *La Chinoise*, Mixi village, Ruijing, Jiangxi province. Site 1

Ingo Gunther's work exhibited in front of Shazhouba Auditorium, Ruijin, Jiangxi province. Site 1

Centre column:

Feng Qianyu, *Crossing the Chishui River Four Times*, installation using used film, Sanjiang, Guangxi province. Site 3

Qiu Zhijie, writing the characters 'Long March' on the road between Guangxi and Kunming. Site 3

Floating exhibition of Sui Jianguo's sculpture *Marx in China*, Jingangshan Mountain, Jiangxi province. Site 2

Right column:

Townspeople paint in the style of Jackson Pollock after a drinking party, Maotai, Guizhou province. Site 9

The Long March Project set up an art stall in a local market, distributing Long March propaganda and materials on contemporary art. Lu Jie, Chief Curator, is handing out Long March postcards to people in the market. Site 3 (on the road in Guangxi)

Dancers at Lijiang, Yunan province, present the Long March flag. Site 5

Images courtesy: Long March Project, Beijing

between human and supernatural, individual and collective, and reality and utopia. This will not only be a process of yearning and following the original Long March — a historic journey that deeply influenced Chinese society, and has reverberated internationally — but one of searching and building the historic journey into something new.

The working model created by the historic Long March provides us with not only a subject to discuss, but a substantive praxis for a critique of contemporary mainstream exhibition culture. Chinese contemporary art is in the earliest stages of constructing a formal system, but has begun the game of comparison and competition with the West, buying wholeheartedly into a system based on major museums and biennial exhibitions. We must think more carefully about the structural relationship of this system to the global artistic hierarchy, and to contemporary tourist culture. Nowadays, a city looking to become a global metropolis has a de facto obligation to develop an apparatus for contemporary art. We need to remain sensitive and respectful of the situation of alternative art in peripheral locales. Otherwise, a Chinese art system which takes 'oppose discursive hegemony' as its slogan will in reality be nothing more than a tool of neo-colonialism. The Long March Project seeks to integrate the production, consumption and interpretation of art in a single scene, three issues which have traditionally remained separate. It looks to overcome the traditional distance between viewer and creator, to close the gap between 'host' and 'guest', and to seek a new understanding of space. In this way, The Long March Project merges exhibition with creation, and allows consumption and production to interact.

The Long March Project is an exhibition about exhibitions. It is not an exhibition in the traditional sense, with art works hanging in a fixed space, both literally and metaphorically. It expands the notion of the exhibition through the juxtaposition of temporality and permanence. The 20 sites along the route of the Long March are excursions into the historical, political, geographic and artistic context of each place. Each activity is divided into three parts: creation, display and debate. The display portion involves original works, slides, video, film and books; the debate portion involves the artists and curators, as well as the workers, peasants, soldiers, students and merchants encountered along the road. Some of the conceptual and performance works created by artists may bridge both the exhibition and debate elements of a given activity, making the activity even more interactive. By exhibiting Chinese and foreign contemporary art to the masses, by re-reading Chinese and Western documents with them, by revisiting history and memory, by collecting their memories and interpretations of the old and the new Long March, by recording the details of these varied interactions, and by restructuring these visual and textual materials and incorporating them into the next stage of the project, the entire project will continue to develop while on the road, becoming a way for every participant to continually adjust their thinking. The Long March Project has become a multimedia, multi-layered study in the anthropology and sociology of art, a hypertext connecting urban with rural and reality with imagination. Through a dialogue with international contemporary artistic thinking, it also serves as a rewriting of post–Cold War art history.

American feminist artist Judy Chicago's work *What if women ruled the world?*, exhibited at Qidishanzhuang, Lugu Lake, Yunan province. Site 6
Image courtesy: Long March Project, Beijing

丽江飞虎队机场

泸定桥

遵义会议旧址

泸沽湖

On 1 September 2002, after completing 12 of the 20 planned sites, the Long March curatorial team returned to Beijing. Although there was a special significance in bringing contemporary art to people who have never been exposed to it, the discourse that could be realised by a moving exhibition was limited because the works created and the ideas expressed were not being brought to a space where they could be heard in serious exchange; instead, they continued to remain on the periphery. For this reason, we stopped the march and established site 13, the 25000 Cultural Transmission Center in Beijing, with the belief that, in doing so, the project will ultimately instigate more dialogue, discourse and sincere engagement.

Although we have stopped the march, we have not stopped marching. A major realisation was that the Long March Project is not, and should not be, limited to the route of the historic Long March. By using the 25000 Cultural Transmission Center as a launch point and the Long March methodology developed on the road as a framework, the project has begun marching into all spaces, be they rural or urban, in China or internationally, geographic or discursive.

A fundamental tenet of the Long March Project has been that space has memory. It is our belief that art has the ability to transcend geographical space temporally by entering into a discursive space. To this end, the Long March Project has not only sought to expose people to contemporary art but has also sought to expand the amount of discourse generated through innovative programming and activities that move beyond simple relationships of artist and viewer. By holding exhibitions, symposiums and lectures, the 25000 Cultural Transmission Center has become a hub for expanding discourse, which enables the works realised on the road to develop in a broader context.

We have been moving into the international arena, holding exhibitions and participating in conferences at many venues. Nevertheless, we have not abandoned the original objective of bringing art to the people. We still believe strongly in the power of the public realm and have continued with projects in China aimed at bringing this creative power to light and demonstrating the contributions such a force can make to the corpus of contemporary art. In January 2006, we established a new Long March space in Hun cave dwellings near Xi'an, and have several upcoming projects that once again revisit the Chinese countryside and continue to involve the people in the creation and interaction of contemporary art. We hope to use this powerful cultural resource to continue to blow open new possibilities in the realm of contemporary art.

LU JIE is the initiator and Chief Curator of the Long March Project. He has curated numerous contemporary art exhibitions internationally, including the Chinese presentation at the 2005 Prague Biennale and the 2005 Yokohama Triennale. He is the founder of the Long March Foundation in New York and the 25000 Cultural Transmission Center in Beijing, and is on the Editorial Board of *Yishu — Journal of Contemporary Chinese Art*.

QIU ZHIJIE is Associate Professor at Studio for Art in General at the China Art Academy, Hangzhou. He was Co-curator of the Long March Project and is an artist, curator and art critic.

Qiu Zhijie, *Left/right* performance, realised throughout the course of the Long March Project. Clockwise from top left, the places in the images are: Flying Tigers Airfield, Lijiang, Yunan province (site 5); Luding Bridge, Sichuan province (site 12); Lugu Lake, Yunan province (site 6); Zunyi Conference Meeting Hall, Zunyi, Guizhou province (Site 8)

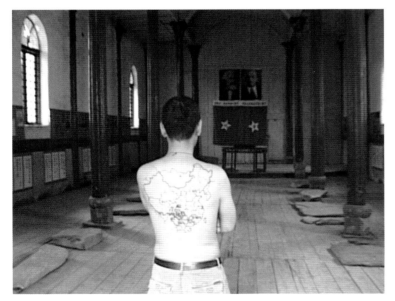

Qin Ga / China b.1971
The miniature long march site 15 — site 23
(still) 2005
Mini DV, 25:30 minutes, colour, sound / Collection: The artist

In the early phase of the Cultural Revolution, which marked its 40th anniversary in 2006, the Red Guards took a lead from the Long March, an ignominious then ultimately heroic flight of Communist Party forces through China's hinterland in 1935.

Many of the young rebels were the progeny of old party leaders who had been on the original march of 1934–35, a tactical retreat that some have called the *hijra*[1] of the Chinese Communist Revolution. But the Red Guards believed that their parents had become reactionary and corrupt following the success of a revolution that led to the establishment of the People's Republic of China in 1949. Nonetheless, when they rebelled against the status quo of their parents in the mid 1960s, rather than looking toward some future communist idyll, they drew inspiration from the Long March of the mid 1930s and the trials and tribulations of its pathfinders.

The art practitioners who inhabit the space of this latest, artistic Long March — itself something of a movement, a 'happening' and a performance, as well as being an undertaking possessed of a physical locale in Beijing, initiated in early 2005 — draw their lessons from the past, too.[2] The whole project, with its showcase at the Beijing 798 cultural factory can be seen as an extended post-socialist prank, but it is also an artistic conglomerate with a nationwide brief and a shifting international agenda.

The post-Mao cultural world has been in constant exchange with the mass culture of China's high socialism. From the time of the Stars collective in the late 1970s, artists have employed party culture for their own ends. One of their number, Ai Weiwei, the son of the famous party poet Ai Qing, is still prominent as an arts demiurge. Later, other cultural figures proved themselves equally adroit in feeding off the power of official culture, and the Long March, akin to a creation myth of modern China, was re-invented, and inverted repeatedly.[3] Cui Jian, for example, the father (and now grandad) of Chinese rock'n'roll, even called one of his albums *Rock on the New Long March*. Not that the country's less-than-revolutionary officialdom has been slow to exploit the party's past; indeed, the economic policies that have transformed China in recent decades have long been hailed as part of the nation's new Long March.

Mao Zedong, who himself rose to prominence and power during the original Long March, said that the trek was not only a military feat but 'a manifesto, a propaganda force, a seeding-machine', one that 'has sown many seeds which will sprout, leaf, blossom, and bear fruit, and will yield a harvest in the future'.[4] The Communist army broadcast its message through the country in the most elemental and direct fashion. But as they traced a tortuous route through the provinces, the Long Marchers were dramatically diminished. There are estimates that they started 80 000 strong, but finished the retreat with approximately 8000 men and women. In contrast, the Long March Project in Beijing today is attracting participants as it unfolds. Its affiliates constitute a veritable who's who and who's not — as well as who's a wannabe — of contemporary Chinese artistic practice. Moreover, its activities segue neatly with the commodified socialist culture of official China, and the symbolic discourse of a cashed-up Communist Party. The project is gaining ground, and not only in China. Its global reach is pinpointed on the world map that features at its website.[5]

TWO STEPS FORWARD, ONE STEP BACK

Mao Zedong (1893–1976) with Zhou Enlai (1898–1976), leaders of the Chinese Communist Party during the Long March, 1935

Collection: Hulton Archive / Image courtesy: Getty Images / Photograph: Keystone

The Red Family (1969) / In the mid 1960s at the height of the Cultural Revolution, the Red Family came to fame. They were popular peasant entertainers from Guangdong province, near Hong Kong, with six children, aged from 3 to 14. Their repertoire consisted of some 100 revolutionary songs and more than 50 song-and-dance numbers. They sang the praises of Chairman Mao to audiences throughout the province. The Red Family was celebrated in the Chinese media and others were encouraged to follow their lead: a family that makes revolution together will stay together

Image courtesy: Long Bow Group Archive, Boston

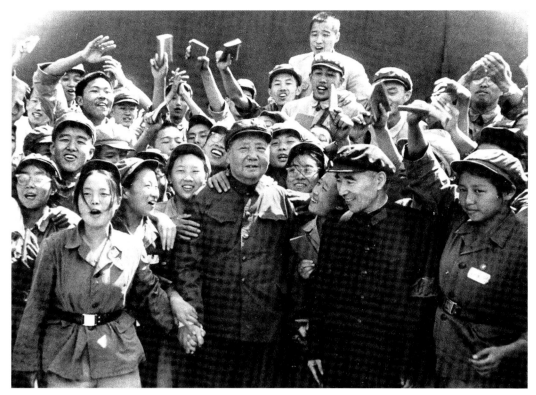

The new Long Marchers are spreading their message in ways, sometimes sincere but often also in the self-conscious mode of modern art production, that attempt to engage with and enliven local China. The culture that would be avant-garde today features a melding of economic change, local initiative, folk tradition and individual quirkiness. Through groups like the Long March Project, the initiatives of the city elites may well penetrate many parts of the country. While poverty, corruption and abuse of power remain common, or are ever more rampant, there are also alternative economies at work in regional China, cultural as well as fiscal. These economies are not limited to the schemes of entrepreneurs, the canny exploiters of rapid change or the indulgent projects of the new rich. Cultural transformation is also taking place at the grassroots. It should not be forgotten that, throughout its history, the regional areas of the country — and not merely the major urban centres — have also been loci for innovation, adaptation and striking development.

Although it is with open irony that the artists participating in this Long March Project utilise the cultural codes of the Communist Party for public effect, there is a level on which some of them re-inhabit aspects of the Long March ethos. For while they play on the concept of spreading the word through art by travelling the country, the multifarious efforts of non-official artists have indeed changed the landscape of Chinese visuality, the way people regard artistic endeavour and the manner in which Chinese culture (and its promise) is perceived globally.

Another body of populist, not necessarily propagandistic or in any way avant-garde, writing and art on the Long March has appeared in recent years. As the local travel industry has flourished, what is dubbed 'Red Tourism' has experienced a boom. Many low-budget, home-grown tourists have (forgive the pun) beaten a march on the artists by retracing the steps of celebrity revolutionaries through provincial backwaters and rugged terrain. And a mini-library of guidebooks provides everything these DIY Long Marchers might need: itineraries, details of regional delicacies, historical incident (and dubious fables), shopping hints, hostels and local colour. While the message that the tourists are spreading throughout China is familiar, that of the artists involved in the Long March Project is more beguiling.

Qin Ga, a participant in the Long March Project, has mapped his own ventures in tattooed miniature on his back. Qin's Long March inks in the progress of both himself and his artistic collaborators as they retrace the steps of the original Long Marchers (and, by default, their latter-day Red Guard imitators).[6] Over time the map of China on Qin's back is filled by their artistic exploits. Similarly, the Long March Space is itself expanding to fill all available opportunities, some truly creative, others as hyperbolic as the claims of Mao's original revolutionaries. How long before another artistic Red Guard thinks it is 'right to rebel'?[7]

GEREMIE R BARMÉ is an Australian Research Council Federation Fellow and Professor of Chinese History at the Australian National University, Canberra.

Mao Zedong and Lin Biao surrounded by a group of Red Guards waving copies of the *Little Red Book*
Image courtesy: Long Bow Group Archive, Boston

Elementary schoolchildren in Hulan county read the *Little Red Book* on their way to a study session of Mao's writings. The boy's sash reads 'It is right to rebel'. Heilongjiang province, China, July 1967
Image courtesy: © Li Zhensheng/Contact Press Images

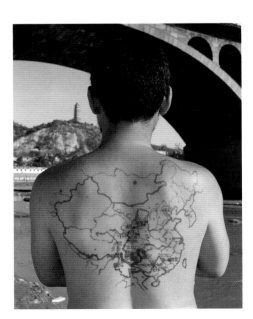

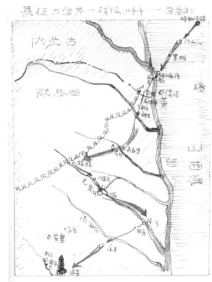

Qin Ga / China b.1971
The miniature long march (detail) 2002–05
Type C photographs, ed. 5 / 23 sheets;
75.5 x 55cm (each) / Collection: The artist /
Image courtesy: Long March Project, Beijing

A hand-drawn map from a Red Guard diary showing a new Long March route from the 1960s
Image courtesy: Long Bow Group, www.morningsun.org

As an artist, Hong Hao has styled himself as something of an impresario, applying his name (in reverse) to the *Oahgnoh Biennale: Esposizione Internazionale d'Arte* 2001–04, a fictional contemporary art event in international biennale–style, for which he produced a lavish catalogue (the cover was impressive but the interior pages were arbitrarily cut from various magazines). Previously, in 1997, he and fellow artist Yan Lei masqueraded as a commissioning curator of Documenta X, Ielnay Oahgnoh (the artists' names spelt backwards), and sent bogus letters to artists in China inviting them to participate in the exhibition. At the time, this lost them some friends. In retrospect, however, it can be understood as a clever gesture highlighting both the omission of Chinese artists from this major international festival and the increasing perception among many Chinese artists that exhibiting in such international arenas was the only validation of artistic success. Aside from these conceptual and performative pieces, Hong has consistently produced works on paper — initially screenprints and later, photographs.

Hong has participated in the Long March Project since its inception in 2002, exhibiting his 'New world map' works at its first site in Ruijin, Jiangxi Province. These were part of a series of *trompe-l'oeil* representations of books of knowledge such as atlases and encyclopedias, which Hong made over a ten-year period, following his graduation from the Central Academy of Fine Arts in Beijing in 1989. In the 'New world maps' series, Hong drew elaborate maps in which he rearranged the constituent parts to form various new worlds. Hong reconfigures the image we hold of the world — in one, the world is rearranged to include only First World countries; in

another, countries are sized according to military capacity; in another, the sea and land masses change places. He has said, 'I would like to reshuffle various aspects of culture, to effectively dissolve boundaries and meanings, just like a computer virus'.[1]

Long March in Panjiayuan A and *Long March in Panjiayuan B* are two large digital images Hong produced in 2004 as part of his involvement with the Long March Project. They continue a personal project begun in the 2002 series 'My things' in which every object shown was digitally scanned at 1:1 scale, and then each scanned image was digitally inserted and arranged within a larger frame to produce the final image. Early works in 'My things' show various ordinary objects — medicine packets, tubes of paint, bottle caps, buttons, rolls of film, razor blades, bath plugs — arranged in a grid according to size, colour or shape. As the title of the series suggests, 'My things' started as a way of documenting Hong's personal belongings. He explained:

> I sorted out all my personal possessions, including the new, the about to be thrown out and the still being used, and then scanned them one by one. When the images were combined into a photograph they retained the dimensions of the original object, becoming a source for portraying personal daily life.[2]

A shift from self-presentation to collection representation seems to feature in Hong's work of the last few years. An important work to mark this shift is *My things no.6: the hangover of Revolution in my home* 2002,

HONG HAO

Hong Hao / China b.1965
Long March in Panjiayuan A 2004
Long March in Panjiayuan B 2004
Type C photographs, ed. 1/9 / 2 sheets:
127 x 230cm (each) / Purchased 2006 /
Collection: Queensland Art Gallery

The new world map series 1997
Print / Collection: The artist / Image courtesy:
Long March Project, Beijing

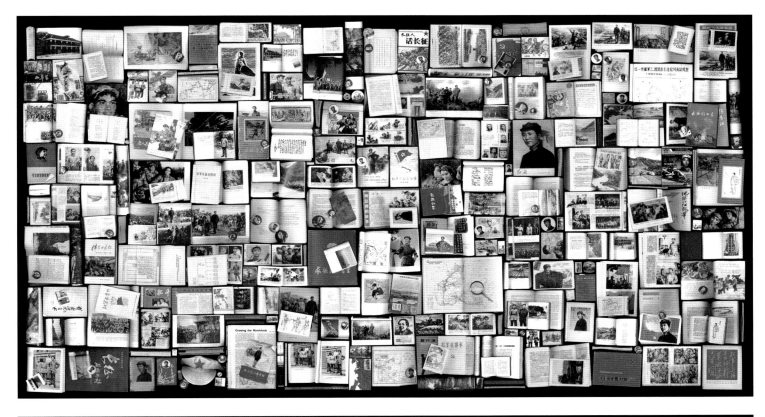

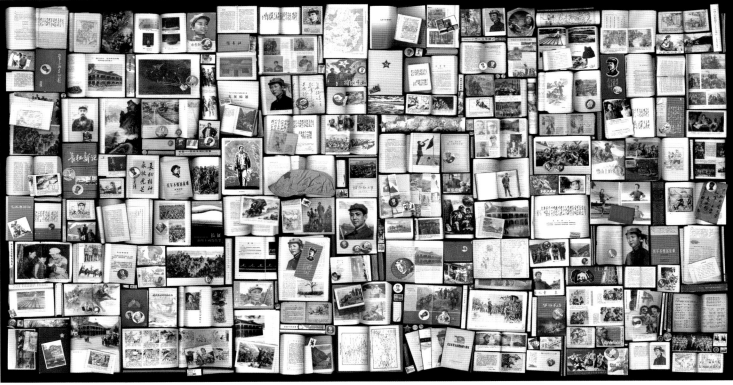

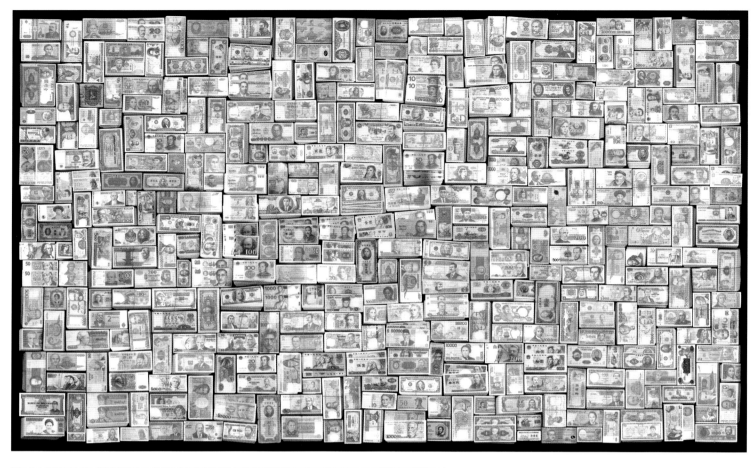

in which various items of Mao idolatry and communist propaganda are dispassionately arranged. During Hong's childhood — he was born in 1965, on the eve of the Cultural Revolution — the personal became the collective, with most households sharing the very tangible legacy of ideology which permeates daily life in China.

In 2004, Hong began to use common materials such as paper currency to create his scanned tableaux. In these works, paper money was arranged in an orderly fashion, regardless of the country of issue and determined by no apparent criterion other than size. The titles of the works — *22 861 518 2004*, for example — were generated by the total sum that was reached when the values of each note were added together, a figure that is meaningless in terms of 'real' value but symbolic perhaps of the incommensurability of national economies in the global market.

By using the material culture of contemporary China, Hong is participating in the broader strategy of the Long March Project. This project might initially seem to involve a strange process of idealisation enabled by a perplexing historical amnesia; in another sense, however, it returns to the germ of the idea of communism, a utopian vision of a world in which hierarchies of power are eliminated and replaced by a singular striving for common prosperity.

Long March in Panjiayuan A and *Long March in Panjiayuan B* are tableaux of memorabilia and commemorative propaganda celebrating the historical Long March. A distinctive portrait of the young Chairman Mao, which adorns badges, posters, postage stamps and pamphlets, appears across the entire surface of the works, as does the symbolic *The Little Red Book*. There are also commemorative poems, idealised pictures of Red Army marchers and revolutionary scenes from the *Yang Ban Xi* (Eight Model Works).[3] Hong collected all these items at the enormous Panjiayuan outdoor markets in Beijing. Considered a major attraction for international tourists, these markets proffer vast quantities of Maoist propaganda and memorabilia. They epitomise the transformations Chinese society is undergoing and the ideological anomalies that arise with the capitalist expansion within post-communist China — what Long March initiator and chief curator Lu Jie and co-curator Qiu Zhijie have called 'cultural losses and ideological voids'.[4]

Hong's works in APT5 do not in themselves suggest any utopian vision; rather they have the analytic clarity of the scanner's eye, documenting and recording without distortion. The digital images are nevertheless metaphorical of the contemporary Long March Project as a whole, in the sense that they materially manifest the original March's historical legacy and imply the way it is imbricated in the visual and material culture of contemporary China.

Hong's taxonomies of Long March memorabilia are collective portraits of today's China — the impulse of capitalism and commerce contrasts with the ideological legacy of a society founded on principles of collectivity and mass struggle aiming to overcome hierarchies of wealth. In them, we see how yesterday's emblems of heroic sacrifice and struggle become junk piles in today's flea markets and thrift stores. Hong restores some visual splendour to these objects and, in doing so, resurrects some of the idealism that their wearers, holders and readers would have invested in each badge and book.

DR MIRANDA WALLACE 's Managerial Researcher, Queensland Art Gallery / Gallery of Modern Art.

556,066,792,000 2004
Type C photograph / 175 x 280cm / Collection: The artist / Image courtesy: Long March Project, Beijing

22,861,518 2004
Type C photograph / 120 x 210cm / Collection: The artist / Image courtesy: Long March Project, Beijing

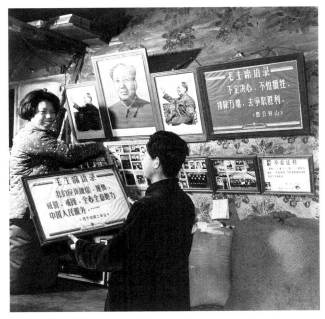

In the Binjiang district, a newlywed couple decorate their bedroom with pictures of and quotations by Mao. Harbin, Heilongjiang province, 1966
Image courtesy: © Li Zhensheng/Contact Press Images

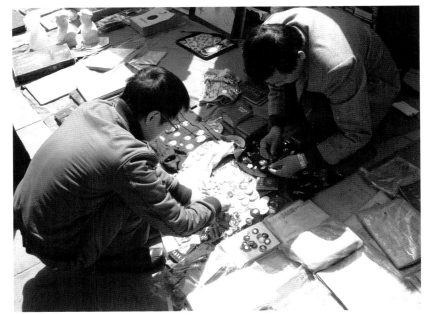

Hong Hao in Panjiayuan Antiques Market, Beijing, 2006
Image courtesy: Long March Project, Beijing

The photographer Li Tianbing is one of a group of practitioners 'discovered' by the Long March Project as the participants travelled through rural China, following the route of the historical Long March. The project uses the Long March as a geographic and discursive framework to engage with issues of economic and social change confronting China today.[1] It is an ambitious attempt to take contemporary art to the countryside, but also to discover what kinds of art were being made in rural areas. In this context Li's photographs represent not just a historical record but a distinctive body of art.

Li has been the village cameraman in Makeng, Fujian province, for nearly 60 years. In 1946, at the age of 12, he worked as an assistant to a British–Chinese cameraman, which inspired his lifelong fascination with photography. The cameraman had been sent to Fujian province to take portraits of the local peasants for a system of identity cards being introduced by the Kuomintang authorities. Although his family was poor, Li sold his grandmother's cow (without permission) to purchase the photographer's camera, which, amazingly, he still uses.

Li's fascination with photography has produced a substantial collection of evocative images that form a unique record of rural Chinese life during the second half of the twentieth century. Since his initial apprenticeship, Li has travelled on foot between hundreds of mountain villages and has taken hundreds of thousands of photographs documenting the great and small changes in people's lives — weddings, Communist Party meetings, festivals and family gatherings, charging 1 yuan (16 Australian cents) for a 120mm photograph. His images are often the only visual documentation of significant events in people's lives in this isolated region of China.

Li is a master of using natural light to develop photographs. Until 2005, Makeng had no electricity, which meant Li relied on natural lighting for the developing process, a technique he learnt as an assistant. He removes film from his 1930s vintage camera under a blanket in his darkened bedroom and exposes it by opening the door for a few seconds. When he enlarges photos, he aims his self-made enlarger (a pipe from the ceiling that lets in an adjustable circle of light) on the photographic paper below. He then works with chopsticks by candlelight to develop the prints.

> It doesn't get much more basic . . . but you have to take account of the weather, which can be tricky. On a sunny day you only need to open the door for one or two seconds . . . you need a bit longer when the clouds roll in.[2]

Li has weathered his own changes. During the Cultural Revolution (1966–76) he was labelled a capitalist roader for using a foreign camera and earning a private income, and his family was forced for a time to disown him. But his contribution has always been acknowledged by the villagers of the region; they celebrate him in song as 'Maestro Tianbing'.

With the support of the Long March Project, Li spent six months returning to villages revisiting friends and relatives whom he had photographed during the past 50 years, collecting photographs representative of his work. In July 2002, in Ruijin in neighbouring Jiangxi province, the first site of the project and the starting place of the original Long March, a selection of Li's black-and-white pictures from 1946 to 2005

LI TIANBING

Li Tianbing / China b.1933
Estate of Li Tianbing (details) 1946–2006
Silver gelatin photographs, ed. of 1 / 194 sheets: dimensions variable / Collection: The artist / Image courtesy: Long March Project, Beijing

Li Tianbing exposing his photographs to the sunlight, 2001
Image courtesy: Long March Project, Beijing / Photograph: Shen Xiaomin

Li Tianbing washing his developed photographs, 2001
Image courtesy: Long March Project, Beijing / Photograph: Shen Xiaomin

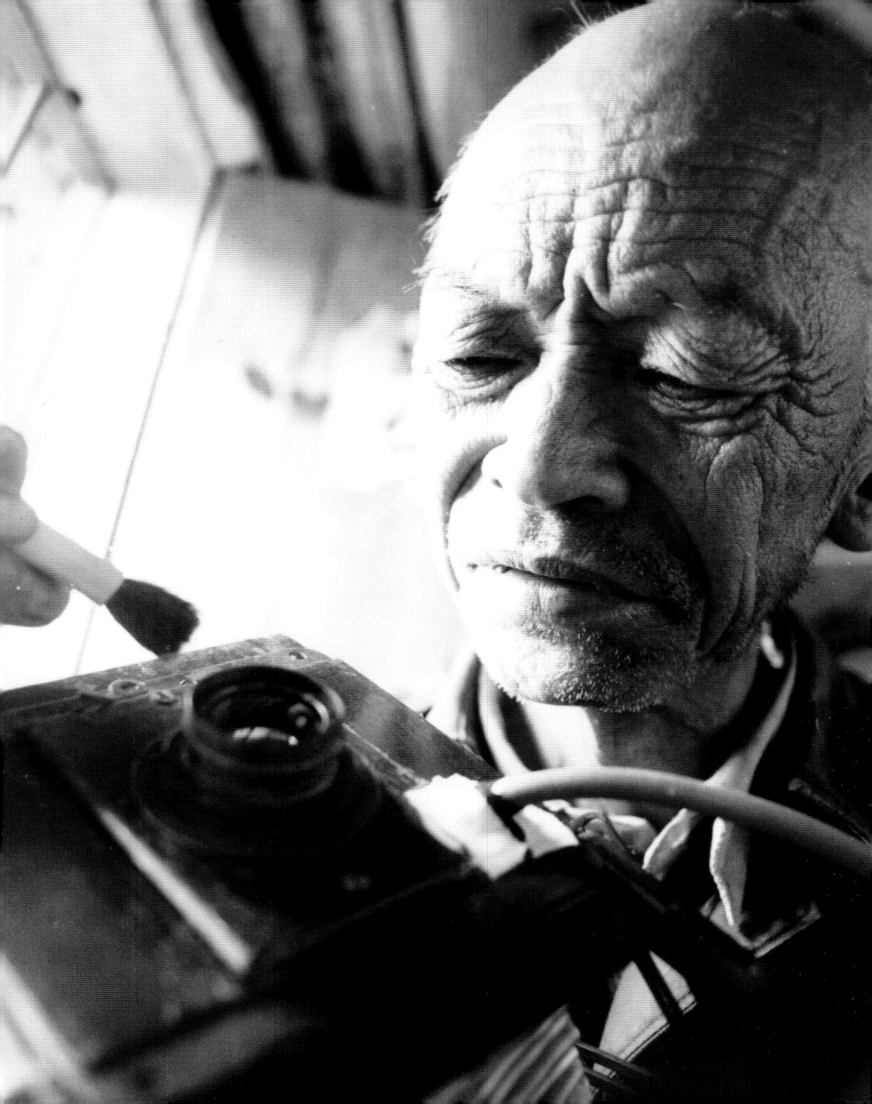

were exhibited with photographic works by his son, Li Jincheng. These were grouped in various series, 'Male comrade', 'Female comrade', 'Comrade companion', 'Family comrade' and 'Collective comrades', which featured images of the social changes evident since the country began its reform efforts. The works by father and son act as a dialogue between old and new China and were a creative bridge for the concept of the Long March Project, exploring the impact of the past on Chinese contemporary visual culture.

Today, Li is a contented man, with his son, Li Jincheng, following in his footsteps and his grandson, Li Hong, showing a keen interest in learning photography from his grandfather. His fellow villagers are now saying: 'Maestro Tianbing has successors'.

MICHAEL HAWKER is Curatorial Assistant, Contemporary Australian Art, Queensland Art Gallery / Gallery of Modern Art.

Li Tianbing cleans his camera, 2001
Image courtesy: Long March Project, Beijing /
Photograph: Shen Xiaomin

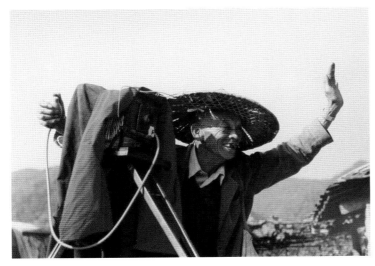

Li Tianbing at work in Fujian province,
China, 2001
Image courtesy: Long March Project, Beijing /
Photograph: Shen Xiaomin

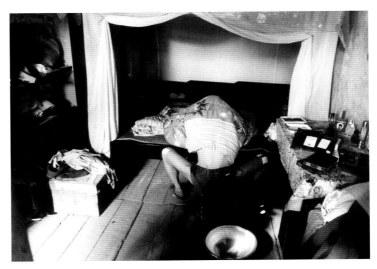

Li Tianbing developing his negatives in his
home-made darkroom, 2001
Image courtesy: Long March Project, Beijing /
Photograph: Shen Xiaomin

CREATIVITY AND TRADITION: CONTEMPORARY FOLK ART

Paper-cutting has existed in China for thousands of years, and early examples dating from the Northern Dynasties period (420–589 CE) have been unearthed by archaeologists in Xinjiang Uygur, from the site of the ancient city of Gaochang.[1] The first papercuts were funeral objects, often in the shape of common household items, which were buried with the dead to provide them with material items in the afterlife. Paper-cutting has since become an integral part of everyday life for many Chinese and is used to celebrate festivals, holidays, births, deaths and marriages; to make offerings to ancestors; or to decorate houses and clothing. Papercuts often tell traditional folk tales, depict symbols that protect their recipients or makers from evil or confer wishes for well-being and good fortune. The colour red is most commonly used, as it symbolises good luck.

Liu Jieqiong is a contemporary folk artist renowned in China for her papercuts. She creates her own unique version of this expressive art form by interpreting long-established designs and motifs. Papercuts are traditionally very small in scale, which allows for minute and intricate detail. In her recent work, Liu has expanded the medium to create vibrant large-scale, semi-narrative works that address the history of communism in China.

Liu was born in Yanchuan county, Yan'an, in Shaanxi province, a region in which paper-cutting has continued to be a living and pervasive tradition. Like many rural women, Liu learnt the art of paper-cutting from her mother who encouraged her to expand her motifs beyond traditional Chinese symbolism. To create her distinctive papercuts, Liu works with the large-handled scissors often used by paper-cutting artists.

It is a rural woman's instinct to use scissors. My mother never willingly accepted her poverty stricken life. We make our own happiness as we beautify life with our scissors.[2]

Traditional arts such as paper-cutting were generally viewed by art critics and historians as folkloric, with little value as contemporary forms of creative expression. This is partly because paper-cutting by its very nature is indifferent to canonical assumptions of authorship and originality, since the designs are based on inherited conventions and its makers are often not named. However, writers such as Homi K Bhabha, Jyotindra Jain and Marian Pastor Roces have greatly contributed to the relatively recent re-evaluation of folk art forms by insisting that tradition and innovation are not mutually exclusive categories.[3] Although papercut artists rely on collective motifs and patterns when creating their distinctive designs, the symbols, images and myths are in each case infused with a unique and personal vision. As the founding curator of the Long March Project, Lu Jie suggests paper-cuttings are the 'most abundant in regional specialties, most thoroughly imbued with the power of individuality, as well as the most subjective "image", and the most rooted aesthetic expression'.[4]

Although Liu has received recognition as a papercut artist, her work has only recently been included in contemporary art forums in China.[5] In 2004, she participated in 'The Great Survey of Paper-cuttings in Yanchuan County', an initiative of the Long March Project, with the support of the Yanchuan county government.[6] This event was intended as a review of the traditional art of paper-cutting, an art form that the Long March Project believed had

LIU JIEQIONG

Liu Jieqiong / China b.1967
Story of the Red Army (detail) 2004
Papercut, ed. 1/6 / 12 pieces: 225 x 432cm
(overall) / Purchased 2006 / Collection:
Queensland Art Gallery

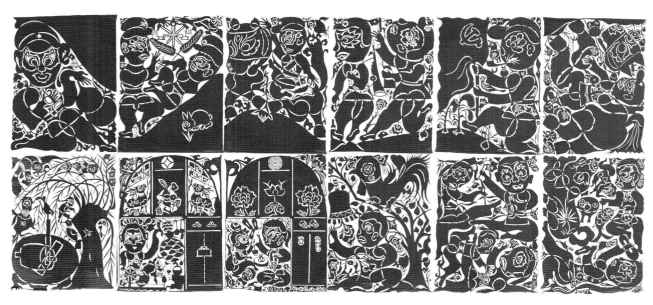

Story of the Red Army 2004
Purchased 2006 / Collection: Queensland
Art Gallery

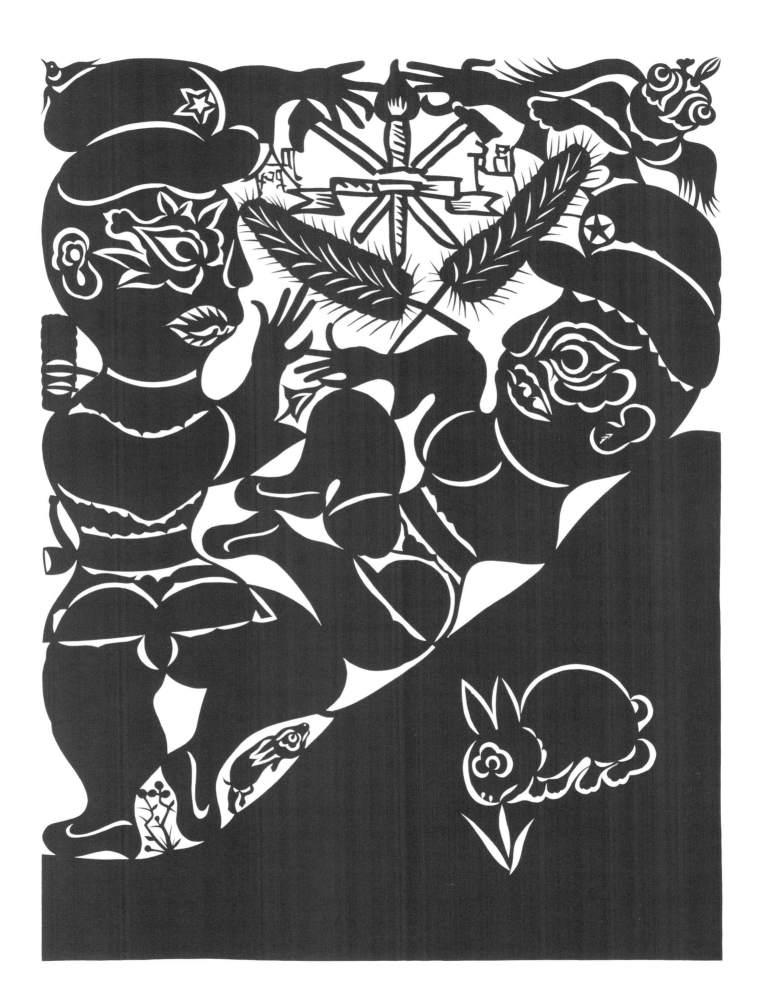

中国陕西省延川县民间剪纸普查表

延川县 城你 村

(表1)

姓名	刘翠琴	性别	女	民族	汉	出生年月	1987.11
文化程度	高中	婚姻或配偶	五保	全家人口	3		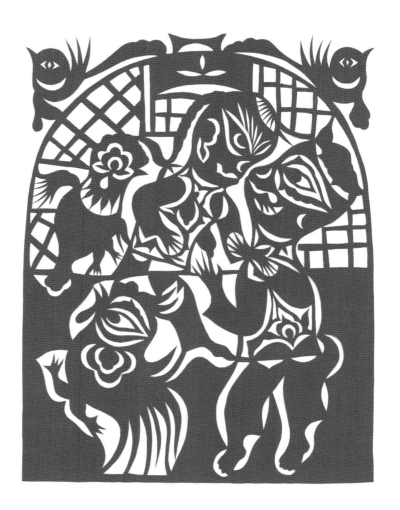
娘家	延川县文安驿河琼塌	家庭主要经济收入	小本生意				
全家年均经济收入	10000	从事剪纸年月	1996.2				
何年何月受过培训	1996年	师承	相传				
主要创作题材	仗义疏	其他特长	唱				
家庭住址	延川县市场路 17号	联系电话	0911-8117156				

从事剪纸简历自述: 以前，老大哥说开店多事不好。的确不假，我家以来，一天家起来无所事事，看见别人生活是彩色的，而且自己的生活是灰色的，在当山云老师的勇敢谈下，我鼓起了勇敢，奋起努力，一发而不可收拾，使我走上艺术之道，有幸入选中国比较……

作品发表、展览、出售情况: 当发表了我马上一篇文章，剪出一巧黄土情，记得那以联一……风趣道……作为一个农民，我已经心满意足了。

填表时间 2004. 8. 13 普查员 刘洁琼 填表人 刘洁琼

been largely ignored by galleries and institutions. Papercuts were collected from 15 006 individuals and subsequently displayed with documentary films, sound recordings, texts and photographs to form a vast archive. A selection of this archive was exhibited at the 2004 Shanghai Biennale.

By initiating the paper-cutting survey, Lu Jie believed that such traditional art forms can create a new understanding of contemporary Chinese art, 'turning local resources into the international language of contemporary art, and conversely imbuing international art with a local context and significance'.[7] The attention to artists from rural and urban environments, and the insistence that each are of equal value, is a particular concern of the Long March Project.

Liu created her large-scale *Story of the Red Army* 2004 specifically for the Long March Project. In this work, Liu goes beyond ritual customs and folk stories to explore contemporary themes in a semi-narrative construction. Mixing traditional Chinese motifs (flowers, animals and stylised figures) with communist regalia, *Story of the Red Army* depicts the original Long March (1934–35), which ended in Yan'an. Engaging with local history, it re-examines the March, which was inextricably bound up with Chinese nationalist identity during the communist era. Yan'an is known for the strength of its unique folk traditions, and is also associated with a 'utopian' period in the early history of the Chinese Communist Party. Both elements come together in Liu's papercut.

The 12 panels of *Story of the Red Army* are executed in a style typical of Shaanxi province, with combined positive and negative space, a lack of single-point perspective, and ornately decorative flora and fauna. Despite the appearance of soldiers with guns, the predominant effect is of a rural idyll, as the soldiers' eyes are formed of leaves and petals, while plants sprout beneath their feet and animals surround them in the trees and fields. Traditional Chinese papercuts are often elaborate pictorial narratives in which visual symbols convey complex meanings. Sometimes these derive from specific historical associations, or from the numerous occurrences of homonyms or tonal associations in the Chinese language. For example, the word happiness (*xi*) is very similar to magpie (*xi que*), and thus magpies are used to symbolise happiness.

The papercut art form is well suited to the now mythologised presence of the Red Army in Yan'an. In the first six panels, the Red Army arrives in the wake of battle, carrying guns and flags. In the subsequent panels, a life of peace and order is established, evident in symbols such as the bats and deer in the seventh and eighth panels, which signify good fortune (*fu* is a homonym for bat and good fortune) and prosperity (*lu* or prosperity is a homonym for deer). Other symbols represent strength and vitality (the rooster), a surplus (fish), wealth (peony) and a quiet and peaceful life (chrysanthemum). In the ninth panel, a quartered circle — the symbol for eternity — is placed above a mother teaching her daughter the traditional art of paper-cutting, evident in the large-handled scissors between them.

Liu Jieqiong's innovative works interpret and expand the traditional practice of paper-cutting. Her papercuts raise questions concerning the distinction between 'high' art and folk art, between individual creativity and collective inheritance. The result is a beautiful and dynamic interplay between past and present, using an ancient Chinese practice.

ABIGAIL FITZGIBBONS is a Research Assistant, Queensland Art Gallery / Gallery of Modern Art.

Liu Jieqiong's sample survey form from 'The Great Survey of Paper-cuttings in Yanchuan County' conducted by the Long March Project in 2004
Image courtesy: Long March Project, Beijing

Liu Jieqiong comes from the Yellow River region of Yanchuan County, Shaanxi province
Image courtesy: Long March Project, Beijing

Artists participating in the 'The Great Survey of Paper-cuttings in Yanchuan County' conducted by the Long March Project in 2004
Image courtesy: Long March Project, Beijing

THE 'ASSEMBLY HALL' SERIES: FROM CLANS TO KARAOKE

Since 2002, Mu Chen and Shao Yinong have been photographing communal halls connected to key events in the history of the Chinese Communist Party. These are spaces that have undergone extreme change. Many were originally built as ancestral halls for familial clans, were later co-opted by the Communist Party for political purposes, and now serve a variety of contemporary functions — from cinemas to karaoke halls. Known as the 'Assembly hall' series 2002–06, this body of work presents a compelling historical and political portrait of Chinese social life. In the vacant rooms photographed by Mu and Shao, ancient clan histories mingle with memories of the physical and psychological violence endured during the Cultural Revolution (1966–76), and with the market-driven imperatives of contemporary China. The photographs are restrained yet eloquent, speaking as much about the physical evidence of China's turbulent modern history as they do about the collective memory and experience of generations of Chinese people.

Mu and Shao engage with their subjects as they find them. Perhaps informed by Shao's training as a journalistic photographer, their images are not staged, they do not intervene by means of artificial lighting or placement of props, but sensitively respond to what is simply there. They approach their work with an aesthetic attitude grounded in a concern for the real and the tangible, one that follows the historical traces without romanticising or idealising.[1] Striking a fragile balance between active engagement and passive detachment, the 'Assembly hall' images carefully track the resonances of past events through the physical, concrete realities of the present.

In the small towns where the majority of Shao and Mu's photographs were taken, halls were often venues for festive community events. During the Cultural Revolution, however, many also became sites for indoctrination and mass criticism. The 'Assembly hall' photographs are haunted by these events. Despite their present day transformation into spaces of leisure and other innocuous pursuits, for the Chinese who lived through the Cultural Revolution, the halls are never able to divest themselves of their traumatic past. This combination of past and present, inherent in the photographs, often produces quite absurd results. *Xiaoqiao*, for example, is a former assembly hall that has been converted into a restaurant and decorated in a highly kitsch style ludicrously out of step with the ideals of the Revolution. As curator Shu Yang wrote:

> . . . sometimes history seems to be playing a joke, but Shao Yinong and Mu Chen have with great meticulousness recorded this joke. I hope our descendants will continue to view these scenes as a joke, and will never resume the serious activities that once took place in these halls.[2]

The group of images selected for APT5 are unique in the series in that they depict halls that appear to have remained unchanged since the Red Army occupied them over half a century ago. Where other examples from the 'Assembly hall' series plainly illustrate the dissipation of revolutionary ideals — the co-option, for example, of military assembly halls as karaoke bars — this group of photographs depicts politically significant halls that have been preserved or reconstructed by the government as cultural tourism sites.

MU CHEN AND **SHAO** YINONG

Mu Chen / China b.1970
Shao Yinong / China b.1961
Gutian (from 'Assembly hall series no.6')
2006

Type C photograph, ed. 1/3 / 182 x 244cm / The Kenneth and Yasuko Myer Collection of Contemporary Asian Art. Purchased 2006 with funds from The Myer Foundation and Michael Simcha Baevski through the Queensland Art Gallery Foundation / Collection: Queensland Art Gallery

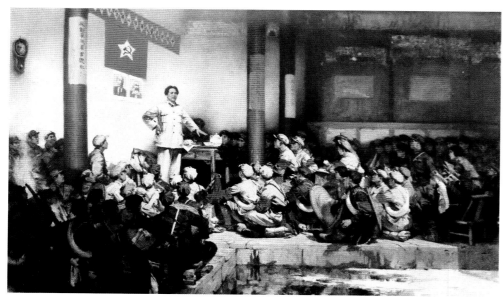

He Kongde / China b.1925
Gutian meeting 1972
Oil on canvas / 220 x 380cm (approx.) /
Collection: National Museum of China, Beijing

The high degree of artifice in these halls is meticulously portrayed in Shao and Mu's images. Each room has been carefully staged by the government to replicate the appearance of a particular mid-century military assembly hall. In several cases the original halls were destroyed and reconstructed in their entirety at nearby locations. The hall at Xibaipo, for example — host to a defining Communist Party meeting in 1949 where it was decided to adopt the socialist revolutionary model espoused by Mao Zedong — was flooded in 1958 due to the construction of the Gangnan reservoir. In 1971 it was reconstructed with an extraordinary level of attention to detail — from the vintage portraits of Mao and Zhu De to the thatched ceiling and austere period furniture.[3]

The halls embody a peculiar clash between a jingoistic respect for the Revolution and the realities of China's developing market economy. In China's recent past, the primary role of these sites was to canonise key events in the history of the Communist Party and to reinforce the principles and beliefs of its founders. Today, the situation is more complex as the ideals of the past become tempered by the social and economic realities of contemporary China. China's National Tourism Administration, for example, declared 2005 the 'Year of Red Tourism' to commemorate the 70th anniversary of the Long March. While a stated aim of this initiative was 'to arouse patriotism among young people', the Administration also intended it as a means of promoting economic development in regional areas by capitalising on the burgeoning internal tourism industry.[4] This industry now generates over 500 billion yuan (A$80 billion) annually in revenue.[5] What is interesting about Red Tourism's pitch for this market is the way that sites of significance to China's revolutionary history take their place alongside pre-revolutionary tourist sites such as Buddhist temples, historic palaces and gardens. In the same way that visitors to the Imperial Palace in Beijing hire period costumes to pose as the last emperor, tourists at the site that incorporates the Maoping Assembly Hall dress up in Red Army uniforms.[6] In this context, the Communist Revolution, rather than defining China, is seen as one historical period among many contributing to a complex picture of Chinese society.

While Mu and Shao's photographs speak to the complexities of Chinese history, they do not prescribe a particular viewpoint. Photographed without the presence of people, who would otherwise anchor the images in a specific historical moment, the halls are suspended between the events that might otherwise define them. *Gutian*, for example, depicts one of the first national cultural tourist sites, a site that is recognised as a model for regional tourism and which attracts over 600 000 visitors annually.[7] The hall was built at the end of the Qing dynasty as the ancestral hall for the Liao clan, converted into a school after the republican period and, in 1929, used by the Red Army for a meeting that approved Mao's plan to establish a national military — an event memorialised by socialist realist painter He Kongde in 1972. In Mu and Shao's photograph, neither the eager young soldiers in He's painting nor tourists armed with video-cameras populate the space. Instead, Mu and Shao show the indeterminate zone occupied by the hall — somewhere between theme park, museum and mausoleum.

NICHOLAS CHAMBERS is Assistant Curator, Contemporary International Art, Queensland Art Gallery / Gallery of Modern Art.

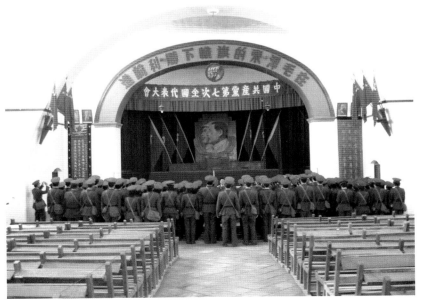

Xibaipo (from 'Assembly hall series no.6')
2006
Type C photograph, ed. 1/3 / 182 x 244cm / The Kenneth and Yasuko Myer Collection of Contemporary Asian Art. Purchased 2006 with funds from The Myer Foundation and Michael Simcha Baevski through the Queensland Art Gallery Foundation / Collection: Queensland Art Gallery

On 15 September 1976, Party officials fill the mourning hall at the office building of Heilongjiang's Party committee, Harbin, following the death of Mao Zedong
Image courtesy: © Li Zhensheng/Contact Press Images

Members of the Chinese military visit Yangjialing, the famous site in Yan'an where The Forurm on Art and Literarture was held in 1942
Image courtesy: Long March Project, Beijing

The map of the Long March traces an historical retreat and a story of Communist Party tenacity; it is instantly recognisable but also multivalent, inspiring conflicting emotions. Mongolian-born Qin Ga investigates the ways in which the map of the Long March has become a reference point for Chinese identity. Using the practice of tattooing to record his own retracing of this journey, Qin's performance project, *The miniature long march* 2002–05, makes sophisticated use of the body as an ethnographic text, as a repository of cultural history and as a mobile art object.

Qin first committed his skin to the Long March Project's 'Walking Visual Display' tour in 2002 which followed the route of the Long March of 1934–35. From his Beijing studio, Qin communicated with the artists who had set out to retrace the original 9500-kilometre journey, recording their progress as dots and routes on a map of mainland China tattooed across his back. Qin's tattoo was left unfinished when the artists called a halt to their expedition at Luding Bridge in Sichuan province. Three years later, in 2005, Qin resolved to complete the remaining march from Luding Bridge to Yan'an in person. Travelling with his tattooist, Gao Fend, and three camera operators — Gao Siang, Li Ding and Mei Er — he embarked upon an arduous journey through the snowy mountains, grassy plains and remote villages of west and northern China immortalised in Long March mythology.

In her book on the history of tattooing, Jane Caplan suggests that tattoos occupy a kind of boundary status on the skin.[1] As acts of initiation and remembrance they are a way of dealing with memory and the past, proclaiming an interior life to others, and reifying collective experiences as a permanent souvenir.[2] Qin draws on this cultural practice to explore the

historic March as an experience in space and time. During the original Long March, up to 80 000 Red Army recruits perished from disease, malnourishment and over-exposure in their forced retreat across 18 mountain ranges and 24 rivers to Yan'an. Communist Party propaganda proclaims Red Army troops averaged nearly one skirmish with Kuomintang troops or provincial warlords per day, and completed 235 day-marches and 18 night-marches in total.[3] While the precise distance in kilometres and the number of casualties are greatly contested, the event's cultural impact and significant losses are both undeniable.[4]

The miniature long march turns Qin Ga's body into a mobile canvas. Braving frostbite and sunburn, and pushing the limits of endurance, the artist becomes gradually connected to, and transformed by, the culture, geography and spectacle of the Long March; his body is marked (and mapped) by each part of the journey. Young Tibetan girls perform a traditional dance to wish him luck; a living Buddha offers sustaining medicine and requests his photograph be taken with the artist; a monk bursts into tears upon seeing the Long March map embodied as a tattoo. Qin solicits contemporary and local variations on Long March history as villagers and fellow travellers articulate their feelings about the Long March in response to the sight of the artist's back. The video camera captures all of this, revealing the strong ideological and emotional investment that many Chinese still have in Communist Party history and, in particular, the story of the Long March. As a fresh collection of narratives, *The miniature long march* points to the personal, creative and local events underpinning the experience of communism in China.

QIN GA

Qin Ga / China b.1971
The miniature long march (details)
2002–05
Type C photographs / 23 sheets: 75.5 x 55cm
(each) / Collection: The artist / Image courtesy:
Long March Project, Beijing

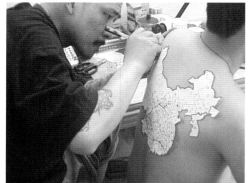
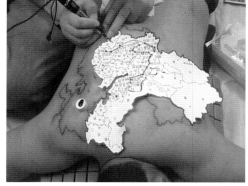
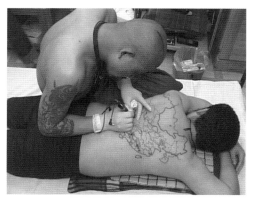

The miniature long march site 1 – site 14
(stills) 2002

Mini DV, 14:50 minutes, colour, sound / Collection:
The artist / Image courtesy: Long March Project,
Beijing

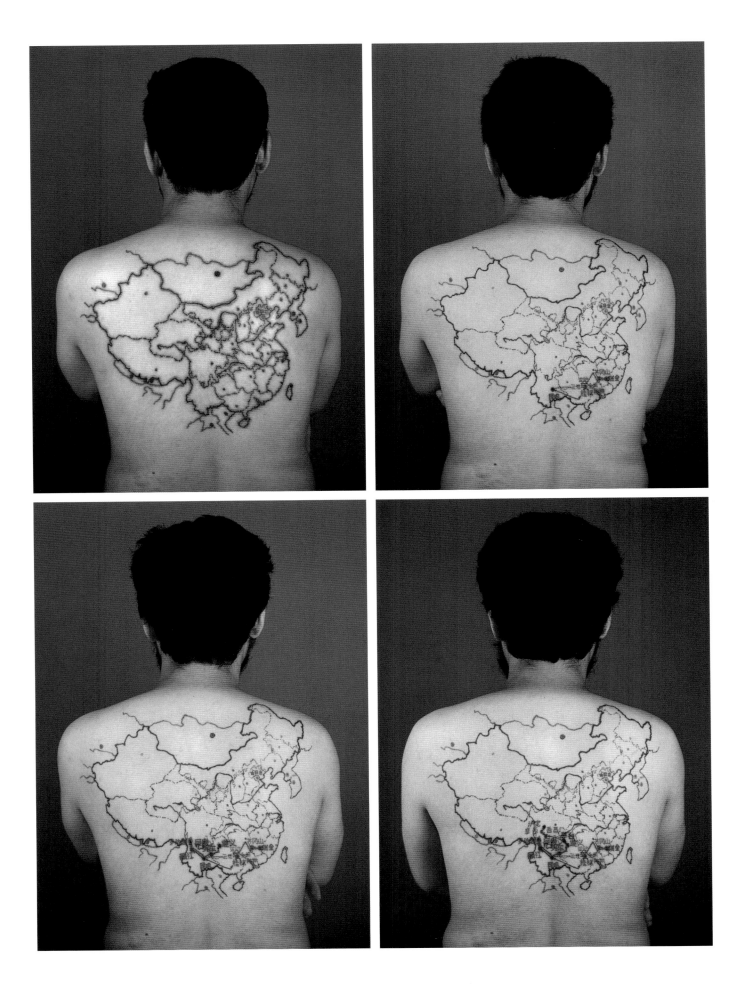

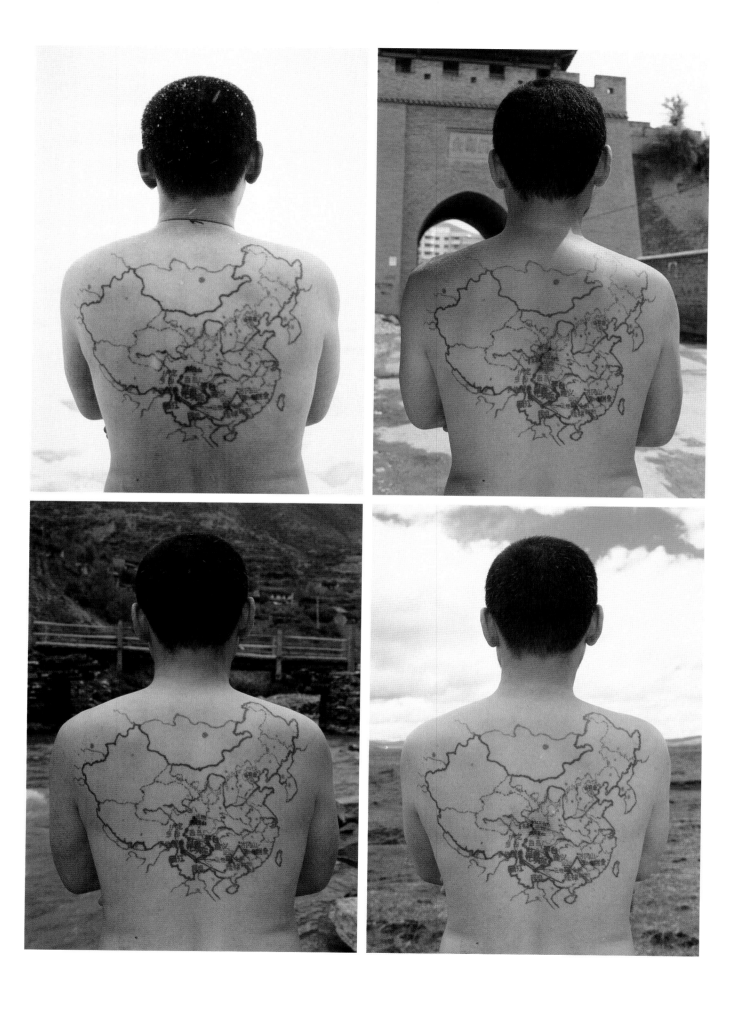

The materials used to construct *The miniature long march* — photographs, daily diary entries, video, and ephemeral items collected on the journey — mirror the Communist Party's use of ethnographic methods to organise first-hand accounts of the Long March into a legitimate Party history.[5] Qin is openly ambivalent about the grand narrative now permanently inscribed on his skin. His decision to invest his own body in the symbolism of the March is not concerned with ideological or empirical precision. He suggests that the Long March:

> . . . exists, but it is not necessary to painstakingly pursue it, to make fun of it, or to worship it. It is history. Within this, I feel that the revolution is very ambiguous. For example, in reality, for the Communist Party at that time it was the Long March, for the Nationalists it was a retreat. I wasn't really concerned with these matters, they were just naturally present. It is still the body that is at the core . . . What I am interested in is the relationship between body and nature. If you don't focus on history it is still there.[6]

Qin's performance at Luding Bridge exemplifies the ambiguous treatment of history that occurs throughout *The miniature long march*. Luding Bridge, an eighteenth-century chain bridge, is a landmark in Sichuan Province and a key site in Communist propaganda. There, soldiers of the Fourth Regiment of the Chinese Workers and Peasants' Army secured a vital river crossing during the Long March in 1935. Edgar Snow's renowned history of the Long March, *Red Star Over China*, depicts Fourth Regiment troops ducking gunfire while crawling on their hands and knees across a bridge partly destroyed and set alight with paraffin by the Kuomintang-aligned forces.[7] More recent histories have suggested the events of that day, and the significance of the battle, were exaggerated for the purposes of mobilising support for the Communist Party.[8] In his re-enactment, Qin crawls across the bridge and nears exhaustion midway, the skin of his arms and legs scraped bare. Chinese military police first order him to stand and walk to the other side, but then recognise the meaning of the tattoo on his skin and allow him to continue crawling; tourists and locals shout and cheer the artist on. Is Qin re-enacting history, or reinforcing a mythology? His performance adds to the many layers of interpretation and understanding that surround this event. The artist's achievement and his audience's fervour point to an emotional resonance that exists beyond history.

The miniature long march engages with this interplay between empirical facts, allegories and acts of imagination. Qin recognises the Long March as a story that taps into a more universal cultural motivation for betterment and change. Rather than deflating past ideologies and Party symbolism with cynicism and caricature, Qin attempts a deeper understanding of local context. In relocating artists, audiences and local participants in relation to representations of this social history, his work asks questions about the importance and meaning of the Long March legacy. To Qin, whether the event is understood as a retreat or a heroic journey, it is still a profound story of bodies transformed.

RACHEL O'REILLY is Curatorial Assistant, Video and New Media, Queensland Art Gallery / Gallery of Modern Art.

The miniature long march (details) 2002–05
Collection: The artist / Image courtesy: Long March Project, Beijing

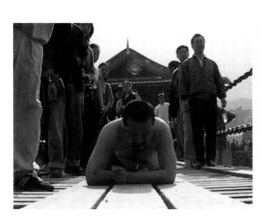

The miniature long march site 15 – site 23
(stills) 2005
Qin Ga crossing Luding Bridge
Mini DV, 25:30 minutes, colour, sound / Collection:
The artist / Image courtesy: Long March Project,
Beijing

Qin Ga, 2005
Image courtesy: Long March Project, Beijing

Shen Xiaomin was born in 1972 in Fujian province, China. He graduated from the Beijing Film Academy in 2002, the same year he joined and documented the Long March Project. As a film maker Shen is both artist and artisan, directing, producing and filming.

The work presented in APT5, *The Village Cameraman and His Son* 2001, and the earlier *Eulogy of Longjiang River* 2000 demonstrate Shen's inventive handling of his subject matter and his keen eye for a story. He explores the traces of revolutionary memory in contemporary Chinese culture, revealing new insights and alternative viewpoints. *The Eulogy of Longjiang River* is a story of self-sacrifice for the greater collective good — in 1963, a group of Fujian province villagers dammed the Longjiang River to help other villages suffering from drought, sacrificing 300 hectares of their own fertile fields in the process. The story became a legend in the region and was developed into one of the *Yang Ban Xi* (Eight Model Works), which were the only operas and ballets permitted during the Cultural Revolution (1966–76). The opera based on the incident, *Song of the Dragon River*, was promoted throughout China as an example of the communist spirit of selflessness. During the Cultural Revolution several million Chinese people watched the *Yang Ban Xi* and listened to patriotic songs.

In *Eulogy of Longjiang River*, Shen revisits the original protagonists of the story — Zheng Fanyong, a young girl who was a local Communist Party secretary, and Zheng Liudan, the village group leader. The film shows how their lives were radically changed through the influence of the *Yang Ban Xi*. While Zheng Fanyong rose quickly through the party ranks and became the town mayor, earning 700 yuan per month, Zheng Liudan was forced to resign as village group leader and assigned to watch the forest, receiving only 24 yuan per month. As Shen discovers in his film, the reason for this was that the *Yang Ban Xi* required every protagonist to have an antagonist. Unfortunately, Zheng Liudan was cast in the role of antagonist.[1]

Shen's documentary follows a number of individual narratives: the interpretation of the interviewer, Shen; the official government version of events; and the perspectives of Zheng Fanyong and Zheng Liudan. Scenes from *Song of the Dragon River* are interspersed throughout the documentary, and the various strands of the narrative separate and converge, supporting and contesting each other. By re-examining this historical event, Shen investigates how the past and the present impact on the telling of the story. Viewed in the light of current government policies on modernisation, the documentary shows how the fate of individuals can be affected 'when an entire society unconsciously absorbs an understanding of events'.[2]

The work presented in APT5, *The Village Cameraman and His Son*, was completed in 2001. It documents the life of Long March Project and APT5 artist Li Tianbing who, for over 50 years, has walked a circuit of more than 300 villages and towns in southern Fujian province, using the same camera to record the lives of the inhabitants. Throughout this time, he has used makeshift darkrooms and washed his prints in the water of local streams. The film also explores his relationship with his son, who runs a modern photography studio in a nearby industrial town, examining the inter-generational changes in the lives of these rural people.

The film's opening scene conveys the very essence of Li's life: walking along a country road, with his camera and tripod hoisted on his shoulders.

SHEN XIAOMIN

Shen Xiaomin / China b.1972
The Village Cameraman and His Son
(still) 2001
Betacam SP, 40 minutes, colour, stereo / Collection: The artist / Image courtesy: Long March Project, Beijing

The Village Cameraman and His Son
(stills) 2001
Collection: The artist / Image courtesy: Long March Project, Beijing

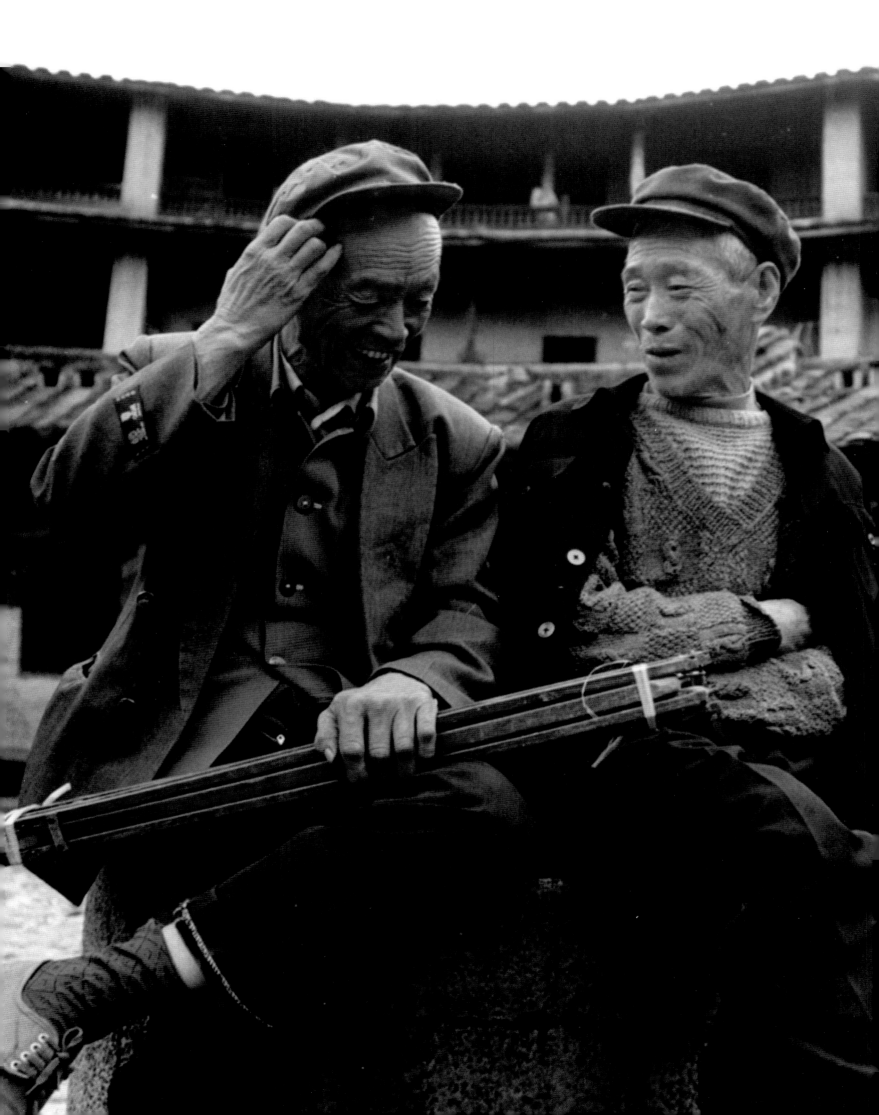

Shen's documentary gives a marvellous insight into Chinese rural life during a period of rapid change. The tempo of country living is captured through a series of poetic scenes of Li's family life — we see them all gathered around the dinner table or performing daily chores. The authenticity is enhanced by the absence of narration. Individuals speak for themselves, while, off camera, Shen may make the odd inquiry to prompt a reply. The minimal dialogue is supplemented by a song composed and sung by local villagers to celebrate the important role 'Maestro Tianbing' fulfils in their lives.

Shen's emphasis is on the craftsmanship of Li's practice and he compares the modern film developing process used by Li's son with Li's own alchemic processes. This feeling of conjuring is beautifully captured in the hand movement that Li makes when he snaps his photographs, flicking his wrist like a magician. Held together with tape and string, Li's old 1930s British camera is a character in its own right in the film — seemingly continuing to function largely through Li's will and admiration for it.

Shen thoughtfully composes his scenes, working with the architectural features of the rough-hewn farm houses to frame many of his shots and marvellously capturing the play of light and shadow. In the final scene, Li is continuing his work in one of Fujian province's famous circular *tulou* communal dwellings.[3] The setting reinforces the cyclical nature of rural life in China — the seasons and events such as births, deaths, family gatherings and social occasions are all captured by Li and his camera. Li sits in the central courtyard, where rice and clothes are left to dry, where children play and people gather — waiting to take his next photograph.

Shen Xiaomin continues to re-invigorate the medium, producing films that are both visually rich and intellectually stimulating and which examine how China's past continues to impact on the present day lives of individuals.

MICHAEL HAWKER is Curatorial Assistant, Contemporary Australian Art, Queensland Art Gallery / Gallery of Modern Art.

The Village Cameraman and His Son (still) (detail) 2001
Collection: The artist / Image courtesy: Long March Project, Beijing

The Village Cameraman and His Son (stills) 2001
From left: A customer of Li Tianbing; view of Fujian Province's famous circular *tulou* communal dwellings
Collection: The artist / Image courtesy: Long March Project, Beijing

For Chinese artist Wang Wenhai, Mao Zedong (1893–1976) and the Cultural Revolution (1966–76) have assumed positions of monumental importance in both his life and art. From 1970, Wang worked as a museum guide for the Yan'an Revolutionary Museum, where he was introduced to visual art. In the early 1970s, he volunteered at Xi'an Academy of Fine Arts as an assistant to a group of professors who were producing paintings and sculptures to decorate the museum. He still lives and works in Yan'an in Shaanxi province, where the Long March ended in 1935. Wang's work takes the form of celebratory monuments to Mao, ranging in size from tabletop clay busts to larger-than-life fibreglass sculptures. His work is a reminder of the enormous respect and dedication that much of China's rural populations hold for Chairman Mao and the extent to which he is part of the folklore and culture of China. Like many of his generation, Wang became a Red Guard in 1966 and was an enthusiastic participant in Mao's Cultural Revolution. Since Mao's death in 1976, Wang has continued to celebrate the great leader of his youth.

Mao Zedong was glorified and memorialised in life and death. His reputation in China is yet to endure the same level of revisionism that has expunged the names of other socialist leaders such as Lenin, Stalin or Ceausescu from more recent historical accounts (and he may prove to be impervious to it). The Cultural Revolution and its consequences are still officially very much off the agenda for public debate or discussion in China. In recent decades, Mao's status has been celebrated and examined in nostalgic terms through popular culture and historical kitsch by younger generations of Chinese. The Long March, Mao's political leadership and the Cultural Revolution have been more broadly discussed in the West and provide key points of reference for historians and commentators.

Mao's 'greatness' is ultimately separate to his actions. The purges, famines and violence — now considered to be his 'mistakes', a result of bad counsel — are largely overlooked by the still vast numbers of rural poor in China, in favour of what are perceived to be Mao's moral qualities. He convinced the majority that egalitarianism was possible, desirable and righteous, and that it was achievable only through labour, struggle and absolute adherence to official policy. Mao's propaganda campaign was ubiquitous and successful. His belief in 'correct thinking' was a euphemism for obedience. For younger generations of Chinese, however, his actions have been progressively depoliticised.

The Mao cult got under way in the early 1980s with Mao memorabilia becoming a significant business enterprise in a gradually reforming economy. He is celebrated in a variety of forms, from snow domes and statues to bronzes and ballpoints. The cult of Mao presents the former leader as a benevolent figure who had his faults but whose popular appeal outweighs the deaths and the ideological extremes of his dictatorial reign.[1] The cultural nostalgia that produces the kitsch and erects the statues appears to be inured to the irony of perpetuating adoration of a leader who ordered the destruction of thousands of monuments in Peking during the late 1950s. More often the memorialising transforms anecdote into fact, the prosaic into the extraordinary. Three decades after Mao's death, his demigod status in the popularised version of his life is a phenomenon that is peculiar to China.[2]

WANG WENHAI

Wang Wenhai / China b.1950
Mao Zedong and Mao Zedong 2003
Fibreglass / 2 figures: 320 x 130 x 130cm (each) /
Collection: The artist / Image courtesy: Long
March Project, Beijing

Museum to Great Men, Jinggang Mountain, China. This mountain has great significance in the annals of modern Chinese history for it was here that important events during the Chinese Revolution took place. Communist military leader and statesman Zhu De joined forces headed by Mao Zedong at Jinggang Mountain. Together, the combined forces of the Chinese Communist Party marched on to a victory that was to establish the new China under the chairmanship of Mao Zedong
Image courtesy: Long March Project, Beijing

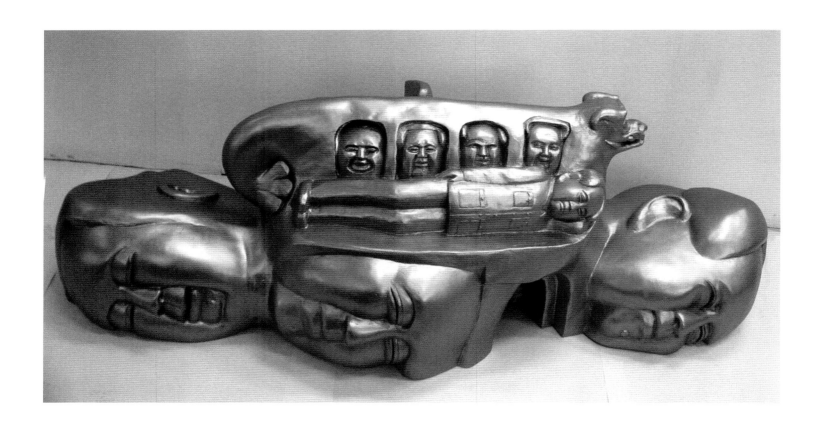

Contemporary China is at a crossroads as it changes from a society of dogma and tradition to one in which political reform and individual opportunism create a radically new agenda. For millions of Chinese, that agenda of change is fraught and uncertain and, for Wang's generation, would appear as a dramatic departure from all that Mao represented.

In *Mao Zedong and Mao Zedong* 2003, the artist presents Mao as both Chairman of the People's Republic and Emperor of China (Mao compared himself to Chin Shih-huang, the first Emperor who unified China in 221 BC). Mao's ultimate status as an autocrat is clearly indicated in this dual representation. The sculpture belongs to a recent development in the artist's work in which Mao is portrayed in a number of guises, including a series of 'mysterious' Mao sculptures. In this series of smaller clay busts and sculptures from 2003, Wang presents Mao at particular times and places or as a sleeping figure. In some, he is portrayed without eyes or facial features. Wang's devotion to Mao as a subject is total, and such works seek to personalise and expand the possibilities for understanding Mao in ways beyond the conventional dignified and imperial poses of traditional monuments.

Memorialising may take the form of statuary, remnant architecture, books, ceremonies, photographs and films. Wang's glorification of Mao Zedong is different in spirit and goes beyond the conventional architectural monument or photographic archive. His continued representation of Mao is a devoted effort to keep the Chairman and his ideology alive so that he remains 'the red sun in the hearts' of the Chinese people.[3] The artist has produced in excess of 1000 works over 20 years, all exclusively dedicated to Mao. His many permutations and interpretations are an effort to transcribe the multiple personas that Mao assumed, including Communist Party Chairman, moralist, poet, philosopher and 'father' of modern China. Wang Wenhai's work is one man's obsessive preoccupation with a potent blend of history, memory and myth.

DAVID BURNETT is Curator, International Art, Queensland Art Gallery / Gallery of Modern Art, and the Public Art Curator for the Millennium Arts Project.

Dragon 2003
Bronze / 70 x 180 x 62cm / Collection: The artist / Image courtesy: Long March Project, Beijing

/ 141

Wang Wenhai in the first stages of producing one of his sculptures, 2003
Image courtesy: Long March Project, Beijing

Wang Wenhai in his studio in Yan'an, 2003
Image courtesy: Long March Project, Beijing

UTOPIAN THEATRE: GLOBAL PUPPET SHOW

In Zhou Xiaohu's recent work, miniature clay models come alive. An invitation to participate in the Long March Project in 2002 inspired Zhou to produce *Utopian machine* 2002, one of his first claymation installations.[1] The ideas behind and scale of this initial work have been expanded in *Utopian theatre* 2006. This spectacular architectural diorama comprises ten tableaux, each containing a set of miniature clay figures. Embedded in each tableau, a television monitor screens a claymation of these tiny human figures enacting an actual story from TV news.

The sculptural scenarios include familiar scenes such as a courthouse in session, a United Nations committee hearing and the busy downtown Pudong district of Shanghai. Nestled amongst this structural order is the calamity at the World Trade Centre on 11 September 2001 — as people frantically run from the destruction; an assassination in full view of a legion of camera crews; and a lone helicopter, struggling to save a community from a landslide. In this monochromatic landscape, the faces of the figures are curiously uniform, with their dress equally nondescript.

Utopian theatre is one response to the dazzling speed of economic transformation occurring in China, which has changed not only the cultural, political and social landscapes under Deng Xiaoping's formulation of 'Socialism with Chinese characteristics', but also the physical landscapes of city and countryside. To encourage international enterprise on a private and governmental scale, China embarked on another revolution, one that struggles with the contradictory task of seeking a balance between communist principles and capitalist ideals.[2] Though Zhou's work responds to the flux of today's communist China, it also recognises its absurd similarities with capitalist bureaucracy in the sustained desire for personal gain and economic growth:

> Our life is constantly planned and changed by a series of meetings, events and technology. We are thought about, conceptualised and decided upon, and the absurdity comes from the collective unconsciousness of this reality. When we take pleasure in the theatricality of political events, viewing them as entertainment, we are blinded.[3]

Utopian theatre is not always set in specific geographical locations. We are drawn into the dioramas, which depict scenes of civil order, human chaos, guarded government buildings, super highways and other 'newsworthy' events. Zhou's miniature world stage is where the search for an idealistic scheme of social and political reform (a utopia) is thrown into question.

Arguably, *Utopian theatre* evokes the principles of the panopticon. Designed by Jeremy Bentham, an eighteenth-century English philosopher and social reformer, the panopticon is a circular prison in which cells surround a central observation tower.[4] Bentham's prison was based on the idea that discipline can be physically and psychologically administered by the power to view all prisoners at any one time from a single vantage point. Each prisoner is aware of this observational mechanism, and therefore forced to control his behaviour.

In *Utopian theatre* the television news room, reporting from across the globe, could be said to operate as the panopticon's central observational

ZHOU XIAOHU

Zhou Xiaohu / China b.1960
Utopian theatre (detail) 2006
Collection: The artist / Image courtesy: Long March Project, Beijing

Utopian theatre 2006
11-channel sculptural video installation, fired clay, 11 DVDs (1 minute each, colour, sound), 11 television monitors, 10 sets of headphones / 140 x 400cm (diam.) (approx.) / Collection: The artist / Image courtesy: Long March Project, Beijing

tower, and the individual clay sets are like the many cells of the prison that are constantly being watched.

> Our daily lives are lived and played out on the 'stage' of this 'news machine' . . . What is enacted is something that comes from both reality and deceit. It is a stage of events and a world which we have produced collectively and which we all take part in, which we entertain and consume ourselves.[5]

The condition of being observed, directed and controlled — in a world where fact and fiction coalesce — has insinuated itself into the fabric of contemporary life: from the sensors that watch our public movements in airports, banks and shopping malls to the phenomenon of email as a traceable official document; from the plethora of reality TV shows to the paparazzi's search for the latest salacious photograph of a celebrity's personal life.

Zhou belongs to a generation of Chinese artists who have embraced technology in their work — in all its crafted, animated, edited and enhanced formulations. By manipulating our familiarity with the subjects of a media-driven culture, Zhou Xiaohu probes our delight in accepting and consuming technology in contemporary life.

ZOE BUTT is Assistant Curator, Contemporary Asian Art, Queensland Art Gallery / Gallery of Modern Art.

Utopian theatre (details) 2006
Collection: The artist / Image courtesy: Long March Project, Beijing

Architectural impression of the panopticon as discussed by the 18th Century philosopher and social reformer, Jeremy Bentham

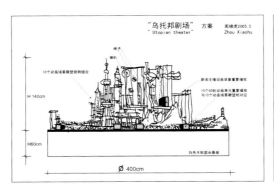

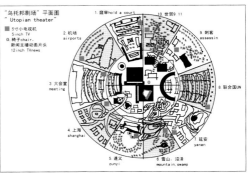

Working drawings for *Utopian theatre* (blue areas indicate position of television monitors screening the corresponding claymations)
Image courtesy: Long March Project, Beijing

MINY'TJI BUKU-LARRNGGAY
(BARK PAINTINGS FROM THE EAST)

Djambawa Marawili's paintings embody the sea and its powerful tides and currents, with baru (crocodile) as a subtle yet potent presence in the configuration of the imagery. Crocodile and fire become symbols for the forces of nature and for complex human emotions and relationships. As the custodian of the source of fire, Marawili paints and sings of its origins; for him, it is a vital recurring theme.

In 2004, during an artist's talk at the Queensland Art Gallery, Marawili captivated his audience when he sang powerfully and unexpectedly to his work, *Burrut'tji (lightning serpent)* 2002. Burrut'tji is in north-east Arnhem Land where baru dived into the waters off Yathikpa, carrying fire on its back. In his painting Marawili uses swathes and ropes of diamonds in a complex interplay of patterns, which:

> . . . express the heat of the flames as they leap through the bush, the boiling waters of the sea as the crocodile thrashes about in the water, the waving tresses of sea grass as they flicker beneath the waters.[1]

Marawili was born in eastern Arnhem Land into the Madarrpa people of Blue Mud Bay, on the north-western shores of the Gulf of Carpentaria in northern Australia. He now lives and works at Yilpara (formerly Bäniyala), a three-hour road trip from Yirrkala in the Northern Territory. He is described as 'an artist, an activist, a hunter, a father, a bureaucrat, a politician, a husband and until recently a dutiful son to his ancient blind father'.[2] Though he lives with his family, far from shops, fuel sources and mains power, Marawili embraces the complexity of modern life. He travels regularly from his remote home to such diverse places as Groote Eylandt, Darwin, Canberra, Sydney, India and Palau to attend political and art world events.

He was taught art and culture by his father, Wakuthi, and by his uncle, the celebrated painter Narritjin Maymuru. Marawili inherited the cultural knowledge that underpins his paintings and the philosophical tools which make him a great leader. Today, he drives much of the creative and political energy of north-east Arnhem Land. Marawili's principal role remains, however, as spiritual and secular leader of the Madarrpa and caretaker for the wellbeing of his own and other, related peoples. Art has been integral to his achievement of these aspirations.

Marawili's artistic heritage dates from the 1950s, when Yolngu artists were discovered by visitors to the region. These artists developed a culturally acceptable visual language to communicate their songs and stories without breaching Yolngu protocol or revealing the sacred content. They started to paint on sheets of eucalyptus bark, covering the surface with symbols representing their clan designs. In 2002, partly in response to current market preferences for abstract or less figurative work, artists from Bäniyala began to emphasise an existing style of painting in the spirit of buwayak (invisibility), in which the representational elements in their work began to disappear from view. Neither the background nor natural forms were given primacy and dividing lines were dissolved to create an overall surface charge. To the initiated eye, however, the geometric designs filled with crosshatching tell important creation stories of the Madarrpa people.

DJAMBAWA **MARAWILI**

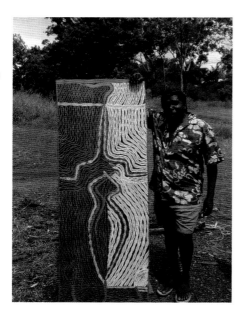

Djambawa Marawili with work in progress at Yirrkala, April 2005
Image courtesy: Will Stubbs, Buku-Larrnggay Mulka Centre, Yirrkala

Marawili speaking about his work at the Queensland Art Gallery in 2004
Queensland Art Gallery Image Archive

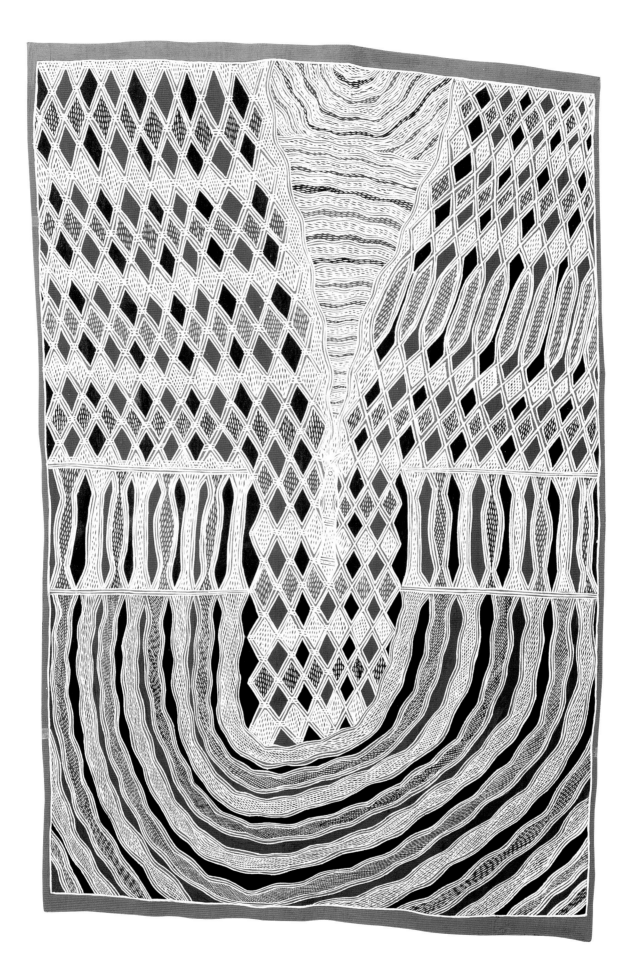

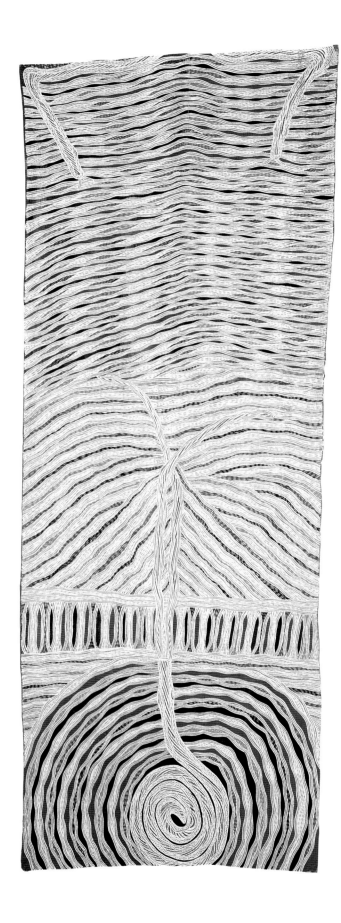
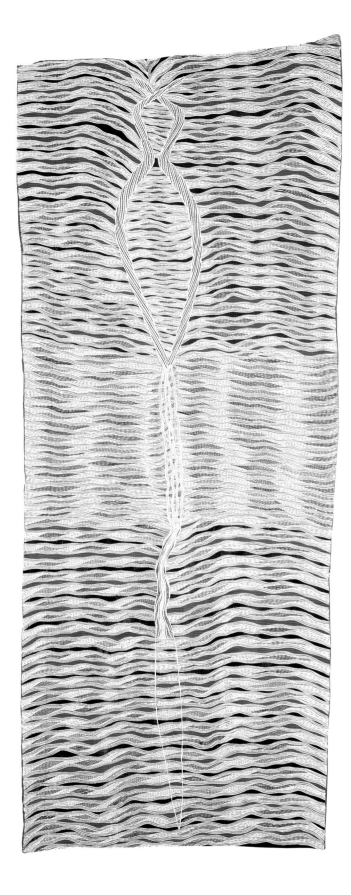

Marawili has refined and elaborated this process to become one of Australia's great contemporary painters, though recognisably from a particular cultural background. In her essay 'Bark painting: a singular aesthetic', Judith Ryan comments:

> The greatest bark painting contains a sensibility of design and surface texture, an inner life, a vital rhythm in the drawing that eludes mathematical definition. The art form has a singular aesthetic of spiritual resonance.[3]

Bark is an organic material. It tends to move and twist in response to climatic and environmental changes long after it has been separated from the tree, shedding ochre pigments in the process. It takes a great leap of faith for both the artist and the collector to invest in it as a medium, as its residual memory threatens to return it from a carefully prepared flat sheet to a circular tree form. However, a bark's irregular shape and textured surface offer an extra dimension that affects the artist's response, at times almost suggesting the content of a work. Marawili chooses bark and ochre pigments as his preferred media — the materials come from the land and maintain his connection with it. Their physical properties also have a metaphorical dimension: white represents the water (which is also part of the land), red stands for blood and black for the Yolngu people on the land.

As a contemporary bark painter Marawili continues a process embraced by generations of Arnhem Land artists to record and communicate their cultural history. Baraltja is an important site in Marawili's clan estate. It is an area of flood plains that drain into northern Blue Mud Bay, with special qualities pertaining to fertility and the seasonal mixing of salt and fresh waters. Marawili uses a complex interplay of patterns in his painting *Baraltja* 2005 with burrut'tji, or mundukul, the lightning serpent coiled at its base. Burrut'tji tasted the first fresh water coming down from Baykultji, which excited the serpent to stand on its tail and spit lightning into the storm front it created. A frieze of elongated forms in Baraltja represents motu, the mangrove leaves that have fallen onto the sandbanks and built up in drifts of red, yellow and black.

As well as working on sheets of bark, Marawili also paints on the surface of hollowed tree trunks to reinvent Dhanbarr (Madarrpa clan burial poles). These memorial poles, painted with complex miny'tji (clan designs) representing Baraltja and Burrut'tji, are similar to those containing the bones of his grandfathers. As contemporary sculptures, they are appreciated now mainly for their aesthetic charm.

Arts coordinator Will Stubbs speaks of Marawili as a man confident in 'taking possession of his own Law and pushing, stretching and bending it to form new shapes for old truths'. He continues, 'Playing against past conformity and flirting with spiritual danger, leaving an altered landscape. He is the source of this fire'.[4] Only an artist of Djambawa Marawili's stature can achieve such ambitious, robust works.

DIANE MOON is Curator, Indigenous Fibre Art, Queensland Art Gallery / Gallery of Modern Art.

Baraltja 2005
Natural pigments on bark / 196.5 x 74.5cm /
Purchased 2005. Queensland Art Gallery
Foundation / Collection: Queensland Art Gallery

Mundukul (lightning serpent) 2005
Natural pigments on bark / 200 x 79.5cm /
Purchased 2005. Queensland Art Gallery
Foundation / Collection: Queensland Art Gallery

Yilpara, on the shores of Blue Mud Bay,
eastern Arnhem Land
Images courtesy: Will Stubbs, Buku-Larrnggay
Mulka Centre, Yirrkala

> The origin of the gesture . . . is linked to the experience of a disappearance, to the feeling of having lost the key to the world, to having been thrown outside. To have acquired all of a sudden the feeling of something precious, rare, mortal. To have to find again, urgently, an entrance, breath, to keep the trace.[1]

The art of Nasreen Mohamedi has long been admired in India, but only in recent years has it been acknowledged internationally, through a series of major exhibitions and publications. It is of course a conundrum that an artist so senior and long-established in the second most populous country on the planet is just now attracting the attention of the Western art world; more than a decade after her death, her name is being written into fulsome sentences that also allude to the practices of fellow abstractionists Agnes Martin and Sol Le Witt.

Mohamedi was precocious, erudite and complex. Born in Karachi, and raised in Bombay, she left for Europe at the age of 16, studying in London and Paris and absorbing a teeming range of influences. She returned to India in the 1960s, establishing a reputation as a distinguished artist and teacher, and as one of the foremost practitioners of Indian Modernism, albeit of a very individual kind.

In particular Mohamedi's intricate and austere drawings, produced between the early 1960s and late 1980s, are informed by an elaborate combination of sources, from the grids of European Modernism to the geometry of Islamic architecture, from Indian metaphysical propositions to the theories of French feminist writer Hélène Cixous (who was born the same year as Mohamedi, and who shared her convictions about the extension of cultures and languages beyond national or linguistic boundaries). However overwhelming the array of influences might seem, in essence they all explore ideas about proportion and dynamism — how they are linked, through some profound need in human psychology, to fundamental structures and shapes in the world.

The drawings also relate, very specifically, to the photography which was until recently a virtually private part of her oeuvre, never publicly displayed during her lifetime. As long as her health permitted, Mohamedi travelled widely — to Bahrain, Turkey, Iran, Japan, the United States. The photographs she took during these journeys reflect her interest in architecture, urban and natural landscapes and modern technology. They constitute a research project, an investigation using the camera instead of drawing tools, into the same concerns that pervade her graphic practice — light, shadows, lines, arcs, ovals, triangles and the poetics of space. In both media, Mohamedi reduces structure to pattern, to what she called 'Dots and points./The point of departure from form/to shadow'.[2] From the age of 22 until the end of her life, her haiku-like diary entries comment on the world while she moves within it, and give precise insights into the aspirations that drive her work.

The vast scale of the subjects in Mohamedi's photographs belies the contained, subjective view the artist frames through the camera — the shots are realised in silver gelatin prints no bigger than 30 by 38 centimetres. Her images describe a somehow sublime but imprecise realm on the margins of iconic representation. A floating ellipse of light hovers

NASREEN **MOHAMEDI**

Nasreen Mohamedi / India 1937–90
Untitled c.1981
Gelatin silver photograph, ed. 7/10 / 23.9 x 30.3cm / Purchased 2004. The Queensland Government's Gallery of Modern Art Acquisitions Fund / Collection: Queensland Art Gallery

Fatehpur Sikri Palace Complex, Daftar Khana, Fatehpur Sikri, India. Interior view of western veranda showing doorway and embedded columns
Image courtesy: Michael Brand, 1984, Aga Khan Visual Archive, M.I.T / Photograph: Michael Brand

Untitled c.1968
Gelatin silver photograph, ed. 7/10 / 23.9 x 30.5cm / Purchased 2004. The Queensland Government's Gallery of Modern Art Acquisitions Fund / Collection: Queensland Art Gallery

Untitled c.1982

Pencil and ink / 56 x 72.1cm / Collection: Deepak
Talwar / Image courtesy: Talwar Gallery, New York

Untitled c.1981

Gelatin silver photograph, ed. 7/10 / 27.3 x 36.3cm /
Purchased 2004. The Queensland Government's
Gallery of Modern Art Acquisitions Fund /
Collection: Queensland Art Gallery

over the horizon; the linearity of taut threads on a loom resembles the lines of Cartesian perspective converging on an infinite point; directional signs painted on a street in Japan are depicted from the exact tilt at which their distortion is most pronounced; grainy, windswept patterns on sand are as mysterious as a moonscape; arched doorways photographed from a curious angle deep inside a courtyard appear to lead nowhere or to nothingness.[3] Each photograph presents a series of vertical, oval, horizontal and diagonal lines and spaces disembodied from any referent, although we are aware the referents are there, just out of sight, packed with meaning: ancient buildings, roads well-travelled, machines animated by human hands.

The group of 24 photographs acquired by the Queensland Art Gallery and displayed alongside selected drawings in the current Asia–Pacific Triennial represents the majority of her work in this medium. Mohamedi uses the photographs to articulate a suspenseful encounter. As Ruth McDougall has written, the artist empties the busy pace of life out of her images in the manner of some modernist films, creating scenes that evoke absent bodies.[4] Taken throughout her career, the photographs encapsulate Mohamedi's passionate commitment to structural languages and even more explicitly provide the actual forms through which she was able to explore her philosophical and aesthetic ideals.

A working through of the multifaceted influences and connections between India and Europe lies at the heart of Mohamedi's work. In her influential essay on the artist, 'Elegy for an unclaimed beloved', Geeta Kapur argues that Mohamedi is best situated 'within a lineage of metaphysical abstraction in a way that no other Indian artist is'.[5]

She explains how Mohamedi was well versed in Eastern metaphysical principles, including the doctrine of *Akimcanna*, or what philosopher Ananda K Coomaraswamy described as self-naughting, standing apart from the thinking of self.[6] As a consequence or extension of such interests she became deeply attracted to the geometric abstractions of the Russian constructivists. Followers of this movement sought a more fundamental reality behind the everyday presence of objects: an immaterial world of thoughts and sensations.

In India, Mohamedi commenced her exhibiting career as a painter. However, by the end of the 1960s she had begun to consolidate the series of small-format drawings for which she became best known. The exacting sketches of intertwining planes, grids and sharply ruled lines seem to be poised at the point of vanishing, taking the view, and any potential iconographic or symbolic content, away with them.

In many ways Mohamedi's interests and intentions can be illuminated through her struggle to overcome the condition of her own body. As an adult Mohamedi suffered from a debilitating neurological disease which caused uncontrolled movements of her limbs and eventually led to her premature death. It was only with tremendous strength of mind that she maintained the rigorous command of her hands and arms that was essential to complete her drawings and photographs.

This experience is expressed in her work behind a kind of formalist veil; there is no doubt it generated an enigmatic web of ambitions and strains that profoundly affected her practice. The rhythms and repetitions which Mohamedi mobilised in her works, the constant linking of line with form,

Untitled c.1981

Gelatin silver photograph, ed. 7/10 / 23.6 x 30.2cm /
Purchased 2004. The Queensland Government's
Gallery of Modern Art Acquisitions Fund /
Collection: Queensland Art Gallery

Fatehpur Sikri Palace Complex, Anup Tala-u,
Fatehpur Sikri, India. Exterior view toward
north-west showing the central platform
and pathways

Image courtesy: Michael Brand, 1984, Aga Khan
Visual Archive, M.I.T / Photograph: Michael Brand

can be seen as a conscious need to locate a place of sanctuary. Her drawings and photographs inscribe the desire for and pain of achieving transcendence at the same time as they reach for its possibility. Deriving from both the material and the ineffable, the works are deeply inflected with signs of the ritualistic methodology that created them.

There is a photograph of the room in which Mohamedi worked which tells us much about the discipline she craved. There is not a single ornate feature. She sat close to the floor at a desk tilted to suit her needs. The table is laid out with pencils, brushes, ink, rulers, a set square, and a compass specially designed for her use. Each spare, restrained drawing took four to five days to complete.

When I look at Nasreen Mohamedi's meticulous drawings, at how they expand then contract and reduce over the years, I can clearly sense the great effort it took to make the lines and shapes appear effortless on the page, the desperate control she exerted over each composition. They were works that came to be both about and despite confinement. It is as if the drawings trace, at one and the same time, the diminution of her physical world and her determination to keep the line moving, to make it express everything.

LYNNE SEEAR is Assistant Director, Curatorial and Collection Development, Queensland Art Gallery / Gallery of Modern Art.

Untitled c.1972

Gelatin silver photograph, ed. 7/10 / 22.9 x 38.1cm /
Purchased 2004. The Queensland Government's
Gallery of Modern Art Acquisitions Fund /
Collection: Queensland Art Gallery

Portrait of the artist c.1972

Image courtesy: The Estate of Nasreen
Mohamedi, Geeta Kapur and Talwar Gallery,
New York

Contemporary art in Vietnam is ridden with complexity and paradox, not unlike the country's current political, social and economic climate. Life under a communist regime and censorship, yet open to globalisation and transnationalism, has frustrated its citizens while the nation's chequered history remains as a major spectre. Young artists are compelled to seek expression through various channels, either through subculture or popular culture. The new generation prefers to focus on the future. As the gap between generations widens, a link needs to be made. Multidisciplinary artist Tuấn Andrew Nguyễn attempts to fill this gap between past and present by talking about the future.

In 1979, when he was three, Nguyễn left Vietnam with his family to resettle as a refugee in the United States, growing up and studying in California.[1] Now living back in Ho Chi Minh City, Nguyễn's work addresses his immediate surroundings and experiences of displacement, locating his subjects between past and present, and investigating them with a strategy that is both intelligent and analytical. His core concerns are the prevailing conditions of Vietnamese youth today, which signal possibilities for change. These concerns are enacted across different media such as performance, video (including documentaries), drawing, painting, sculpture and installation.

The two Tuấns: A civil self-portrait 2002 is a one-minute video in which he appropriated Eddie Adams's famous photograph Murder of a Vietcong by Saigon Police Chief (Vietnam, 1968). Performing both characters, he spits 'yo mama' insults back and forth at himself, trying to find a resolution to the foolish battle. Seen in a loop, it becomes a cycle of cynicism, self destruction and confusion. The key transition in his artistic development is perhaps depicted in From Outside 2003, a video documentary of his brother's first trip to Vietnam, which portrays the awareness of an outsider's perspective in both their motherland and their adopted country. Nguyễn then revisited Ho Chi Minh City in 2003 and shot two documentaries. The first was Portrait of a Poet, an eight-minute video sketch about the daily life of his grandmother, a published poet who was also the first female editor of a major newspaper during the years between the liberation of Vietnam from the French and liberation of Vietnam from the United States. His next project was a longer documentary, Better than Friends, about the daily economic, political and social struggles of a young couple living in Ho Chi Minh City as they run a specialised dog-butchery business.[2]

Nguyễn characteristically addresses daily life in the Vietnamese urban landscape. Using various voices and positions, he brings layers of worlds together in his 2006 project, 'Proposal for a Vietnamese landscape # 1–3', which represents a 'socialist and capitalist urban utopia' and critiques the situation in Vietnam today. This new work marks a shift from his self-portrait series to thinking about landscape painting. His aim is to explore 'how signage, both propaganda and advertising, resemble each other in such remarkable and uncanny ways'.[3] Conceived and facilitated by Nguyễn, it is a collaboration between three generations of Vietnamese artists including Ngô Đồng, a former Vietnam People's Army artist from the north who trained at the Fine Arts University in Ho Chi Minh City, and home-grown graffiti artists Link-Fish and Cá Sấu Yellow (aka Mabu) from Hanoi, and Gil from Ho Chi Minh City. As part of the project, Nguyễn made

TUẤN ANDREW **NGUYỄN**

Tuấn Andrew Nguyễn / Vietnam b.1976

In collaboration with Hà Thúc Phù Nam, Link-Fish, Cá Sấu Yellow, Gil, Ngô Đồng and Jason Huang

Proposal for a Vietnamese Landscape #2: Độc lập tự do, Gil, tóc luôn vào nếp (Independence and freedom, Gil, your hair back into place) 2006

Oil on canvas / 120 x 180cm / Collection: The artist

The two Tuấns: A civil self-portrait
(still) 2002
DV, 1 minute, b. & w., sound / Image courtesy:
The artist

a video, which serves as a sketch for his larger documentary on youth and graffiti art in Vietnam.

This collaboration began when Nguyễn started to work with cinematographer–photographer Hà Thúc Phù Nam to document the growing graffiti scene in Vietnam and the ever-changing urban landscape. Nguyễn and Hà built a wall in their studio space and invited some local graffiti artists to paint pieces that they'd like to see in the urban mix. Nguyễn and Hà photographed those graffiti pieces then collaborated with a graphic designer in Ho Chi Minh City to insert the graffiti into photographs they had taken of street locations, advertising and propaganda posters. These images were then brought to the master replica-painter, Ngô Đồng, to be transferred into oil paintings that reference traditional landscape paintings of Vietnam.

The titles of these paintings combine different slogans from the propaganda signs, advertising slogans and graffiti tags — for example, *Proposal for a Vietnamese Landscape #2: Độc lập tự do, Gil, tóc luôn vào nếp (Independence and freedom, Gil, your hair back into place)* 2006. Nguyễn also invited a graphic designer and a photographer to contribute to the project, while he documented the process on video to be screened alongside the finished paintings. The graffiti artists' playful use of imagery between the billboards apparently transforms the Third World landscape into a metropolis. The idea underlined their generation's effort to move forward, to the future, to join the global village. In coming to terms with issues of censorship, public space and the contradictory (and humorous) political climate in Vietnam, Nguyễn says:

. . . I think it captures the reality of a very unique situation . . . And then I suggest a third style of signage, one that departs from a communist agenda or a capitalist one. Modern American-style graffiti, like the other existing signs, is yet another adopted style of signage.[4]

How do people deal with this open and closed system simultaneously? In Vietnam, people need to remain well-balanced enough to be able to negotiate with the free-market system, authoritarianism and unpredictable situations in their daily lives. In Nguyễn's work, art-making serves as a social tool and an alternative model for the current situation in Vietnam. On canvas, his collective works subtly change an urban reality according to his own interpretation of 'socialist and capitalist urban utopia', one that re-contextualises the art of graffiti in the 'imaginative landscape' of urban Vietnam. Tuan's expression serves first as a proposition within the exhibition space, but is transformed into a social intervention about communist propaganda and capitalist advertising when installed as a billboard in the public space.

Nguyễn's 'socialist and capitalist urban utopia' constitutes an expressive ground for three generations of artists, whose experiences are not created by their own wills but are shaped by post-colonial and post-trauma realities. It is a space in which they reclaim their own territory and their voices as the contemporary spirit of Vietnam, critically and humorously. And hopefully they will have a chance to direct and reshape their own destiny.

GRIDTHIYA GAWEEWONG is an independent curator based in Bangkok. A co-founder and director of Project 304, a Bangkok based independent art organisation since 1996, she has curated and co-curated numerous regional and international exhibitions. She is co-artistic director with Rirkrit Tiravanija, of Saigon Open City, a series of exhibitions in Ho Chi Minh City.

In collaboration with Hà Thúc Phù Nam, Link-Fish, Cá Sấu Yellow, Gil, Ngô Đồng and Jason Huang

Proposal for a Vietnamese Landscape #3: Link Sao, đẩy mạnh công nghiệp hoá, công nghệ mang tính nhân bản (Link Sao, push industrialisation, human technology)
2006
Oil on canvas / 120 x 180cm / Collection: The artist

From outside (still) 2002
Mini DV, 18 minutes, colour, sound / image courtesy: The artist

From left to right: Tuấn Andrew Nguyễn with collaborating artist Ngô Đồng in Ngô Đồng's studio, discussing APT5 works in progress, 2006

Dennis Nona is a Torres Strait Islander whose traditional background is an important part of his artistic practice. The Torres Strait lies between the two neighbouring land masses of Papua New Guinea to the north and Australia to the south. Badu Island, where Nona was born in 1973, is in the western geographic and cultural group of islands, which were formed after rising sea levels flooded the exposed shelf that linked Cape York Peninsula to what is now the New Guinea mainland.

In response to their geographic environment, the western Islanders led a hunter–gatherer lifestyle, relying partly on the land and, to a much larger extent, on the shallow seas that supported, and continue to support, an abundance of seafood including turtles and dugongs.

'Traditional' Torres Strait art — cultural objects collected during the first period of sustained contact with Europeans in the middle of the nineteenth century, which reflect the type of material produced by Islanders in the past — was confined to three-dimensional objects, the most distinct form being masks and associated paraphernalia used in various mortuary, birth, initiation and cult practices. Any two-dimensional art was limited largely to decorative elements such as inscribed and pigmented lines on three-dimensional objects.

Nona's background is in traditional woodcarving, which he was taught as a young boy. His current art practice can be traced directly to his studies in the Printmaking Department of the Faculty of Aboriginal and Torres Strait Islander Studies at the Tropical North Queensland Institute of TAFE, Cairns.[1] In terms of style, however, Nona's art can be linked not only to his woodcarving tradition, which has assisted him in working with the linocut medium, but also to the pre-contact two-dimensional tradition. In particular, the patterning in Nona's work can be compared to the inscribed designs seen on nineteenth-century Torres Strait masks and drums.[2] However, the subject matter of Nona's work is influenced purely by his Torres Strait Islander heritage and, more particularly, his cultural and geographic connection to Badu and the surrounding waters. This connection has resulted in an intimate knowledge and an innate respect for the environment.

All these influences are clearly seen in the works Nona has produced for APT5. *Ara* 2006 stylistically portrays the particular type of wave formation that results at the edge of the reef when there is a fast current running (ara or boxing waves formed by the fast current known as yaram kulis), but it also relates the importance of reading sea patterns for food gathering and general survival if lost at sea. In terms of food gathering, when hunting for turtles, the hunter knows that turtles will only cross onto the reef shelf at the time of day when gutat (the weaker current) dissipates ara. Until then, turtles will bide their time swimming amongst ara. Because of the triangular shape of ara, it may also be difficult to spot a turtle who, when breathing, will only put its beak above the water: the triangular shape of the beak blends perfectly with the shape of the wave. In terms of survival, Nona is imparting to the viewer (and particularly Torres Strait Islanders) his knowledge of survival when sarup (lost at sea). In *Ara*, Nona is saying that when sarup, you should not panic. If you reach a reef, you wait on the reef until the current changes. When the current turns towards where you wish to go, and your boat turns towards that point, that is when you heave anchor and allow yourself to float in the chosen direction.

DENNIS **NONA**

Dennis Nona / Australia b.1973
Kala Lagaw Ya people
Ara (detail) 2006
Purchased 2006. Queensland Art Gallery
Foundation Grant / Collection: Queensland
Art Gallery

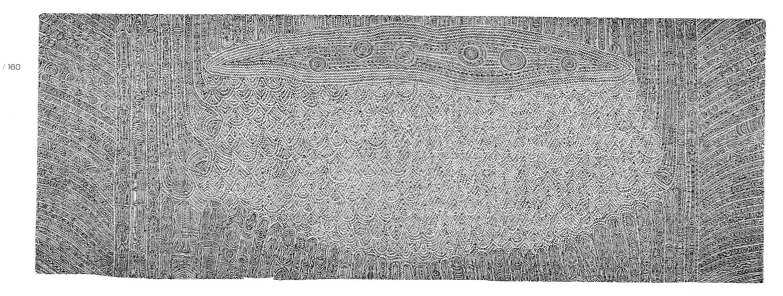

Ara 2006
Linocut A.P. / 90 x 240cm / Purchased 2006.
Queensland Art Gallery Foundation Grant /
Collection: Queensland Art Gallery

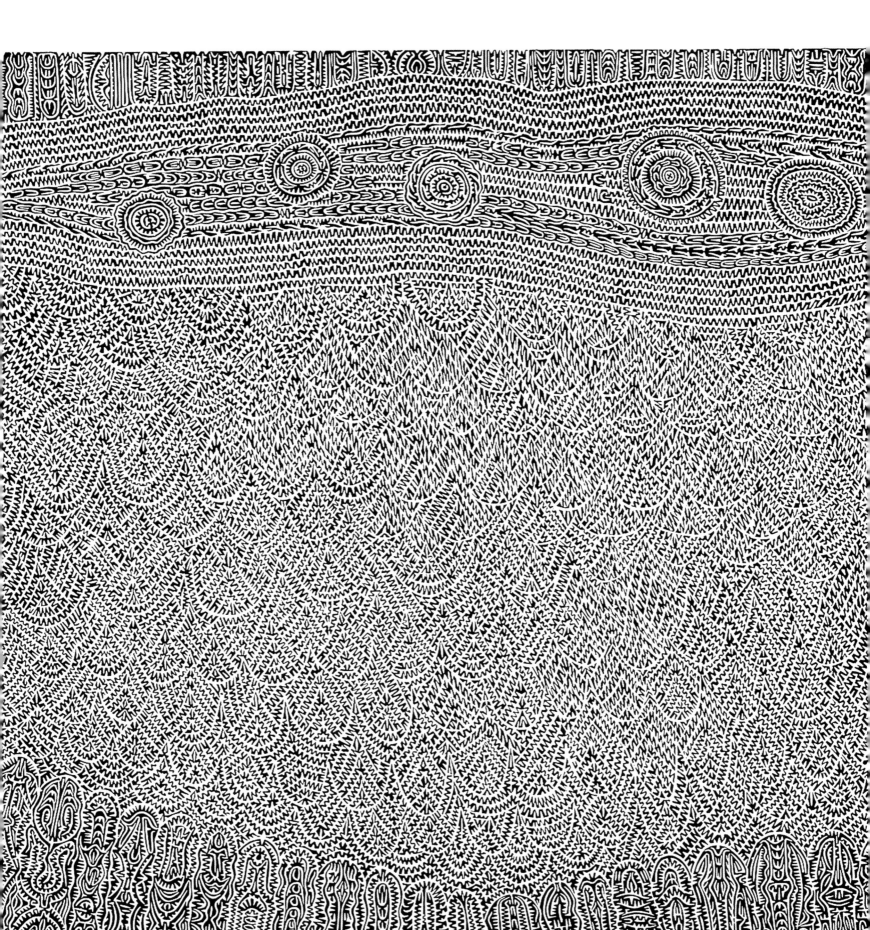

Torres Strait Islander life is also governed by the seasons. In *Baidam* 2006, where Nona is referring to the shark constellation zugubal tituil, he relates the rise and fall of the constellation and the associated seasonal changes. In February, the nose of baidam rises above the horizon. Gradually the body of baidam appears and is entirely visible by the end of March. By June, baidam is to be found lying parallel to the horizon and the sager (south-east wind) rises, resulting in stormy weather. At this time of the year, travel by sea is difficult. Gradually, baidam moves across the sky and baidamau id (his liver) starts to 'melt'. The oil from the melting liver calms the sea and heralds a time of naigai (fine weather). However, this is when the mating season for sharks begins and, while the fine weather is tempting for water activities, it is a dangerous period. Baidam meanwhile continues to position himself and, by August, his nose starts to disappear over the horizon. This heralds the kuki (monsoon season) and gradually, by December, baidam has all but vanished, and only remnants of his tail are visible. This is when the rainy season is in full force. Baidam will not appear again until February.

In *Baidam*, Nona is also relating the dance of the kaigasal usulal (shovel nose shark) as it turns in the Milky Way. When the galaxy has one of its arms extended towards Papua New Guinea and the other towards Australia, the ocean currents are weak. However, when it turns and its arms extend towards the central islands, strong currents can be expected.

Nona imparts in these works a sense of the wonderment of living in a close to pristine environment. Only in such isolated places can you view the Milky Way in all its glory and study the movement of the constellations without the visual and aural pollution associated with life in an urban environment. Only on an island can you develop knowledge of the patterns of stars and waves and currents to tell you when it is the best time to travel and to hunt. Inherent in Nona's art is a respect for the dangers of living in an island environment and why it is important to be able to read the movement of stars and sea. Dennis Nona produces works of an artistic quality that have ensured his place at the forefront of Indigenous art practitioners. However, he also draws on his personal experience to impart his knowledge to younger generations of Torres Strait Islanders who have grown up displaced from this environment.

TOM MOSBY is Senior Associate, Litigation and Dispute Resolution, Clayton Utz, Melbourne, and curator of 'Ilan Pasin (This Is Our Way): Torres Strait Art' 1999–2001, the first exhibition to comprehensively survey the art of the Torres Strait.

Baidam (detail and full work) 2006
Linocut A.P. / 95 x 239cm / Purchased 2006.
Queensland Art Gallery Foundation Grant /
Collection: Queensland Art Gallery

Dennis Nona, 2006
Image courtesy: Newspix/Tony Phillips

Badu Island, Torres Strait
Image courtesy: © Kerry Trapnell

While contemporary Indonesian art is mainly presented in gallery exhibitions — commercial as well as alternative, and both local and international in scope — some young artists have diverted from this mainstream. Since the mid 1990s young artists, particularly in Yogyakarta, have formed their own associations, getting together and creating unusual names for their groups, but often dispersing again after a short time. This fluidity can be interpreted as a 'post-ideological' tendency in the development of art in Indonesia.

Yogyakarta is well known as one of the main centres for art and the location of the oldest university in Indonesia. It is also home to a number of artists who have been creating superhero comic characters since the 1970s. These artists are generally interested in a diversity of styles in drawing and in narrative comics. In this environment, two groups of young artists — *Apotik Komik* (Comic Chemist), formed in 1997, and *Taring Padi* (Fang of Rice), formed in 1998 — encouraged discussions and raised questions about the relationship between art and its audiences. While neither group could agree on the right form of art for the public or the appropriate model to represent it, both groups generally tried to show their concern about the social issues around them. What is most obvious is that they distanced themselves from mainstream art.

The *Apotik Komik* group initiated drawing projects at community rooms, *kampong* (village) and station walls, flyover columns in the middle of the city and public schools. Meanwhile, the *Taring Padi* group demonstrated their proximity to the critical ideas of socialism through discussions, exhibitions, banners, posters, postcards, community festivals, music recordings and by publishing comics. Some artists publicly exhibited their work at eateries, openly calling them *Perang kelas* (Battle of classes).

In 2000 in Yogyakarta, a compilation of unusual drawings was published as a comic-like book called *Daging Tumbuh* (Diseased Tumour), with artist Eko Nugroho emerging as the 'president' and 'publisher'. Several drawings by unknown artists were published in the first edition of *Daging Tumbuh*, just as they were, complete with vulgar themes and blurbs. Nugroho's drawings, 16 pages altogether, appeared in that edition. Reminiscent of underground cartoons, the 'dark' text and drawings appeared unconnected, making an interpretation of the images difficult. Nugroho's work is minimalist in verbal expression as well as in the drawings, marking a new kind of fusion between art and comics.

The idea of *Daging Tumbuh* (published 6-monthly until recently) was to attack all taboos, discarding the involvement of publishers and encouraging artists to draw without limitation. Anybody could send in their work and be published. As producer, Nugroho collated the drawings, made multiples and distributed them himself. *Daging Tumbuh* encouraged readers to pirate it by photocopying without seeking permission, 'for the sake of the future', and to signify a lack of preciousness about the publication.

The 'politics' of representation in *Daging Tumbuh* can be seen in Nugroho's pluralist style: it is non-hierarchical and playful without any intention to convey particular meanings. If we closely observe the texts and stories which are often inserted in his art work — either consciously or unconsciously — we find evidence of a biased and confusing social life in the scenarios. Nugroho often repeats well-known expressions completely

EKO **NUGROHO**

Eko Nugroho / Indonesia b.1977
Trick me please 2006
Machine embroidered rayon thread on a fabric backing / 181 x 153.5cm (irreg) / Purchased 2006 / Collection: Queensland Art Gallery

Untitled (1) 2005
Machine embroidered rayon thread on a fabric backing / 30.5cm (diam.) (irreg.) / Purchased 2006 / Collection: Queensland Art Gallery

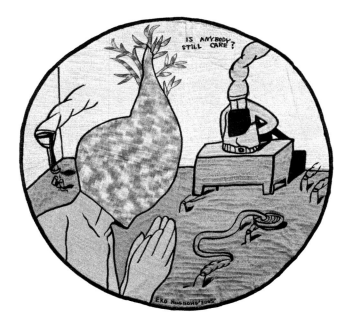

Is anybody still care? 2005
Machine embroidered rayon thread on a fabric backing / 53.5cm (diam.) (irreg.) / Purchased 2006 / Collection: Queensland Art Gallery

out of context. Words such as *persatuan* (unity), *jangan percaya sejarah* (don't trust history), *pancasila* (the five principles — the basic nationalist principles of Indonesia) are used interchangeably so that they become meaningless: no different from any other word, able to be replaced by any other word.

Texts in Nugroho's art often mimic the smooth rhetoric and slogans of Indonesian officials and authorities, labelled by critical observers in Indonesia as the phenomenon of 'split personality', where action and speech may be treated as equivalent or interchangeable. Certain characters in his art works, such as those in his animated video work *Fight me* 2005, experience a social life full of scheming and pretension. His characters are often in conflict with their changing ideas and confusing thoughts: they are tossed about between the deceptive and true roles in their lives. The texts and visual style of Nugroho are created as if to be played with, to be repeated, to be a bit off the mark, to make them relative, as with the final page of *Daging Tumbuh* — the publication ends with the scene of 'going to the toilet'.

Nugroho's passion for playing with text and visual style originates from diverse sources: conversations with people around him, the languages they use, things which are familiar, as well as techniques of production such as sewing, painting, silkscreen printing, photocopying, copying and redrawing. For his embroidered work, for example, Nugroho employs an embroiderer to apply his drawings and writings to fabrics.

Eko Nugroho's free-ranging style is an effort to discard the planned meaning of a communication or representation. He says words are poisonous. Words can be repeated to change an original meaning and to create new representations. The example he points to are the words 'Daging Tumbuh' themselves. These words can be defined as 'damaged tumour', but in fine art they are 'comics'. Hence, anything that may be believed will always change and become meaningless if repeated again and again.

HENDRO WIYANTO is a curator based in Jakarta, Indonesia.

Pages from the artist's sketchbook. Preparatory drawings by the artist for the mural *It's all about the Destiny! Isn't it?* 2006, created for the Gallery of Modern Art for APT5

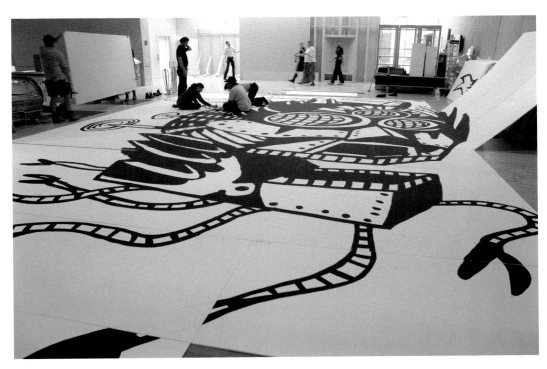

The artist working with Gallery staff to create *It's all about the Destiny! Isn't it?*, Brisbane, September 2006

A MOVE IN THE GAME OF ALTERNATIVE SYSTEMS

Like a chess player who advances one piece at a time, Tsuyoshi Ozawa has strategically constructed his own unique world, developing several concurrent series of works over the last two decades. During the 1990s, the generation of Japanese artists born in the 1960s experimented with concepts of contemporary art, seeking a uniquely Japanese form of contemporary culture. This can be glimpsed in Ozawa's work, which uses both a critical stance and a gentle touch to reflect on changing social environments and conditions.

In 1991, Ozawa published a manifesto on *Sodan bijutsu* (literally, consultative art), a term he uses to describe his practice.[1] Art based on the participation of others was highlighted in the 1990s by artists such as Felix Gonzalez-Torres and Rirkrit Tiravanija, and can be connected to the theories presented by Nicolas Bourriaud in his influential study, *Relational Aesthetics* 1998. Within this context, Ozawa develops defiant, alternative systems of making art in which the participation of others is integral to the production and presentation of the work.

Ozawa began his collaborative Nasubi Gallery project in 1993. A series of milk crates set up as miniature galleries, the Nasubi project allowed Ozawa, as the 'gallery owner', to present exhibitions by various artists. These works critiqued the role that rental spaces played in presenting the works of young Japanese artists of the time. In particular, they inverted the interest in the large-scaled art and cultural events that were so popular during Japan's bubble economy of the late 1980s. They also reveal Ozawa's distinctive sense of fun, particularly in their parody of the renowned Nabisu Gallery in Tokyo. The Nasubi Gallery was originally presented in 1993 as part of Ginbuart, a guerilla street-art event organised by artist

Masato Nakamura (who was in the 'Third Asia–Pacific Triennial of Contemporary Art', 1999). Ozawa then developed the idea with other permutations, such as the publication of the *Nasubi Shimbun* newspaper and his portable Ai Ai Gallery (a backpack-version of the Nasubi Gallery). This gave him a chance to further critique existing hierarchies by presenting their systems as parodies while also allowing for contradictions.[2] As part of APT5, Ozawa has invited a number of artists participating in the Triennial to create works for the New Nasubi Gallery project.

For his 'Vegetable weapon' series, started in 2001, Ozawa travels to various parts of the world, chooses young local women as his models and asks them to select a regional specialty dish. Ozawa then assembles the ingredients of the dish into a weapon-like form, and photographs the woman wielding the vegetable weapon. They then disassemble the weapons, cook the dishes and sit down to eat together. The basis for this series can be seen in two works displayed by Ozawa in his 'One-Man Group Show' at Tokyo's Mori Art Museum in 1998, in which he presented the work of the fictional brothers Ichitaro Okamoto, Nitaro Okamoto and Saburo Okamoto, works that emphasised a masculine tendency for weapons and violence. On the other hand, the 'Vegetable weapon' series is based on the concept of *Sodan bijutsu*, the works deconstruct the idea that problems can be solved through violence, rather than through mutual cooperation and cultural awareness. By cooking and eating the vegetables that composed the weapons with the young women, Ozawa humorously trumps our assumptions about the world. Like Rirkrit Tiravanija's projects, which treat spectators to curry and the Thai noodle dish Pad Thai, Ozawa's

TSUYOSHI **OZAWA**

Tsuyoshi Ozawa / Japan b.1965
Seafood hotpot/Beijing (from 'Vegetable weapon' series) 2002
Type C photograph, ed. of 1 / 157 x 114.1cm / Purchased 2005 with funds from John Potter and Roz MacAllan through the Queensland Art Gallery Foundation / Collection: Queensland Art Gallery

New Nasubi Gallery by Hong Hao 2006
Wooden box with mixed media / 33 x 19.6 x 14.2cm / A collaborative project by Tsuyoshi Ozawa with APT5 artists / Collection: Hong Hao

New Nasubi Gallery by Finau Mara 2006
Wooden box with mixed media / 33 x 19.6 x 14.2cm / A collaborative project by Tsuyoshi Ozawa with APT5 artists / Collection: Finau Mara

New Nasubi Gallery by Eko Nugroho 2006
Wooden box with mixed media / 33 x 19.6 x 14.2cm / A collaborative project by Tsuyoshi Ozawa with APT5 artists / Collection: Eko Nugroho

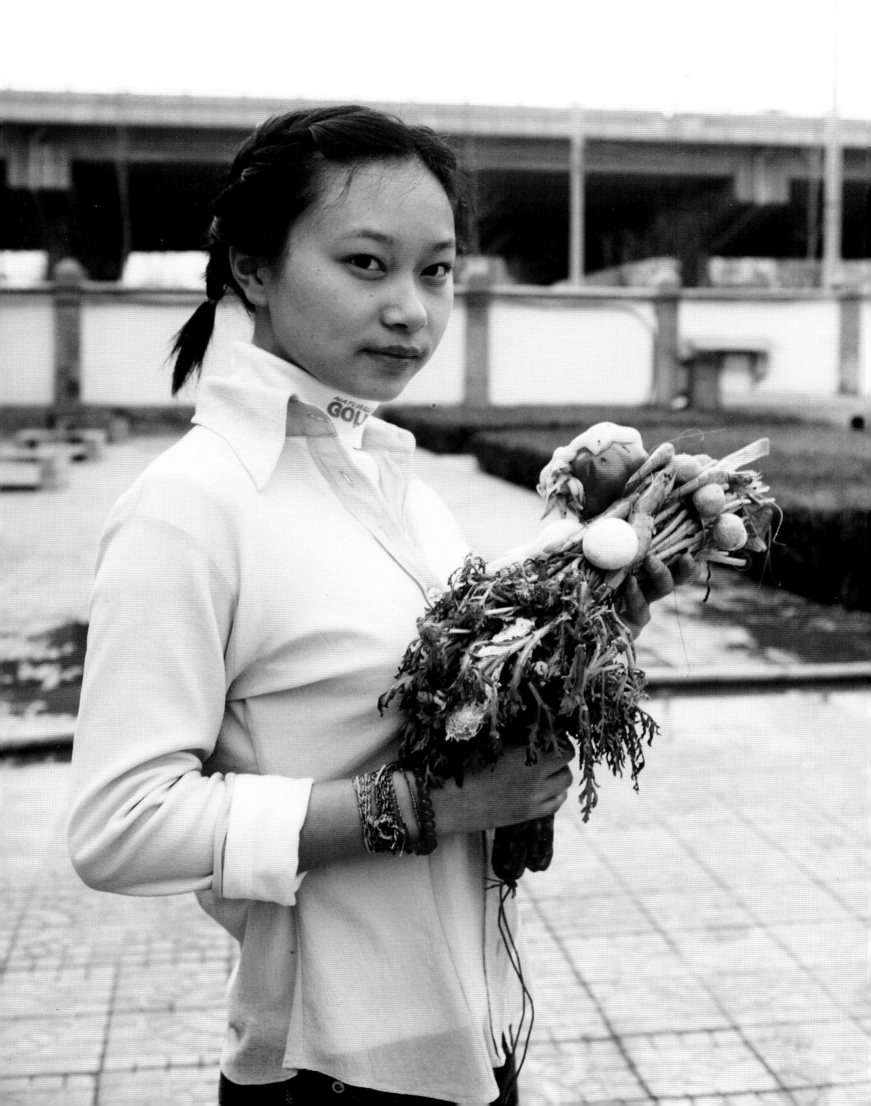

projects bring everyday things (such as food culture) into the context of contemporary art.[3] APT5 includes nine of Ozawa's 'Vegetable weapon' works, including three that he recently created in Brisbane. His inclusion of an Indigenous Australian woman in one of the Brisbane works, and the Indian curry dish she chose as her signature recipe, allow viewers to glimpse how multicultural coexistence has permeated Australian culture.

In another of Ozawa's collaborative projects, his 'Sharaku work' (begun in 1996), he wrote instructions on postcards featuring the work of famous *ukiyo-e* woodblock artist Toshusai Sharaku. The instructions read: 'Please draw the face of your favourite person on this card'. Couples often drew one another, while others drew their bedridden mother or family members living faraway. Some drew on a small corner of the postcard while others filled the entire space. This superbly moving work, with its accumulation of emotions, captured the often profound ways people think about others.

As an interactive element of his work for APT5, children can climb a mountain of futons and draw pictures to exchange with those previously drawn by Japanese children. Versions of this installation can be seen in Ozawa's earlier projects, such as his collection of black-and-white photographs of evening scenes shot throughout the world during his days as a backpacker, and the 'Jizoing' exhibition in which he hand-coloured photographs of sunsets. A space filled with soft mattresses is sometimes viewed as the most inviting and personal space in a home. Ozawa takes this highly private experience and brings it into the public space of a gallery. Needless to say, the experience of slipping down a mountain of futons will captivate exhibition visitors of all ages.

MAMI KATAOKA is Senior Curator, Mori Art Museum, Tokyo, Japan.

Opposite top:

Chicken and spinach risotto/Brisbane, Australia (from 'Vegetable weapon' series) 2005

Type C photograph / 114 x 157cm / Purchased 2005 with funds from John Potter and Roz MacAllan through the Queensland Art Gallery Foundation and the Queensland Art Gallery Foundation Grant / Collection: Queensland Art Gallery

Opposite below:

Tsuyoshi Ozawa travelling to Coochiemudlo Island, near Brisbane, in 2005 to create and photograph **Chicken and spinach risotto/Brisbane, Australia** (from 'Vegetable weapon' series) 2005 — one of three new 'Vegetable weapon' works

Photograph: Natasha Harth

Sodan Art Café — Manga Café 2001

Mixed media / installation view: 'The 2nd Berlin Biennale', Germany, 2001 / Image courtesy: Ota Fine Arts, Tokyo

AiAi Gallery 1994

Milk box, shoulder strap / 32 x 17.5 x 13cm / Private collection, Tokyo / Photograph: Mikio Kurokawa / Image courtesy: Ota Fine Arts, Tokyo

Made by women across the South Pacific, the striking works in the Pacific Textiles Project exude confidence in the use of bold motifs and command attention in their transposition of important personal and collective narratives. The objects — *tivaevae*, *tifaifai*, *kapa kuiki* (quilts in the Cook Islands, Tahiti and Hawai'i respectively) and *ibe vakabati*, *fala pati* and *fala su'i* (mats in Fiji, Tonga and Samoa) — are representative of some of the most important forms of current art making in the region. In most cases, they are synonymous with the nations from which they come. The creation, exchange and display of these cloths and woven works are central to local cultural and artistic expressions. Their mesmerising line work and recurring symmetry of colour resonate in the warp and weft of the fibre and the shapes and designs of the cloths. Combined with new materials and techniques, they are testaments to the ingenious continuation of customary practice.

The two centuries following European contact in the South Pacific have wrought significant changes in the materials, meanings and methods of textile creation. In Hawai'i, Tahiti and the Cook Islands, political impositions and the introduction of Christianity, and European culture in general, ran parallel to the creation of new forms of cloth textiles. Islander women listened to biblical stories as they learnt to stitch, plying needle and thread through the new cotton fabrics.

The inculcation of European notions of propriety, and the promotion of needlework as an ideal female past time may have been new, but the gathering of women to produce objects for ceremonial use was not. Weaving and the making of bark-cloth (tapa) were the primary forms of

cultural expression in pre-colonial Polynesia. Particular designs and markings can be seen in early cloth textiles across these Islands. Hawaiian quilts, for example, were initially designed with strikingly simple geometric patterns that reflected those used in weavings and *pai'ula* (tapa).[1]

In Hawai'i, quilting techniques originally taught by American missionaries have been adapted to create inimitable textiles that appear to pulsate through the use of rippling background patterns. One of the earliest written accounts of this needlework practice refers to the last days of the Hawaiian monarchy in the late nineteenth century, where, under detention in the 'Iolani Palace, Queen Lili'uokalani was joined by a group of women who passed the hours by quilting a silk patchwork. Embroidering these rich materials with their names, Lili'uokalani's subjects created a work that steadfastly declared their loyalty for the beleaguered Queen.[2]

Many designs in *kapa kuiki* illustrate the desire to perpetuate knowledge of the royal family of Hawai'i and the circumstances surrounding its overthrow.[3] Deborah U Kakalia's visually arresting textile, *Lili'uokalani* c.1993, with its bold yet intricate placement of royal motifs, recapitulates a rich historical narrative imbued with personal traces. Commemorating the 100th anniversary of the overthrow of the Hawaiian kingdom, Kakalia stitched Lili'uokalani's name on the lower right of the quilt, followed by 'Jan 1883 [sic 1893] – Jan 1993' and her own indigenous name, 'Kepola'. In this considered composition, Kakalia uses the crossed diagonals of the design to focus attention on the central cluster of crowns and *kāhili* (feather standards). The *kāhili* were used to denote the presence of *ali'i* (chiefs). This vivid combination of European and customary emblems of

PACIFIC TEXTILES PROJECT

Deborah (Kepola) U Kakalia / Hawai'i, United States 1915–2002

Lili'uokalani c.1993

Kapa kuiki quilt: commercial cotton cloth, synthetic batting with hand appliqué and contour quilting / 269.2 x 248.9 cm / Gift of Deborah (Kepola) U Kakalia, 1996 / Collection: Bishop Museum, Honolulu

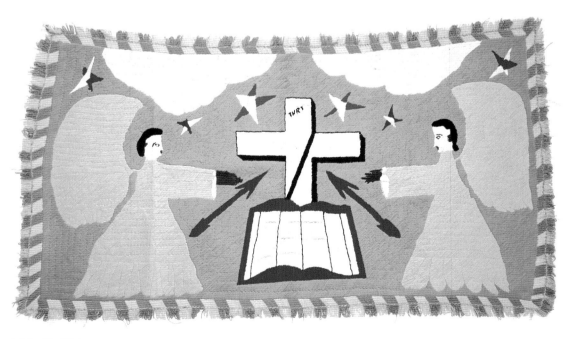

Artist unidentified / Samoa

Fala su'i c.1980–85

Mat: woven laufala (pandanus) and commercial wool / 128 x 224cm (irreg, including fringe) Purchased 2005 / Collection: Queensland Art Gallery

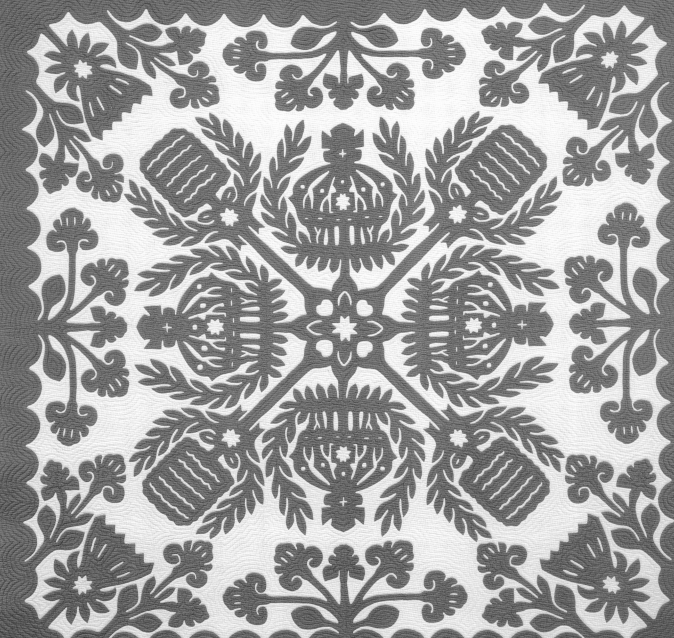

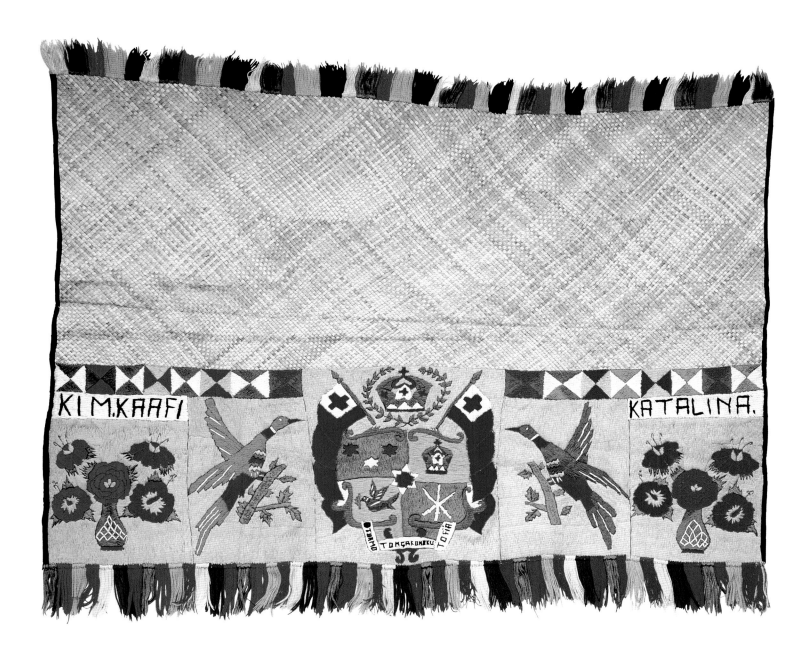

ultimate power is softened by the images of flowers and fans on the border. These flowers, known as *puakalaunu* (crown flower/milkwood), were favourites of the deposed queen. Amidst this evocative honouring of a dynastic past is Kakalia's signature mark, the eight-pointed star that tenderly refers to her husband, David.[4]

Susana Kaafi sewed the names of her grand-daughters into the very fibres of the pandanus of her *Fala pati* (mat) 1988. Kim and Katalina's names are featured with rich hibiscus bouquets at the beginning of the *fala pati*'s storyboard format. The tropical birds that follow are placed beside the Tongan national emblem, complete with flags, crowns and the motto, '*Koe Otua mo Tonga ko hoku tofia*' (God and Tonga are my inheritance). Now 86 years old, Kaafi arrived directly from Tonga 15 years ago to live in Mt Druitt in western Sydney. Her *fala pati* depicts all that is most precious to her. On this mat, along with a second *fala pati*, both now in the Gallery's Collection, she inscribed the names of her grandchildren and reverentially placed them above her deceased son's open casket. Although not always so poignantly illustrative of a family's genealogy and national fervour, *fala pati*, and the Samoan equivalent of *fala su'i*, are the contemporary continuations of a significant tradition of woven mats. The most revered of these, the *kie hingoa* and the *'ie toga* (Tongan and Samoan mats respectively), are sacred objects that confer power to their owners.[5] These finely woven mats designate the political and social hierarchies of the two nations.[6] When the mats are presented in ceremonies such as births, marriages and deaths, the accompanying speeches, with their detailed evocation of complex genealogies, give meaning and status to the intricate and time-consuming weavings. About 60 years ago, women began to use synthetic wool on pandanus mats to create their own narratives through the use of colour, image and text.[7] These new weavings, which were originally created to cover European frame beds, have not surpassed the *kie hingoa* and *'ie toga* in the cultural hierarchy, but they do coexist in the many ceremonies, giving women a specific avenue of expression.

Using a lively colour palette, Samoan Sivaimauga Vaagi recreates the biblical story of Adam and Eve in her *fala su'i* of 2005. Even before biting the apple, her white-skinned protagonists have already covered their naked bodies and appear as if floating on large leaves. The garden of their sin is filled not only with the fabled apple tree, but also with brightly coloured tropical plants. To this iconic story, Vaagi has added domesticated animals, a common sight in the villages, thus situating God's first man and woman within a Samoan Eden.

These richly expressive cloth and woven works encourage alternative views of the South Pacific, including the intricate political and social stratification of nations that often eludes mainstream portrayal. Through the innovative continuation and renewal of customary practices, the textiles also question established notions of the contemporary. Monumental in scale and presence, and arresting in their use of rhythm and vibrant colouration, these highly tactile works articulate Pacific histories and current experiences and confirm the vigour of Pacific art today.

MAUD PAGE is Curator, Contemporary Pacific Art, and RUTH McDOUGALL is a Curatorial Assistant, Queensland Art Gallery / Gallery of Modern Art.

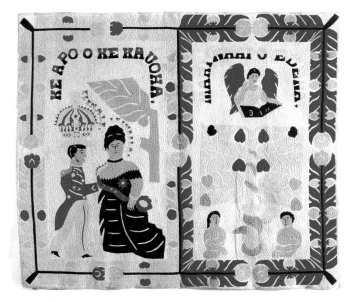

Artist unidentified
Na kihapai nani lua 'ole o Edena a me Elenale (The beautiful unequalled gardens of Eden and Elenale)
Bed cover, Hawai'i, before 1918 / Cotton, plain weave, with cotton appliqué, quilted and with knotted fringe / 199 × 234cm / Gift of Mrs Charles M Cooke, 1929 / Collection: Honolulu Academy of Arts

Susana Kaafi / Tonga/Australia b.1920
Fala pati 1988
Mat: woven lau'akau (pandanus) and commercial wool / 237 × 178.5cm (irreg., including fringes of 17.5cm and 9cm) / Purchased 2004 / Collection: Queensland Art Gallery

Weavers with *fala su'i* 2005, depicting the story of Adam and Eve, Moata'a village, Samoa. This work has been acquired for the Queensland Art Gallery Collection
Queensland Art Gallery Image Archive

In many Pacific Island languages, 'the nation' does not exist as a discrete concept separate from notions of leadership, government and, most importantly, land. The state motto of Hawai'i for example is '*Ua mau ke ea o ka 'aina i ka pono*' (The life of the land is perpetuated in righteousness). Sometimes the nation is also articulated through evocations of the divine, as in the national motto of Fiji, '*Rerevaka na Kalou, ka doka na tui*' (Fear God, respect the chiefs). In the Pacific Islands of today, however, such dictums are increasingly becoming relics of more optimistic or assured visions.

For over 100 years the life of the land in the Hawaiian archipelago has been eroded by United States colonial and multinational agricultural, military and tourist exploitation. Native Hawaiians are over-represented among the malnourished and unemployed, in jails and the military service, yet at the same time their cultural identity has been intensely commodified for the tourist market.

Building on astute analyses of the contradictions inherent in this socio-economic profile, the anti-colonial sovereignty movement in Hawai'i reached a turning point in 1993 when over 120 000 native Hawaiians and supporters marched in protest and commemoration of the 100th anniversary of the US military overthrow of the independent monarchy. Around the same time, it became apparent that erstwhile opponents of the anti-colonial sovereignty movement, such as key state institutions of Hawai'i, were making moves to co-opt the discourse and the very project of sovereignty.[1]

The life of the land will erode without righteousness, but, as native Hawaiian academic and activist Haunani-Kay Trask points out, the only way to achieve *pono* (righteousness) is to restore balance among people, land and the cosmos. The Hawaiian quilts in the Pacific Textiles Project evoke that notion of *pono* through both content and aesthetics. Two of the quilts, Gussie R Bento's *Na kalaunu a me na kāhili o Kamehameha IV (The crown and kāhili of Kamehameha IV)* c.1980 and Deborah U Kakalia's *Lili'uokalani* c.1993, cannot help but remind us of the roots of Hawai'i's struggle for national sovereignty and integrity. King Kamehameha IV, who reigned from 1855 to 1863, and the last Hawaiian monarch, Queen Lili'uokalani, who reigned from 1891 to 1893, both attempted to restore *pono* to their nation and both were tragically defeated.

When one understands that most of the existing nations of the Pacific came into being as much through the acts of imperialist and colonial agents as any indigenous cultural logic, that a nation is not simply born but must be strenuously constructed, and that nations, once made, can also be unmade, the works in the Pacific Textiles Project are very poignant.

The other nations represented in the project — Fiji, French Polynesia, Samoa, and Tonga — have political histories just as interesting and complex. Fiji has been wracked by two military coups and one semi-civilian coup in its 36 years of independence from Great Britain. In 2005, for the first time since it achieved legislative autonomy from France some 20 years ago, French Polynesia decisively gained a coalition government led by pro-independence leader Oscar Temaru. In Samoa, the same political party has remained in government since 1982, which for some would indicate stability and for others would indicate imbalance. In Tonga in the meantime, the Pacific's last remaining monarchy and the only Pacific nation not to have

KEEPING FAITH
AND THE NATION

Gussie R Bento / Hawai'i, United States b.1932
Na kalaunu a me na kāhili o Kamehameha IV (The crown and the kāhili of Kamehameha IV) c.1980
Kapa kuiki quilt: commercial cotton cloth, synthetic batting with hand appliqué and contour quilting / 254 × 269.24cm / Collection: The artist

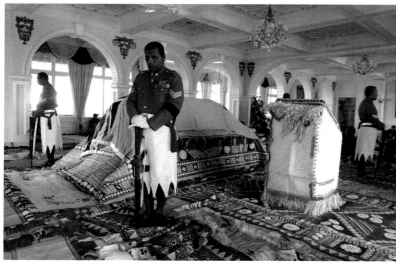

Funeral of Ratu Sir Kamisese Mara, the former President of Fiji. Suva, 2004
Photograph: Bruce Southwick/Zoomfiji

Artist unidentified / Lau Islands, Fiji
Ibe vakabati c.2001
Mat: woven voi voi (pandanus) and commercial wool / 185.5 × 210.5cm / Purchased 2005 / Collection: Queensland Art Gallery

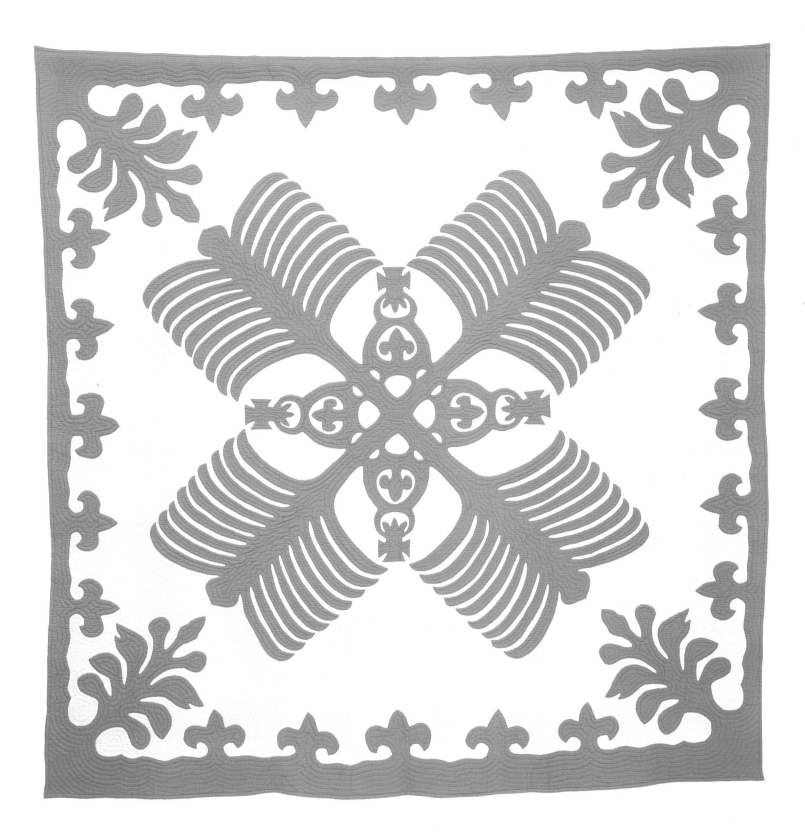

FAAVAE I LE ATUA SAMOA

been formally colonised by a foreign power, the day of reckoning against the forces of democratic change seems to have well and truly dawned.

In a sense, what we are called upon to both acknowledge and interrogate here is faith in the stability of Pacific Island nations. But what of faith itself? The national motto of Samoa is 'Fa'avae i le Atua Samoa' (Samoa is founded on God). Laupule Poutasi and her daughter Tusi Luafutu have placed this motto and an emblem of the Samoan flag as the centrepiece of their Fala su'i (woven mat) c.1984, reworked 2004. Two feline creatures on either side crown and protect the emblem and other national symbols like the kava bowl. While some anthropologists squabble over whether white men were ever considered gods by Polynesians, some native anthropologists and linguists posit that atua or akua, gods in the Polynesian languages of the first contact period, would not have had the omniscient or all-powerful connotations of 'God' in English. Some cultural historians and post-colonial scholars scrupulously describe wilful and skilful processes of indigenising Christianity; most Samoans simply take their national motto to heart and woe to anyone who impugns their piety.

Indeed, all over the Pacific, from Guam to Rapanui, Christianity is not only the dominant religion, it is undergoing fundamentalist revivals of such vigour that the earliest missionaries — Sanvitores in Guam in 1668 and John Williams in Tahiti in 1817 — would be amazed. Drawing on biblical themes and traditional religious iconography, several works in the Pacific Textiles Project reflect the strong influence of Christianity in the region. As with the theme of nation, the works on religious themes are best appreciated in a wider context, and one of the most obvious questions

to ask is why? What motivates these craftswomen to embroider woollen angels or tableaux of the temptation in the Garden of Eden onto pandanus mats? Pacific women have been crucial in sustaining Christianity's hegemony and relevance in the Pacific: most have actively participated in bolstering religion as a conservative and moralising force, and many have been influential proponents for Christianity's engagement with questions of justice and progressive social change.

If we recall Trask's association of the health of a nation with balance or pono, another useful Polynesian concept to bring into the discussion is mana (divine or supernatural power, authority or dignity). What better way to invoke the divine and imbue one's work with mana than to portray religious scenes? Ironically, women's textile arts continue to be highly valued as social and cultural capital in the Pacific, while most other forms of women's labour continue to be grossly undervalued.

The Pacific Textiles Project invites us into a range of subjects for contemplation. We could consider the works as examples of decorative arts or folk art from an 'exotic' region. We could reflect on their significance as women's crafts. We might study their social functions as gifts and commodities. Whatever angles we choose to examine, it would be a shame if we could not see how precious they are. Precious because they constitute imaginative moments of marking and honouring historical events. Precious in their weaving and stitching because the delicacy of the work constitutes a powerful resistance to globalising forces of alienated labour, mechanised production, mass production and consumerism. Precious because they are keeping faith and the nation.

TERESIA TEAIWA is Senior Lecturer and Programme Director, Pacific Studies, Victoria University of Wellington, New Zealand.

Laupule Poutasi / Samoa 1912–2004
Tusi Luafutu / Samoa/Australia b.1951
Fala su'i c.1984, reworked 2004
Mat: woven laufala (pandanus) and commercial wool / 140.5 x 206.5cm (irreg.) / Purchased 2004
Collection: Queensland Art Gallery

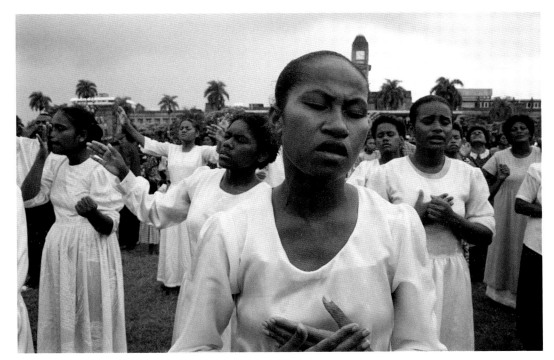

Don Clowers Healings and Miracles rally in Albert Park, Suva. Young members of the new Fijian religious group, The All Nation Christian Fellowship, are encouraged to actively participate in church services, performing song, dance and drama
Photograph: © Jocelyn Carlin 2003

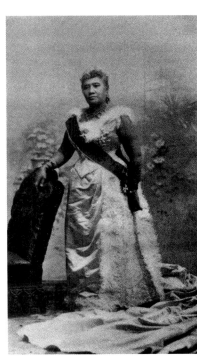

Queen Lili'uokalani of Hawai'i was the last reigning monarch of the Hawaiian Islands. She reigned from 1891 to 1893

We spin a yarn, string words together, follow a thread of narrative or tie up loose ends, fabricate or embroider a tale and dismiss something as a tissue of lies. The recognition that 'text' and 'textile' are cognate — from the Latin *texere* (to weave) — is now commonplace.[1] Language and textile production share a pliability which facilitates building relationships — between words and things, senses and selves, folds and fibres. The value of textiles as a primary source of cultural knowledge and experience is increasingly being recognised. Textiles are part of our everyday life and embody a complex set of histories, inviting a range of speculations about their wider cultural meanings and social interpretations. With connections to the feminine, to class and to Third World traditions of production, textiles raise further debate about the value of labour, the use of the hand, the body and physical senses, and about the construction of identity — they provoke the senses to a heightened awareness.

The Pacific Textiles Project takes us on a visual journey through the histories of the Pacific.[2] The various techniques associated with fibre and fabric celebrate cultural diversity, tradition and language, transformed and translated by mediating new meanings of home and belonging. Within the textiles — most of which are drawn from the Queensland Art Gallery's growing collection — several inscriptions convey a range of communal narratives and the ongoing energy for processing lived experiences from the past as well as the present.

Laupule Poutasi and Tusi Luafutu's *fala su'i* (mat) began its life in 1984 and was reworked in 2004. It is intriguing to think how this collaboration operated across generations and different geographical locations and experiences. Poutasi made this mat in Samoa and gave it to her daughter when Luafutu moved to Australia in 1991. Thirteen years later Luafutu added the red and white band above the main design and the hibiscus flowers. The boldness of colour achieved through the use of synthetic wool, animal motifs and sewn text creates a highly charged physical presence. Textiles absorb time, giving it a visible form; not merely describing or circumscribing time, but giving to time a range of possibilities while keeping connected — as in this case, with work that has taken 20 years to come into being. With its personal and cultural meanings, Susana Kaafi's *Fala pati* (mat) 1988, becomes a powerful medium for the expression of identity. The motif mapping the artist's territory connects it to a lifetime of experience, which is itself inflected by specific geographic, cultural, familial and economic histories. The artists in the Pacific Textiles Project reveal hidden histories, confront stereotypical images and present new perspectives.

These works articulate a 'social biography of things'.[3] This beautiful idea has been gaining strength since it was first articulated in the writings of anthrolopologists over two decades ago, and like most ideas that have found their time, it was called into being through necessity. Objects, like people, argued Ivan Kopytoff and Arjun Appaadurai, have life cycles, in the course of which they age and move in and out of economic circuits of exchange and appreciation. When this happens, we learn something different about not only what these things are but about how we value them, and about the changing meanings that we give them over the course of their lives. Objects are never just things in themselves, according to this point of view, and cannot be dissociated from bodies of knowledge

TEXT AND **TEXTILES**

Tungane Broadbent / Mangaia/Rarotonga, Cook Islands b.1940
Tairiiri (fan) 2005–06
Tivaevae, Manu style quilt: commercial cotton cloth and thread in appliqué technique / 260 x 225cm / Commissioned 2006 / Collection: Queensland Art Gallery

Tungane Broadbent preparing to cut a *tivaevae*. Rarotonga, Cook Islands
Queensland Art Gallery Image Archive

Fabric pieces prepared for sewing into *tivaevae* in the *taorei* style. Cook Islands, 2005
Queensland Art Gallery Image Archive

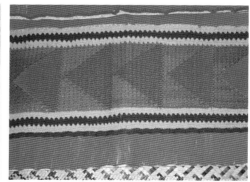

Detail of crochet edging on mat. Lau Islands, Fiji, 2005
Queensland Art Gallery Image Archive

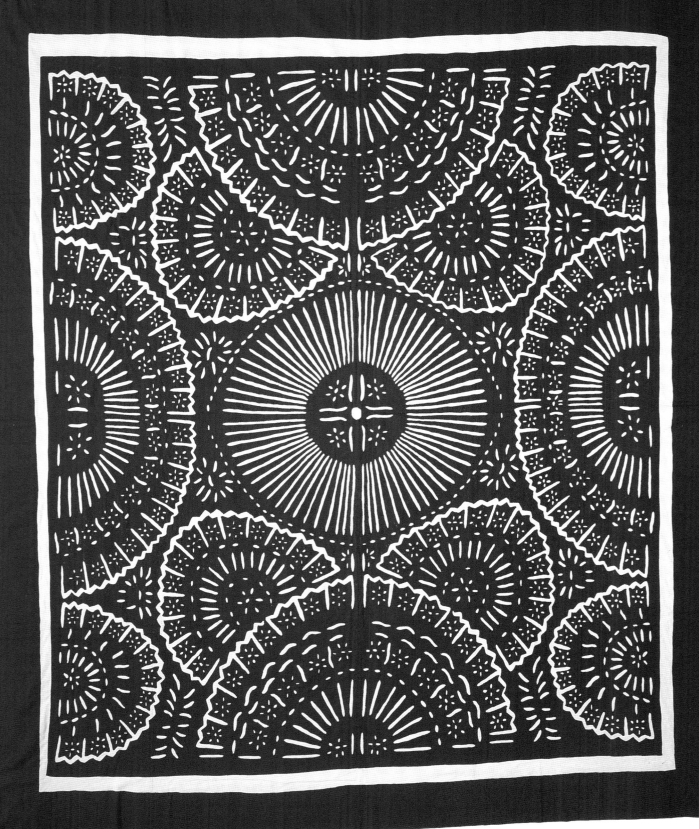

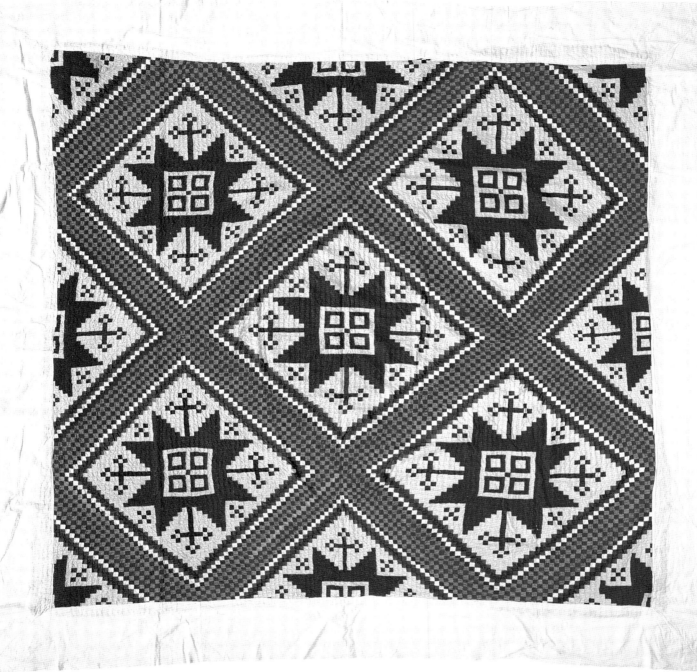

and values. As Nicholas Thomas later pointed out about the histories of certain Polynesian garments, how we are led into and then become detached from these objects, as viewers, invites speculations around implicit effects and meanings at a distance.[4] Objects tell stories of our relationship to the world; they change context and we change them. They offer a material base; not just in terms of production — hand, industrial or even digital media — but also in relation to how we consume them, long for them and obsessively collect them.

In this sense, objects can be possessed by the self in many surprising ways. This 'possession' is, paradoxically, a guarantee of the presence of the absent other.[5] Even if possessions are principally thought of in modern societies as commodities and, in other more traditional contexts as items for ceremonial exchanges, we can be sure that the imagination is brought into play in both cases, that stories are told. Who tells the story and to whom? Stories are everywhere. As Roland Barthes famously asserted in 1966:

> The narratives of the world are numberless. All classes, all human groups, have their narratives, the enjoyment of which is very often shared by men with different even, opposing cultural backgrounds'.[6]

The point is that possessions draw their power from biographical experiences and from the stories told about them. And this power depends on how *we* listen and pay attention to them in order to understand something of metaphoric modes of their enunciation and the shifting of *our* own subjectivities within their telling.

Objects, like people, may also be considered in spatial and geographical terms. For example, the paths through which things and people move help define the rhythms and pulse of urban life from place to place, describing patterns of migration on route, resting in newly configured domestic interiors, stopping from time to time in private collections or temporary exhibitions — like now, at this moment, in APT5.

These paths are traced in song and story. The long term value of oral history is its capacity to reveal how makers narrate their relationship to things, processes and personal histories — even as memory fades, the object is destroyed, a family member dies. However, when words fail, our possessions continue to speak; when the familiar is lost, patterns of survival emerge through new acts of making things. Textiles are not only signs representing acts of personal history, migration and relocation, but they are also material objects that speak to the varied processes of telling stories, thread by thread, line by line, motif by motif and stitch by stitch. The pleasures of cloth can act as both material and metaphor for complex ideas about objects and values in society.

JANIS JEFFERIES is a Professor of Visual Arts, Goldsmiths College, University of London, United Kingdom. She is a writer and curator and works in interactive textiles.

Tekauvai Teariki Monga / Aitutaki/Rarotonga, Cook Islands 1900–61
Etu popongi (Morning star) 1958
Tivaevae, Taorei-style quilt; commercial cotton cloth and thread in patchwork technique / 232 x 219.5cm / Purchased 2006. Queensland Art Gallery Foundation / Collection: Queensland Art Gallery

Detail of crochet fringe on mat by Seruwaia Kudruvi. Fiji, 2005
Queensland Art Gallery Image Archive

Seruwaia Kudruvi weaving a mat. Fiji, 2005
Queensland Art Gallery Image Archive

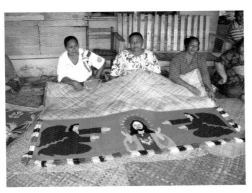

Weavers. Moata'a village, Samoa 2005
Queensland Art Gallery Image Archive

Stephen Page has an international reputation as a visionary director and choreographer. Under his artistic direction from 1991 to the present, Bangarra Dance Company's unique productions, which merge styles of contemporary and traditional Indigenous Australian dance, oral traditions and social history, have stood at the forefront of Australia's cultural production. Page's contribution to 'The 5th Asia–Pacific Triennial of Contemporary Art' (APT5) is a commissioned work entitled *Kin*, a performance about local Brisbane youth, culture and social history. The work stars Page's son and six of his nephews, and features a music score by his brother, the renowned composer and actor David Page.[1] The themes Page explores in *Kin* are those central to his upbringing: kinship and family values.

Page is descended from the Nunukul, Munaldjali and Yugambeh people of south-east Queensland. His older brothers and sisters were born in their father's traditional country in Beaudesert shire, 45 minutes south of Brisbane in the Gold Coast hinterland. Before Page was born in 1965, the family moved to the Brisbane suburb of Mt Gravatt, where Page grew up. This point in Australia's history saw many Indigenous families travelling to cities in search of permanent work, and it was on this generation that Western ways of thinking had a profound effect. This was a time when the traditional and ceremonial side of Indigenous culture was discouraged by the government and mission stations, while a European lifestyle was actively encouraged.

Page's father worked in the construction business, and their home life was like that of many working-class families of the time. In their suburban Brisbane backyard, Page and his siblings let their imaginations run riot, treating their neighbours and extended family to their own productions and performances, including impersonations of the Jackson 5 on the laundry room roof. Sport, art and culture were part of daily life, but performance in particular struck a chord with Page. After initially pursuing a career in law, a chance sighting of a poster for the Aboriginal Dance Theatre prompted him to apply. His audition was successful and he left Brisbane in 1981 to pursue dance studies in Sydney, where he has since remained. Prior to his appointment as Artistic Director of Bangarra in 1991, Page was a dancer for the Sydney Dance Company.

With much of his extended family remaining in Beaudesert, Page's immediate family frequently travelled back there for social gatherings and parties. These special occasions were also opportunities to rekindle memories and songs, and their cultural traditions. The older fellas would talk in broken lingo and would tell stories and sing late into the night. Witnessing the handing down of a living culture that was not present in his everyday life in Sydney is the source of many special memories for Page.

In preparation for *Kin*, Page worked closely with three generations of his family to produce a personal and dynamic work that explores the urban upbringing of Indigenous boys, and the close ties they have with their own communities, families and histories. In July 2006, Page arranged a trip to Beaudesert with his son and nephews, as well as his father, who discussed traditional ceremonies and spoke the stories of the land. This experience provided the first workshop to generate ideas for *Kin*.

Kin was inspired by a performance called 'Spear', a significant work which was part of the Bangarra production *Skin* 2000. Page remembers

STEPHEN **PAGE**

Ryan Jarden, nephew of Stephen Page.
Beaudesert, July 2006
Photograph: Natasha Harth

Stephen Page / Australia b.1965
Nunukul/Munaldjali/Yugambeh people
Stephen Page, Sydney Dance Company, 1987
Image courtesy: Sydney Dance Company /
Photograph: Branco Gaica

Family photograph, 1973. Clockwise from left: Lawrence Page, David Page, Michael Page, Russell Page, Stephen Page
Image courtesy: Roy and Doreen Page

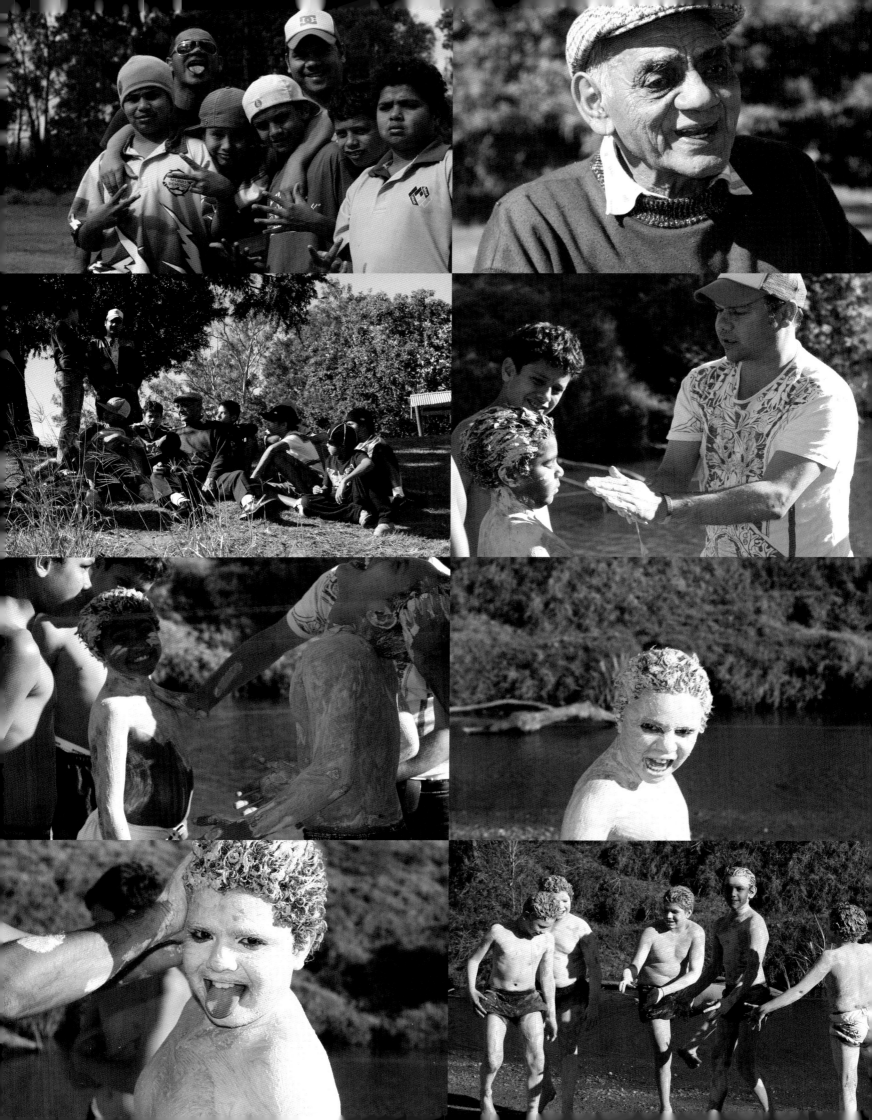

it as one of his favourite pieces, particularly as it dealt with 'men's business' and because of the talented cast he was able to work with, including singer and song writer Archie Roach, actor–director Wayne Blair and dancer Djakapurra Munyarryun. 'Spear' also featured Page's late brother, the internationally acclaimed dancer Russell Page, who was (and continues to be) an inspiration for his nephews as well as Page himself. It was also the first time Hunter Page-Lochard — Page's son, then eight years old — worked with Bangarra. Page sees the boys performing together in *Kin* as a celebration of his brother's legacy. Now 13, Page-Lochard is one of the oldest boys in *Kin* and he is able to share his knowledge and experience with his younger cousins. While elements of *Kin* are reminiscent of 'Spear' — particularly the theme of 'men's business' and some set design elements such as a burnt-out old Holden Torana car — *Kin* deals with issues relevant to adolescent boys today.[2]

Kin takes shape through the eyes of seven young male jarjums (kids), aged between nine and thirteen. Immersed in popular culture and a love of hip-hop and football, the boys are also at an age where they are starting to form their own identities, beliefs and understanding of the world around them. Their ideas about culture and their understanding of their spirits as Indigenous Australian men are becoming increasingly important.

The performance explores themes with a sense of hope, strength and understanding for people of all ages and cultural backgrounds. Page's style of working took the boys away from the conformity of a structured environment. The story has developed in an organic way, from the journey to Beaudesert to the workshops in the months leading up to its final

presentation as part of the opening celebrations for APT5.[3] The process was challenging for the young boys, who had to draw on their raw energy and learn to trust their own natural talents. The work also highlights the influence of current forms of popular expression and gives the boys the opportunity to showcase their interests in hip-hop dance and music. Stephen Page's intention, through *Kin*, was to give the boys the confidence to express themselves. This initiation will remain sacred to the cast, will allow them to celebrate their identity and will empower them for the future.

TONY ALBERT is Exhibitions Project Officer and Indigenous Trainee Coordinator, Queensland Art Gallery / Gallery of Modern Art.

Stephen Page working on *Kin* with his nephews — Curtis Walsh-Jarden, Sean Page, Ryan Jarden, Samson Page, Isieli Jarden and Josiah Page — and his son, Hunter Page-Lochard, joined by Stephen's father Roy and brother David. Beaudesert, July 2006

Photograph: Natasha Harth

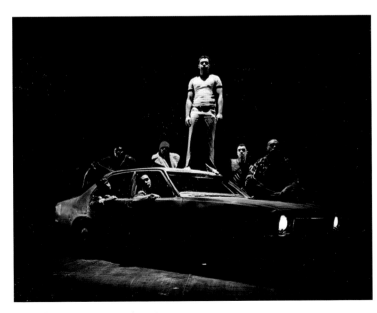

'Spear' from Bangarra Dance Theatre's
Skin 2000

Image courtesy: Bangarra Dance Theatre

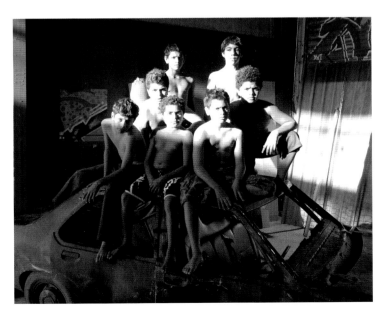

The young performers who will feature in *Kin*. Clockwise from left: Curtis Walsh-Jarden, Sean Page, Ryan Jarden, Hunter Page-Lochard, Samson Page, Isieli Jarden and Josiah Page

Photograph: Natash Harth

'The Code' series 2005 by Noor Azizan Rahman Paiman, more popularly known as Paiman, revisits a number of controversial events that have come to shape the development of Malaysia's socio-political history. The past 50 years of democracy and peace have not been without controversy. In the name of national unification and a peaceful multicultural coexistence, distinct histories, memories and differences have been recast and smoothed over. The uprooting of our colonial and immigrant past has resulted in a conveniently forgetful nation that has a limited sense of history and critical reflexes. The socio-political climate of the past 20 years or so has been marked by sharp divisions, both between and within communities, institutions and political parties. It was a period when the power or 'excesses' of the royal families were curbed, social and political activists were interned under the *Internal Security Act* (ISA), the public lost confidence in the judiciary, and two Deputy Prime Ministers (Musa Hitam and Anwar Ibrahim) were sacked — any source of opposition to the ruling power was suppressed, and a raft of allegations of corruption, nepotism, cronyism and general misbehaviour by the ruling classes were made.[1]

First seen in a two-man — Paiman and Roslisham Ismail (or Ise) — exhibition entitled 'Lightweight Heavyweight' at Galeri Seni Maya in Kuala Lumpur in 2005, this body of work began as a daily exercise of marrying playful drawings of monsters and super (anti)heroes with quotes by local public figures. The quotes were collected by the artist over the years and transcribed using a typewriter.

My work consists of many entry points such as through images, text and size. I use them to create my art works. I believe it makes the ordinary everyday life become something extraordinary.[2]

The drawings, mainly in watercolour and ink, are 'lightweight' in that they display a childlike indulgence with impulsive doodling and layering of colours and marks. Paiman's images are playfully grotesque: 'you are more likely to notice the images if they are ugly, that's how the eye works'.[3] His macabre cast of ogres and creatures recalls motifs derived from *wayang kulit* (shadow puppet) characters, particularly in their faces and lean elongated limbs, while others gaze out from the picture frame with blank looks — cartoon-like and wide-eyed, resplendent in silly, heavily embellished psychedelic costumes.

Layers of socio-political commentaries are camouflaged behind strange, candy-coloured creatures. The quotes, which are familiar at least to Malaysians old enough to remember, are from daily newspapers, magazines and other media sources. They stir up memories of all those 'forgotten' incidents, the controversies and scandals, as well as the absurdities and atrocities, to reveal the underside of Malaysia's history stretching back two decades and more. We are reminded of the controversy surrounding a particular Minister of State when he was charged with statutory rape; the story about a member of one of the royal families who had allegedly kidnapped his children from their Australian mother; the infamous 2.4 million ringgit (A$855 000) case, when a former Chief Minister was charged with falsely declaring the amount of money

PAIMAN

Paiman / Malaysia b.1970
Tun Salleh Abas (from 'The Code' series) 2005
Watercolour and ink / 28 x 19cm / Purchased 2006 / Collection: Queensland Art Gallery

'Lightweight Heavyweight', a two-man exhibition of work by Paiman and Ise (Roslisham Ismail) at Galeri Seni Maya in Kuala Lumpur, 2005

Sharir Samad (from 'The Code' series) 2005
Watercolour, synthetic polymer paint and ink / 19 x 27cm / Purchased 2006 / Collection: Queensland Art Gallery

"HOWEVER
IT IS RIGHT TO SAY THAT
MALAYSIA IS AN ISLAMIC COUNTRY,
POPULATION WISE, BECAUSE THE MAJORITY
OF HER CITIZENS ARE MUSLIMS. BUT IT IS
WRONG TO SAY THAT WE HAVE AN ISLAMIC
GOVERNMENT."

Tun Salleh Abas
Former Lord President.

" I have to admit that politics is still
in my blood and I miss going to
Parliament.

" However, life goes on and I just have
to continue soldiering on,"

KERK KIM HOCK

"WHEN I WAS SICK, I LOST THE PLEASURE OF EATING AND
DRINKING AS WELL AS CARRYING OUT MY DAILY ACTIVITIES."

Nik Abdul Aziz Nik Mat
Kelantan Chief Minister.

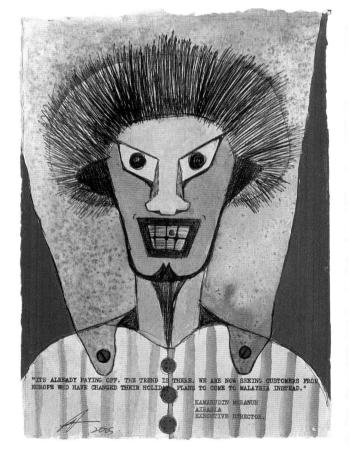

"IT'S ALREADY PAYING OFF. THE TREND IS THERE. WE ARE NOW SEEING CUSTOMERS FROM
EUROPE WHO HAVE CHANGED THEIR HOLIDAY PLANS TO COME TO MALAYSIA INSTEAD."

KAMARUDIN MERANUN
AIRASIA
EXECUTIVE DIRECTOR.

" If there is any dichotomy at all, it is between ruling elites and the people."

DR CHANDRA MUZAFFAR

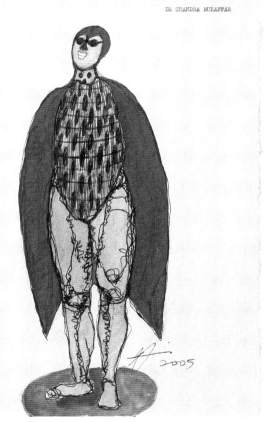

he carried in and out of Australia — incidentally, he was also charged for not declaring his assets to the Anti-Corruption Agency (but charges were subsequently dropped); the legal issues raised when permission for the exiled leader of the Communist Party Malaya to return to Malaysia was rejected; and other topical events.

Paiman's engagement with the thorny issues surrounding Malaysia's state of affairs is no less profound for its whimsy and quirkiness, and made all the more charming as he wipes away the solemn and lampoons situations and public figures through a series of gleeful pokes in the ribs. This collection of drawings simultaneously provides an 'alternative' guide to Malaysian history, and highlights the flaws and ruptures of the Malaysian condition, reiterating our current Prime Minister Abdullah Badawi's comment that Malaysia is 'a nation with a world-class infrastructure and Third World mentality'.[4] The work is also a critique of the power and influence of the media and political spin, alerting us to the dangers of believing what we read and hear. The 'Big Lie' theory claims that if a lie is told repeatedly it will ultimately become a truth, and if one has to lie then lie big and stick to it.

ADELINE OOI is an independent curator and arts writer from Malaysia.

Kerk Kim Hock (from 'The Code' series) 2005
Watercolour and ink / 28 x 19cm / Purchased 2006 / Collection: Queensland Art Gallery

Nik Aziz (from 'The Code' series) 2005
Watercolour, synthetic polymer paint and ink / 28 x 19cm / Purchased 2006 / Collection: Queensland Art Gallery

Kamaruddin Meranun (from 'The Code' series) 2005
Watercolour and ink / 25 x 17.5cm / Purchased 2006 / Collection: Queensland Art Gallery

Chandra Muzzafar 1 (from 'The Code' series) 2005
Watercolour and ink / 28 x 19cm / Purchased 2006 / Collection: Queensland Art Gallery

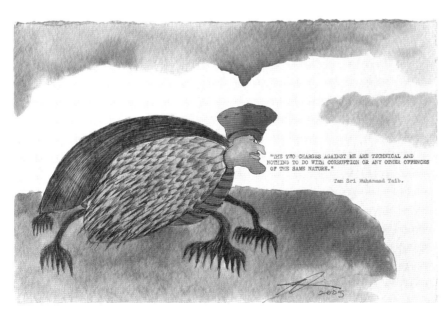

Muhammad Taib 1 (from 'The Code' series) 2005
Watercolour and ink / 19 x 28cm / Purchased 2006 / Collection: Queensland Art Gallery

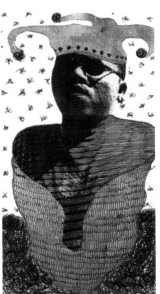
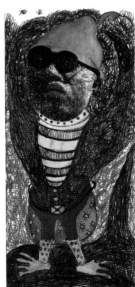

Paiman's self portraits, 2006
Images courtesy: The artist
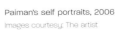

Knowledge is variously local. Samuel Johnson coined the term 'conceit' for a figure of speech popular with seventeenth-century poets in which 'the most heterogeneous ideas are yoked by violence together'.[1] Michael Parekowhai's works are certainly conceited in this sense. Juxtapositions of title and work, of work and work (his own and others), and of models and sources yoke together sharply disparate local knowledges for the purposes of remapping cultural geography.

APT5, a conceited event by Johnson's definition you would think, yokes together a group of Parekowhai's works, made between 1990 and 2005 in New Zealand, for the benefit of viewers in Brisbane. Local viewers who recall Parekowhai's *Ten guitars* 1999 at APT3 and had him tagged as a popular culture guy, will wonder about the customised concert grand piano in *The story of a New Zealand river* 2001 — Parekowhai's work is certainly savvy to that. Some, who know their Imants Tillers well, will see a resemblance between *The indefinite article* 1990 and the Australian artist's *Towards the shining light* 1989 and between *Kiss the baby goodbye* 1994 and a section of the almost contemporaneous *Paradiso* 1994. Those who know the National Gallery of Australia's collection may reckon *The indefinite article* an appropriation of Colin McCahon's *Victory over death 2* 1970. All this is a sort of local knowledge.

Kiss the baby goodbye is an appropriation of Gordon Walters's painting *Kahukura* 1968. Appropriation was, of course, pretty general knowledge by the time Parekowhai came to it, but the purposes to which he put it were conspicuously local, which is where I come in, I guess, with my Kiwi know-how and know-what.

Obviously none of the three words in *The indefinite article* is an indefinite article, not in English anyway. 'I am' is God's phrase, his name for himself quoted in McCahon's small painting *I am* 1954, which is the sculpture's actual source. 'He', Parekowhai's addition, the largest and most emphatic word, changes God's name from an assertion of being to one of masculinity, of patriarchy. In Maori, however, 'he' is an indefinite article, so that this sentence is really a bilingual conceit, which reads 'I am [one sort of . . . not the one and only]'. We have only limited licence to rephrase this as 'I am [Maori]', as limited a licence as we have to say McCahon equates his own being with God's. Or to deny that the claim/admission of patriarchal authority stands. It is not definite who speaks or what language is spoken; 'he' is where local knowledges fail to answer the question of identity. On the other hand, indefinite meaning is itself a kind of meaning, one crucial to Parekowhai's idea of bi-cultural space, one we enact as we move and circulate among these words and letters.

By upping the ante on *Kahukura*, does Parekowhai's work tell Walters to kiss his op-art *kowhaiwhai* patterns, with their claims to bi-cultural knowledge, goodbye? Or does it say to those Maori and pakeha who accused Walters of theft, 'Forget it! Move on. The argument has passed its use-by date'. The title is equivocal, and its tone at odds with the material gravitas that this massively enlarged version bestows on its original. Less evidently, but crucially, *Kahukura* gains an indefiniteness through the conceit of the kitset. These individual *koru* devices might be snapped out of their frames and rearranged, the frames themselves rearranged. Parekowhai undoes Walters, much as he undid McCahon, not by way

MICHAEL **PAREKOWHAI**

Michael Parekowhai / New Zealand b.1968
Acts II 1994
Wood with enamel paint / 3 components: 284 x 90 x 40cm (each) / Purchased 2004. The Queensland Government's Gallery of Modern Art Acquisitions Fund / Collection: Queensland Art Gallery

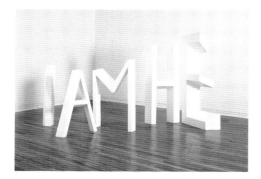

The indefinite article 1990
Synthetic polymer paint on wood / 5 components: 250 x 500 x 200cm (installed) / Jim Barr and Mary Barr loan collection / Collection: Dunedin Public Art Gallery

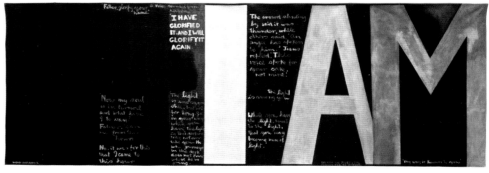

Colin McCahon / New Zealand 1919–87
Victory over death 2 1970
Synthetic polymer paint on unstretched canvas / 207.5 x 597.7cm / Gift of the New Zealand Government 1978 / Collection: National Gallery of Australia, Canberra / © Colin McCahon Research and Publication Trust

of post-colonial finger-wagging but with the aim of rescuing the currency of their work, in his own eyes and on his own terms. He rescues them not so much from canonisation as from a gung-ho culture industry incorporation of such pakeha art 'icons' and a far cry from folding contemporary 'contemporary Maori art' into the national 'brand'.

A resistance to official culture variously characterises some of the best recent New Zealander art and lies behind the emergence of a 'settlement studies' approach to local history, disdainful of academic post-colonialism. In Parekowhai's other three works, the subject of colonisation is to the fore. *Acts (10: 34–38) 'He went about doing good'* 1993 and *Acts II* 1994, query the Christian purposes of settlement. Guns, swords, cannon ramrods and firers, oars, axes, saws and spades were all instruments of colonisation. If, as Robert Leonard and Lara Strongman suggest, 'the crutches and walking sticks . . . could be understood as shorthand for the raw end of the deal', then 'good' wasn't all the apostles of settlement went about doing.[2] These two pieces appear to stand as different stages in the course, the 'game', of settlement — as their association with the pair *They comfort me* 1993 and *They comfort me too* 1994 might suggest — or, more to the point, as stages in the game of the interpretation of the history of settlement.

If Parekowhai's subtle and complex wit has tended in the past to constrain the effectiveness of his work, it does so no more. His stuffed bunny showdowns — *Clayton Moore and Harold Smith* 2003, otherwise known as Tonto and the Lone Ranger — are out and out hilarious, weirdly hilarious. Rabbit-settler-pests engaged in games of mutual eradication,

whoa! These kiddie culture conflations of prairie and paddock are fabulous travesties of that major settlement genre: the Western.

On the other hand, we have *The story of a New Zealand river*, which prompts Allan Smith to write of 'melancholia and exuberance; an overflow of feeling toward the diva who has just left the stage'.[3] In settlement stories, such as the 1920 Jane Mander novel after which the work is named or *The Piano* 1993, Jane Campion's famous film, pianos have to do with the fate of women and 'civilisation' on the frontier. And it is not a rosy one; as we see, Parekowhai's lilies make a coffin of his concert grand. The inlaid *paua* ribbon, or river, which runs round its side, and the disturbing lacquered blackness of the lilies, customise the theme and complicate the retellings foreshadowed by the piano's silent presence in the Queensland Art Gallery.

WYSTAN CURNOW is a critic, curator and poet, who works as a professor of English, School of Arts, University of Auckland, New Zealand. He founded and was the first Chairman of Auckland's Artspace.

Kiss the baby goodbye 1994

Powder coated steel / 2 components: 360 x 460cm (overall) / Chartwell Collection / Collection: Auckland Art Gallery Toi o Tāmaki

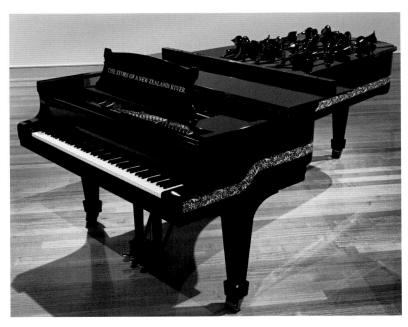

The story of a New Zealand river 2001

Paua, capiz, lacquer and wood on a concert grand piano / 101.5 x 158 x 272.5cm / The Auckland Triennial Collection on loan from the Thanksgiving Foundation, 2001 / Collection: Auckland Art Gallery Toi o Tāmaki

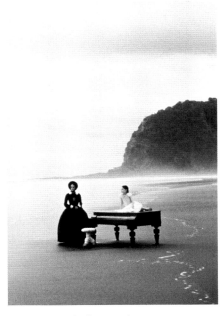

Anna Paquin and Holly Hunter in a production still from the film **The Piano** 1993

Director: Jane Campion / 35mm, 121 minutes, colour, Dolby Digital, New Zealand, English / Image: © MIRAMAX

In the past twenty years of my life I have been a witness to extreme human behaviour towards violence, sex, war, religion . . . Much of the imagery refers to the world we live in, how we relate to it, how we talk with it.[1]

Every inch of John Pule's canvases are used to enact vignettes depicting experiences and memories. His bold compositions, invigorated with strong vertical lines and bright red expanses of colour, act as maps to multiple narratives about migration and Niuean oral histories. Androgynous figures carry impossibly heavy objects like sailing boats, houses and sickly people up rickety ladders. They are bent with effort and their tasks seem futile. The ladders lead to red clouds, which have variously been interpreted as stains of blood, stepping stones to sanctuaries or tracts of fertile land. As Pule says, '[t]he heart of my story is about generating and making soil to stand on'.[2]

Pule left Niue, a tiny limestone coral atoll in the middle of the South Pacific, when he was two years old. He was the youngest of 17 children and grew up with his extended family in South Auckland, New Zealand. At the age of 17, he worked in a meat freezing factory as many Pacific Island migrants did. This was also the time when he discovered poetry and, enamoured by its economy of means, he 'wrote about the violence in [his] life as a child, the uncertainty of family, the sadness and the joys . . .'[3] He began imaging these experiences in the late 1980s, sometimes incorporating words as part of his picture making.

In his early works, Pule created instantly recognisable canvases by stylistically adapting the grid-like formation of Niuean *hiapo* (bark cloth) — *Halahala (The pathway is clear for the child to be born)* 1992 and *Untitled* 1998

are strong examples. Key images emerged in his iconography — depictions of Christ being taken down from the cross or carried, and the appearance of people grieving, huddled together or alone. These representations of loss and quietude were often illustrated alongside images of movement. Aeroplanes, cars, ships and canoes populated the canvases, evoking the possibility of choice and new directions. Modes of transport were accompanied by images of reproduction and the creation of life. Oversized sexual organs morphed into mythological animals and humans copulating.

Biological fecundity continues to permeate Pule's recent work. At times, this is barely contained, as with the proliferation of vines and peonies that sinuously mark his canvases such as *Tukulagi tukumuitea (Forever and ever)* 2005. Pule conjures stories of missionaries' wives sowing European plants as they attempted to recreate a sense of home amid the abundant and fertile Niuean forests. These introduced species, like peonies, outgrew the carefully tended garden plots to merge with the native flora.[4] Whether altered or not, it is the Niuean soil and the picturing of its natural environment and fauna (mythical or otherwise) that invigorates Pule's work. Similarly, Pule's writing uses these depictions to draw on the collective memory of the Niuean diaspora.

'Lagaki', which means 'to lift', is a chapter of Pule's second novel, *Burn My Head in Heaven* 1998, and was later imaged in Pule's 2000–05 'Lagaki' series of 15 drawings.[5] The text tells of the daily activities and internal dialogues of one group of Niuean performers who compete at a young girl's ear piercing ceremony in 1950s' New Zealand. The story begins with rehearsals and is interrupted by a death on a factory machine in the

JOHN **PULE**

John Pule / Niue/New Zealand b.1962
Lagaki (To lift) (series) (detail) 2000–05
Ink, oil stick, pencil and pastel / 15 sheets:
76.3 x 56.4cm (each, approx.) / Purchased 2005.
The Queensland Government's Gallery of Modern Art Acquisitions Fund / Collection: Queensland Art Gallery

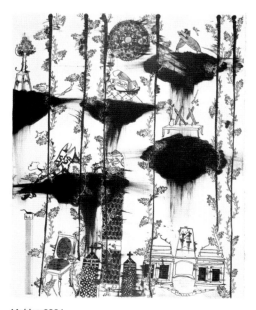

Mahina 2004
Lithograph, ed. 8/40 / 76.4 x 61.1cm / Gift of the artist 2005 / Collection: Queensland Art Gallery

Lagaki (To lift) (series) (detail) 2000–05
Purchased 2005. The Queensland Government's Gallery of Modern Art Acquisitions Fund / Collection: Queensland Art Gallery

Niuean headstones in the churchyard of St Andrew's, Hornchurch, United Kingdom. The graves are shared and are a part of an extensive burial ground which contains 37 war graves
Image courtesy: University of the South Pacific, Fiji / Photograph: Terry Trimmer

poorer suburbs of South Auckland. Protagonists reminisce about Niue; amid the cooking of eggs, copious drinking, gambling, jokes and sighs, they talk politics and news and remember their first glimpse of New Zealand from the ship's deck.[6]

When the performers reach the community hall, Pule readily evokes the sensual imagery of glittering dancers acting out legends and comical historical moments, to a raucous response from the audience:

> I danced in a group as a child, and hated the moment when my aunties would rush up and lick the dollar notes before sticking it onto my forehead — having Mcintosh lollies thrown at my feet, having talcum powder sprinkled over my head and body.[7]

In the drawings, Pule punctuates this intimate narrative with rich imagery. Half bird, half human creatures wrestle with other life forms and often appear birthing into the soil itself. These mythological beings, alongside others with long tails and protruding tongues, animate the drawings and allude to different understandings of Niuean history. The creatures materialise alongside weighty motifs used by Pule to interrogate Christianity and its ubiquitous presence across the Pacific. Through this rich melding of text, symbolism and image, he creates a specific taxonomy from which to 'make soil to stand on'.

Pule's inked words in the last drawing of the 'Lagaki' series are variously interrupted by mythological insects, ambulances, peonies, crosses and colour, all of which change the pace of the story, slowing, hastening or emphasising particular parts. Like the disparate imagery that coexists in dreams, different scenarios are enacted, seemingly with little reference to the text they accompany. The words 'Savage Island' have been magnified, and sit with the rest of the prose in a prominent black box: 'Niueans were trying desperately to forget about the heathen days, trying to overcome the stigma of being known on the map as "Savage Island".[8] In 1953, the Resident Commissioner of Niue, Cecil Larsen, was hacked to death by three Niueans. The perpetrators were quickly sentenced and a curfew imposed on the rest of the population. The performers in the 'Lagaki' text recite their disappointment at still being bound by foreign laws, which resulted in young Niueans being sent to die in two world wars. The accompanying images of mutilated and injured individuals and children, and skulls and strange creatures vomiting, evoke the violence of these memories. Pule elaborates, '[t]he wiping and smudging effect actually assists in carrying the story elsewhere . . . shifting images to another time . . .'[9] The effect of this spirited use of colour echoes Pule's nonlinear prose style and allows for metaphorical as well as chronological movement in the picturing of 'Lagaki'.

By recounting a girl's coming-of-age ceremony, Pule reflects on 'how the dancers and characters thought about themselves and about the world. It also gave me [Pule] a chance to see myself in those community dance situations . . .'[10] Pule's works exult in personal experiences intertwined with historical moments, anchoring his imagery in both Niue and New Zealand. The present intermingles with memories and cultural legacies that shape thought and actions. Pule says, 'the reason why we exist is memories'.[11]

MAUD PAGE is Curator, Contemporary Pacific Art, Queensland Art Gallery / Gallery of Modern Art.

Untitled 1998
Oil on canvas / 246.4 x 225.7cm (unstretched) / Gift of the artist 2005 / Collection: Queensland Art Gallery

Tukulagi tukumuitea (Forever and ever) 2005
Oil on canvas / Triptych: 199.9 x 199.9cm (each panel) / Purchased 2005. The Queensland Government's Gallery of Modern Art Acquisitions Fund / Collection: Queensland Art Gallery

Nusra Latif Qureshi's ruminations on the feminine form are drawn from the rich literary and visual traditions of South Asia. Her delight in painting these figures is revealed in the subtle and sensual handling of detail. The graceful gesture of hands, the polished sheen of pearl earrings and bead necklaces, the fall and curl of locks of hair, and the folds of cloth around each figure are finely executed, recalling motifs from classical paintings of the Mughal, Rajastani and Pahari schools of north India.[1] Qureshi's paintings take pleasure in focusing on the female subject — early works such as *Afterthoughts* 2001 are semi-autobiographical, and the most recent reference the love stories of the Punjab and Sind regions.[2] Her protagonists are lone figures in reverie, entwined and interlaced with the sinuous forms of leaves and fruits, and sometimes with the ghostly figure of a lover.

In each of Qureshi's paintings, the range of imagery is composed as a series of layers, with the central female subject painted in complete, flawless detail. These refined figures, often citing a precedent from a Mughal illuminated manuscript of the sixteenth century, are the only part of the paintings depicted in full. Surrounding each are various outlines drawn from colonial photography from northern India, botanical drawings, stencils and wallpaper patterns by William Morris (of Morris & Co.) or textile patterns from the Ottoman and Persian empires. These sources are usually illustrated as silhouettes, fragments or outlines, or are coloured in with a single vibrant colour in which the suppression of detail adds to the overall complexity of composition. Qureshi's most recent paintings are filled with an abundance of botanical imagery from the Company School, and the foliage forms an ethereal web of lines around the central figure that accentuates an earthy

sensuality.[3] The addition of the silhouette of a mechanical instrument or tool such as a microscope disrupts these paintings, hinting that there is no single narration. The implication is that the paintings are also visual conundrums that offer an opportunity for an open ended interpretation, dependent on the history and knowledge of each viewer.

Justified behavioural sketch 2002 depicts a woman with long black hair, wearing a white *salwar kameez* and sitting on a platform. Layered on this image are the outlines of several men dressed to play polo. This cut-out sketch taken from a photograph refers to another important cultural sphere — the imperial game of polo. Originating in Persia (now Iran) around 600 BCE, polo was important for the kings and courtiers of the Mughal and Rajput courts of India. During colonial times, the sport was avidly adopted by the British and is today a defining aspect of the British establishment. The British also commandeered the skills of the miniature painters of the courts to create astonishing albums of the flora and fauna encountered in the subcontinent. Instructed to paint a single species on each page without contextual landscapes, court painters made exacting free floating images. *Justified behavioural sketch* pictures these distinct Indian traditions — polo and the Mughal miniature. Both remain an inherent part of the cultural history of the subcontinent. Qureshi uses this history to develop her own taxonomy of images. The figure of a woman poised in reflection, contemplation and concentration is the anchor point at the heart of Qureshi's work in APT5.

The poetic figure of the female heroine is also central to the mystical verse by the renowned Sindhi poet and saint Shah Abdul Latif (1689–1752), one of a group of Muslim poets to innovate the mystical Islamic Sufi

NUSRA LATIF **QURESHI**

Nusra Latif Qureshi / Pakistan/Australia b.1973
A garden of fruit trees 2006
Gouache on wasli paper / 34 x 26cm /
Purchased 2006 / Collection: Queensland
Art Gallery

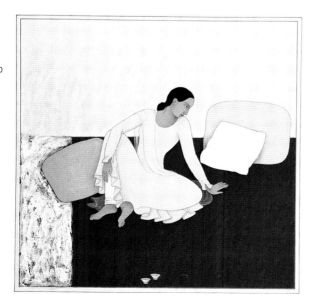

Afterthoughts 2001

Gouache and silver leaf on wasli paper /
19.5 x 14.3cm / The Kenneth and Yasuko Myer
Collection of Contemporary Asian Art. Purchased
2003 with funds from Michael Simcha Baevski
through the Queensland Art Gallery Foundation /
Collection: Queensland Art Gallery

Justified behavioural sketch 2002

Gouache and ink on wasli paper / 21 x 14.7cm /
The Kenneth and Yasuko Myer Collection of
Contemporary Asian Art. Purchased 2003 with
funds from Michael Simcha Baevski through the
Queensland Art Gallery Foundation / Collection:
Queensland Art Gallery

tradition using the popular love stories of Hindu north India. Of Shah Abdul Latif's celebrated composition, *Risalo*, the eminent scholar Ali Asani says:

> . . . we may identify the Quran, the traditions of Muhammad, the Prophet of Islam, Persian mystical poetry and indigenous Sindhi folk literature. It is the folk literature, especially the popular romance that provides Shah Abdul Latif with the framework on which to base the major themes of most of the *Risalo's* thirty chapters or surs.[4]

It is the female heroine with whom the poet exclusively identifies, and whose stories invariably include the endurance of ordeals, trials and journeys to arrive at a place of transformation where she may attain the object of her desire. The adoption of the feminine voice by Shah Abdul Latif was common to medieval Indian poets but contrary to the customary usage in the Sufi literary tradition of the Middle East. By adopting this Indian device and using the concept of the central feminine voice, Shah Abdul Latif immortalises these verses in the ecstatic Sufi tradition. Thus, the folk heroines of *Risalo* personify all the varied facets of love and desire in the context of Islamic esoteric forms, and invariably these heroines find themselves to be alone. This is not to say that they are lonely, rather they become figures that epitomise and embody love. These are some of the interests captured by Qureshi's exquisite paintings — *Gardens of desire II* 2002, *A garden of fruit trees* 2006 and *My sister in the garden of wonders* 2006, for example. They depict a female heroine who is an active, corporeal personification of love, not a passive receiver.

Qureshi majored in miniature painting at the National Art School in Lahore, Pakistan. Formalised in the 1980s, the course is known for its traditional instruction in the precise techniques of the practice. Debates surround the validity and relevance of teaching this discipline as a critical contemporary art practice. They include the revivalist impulse of a Pakistani nationalist strategy associated with cultural heritage, and the related risks of fuelling a myopic nostalgia for an art associated with the flowering of courtly traditions.[5] Sensitive to the complexities of the blossoming 'contemporary miniature' project since the early 1990s, Qureshi is one of a number of female artists participating in a discussion about broader cultural and aesthetic parameters.[6] Critical of the use of the English term 'miniature', which she contends is confusing as it suggests smallness, Qureshi prefers to use *musaviri* — a Persian and Urdu term which means 'figurative painting'.[7] She argues that *musaviri* is still commonly used to explain refined figurative painting in the tradition of the fine arts of Pakistan and Iran. For Qureshi the term *musaviri* not only references a specific tradition but provides a clearer definition of the practice. She says:

> I believe the language of tradition to be a living, potent and valid system of expression, not accepting, necessarily, the ritual. Many of us think of tradition as something of the past that should be treated like a relic and ritualized. I do not attach nostalgia to tradition.[8]

In the suite of paintings in APT5, Nusra Latif Qureshi savours what tradition offers but is not afraid to alter this form of painting to make it her own.

SUHANYA RAFFEL is Head of Asia, Pacific and International Art, Queensland Art Gallery / Gallery of Modern Art.

A set of serviceable shapes 2006
Gouache on wasli paper / 34 x 26cm / Purchased 2006 / Collection: Queensland Art Gallery

/ 203

Bikaner, Rajasthan, India
A lady on a terrace c.1700
Opaque watercolour and gold paint on paper / 18.4 x 12.6cm / Felton Bequest, 1980 / Collection: National Gallery of Victoria, Melbourne

Company School / probably Calcutta
Custard apple. The fruit of Anora Reticulata c.1785
Watercolour / 51.5 x 36cm / Presented by Lady Sylvia Inglis, 1958 / Collection: Victoria and Albert Museum, London / Image courtesy: V&A Images

Indian princes and British Army officers in the Hyderabad contingent polo team, late 1800s
Image courtesy: Hulton Collection

Exploring a media-oriented visual landscape, Rashid Rana manipulates the concept of the pixel to portray the projected desires, dreams and ambitions of Pakistani society.[1] At first glance, his meticulous photographs depict famous Indian film stars or idyllic scenic landscapes; but peer closer, adjust focus, and the subject shifts to the smaller, pixel-like images embedded within. Rana's photographs respond to the urban environment of Lahore in Pakistan: the rickety street stalls selling popular American and Indian cinema posters, the architectural scale and grandeur of Mughal monuments, the continuous cycle of national parades, and the devastating consequences of war. The synthesis of these signs and symbols is ironically commemorated in Rashid Rana's art.

Rana's attention to the minutiae of an image draws on the historical tradition of miniature painting from South Asia. This intimate art form of the Mughal and Rajput courts depicted the royal duties of the emperor as well as his religious aspirations.[2] It has since been revived at the National School of Art in Lahore, where Rana learnt of the technical skills of the genre and of its role in Indian history.[3] The influence of this illuminated manuscript tradition, its detailed attention to composition, surface, form, colour and scale, is clear in his photographic works. However, they also depart from its traditional frame and medium.

'I consider myself a traditionalist. I love the word "parampara", a Hindi word for "tradition", which means continuation.'[4] In classical Indian culture, *parampara* refers to the tradition of successively passing on wisdom from guru to *shishya* (disciple), in which the *shishya* resides with the guru as a family member.[5] Inspired by the legacy of *parampara* and its disciplined

adherence to custom and ritual, Rana attempts to demonstrate this tradition as an innovative aspect of cultural life today. 'Re-ornamented' 2004 is one of Rana's first photographic series experimenting with 'pixelated' photographs. Classical Mughal architecture is strikingly depicted, though a closer inspection reveals details taken from commercial billboards, signage and consumer brands found on the streets of Lahore. Rana's contrast of the classical with the vernacular articulates the synthesis of traditional and contemporary custom in an increasingly technological landscape.

Moving away from the painterly art of the manuscript and its attention to surface and the subjects of the past, Rana's practice nevertheless parallels the historical role of the miniature as a visual form of commentary on the social, political and cultural aspects of contemporary life. *All eyes skyward during the annual parade* 2004 depicts an affluent middle class gathering at a stadium to celebrate Pakistan's national day of independence. In this mirror-like, large-scale image, families congregate, gazing at the sky as military pilots demonstrate their daring aerobatics. This portrayal of patriotic pride is subtly undermined, as the photograph is composed of thousands of film stills from popular Indian cinema.[6] By using film stars to construct the larger image of middle-class spectators, Rana humorously suggests how cinema is digested by this class of society. The work accentuates the irony of both Pakistan and India's political and cultural aspirations. As art historian Kavita Singh points out:

RASHID **RANA**

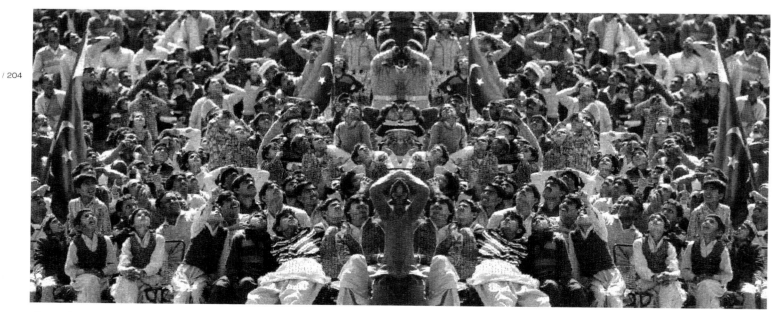

All eyes skyward during the annual parade 2004

Type C photograph, ed. 5/5 / 250.4 x 609.6cm /
Collection: The artist

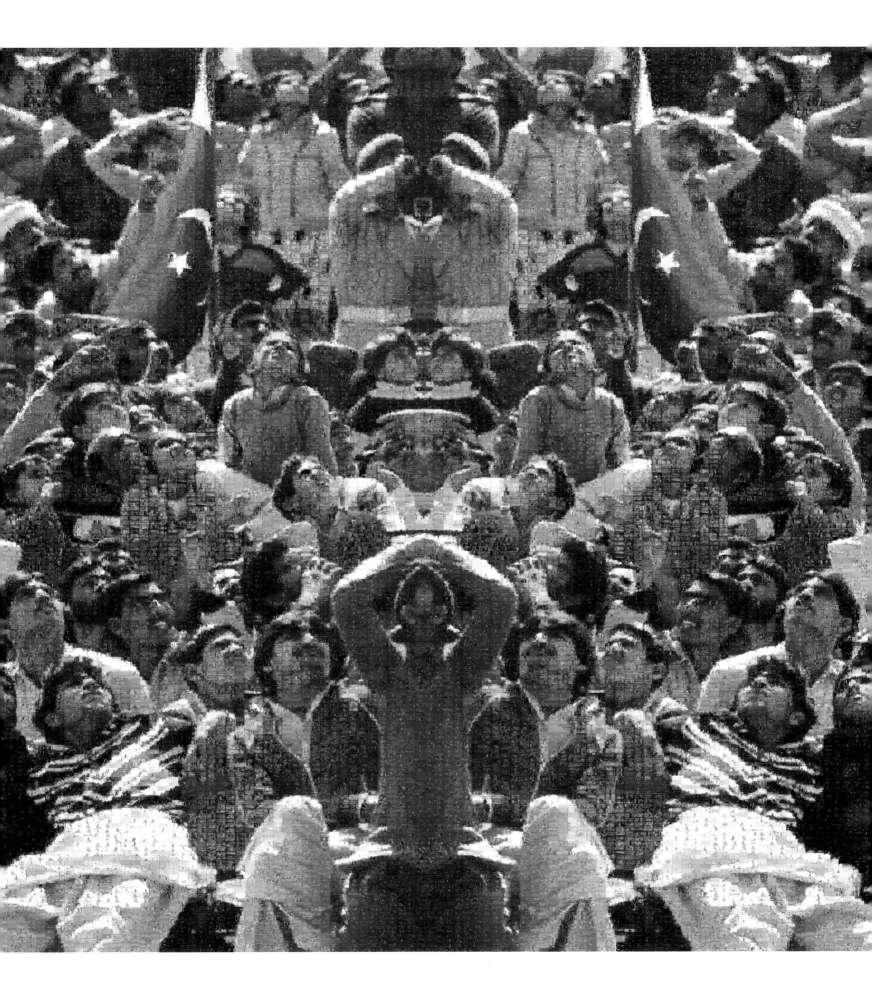

Here, in India, as much as there, in Pakistan, we live with the annual cycle of parades and National Day celebrations and invocations of patriotism. We live also with the regular cycles of aggression and conciliation in our relationship with them; decade after decade of taxes poured into military build-up to protect each against its dark neighbour.[7]

Rana's satirical engagement with the tension between India and Pakistan and their shared cultural history is further elaborated in his 2004 'Ommatidia' series of portraits, where stereotypical poster images of Bollywood super stars Salman Khan, Hrithik Roshan and Shah Rukh Khan are comprised of tiny portraits of men, young and old, from the city of Lahore. The ommatidia are the structural elements which hold the many lenses of the compound eye of a fly. In Rana's photographs, the structure (or ommatidium) of these film stars is sustained by the collective dreams and desires of ordinary Pakistani men.

Masculine stereotypes of heroism and violence fuelled by filmic narratives are the subject of Rana's *When he said I do, he didn't say what he did* 2004. The work draws its title from the tag-line of the film *True Lies* 1994 and depicts a double image of the film's hero, played by actor Arnold Schwarzenegger, loaded with guns and ammunition as he runs across a deserted landscape. Rana subverts the heroic image by constructing this 'film still' from tiny scenes graphically illustrating the despoliation and human suffering endured in Afghanistan as a result of the United States—led invasion in 2001. These repetitive images of destruction and helplessness are deliberately placed inside this gung-ho scene featuring

Schwarzenegger, the popular action hero of American movies, suggesting the sinister and narrow divide between popular and political stereotypes.

Rana's photographs toy with fact and fiction, the ordinary and the extraordinary, moving between the political and the popular. His mirrored grid of images should not be mistaken for a merely ironic representation of hypocrisy or deceit. Rather, Rana's careful choice of unique parts within a whole fundamentally undermines assumptions of identity that are created and distributed through the mass media. As critic Quddus Mirza suggests:

> In this age of uncertainty we have lost the privilege of having only one worldview. Now every image, idea and truth (may it be ancient or media generated) encompasses its opposite within itself. Thus we live in a state of perpetual conflict and duality.[8]

The pixel-like constituents in Rashid Rana's works provide an important context to the meaning of the larger images portrayed, raising questions about cultural identity and individuality in contemporary visual culture.

ZOE BUTT is Assistant Curator, Contemporary Asian Art, Queensland Art Gallery / Gallery of Modern Art.

Off shore accounts - II (detail and full work) 2006
Type C photograph, ed.1/5 / 199.4 × 373.4cm / Collection: The artist

A cinema showing a 1960s Indian film *The Emperor of the Mughals (Mughal-e-Azam)* (Director: K Asif) 1960, on McLeod Road in Lahore in 2004. Following the conflict of 1965, both countries were reluctant to show each other's films in their cinemas. People in Pakistan generally watch Indian films on VHS or DVD
Photograph: M Aasif

Poster seller at Nila Gumbad in Lahore in 2004
Photograph: Rashid Rana

Sangeeta Sandrasegar draws with shadows. Her delicate papercuts float just above the gallery wall, projecting images by stopping out light and making from each delineated shape a conjoined pair, both positive and negative. As one walks past, as one moves backwards and forwards, the vantage point shifts — shapes and shadows slide and slip sideways before lining up again for just an instant. Both shadow and substance are integral to the work: one creates the other. And between the two, between the (relative) substance of the cardboard and the shadows on the wall, lie the fleeting meanings of Sangeeta Sandrasegar's art.

Originally trained as a painter, Sandrasegar began making papercuts in 1999 during her postgraduate studies in Melbourne. Drawing on her mixed Australian and Indian–Malaysian cultural heritage, Sandrasegar chose papercuts precisely because they allowed her to explore ideas about cultural diversity. Multiple lineages of shadow puppets from India and South-East Asia lie behind Sandrasegar's cut-outs, but she is equally alive to the rich tradition of Chinese folk papercuts as well as to narrative traditions ranging from Pahari miniatures to Bollywood cinema, from Chinese martial arts films to Japanese manga and animē.[1] The cosmopolitan character of Sandrasegar's borrowing is part of the burden of her work: the disparate imagery she mines suggests that certain themes — good and evil, love and hate, revenge and salvation — resonate across cultures, often through retelling stories like that of Phoolan Devi, the celebrated 'Bandit Queen' of India.

The series 'Goddess of flowers' 2003–04 was inspired by the extraordinary true story of Phoolan Devi (1963–2001), whose Hindi name means 'Goddess of flowers'.[2] In her youth, Phoolan Devi, who was from a low-caste family, was sexually assaulted numerous times, including by a group of high-caste landowners called *Thakurs*. Seeking revenge, she became involved with rebel bandits and, in 1981, became notorious when she led a bandit group in the massacre of some 20 *Thakurs* in an area just south of the capital, New Delhi. Her activities led to imprisonment without trial from 1983 to 1994 but, after her release, Phoolan Devi continued to fight for the poor and oppressed. In 1996, she won a seat in Parliament but she was assassinated in 2001. In Sandrasegar's series, we see some scenes drawn directly from Phoolan Devi's life, such as her jail term in *Untitled no. 34*. Others refer more generally to women in Indian history and mythology, such as the widow in *Untitled no. 1* performing *sati* (self-immolation); or to images of feminine power, such as the vengeful Kali-like destroyer, with her necklace of men's skulls in *Untitled no. 26*. Yet others, such as the erotic vignette featuring the assertive female lover in *Untitled no. 27*, are sourced from non-Indian films, despite the intricate Indian-style henna decoration of the feet.

When Sandrasegar shapes decorated cut-outs as feet or hands, as she did with other pieces in 'Goddess of flowers', she recalls the elaborate jewellery and henna body decorations that women apply to their bodies during Indian festivities, especially to the bride for her wedding. Sandrasegar's papercuts are exquisite: finely cut, coloured card forms each image; henna patterns circle ankles and decorate toes, effectively bordering the pieces; and cut-out bangles and rings, and coloured glitter embellish each foot. The choice of feet and hands is crucial as they are

SANGEETA **SANDRASEGAR**

Sangeeta Sandrasegar / Australia b.1977
Untitled no. 26 (from 'Goddess of flowers' series) 2003
Paper, beads and glitter / 29.5 x 40cm (irreg.) / Purchased 2004. Queensland Art Gallery Foundation Grant / Collection: Queensland Art Gallery

Untitled no. 34 (from 'Goddess of flowers' series) 2003

Paper, beads and glitter / 29.5 x 41.5cm (irreg.) / Purchased 2004. Queensland Art Gallery Foundation Grant / Collection: Queensland Art Gallery

the active parts of the body, the parts that effect signs, movements and transitions. In Sandrasegar's work, the feet throw off their shadow-selves, the dark side of each story. About 'Goddess of flowers', Sangeeta Sandrasegar said, 'The foot is the narrative function of the story, it literally represents the passages traversed by Phoolan Devi, physically and metaphorically'.[3]

At a more general level, the separate episodes contained within each 'foot' sketch moments of feminine assertiveness or resistance (and occasional tranquillity) through the established conventions of subcontinental feminine beauty. The problem posed in 'Goddess of flowers' is therefore not between beauty and power — it is far more complex than that. Sandrasegar suggests, in the very fabric of the work, that decor is inseparable from indecorous behaviour by women, that each bright shining picture has its shadow; conversely, it is by no means clear whether decorum is a symptom or a cause of social harmony. Here beauty is evidently contingent, local custom is various, and exchanges and transitions between cultures are important as they may suggest changes in the very conditions of life.

A pivotal life experience is central to Sandrasegar's major new work for 'The 5th Asia–Pacific Triennial of Contemporary Art'. In *Untitled* 2006, with hundreds of papercut hands forming a flock of flying birds, Sandrasegar summons a key episode from the novel *I Served the King of England* 1989 by the Czech writer Bohumil Hrabal. Ditie, Hrabal's central character, is a naïve waiter in Prague who works hard for his dreams. He gradually rises to become a millionaire hotel-owner but loses everything amid the political backdrop of World War Two. Eventually Ditie, now jailed by the postwar communist regime, has neither fortune nor faith. His daily chore — feeding two hundred pairs of abandoned courier pigeons — becomes, paradoxically, his daily joy:

> . . . all four hundred pigeons would swoop down from the roof and fly straight at me, and a shadow flew with them, and the rustling of feathers and wings was like flour or salt being poured out of a bag. The pigeons . . . would sit on my shoulders and fly around my head and beat their wings against my ears, blotting out the world, as though I were tangled up in a huge bridal train stretching in front of me and behind me, a veil of moving wings and eight hundred beautiful blueberry eyes.[4]

Here the moment of transition in Ditie's life, of cathartic change and of future possibility glimpsed in his darkest hour, is signalled by the cloud of birds, which are traditional emblems of metamorphosis and freedom. But the birds in *Untitled* are once again in the form of hands joined together at the thumbs in the familiar gesture of home-grown shadow plays. Clearly, Ditie is the architect of his own emancipation, since he is able to see the meaning of the birds for his future. Importantly, unlike the brilliantly coloured card of earlier series, the birds in *Untitled* are white, made from thick luxurious artist's paper. While the coloured card of 'Goddess of flowers' relates to the celebratory colours of Indian art and to red henna, here white refers explicitly to the bridal garment mentioned by Ditie and signals purification and renewal. However, these bird-hands are once again

Untitled no. 27 (from 'Goddess of flowers' series) 2003

Paper, beads and glitter / 28.5 x 42cm (irreg.) / Purchased 2004. Queensland Art Gallery Foundation Grant / Collection: Queensland Art Gallery

decorated in the Indian fashion and follow Sandrasegar's earlier placement of the female persona at the heart of her work. Equally significantly, the hand-birds are modelled on the artist's own hands and the negative shape of the figure left on the wall by the crowding birds is modelled on her height. As the feminine agency seen in 'Goddess of flowers' suggests, the possibility of action in and on the world is a key concern for Sandrasegar.

Paradoxically, here freedom is enacted by birds leaving shadows on a wall. With the lightest of touches, weighty issues are transformed and what first appeared to be negative becomes positive. For Sangeeta Sandrasegar, this crucial episode from Hrabal's novel is both emblematic and redemptive.

> . . . the constant will for dreaming. It is about the hope of dreams and the loss of them, and then about the strength to seek them anew, or as readjusted, realigned or refreshed.[5]

JULIE EWINGTON is Head of Australian Art, Queensland Art Gallery / Gallery of Modern Art.

Untitled no. 1 (from 'Goddess of flowers' series) 2003
Paper, beads and glitter / 28.5 x 42cm (irreg.) / Purchased 2004. Queensland Art Gallery Foundation Grant / Collection: Queensland Art Gallery

Kumar Shahani opens his film adaptation of Rabinandrath Tagore's novella, *Char Adhyay (Four Chapters)*, with a sequence of extraordinary beauty which also warns the viewer to be alert. The camera travels across branches vibrant with red, spiky flame-of-the-forest flowers; a river flows behind the tree and a ove poem is spoken in voice-over, 'Reflecting embers of the twilight of early spring in your eyes . . .'. Cut to a close shot of a train funnel blowing steam. The red flowers return, lovingly held by the lens, and a train whistle blows. Cut to a close shot of a wooden boat's stern, a paddle breaking river water. Cut again to a beautiful woman in a red sari anointing a young mar. Back to the boat in a wider frame showing young men travelling together, singing, 'The motherland beckons her children. Heed her call'. A handsome young man waves a pistol. Mahatma Gandhi appears in high contrast sepia archival footage; he sits, writing, bare-chested and bespectacled, on a train.

The meanings of these images will unfold through the film, yet already they encapsulate Shahani's re-visioning, 50 years after Independence, of Tagore's great exploration of passion, ideology and history. Written in 1934, *Char Adhyay* is a story of forbidden love set in a terrorist cell of the freedom movement in Bengal; it exposes the destruction wrought by dogma valued above individual humanity. Shahani's visual interpretation would likely have pleased Tagore, who believed in cinema as an art form in which visual language should be self-sufficient and not dependent on words.[1] When the filmmaker adduces Gandhi to his cinematic overture, he offers the counterpcint of nonviolent resistance to Tagore's story of patriotism and violence.[2]

The great Bengali director Ritwik Ghatak imparted to Shahani (whom he taught at the National Film Institute of India in the 1960s) his interest in cultural and historical ties as unifying forces beyond immediate political divisions. Ghatak's films, marked by the trauma of Partition, open the path, as Shahani notes, to an integration of 'neo-realism with an operatic, epic structure working directly from the folk arts and the theories of Eisenstein and Brecht'.[3] Ghatak's *Meghe Dhaka Tara (The Cloud-Capped Star)* 1960 is a compassionate but completely unsentimental critique of the family showing the desperation caused by displacement and poverty. Formally exhilarating, it uses unusual framing and sound to isolate characters and intensify emotion. The most celebrated scene shows the mother of the film's central refugee Brahmin family resolving to undermine the marriage plans of her eldest daughter, Neeta, as they threaten the family's financial stability; a close up of the mother's face is accompanied by loud sounds of boiling cooking oil, conveying intense emotion and the literal association of the food with the daughter whose income provides it. Later, Ghatak uses the noise of a lashing whip over a scene in which Neeta discovers that her fiancé, Sanat, will marry her younger sister. Neeta dies of consumption and neglect, protesting, 'I want to live', in a heart-rending cry against injustice.

In Shahani's first feature film, *Maya Darpan (Mirror of Illusion)* 1972, protagonist Taran (Aditi) responds to Neeta's plight.[4] Taran represses her desire for life as she moves through the corridors of her father's large, empty house. Unlike Neeta, she will decide to transgress feudal social restraints; she seeks out a sexual encounter with an engineer, recently

KUMAR **SHAHANI**

Kumar Shahani / b.1940, Larkana, Sind (now Pakistan)

Production still from *The Khayal Saga (Khayal Gatha)* (detail) 1988

Director/Script: Kumar Shahani / 35mm, 103 minutes, colour, mono, India, Hindi and Urdu / Collection: Queensland Art Gallery / Image courtesy: Roshan Shahani

Four Chapters (Char Adhyay) (stills) 1997
Director/Script: Kumar Shahani / 35mm, 110 minutes, colour, mono, Hindi / Image courtesy: National Film Development Corporation, India

Production still from *The Cloud-Capped Star (Meghe Dhaka Tara)* 1960
Director: Ritwik Ghatak / 35mm, 126 minutes, b. & w., mono, India, Bengali / Image courtesy: Chitrakalpa, India, and British Film Institute

arrived in the new industrial landscape of Rajasthan surrounding the house. The film climaxes with *chhou* dancers performing a celebration of fertility in black and red; the camera pans vertically, travelling down through the line of the earth. Taran's release from her family household is shown in a cut to the green, fertile riverbanks of Assam, where she has fled to her brother. A final circular shot inside a small, white vessel afloat on a river stands in for Taran's feudal self cut adrift, but still constrained. Earlier in the film, the engineer offers Friedrich Engels's formulation: 'Freedom is the recognition of necessity'. In the character of Taran, Shahani presents a woman who chooses individual fulfilment and shifts from the palatial house of her forebears to a small vessel in a more fertile landscape.

Shahani's films are deeply entwined with the Indian classical arts, including music, theatre, painting and architecture. *Kasba* 1990, Shahani's transposition of Anton Pavlovich Chekhov's short story 'In the Hollow' 1900 to the Kangra region of India, captures murals in the style of Pahari miniatures on the walls of the house chosen as the primary shooting location. In *Maya Darpan*, tracking shots across architectural elements of Taran's father's house create an atmosphere of stifling enclosure. Shahani also shows his formal mastery of colour in this film, working against the constraints of existing colour film emulsions. With his cinematographer, KK Mahajan, he desaturated colours across the spectrum, eliminated blues and strengthened the warmth of skin tones, creating a very particular atmosphere and aesthetic.[5] Highly conscious of the cultural implications of cinema technology and conventions, Shahani observes that:

> . . . the way a film is made, the different layers of colour, the way it is produced chemically, the way it registers, is already a certain kind of language which has its roots in the Renaissance.[6]

He also consciously works against the vanishing point and spatial organisation implied by camera lenses as they have been developed:

> . . . you cannot, let us say, imitate the Mughal miniature through the lens, but . . . you can reorganize the format given to you of working within the golden section in such a way as to bring in proportionate relationships, of volume, of distance, of focus, of colour, which will recall the experience of seeing miniature painting or a fresco. And . . . you can use camera movement, and the relationship between camera and actor/object in such a way as to destroy all that goes with the idea of scientific perspective.[7]

Shots of breathtaking beauty are composed to recall Mughal miniatures in *Khayal Gatha (The Khayal Saga)* 1988, which presents the history and mythological origins of a form of north Indian classical music which emerged in the eighteenth century from the earlier religious Dhrupad form. Intertwining narrative and performance in this visual and musical feast, the film also brings together the foremost musicians and dancers associated with the Khayal tradition. In a similar vein, *Bhavantarana (Immanence)* 1991 is a documentary with fictional elements celebrating *odissi* classical dance exponent Kelucharan Mohapatra. *The Bamboo Flute* 2000 extols an instrument long associated with natural sounds and with Krishna's

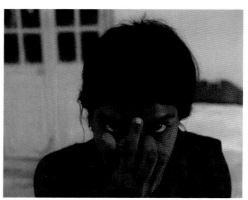

Mirror of Illusion (Maya Darpan) (stills) 1972
Director: Kumar Shahani / 35mm, 107 minutes,
colour, mono, India, Hindi / Image courtesy:
National Film Development Corporation, India

'waking into an auditory world'.[8] Considered by the filmmaker as the most important of the arts, music has influenced his ideas of sequencing and editing, particularly classical Indian music's nonlinear possibilities.[9]

Kumar Shahani develops the imagist, non-narrative potential of film and moves towards a 'more deeply sensuous and abstract' cinema.[10] He addresses profoundly political subjects in his films, which are simultaneously entwined with the art, music and narrative forms of Indian civilisation. His works are not conventional and often point consciously to the limits of cultural translatability. The viewer who enters into his universe with great curiosity and attentiveness is rewarded with an experience of exquisite cinematic poetry which lingers long after the screen has gone dark.

KATHRYN WEIR is Head of Cinema, Queensland Art Gallery / Gallery of Modern Art.

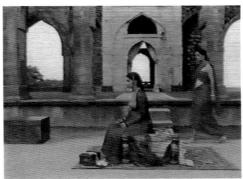

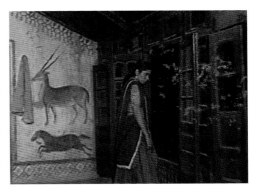

The Bamboo Flute (Birah Bharyo Ghar Aangan Kone) (still) 2000
Director/Script: Kumar Shahani / 35mm, 84 minutes, colour, mono, India, Hindi and Tamil / Collection: Queensland Art Gallery / Image courtesy: Ministry of External Affairs, India

The Khayal Saga (Khayal Gatha) (still) 1988
Collection: Queensland Art Gallery / Image courtesy: Kumar Shahani

Kasba (still) 1990
Director: Kumar Shahani / 35mm, 115 minutes, colour, mono, India, Hindi, Urdu and Punjabi / Purchased 2006. The Queensland Government's Gallery of Modern Art Acquisitions Fund / Collection Queensland Art Gallery / Image courtesy: National Film Development Corporation, India

Professor Simon Frith, the grand-daddy of academic pop music studies, has written, 'Music is the cultural form best able to cross borders — sounds carry across fences and walls and oceans, across classes, races and nations'.[1] Indeed while politicians, cultural commentators and academics have engaged in lengthy debate on weighty subjects such as cultural integration, globalisation, multiculturalism, reconsidering the nation-state and the post-colonial world, it is frequently music that has provided a more succinct expression of all of the above in the late twentieth and early twenty-first centuries. Music created by second generation British–Asians has provided some of the most refreshing and innovative listening material of recent years, making it a particularly fitting soundtrack to our era — characterised as it is by fusion (or should that be confusion?)

Recent years have seen the rise and rise of a bunch of styles. These remain difficult to characterise despite erroneous attempts to attach labels to them, and to treat second generation Asian music as if it were some type of homogenous entity rather than the diversity of practices that it is. We've had Bhangra, Asian kool, Asian underground, the new Asian dance music and others. This genre-defying music has spanned the cheerful indie of Cornershop, the angry political hip-hop meets Qawwali of Fundamental, the playful rap of Panjabi MC and the punk attitude of Asian Dub Foundation.[2] More recently second generation Canadian–Asian exports have also been making their chart presence felt in the shape of Raghav and Jay Sean.

One of the best exponents of second generation Brit–Asian sounds is London-based producer and percussionist Talvin Singh, whose multi-layered work has won him numerous plaudits. His album *OK* 1998 received the prestigious Mercury Music Prize, bolstering his fame and placing him in the spotlight of the UK music media. By autumn 1998, however, while he picked up mainstream acclaim, an anti-Talvin backlash was well underway in the Asian press. When I interviewed Singh later that year, he claimed to have done over 300 interviews in the preceding month, and that he was 'stitched up' most severely by Asian youth magazines *Second Generation* and *Snoop*, 'specially as they give you all that "Asian brothers" bullshit'.[3] He also expressed understandable displeasure with the fabricated quote attributed to him in the men's magazine *Loaded* (September 1998): 'To me a pair of tablas is like a pair of tits'. Obviously, there is often a mismatch between representations and realities for the second generation Asian performer — perhaps more so than for the average pop star, given the heightened 'burden of expectation' that they have to carry as 'spokespeople' for their generation and culture.

How would Singh place himself in coming to terms with the post-colonial settlement? He told me that he sees himself essentially as a drummer:

> I don't really want to be political all the time. I don't fit into that and I don't want to. I wanna enjoy things which I like whether they have an Asian value or not.[4]

Visiting India at age 11 to be shunned by his Indian peers for being 'too British' and by his English classmates, on return, for being 'too Indian' has marked Singh more than any post-colonial political vengeance:

TALVIN **SINGH**

Talvin Singh / United Kingdom/India b.1970
Talvin Singh, classical performance at the British Embassy, Delhi, India, June 2006
Image courtesy: The artist / Photograph: Ruth Bayer

Talvin Singh, *OK*, Island Records, 1998

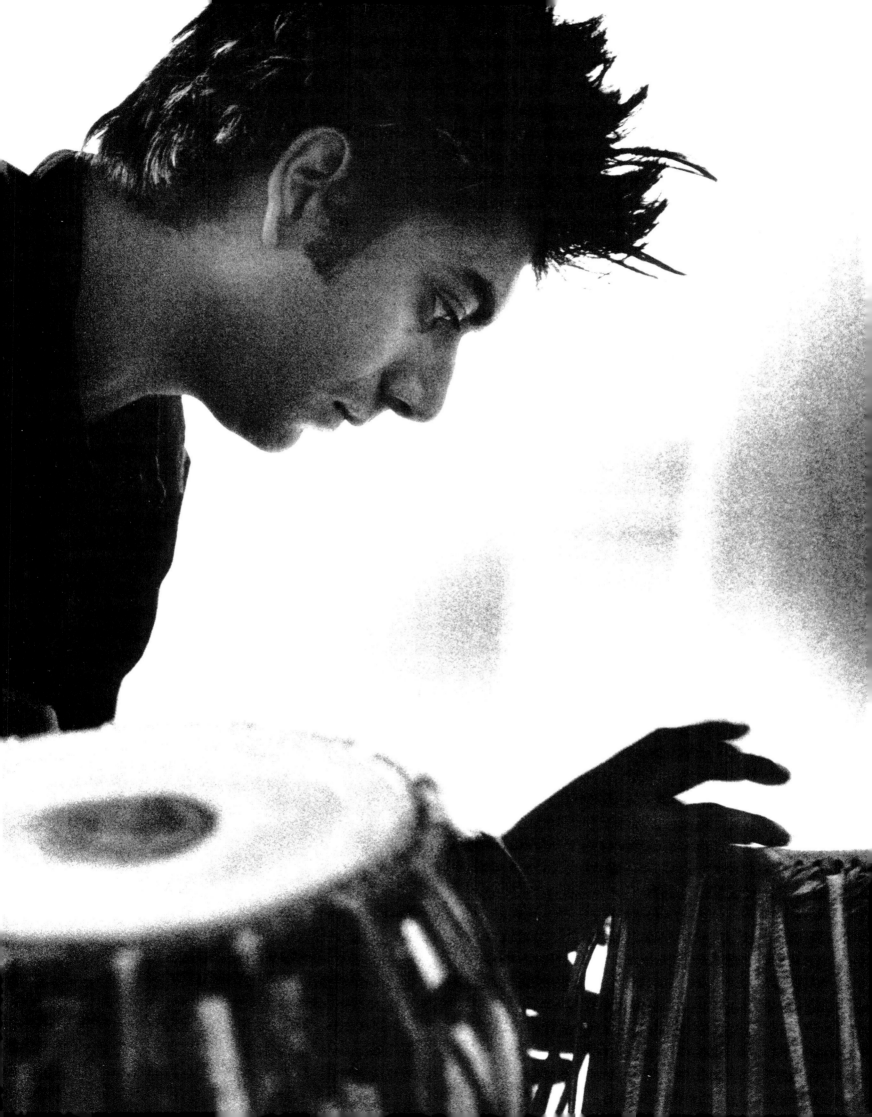

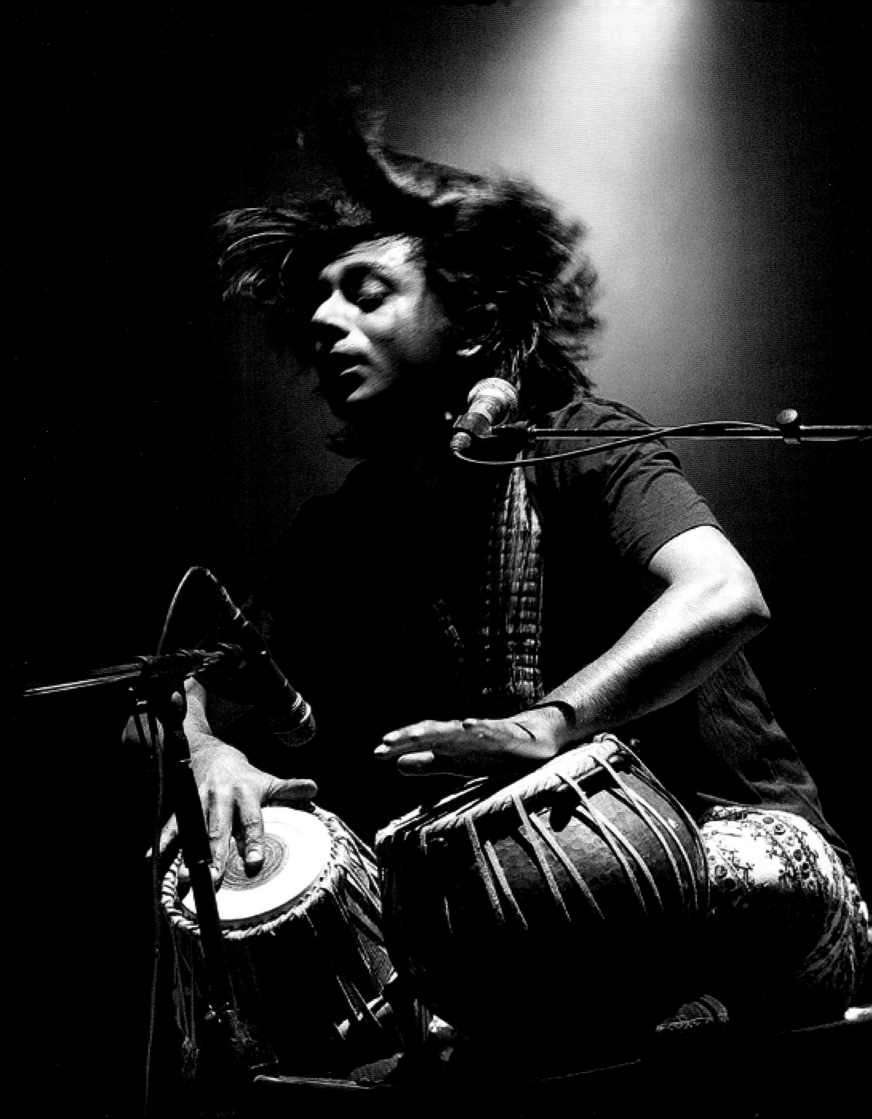

These cultural crises really stay in your blood but instead of being sour about it, I bring that into some beautiful energy rather than going 'you fucked us up. I'm gonna fuck you up'. Fuck who up? Are these people any part of that? Let's move our shit on.[5]

The second generation has a rich array of influences at their disposal. Cornershop's 'Brimful of Asha' 1997 — which became a number one UK hit after it was remixed by Fatboy Slim in 1998 — name-checked a number of influences that singer Tjinder had become familiar with growing up among his parent's record collection, including 1950s and 1960s favourites Mohd Rafi and Asha Bhosle — both Bollywood film playback singers. This is in contrast to the usual preoccupations of youth-culture academics who centre on a perceived generation gap in which young people actively oppose anything from their parents' generation. Talvin Singh's concert with classical Indian musicians and the Fundamental tour with devotional Qawwali singer Aziz Mian gave rise to some mixed audiences, spanning the Asian 'parent' and youth generations plus white indie and world music fans. Similarly, the use of the late Nusrat Fateh Ali Khan's Qawwali songs on film soundtracks, such as *Natural Born Killers* 1994, and various remixes have contributed to his status as one of the most unlikely pop stars of recent times.

Our understanding of migration as an essentially one-way process is also in need of re-evaluation. Migratory flows are much more complex than this. The crossover of music created by British-born Asians to whom the Indian subcontinent is often best known through holidays raises questions of how authentically 'Asian' the new Asian dance music is. Singh enthuses about the often overlooked dynamism of the modern subcontinent:

> People have this idea of Bombay being a place with loads of poor people. It's a crazy city. I find Bombay closer to New York than London . . . every other person is a video maker. Rave music is so big among Asian kids now.[6]

The consumption of this music is best sampled not as recordings at home but at live events, where predominantly (but not exclusively) British second generation Asians go to dance. Contrary to the convenient stereotyping of Asian youth as repressed by their parents, requiring them to organise and attend events during daylight hours, there are now a number of 'Asian nights' in the clubs of Britain's big cities.[7]

Second generation British–Asian pop is constantly in a state of flux but then so are culture and politics, the two themes that it reflects and refracts so well. During the decade in which this grouping of musical styles has gained popularity in the UK, we have gone from conceptualisations of British–Asians interwoven into the fabric of Tony Blair's multicultural 'Cool Britannia', to a category often portrayed in the public imagination as scary figures on the wrong side of the so-called 'war on terror'. Where to next is anyone's guess. Either way, what remains certain is that British–Asians are here to stay, spanning a second and now a third generation, with music that the world awaits with anticipation.

DR RUPA HUQ is author of *Beyond Subculture* and Senior Lecturer in Sociology at Kingston University, London. She was a DJ and music journalist and was employed in local government cultural services. Her PhD was on popular music and subculture and her first degree was in law from Cambridge University.

Talvin Singh, Tabtek performance, MIDEM, Cannes, France, January 2006
Image courtesy: The artist / Photograph: Yann Coatsaliou

'Desi Junction' daytime bhangra event, Big Western Pub, Manchester, UK, 5 July 2002
Image courtesy: Rupa Huq / Photograph: Ian Kaplan

The driving musical force behind Talvin Singh's art is rhythm. In Indian tradition, rhythm is the generative force of the universe. According to one ancient text, 'the arising, enduring and disappearance of the three worlds comes from rhythm; all the works of the world depend on rhythm'.[1] The underlying cyclic structure of tala (rhythmic patterns) is a point of departure for Singh's rhythmic explorations. Each cycle forms an inaudible matrix of weighted beats, a universal reference point from which the unique creative impulse of the individual can launch into free creative play, placing cycles within cycles with endless possibilities. While Singh often departs from traditional Indian rhythm, it still forms a consistent point of reference, and tabla playing remains an integral part of his art, especially in live performance.

In spite of Singh's Punjabi heritage, he has also shown a consistent interest in the great tradition of Carnatic music from south India. Carnatic music has preserved ancient elements of Indian music, and its intricate rhythmic structures reach levels of complexity that are unequalled. Singh has avoided using the most familiar north Indian stringed instrument, the sitar, perhaps because it is tainted by post-colonial cultural baggage through its exploitation in Western popular music of the 1960s. Instead he has preferred to use the Carnatic veena, the most fundamental of all Indian instruments — its very shape is a metaphor for the human body — an instrument dedicated to Sarasvati, the goddess of music and vidya (knowledge that leads to liberation from the cycles of life and death). Thus Singh, for all his evident modernity, reveals his deep connections with tradition. Though mediated through the most contemporary

technology, Singh's art also seems determined (to borrow the words of Harry Partch) 'to remind us how ancient we are'.

Talvin Singh was born in Leytonstone, East London, in 1970. His parents had fled Uganda during the brutal regime of Idi Amin. His upbringing was conventionally urban in most respects, but a link with Indian traditional culture was maintained through tabla lessons from the age of five. A transformative journey began at the age of 15 when he set off with 100 pounds in his pocket to immerse himself in Indian music in the Punjab, under the guidance of Pandit Lakshman Singh, a prominent member of the Punjabi gharana (school) of tabla playing, who had studied with the same guru as the great Ustad Alla Rakha.[2] A year and a half in India fuelled Singh's passion for the tabla, and he has returned to India frequently since then to continue studying with his guru.

Singh's return to the London musical scene was not without problems. His approach to tabla playing was perceived by traditionally minded musicians as too Western. Singh saw a close connection between the improvised structures of classical Indian music and jazz — something that had been recognised in the 1960s by jazz great John Coltrane. One of his earliest collaborations was with astral jazz mystic Sun Ra. Subsequently he worked with Björk on her first two albums, and with ambient techno pioneers The Future Sound of London on their album Lifeforms 1994. In 1995, Singh founded the Anokha (meaning 'unique') club night at the Blue Note in East London, where the intoxicating combination of techno, drum and bass, and Indian music attracted a multicultural audience. The album Anokha — Soundz of the Asian Underground 1997 mixed computerised

Talvin Singh, Tabtek performance with
Oskar Vizan, Jazznojazz Festival, Zurich,
Switzerland, April 2005
Image courtesy: The artist / Photograph:
Pascal Mora

drum and bass with classical Indian forms to produce a kaleidoscopic effect. The bold contrast between tracks like State of Bengal's rap-influenced 'Chittagong chill' and A Rahman's cinematic flute and string 'Mumbai theme' was striking, and helped propel the album to six-figure sales in the UK and North America.

Singh's first solo album, *OK* 1998 continued the heady cultural mix. To create the album, Singh recorded in New York (at the studio of Bill Laswell, bassist and stalwart of the downtown alternative music scene), India, Japan and London. This process took nine months. The complexity of the production is reflected in the album's credits, which list 22 individual musicians (among them Ryuichi Sakamoto and Ustad Sultan Khan), plus the Madras Philharmonic Orchestra and a choir from Okinawa, Japan. The album was assembled in Singh's basement, with Singh himself responsible for tabla, drums and percussion, as well as the electronic components. The significance of Singh's achievement with *OK* was recognised when he became the first British–Asian to receive the prestigious Mercury Music Award for the most outstanding contribution to new music.

In 2000, Singh linked up with Zakir Hussain (son of Ustad Alla Rakha), Trilok Gurti, and Karsh Kale in Bill Laswell's innovative Tabla Beat Science project. Two solo albums, *Back to Mine* 2001 and *Ha* 2001, while less innovative, deepened Singh's exploration of Indian classical music in new contexts. This was taken further in his collaboration with the richly expressive *bansuri* flute playing of Rakesh Chaurasia on *Vira* 2002. The culmination (to date) of Singh's cross-cultural experimentation appears on *Songs for the Inner World* 2004, which began as a commission for

the 2003 Festival de Saint-Denis in Paris. Singh assembled a remarkable group of musicians for the project: Tunisian *oud* (lute) player Smadj (Jean-Pierre Smadja), noted for his use of guitar effects such as wah-wah; *thumri* (light classical romantic-devotional music dedicated to Krishna) singer and musicologist Vidya Rao; *kora* player, cellist and composer Tunde Jegede, a musician equally steeped in the Western classical tradition and the *griot* (professional singer) tradition of Mali; flautist Rakesh Chaurasia; vocalist percussionist Ravi Prasad; and vocalist and pianist Pankaj Awasthi. The project reveals Talvin Singh's genius for bringing together highly educated musicians from diverse traditions and creating a fusion that is at once bold and thoughtful, respecting the traditions of each contributor. He produces something genuinely new from the cross-cultural encounter.

STEPHEN WHITTINGTON is Head of the Electronic Music Unit at the Elder Conservatorium of Music, University of Adelaide. A well-known composer and pianist, he also writes extensively on music for various publications, including the *Adelaide Advertiser* and *RealTime*.

Talvin Singh, Tabtek performance /
Adelaide Bank Festival of Arts 2006,
Adelaide, Australia
Image courtesy: Adelaide Bank Festival of Arts /
Photograph: Shane Reid

Social history museums aspire to tell stories. Which is odd, because they tell stories rather badly compared to books or movies, which can be gripping and immersive. The problem is that artefacts don't explain themselves. Without a label, the nails used in the Crucifixion are indistinguishable from other vintage nails. That's why museums place artefacts in dioramas to activate them, or display them with explanatory texts and collaterals. Also, museums seldom have enough artefacts or the right ones, so they routinely make do with stand-ins. Grafting different logics — the genuine and the replica, the actual and its index, the signifier and the signified — museum displays suggest history coming unstuck, knowledge in ruins. This quality has been the crux of many recent art works that flaunt, deconstruct and adore the already shaky logic of museum displays, from Marcel Broodthaers's inanely taxonomical *Department of Eagles* 1969–76 to David Wilson's absurd Museum of Jurassic Technology (established 1989). However Michael Stevenson's elaborate, fastidiously researched pseudo-museum displays couldn't be more different. Despite their initial fragmentary appearance, they pull us in. Ultimately, they convince.

Stevenson's displays explore historical incidents that are stranger than fiction. His tales are so obscure and bizarre that one might naturally question their authenticity. Indeed Stevenson deliberately plays off the mockumentary and other hoax genres. He goes for stories that never found a place in capital 'H' History, yet redeems them as unlikely keys to the big picture.[1] Stevenson's 'Argonauts of the Timor Sea', produced for Sydney's Darren Knight Gallery in 2004, addresses a sidebar story in the life of canonical Australian artist Ian Fairweather: his heroic — or foolhardy — voyage across the Timor Sea in 1952. Inspired by tales of Thor Heyerdahl's Kon-Tiki, Fairweather built a shoddy raft with materials scavenged from the local tip and flotsam and jetsam combed from Darwin beaches. A lot of it was World War Two debris: he converted warplane fuel tanks for flotation. The raft was tiny. He could not stand up on it and controlled it lying down. It was totally unseaworthy and ill-equipped to negotiate the monstrous waves and perilous currents. The sail quickly fell apart and basically he drifted. The 650 kilometre trip took 16 days. He ran out of food and became delirious. He almost missed Indonesia and was lucky not to be swept out into the vast expanses of the Indian Ocean and certain death. When he finally landed on the island of Roti, Fairweather was terribly ill. He was taken in and nursed by a local village family. The locals were curious about his makeshift vessel and cannibalised it, as if in exchange for their kindness. It was an unmeditated, unmediated, unofficial exchange. Later the authorities deported him to Britain, where he had to dig ditches to repay his passage. For Stevenson, Fairweather's trip exemplifies a gift economy, exchange unmediated by money. He got from Darwin to Britain without spending a cent.

What Stevenson shows, however, is not this story, but a curious collection of pseudo-artefacts relating to it. No photos of the raft existed, but Stevenson reconstructed it based on rough drawings made by an observer and published descriptions. In the gallery it perches on piles of *National Geographic* magazines, Fairweather's preferred reading. There are maps, or paintings of maps. Some show trade winds and migratory routes,

MICHAEL **STEVENSON**

Michael Stevenson / New Zealand/Germany
b.1964

The gift 2004–06

Aluminium, wood, rope, bamboo, synthetic polymer paint, World War Two parachute and National Geographic magazines / 400 x 600 x 300cm (installed, approx.) / Collection: The artist / Courtesy: Darren Knight Gallery, Sydney

Frame saw (from 'Argonauts of the Timor Sea') 2004

Wood, metal, string and bamboo / 86 x 114 x 8cm (irreg.) / Purchased 2004. The Queensland Government's Gallery of Modern Art Acquisitions Fund / Collection: Queensland Art Gallery

one presents Roti in detail. There is a drawing of an old newspaper clipping, reporting the misadventure. A print reproduces the title page of Heyerdahl's *Ekspedisi Kon-Tiki*, and there's a curious woodcarving of Marcel Mauss's book *The Gift*, the classic study of gift economies. There's not enough in the show itself to 'get it'. Stevenson relies on the story being recounted around the objects. He will tell it; curators, critics, education officers and journalists will repeat it; and so his otherwise dense display will be activated by legend.

After the Darren Knight Gallery exhibition, Stevenson continued to elaborate the project. Observing that the art world is largely a gift economy, dominated by plays of non-cash exchange and obligation, he accepted an invitation from Germany's Twodo art patrons.[2] Each year they fund an art project, with a condition: at the end the spoils must be evenly divided among them. Stevenson constructed another Fairweather raft. After showing it, he organised a special closing event where he gave the Twodo a ceremonial saw and invited them to dismember his handiwork (as the Roti islanders had done with Fairweather's original raft). From the pieces, Stevenson fashioned sculptures, including primitivist cooking utensils and musical instruments, one for each collector, returning the favour.

A curmudgeonly critic once complained that Stevenson's yarns were fascinating but 'where is the art?' It's true that Stevenson's stories are so compelling that it's easy to lose sight of the exquisitely fashioned and over-specified objects around which they are spun. Since he embarked on these projects, no one has written much on Stevenson's work *as art*, preferring to elaborate on the implications of its arguments. What makes this art, rather than simply social history? I would like to argue that Stevenson's projects enact a kind of phenomenological flicker, making us stall between apprehending the form (seeing a scatter of things in the gallery) and a gestalt of content (getting the big idea). That would be perfect. The problem is, I don't think they do. Once you get your head around it, *Argonauts* really does work like social history (even if the objects are scrupulously forged), albeit social history staged in the place of art. Which is why Stevenson's project must ultimately be understood through relational aesthetics, for how it activates social relations around it.[3] As we 'get it', we become incorporated into its knowing community, and there's no return.[4] Stevenson is framing not only his objects but their reception — their use — as his art. This simply became explicit with the Twodo.

Stevenson's projects are transactional. His gifts are received in different ways by different communities. When he showed *Call me Immendorff* 2001 in Berlin, it was about a once respected German artist who had descended into self-parody. In New Zealand, the same work was read as a commentary on New Zealand's provincialism. When *This is the Trekka* 2003 opened in Venice, it was about European Cold War economics. Relocated to Wellington's Museum of New Zealand Te Papa Tongarewa (an institution itself perplexed by the distinction between art and social history), it became a treatise on structures of New Zealand national identity and kiwi can-do. And it's anybody's guess what will happen when *Can dialectics break bricks?* 2002 is finally shown in Iran. Similarly, the raft is one thing when it is being greedily dismembered by the Twodo, another enshrined at the Queensland Art Gallery. It meets different desires.

Timor Sea crossed on raft (from 'Argonauts of the Timor Sea') 2004
Pastel on paper / 30.8 x 10.5cm / Purchased 2004. The Queensland Government's Gallery of Modern Art Acquisitions Fund / Collection: Queensland Art Gallery

Ekspedisi Kon-Tiki (from 'Argonauts of the Timor Sea') 2004
Letterpress on paper in coconut wood frame, ed.1/20 / 20.6 x 15cm / Purchased 2004. The Queensland Government's Gallery of Modern Art Acquisitions Fund / Collection: Queensland Art Gallery

Clearly, the inclusion of 'Argonauts of the Timor Sea' in the Gallery's APT5 is keyed to honouring the Fairweather story as much as Stevenson's art. Fairweather, who ultimately settled on Bribie Island, is a local hero. And one can foresee Queensland audiences now and in the future approaching the piece *both* as an art work and as a social history exhibit; as a Stevenson *and* as a Fairweather. And paradoxically, by presenting that raft in its pristine state — editing out the next chapter, its having been cannibalised by the Roti islanders and the Twodo — the Queensland Art Gallery has preserved, interrupted and transformed Stevenson's project. While they have not torn the raft apart, they too have appropriated it for their own purposes. But then that's what the project demands. It's what makes it a gift, and what makes the Gallery's reception of it part of the art.

ROBERT LEONARD is director of Brisbane's Institute of Modern Art. He co-curated Stevenson's 2003 Venice Biennale project, 'This is the Trekka'.

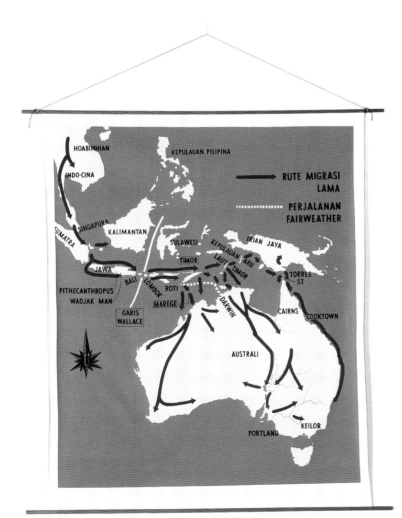

Rute migrasi lama (from 'Argonauts of the Timor Sea') 2004

Synthetic polymer paint on canvas with maple rods and string / 191 x 168 x 2.3cm (including rods) / Purchased 2004. The Queensland Government's Gallery of Modern Art Acquisitions Fund / Collection: Queensland Art Gallery

CROSS-CULTURAL TRAVELLER:
THE FLOATING WORLD OF MASAMI TERAOKA

In 1961, after completing formal studies in Japan, Masami Teraoka travelled to the United States to study art, first at the Los Angeles Harbor College and later at the Otis Art Institute in Los Angeles. Unencumbered by the rigid traditions of his home country, he could mix artistic styles in his paintings and observe and comment freely on the values and conditions of both Japanese and American societies as they interacted. By using the language of *ukiyo-e* (Floating World–pictures) woodblock prints, particularly those of his 'mentors', Katsushika Hokusai (1760–1849) and Utagawa Kunisada (1786–1864), Teraoka was able to provide a visual context for cross-cultural interaction — it was as if a nineteenth-century Japanese time-traveller had been transposed into a different century and place. In these works, Teraoka is often depicted as this traveller–observer. However, increasingly — in series such as his 'McDonald's Hamburgers Invading Japan', begun in 1974, and the '31 Flavours Invading Japan' 1977–79 — it is his symbol of Japan, the geisha (depicted as a courtesan), who is more often placed in this position. In other images the kabuki-style posturing of a samurai represents the male symbol of Japan.

The American ice-cream chain Baskin-Robbins was amongst the first fast-food chains to 'invade' Japan, and their 31 flavours prompted Teraoka to construct a series of images individually titled after one of these flavours. In *31 Flavours Invading Japan/French Vanilla* 1978, a Kunisada-style courtesan, distinguished by her halo of tortoise shell hairpins and comb, struggles to come to terms with a new food and way of eating. In this image, by adopting the format and visual language of *ukiyo-e* and inserting the incongruous forms of an ice-cream cone and paper-towel dispenser,

Teraoka's cross-cultural commentary is made strikingly apparent. The erotic undertones of *ukiyo-e* are humorously evoked in the juxtaposition of a well-lubricated, phallic-shaped cone labelled with both 'drip' and 'juice', and the ubiquitous presence of the *ukiyo-e* erotic indicator, the 'paper for the honourable act'. In this and other works from the series the graphic qualities of *ukiyo-e* are used to provide a rich, decorative backdrop while the various calligraphic cartouches and seals provide an opportunity for Teraoka to make further comment, usually of a humorous nature.

Ukiyo-e flourished in Edo-period Japan (1600–1868). Its subjects of beautiful courtesans, kabuki actors, erotica and travel reflected the hedonistic values of the demimonde. The first truly egalitarian Japanese art form, *ukiyo-e* was made accessible to a wide public through affordable woodblock prints. This affordability, in comparison with other Japanese art forms, continues until this day and was partly responsible for the wide dissemination of *ukiyo-e* imagery. Teraoka's grandparents owned a small collection of *ukiyo-e* and he was also able to amass his own collection, particularly of works by Kunisada. This access to original art works inspired many of his compositions. Although *ukiyo-e* reflected popular tastes, a strictly enforced system of censorship meant that *ukiyo-e* artists could not comment directly on politics or social conditions. *Ukiyo-e* artists were, however, able to subvert the power of the ruling class through their often libidinous subject matter and subtle parody, and by asserting a bold new aesthetic taste. Teraoka's *ukiyo-e*–inspired works draw on the ability of nineteenth-century woodblock prints to initially entrance its viewers with the beauty of rhythmic line, bold colour combinations and powerful design,

MASAMI **TERAOKA**

Masami Teraoka / Japan/United States b.1936
AIDS Series/Geisha in Bath 1988
Watercolour on canvas / 274.3 x 205.7cm /
Collection: The artist / Image courtesy: Catharine
Clark Gallery, San Francisco

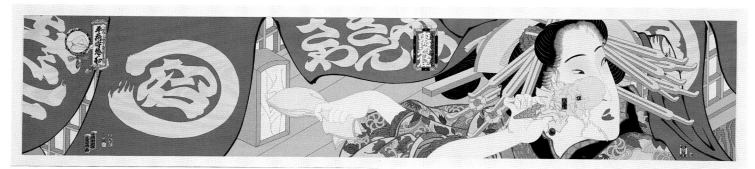

31 Flavors Invading Japan/French Vanilla 1978
65 colour screenprint on Roll Rives paper ed. 48/58 /
28 x 140cm / Purchased 2005 with funds from Jan
and Spencer Grammer through the Queensland Art
Gallery Foundation / Collection: Queensland Art Gallery

AIDS Series/Geisha and Ghost Cat
1989/2002

Aquatint and sugar lift etching, with spit bite
and direct gravure on kozo paper, ed. 8/35 /
70 x 50.3cm / Purchased 2005. The Queensland
Government's Gallery of Modern Art Acquisitions
Fund / Collection: Queensland Art Gallery

***McDonald's Hamburgers Invading
Japan/Chochin-me*** 1982

36 colour screenprint on Arches 88 paper, ed.
41/91 / 54.3 x 36.5cm / Purchased 2005. The
Queensland Government's Gallery of Modern
Art Acquisitions Fund / Collection: Queensland
Art Gallery

and to later shock them when they become aware of the content of the image. As if to parody this subversive role, many of Teraoka's paintings incorporate the circular *kiwame* (approved) censor's seal, which was affixed to prints deemed acceptable by the authorities but missing on banned *ukiyo-e* such as pornographic 'spring pictures' ('spring' is a common Japanese euphemism for sex).

One such 'spring picture' that fascinated Teraoka was Hokusai's image of two lascivious octopuses aggressively ravishing a naked female pearl diver from his 1814 erotic volumes *Kinoe no Komatsu* (*Pining for Love*). This wildly imaginative image exploits the potential of multiple entwined limbs to provide a rhythmic flow to the composition as well as shock through its sexual explicitness — for example, the firm grip the ecstatic diver has on the 'male' tentacle. Teraoka capitalises on the ability of such erotic bestiality to provide limitless compositional possibilities. In Teraoka's *Wave Series/Tattooed Woman at Makapuu Beach* 1984, Hokusai's work has provided a point of departure for Teraoka to explore his own unique design. Unlike Hokusai's woodblock print, where graphic qualities are paramount, the use of watercolour on paper has allowed Teraoka to exploit his deft handling of the Japanese brush and a broader colour tonality to enhance a painterly expression. Such a means is better suited to Teraoka's emphasis in his image on mutual sexual pleasuring — notice how the eyes of Teraoka's octopus are less predatory than Hokusai's and the calligraphic shape of the animal's irises mirrors that of the closed eyes of the woman. A feature of this work, which is shared by Teraoka's other *ukiyo-e*–inspired works, is the contrast of earthy reds and beige-yellows with cool tones of

blue, a colour combination seen in nineteenth-century *ukiyo-e*. This colouration also characterises seascapes produced by Teraoka in the 1980s, which, in both form and content, evoke the rhythmic movement of water seen in Hokusai's various studies of waves and the lyrical evocation of mood in Utagawa Hiroshige's (1797–1858) landscapes. Like the great landscape series of Hokusai and Hiroshige, Teraoka adopts a high viewpoint in *Sunset Beach* 1989, which allows him to indulge in an expansive view of Hokusai-inspired waves while, in contrast, the thin strip of skyline tinged with red suggests the melancholic mood of twilight in a Hiroshige landscape.

The works discussed so far augment their serious content with a captivating and seemingly cheerful graphic design mostly inspired by *ukiyo-e* images of beauties (*bijin-ga*), erotica (*shunga*) and landscape. However, the death of a friend's child in 1986 through an AIDS-infected blood transfusion transformed Teraoka. His subsequent works gradually took on a darker context, dealing with disease and death and using the *ukiyo-e* genre of kabuki-actor portraits (*yakusha-e*), whose visions of ghosts and demons are better suited to themes such as the spread of AIDS. In these works, the juxtaposition of cool and warm colours — which emphasise a female–male dichotomy in his erotic works — are darker, reflecting a more sinister intent. The work that marks the beginning of this transition is *American Kabuki/Oishiiwa* 1986. Drawing upon the imagery of the kabuki ghost tale *Yotsuya Kaidan* in which the main protagonist is a vengeful female ghost by the name of Oiwa, Teraoka's depiction of a deathly blue ghost rising from a turbulent ocean is full of foreboding and

Wave Series/Tattooed Woman at Makapuu Beach 1984
Watercolour / 50.8 x 73.7cm / Collection:
Brian Pawlowski, USA

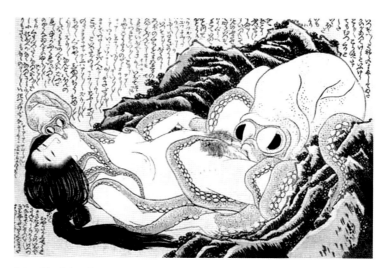

Katsushika Hokusai / Japan 1760–1849
The dream of the fisherman's wife
Edo period, c.1820
Woodblock print / Private collection

dread. While flames (the traditional Japanese indicator of a ghostly presence) fall from the sky, the dark clouds and predatory bird intensify a fearful mood. Against the dark blue background, highlights of a dirty red stand out like the bloody welts on the woman's face and arm. *Oishiiwa*, meaning 'delicious', is a play on words evoking the image of Oiwa and repugnance at a scene that is anything but delicious.

Teraoka's work in APT5 deals with the period from the late 1970s and 1980s when the visual language of *ukiyo-e* provided him with a means to express his experience as a Japanese living in a foreign country. His recent works, although still passionately engaged with social issues, have deliberately abandoned the style of *ukiyo-e* in preference for a method that draws upon the western painting tradition. Philosophically, this change is a deliberate move by the artist to mark a time of 'having lived longer in the United States than in my birth country of Japan'; artistically, this change marks his journey across cultural traditions.[1]

GARY HICKEY is Lecturer, Asian Art History and Curatorship, in the School of Art History, Cinema, Classics and Archaeology at the University of Melbourne.

Katsushika Hokusai / Japan 1760–1849
The Great Wave off Kanagawa (from the 'Thirty-six Views of Mount Fuji' series) Edo period, c.1831
Woodblock print / 25.4 x 37.6cm / Clarence Buckingham Collection / Collection: The Art institute of Chicago / Photography: © the Art institute of Chicago

Sunset Beach 1989
Watercolour and sumi on canvas / 205.7 x 269.2cm / Private Collection, San Francisco

That Yuken Teruya was born in Okinawa is essential to any discussion of his work. Indeed, for better or worse, the same can probably be said for all Okinawa-born artists. The position of this group of islands at the southern extreme of the Japanese archipelago makes it of strategic importance. Okinawans are aware that their homeland is frequently embroiled in geopolitical contexts. It was under the direct control of the United States military from the end of World War Two in 1945 until its return to Japanese sovereignty in 1972, and today approximately 75 per cent of Okinawa is still used for American military bases. In the fifteenth century, the Ryukyu kings ruled there until the islands were taken over by Japan in 1879. Since then, Okinawa has had a somewhat strained relationship with the rest of Japan, and these circumstances govern the daily lives of those who live there.

Teruya's *You–I, You–I* 2002 presents a kimono dyed in the traditional Okinawa *bingata* dyework–style, but the usual motifs of flowers and butterflies are combined with images of American military planes and helicopters, parachuting soldiers and dugongs (sea cows).[1] This reflects the fact that the site chosen for the construction of a new military base in Okinawa threatens the breeding grounds of the dugong. Ironically, the military bases, which have been the symbol of the protection of the islands from foreign enemies, have themselves become enemies that destroy Japan's natural habitats. Yet the long-term military use of the islands has also hindered their development for leisure sports and other uses, preventing the destruction of the environment by commercial developers.

Teruya turns a dispassionate gaze on Okinawa's complex situation, choosing not to superficially claim the rights or wrongs of the relationship between ruler and ruled. This attitude also appears in his 'Notice — Forest' series in which he recreates trees using paper shopping bags. While Teruya's use of a wide range of paper bags suggests an awareness of consumer society, his emphasis is not a direct critique of consumerism. Instead, he questions what is natural within an urban environment — newly planted trees in concrete-bound cities for example — sites characterised by endless cycles of consumption. The artist considers his subjects from many different angles to explore the potential for human existence within these environments. Yuken Teruya creates new miniature worlds that inspire dialogue between people with varying viewpoints.

YUKEN **TERUYA**

TARO AMANO is Chief Curator of the Yokohama Museum of Art (since 1988) and was a curator for the second International Triennale of Contemporary Art, Yokohama, 2005.

Yuken Teruya / Japan/United States b.1973
Notice — Forest (detail) 2005
Paper / 5 components: 9.3 x 15 x 27.5cm; 9.3 x 15 x 28.3cm; 9.2 x 15 x 28cm; 10.3 x 16.8 x 33cm; 9.2 x 15.2 x 28.2cm / Collection: Ota Fine Arts, Tokyo

You-I, You-I (detail) 2002
Fabric dye on hemp / 180 x 140cm (irreg.) (approx.) / Collection: The artist

Notice — Forest (detail) 2005
Collection: Ota Fine Arts, Tokyo

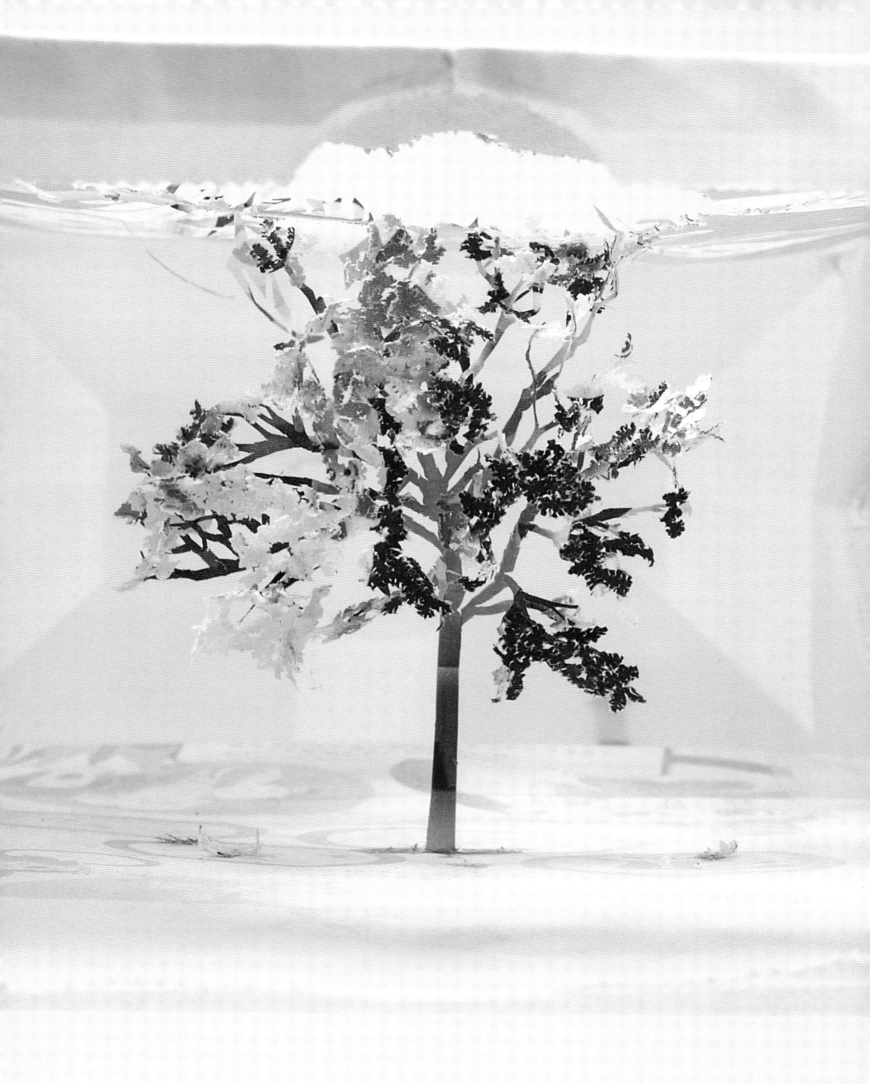

SOMETHING SURPRISING

Can we speak about your process for making the 'Notice — Forest' works? I understand each is based on a photograph.

Yes, I mostly take pictures of trees growing in urban environments because I'm interested in the way that their environment impacts upon their overall shape. The shape of a tree is a reflection of the environment in which it's living. To me, a tree itself is a community, it moves around with its branches to make sure all the leaves get sunlight evenly. If a tall building casts shadows on the tree it will change its form to try and find sunlight. The community of the tree moves together to find a solution and this is an interesting contrast with our urban environment. The bags represent this environment. There's a contrast between the flexibility of the form of the trees and the structure of both the bags and human society. There's also a contrast between mass produced products and the individuality of each tree.

Each of the installations of 'Notice — Forest' contains particular groupings of paper bags. I'm interested in the way that you tend to bring together bags from seemingly opposite ends of the consumer spectrum — for example, McDonald's and Tiffany's. Would it be fair to say that you have an unprejudiced or dispassionate approach to consumerism?

I don't really have specific intentions in relation to juxtapositions of different bags . . . that McDonald's can be found all over the world and Tiffany's is seen as valuable is a reflection on consumerism that is implicitly political but is something that the audience might bring to the work. It's not my intention to deal with these issues. I want to simply show something surprising: by having a tree inside them, both bags have something in common. They are on the same level.

You could say that there are two parts of the work for the viewer. When looking closely at the works, they might forget where the bags come from and just enjoy looking at the tree but, when they step back and see the bags, they can think about the combination of which bag and which tree.

Could you tell me about the group of bags selected for APT5?

I thought I would like to invite trees from all over the world to APT5. Many of the bags are connected to culture and art, things that don't really fit into the idea of 'the bag'. If it's McDonald's we know it's a bag for a burger and French fries. But if it says 'Australia Council', what is this for? Or 'MOMA'? Of course MOMA (the Museum of Modern Art, New York) sells T-shirts and has a book store but it looks strange to place bags that we don't think of as being directly connected to merchandise alongside bags produced by more obviously commercial enterprises.

NICHOLAS CHAMBERS is Assistant Curator, Contemporary International Art, Queensland Art Gallery / Gallery of Modern Art.
He spoke with Yuken Teruya in Sydney on 16 September 2006.

Notice — Forest (detail) 2005
Paper / 6 components: 7.9 × 13 × 24cm;
9 × 14.9 × 27.3cm; 11.4 × 17.6 × 32.5cm;
9.5 × 15.1 × 27.9cm; 8.1 × 12.2 × 24.3cm;
12.2 × 17.8 × 28.1cm / Collection: Obayashi Collection, Tokyo / Image courtesy: Ota Fine Arts, Tokyo

Yuken Teruya in the Artspace studio, during a residency in Sydney, September 2006
Queensland Art Gallery Image Archive

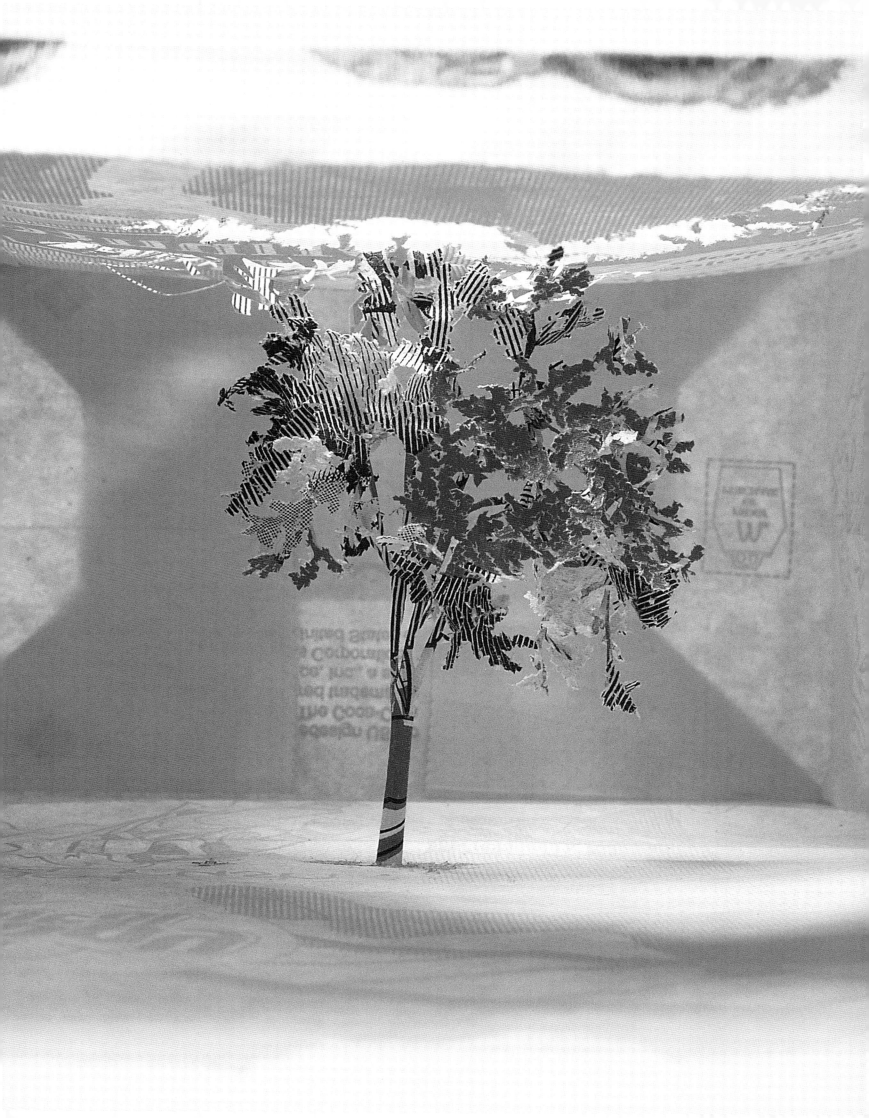

FROM DUSK 'TIL DAWN: THE OLD, THE
YOUNG AND THE DUSKY

Skin — brown, white, old, young — fills every inch of the screen in Sima Urale's films. Bare breasts, a newborn baby and wrinkled skin folds are as naked as the forlorn features of a ten-year-old boy, telling a tale or two about life, love and family. These images of exposure, vulnerability and sensuality are mostly silent, speaking volumes in vision rather than sound. In *O Tamaiti* 1996, silence is as golden as the autumn years of the elderly couple in *Still life* 2001; little is said, much is conveyed. Yet these quiet visions are from a woman whose sentences rush out of her with the force of a Samoan whirlwind. Once dubbed 'Cyclone Sima' by friends and family, she held a fundraising concert of the same name, looking for 'relief funding' to support three years of film study in Melbourne.

Babies characterise the opening moments of *O Tamaiti*, Urale's first short film, which literally starts with the birth of yet another baby into an already large Samoan family. *O Tamaiti* is an evocation of life through the big, brown eyes of children who must look after their many siblings. The frames of the film create family portraits but, unlike the many photographs of proud Pacific moments on the living room walls of island houses, these are the moments behind the smiles, behind the closed doors. Close-ups are Urale's forte: the entire screen is often composed of a single expression, but the expressions she focuses on are not those conventionally shown in the patchy history of Pacific people in cinema.

O Tamaiti captures instances of burden, panic, despair and joy as well as the mundane. Simple moments, set in a black-and-white landscape, reflect the starkness of stretched incomes, absent working parents and shared resources. The land of milk and honey translates here into a can of corned beef opened with a knife on the beach and coconut oil splashed onto untamed hair. Tino, the eldest boy, must bear the weight of caring for his younger siblings, carrying the responsibility meant for the missing adults. The desperate cycle of dual jobs and shift work is part of the film's subtext. There is no cheesy manipulation of the audience's sensibilities, no instrumentals to signal a sentimental moment; doors slam and babies cry. Such are the basic realities of this child's story told for adults.

There are no violin moments in Urale's *Still life* 2001, either. The camera floats in close-up over the folds of skin, crevices and expressions of an elderly couple at the end of their lives. Cyclic themes run through this piece in much the same way as in *O Tamaiti* — one starts with a birth and both end with a death. But the subjects are different. Perhaps in reaction to the tag 'brown filmmaker', Urale's *Still life* is deliberately about a world that is the polar opposite to *O Tamaiti* — the world of the white and the old, as opposed to the young and the brown.

The title of *Still life* is a telling illustration of the content of the film, as the two characters literally 'still' their lives. The still life genre of objects symbolising mortality also resonates here with the close-ups of the couple's inanimate features. As in *O Tamaiti* and her earlier work, *Velvet Dreams* 1997, images are presented almost as snapshots or studio portraits. The careful composition of expressions within painterly frames, the contrasts in textures and the close-ups of skin connect the images to the painterly tradition.

The extreme close-up is the ultimate intrusion into the characters' lives in these films. Literally getting under their skin, these close-ups elicit

SIMA **URALE**

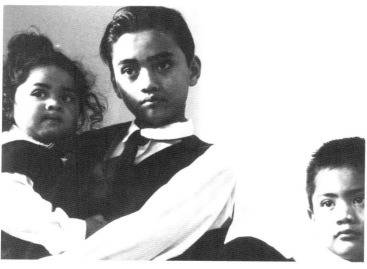

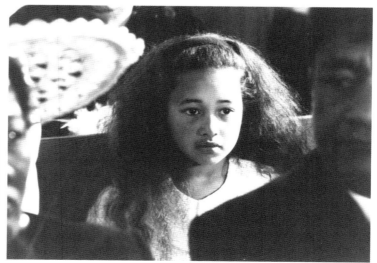

Production stills from *O Tamaiti* 1996

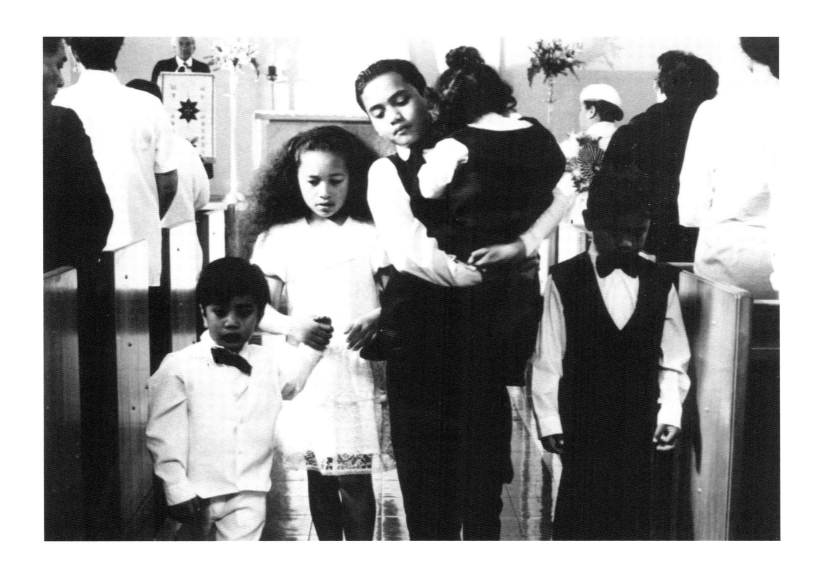

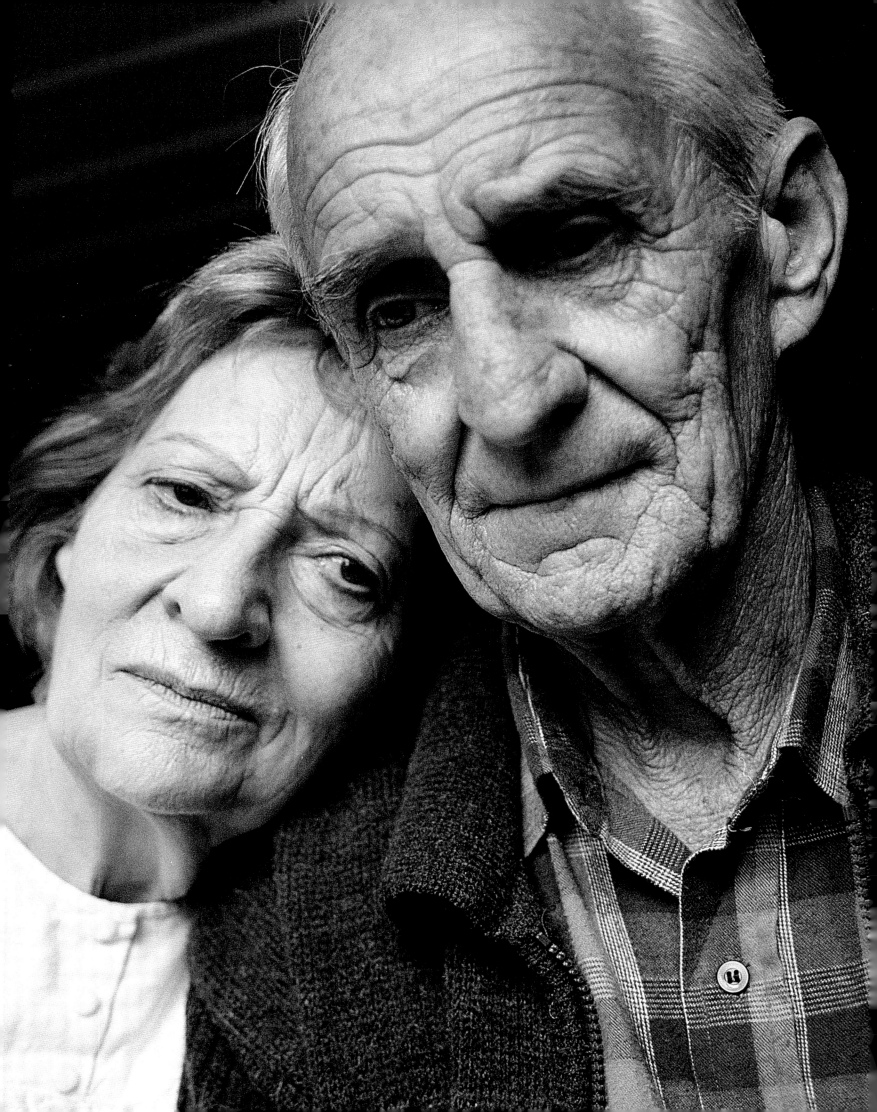

emotion rather than dialogue or narrative. *Still life* is about love and trust in an old-age (and age-old) relationship that transcends time and space. Euthanasia has never looked so good on screen, and the textures of the elderly have rarely been presented with this aesthetic, reverential treatment — the same used to present the lush wahine of *Velvet Dreams*.

This 1997 documentary explores the lives of white men who painted a plethora of sumptuous young brown skin in the tradition of velvet painting. Of all her films, Urale presents skin here in the most intentionally clichéd form, luxuriating in the luminous qualities of the dusky skin that turns the screen into a canvas. Naked maidens are blown up and lovingly lit to take on the velvet-like qualities of the paintings. Well-known velvet painter, adventurer and party boy of the Pacific, Charles McPhee paints young South Seas maidens, naked and seemingly vulnerable, and the viewer becomes complicit in this fetish for dusky skin.

As a 'skin flick', *Velvet Dreams* takes an ironic stance on the kitsch world of velvet painting — a world aligned with the 'hot rod' airbrush school of ersatz porno art. The views of the painters of this Venus-like iconography were coloured by their privileged position as tourists travelling through the Pacific playground of Western fantasy. That a brown, female director then takes charge of putting their story to screen takes another twist; it has been suggested by critics that hiring Urale as the director for the project was an attempt to legitimise aspects of a documentary that might have taken on a different context if a white male director had made it.

These three contrasting stories told by one woman have attracted many and varied viewers, from local Polynesians to the audiences of international art houses and popular-culture venues. Urale's films have been indigenised by the auteurship of her presence, but they don't tell the usual 'Pacific' stories. The images of troubled children, native nymphs and dying old people almost trace a chronology of flesh lived out in various stages. In baring these lives, Sima Urale brings us visions of what lies beneath the skin, as well as the skin-deep nature of clichés about the Pacific.

LISA TAOUMA is a Samoan director and reporter for Aotearoa New Zealand's only television program devoted to Pacific culture, 'Tagata Pasifika'. She has written two short films, which featured at the 1996 Montreal Film Festival.

Production still from ***Still life*** 2001

Director/Script: Sima Urale / 35mm, 11 minutes, colour, stereo, New Zealand, English / The James C Sourris Collection. Purchased 2005 with funds from James C Sourris through the Queensland Art Gallery Foundation / Collection: Queensland Art Gallery

Production stills from ***Still life*** 2001

The James C Sourris Collection. Purchased 2005 with funds from James C Sourris through the Queensland Art Gallery Foundation / Collection: Queensland Art Gallery

Production still of a velvet painting from ***Velvet Dreams*** 1997

Digital Betacam, 47 minutes, colour, stereo, New Zealand, English / Image courtesy: Shelly Kostanic, Top Shelf Productions and Alliance Atlantis

Việt Linh is something of a phenomenon, a woman filmmaker from the Socialist Republic of Vietnam whose films have achieved international acclaim. Her life spans the shifts in Vietnamese society brought about by war, independence and reunification, then by Đổi mới (Renovation) and an increasingly market-oriented economy.[1] Her work for the state-run Giai Phong Film Studio, despite censorship and considerable material and financial constraints, has resulted in multi-layered, independent-minded films.

Việt Linh's films made since the introduction of Đổi mới are characterised by two main themes: the ambivalent relationship between community and change, and the way in which this is experienced by the most vulnerable members of society — women, children, the elderly and the infirm. To underline the harsh realities and the intense but fleeting pleasures of her characters' lives, Việt Linh often extensively reworks the texts on which her screenplays are based. Her films are an intricate mix of realism, symbolism and melodrama.

Three of Việt Linh's key films — Gõnh Xiếc Rong (Travelling Circus) 1988, the first to be shown outside of Vietnam; Dấu Ấn Cũa Quỹ (Devil's Mark) 1992, the most popular of her works in Vietnam; and Mê Thõo, Thờ'i Vang Bõng (Me Thao, Once upon a Time) 2002 — are fables addressing village life, which have an allegorical power in relation to broader Vietnamese society and history. The films dwell with pleasure on spectacularly beautiful Vietnamese mountains, coastal and rural landscapes and on the music and traditions of village life. Through the passion and despair of their protagonists, they also point to the shortcomings of Vietnamese society and the need for social responsibility.

Travelling Circus is set in a remote mountain village struggling with drought and famine. A young orphan, Dac, is drawn to Lan, a woman performing in the travelling circus from Hanoi. Dac and the other villagers are entranced by a circus trick in which Lan appears to fill an empty basket with rice. The villagers abandon their fields to help the circus manager search for gold, until Dac discovers the perfidy of the circus tricks and Lan realises the ruthlessness of her employer. If the villagers finally reject the lure of easy gain however, there is no guarantee that they will survive. The film, which offers a layered critique of imperialism, capitalism and of the central government in Hanoi (which originally censored the film in Vietnam), is given extraordinary visual and mythic power by its superb black-and-white cinematography.

Devil's Mark, a folk tale, comments on a fishing community from the viewpoint of its outcasts, the victims of the villagers' ignorance and prejudice: a foundling abandoned when the villagers attributed her purplish birthmark to the devil; the elderly leper who raised her; and an escaped prisoner, an artist who was wrongly arrested, with whom she falls in love. The couple are doomed; the girl only finds acceptance when she dies in childbirth and the local midwife adopts her baby. The film makes the case for an inclusive, open-minded and just society — relevant to postwar Vietnam, where certain sections of society were often victims of prejudice.

In Me Thao, an adaptation of Nguyễn Tuân's novella, Chũa Đàn (Dan Pagoda) 1946, Việt Linh explores the fate of the community of Me Thao, the domain of a lovesick nobleman, Nguyễn, who, after the death of his fiancée in a car accident, decides to ban all machines and machine-made

VIỆT LINH

Việt Linh / Vietnam b.1952
Travelling Circus (Gõnh Xiẽc Rong)
(stills) 1988
Director: Việt Linh / 35mm, 80 minutes, b. & w.,
mono, Vietnam, Vietnamese / Image courtesy:
Giai Phong Film Studio and Discovery
Communications

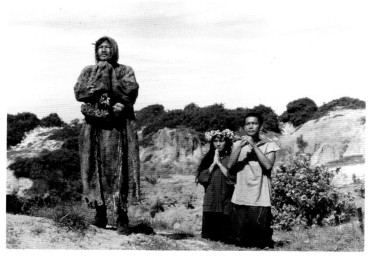

Production stills from *Devil's Mark (Dấu Ẩn Cũa Quỹ)* 1992
Director: Việt Linh / 35mm, 90 minutes, colour,
mono, Vietnam, Vietnamese / Image courtesy:
Giai Phong Film Studio

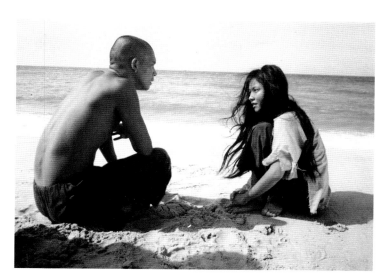

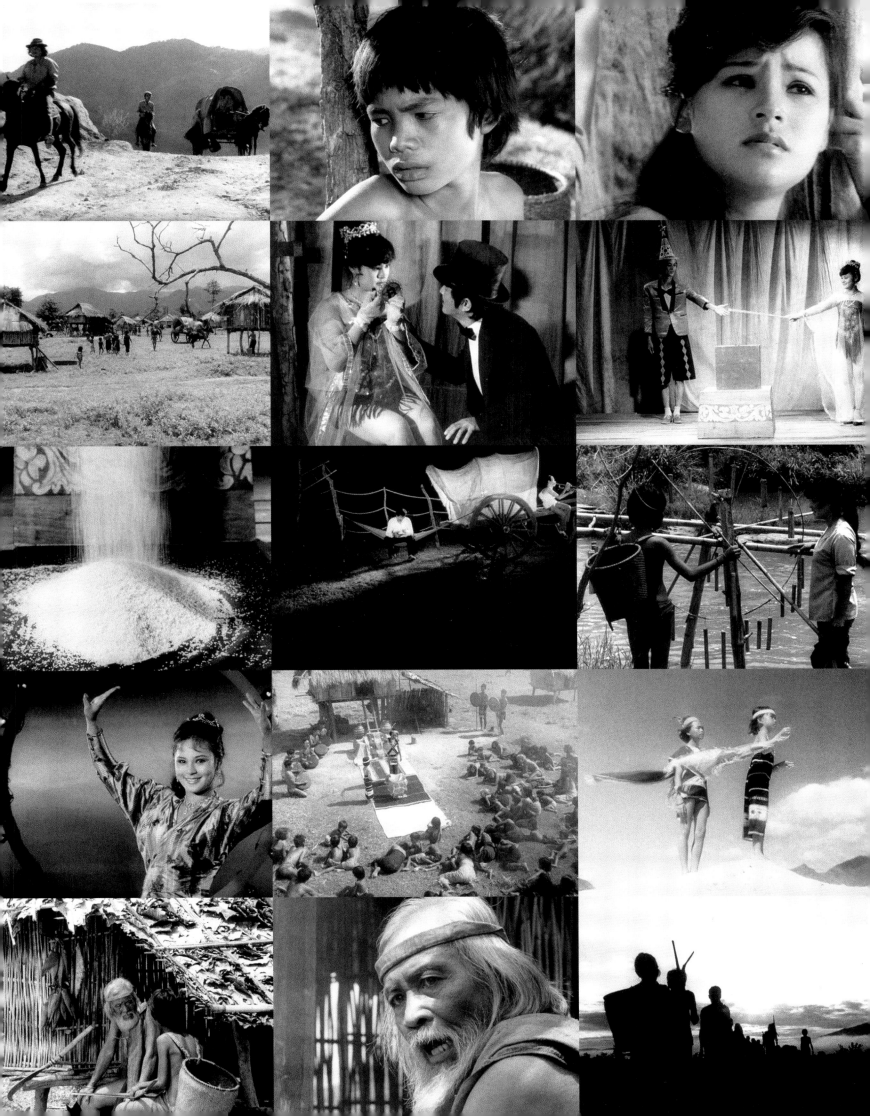

HÃNG PHIM GIẢI PHÓNG
Sản xuất năm 1992

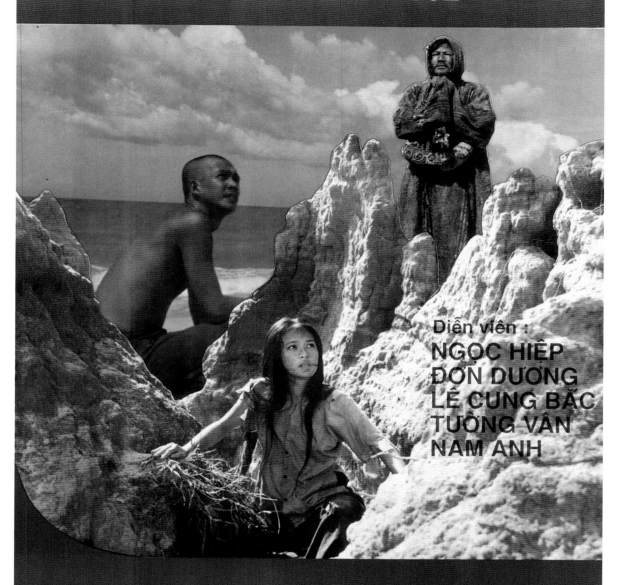

Diễn viên :
**NGỌC HIỆP
ĐƠN DƯƠNG
LÊ CUNG BẮC
TƯỜNG VÂN
NAM ANH**

DẤU ẤN CỦA QUỶ

Kịch bản : **PHẠM THÙY NHÂN**
Đạo diễn : **VIỆT LINH**
Quay phim : **ĐOÀN QUỐC**
Họa sĩ : **PHẠM HỒNG PHONG**

products from his estate, thus willing it into a sharp decline. Việt Linh's sympathetic treatment of the deluded nobleman is balanced by her introduction into the story of a young servant girl, Cam, who is mute. Her love for her master underlines his indifference to the sufferings of others. The estate's recovery is made possible by the coming of the railway (which Nguyen had attempted to prevent) at the instigation of the somewhat comical representatives of the equally autocratic French colonial regime.

In contrast, *Chung Cu' (Collective Flat)* 1999, loosely based on a short story by Nguyễn Ho, has an urban setting and explicitly comments on pre- and post-Renovation Vietnam. The narrative opens on 1 May 1975, the day the victorious National Liberation Front troops entered Saigon (now Ho Chi Minh City) — Việt Linh herself participated in this historic event with her father, a documentary filmmaker. The film charts the history of the deserted Victory Hotel, requisitioned for use by army cadres until the late 1980s. A metaphor for Vietnam itself, the hotel is a legacy of the colonial past but comes to symbolise the victorious, idealistic communist nation as a community of inhabitants creates a new life there. However, as *Đổi mới* takes effect, collective ideals give way to individualism and consumerism, and the decaying hotel is acquired for redevelopment as a luxury tourist hotel. The changes are primarily shown through the eyes of its caretaker, the elderly Tham, who is devastated by the hotel's disintegration. However, *Collective Flat* expresses some hope in the future in the character of an idealistic youth befriended by Tham. The film avoids addressing the increasingly negative effects of the contemporary intensification of globalisation. In contrast, the new generation of popular Vietnamese films, from Trấn Anh Hũng's *Cyclo* 1995 to Lê Hoãng's *Gái Nhảy (Bar Girls)* 2003, take a darker view of the possibilities for young people in contemporary urban life in Vietnam.

Việt Linh's films show a critical concern with the continuity of the national narrative and the struggle of social equality while also charting her pragmatic acceptance of Vietnam's increasing economic liberalisation. Ironically, that same liberalisation has recently led the state film funding body, the Cinema Department of the Ministry of Culture, to prioritise the production of popular entertainment films, making it more difficult to find funding in Vietnam for auteur films of the kind that have established Việt Linh's reputation. She may remain unique in Vietnam as a filmmaker whose work balances a deeply held belief in the power of cinema to transform society with an extraordinary mastery of the visual and mythical qualities of the 'seventh art'.

DR CARRIE TARR is Research Fellow in Film Studies, School of Performance and Screen Studies, Kingston University, United Kingdom. She has published widely on gender, ethnicity and post-colonialism in relation to French and Francophone cinema. Publications include *Cinema and the Second Sex: Women's Filmmaking in France in the 1980s and 1990s* (with B Rollet) 2001, and *Reframing Difference: Beur and Banlieue Cinema in France* 2005.

Vietnamese release poster for *Devil's Mark (Dấu Ấn Cũa Quỹ)* 1992
Image courtesy: Giai Phong Film Studio

Production stills from *Me Thao, Once upon a Time (Mê Thảo, Thờ'i Vang Bóng)* 2002
Director: Việt Linh / 35mm, 107 minutes, colour, stereo, Vietnam, Vietnamese / Image courtesy: Giai Phong Film Studio

When answering a letter in 1979 from an art history student asking about international influences in his work, Gordon Walters wrote that 'generally speaking, my present style was formed not by what was far away, but by what was under my nose here in New Zealand'.[1]

As a young artist in Wellington in the late 1930s, Walters was more attracted to the Maori and Pacific collections of the Dominion Museum than the displays at the conservative National Art Gallery. That conservatism also marked his academic art training, which strongly resisted anything to do with Modernism. Instead, like many New Zealand artists, his knowledge of movements like Cubism and Surrealism came from books and magazines. This knowledge was reinforced, along with his interest in Maori and Pacific art, by Walters's friendship with Theo Schoon, a Dutch–Javanese artist brought to New Zealand by World War Two.

In 1950, Walters travelled to Europe to experience first-hand the works he had known in reproduction. He immediately 'understood how much of the vitality of twentieth-century European art came from the discovery by artists of [indigenous] material'.[2] Following the example of abstract painters such as Victor Vasarely and Giuseppe Capogrossi, he saw Maori art with a reinvigorated eye. It was an eye that was especially responsive to the repetition and variation, the play of ambiguities between figure and ground that characterises *kowhaiwhai* painting (scroll work often painted on the rafters of Maori meeting houses) and *moko* (facial tattooing). Seen through the filter of European abstraction, other art traditions as diverse as Marquesan tattooing and Samoan tapa provided Walters with further stimulus. 'The penny dropped', he later recalled.

This was one way out of the dilemma of what to paint in New Zealand. I was elated . . . but between this inspiration and the realisation of the idea was a huge gap. It was a long and painful struggle.[3]

Returning to New Zealand in 1953, Walters began that struggle in earnest. The first *koru* paintings tentatively emerged in 1956, following a wide-ranging period of experimentation, and it took a further eight years for the series to reach a mature state.[4] Following their first public exhibition, at Auckland's New Vision Gallery in 1966, the *koru* paintings were immediately recognised as a major achievement in New Zealand art.

Walters continued to work with the motif over the next 20 years, testing, varying and refining it in paintings, drawings and prints. Other forms and motifs — some entirely abstract, others referencing Maori and Pacific art — co-existed with the *koru* during this time. In the 1980s, these took precedence as the *koru* series went into abeyance. Walters explained that:

I had developed the work to the point where there were no longer any real discoveries for me to make in deploying the image, not surprising after the time I had spent realising the work.[5]

The motif returned, however, in several paintings during Walters's final years, including *Untitled* 1995, his last completed work.

The paintings selected for APT5 span Walters's mature style. They show something of the range and diversity in his use of the *koru* motif, from the austere refinement of *Black Centre* 1971 and imposing symmetry

GORDON **WALTERS**

Gordon Walters / New Zealand 1919–95
Blue on Yellow 1967
Synthetic polymer paint on canvas /
182.5 x 136.5cm / Collection: Jennifer Gibbs Trust,
Auckland / Image courtesy: Jennifer Gibbs Trust,
Auckland

Gordon Walters working on *Painting no.9*
1965 at his Brougham Street studio.
Image courtesy: EH McCormick Research Library,
Auckland Art Gallery Toi o Tāmaki / Photograph:
Margaret Orbell

Main Hall of the National Museum
(formerly Dominion Museum), Wellington,
New Zealand, 1949
Image courtesy: Museum of New Zealand
Te Papa Tongarewa

of *Genealogy 5* 1971, to the all-over, almost random composition of *Maheno* 1981. Although best known for his work in black-and-white, which he said was 'reinforced by the example of Chinese calligraphy', the paintings in the APT also reveal something of Walters the colourist, notably the forceful contrasts of *Blue on Yellow* 1967.[6] They show the enormous subtlety with which he deployed the motif, tempering and balancing positive and negative space and the proportions of line and circle.

They demonstrate, too, the extraordinary refinement of his technique, an almost anonymous precision that belies the fact that these are hand-painted works built up through many layers of carefully applied, thin colour and without the use of masking tape or other aids. This quality is reinforced by the size of the paintings: even at their largest, Walters's canvases maintain a sense of human scale.

When they were first exhibited, no reviewer made any connection between the artist's *koru* paintings and Maori art; they were seen instead as local expressions of Op Art. At the time, Walters described his work as 'an investigation of positive/negative relationships within a deliberately limited range of forms. The forms I use have no descriptive value in themselves and are used solely to demonstrate relations'.[7]

By 1968, however, Walters was acknowledging the influence of Maori art by titling his works with Maori words, often taken from the Wellington street names of his childhood. It was, he later explained, a means for him 'both to pay tribute to the Maori tradition, which has meant a great deal to me, and to re-interpret it in terms of my own art and my immediate environment'.[8] In the 1980s, this re-interpretation came to be seen by some

commentators as inappropriate. They argued that Walters had stripped Maori art from its original context and removed its narrative and spiritual dimensions. One Maori art historian famously accused Walters of 'residual colonialism'.[9] The ensuing debate between the artist's supporters and detractors was bitter and divisive.

In the end, the debate had no winners. If nothing else, it served to highlight the scope of Gordon Walters's original ambition to navigate his own path through the two art traditions of New Zealand — Maori and pakeha. This is not necessarily to present his paintings in utopian terms, 'a synthesis, on the basis of equality, of elements from two cultures'.[10] Indeed, it is perhaps just as productive to read the ambiguities of figure and ground and Polynesian and European visual modes in the works (to borrow Rex Butler's assessment of Emily Kngwarreye) as representing 'an interplay of differences that are at once inseparable and irreconcilable'.[11] The inclusion of this selection of *koru* paintings in the APT is a reminder of just how powerful those tensions remain, but how richly productive and beautifully resolved they might be.

WILLIAM McALOON is Curator of Historical New Zealand Art at the Museum of New Zealand Te Papa Tongarewa, Wellington.

Untitled 1995
Synthetic polymer paint on canvas / 152 x 114cm / Collection: Gordon Walters Estate / Image courtesy: Sue Crockford Gallery, Auckland

Untitled 1960
Collage of black and white paper / 37.7 x 30.5cm / Purchased 1992 with New Zealand Lottery Grants Boards funds / Collection: Museum of New Zealand Te Papa Tongarewa

Genealogy 5 1971
Synthetic polymer paint on canvas / 152.3 x 152.3cm / Collection: Jennifer Gibbs Trust, Auckland / Image courtesy: Jennifer Gibbs Trust, Auckland

Rongotai 1970
PVA and synthetic polymer paint on canvas / 152 x 115cm / Collection: Jennifer Gibbs Trust, Auckland / Image courtesy: Jennifer Gibbs Trust, Auckland

EVERYTHING IS ILLUMINATED:
OLD STORIES WITH NEW CLARITY

My mother used to listen to radio dramas in her kitchen. While she cooked, the crackling AM-sound echoed through our house as it played out overwrought, irresistibly addictive drama series of lovers torn apart, of hopelessly cheated wives and vindictive mistresses, and of a haunted mansion where wicked ghosts wander. In my memories, they were among the oldest stories. They became the foundation of my taste despite my subsequent exposure to smarter, better stories of imported novels and films. And maybe I had forgotten them, consigning their home-grown appeal to the back of my head. But when those maudlin voices from the transistor radio turned up with their characteristic candour in Apichatpong Weerasethakul's movies, they evoked a kind of primal dream, a pure, clean, illuminated pleasure buried beneath the years of cluttered consciousness.

For all the complex analysis of Apichatpong's body of work, the laboured dissection of his Euro-art influence and all the abstract talk about the post-everything aesthetics of his movies, it's clear that this Thai filmmaker thrives on a creativity that's firmly based on the virtue of telling the oldest stories, perhaps the simplest as well. They're the stories most Thais grew up hearing, a collection of Third World myths and melodramas, legends and old movies, cine-fused with his own personal visions and private dreams.

Apichatpong grows these stories into his films with an organic touch, just like his own inspiration has grown out of the narrative history of this land. The tale of village rivalry lifted from a vintage radio drama that dominates the soundtrack of *Like the Relentless Fury of the Pounding Waves* 1995 is a nostalgic diary at its most experimental. An earnest sound bite in the opening sequence of *Mysterious Object at Noon* 2000 plays like

a prologue to the strange, improvised tale that follows in this black-and-white travelogue. In *Haunted Houses* 2001, Apichatpong retells one of the most popular Thai soap operas — the story of a nobleman, his aristocratic wife and a young mistress — by transporting the whole set-up to a rural environment and wryly accenting the universality of human drama by using different actors (all of them real villagers) to play the same key characters. Yet another of the oldest Siamese stories received a mystical re-imagination in his Cannes-winning *Tropical Malady* 2004. The ancient fable of a tiger-ghost that terrorises hunters becomes a meditation on gay love and the obliteration of the self, complete with cameos of the jungle gods in the guises of a talking monkey and a phosphorescent cow.

It would be imprudent — and simply wrong — to label Apichatpong's filmmaking approach as a form of the postmodern urge to embrace trash. The 36-year-old director, who grew up in the province of Khon Kaen and studied filmmaking at the School of the Art Institute of Chicago, doesn't reach back to the legacies and kitsch of old-fashioned, unsophisticated melodramas for their quirky effects. Rather, he attempts to reclaim the honesty, the integrity, as well as the characteristic awkwardness and inherent narrative power that have been lost in the gloss of contemporary Thai cinema. Apichatpong's films certainly boast an experimental edge (even a sci-fi impulse) but they're always grounded in what I'd like to call anthropological sincerity. This is expressed through the invariably dusty rural settings, the non-professional actors who sometimes have the habit of smiling at the camera, and the gentle, clear-headed temperament — even when he's presenting something as subversive as a shot of a penis being coerced into an erection.

APICHATPONG
WEERASETHAKUL

Apichatpong Weerasethakul / Thailand b.1970
Production still from *Syndromes and a Century (Sang Sattawat)* (detail) 2006
Director/Producer/Script: Apichatpong Weerasethakul / 35mm, 104 minutes, colour, Dolby SRD, Thailand, Thai / Image courtesy: The artist and Fortissimo Films

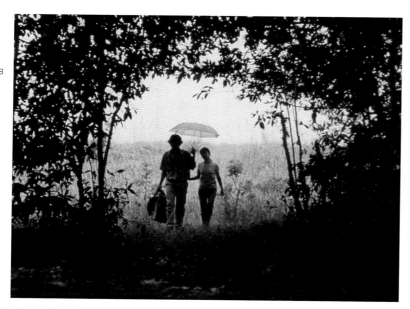

Production still from *Blissfully Yours (Sud Sanaeha)* 2002

Director/Script: Apichatpong Weerasethakul / 35mm, 122 minutes, colour, Dolby SRD, Thailand, Thai and Burmese / Image courtesy: The artist

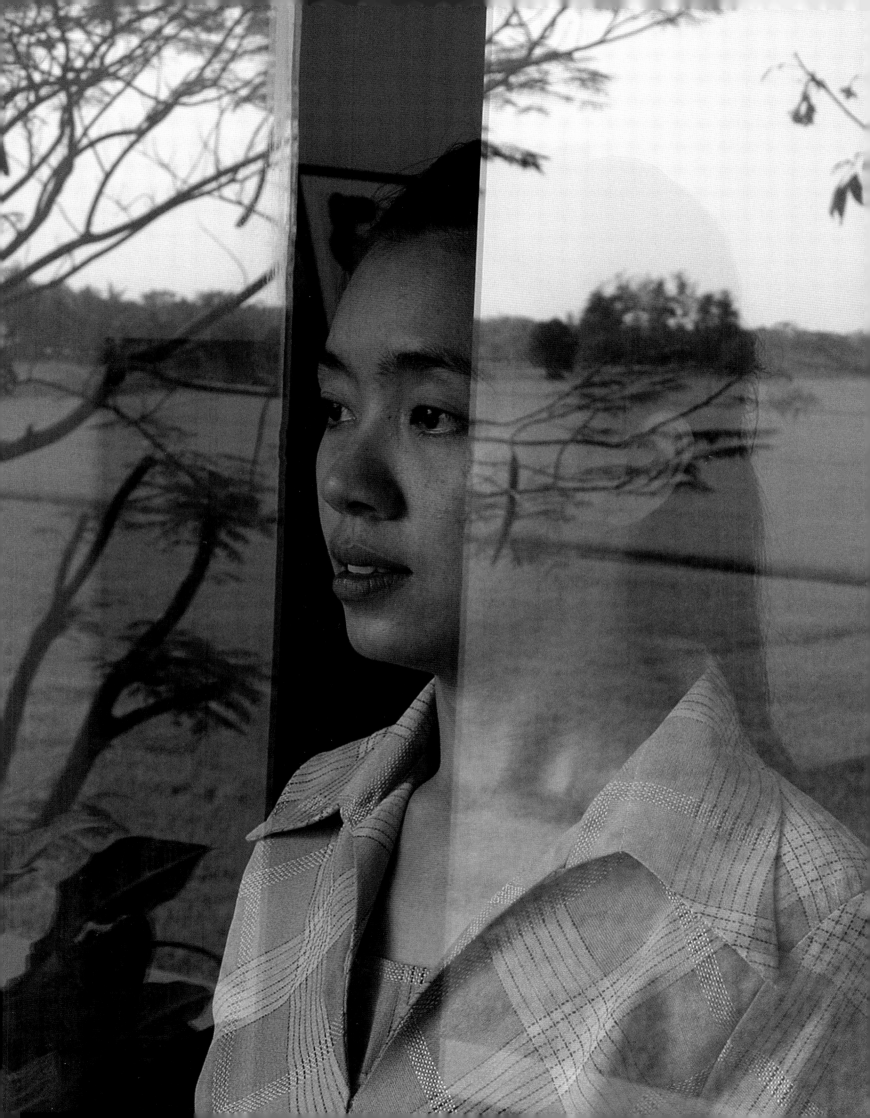

By going back to tell the old stories, Apichatpong has made movies that do not belong to middle-class sensibility — which has become the unmistakable tendency of most Thai films of the past decade. His fascination with the everyday drama of country people means he's perceptive to their humour, their guilelessness and the grassroots wisdom patented by the Thais.

This is apparent in *Mysterious Object at Noon*, in which the various villagers the filmmaker met on his journey happily graft their eccentric imaginations onto the story of the mysterious object of the title, creating a brand of Third-World Surrealism that is unique. But there are also off-handed moments in *Blissfully Yours* 2002, *The Adventure of Iron Pussy* 2003 and *Haunted Houses* that tap into the rich resources of rural wit and unadorned realism. At one point in *Tropical Malady*, a male character, Tong, puts his palm next to that of his lover, Keng, and teasingly reads their romantic destiny: 'If the lines on our hands form the shape of the Royal Barge, they say we're soul mates'. When I saw the movie at Cannes Film Festival, no one in the theatre let out even a giggle. Back in Bangkok, the audience roared with laughter at the candid wit and blatant melodrama. Likewise, the spirit of pure storytelling in the radio soaps so loved by Apichatpong may remain elusive to some international audiences, but it always carries a special meaning to the Thais.

Some European critics wrote that Apichatpong made fun of country people and their unfashionable antics. The truth is the contrary, since the filmmaker celebrates the clarity of their existence. Many times in his films, the characters seem awkward, uncertain, or simply aware of the presence of the camera. But instead of making everything less real, this

awkwardness enriches the realism of the story and situation, and that is why Apichatpong's movies are often referred to as intriguingly blurring the line between documentary and fiction.

Unmistakably the locations lend themselves to an air of naturalism. There are the desolate streets of his hometown, Khon Kaen, in *Like the Relentless Fury of the Pounding Waves*, and the dusky southern islands that provide the backdrop to the bizarre dreams recounted in *thirdworld* 1997. And of course there's the jungle. First in *Blissfully Yours*, in which two lovers carve out their private space and time wandering the soulful woods that reminds us of Eden. Then it's the moist jungle that becomes less a physical world than a fevered state of mind as a soldier treks deeper in search of the tiger-ghost in *Tropical Malady*. So fascinated was he by the verdant inferno of tropical forests that Apichatpong made *Worldly Desires* 2005 as a personal diary dedicated to his months of shooting in their smothering midst.

In his latest feature, *Syndromes and a Century* 2006, Apichatpong loosely bases the story on the experience of his parents when they first met, and he shot most of the film near a hospital in Khon Kaen where his father worked. Once again, the poet of new Thai cinema is telling us the oldest story, the one that took place even before his birth. But it's the story that's closest to his heart, and maybe ours, too.

KONG RITHDEE writes about films and popular culture for the *Bangkok Post*, a daily English-language newspaper in Thailand.

Like the Relentless Fury of the Pounding Waves (stills) 1995
Director/Script/Cinematography: Apichatpong Weerasethakul / 16mm and video, 30 minutes, b. & w., stereo, Thailand, Thai / Image courtesy: The artist

Production still from *Tropical Malady (Sud Pralad)* 2004
Director/Script: Apichatpong Weerasethakul / 35mm, 118 minutes, colour, Dolby SRD, Thailand, Thai / Image courtesy: The artist and Celluloid Dreams

In a relatively short career, emerging into public view only after 1999, Yang Fudong has established an identifiable style in his films and videos. He has captured a mood that characterises China's new urban generation, giving us a taste of the ambience and visual imagination of the new educated class — a privileged class in a position to contribute to China's change in a critical time. Without being didactic, in fact often quite obscure in his narratives, Yang teases the audience with promises of new cultural visions that are both nostalgic and utopian, sophisticated and inarticulate.

When seen separately, Yang's films appear like fragments or clips, or comments made on other vaguely familiar films. When seen as a whole, with the disparate fragments gathered up, Yang emerges as an ambiguous storyteller who appears to be piecing together a loosely connected epic that refuses to reveal a cohesive narrative. That epic, if indeed it is the true shape of Yang's eventual oeuvre, will be a diverse collection of imaginative moments that his generation can recognise as the visual experience of their own history; an experience of the modern era presented from the position of a 'minor literati/intellectual', an identity the artist has assigned to himself and his friends. At a time when most of China's contemporary art scene is still mesmerised by the continental shift of changing ideologies — and feels obliged to focus on themes such as identity politics and post-colonial issues — Yang has been quietly looking for a way to make art serve our time by opening up the imagination for a specific audience. This imagination transcends the bounds of ideological politics or cultural identity, and is grounded on a mood, an attitude, that refuses to be defined as a political position.

People who go to a Yang Fudong production expecting a good yarn will be sorely disappointed. The films are full of scenes that remind the audience of other cinema productions, but the associations stop there. Individual images may be memorable, but the full dramatic story is missing. Yang has consistently edited out the links necessary for a developed plot, leaving the audience with only the images one usually retains after seeing a captivating promotional clip. Shots framed with painterly elegance, filling viewers with yearning and nostalgia, and drawing them into a screen-world of dreams, soon turn to puzzling mysteries, throwing the audience out into the cold and back on themselves. Yang does not endeavour to keep his audience in the story. Instead, he consciously allows them to slip out, just like he allows his actors to ramble on in the scene about the dream of utopia in the *Seven Intellectuals in Bamboo Forest, Part 2* 2004 — the dialogue developing into the actors' own unscripted fantasies. There is much posing and posturing, as though he has prepared them for still shots. The actors usually keep emotional expressions to a minimum, so that the audience is neither allowed to enter the role of the fictionalised protagonist nor the personality of the film star. The truncated storyline and abbreviated acting create a partition between the cinematic dream and imaginative engagement of the audience.

Bridging the real and the cinematic is a leap of faith on the part of the audience, implying a willingness to be seduced. When the narrative is simple to follow, especially in action film, the audience is easily drawn into the drama. One cannot argue with the storyline of a Hollywood production, for example; the fictional world takes over and its drama temporarily

YANG FUDONG

Yang Fudong / China b.1971
Production still from *Seven Intellectuals in Bamboo Forest, Part 2* (detail) 2004
Director: Yang Fudong / 35mm, 46 minutes, b. & w., stereo, China, Mandarin / Image courtesy: ShanghART Gallery, Shanghai

Production still from *Seven Intellectuals in Bamboo Forest, Part 1* 2003
Director: Yang Fudong / 35mm, 29 minutes, b. & w., stereo, China, Mandarin / Image courtesy: ShanghART Gallery, Shanghai

becomes the only reality. Yang plays against this rule. In his work, the audience cannot sit back passively, but needs to contribute to the missing narrative, and sometimes reshuffle the sequence of the scenes. In a work like *Jiaer's livestock* 2002/2005, Yang actually provides several versions of the story and presents the work in an installation of multiple screens to press his point. Yang also disengages the identification between actor and audience by playing down the dramatic character of the actor; here, the 'star' personality, which continues to exert its magic beyond the film, cannot take hold.

Yang creates his own world of imagination by focusing on memorable images, images that are immensely 'quotable' and iconic. He prefers a slow tempo to impress these images on the audience, trusting the visual moments to their magic. For this purpose he often makes use of time tried imagery, which already comes laden with narratives. The Huang Shan Mountain in *Seven Intellectuals in Bamboo Forest*, *Part 1* 2003 harks directly back to China's traditional literati world, but it also recalls the stock poster print in a Chinese living room, while the outfits of the seven intellectuals pay homage to 'new intellectuals' from the Republican era, who were important modern reformers. *No Snow on the Broken Bridge* 2006, filmed at classic scenic spots around the West Lake of Hangzhou, presents a collection of images that epitomise the luxury of old-world Chinese life. The same backdrop of Hangzhou also serves to highlight the lethargy of modern youth in *Estranged Paradise* 2002.

Yang's style of filmmaking is consistent with his intention to illuminate the aspirations of the 'minor literati/intellectual'. He is not interested in great ideological ideas and shies away from the grand historical circumstance, but this does not mean he is unaware. His concern is with human sensibilities and values that underlie dramatic historical moments. Yang does not refer directly to historical settings, he keeps them out of sight — just around the corner. The easy luxury of *No Snow on the Broken Bridge*, set in the early twentieth century, stirs a slight unease in the Chinese audience as they have been conditioned to think only of threats to nationhood and traditional culture during that turbulent time. Both *Lock Again* 2004 and *The Revival of the Snake* 2005 suggest war and strife in the world beyond; but one is set in a town during a moment of reprieve, and the other on mountain ranges worthy of an epic. By putting the larger historical context behind the scene, Yang is better able to focus on the nuances of sentiments involved, and expose individual aspirations beneath the crass noise of politics and ideologies. For him these human qualities are more significant and true than abstract ideas, and they point to sensibilities representative of this age.

Against the background of great social strife and political change, Yang champions the dignity of life and the loyalties that matter. The like-minded intellectuals of the 'Seven Intellectuals in Bamboo Forest' series try to find their own path in a changing world, and they begin their odyssey by returning to a timeless stereotypical China. The sword players of *Backyard — Hey! Sun is Rising* 2001 keep up their vigilance even though the rigorously structured society they know has been taken over by a traffic jam. The lovers of *Flutter Flutter Jasmine Jasmine* 2002 maintain their special feeling even across the chasm of skyscrapers, just as lovers of old used to sing to

Production still from *Jiaer's livestock* 2002–05

Director: Yang Fudong / 10-channel video installation; 35mm, 18 minutes, colour, sound, suitcases and clothing / Collection: The artist / Image courtesy: ShanghART Gallery, Shanghai

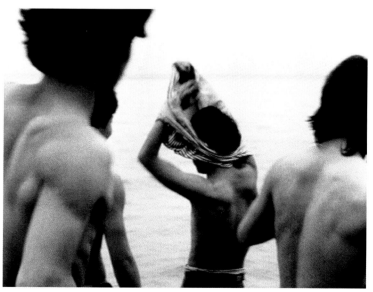

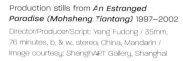

Production stills from *An Estranged Paradise (Mohsheng Tiantang)* 1997–2002

Director/Producer/Script: Yang Fudong / 35mm, 76 minutes, b. & w., stereo, China, Mandarin / Image courtesy: ShanghART Gallery, Shanghai

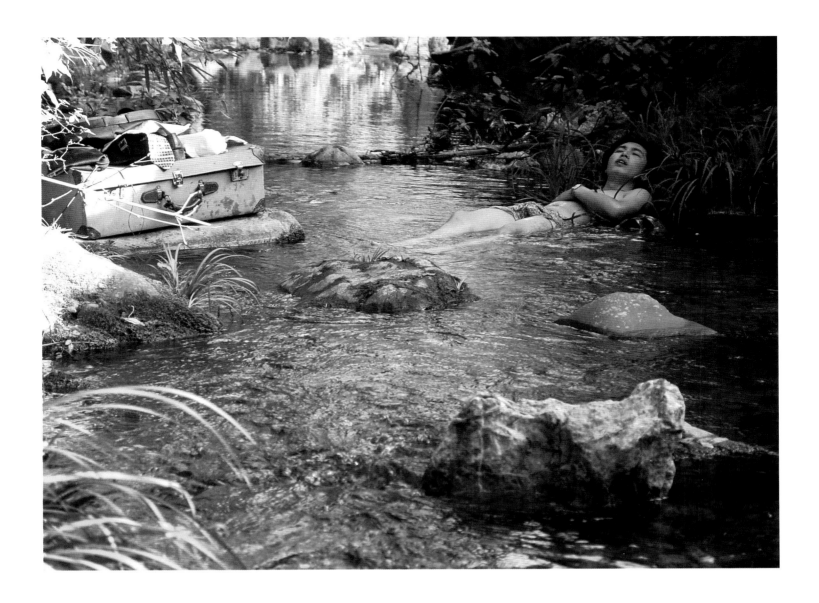

each other across mountains. These moments touch us even as they seem ridiculous. They rise above restrictions of historical circumstance and social boundaries.

The natural world plays a special role in many of Yang's works. In the case of Huang Shan Mountain, West Lake in Hangzhou and occasional garden scenes, it is the association with Chinese cultural history the artist wishes to evoke. They show a civilised and cultured natural world that forms a part of China's historical legacy. There is another aspect of nature with which Yang is fascinated. It is the agrarian world to which the seven intellectuals go to seek their cultural roots and arcadia in *Seven Intellectuals in Bamboo Forest, Part 3* 2005; it is the country life the hapless townsman escapes to with his city luggage in *Jiaer's lifestock*; it is the border between civilisation and wilderness the deserter would not cross in *The Revival of the Snake*. Nature is not always a welcoming, regenerative power; it has its own order and is equally merciless to the deserter and the farmer. Timeless nature, often as unsentimental and brutal as any ideological movement, has shaped a way of life and a set of values both resilient and seemingly unenlightened to the urban mind. Country life is not for everyone, especially those who have come to it as an escape. Yang is not optimistic about bringing together town and countryside, hard as his protagonists have tried.

It is the state of being in transition, of being caught 'in between' that best characterises the situation of most of the protagonists in Yang's films. They are in between historical eras, in between the past and the future, in between civilisation and wilderness, in between dream and reality. Some of them have got into the situation through their own volition —

like the young people trying to find their own way of life in the 'Seven Intellectuals in Bamboo Forest' series, the urbanites lured or escaping to the countryside in *Jiaer's livestock* and *Hitching Post* 2005, or the deserter escaping to the steppe in *The Revival of the Snake*. Some have been unable to cope with change, like the sword players in *Backyard — Hey! Sun is Rising*. This manifests as malaise in the hypochondriac youth seeking a career in *Estranged Paradise* and as schizophrenic comedy in *City light (Chengshi zhiguang)* 2000. Some of them, like the deserter and the sword players, are outcasts; others are perhaps more like Yang himself, seeking to find alternative approaches to living, and making sense of contemporary China and its recent past. Being in between means there is the possibility for freedom and change, it means being sympathetic to different interpretations of history, so as to stray at the edge of simple political or social causes, being neither for nor against the status quo. It is a state in which idealists and dreamers find themselves, and to persevere requires personal integrity and devotion to alternative loyalties. To be in the 'in-between' state is to slip through the web of society and, perhaps, also history. As Yang himself once said in an interview with Zhang Yaxuan, the 'minor literati/intellectuals' are:

> . . . a group of special people, who may not do anything astonishing or remarkable. They may not create masterpieces but they have their own qualities. Maybe you do not notice them on a daily basis and they will never be anything special, but when you suddenly discover them they are very adorable. They can touch your heart.[1]

CHANG TSONG-ZUNG is the director of Hanart TZ Gallery and a professor of the China Art Academy, Beijing. Since the 1980s, he has played an important role in promoting contemporary Chinese art and has written numerous essays for books and exhibition catalogues.

Production still from *Backyard — Hey! Sun is Rising (Hou Fan — Hei, Tian Liang Le)* 2001
Director: Yang Fudong / 35mm, 13 minutes, b. & w., stereo, China / image courtesy: ShanghART Gallery, Shanghai

City light (Chengshi zhiguang) (still) 2000
Mini DV, 6:40 minutes, colour, sound, ed. 3/10 / The James C Sourris Collection. Purchased 2003 with funds from James C Sourris through the Queensland Art Gallery Foundation / Collection: Queensland Art Gallery

Yang Zhenzhong's videos and photographs use visual puns and digital media to comment on abstract notions of progress and convention, through first-hand observations of the urban Shanghai culture in which he lives. The artist captures common expressions, objects and social behaviours and sets them loose from their everyday meanings — often through simple digital photographic effects and temporal distortions. His conceptual treatment of everyday images, marked by a signature sense of humour, unfolds over time and — through repetition — creates room for political comment. Yang's work explores Shanghai's rapid urban change and notions of progress specific to China's recent history. It also translates cross-culturally through its philosophical reflections on contemporary urban life.

Since the economic reforms of 1991, millions of workers from China and abroad have descended upon Shanghai. The focus of foreign investment in the 1990s, Shanghai presented opportunities in corporate enterprise, improved living conditions and technologically advanced infrastructures. At least 50 per cent of the buildings that existed in 1949 have been razed to make way for towering residential skyscrapers and commercial districts.[1] Whole neighbourhoods and precincts of culturally significant architecture from Shanghai's cosmopolitan past have literally disappeared overnight. Coinciding with this period of mass urbanisation, many Shanghai artists of Yang's generation broke from their traditional fine arts training to work with newly available digital media. Video and photography offered an immediate means of capturing and commenting on the city's 'economic miracle', and a surreal rate of cultural change.

Yang's photographic series 'Light and easy' 2002 captures, in freeze-frame, the new individualist ethos of the city's burgeoning middle classes. Young people pose on Shanghai's streets, each balancing a large upturned object — a motorbike, a police car, a vending machine, a military truck — on a single outstretched finger. Referencing a culture of speed, control, capitalistic desire and militarism, the artist questions the usefulness and logic of these objects as material references for the city's new-found progress by depicting their weight as absurdly feather-light. Acknowledging and mocking the heroic ambitions of his subjects, Yang suspends the logic and gravity of the city's increasingly capitalist order, where time and space for reflection are luxuries.

Some of the artist's most humorous and political works reference imagery from the Cultural Revolution to comment on present-day concerns about identity, relationships and the state. Plump hens and cockerels were a common motif in Cultural Revolution propaganda paintings, which lauded the productivity of rural life. Yang's earlier, much-discussed photographic series, 'Lucky family' 1995, posed pairs of docile, happy hens and cockerels, surrounded by chicks, in portraits of nuclear-family togetherness. Essentially reducing government policy to a breeding program, 'Lucky family' comments on the impact of China's 'one–child' policy on Confucianist traditions and the wellbeing of the nation's future generations.[2]

Chickens appear again in Yang's *922 rice corns* 2000, which playfully invokes China's past policies on gender equality, consumption, and economic rationalisation. A performance for digital video, *922 rice corns* sets a hen and a cockerel before the camera, alongside a large pile of rice. Aided by tallies at the bottom of the screen, two breathless voiceovers —

YANG ZHENZHONG

The Huangpu River looking toward Pudong. Suzhou Creek is at the bottom and Huangpu Park (previously the British Public Park) is at the lower right corner. The photograph was taken from the Shanghai Mansions in 1980

Photograph: Robert D Fiala

Roughly the same scene as the image to the left. The construction in Pudong only began in earnest in the mid 1990s. On the right is the tip of Huangpu Park and the recent Shanghai Monument to Heros. Taken from the Garden Bridge, 2001

Photograph: Robert D Fiala

Light and easy 2002
Type C photograph on paper, ed. 8/10 / 120 x 181.7cm / Purchased 2005. Queensland Art Gallery Foundation / Collection: Queensland Art Gallery

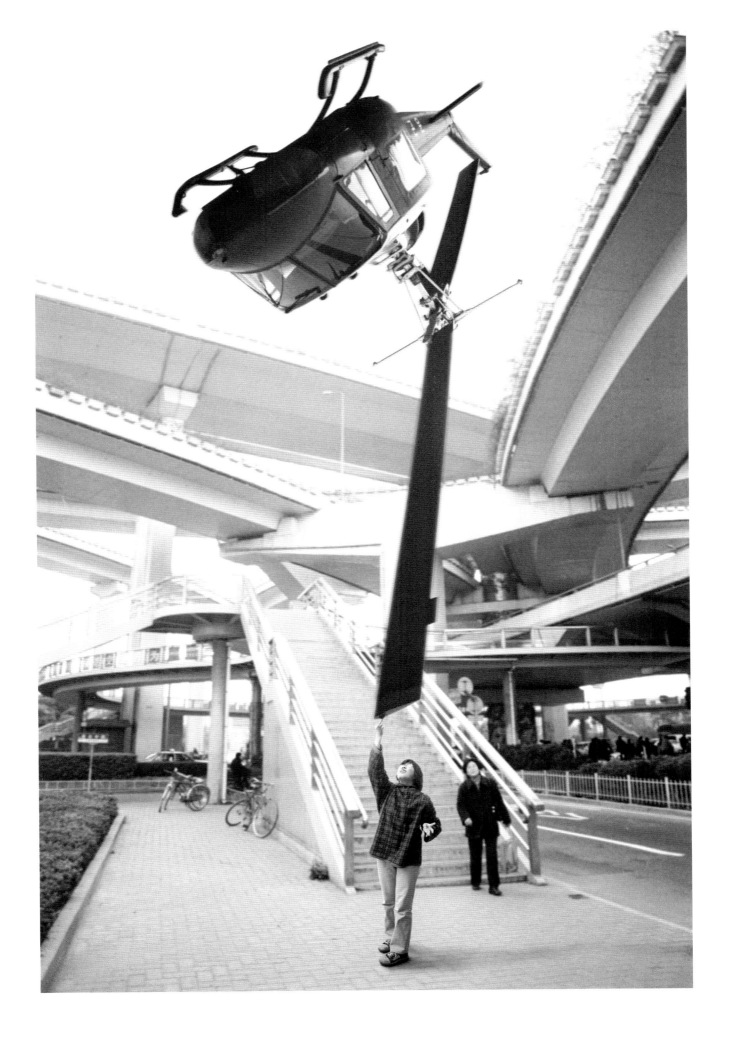

one male and one female — enumerate each fowl's progress in eating grains from the pile, in an absurd dramatisation of counting and consumption. The parody is drawn out in the manner of a joke without a punch line. *922 rice corns* refers to anachronistic cultural codes, but also draws connections to more timeless forms of introspection. The artist describes his deceptively simple premise:

> I held a handful of rice in my palm. I wanted to know how many grains there were. If I counted them one by one, it would take too much time. So I put the rice on the ground and let two chickens help me count them. I thought this was a clever way to do it. But the chickens were not teachable. Sometimes they didn't finish the rice, sometimes they fought each other. I tried again and again to film them . . . In the end, I got the number: 922. Now I know I am foolish. Chickens never want to know how much they eat. This is a human problem. Humans are stupid.[3]

The irreverence and striking visual humour in Yang's work is rooted in Buddhist philosophies about time and making. He explores general concepts through singular anecdotes, and uses humour to interrogate deep personal and cultural anxieties; explicit opinion is absent, and the artist refrains from making judgments. A meditation on the subject of mortality, *I will die (Shanghai version)* 2001 features people of varying ages and backgrounds in Shanghai's cafes and bars, and in their homes and offices. Yang asks these people to recite the simple phrase, 'I will die', directly to his camera. As the camera zooms in on each face, attention is drawn to the nonverbal expressions individuals bring to this innocent admission. The difficulty each subject has in acknowledging this truth in day-to-day language is variable and striking. Many laugh or giggle at the weight of the words. Yang has completed versions of this popular work in other countries, juxtaposing cultural responses to a subject that affects us all.

Yang understands that cultural and aesthetic change in China is increasingly mediated by commercial imagery and the moving image, above and beyond traditional artistic languages. His practice is driven by an interest in connecting local experiences to universal readings. He uses technology to engage with time and to create moments to reflect on past and future in a fast-moving present. At the core of his approach is a critical acknowledgment that sometimes it is only through artificial digital effects and gross temporal juxtapositions that such a synthesis of cultural realities can be achieved. Yang's practice is simultaneously funny and absurd, simple and exhilarating. Although containing a rich array of references most familiar to Chinese viewers, Yang Zhenzhong's deconstructive philosophy liberates broader audiences — if only for a moment — from some of the most futile aspects of contemporary urban life.

RACHEL O'REILLY is Curatorial Assistant, Video and New Media, Queensland Art Gallery / Gallery of Modern Art.

922 rice corns (stills) 2000
Betacam SP, 8 minutes, colour, sound, ed. 7/10 /
Purchased 2005. Queensland Art Gallery
Foundation / Collection: Queensland Art Gallery

I will die (Shanghai version) (stills) 2001
Betacam SP, 20 minutes, colour, sound /
The Kenneth and Yasuko Myer Collection of
Contemporary Asian Art. Purchased 2006 with
funds from Michael Simcha Baevski through the
Queensland Art Gallery Foundation Collection:
Queensland Art Gallery

Yoo Seung-ho is best known for his word-pictures. For a contemporary artist, his landscape works — one form that the word-pictures take — look anachronistic. At first glance, they appear to be a homage to a glorious, much earlier age of Chinese landscape painting. Beneath their apparently conservative visage, however, lies a playful and mildly irreverent attitude that is revealing of the artist's background and age. Yoo was born in 1973 and studied Western painting at Hansung University in Seoul.[1] Since graduating in 1999, his work has been included in the Gwangju Biennale 2002 and numerous exhibitions in Asia, North America and Europe.

When examined at close range, Yoo's landscape pictures are found to be composed of thousands of tiny Korean words or Hangul characters. The words are written rather than painted. They are selected for the sound they create when spoken out loud. They are onomatopoeic and generally funny. In some cases Yoo copies a detail from a famous Chinese painting or reworks elements from that painting, actively engaging with feelings of nostalgia and familiarity. Words are employed in the manner of a dot-screen, abstracting form and translating the painting into a language of the present. The work is slow, virtuosic and obsessive, requiring the painstaking repetition of the word or word phrase until the image approximates the outward appearance of the original.

In a series of works titled 'Yodeleheeyoo!', which draw on Chinese Northern Song dynasty (960–1127 CE) landscape painting — the Hangul word *ya-ho* is written out over and over again. Words are grouped tightly together in some areas to create a density of form, and sparsely in others to create the impression of a graded wash or a transition to an area of void. 'Yodeleheeyoo' is the song-like sound of Tirolean mountaineers, and *ya-ho* is the sound Koreans make when yodelling in the mountains. Yoo describes *ya-ho* as an echo word, one that reflects what he felt when looking at the original Chinese landscape painting. It is a word that activated his imagination. The title 'Yodeleheeyoo!' creates a bemused response in the viewer, who is encouraged to assume the role of a time-traveller, reclaiming and reconstituting the past.

Yoo writes his art works with a Rotring pen and ink, not brush and ink. He uses Korean mulberry paper called *hanji*, which he then mounts onto wooden boards for display. His tools combine those of a contemporary draftsman or cartoonist and a traditional painter. While Yoo employs calligraphy he denies its scholarly heritage. He also turns his back on the arcane Chinese tradition of textural brush strokes — a highly codified language in itself — that has historically been used to emulate nature and convey a particular artist's style. Chinese characters have long been used in inscriptions on traditional Chinese and Korean paintings and, when written by a skilled hand in brush and ink, are said to carry within them the spirit of the artist. Instead, Yoo uses Korean script known as Hangul, a phonemic writing system with an alphabet comprising letters, consonants and vowels. It was developed in the fifteenth century to create a national language that was distinct from Chinese. Today, Hangul is the script of everyday life in Korea and the writing system that Yoo grew up with. While Yoo's Rotring-drawn Hangul characters lack the modulation and lyricism of Chinese brush and ink calligraphy, they are not weighed down with serious and lofty emotion. Instead, Yoo's words are employed to perform a more

YOO SEUNG-HO

Yoo Seung-ho / Korea b.1973
Eoheung — Once upon a time 2006
Ink on paper / 231.5 x 140cm / Collection: The
artist / Image courtesy: One and J Gallery, Seoul

yodeleheeyoo! 2006
Ink on paper / 231.5 x 135cm / Collection: The
artist / Image courtesy: One and J Gallery, Seoul

Shoooo 2003–04
Ink on paper / 244 x 143cm / Private collection,
Seoul / Image courtesy: One and J Gallery, Seoul

analytical function. Disengaged from their subject, they are set free to engender feelings of humour and absurdity.

Despite their seductive and familiar appearance Yoo's word-pictures or 'character-figurations' remain curious texts. Viewers have no choice but to participate in a disorienting interactive experience involving image, word and sound. Yoo's word-pictures resonate with the early-twentieth-century French poet Guillaume Apollinaire's calligrams; the écriture works of Korean artist Park Seo-bo (b.1931); and Lee Ufan's calligraphic 'With winds' series, which reverberate with sound and movement. They may also be regarded as a reaction to the character abstractions of Korean modernist artists Nam Kwan (1911–90) and Lee Ung-no (1904–89) — artists who employed elegant and spare forms derived from Hangul script in the creation of an abstract art.[2] They can also be considered in relation to the large and symbolic illustrated Chinese characters found in Korean folk art known as *min-hwa*. Decorative folk paintings, which date from the eighteenth and nineteenth centuries, were freely brushed onto walls or onto multi-fold screens. In some of these paintings, vignettes of elegant lives, as well as symbolic motifs and auspicious emblems are contained within the outlines of large Chinese characters. These are intended to impress upon the viewer sentiments such as filial piety, loyalty, devotion or longevity.[3] These paintings draw on Chinese calligraphic and visual traditions, as well as wordplay and are paintings within words. What Yoo creates is very different, but perhaps not entirely unrelated. Yoo employs words within his paintings — Korean words, with global references and applications that do not require such intensive decoding. In doing so, he creates a form of conceptual art that plays with and subverts the idea of Chinese landscape painting, which is widely regarded as the ultimate expression of east Asian art.

Yoo combines elements of the past and the present in a quietly confrontational manner. His word-pictures refer to the cultural and artistic baggage that many artists from east Asia carry around with them and find hard to shake off. At the same time, he denies specific cultural and artistic references by introducing words and sounds that are familiar to all people. By employing transnational elements in his pictures, Yoo forges a new artistic language that places the past firmly in the service of the present. Yoo dismantles and transforms canonical works of art and creates structures that are suffused with a breath-like insubstantiality that is fragile and appears on the verge of disintegration. Drawing on faculties of sight, hearing, imagination and humour, he reconstitutes works of art in his own image.

CLAIRE ROBERTS is Senior Curator, Asian Decorative Arts and Design, at the Powerhouse Museum. She has curated numerous exhibitions and written widely on east Asian art and decorative arts, with a particular focus on twentieth century and contemporary art.

Plush, plush 2006
Ink on paper / 231.5 x 135cm / Collection: The artist / Image courtesy: One and J Gallery, Seoul

Wang Jianzhang / China active c.1620–50
Returning home from gathering fungus 1628
Hanging scroll, ink and colour on paper / 85.4 x 51.2 cm / Purchased with Funds provided by Mr Edward Sternberg 1991 / Collection: Art Gallery of New South Wales, Sydney

Suraksan Mountain, near the artist's studio in Seoul, South Korea, 2006
Queensland Art Gallery Image Archive

AESTHETIC POLITICS

1 Debate abounds about the main theme of *The Searchers*. Many commentators look past the theme of racism to focus on the theme of obsession. Others see revenge or the dehumanising loss of tenderness as the foregrounded concern. Even so, no matter which theme is spotlighted, while viewing *The Searchers* one always feels a deep, emphatic yearning for one's own alteration, the desire to find a different, more humane way to engage with the world and its harshness.

2 GA Wilkes and WA Krebs (eds), *Collins English Dictionary*, 3rd edition, Harper Collins, Sydney, 1991, p.24.

3 Nicholas Bourriaud, *Relational Aesthetics*, trans. Matthew Copeland, Les Presses du réel, Paris, 2002 (originally published in French in 1998).

OUR HISTORY IS WRITTEN IN OUR MATS

Thanks to Annie Coombes for a short discussion that gave me the confidence to complete this essay, and thanks to Maud Page for her encouragement and patience.

1 For its opening installations, the Tate Modern, London, opted to configure objects thematically in an effort to create a more lateral and ambient dialogue between objects and the ideas inherent in them. Within each collecting area, the works of artists from different generations were linked by thematic associations rather than historical time frames. More recently the Tate has reviewed its collection installations to accord with a more linear, 'art historical' model.

2 This was not much ameliorated by 'Century City', 1 February – 29 April 2001, a major temporary exhibition that used the art of ten cities over ten decades to reflect on the twentieth century. Although the concept had real potential — certainly some sections, such as that which presented Bombay, were genuinely exciting — the realisation was flawed and, in the end, unadventurous. The mixed reception that this show received, moreover, it appears, gave Tate managers and curators cold feet. If one is to venture beyond the art of Europe and the United States, Frida Kahlo does not represent much of a risk.

3 See Susanne Küchler, 'The modality of time-maps: Quilting in the Pacific from another point of view', *Res*, no.47, 2005, pp.179–190.

DANCING OCEANIA

I wish to thank David Hanlon, Director of the Center for Pacific Islands Studies, for funds that allowed me to attend the Dance conference and carry out research. I am also grateful to Epeli Hau'ofa as well for my brief stint at the Oceania Centre for Arts and Culture. This paper has benefited from the comments of Jane Moulin and Katerina Teaiwa.

1 There have been recent developments in the Hawai'i dance scene that are worthy of mention here. In particular, the *Holo Mai Pele* productions led by the Kanahele sisters; innovative choreography of the Tau Dance Theatre, led by Peter Rockford Espiritu, which draws from Western as well as traditional Hawaiian dance movements; and Patrick Makuakane's *halau, Na Lei Hulu I Ka Wekiu*. Tau Dance Theatre has collaborated with the Kanahele sisters and their *halau* in the past, producing dance movements and music that were fresh and energetic, while Makuakane's San Francisco *halau* has the potential to be the best contemporary dance group in the United States. Their brilliant *The Natives are Restless* 2000 comes closest to the kind of productions that the Oceania Dance Theatre have produced in the last five years — in terms of dramatic style and generous borrowing from different dance and music traditions.

2 Jane Moulin, 'What's mine is yours? Cultural borrowing in a Pacific context', *The Contemporary Pacific*, vol.8, no.1, 1996, pp.128–153. Moulin discusses cultural borrowing among the Cook Islands, Tahiti and the Marquesas Islands, and how protective each of these cultures can be about what they see as their unique dances or music.

3 Moana Jackson, 'Reality, identity, and the eating of M & Ms', paper given at a United Nations Global Seminar organised by the School of Hawaiian, Asian, and Pacific Studies, University of Hawai'i, 19–22 March 2004.

4 Epeli Hau'ofa, 'Our place within: Foundations for a creative Oceania', keynote address at the Museum of New Zealand Te Papa Tongarewa, Wellington, 9–12 November 2005.

5 In 2006, a number of traditional dances (such as the hula) became acceptable in some Christian churches.

6 FLS Angas, *Polynesia: A Popular Description of the Islands of the Pacific*, Society for the Promotion of Christian Knowledge, London, 1866, p.287.

7 William Ellis, *Polynesian Researches, During a Residence of Nearly Six Years in the South Sea Islands*, 1829, 2nd edn, Fisher, Son and Jackson, London, 1832–1834, p.219.

8 Another example is Pulapese dance, which the missionaries stopped in the late 1940s. See Juliana Flinn, 'Pulapese dance: Asserting identity and tradition in modern contexts', in *Pacific Studies*, vol.15, no.4, 1992, pp.57–66.

9 For example, imported fabric may be used as loincloth. See Flinn, p.58, where the author reports that the Pulapese want to appear 'part of modern Micronesia' rather than museum pieces. Flinn also makes the case that the Pulapese invoke tradition in the present for 'prestige, recognition, or power'. Also see Adrienne L Kaeppler, 'Epilogue: States of the arts', *Pacific Studies*, vol.15, no.4, 1992, pp.311–318. Kaeppler uses the term 'evolved traditional' for art that has 'evolved along traditional lines, retaining its indigenous basic structure and sentiment'. She contrasts this with 'folk art' and 'airport art'. And see Karen Stevenson, '"Heiva": continuity and change of a Tahitian celebration', *The Contemporary Pacific*, vol.2, no.2, 1990, pp.255–78.

10 See Moulin, 'Oltobed a Malt (Nurture, Regenerate, Celebrate): The 9th Festival of Pacific Arts, Koror, Palau, 22–31 July 2004', *The Contemporary Pacific: A Journal of Island Affairs*, vol.17 no.2, 2005, pp.512–16. Also see Karen Nero, 'Introduction: Challenging communications in the contemporary Pacific', *Pacific Studies*, vol.15, no.4, 1992, pp.1–12. According to Nero, the festival was supposed to be held in New Caledonia in 1984 to coincide with Kanaky independence but the French government postponed the festival because of political unrest. It was held in Tahiti a year later.

11 See Moulin, 2005, p.515, for another account of how 'false breasts and buttocks' offended many Islanders. According to Moulin (personal communication with author, 2006), this quote refers to Taiwanese dancers who wore plastic buttocks and breasts under their costumes and then exposed them in a rather crude fashion. For a different perspective, see Glenn Petersen, 'Dancing defiance: The politics of Pohnpeian dance performances', *Pacific Studies*, vol.15, no.4, 1992, pp.13–28. Peterson reports that at the 1985 Festival of Pacific Arts in Tahiti, 'the Pohnpeian women, as well as the men, danced bare-breasted'. Upon their return, they reported that 'they were the only dancers to perform in true island style' and that viewers were enchanted.

12 Countries such as Tonga and Tuvalu are good examples.

13 For examples, see Moulin, 1996, pp.128–53.

14 Hau'ofa, 'Our place within: Foundations for a creative Oceania', Forge Memorial Lecture, Australian National University, Canberra, 2003.

15 Pule was an artist-in-residence at the Oceania Centre for Arts and Culture at the beginning of 1998, a year after it opened.

16 See *Culture Moves! Dance in Oceania from hiva to hip hop: A Pacific Studies Conference* [program booklet], 9–12 November 2005, p.32, <www.hawaii.edu/cpis/dance>, viewed 2006. In 2000, two performances were held at the Australian National

ENDNOTES

University and at a conference organised by the Center for Pacific Islands Studies at the University of Hawai'i. Titled *The Boiling Ocean*, this performance drew its inspiration from the political crises in Fiji and the Solomon Islands.

17 *Culture Moves!* [program booklet], p.26.

18 Alo had left already for Samoa since the University was in recess for the Christmas holiday.

19 Dance members, personal communication with author, December 2005.

20 Hau'ofa, 2003.

21 Hau'ofa, 2003.

22 Hau'ofa, 2003.

23 Hau'ofa, 2003.

24 *Culture Moves!* [program booklet], p.1.

25 See Moulin, 1996, pp.147–48, for a brief report on negative reactions to contemporary forms such as an emphasis on theatre groups and popular music stars at the Festival of Pacific Arts held in the Cook Islands in 1992. I am inclined to agree with Moulin that 'The new and the old can coexist in the Pacific as they do elsewhere — one does not threaten the other'.

26 See Petersen, pp.13–28, for a discussion on how dance and politics are closely linked on Pohnpei. Also see Dorothy K Billings, 'The theater of politics: Contrasting types of performance in Melanesia', *Pacific Studies*, vol.15, no.4, 1992, pp.211–33. Billings asserts that 'Without politics, art has no power; without art, politics has nowhere to go'.

27 At the Oceania Dance Theatre's performance at Te Papa Tongarewa, one of the dancers was Caucasian.

28 In December 2005, Hau'ofa expressed concern that some colleagues at the USP were advocating the attachment of the centre to another School or program. Once this happens, the centre will lose its autonomy and freedom, and Hau'ofa will have to contend with bureaucratic structures and their constraints.

SEEING WHAT IS (THERE)

1 Paul Willemen's formulation is discussed in E Ann Kaplan, 'Melodrama/subjectivity/ideology: Western melodrama theories and their relevance to recent Chinese cinema', in *Melodrama and Asian Cinema*, ed. Wimal Dissanayake, Cambridge University Press, Cambridge, 1993, p.26.

2 Walter Benjamin, 'The task of the translator', in *Illuminations*, Knopf Publishing Group, New York, 1969.

3 Sarat Maharaj, '"Perfidious fidelity": The untranslatability of the other', in *Global Visions: Towards a New Internationalism in the Visual Arts*, ed. Jean Fisher, London, Kala Press, 1994, pp.31–2. See also Jacques Derrida, *Monolinguilism of the Other, or the Prosthesis of Origin*, trans. Patrick Mensah, Stanford University Press, Stanford, 1996; and Gayatri Spivak, 'The politics of translation', in *Outside in the Teaching Machine*, Routledge, New York, 1993, pp.179–200.

4 Hong Kong, Shanghai: Cinema Cities, from 2 March to 27 May 2007, is timed for midway between the centenary of mainland Chinese cinema in 2005 and

of Hong Kong cinema in 2009. Focus seasons will be presented on Ruan Lingyu, Sun Yu, Li Lihui, Linda Lin Dai, Grace Chang, the screenplays of Eileen Chang, and on 'tenement' films. The earliest title included is the earliest Chinese film known to be still in existence, Zhang Shichuan's *Zhi Guo Yuan/Laogong Aiqing (Labour's Love)* 1922. The latest mainland Chinese film included in the program is *Wang Ping, Nihongdeng xia de Shaobing (Sentinels under the Neon Lights)* 1964 and the last film produced in Hong Kong to be screened is Yi Wen and Wang Tianlin, *Jiao Wo Ru He Bu Xiang Ta (Because of Her)* 1963.

5 Miriam Bratu Hansen, 'Fallen women, rising stars, new horizons: Silent film as vernacular modernism', *Film Quarterly*, vol.54, no.1, p.20.

6 Zhang Zhen, *An Amorous History of the Silver Screen: Shanghai Cinema, 1896–1937*, University of Chicago Press, Chicago, 2005, p.21.

7 Hansen, *Film Quarterly*, p.14.

8 'Boule de Suif' has been filmed many times in Europe, the United States and the USSR. A similar story is told by Josef Von Sternberg in *Shanghai Express* 1932, in which Marlene Dietrich plays Shanghai Lily who sacrifices herself to ruthless Revolutionary commander Henry Chang to save other passengers on a train travelling to Shanghai.

9 Hansen, *Film Quarterly*, p.12.

10 Hansen, 'The mass production of the senses: Classical cinema as vernacular modernism', in *Reinventing Film Studies*, eds C Gledhill & L Williams, Arnold, London, 2000, pp.341–2.

11 Wimal Dissanayake, 'Introduction', in *Melodrama and Asian Cinema*, ed. Wimal Dissanayake, Cambridge University Press, Cambridge, 1993, p.3.

12 Compare to Ravi S Vasuevan, 'The politics of cultural address in a 'transitional' cinema: A case study of Indian popular cinema', in *Reinventing Film Studies*, eds C Gledhill & L Williams, Arnold, London, 2000, p.134: 'Recent analyses of the popular cinemas in the "non-Western" world have indicated that the melodramatic mode has, with various indigenous modifications, been a characteristic form of narrative and dramaturgy in societies undergoing the transition to modernity'.

13 Vasuevan, p.136.

14 Gina Marchetti, 'Two stage sisters: The blossoming of a revolutionary aesthetic' in Harry H Kuoshu, *Celluloid China: Cinematic encounters with culture and society*, Southern Illinois University Press, Carbondale and Edwardsville, 2002.

15 E Ann Kaplan, 'Melodrama/subjectivity/ideology: Western melodrama theories and their relevance to recent Chinese cinema', in *Melodrama and Asian Cinema*, ed. Wimal Dissanayake, Cambridge University Press, Cambridge, 1993, p.10.

16 See Benjamin, 'The work of art in the age of mechanical reproduction', in *Illuminations*; Susan Buck-Morss, 'Aesthetics and anaesthetics: Walter Benjamin's art work essay reconsidered', *October*, no.62, pp.3–41;

Hansen, 'Benjamin and the cinema: Not a one-way street', *Critical Inquiry*, vol.25, no.2, pp.306–43.

17 Geeta Kapur, 'Place of the modern in Indian cultural practice', in *Creative Arts in Modern India: Essays in Comparative Criticism*, eds R Parimoo and I Sharma, Books & Books, New Delhi, 1995, p.28.

18 Kumar Shahani, interview with June Givanni, *Black Film Bulletin*, vol.4, no.2, pp.4–5.

19 See 'Specially commissioned introduction to The River by Indian filmmaker Kumar Shahani' on Jean Renoir, *The River* 1951, DVD, BFI Video Publishing, British Film Institute, London, released 2006.

20 Kumar Shahani, 'Ideological ironies', *Framework: Journal of Cinema and Media*, no 30/31, 1986, p.97.

AI WEIWEI

1 Chin-Chin Yap and Jonathan Napack, *Ai Weiwei Works: Beijing 1993–2003*, ed. C Merewether, Timezone 8, Hong Kong, China, 2003, p.30.

2 The importance of the Han dynasty (206 BCE – 220B CE) is such that even today China's ethnic majority refers to itself as the 'people of Han'. It was an era of political consolidation, military expansion, economic prosperity, cosmopolitanism, scientific advancement and artistic florescence in which China officially adopted Confucianism as the state orthodoxy, a philosophy that remains a seminal influence on Chinese political and social thinking to the present day.

3 Yap and Napack, p.31.

4 He Wenzhao, 'Excerpts from interview with Ai Weiwei', *Beijing 798: Reflections on Art, Architecture and Society in China*, ed. Huang Rui, Timezone 8 and Thinking Hands, Hong Kong, China, 2004, p.26.

JACKIE CHAN

1 This scene of sending young Jackie Chan to the Peking Opera school is recaptured and sentimentally represented in Alex Law's film *Painted Faces* 1988.

2 Hong Kong Film Archive, *The Making of Martial Arts Films — As Told by Filmmakers and Stars*, Provincial Urban Council, Hong Kong, 1999, p.47.

3 David Bordwell, *Planet Hong Kong: Popular Cinema and the Art of Entertainment*, Harvard University Press, Cambridge, 2000, p.58.

BECK COLE

1 After graduating in 2002, Cole became a regular crew member of Central Australian Aboriginal Media Association (CAAMA) Productions. Owned by the Aboriginal people of Central Australia, CAAMA Productions' objectives focus on the social, cultural and economic advancement of Aboriginal peoples.

2 This fly-on-the-wall or observational documentary style allows the audience to view the subjects' stories unfolding without the overt presence of the filmmaker.

3 *Wirriya Small Boy* 2004, Mini DV and Digital Betacam, colour, 26 mins, Australia, Warlpiri and English (English subtitles).

4 Beck Cole, interview with author, 16 June 2006.

5 TAB is a company that provides wagering and gaming services in venues around Australia.

JUSTINE COOPER

1 This is believed to have been the camera used by museum research scientist Samuel Harmstead Chubb; an animal specimen mounted by Chubb appears in a glass case behind a stuffed polar bear in Cooper's photograph, *The waiting room* 2005, from the 'Saved by science' series.

2 Over the six-year Lang–Chapin Expedition, extensive diaries and field notes were maintained. Lang took over 9500 photographs and Chapin completed around 300 drawings in watercolour and ink. See Gordy Slack, 'The Lang–Chapin zoological collections', American Museum of Natural History, <http://diglib1.amnh.org/articles/bio_collections/bio_collections.html>, viewed August 2006.

3 Anthony Troncale, 'The field photographs of Herbert Lang from the American Museum Congo Expedition, 1909–1915', <http://diglib1.amnh.org/articles/lang_photos/lang_photos1.html>, viewed August 2006. Skins sent back by the Lang–Chapin Expedition feature in a number of the celebrated dioramas in the museum's African Hall, famously redesigned by Carl Akeley and reopened in 1936. Akeley, adventurer, taxidermist and sculptor, promoted the role of artistic interpretation in the museum displays, especially its large-scale models and dioramas. See Penelope Bodry-Sanders, *Carl Akeley: Africa's Collector, Africa's Saviour*, Paragon House, New York, 1991; and Donna Harraway, *Primate Visions: Gender, Race, and Nature in the World of Modern Science*, Routledge, New York, 1989.

4 Justine Cooper, 'Rapt', *Prefiguring Cyberculture: An Intellectual History*, eds Darren Tofts, Annemarie Jonson and Alessio Cavallaro, MIT Press, London, and Power Publications, Sydney, 2003, pp.188–9.

5 The soundtrack was created in collaboration with Tammy Brennan and Mazen Murad, as described by Cooper in an email to the author (August 2006): 'I mapped out the space by department and made suggestions of sounds, including providing some of the field recordings that I or my husband, Joey Stein, had made in upstate New York and Australia. Tammy worked at the BBC sound archive and collected the other sounds we needed from there, including the baby, chanting, wailing, and chain saw. I made suggestions for "Anthropology" to be people using tools, instruments, talking, walking through brush, etc., but gave them the freedom to put it together and add to that. The first "draft" actually sounded like the sacking of a village and was pretty terrifying'.

6 Justine Cooper, quoted in *Justine Cooper*, Nova Media, 2004, <http://www.novamedia.com.au/artists.

php?view=Justine%20Cooper&sub=About&PHPSESSID=9667cd9a2370c1bbec1dfa053c454e11>, viewed July 2006.

EX **DE MEDICI**

1 eX de Medici, conversation with author, September 2006.

2 Norman Bryson, *Looking at the Overlooked: Four Essays on Still Life Painting*, Reaktion, London, 1990, p.106.

3 Viewed in the touring exhibition, 'An Exquisite Eye: The Australian Flora and Fauna Drawings 1801–1820 of Ferdinand Bauer', Historic Houses Trust, Sydney, 13 December 1997 – 19 April 1998.

4 An Australia Council Visual Arts and Craft Award enabled de Medici to undertake her research in 2001 at the ANIC, which is managed by the Entomology Division of the Commonwealth Scientific and Industrial Research Organisation in Canberra.

5 The great age of Dutch painting coincided with the advances in optics that produced both the microscope and the telescope. See Svetlana Alpers, *The Art of Describing: Dutch Art in the Seventeenth Century*, Penguin, London, 1983, ch.3.

6 eX de Medici, conversation with author, September 2006.

7 Margaret Plant, 'Endisms and Apocalypses in the 1980s', *Art and Text*, no.39, May 1991, p.29.

8 Craig Owens, 'The Allegorical Impulse: Toward a theory of Postmodernism', in ed. Brian Willis , *Art after Modernism: Rethinking Representation*, New Museum of Contemporary Art, New York, 1984, p.205.

9 The 'Enlightenment' refers loosely to developments in European philosophical and scientific thought in the seventeenth and eighteenth centuries which were perceived as a rejection of ignorance and obscurity in favour of the 'light' of truth. The motto of the Enlightenment is *Sapere aude* — Have courage to use your own reason — which champions the individual's rational thought over received doctrines or superstitions. Enlightenment thought instilled in the Western ethos the notion of progress, whose attendant evils make up one of the themes of de Medici's art.

10 eX de Medici, quoted in Kelly Gellatly, *Soft Steel: eX de Medici — Recent Work* [exhibition catalogue], Heidi Museum of Modern Art, Melbourne, 2003, p.15.

JITISH **KALLAT**

1 The massacres in Gujarat in 2002 were not unprecedented. Since the demolition of the Babri Mosque in Ayodhya in December 1992, heralding the rise of Hindu fundamentalism in Indian politics, there have been numerous attacks on Muslim and Christian minorities, most often with state machinery abetting the violence.

2 Among Kallat's formidable array of technical skills is his speed with freehand typography. He frequently uses text in regular as well as modified English fonts in his works, spelling out titles and allegorical messages onto their various surfaces.

3 The whole process was a messy and toxic business that required him to wear multiple masks saturated with water to protect him from the fumes, while hoping that the landlord would not prematurely terminate his lease on a rented space because of the stink. Jitish Kallat, email to the author, 14 June 2006.

4 See Britta Erickson, *The Art of Xu Bing: Words without Meaning, Meaning without Words* [exhibition catalogue], University of Washington Press, Seattle, and Arthur M Sackler Gallery, Smithsonian Institute, Washington, 2001.

5 See Julie Ewington, 'Savanhdary Vongpoothorn: Floating words' in *Zones of Contact: 2006 Biennale of Sydney* [exhibition catalogue], Biennale of Sydney Ltd, Sydney, 2006, pp.280–81.

6 Jawaharlal Nehru, 'Speech on the Granting of Indian Independence', to the Constituent Assembly of India, New Delhi, 14 August 1947.

7 Jitish Kallat, email to the author, 14 June 2006.

BHARTI **KHER**

1 Based in the United Kingdom in the 1990s, the Young British Artists were noted for their shock tactics and use of throw-away materials. Their controversial art work and often wild lifestyles attracted considerable media attention.

2 The term bindi is derived from *bindu*, the Sanskrit word for a dot or a point.

3 Bharti Kher, interview with author, 11 July 2006.

4 See Anita Roy, 'When your third eye becomes a second skin', *The Oberoi Group Magazine*, winter, 2003–04, pp.61–5.

5 Also see Meera Menezes 'Composite creatures, hybrid selves', in *Art India*, vol.9, no.3, 2004, pp.108–9.

SUTEE **KUNAVICHAYANONT**

1 Somsak Chowtadapong, in *Bangkok Art Project 1998 Thailand* [exhibition catalogue], Committee of Bangkok Art Project, 1999, p.173.

2 'Raindrops: Pig's Shit Running', Tadu Contemporary Art, Bangkok, 12 June – 26 July 1998.

3 *Elephant (breath collecting)* first appeared at Tadu Contemporary Art gallery in 1998, along with other works and inflatables including a water buffalo — *The myth from the rice field (breath donation)* 1998 — and a tiger.

4 Elizabeth Sussman, 'Britannia's Biennial', *Art in America*, vol.88, no.7, 2000, pp.55, 57, 59.

5 Sutee Kunavichayanont received a BFA (Graphic Arts) from Silpakorn University in 1989, and an MA (with a focus on printmaking) from Sydney College of the Arts in 1993.

6 Sutee Kunavichayanont, quoted in Steven Pettifor, 'For all times', *Asian Art News*, vol.12, no.1, 2002, pp.76–77.

7 The student was quoted in 'Sutee Kunavichayanont: Works 1993–2005', unpublished document from the artist, 2006.

8 *Stereotyped Thailand* was first exhibited at 100 Tonson Gallery, Bangkok, 25 August – 2 October 2005.

9 Sutee Kunavichayanont, quoted in

Khetsirin Pholdhampalit, 'Attention class', *The Nation*, Bangkok, 3 September 2005, <www.nationmultimedia.com>, viewed August 2006.

KWON KI-SOO
Translated from Korean by Minkyu Lee and SBS Language Services, Sydney.

1 Neo-Pop, a movement of the 1980s, is characterised by popular iconography and applies mass media communication techniques to 'package' complex ideas for a wider audience.

2 The literati were the intellectual elite in Korea. Becoming a member of this class involved rigorous study of Confucian texts and ancient poetry and the disciplined practice of calligraphy to pass difficult bureaucratic examinations for government service.

DINH Q **LÊ**

1 In this publication, the term Vietnam–US War is generally used, seeking to accommodate various names given to the war in Vietnam (1959–75) between the Vietcong, supported by North Vietnam, and the South Vietnamese government, supported by the United States. Many Vietnamese (particularly from the North) know it as the American War or American–Vietnam War or Anti-American War of Resistance for National Salvation, although it is commonly known in the West as the Vietnam War.

2 In 1978, Vietnamese forces invaded Cambodia in response to the invasion of Ha-Tien by the Khmer Rouge, who slaughtered thousands of Vietnamese women and children. In 1979, Vietnam took Phnom Penh, forcing the Khmer Rouge to flee to the Thai border.

3 Dinh Q Lê, quoted in Moira Roth, 'Obdurate history: Dinh Q Lê, the Vietnam War, photography, and memory', *Art Journal*, vol.60, no.2, 2001, p.44.

4 Jill Bennett, *Empathic Vision: Affect, Trauma, and Contemporary Art*, Stanford University Press, Palo Alto, 2005, p.24.

5 Karen Irvin, *Stages of Memory: The War in Vietnam* [exhibition catalogue], Museum of Contemporary Photography, Chicago, 2005.

6 *The farmers and the helicopters* was made in collaboration with Tuấn Andrew Nguyễn and Hà Thúc Phù Nam. The video installation includes interviews with Lê Văn Đành, Trần Quốc Hải, Trần Văn Giác, Vương Văn Bang, Phạm Thị Hồng and Trần Thị Đào and footage from *Apocalypse Now* (Francis Ford Coppola, 1979), *Platoon* (Oliver Stone, 1986), *The Deer Hunter* (Michael Cimino, 1978), *We Were Soldiers* (Randall Wallace, 2002), *Full Metal Jacket* (Stanley Kubrick, 1987) and *Born on the Fourth of July* (Oliver Stone, 1989).

7 The Vietnam–US War is regarded as the first major helicopter war. On 11 December 1961, the first US military helicopter unit, 33 Vertol H-21C Shawnee helicopters and 400 crewmen, arrived in Vietnam. Over the

next 15 years, approximately 12 000 helicopters were in action.

8 American forces sprayed an estimated 14–19 million gallons of herbicides from 1961 to 1971, covering 6 million acres of land in Vietnam.

9 In June 2006, the United States government reiterated its policy not to compensate Vietnamese victims of Agent Orange; instead, offering the Vietnamese government scientific information and advice to deal with the effects. In 2005, a lawsuit by the Vietnam Association for Victims of Agent Orange/Dioxin (VAVA) against the chemical manufacturers was dismissed. At the time of publication, the VAVA are appealing the court's decision.

10 In 1998, *Damaged gene* sold US$100 worth of materials. Proceeds from the ongoing project are donated to the Thanh Xuan Peace Village, a Hanoi-based non-profit organisation that provides accommodation and support for children affected by Agent Orange.

11 Susan Sontag, *Regarding the Pain of Others*, Farrar, Straus and Giroux, New York, 2003, p.90.

TWO STEPS FORWARD, ONE STEP BACK

1 The flight of Muhammad from Mecca to Yathrib (later Medina) in 622 CE.

2 It is enlightening, if not essential, to consider this recent artistic undertaking in light of the republication of Frederic Tuten's pop classic, *The Adventures of Mao on the Long March*, originally published by Citadel Press (New York) in 1972 and reissued as a New Directions Classic in 2005.

3 See my comments on Feng Mengbo's early work in my *In the Red: On Contemporary Chinese Culture*, Coumbia University Press, New York, 1999, p.231.

4 Mao Zedong, 'On tactics against Japanese imperialism' (27 December 1935), in *Selected Works of Mao Tse-tung*, vol. 1, Foreign Languages Press, Peking, 1967, pp.153-78.

5 *The Long March — A Walking Visual Display*, Long March Foundation, New York, and The 25000 Cultural Transmission Center, Beijing, <www.longmarchspace.com>.

6 For an example of one of the Red Guard marches and a detailed map drawn by one of the participants, see the film *Morning Sun*, Longbow Group, Boston, 2003, and related website <http://www.morningsun.org/living/redguards/nlm02.html>.

7 'It is right to rebel' (*zaofan you li*) was the slogan and clarion call of the first Red Guards in 1966.

HONG HAO

1 Hong Hao, 'About the selected scriptures', in *The Selected Scriptures of Hong Hao*, eds J Escher and M Kielstra, Canvas Foundation, Amsterdam, 1999, p.14.

2 Hong Hao, 'Brief statement', in *Young Chinese Artists, Text and Interviews: Chinese Contemporary Art Awards 1998–2002*, ed. Ai Weiwei, Timezone 8, Hong Kong, 2002, p.105.

3 *The Yang Ban Xi* (Eight Model Works) were officially sanctioned operas or

ballets performed on stage and screen during the Cultural Revolution (1966–76). With elaborate stage-settings, chorus lines and costumes, the *Yang Ban Xi* were rousing tales of personal sacrifice and heroic battles. Many were about the formation of the Red Army, victorious battles against the Kuomintang or the overthrow of feudal landlords. The most popular were *The Red Detachment of Women*, *The Red Lantern*, *Taking Tiger Mountain by Strategy* and *The White Haired Girl*.

4 Lu Jie and Qiu Zhijie, 'Long March: A Walking Visual Exhibition', *Yishu*, vol.1, no.3, p.58.

LI TIANBING

1 Lu Jie and Qiu Zhijie. 'Curators' words', *Long March — A Walking Visual Display*, Long March Foundation, New York, 2003, unpaginated.

2 Li Tianbing, quoted in Jonathan Watts, 'My old China', *Guardian Unlimited*, 13 October 2004, <http://arts.guardian.co.uk/features/story/0,,1326115,00.html>, viewed March 2006.

LIU JIEQIONG

1 Zhang Daoyi, *The Art of Chinese Papercuts*, Foreign Languages Press, Beijing, 1989, p.5.

2 Liu Jieqiong, quoted in Wang Shanshan, 'Scissor kicks: art of the paper cut', *China Daily*, 12 April 2004, <http://www.chinadaily.com.cn/english/doc/2004-04/12/content_322591.htm>, viewed June 2006.

3 See Homi K Bhabha, 'How newness enters the world: postmodern space, postcolonial times and the trials of translation', in *The Location of Culture*, Routledge, London and New York, 1994, pp.212–35; Marian Pastor Roces, 'Consider post culture', in *Beyond the Future: Papers from the Conference of the Third Asia–Pacific Triennial of Contemporary Art*; 10–12 September 1999, Queensland Art Gallery, Brisbane, 2000, pp.34–8; and Jyotindra Jain, *Other Masters: Five Contemporary Folk and Tribal Artists of India* [exhibition catalogue], Crafts Museum and the Handicrafts and Handlooms Exports Corporation of India, New Delhi, 1998.

4 Lu Jie & David Tang, *The Great Survey of Paper-cutting in Yanchuan County* [exhibition catalogue], 25000 Cultural Transmission Center, Beijing, 2004.

5 Liu's work has been featured in a number of exhibitions and publications in Beijing. See, for example, Feng Shanyun, Gao Fenglian (eds), *The Patchwork Art of Shaanxi Province*, Foreign Languages Press, Beijing, 2002; and *Getting Close to the Origins of Chinese Paper-cutting* [exhibition catalogue], National Art Museum of China, Beijing, China, 2004.

6 Yanchuan was chosen for the exhibition as the area is famous for its many papercut artists, most of whom are women. Accompanying a small surveying team, Liu travelled to many villages in the region, to collect paper-cutting samples and interview artists. The Long March's follow up to the project, 'Revisiting Yanchuan County',

commenced on 2 May 2006 and aims to establish paper-cutting as part of an art education curriculum and teacher training program in primary schools in Yanchuan.

7 Lu Jie, *Long March Capital — Visual Economies of TransMedia*, tm.06 conference, <http://www.transmediale.de/page/detail/detail.0.persons.645.3.html>, viewed June 2006.

MU CHEN AND SHAO YINONG

1 Compare with ideas about photography in Claude Lichtenstein and Thomas Schregenberger, *As Found: The Discovery of the Ordinary: British Architecture and Art of the 1950s*, Princeton Architectural Press, New York, 2001.

2 Shu Yang, 'Documents of collective memory', in *Shao Yinong & Muchen*, Éditions de l'Oeil, Montreuil, 2003, pp.14–21.

3 Zhu De was the commander of the Red Army and subsequently the commander of the People's Liberation Army.

4 *Chinese Young People Prefer Red Tourism in May Day Holiday*, People's Daily Online, <http://english.people.com.cn/200505/03/eng20050503_183639.html>, viewed May 2006.

5 China National Tourist Office, *China Tourism Statistics*, April 2006, <http://www.cnto.org/chinastats.asp>, viewed May 2006.

6 Yan Wei, 'New march of red tourism', *Beijing Review*, vol.48, no.19, 2005, <http://www.bjreview.com.cn/En-2005/05-19-e/china-2.htm>, viewed May 2006.

7 Zheng Li, '"Red Tourism" can be more colourful', *China Daily*, 7 November 2005, <http://www.chinadaily.com.cn/english/doc/2005-07/09/content_458718.htm>, viewed May 2006.

QIN GA

1 Jane Caplan, 'Introduction', in *Written on the Body: The Tattoo in European and American History*, ed. J Caplan, Princeton University Press, Princeton, 2000, p.xiv.

2 Makiko Kuwahara, *Tattoo: An Anthology*, Berg, Oxford, 2005, p.17.

3 'Mao Tsetung: the art of war', in *Revolutionary Worker*, no.1031, 21 November 1999, <http://revcom.us/a/v21/1030-039/1030/50mhis1.htm>, viewed 10 July 2006.

4 See for example Ed Jocelyn & Andrew McEwan, *The Long March*, Constable and Robinson, London, 2006. The authors retraced the Long March journey in 2003. They argue that the Long March was slightly more than half the length Mao recorded it to be, though still a punishing 6035 kilometres.

5 Enhua Zhang, *The Long March across the Twentieth Century and Beyond*, 3 April 2003, <http://www.longmarchspace.com/huayu/9.7/Zhang%20Enhua.htm>, viewed 10 June 2006.

6 Qin Ga in Lu Jie, 'Qin Ga: Miniature Long March', *Artlink*, no.3, vol.25, p.52.

7 Edgar Snow, *Red Star over China*, 1st rev. ed., Grove Press, New York, 1968. In his letters, Snow expressed dismay at the extent to which the Communist Party was involved in the production of *Red Star over China*; however, he later denied Mao's significant influence on the final draft of the text.

8 Few eye-witness accounts of the Luding Bridge battle involve burning paraffin, and many suggest Kuomintang-aligned forces were poorly armed. See Sun Shuyun, *The Long March*, Harper Collins, 2006; and Jung Chang and Jon Halliday, *Mao: The Unknown Story*, Random House Australia, Sydney, 2005.

SHEN XIAOMIN

1 'About Eulogy of Longjiang River'; synopsis provided by the Long March Project, unpaginated.

2 'About Eulogy of Longjiang River'; synopsis provided by 'The Long March Project', unpaginated.

3 The *tulou* is a unique three or four storey, usually round, clan home and is in many respects a village under one roof. Aaberg-Jorgensen, Jens. 'Clan Homes in Fujian', <http://www.chinadwelling.dk/hovedsider/clan_homes-tekst.htm> viewed on 5 July 2006.

WANG WENHAI

1 Jonathan Watts, 'Mao returns to haunt and comfort his people', *The Guardian*, 27 December 2003, <http://www.longmarchspace.com/media/guardian per cent20unlimiter.htm>, viewed August 2006.

2 Ian Buruma, 'Cult of the chairman', *The Guardian*, 7 March 2001, <http://www.guardian.co.uk/china/story/0,7369,467840,00.html>, viewed July 2006.

3 Craig Simmons, 'China's Long March retraced with artistic steps', *New York Times*, 18 August 2004, <http://www.longmarchspace.com/media.htm>, viewed May 2006.

ZHOU XIAOHU

1 Claymation is an animation process in which clay figurines are manipulated and filmed to produce an image of lifelike movement

2 'Socialism with Chinese characteristics' is the Chinese official term given to the mixed economy of the People's Republic of China as it moves from public ownership of property to an economy that allows for the simultaneous operation of publicly and privately owned enterprises.

3 Zhou Xiaohu, interview with author, July 2006. Translation courtesy of the Long March Project.

4 Bentham's panopticon has been instrumental in the discussion of the modern relationship between power and knowledge, particularly in relation to ideas of social conformity, most notably by the French theorist Michel Foucault. See Michel Foucault, *Discipline and Punish: The Birth of the Prison*, Vintage, New York, 1979.

5 Zhou, interview.

DJAMBAWA MARAWILI

1 Howard Morphy, 'Buwayak: surface and inner form', in *Buwayak: Invisibility* [exhibition catalogue], Annandale Galleries, Sydney, in association with Buku-Larrngay Mulka, Yirrkala, 2003, p.17.

2 Will Stubbs, 'Introduction', in *Djambawa Marawili: Source of Fire* [exhibition catalogue], Annandale Galleries, Sydney, 2005, p.4.

3 Judith Ryan, 'Bark painting: a singular aesthetic', in *Rarrk — John Mawurndjul: Journey through Time in Northern Australia*, Museum Tinguely, Basel, and Crawford House Publishing Australia, Belair, 2005, p.180.

4 Stubbs, *Djambawa Marawili: Source of Fire*, p.4.

NASREEN MOHAMEDI

1 Hélène Cixous, 'De la scène de l'inconscient . . .' in *Hélène Cixous: Chemins de l'Écriture*, Rodopi, Amsterdam, 1990, p.14. See translation in Verena Andermatt Conley, *Hélène Cixous*, University of Toronto Press, Toronto, 1992.

2 Nasreen Mohamedi, quoted in Dalmia Yashodhara, 'Nasreen's Diaries: An Introduction', in *Nasreen in Retrospect*, ed. Atlaf, Ashraf Mohamedi Trust, Bombay, 1995, p.84.

3 Deborah Garwood, 'Nasreen Mohamedi', *artcritical.com*, September 2003, <http://www.artcritical.com/garwood/DGMohamedi.htm>, viewed September 2006.

4 Ruth McDougall, 'Nasreen Mohamedi', Queensland Art Gallery files, Brisbane, unpaginated.

5 Geeta Kapur, 'Elegy for an unclaimed beloved: Nasreen Mohamedi 1937–1990', in *When Was Modernism: Essays on Contemporary Cultural Practice in India*, Tulika, New Delhi, India, 2000, p.61. I am indebted to Geeta Kapur's moving and comprehensive account of Nasreen Mohamedi's work in the framing of my ideas for this essay.

6 Kapur, *When Was Modernism*, p.5.

TUẤN ANDREW NGUYỄN

Thanks to Tang Fu Kuen, a senior specialist at SEAMEO–SPAFA, and Mai Chi, co-founder and facilitator at Talawas <www.talawas.org>.

1 In California, Tuấn Andrew Nguyễn went to University of California, Irvine, for his Bachelor degree in Studio Art, and the California Institute of the Arts for his Master of Fine Arts.

2 *Bangkok Democrazy — BEFF4: Bangkok Experimental Film Festival* [exhibition catalogue], Project 304, Bangkok, 2005, pp.212–13.

3 Tuấn Andrew Nguyễn, email correspondence with author, 21 July 2006.

4 Nguyễn, email correspondence with author, 12 July 2006.

DENNIS NONA

1 Nona holds a Diploma of Art from the Tropical North Queensland Institute of TAFE, a Diploma of Visual Arts in Printmaking from the Institute of Arts, Australian National University, Canberra, and is currently completing a Master of Arts degree in Visual Arts

at Queensland College of Art, Griffith University, Brisbane.

2 Parallels can also be drawn in Nona's art to the Indigenous Australian painting tradition where an entire story is not only narrated in the confines of the one work, but the story itself can be interpreted in a number of ways. This is not surprising given that Nona is operating in a contemporary Australian art market in which Indigenous art is a major player in both national and international forums.

EKO **NUGROHO**

Translated from Bahasa Indonesia by Pitoresmi Pujiningsih and SBS Language Services, Sydney.

TSUYOSHI **OZAWA**

Translated from Japanese by Heather Glass, Japan Australia Word Services, and Martha J McClintock, Pixels & Ink.

1 *Sodan bijutsu* (Sodan art), or art born from communication with the audience, was conceived in 1989 and published for the first time in 1991 in an exhibition at Gallery Kigoma, Tokyo.

2 The Nasubi Gallery project was temporarily halted in 1996. The final issue of *Nasubi Shimbun* indicated the direction of the project in its contents: 1. Summary of the project to that point, 2. Emphasis on the quality of the art work rather than a sense of event or performance, 3. The continuation of the activities in countries with different cultural backgrounds. Ozawa revived the Nasubi Gallery concept in the 1998 exhibition 'Jizoing and New Nasubi Gallery' held at the Asian Fine Arts Factory, Berlin.

3 Rirkrit Tiravanija first displayed food stuffs and cooking utensils in his *Untitled ()* 1989. In 1990, his work *Pad Thai* was held at the Paula Allen Gallery in New York, followed in 1992 by his *Untitled (free)* 1992 — both involved the artist cooking noodles or curry and handing out the dishes, free of charge, to the audience.

PACIFIC TEXTILES PROJECT

1 Lee S Wild, *The Hawaiian Quilt*, Kokusai Art, Tokyo, and Honolulu Academy of the Arts, Honolulu, 1999, p.13.

2 Reiko Mochinaga Brandon and Loretta GH Woodard, *Hawaiian Quilts: Tradition and Transition*, eds C Shankel and M Nakao, Kokusai Art, Tokyo, 2003, p.15.

3 The most obvious are the many derivations of the '*Ku'u hae aloha*' (my beloved flag) design. Many Hawaiian women responded to Queen Lili'uokalani's forced abdication (1893) and the lowering of the flag by creating *kapa kuiki* with flag motifs. Contemporary examples of these continue to be created to commemorate significant dates relating to the monarchy and its overthrow. See Brandon and Woodard.

4 Brandon and Woodard, p.38.

5 For more information on the naming and genealogies of Tongan and Samoan mats see Adrienne Kaeppler, Penelope Schoeffel and Phyllis Herda, "Kie hingoa" "named mats", "ie toga" "fine mats" and other treasured textiles of Samoa and Tonga', *Journal of the Polynesian Society*, special issue, vol.108, no.2, 1999.

6 *Kie hingoa* and '*ie toga* are more often than not adorned with a single border of red feathers along one edge of the textile. Some *kie hingoa* and '*ie toga* have short lines or tufts of feathers decorating the main body of the mat. In the nineteenth and early twentieth centuries, red feathers were sourced from parakeets; today, dyed chicken feathers are used. Red is an important colour that signifies status in Tonga and Samoa and other east Polynesian societies. Sean Mallon (Senior Curator, Pacific Cultures, Te Papa Tongarewa Museum, NZ), email conversation with author, 3 August 2006.

7 Roger Neich, 'Material culture of Western Samoa: persistence and change', *National Museum of New Zealand Bulletin*, no.23, 1985, p.34.

KEEPING FAITH AND **THE NATION**

1 Since this time (c.1993), Hawai'i has witnessed some strange historical inversions. In 2000, a *haole* (white American resident of the state) lodged a suit in the US Supreme Court, claiming it was unconstitutional for the State of Hawai'i to reserve for Native Hawaiians the right to vote for members of the board of the Office of Hawaiian Affairs, the official body for administering services and funds for the welfare of native Hawaiians. The Supreme Court ruled in his favour, opening up the way for more claims of unconstitutional practices of 'reverse racism'. Now, not only can non-native Hawaiians vote for members of the board of the Office of Hawaiian Affairs but they can also stand as candidates themselves.

TEXT AND **TEXTILES**

1 Janis Jefferies, 'Text and textiles: Weaving across the borderlines', in *New Feminist Art Criticism*, Manchester University Press, Manchester, 1995.

2 The author first viewed some of APT5's Pacific textile works in the 'Island Beats' exhibition at the Queensland Art Gallery, 6 March – 14 June 2004.

3 Ivan Kopytoff, 'The cultural biography of things: Commoditization as process', in *The Social Life of Things: Commodities in Cultural Perspective*, ed. Arjun Appadurai, Cambridge University Press, Cambridge, 1986, p.66; and see Appadurai's influential introduction, pp.3–63. See also Janet Hoskins, *Biographical Objects: How Things Tell Stories of People's Lives*, Routledge, London and New York, 1998.

4 Nicholas Thomas, 'The case of the misplaced ponch: Speculations concerning the history of ponchos in Polynesia', in *Clothing the Pacific*, ed. Chloe Colchester, Berg Publishers, Oxford, 2003, pp.79–96.

5 See Susan Stewart, *On Longing: Narratives on the Miniature, the Gigantic, the Souvenir, the Collection*, Duke University Press, Durham and London, 1993, p.126.

6 Roland Barthes, 'Introduction to structural analysis of narrative', trans. Stephen Heath, in *A Roland Barthes Reader*, ed. Susan Sontag, Vintage Books, London, 1994, pp.251–2.

STEPHEN **PAGE**

1 Stephen Page's son is Hunter Page-Lochard and his nephews are Curtis Walsh-Jarden, Isieli Jarden, Ryan Jarden, Josiah Page, Samson Page, Sean Page.

2 Launched in 1967 and subsequently phased out by 1980, the Holden Torana has become an icon of 1970s' Australia. Its name is derived from an Indigenous Australian word meaning 'to fly'.

3 The opening celebrations for APT5 (2–4 December) also include performances by international acts such as Talvin Singh, Scribe and Cornelius, among other performers from the Asia–Pacific region.

PAIMAN

1 *The Internal Security Act* (ISA) is a preventive detention law originally enacted in the early 1960s during a national state of emergency as a temporary measure to fight a communist rebellion. Under Section 73 (1) of the ISA, police may detain any person without warrant or trial and without access to legal counsel, on suspicion that 'he has acted or is about to act or is likely to act in any manner prejudicial to the security of Malaysia or any part thereof or to maintenance of essential services therein or to the economic life thereof'. Some of the major ISA operations and arrests included 'Operasi Lalang' (Operation Lalang), a major crackdown on 'political dissidents' in October 1987, politicians in 1990 in Sabah, East Malaysia, whose party was considered a major rival to the ruling party, UMNO. In November 1997, ten people were arrested for allegedly spreading Shiite teachings deemed detrimental to national security; Muslims in Malaysia are Sunnis. The ISA was used in 1998 to arrest Deputy Prime Minister Anwar Ibrahim and six of his political supporters. Anwar was the primary leader of opposition to Mahathir, and is currently serving a 15-year sentence following convictions in 1999 and 2000 in politically motivated trials for sodomy, corruption and abuse of power.

2 Paiman, telephone interview with author, 26 April 2006.

3 Paiman, interview with author.

4 This was one of the first major speeches delivered by Abdullah Badawi in his position as current Prime Minister of Malaysia. He suggested that Malaysians need a change of mindset if we are to successfully compete with other economies. 'The way I see it, the malaise affecting Malaysia that may well jeopardise our way forward is a case of having world-class infrastructure and [a] Third World mentality.' Abdullah Badawi, 'Competing for Tomorrow', paper presented to the Oxbridge Society of Malaysia, Sunway Convention Centre, Petaling Jaya, 6 March 2003, p.4, <http://oxbridgemalaysia.com/events/2003/OC%20Acting%20PM%20Keynote%20Address.pdf>, viewed April 2006.

MICHAEL **PAREKOWHAI**

1 'The most heterogeneous ideas are yoked by violence together; nature and art are ransacked for illustrations, comparisons, and allusions; their learning instructs, and their subtlety surprises; but the reader commonly thinks his improvement dearly bought and, though he sometimes admires, is seldom pleased.' Samuel Johnson, *Lives of the Most Eminent English Poets*, Oxford English Texts, vol.1, Bathurst, London, 1781.

2 Robert Leonard and Lara Strongman, *Michael Parekowhai: Kiss the Baby Goodbye* [exhibition catalogue], Govett-Brewster Art Gallery, New Plymouth, 1994, unpaginated.

3 Allan Smith, 'The paradise conspiracy', in *Bright Paradise: Exotic History and Sublime Artifice — The 1st Auckland Triennial* [exhibition catalogue], eds R Leonard and A Smith, Auckland Art Gallery, Auckland, 2001, p.19.

JOHN **PULE**

1 John Pule, email conversation with the author, 11 September 2006.

2 Pule, 'When you return . . .', in *APT 2002: Asia–Pacific Triennial of Contemporary Art* [exhibition catalogue], Queensland Art Gallery, Brisbane, 2002, p.28.

3 Pule, 'Life is worthless if we forget', interview with Ian Were, *Artlines*, no.1, 2006, p.12.

4 See John Pule and Nicholas Thomas, *Hiapo: Past and Present in Niuean Barkcloth*, University of Otago Press, Dunedin, 2005, p.20.

5 Pule, *Burn My Head in Heaven*, Penguin, Auckland, 1998, pp.130–145.

6 Niue was annexed by New Zealand in 1900 and was granted self government in association with New Zealand in 1974. Consequently many Niueans migrated to New Zealand from the 1940s onwards.

7 Pule, email conversation with author, 25 August 2006.

8 Pule, *Burn My Head in Heaven*, p.142. In 1774, Captain James Cook was thrice turned away by Niueans with red smeared on their mouths. A disgruntled Cook changed course and charted the coral atoll as the 'Savage Island'.

9 Pule and Thomas, p.47. Pule also details the wiping of surfaces in most *tiputa* (bark cloth ponchos).

10 Pule, email conversation with the author, 25 August 2006.

11 Pule, *Burn My Head in Heaven*, p.94.

NUSRA LATIF **QURESHI**

1 The classical Mughal, Rajastani and Pahari schools of north India each had their own distinct painting styles. Before the 16th century, Muslim courts of India employed Persian émigrés and a few locals who struggled to imitate the style of their masters. The Imperial Mughul painting workshops of the 16th century were the most complex in organisation and were recognised as producing some of India's most celebrated paintings. Other regional courts established painting workshops in Rajasthan and in the Punjab hills, and centres such as Kangra, Basholi, Guler and Mandi subsequently developed their own painting styles.

For more information, see John Seyller, 'Painting workshops in Mughal India', in *Kharkhana: A Contemporary Collaboration* [exhibition catalogue], ed. Hammad Naser, The Aldrich Contemporary Art Museum and Green Cardamom, London, 2005, pp.12–17.

2 Punjab is a northern Indian province and Sind province now forms part of Pakistan. Both were once part of the Indian, Mughal and British Empires until partition in 1947.

3 The term 'Company School' refers to a disparate collection of drawings, watercolours and paintings on paper, mica, glass, ivory and shell produced during the period when the British East India Company expanded to South Asia from the early 17th century to the mid 19th. Company School paintings were created by Indian court painters specifically for British tastes and are often defined as an observation of all aspects of colonial India, including natural history, historical architectural sites and contemporary life.

4 Ali S Asani, 'Folk legends from the Indus and traditions of spirituality', in *Legends of the Indus*, ed. Samina Quraeshi, Asia Ink, London, 2004, p.37.

5 See Salima Hashmi, *Negotiating Borders: Contemporary Miniatures from Pakistan* [exhibition catalogue], Siddhartha Art Gallery, Nepal, 2003; and Virginia Whiles, 'Kharkhana: Revival or re-invention?', in *Kharkhana: A Contemporary Collaboration* [exhibition catalogue], pp.26–33.

6 Artists from Pakistan who trained at the National Art School, Lahore, in the 'Miniature Painting' course include Imran Qureshi and Shahzia Sikander, both of whose work was featured in the 'Third Asia–Pacific Triennial of Contemporary Art' in 1999. Nusra Latif Qureshi, Rashid Rana and Khadim Ali, participating in APT5, were also students of this course. A number of other artists continue to extend the 'contemporary miniature' project including Saira Wasim, Aisha Khalid, Talha Rathore and Mahreen Zuberi.

7 The word '*miniare*' — literally 'to colour red' — was used to describe the illustrations of illuminated manuscripts as opposed to border designs. Early European medieval illustrations were originally painted with red oxide of lead or minium. Thus, the term 'miniature' had nothing to do with the size of the paintings but referenced a conventional use.

8 Nusra Latif Qureshi, quoted in Virginia Whiles, in *Kharkhana: A Contemporary Collaboration* [exhibition catalogue], p.27.

RASHID RANA

1 'Pixel' is short for 'picture element'.

2 The Mughal Empire (1526–1707) incorporated present day Afghanistan, Baluchistan and the Indian subcontinent, then known as Hindustan.

3 The National School of Art in Lahore provides a fine arts degree majoring in the Mughal and Pahari art of the miniature.

4 Rashid Rana, email correspondence with author, 22 February 2006.

5 'The domains [of *parampara* knowledge] may include teachings of a spiritual, artistic (dance or music) or educational nature.' Wikipedia, *Parampara*, <en.wikipedia.org/wiki/Parampara>, viewed March 2006.

6 'Pakistan Day' (23 March) celebrates the 1940 'Pakistan Resolution' which divided India to create the first independent Muslim state in the north-western and eastern zones of the subcontinent. Millions died in the wake of partition due to religious unrest, with thousands more left homeless. Since 1947, the dispute over the sovereignty of Kashmir and Jammu has caused great military conflict and political tension between the two countries.

7 Kavita Singh, 'Between the part and the whole', in *Rashid Rana: Identical Views* [exhibition catalogue], Nature Morte, New Delhi, India, 2004, p.23.

8 Quddus Mirza, 'Rashid Rana at Nature Morte', *Flash Art*, vol.37, no.238, 2004, p.63.

SANGEETA SANDRASEGAR

1 Pahari is the popular term given to various Hindu- and folk-influenced schools of miniature painting from the Himalayan hill kingdoms; these flourished between the seventeenth and nineteenth centuries and were unusually attentive to images of women. in other series, Sandrasegar has borrowed from images and literary sources as various as Chinese erotica, the story of 'The Porter and the Three Ladies of Baghdad' from the Arabian anthology *The Book of The Thousand Nights and A Night*, and the *Kathakali*, the classical dance drama of Kerala in South India.

2 The 'Goddess of flowers' series 2003–04 eventually comprised 45 works. Shekhar Kapur's 1994 film about the life of Phoolan Devi was based on the biography by Mala Sen, *Indian Bandit Queen: The True Story of Phoolan Devi*, Harvill Press, London, 1991. Sen also co-wrote the screenplay for the film.

3 Sangeeta Sandrasegar, 'Goddess of flowers', artist's statement, Artist File, Queensland Art Gallery Research Library.

4 Bohumil Hrabal, *I Served the King of England*, trans. Paul Wilson, Harcourt Brace Jovanovich, Orlando, 1989, pp.196–7. For commentary on the writing of Hrabal, see Radko Pytlik, *The Sad King of Czech Literature: Bohumil Hrabal*, Emporium, Prague, 2000.

5 Sangeeta Sandrasegar, correspondence with author, April 2006.

KUMAR SHAHANI

1 Tagore wrote in a letter to Murari Bhaduri in 1929, 'The principal element of a motion picture is the "flux of image". The beauty and grandeur of this form in motion has to be developed in such a way that it becomes self-sufficient without the use of words'. Cited in Ashish Rajadhyaksha and Paul Willemen, *Encyclopedia of Indian Cinema*, Oxford University Press, New Delhi, 1995, p.209. Shahani's film did not please Visvabharati University, copyright owners of Tagore's work, who continue to suppress the critique of militant nationalism in Tagore's late work in favour of their version of Tagore as an unmitigated patriot. Some parts of the freedom movement vilified Tagore for writing *Char Adhyay*. An attempt was made to censor Shahani's film nominally for an infringement of copyright by the producers, the National Film and Development Corporation and Doordarshan. Sixteen seconds from near the end of the film were removed for a period, but later reinstated.

2 Cultural theorist Geeta Kapur suggests that 'modern India has aspired to position — most credibly through Gandhi — a selfhood that allows one to extrapolate an exemplary nationhood or at least exemplary communities within the nation'. She also notes that 'in recent years, several artists have tried to articulate the loss betokened by Gandhi . . . who stands alone in India and in the world for realizing his vision of a peaceful struggle for truth and justice'. Geeta Kapur, 'SubTerrain: artists dig the contemporary', in *Body.City: Siting Contemporary Culture in India*, The House of World Cultures, Berlin and Tulika, New Delhi, 2003, pp.58–9.

3 Kumar Shahani, 'Ideological ironies', *Framework: Journal of Cinema and Media*, no.30/31, 1986, p.97.

4 Shahani uses sections of the soundtrack of *Meghe Dhaka Tara* 1960 in *Maya Darpan* in direct quotation of Ghatak.

5 Kumar Shahani, 'Interrogating internationalism', in *Creative Arts in Modern India (Essays in Comparative Criticism)*, eds R Parimoo and I Sharma, Books & Books, New Delhi, 1995, p.390.

6 Kumar Shahani, 'Report on the debate on film', in *Global Encounters in the World of Art: Collisions of Tradition and Modernity*, ed. R Levrijsen, Royal Tropical Institute, Amsterdam, 1998, p.151.

7 Shahani, *Creative Arts in Modern India (Essays in Comparative Criticism)*, p.390.

8 Gowri Ramnarayan, 'The bansuri comes alive', *The Hindu*, 29 November 1998, <http://www.hinduonnet.com/folio/fo9811/98110360.htm>, viewed September 2006.

9 Shahani has also studied epic traditions across cultures on a Homi Bhabha Fellowship (1976–78), including Buddhist iconography, Brechtian epic theatre, classical Indian music, and Indian epic theatre, reaching its apex in the Mahabharata. This culminated in his major statement on the epic form, *Tarang (The Wave)* 1984.

10 Kumar Shahani, interview with June Givanni, 'Indian cinema: a quest for depth, sensuality and abstraction', *Black Film Bulletin*, vol.4, no.2, p.5.

TALVIN SINGH
POP'S ASIAN INVASION

1 Simon Frith, *Performing Rites: On the Value of Popular Music*, Oxford University Press, Oxford, 1996.

2 Qawwali is a vibrant tradition of Sufi music, dating back more than 700 years. Its mainstream popularity has risen recently due to musicians such as Nusrat Fateh Ali Khan.

3 Talvin Singh, interview with author, The Vibe Bar, 1 October 1998.

4 Singh, interview with author.

5 Singh, interview with author.

6 Singh, in a press release biography by David Toop, 1998, issued for Singh's album, *OK* 1998.

7 For a more lengthy discussion of the 'daytimer' phenomenon, where events are held in daytime hours to avert parental restrictions on their children's nocturnal sorties, see Rupa Huq, *Beyond Subculture: Youth, Pop and Identity in a Postcolonial World*, Routledge, London, 2006.

A WORLD OF RYHTHM

1 *Raga-kalpa-druma*, quoted in Alain Danielou, *Northern Indian Music*, Praeger, New York, 1969, p.66.

2 The late Ustad Allarakha Khan was an internationally acclaimed master tabla player. In the 1960s and 1970s, he raised the status of the tabla from accompanying instrument to that of a virtuosic solo instrument.

MICHAEL STEVENSON

1 *Call me Immendorff* 2001 considered art-star Jorg Immendorff's 1987–88 sojourn in Auckland against the background of the concurrent stock market crash and the subsequent fall of the Berlin Wall. While downing bubbly, wowing the ladies and seducing the media, the blue-chip, left-wing artist was served a death threat. *Can dialectics break bricks?* addressed the role contemporary art played in the 1979 Iran hostage crisis, turning on the little-known fact that New York dealer — and one-time art-terrorist — Tony Schfrazi once had a gallery in Tehran, Iran. Stevenson juxtaposed Western contemporary art's extremist rhetoric with Iran's real political extremism. *This is the Trekka*, Stevenson's project for the 2003 Venice Biennale, dealt with New Zealand's dream to produce a home-grown car in the late 1960s and 1970s, in relation to Cold War cultural politics, economics and the provincial problem.

2 Established in 1998, Twodo is a collectors group comprised of members of the Neuer Aachener Kunstverein in Germany.

3 See Nicholas Bourriaud, *Relational Aesthetics*, trans. Matthew Copeland, Les Presses du rēel, Paris, 2002 (originally published in French in 1998).

4 Brought up with fundamentalist Christianity, Stevenson has always been preoccupied with communities of belief, congregations: with how the world appears from within an extremist paradigm and with how the believers appear from without. His early folksy paintings were characterised as Pentecostal Realism — no one knew if they were for real. Later works trafficked in conspiracy theories and various fundamentalisms.

MASAMI TERAOKA

1 Masami Teraoka, with Lynda Hess, *Vision Possible: Recent and Early Work*, Masami Teraoka's Art Theatre, <http://www.lava.net/~artbeat/index2.html , viewed 14 April 2006.

YUKEN **TERUYA**

PAPER BAG ENVIRONMENTS
Translated from Japanese by Martha
J McClintock, Pixels & Ink.

1 *Bingata* are traditional vividly coloured
 dyed cloths of Okinawa. Their designs
 often include natural subjects such as
 birds, fish, turtles, plum trees and
 flowers.

VIỆT **LINH**

1 Introduced in Vietnam by the Sixth
 Party Congress of the Communist
 Party of Vietnam in 1986, *Đổi mới*
 (Renovation) is the broad economic
 reform package that replaced the
 country's previous Marxist economic
 planning.

GORDON **WALTERS**

1 Gordon Walters, letter to Sally Martin,
 dated 12 September 1979, Gordon
 Walters papers, Museum of New
 Zealand Te Papa Tongarewa archives,
 CA030/1/4.
2 Gordon Walters, undated draft letter,
 c.1989, Gordon Walters papers,
 CA037/1.
3 Walters, undated draft letter.
4 *Koru* are Maori spiral designs that are
 often used in carving and tattooing.
5 Gordon Walters, letter to Michael Dunn,
 20 October 1991, quoted in Michael
 Dunn, 'Gordon Walters: remaking the
 modern', *Art New Zealand*, no.63, 1992,
 p.73.
6 Walters, letter to Sally Martin.
7 *Gordon Walters* [exhibition catalogue],
 New Vision Gallery, Auckland, 1966,
 unpaginated.
8 Michael Dunn, 'Statements by Gordon
 Walters', in *Gordon Walters* [exhibition
 catalogue], Auckland City Art Gallery,
 Auckland, 1983, p.125.
9 Rangihiroa Panoho, 'Maori: At the
 centre, on the margins', in *Headlands:
 Thinking through New Zealand Art*
 [exhibition catalogue], ed. Mary Barr,
 Museum of Contemporary Art, Sydney,
 1992, p.133.
10 Leonard Bell, 'Walters and Maori art:
 the nature of the relationship?', in
 Gordon Walters: Order and Intuition,
 eds James Ross and Laurence
 Simmons, Walters Publications,
 Auckland, 1989, p.11.
11 Rex Butler, 'Emily Kame Kngwarreye and
 the undeconstructible space of justice',
 Eyeline, no.36, 1998, p.36.

YANG **FUDONG**

1 Yang Fudong, interview with Zhang
 Yaxuan, 'The uncertain feeling: an
 estranged paradise', *Yishu*, vol.3, no.3,
 2004, p.81.

YANG **ZHENZHONG**

1 Stephen Wright, 'Shanghai/Shanghai:
 Spaces without qualities/spaces of
 promise', *Parachute*, no.114, 2004, p.30.
2 Deng Xiaoping's response to China's
 pandemic population problem, the
 Jihua Shengyu (Planned Birth) policy
 of the People's Republic is known as
 the 'one-child' policy in the West due
 to its enforced limitation of one child
 per couple in urban areas. The policy
 attracted controversy inside and
 outside of China due to social
 problems exacerbated by its
 implementation: forced and sex-
 selective abortions, abandoned and
 orphaned children and infanticide. As
 the one-child policy affects the third
 generation, it is common that a single
 adult child must support two parents
 and four grandparents. This leaves the
 oldest and most vulnerable dependent
 on retirement funds, the state or
 charity for support. See Tyrene White,
 *China's Longest Campaign: Birth
 Planning in the People's Republic,
 1949–2005*, Cornell University Press,
 Ithaca, 2006.
3 Yang Zhenzhong, 'Artist statement',
 in Wu Hung & Christopher Phillips,
 *Between Past and Future: New
 Photography and Video from China*,
 Steidl Publishers, Göttingen, 2004,
 p.216.

YOO **SEUNG-HO**

1 For more information about Yoo
 Seung-ho's art see Lee Chung-woo,
 'Point and word pictures that scatter
 about in an idiot wind — Yoo Seung-
 ho', *Art in Culture*, no.2, 2006,
 pp.120–27; and Gabriel Ritter, 'Words
 worth: fine print', *Giant Robot*, no.42,
 2006, pp.70–73.
2 See *Spirit of Korean Abstract Painting
 from the Ho-Am Museum Collection*
 [exhibition catalogue], Ho-Am Art
 Gallery, Seoul, 1996, p.p.19–25, 42–57,
 104–11; and *With Winds: Lee U-fan*
 [exhibition catalogue], Tokyo Gallery,
 1989.
3 *Auspicious Dreams: Decorative
 Paintings of Korea* [exhibition
 catalogue], Ho-Am Art Museum, Seoul,
 1998.

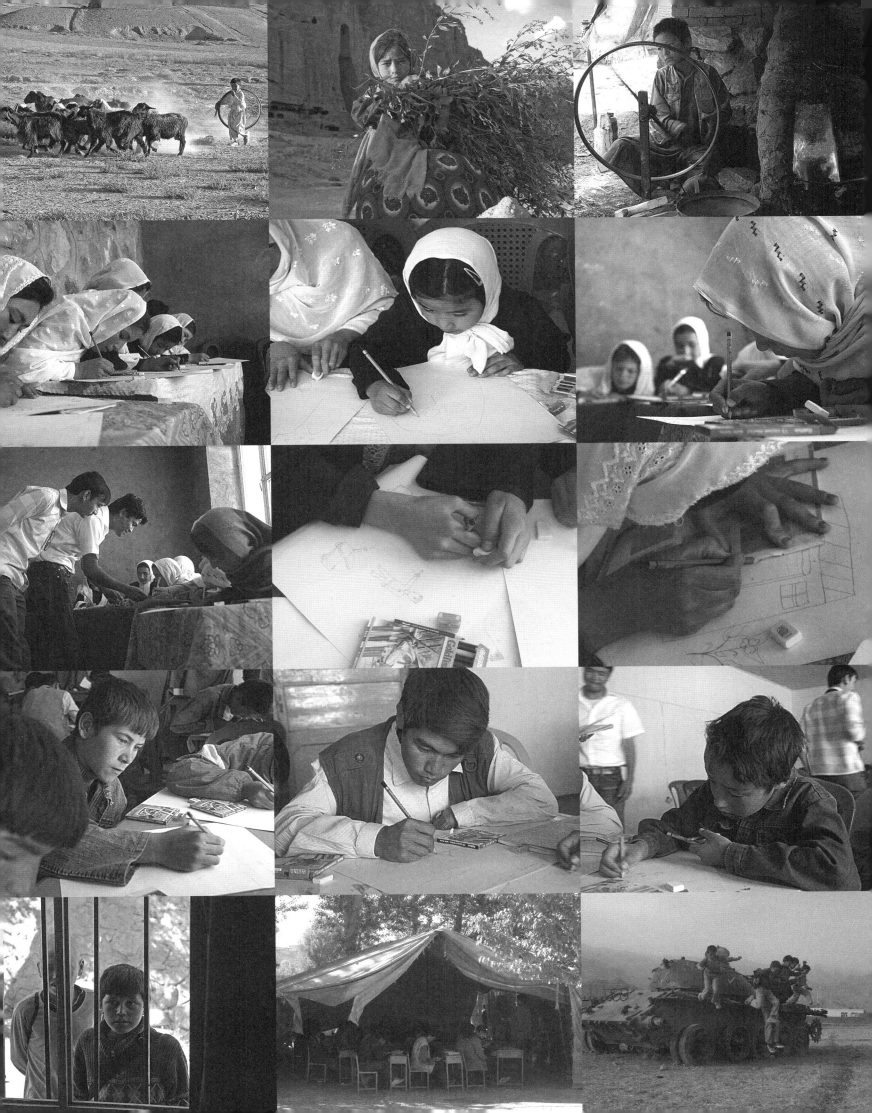

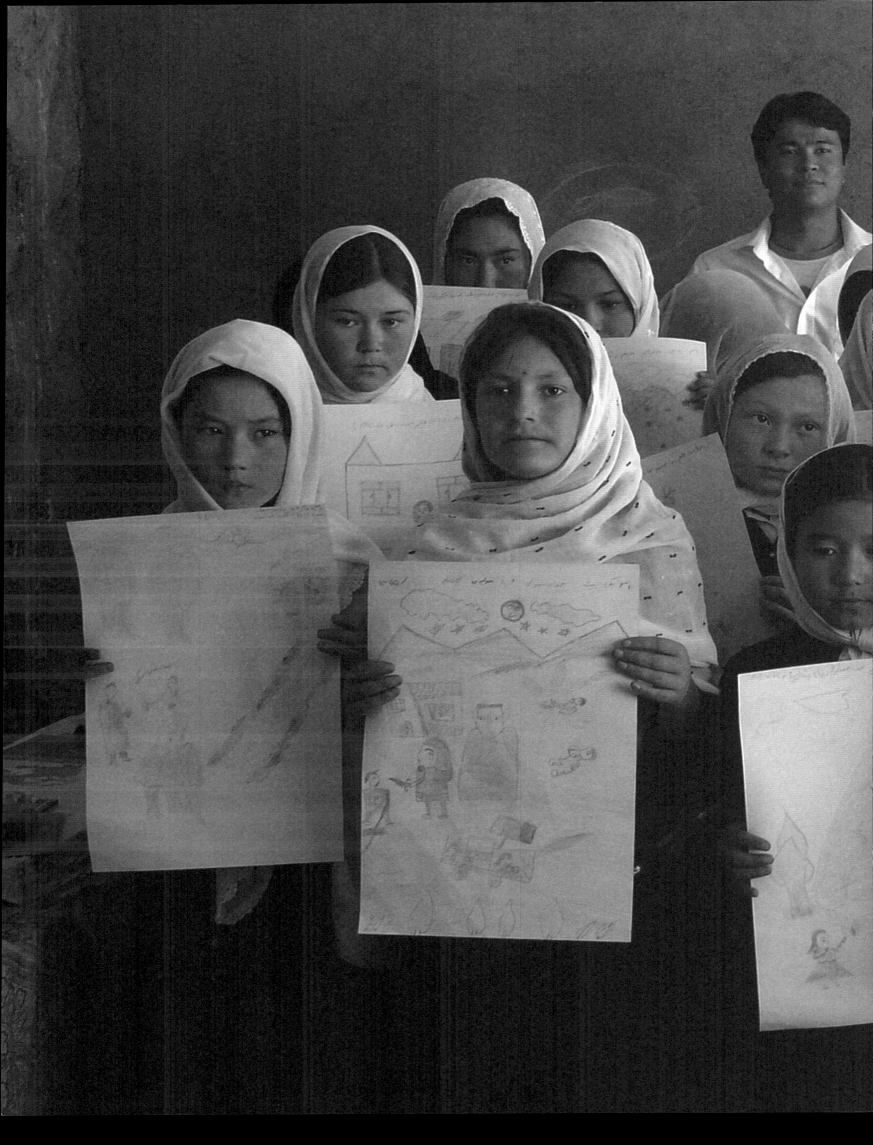

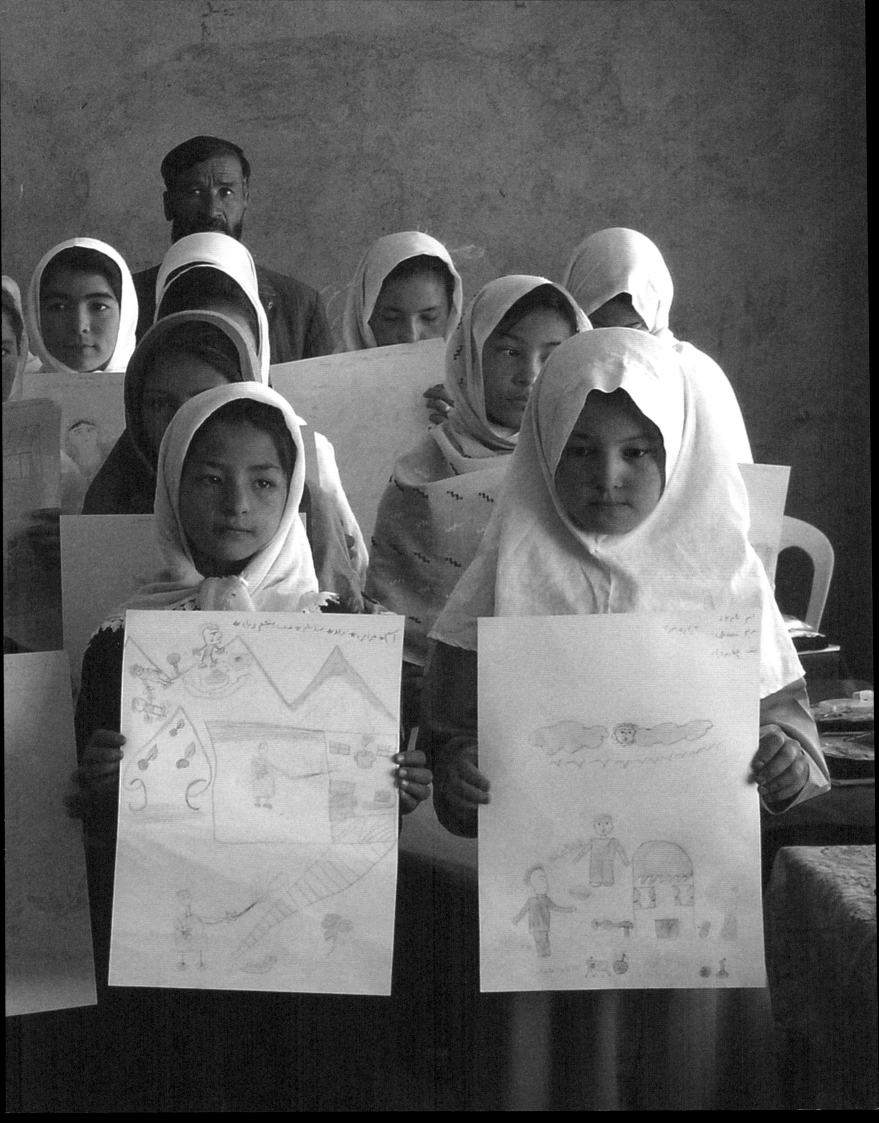

AI WEIWEI
CHINA B.1957

Dropping a Han Dynasty urn 1995
Gelatin silver photograph, A.P. / 3 sheets:
180 x 169.5cm (each)

Table with two legs 2004
Reassembled wooden table (Qing
dynasty 1644–1911) / 65 x 184 x 119cm

Pillar through round table 2004–05
Pair of elmwood half tables assembled
into a single table (Qing dynasty
1644–1911), bisected horizontally by an
ironwood pillar (Qing Dynasty 1644–1911),
on two ironwood pillar fragments /
142 x 513 x 117cm (installed)

Feet 2005
Fragments of stone sculpture (Northern
Wei dynasty 386–535 and Northern
Qi dynasty 550–577) with individual
wooden plinths and wooden table /
14 components: 88 x 220 x 68cm
(installed)

CATALOGUE OF WORKS

DIMENSIONS ARE GIVEN IN CENTIMETRES (CM),
HEIGHT PRECEDING WIDTH, FOLLOWED BY DEPTH.

Table with two legs on the wall 2005
Reassembled wooden table (Qing
dynasty 1644–1911) / 115.5 x 95.2 x 120cm

Painted vases 2006
Synthetic polymer paint on ceramic
(Neolithic period) / 14 components ranging
from 17 x 21cm (diam.) to 33.7 x 29 x 27cm

Purchased 2006. The Queensland
Government's Gallery of Modern Art
Acquisitions Fund / Collection:
Queensland Art Gallery

Boomerang 2006
Glass lustres, plated steel, electrical
cables, incandescent lamps /
700 x 860cm x 290cm (irreg.) /
Site specific installation for APT5 /
Collection: The artist

Red bowl with pearls 2006
Cultured pearls, ceramic / Ceramic:
42 x 99cm (diam.) (installed size variable) /
Collection: The artist

KHADIM ALI
PAKISTAN B.1978

Untitled (from 'Jushn-e-gulle surkh'
(Celebration of red tulips) series)
2004–05
Gouache on wasli paper on card /
3 sheets: 21 x 15cm (each approx.);
2 sheets: 25 x 19cm (each approx.);
1 sheet: 19 x 28.7cm / Purchased 2005 /
Collection: Queensland Art Gallery

Untitled (from 'Rustam-e-pardar'
(Rustam with wings) series) 2006
Watercolour, ink, silver leaf and gold leaf
on wasli paper (variable) / 4 sheets:
16 x 25.2cm (each, approx.); 1 sheet:
22.5 x 16.3cm; 1 sheet: 27.2 x 15.8cm

Heroes with weapons 1 2006
Heroes with weapons 3 2006
Gouache, metal leaf and ink on wasli
paper / 2 sheets: 17.4 x 25.7cm,
15.5 x 23.3cm

Purchased 2006 / Collection: Queensland
Art Gallery

JACKIE CHAN
HONG KONG B.1954

*Snake in the Eagle's Shadow
(She Xing Diao* Shou) 1978
35mm, 98 minutes, colour, mono, Hong
Kong, Cantonese (English subtitles) /
Director: Yuen Woo-ping / Action directors:
Yuen Woo-ping, Tyrone Hsu Hsia, Corey
Yuen Kwai / Producer: Ng See-yuen /
Script: Ng See-yuen, Choi Gai-gwong,
Tsai Chi-kuang, Jackie Chan (uncredited) /
Cinematography: Chang Hai / Editor: Hung
Yiu-poon / Art direction: Yuen Tan Ting /
Music: Chou Fu-liang / Cast: Jackie Chan,
Siu Tien Yuen, Jang Lee Hwang, Dean
Shek, Roy Horan / Production company:
Seasonal Films Corporation / Rights: Sony
Pictures Releasing, Australia / Screening
format: Digital Betacam

Drunken Master (Jui Keun) 1978
35mm, 111 minutes, colour, mono, Hong
Kong, Cantonese (English subtitles) /
Director/Action director: Yuen Woo-ping /
Producer: Ng See-Yuen / Script: Yuen
Woo-ping, Hsiao Lung / Cinematography:
Chang Hui / Editor: Pan Xiong / Art
direction: Yuen-Tai Ting / Music: Zhou
Fuliang / Cast: Jackie Chan, Simon Yuen
Siu Tin, Hwang Jang Lee, Dean Shek Tien /
Production company: Seasonal Films
Corporation / Rights: Sony Pictures
Releasing, Australia / Screening format:
Digital Betacam

The Young Master (Shi Di Chu Ma) 1980
35mm, 101 minutes, colour, mono, Hong
Kong, Cantonese (English subtitles) /
Director/Action director: Jackie Chan /
Producers: Raymond Chow, Leonard Ho /
Script: Jackie Chan, Lau Tin-chee, Tung Lu,
Edward Tang King-sang / Cinematography:
Chen Ching-Chueh / Editor: Cheung Yiu-
Chung / Art direction: Huang Hsun Chang /
Sound: Chou Shac-lung / Music: Frankie
Chan, Gustav Holst / Cast: Jackie Chan,
Wei Pai, Tian Feng, Shek Kin, Li Lili /
Production company: Golden Harvest
Company, Leonard Ho Productions / Print
source/Rights: Fortune Star Entertainment /
Screening format: Digital Betacam

Project A (A'gai Waak) 1983
35mm, 106 minutes, colour, mono,
Hong Kong, Cantonese (English subtitles)
Director/Action director: Jackie Chan /
Producers: Raymond Chow, Leonard Ho /
Script: Jackie Chan, Edward Tang King-
sang / Cinematography: Cheung Yiu-Jo /
Editor: Cheung Yiu-Chung / Art direction:
Pan Yuanhe, Zhan Fuxing / Sound:
Michael J. Fox, Todd Beckett / Music:
Li Xiaotian / Cast: Jackie Chan, Sammo
Hung, Yuen Biao, Wong Man-ying /
Production company: Golden Harvest
Company / Print source/Rights: Fortune
Star Entertainment / Screening format:
Digital Betacam

Police Story (Ging Chaat Goo Si) 1985
35mm, 101 minutes, colour, mono, Hong
Kong, Cantonese (English subtitles) /
Director/Action director: Jackie Chan /
Producers: Raymond Chow, Leonard Ho /
Script: Jackie Chan, Edward Tang King-
sang / Cinematography: Cheung Yiu-Jo /
Editor: Cheung Yiu-Chung / Art direction:
Huang Rulmin / Sound: Terry Desling /
Music: Li Xiaotian / Cast: Jackie Chan, Lin
Ching-hsia, Maggie Cheung, Chu Yuan /
Production company: Golden Harvest
Company / Print source/Rights: Fortune
Star Entertainment

Armour of God (Long Xiong Hu Di) 1986
35mm, 97 minutes, colour, mono, Hong
Kong, Cantonese (English subtitles) /
Directors: Jackie Chan, Eric Tsang
(uncredited) / Action director: Jackie Chan /
Producers: Leonard Ho, Chua Lam / Script:
Jackie Chan, Edward Tang King-sang,
Szeto Cheuk-hon, Lu Jian, John Sheppard /
Cinematography: Peter Ngor, Bob
Thompson, Arthur Wong, Cheung Yiu-Jo /
Editor: Cheung Yiu-Chung / Art direction:
William Cheung, Zhang Kailin, Ma Panchao /
Sound: Gary Ulmer / Music: Li Xiaotian /
Cast: Jackie Chan, Alan Tam, Guan Zhilin,
Maria Delores Forner / Production
company: Golden Harvest Company,
Golden Way Films / Print source/Rights:
Fortune Star Entertainment

Project A Part II (A'gai Waak Juk Jaap)
1987
35mm, 101 minutes, colour, mono, Hong
Kong, Cantonese (English subtitles) /
Director/Action director: Jackie Chan /
Producers: Leonard Ho, Raymond Chow /
Script: Jackie Chan, Edward Tang King-
sang / Cinematography: Cheung Yiu-Jo /
Editor: Cheung Yiu-Chung / Art direction:
Eddie Ma / Sound: Michael Lai / Music:
Michael Lai / Cast: Jackie Chan, Maggie
Cheung, David Lam, Rosamund Kwan,
Carina Lau / Production company: Golden
Way Films / Print source/Rights: Fortune
Star Entertainment

Police Story 2 (Ging Chaat Goo Si Juk Jaap) 1988
35mm, 101 minutes, colour, mono, Hong Kong, Cantonese (English subtitles) / Director/Action director: Jackie Chan / Producers: Raymond Chow, Leonard Ho, Edward Tang King-sang / Script: Jackie Chan, Edward Tang King-sang / Cinematography: Cheung Yiu-Jo, Lee Yau Tong / Editors: Cheung Yiu-Chung, Keung Chuen Tak, Shek Chi Kong / Art direction: Yui Man Lai / Sound: John Ross / Music: Michael Lai / Cast: Jackie Chan, Maggie Cheung, Bill Tung, Lam Kok-hung / Production company: Golden Way Films / Print source/Rights: Fortune Star Entertainment

Miracles (Qiji) 1989
35mm, 127 minutes, colour, mono, Hong Kong, Cantonese/English (English subtitles) / Director/Action director: Jackie Chan / Producer: Leonard Ho / Script: Jackie Chan, Edward Tang King-sang / Cinematography: Arthur Wong / Editor: Cheung Yiu-Chung / Art direction: Ma Panchao / Music: Zhou Qisheng / Cast: Jackie Chan, Anita Mui, Dong Biao, Wu Ma, Ke Junxiong, Luo Lie, Richard Ng, Gui Yalei / Production company: Golden Harvest Company, Golden Way Films / Print source/Rights: Fortune Star Entertainment

Armour of God II: Operation Condor (Fei Ying Gai Wak) 1990
35mm, 106 minutes, colour, mono, Hong Kong, Cantonese (English subtitles) / Director/Action director: Jackie Chan / Producers: Raymond Chow, Leonard Ho / Script: Jackie Chan, Edward Tang King-sang, Fibe Ma / Cinematography: Arthur Wong / Editor: Cheung Yiu Chung / Art direction: Yui Man Wong / Sound: Robb Boyd, Eric Flickinger, Richard Ford / Music: Chris Babida / Cast: Jackie Chan, Do Do Cheng, Eva Cobo De Garcia, Shōko Ikeda / Production company: Golden Way Films / Print source/Rights: Fortune Star Entertainment

Police Story 3: Supercop (Jing Cha Gu Shi III: Chao Ji Jing Cha) 1992
35mm, 95 minutes, colour (DeLuxe), mono, Hong Kong, Cantonese/Mandarin (English subtitles) / Director/Action director: Stanley Tong / Producers: Leonard Ho, Jackie Chan / Script: Edward Tang King-sang, Fibe Mei-ping, Lee Wei-yee / Cinematography: Lam Kwok Wah / Editors: Cheung Yiu-Chung, Cheung Ka-fai / Art direction: Yui Man Wong / Sound: Dean Beville / Music: Richard Lo, Lee Chung Shing, Chan Oi Ling, Chow Kwok Yee / Cast: Jackie Chan, Michelle Yeoh, Maggie Cheung, Tsang Kong, Yuen Wah / Production company: Golden Harvest Company / Print source/Rights: Fortune Star Entertainment, Hong Kong

Drunken Master II (Jui Kuen II) 1994
35mm, 103 minutes, colour, Dolby Digital, Hong Kong, Cantonese (English subtitles) / Directors: Lau Kar-leung, Jackie Chan (uncredited) / Action director: Jackie Chan / Producers: Leonard Ho, Edward Tang King-sang, Eric Tsang, Barbie Tung / Script: Edward Tang King-sang, Man-Ming Tong, Kai-Chi Yun / Cinematography: Cheung Yiu-Jo, Jingle Ma, Man-wan Wong / Editor: Cheung Yiu Chung / Sound: Chong-Sing Ho, Eddie Ma / Music: Woo Wai-lap / Cast: Jackie Chan, Lau Kar-leung, Anita Mui, Ti Lung, Ken Lo, Lo Wei Kong / Production company: Golden Harvest Company / Print source: Warner Bros Pictures, USA / Rights: Alliance Atlantis, Canada

Traces of a Dragon: Jackie Chan and His Lost Family 2003
35mm, 96 minutes, colour, Dolby SR, Hong Kong, Cantonese/Mandarin (English subtitles) / Director: Mabel Yuen-Ting Cheung / Producers: Jackie Chan, Willie Chan, Solon So / Cinematography: Arthur Wong / Editor: Maurice Li / Researchers: Henry Ng, Heman Peng, Cheung Wing Hung, Wang Biao / Sound: Kinson Tsang / Music: Henry Lai / Production company: Jackie & Willie Productions / Print source/Rights: Jackie Chan Group, Hong Kong

New Police Story (San Ging Chaat Goo Si) 2004
35mm, 123 minutes, colour, Dolby Digital, Hong Kong, Cantonese (English subtitles) / Director: Benny Chan / Action director: Jackie Chan / Producers: Benny Chan, Jackie Chan, Willie Chan, Solon So, Barbie Tung / Script: Alan Yuen / Cinematography: Anthony Pun / Editor: Chi-wai Yau / Art direction: Sung Pong Choo, Ching Ching Wong, Oliver Wong / Sound: Kinson Tsang / Music: Tommy Wai / Cast: Jackie Chan, Nicholas Tse, Charlie Young, Charlene Choi, Daniel Wu, Wong Chieh / Production company: JCE Entertainment, China Film Group Corporation / Print source/Rights: Force Entertainment, Australia

BECK **COLE**
AUSTRALIA B.1975
WARRAMUNGU/LURITJA PEOPLE

Flat 2002
16mm and Mini DV, 13 minutes, colour, stereo, Australia, English / Director/Script: Beck Cole / Producers: Darren Dale, Rachel Perkins / Cinematography: Warwick Thornton / Editor: Karen Johnson / Art direction: Daran Fulham / Music: Cliff Bradley / Cast: Carmen Glynn-Braun, Savannah Glynn-Braun, James Aitken / Production company: Blackfella Films / Print source/Rights: Beck Cole / Screening format: Digital Betacam

Wirriya Small Boy 2004
Digital Betacam and Mini DV, 26 minutes, colour, stereo, Australia, Warlpiri and English (English subtitles) / Director: Beck Cole / Producers: Beck Cole, Citt Williams / Cinematography: Beck Cole, Warwick Thornton / Cast: Ricco Japaljarri Martin, Maudie Nelson, Charmaine Nelson, Rochelle Dickenson, Delena Dickenson / Production company: CAAMA Productions / Print source: CAAMA Productions / Rights: CAAMA Productions, Beck Cole / Screening format: Digital Betacam

Plains Empty 2005
35mm, 27 minutes, colour, Dolby Digital, Australia, English / Director/Script: Beck Cole / Producer: Kath Shelper / Cinematography: Warwick Thornton / Music: Cliff Bradley / Cast: Ngaire Pigram, Gerard Kennedy, Kerry Naylon, Josef Ber / Production company: Film Depot / Print source: Film Depot / Rights: Film Depot, Beck Cole, Australian Film Commission, SBS Independent, South Australian Film Corporation and NSW Film and Television Office

Lore of Love 2005
Digital Betacam, 25 minutes, colour, stereo, Australia, Pintupi, Waripiri, Luritja and English (English Subtitles) / Director/Script: Beck Cole / Cinematography: Warwick Thornton / Cast: Jessie Bartlett Nungarrayi, Mitjili Gibson Napanangka, Nancy Gibson Napanangka, Lizzie Spencer Nungarrayi / Production company: CAAMA Productions / Print source/Rights: CAAMA Productions

JUSTINE **COOPER**
AUSTRALIA/UNITED STATES B.1968

From 'Saved by science' series 2005:

Accession books
Herpetology collections
Leopards (Panthera pardus), Congo 1911
3 sheets: 76.3 x 99.2cm (each, approx.)

Blue triangle butterflies (Graphium sarpedon)
African lion (Panthera leo)
The bustroom
Trophies
Yellow honeyeaters (Lichenostomus flavus)
5 sheets: 99.2 x 76.3cm (each, approx.)

Digital colour print on Fuji Crystal Archive Matte paper, ed. of 8 / Purchased 2005 / Collection: Queensland Art Gallery

S.O.S. (Sounds of science) (from 'Saved by science' series) 2005
Digital Betacam, 4:55 minutes, colour, sound, ed. 2/10 / Purchased 2005 / Collection: Queensland Art Gallery

EX **DE MEDICI**
AUSTRALIA B.1959

Blue (Bower/Bauer) 1998–2000
Watercolour, traces of pencil / 114 x 152.8cm / Purchased 2004 / Collection: National Gallery of Australia, Canberra

Red (Colony) 2000
Watercolour / 114.1 x 152.1cm (irreg) / Purchased with funds from Beleura — The Tallis Foundation, 2002 / Collection: Mornington Peninsula Regional Gallery

Skull (blue and green) 2004
Watercolour on Arches paper / 57.5 x 55cm / Purchased 2004. Queensland Art Gallery Foundation Grant / Collection: Queensland Art Gallery

The theory of everything 2005
Watercolour and metallic pigment on Arches paper / 114.3 x 176.3cm / Purchased 2005 / Collection: Queensland Art Gallery

♂Gun(n)s 'n Styx 2006
Watercolour / 114 x 178.5cm

Desire overcoming duality 2006
Watercolour and metallic pigment on paper / 114 x 134cm

Live the (Big Black) Dream 2006
Watercolour / 114 x 166cm

Collection: The artist

JITISH **KALLAT**
INDIA B.1974

Public notice 2003
Burnt adhesive on acrylic mirror, wood and stainless steel frames / 5 panels: 198.1 x 137.2 x 15.2cm (each) / Collection: Shumita and Arani Bose, New York

ANISH **KAPOOR**
INDIA/UNITED KINGDOM B.1954

1000 Names 1981
Wood, gesso, pigment / 5 components: 122 x 183 x 183cm (installed) / Collection: The artist / Courtesy: Lisson Gallery, London

Void (#13) 1991–92
Fibreglass and pigment / 161 (diam.) x 120cm / Purchased 1998. Queensland Art Gallery Foundation / Collection: Queensland Art Gallery

Untitled 1992
Sandstone and pigment / 230 x 122 x 103cm

Untitled 1995
Fibreglass and pigment / 202.5 x 202.5 x 330cm

Untitled 1997
Kilkenny limestone / 247 x 145 x 178cm

Collection: The artist / Courtesy: Lisson Gallery, London

BHARTI **KHER**
UNITED KINGDOM/INDIA B.1969

The skin speaks a language not its own 2006
Fibreglass and bindi, ed. 1/3 / 167.6 x 152.4 x 457.2cm (irreg., approx.)

Never deny the other 2006
Bindi on aluminium composite panels / 4 panels: 243.8 x 121.9cm (each)

Collection: The artist

SUTEE **KUNAVICHAYANONT**
THAILAND B.1965

Stereotyped Thailand 2005–06
Teak wood and steel chairs with writing arms, wallpaper, paper and crayons, ed. 2/2 / 20 chairs: 86 x 72 x 53cm (each) / Collection: The artist

KWON KI-SOO
KOREA B.1972

Two heads or look right and left 2002
Flash animation on DVD, 3:57 minutes, colour, sound

Standing on the stars 2003
Flash animation on DVD, 3:41 minutes, colour, sound

Circus 2003
Flash animation on DVD, 30 seconds, colour, sound

Plum blossoms around a cottage — visiting a friend on a snowy day 2003
Flash animation on DVD, 1:31 minutes, colour, sound

Farting 2004
Flash animation on DVD, 30 seconds, colour, sound

Untitled 2005–06
Synthetic polymer paint on canvas on board / 162 x 130cm

Colour forest 2006
Synthetic polymer paint on canvas on board / 181 x 227cm

In the fountain 2006
Synthetic polymer paint on canvas on board / 130 x 190cm

Black forest 2 2006
Synthetic polymer paint on canvas on board / 227 x 182cm

Collection: The artist

DINH Q **LÊ**
VIETNAM B.1968

Lotusland 1999
Fibreglass, polymer, wood and synthetic polymer paint / 27 components ranging from 30 x 57.5 x 52.5cm to 77.5 x 55 x 45cm (installed dimensions variable) / Purchased 2006. The Queensland Government's Gallery of Modern Art Acquisitions Fund / Collection: Queensland Art Gallery

Damaged gene 1998
Plastic and fabric / Dimensions variable

In collaboration with Tuấn Andrew Nguyễn and Hà Thúc Phú Nam
The farmers and the helicopters 2006
3-channel video installation, High Definition Video, 15 minutes, colour, sound, ed. 1/10 / Dimensions variable

Collection: The artist

LONG MARCH PROJECT

HONG HAO
CHINA B.1965

Long March in Panjiayuan A 2004
Long March in Panjiayuan B 2004
Type C photographs, ed. 1/9 / 2 sheets: 127 x 230cm (each) / Purchased 2006 / Collection: Queensland Art Gallery

LI TIANBING
CHINA B.1933

Estate of Li Tianbing 1946–2006
Silver gelatin photographs, ed. of 1 / 194 sheets: dimensions variable / Collection: The artist / Courtesy: Long March Project, Beijing

LIU JIEQIONG
CHINA B.1967

Story of the Red Army 2004
Papercut, ed. 1/6 / 12 pieces: 225 x 432cm (overall) / Purchased 2006 / Collection: Queensland Art Gallery

MU CHEN
CHINA B.1970
SHAO YINONG
CHINA B.1961

From 'Assembly hall series no. 6' 2006
Changgang
Gutian
Maoping
Qixianzhuang
Xibaipo
Yangjialing
Type C photographs, ed. 1/3 / 6 sheets: 182 x 244cm (each) / The Kenneth and Yasuko Myer Collection of Contemporary Asian Art. Purchased 2006 with funds from The Myer Foundation and Michael Simcha Baevski through the Queensland Art Gallery Foundation / Collection: Queensland Art Gallery

QIN GA
CHINA B.1971

The miniature long march 2002–05
Type C photographs / 23 sheets: 75.5 x 55cm (each)

The miniature long march site 1 – site 14 2002
Mini DV, 14:50 minutes, colour, sound
The miniature long march site 15 – site 23 2005
Mini DV, 25:30 minutes, colour, sound / Collection: The artist / Courtesy: Long March Project, Beijing

SHEN XIAOMIN
CHINA B.1972

The Village Cameraman and his Son 2001
Betacam SP, 40 minutes, colour, stereo / Collection: The artist / Courtesy: Long March Project, Beijing

WANG WENHAI
CHINA B.1950

Mao Zedong and Mao Zedong 2003
Fibreglass / 2 figures: 320 x 130 x 130cm (each) / Collection: The artist / Courtesy: Long March Project, Beijing

ZHOU XIAOHU
CHINA B.1960

Utopian theatre 2006
11-channel sculptural video installation, fired clay, 11 DVDs (1 minute each, colour, sound), 11 television monitors, 10 sets of headphones / 140 x 400cm (diam.) (approx.) / Collection: The artist / Courtesy: Long March Project, Beijing

DJAMBAWA **MARAWILI**
AUSTRALIA B.1953
MADARRPA PEOPLE

Madarrpa at Yathikpa and Biranybirany 1997
Natural pigments on bark / 326.5 x 99.8cm / Santos Fund for Aboriginal Art 1998 / Collection: Art Gallery of South Australia, Adelaide

Burrut'tji (lightning serpent) 2002
Natural pigments on bark / 150 x 92cm (irreg.) / Purchased 2003. Queensland Art Gallery Foundation / Collection: Queensland Art Gallery

Miny'tji 2002
Natural pigments on bark / 193 x 101cm Purchased 2003 / Collection: National Gallery of Australia, Canberra

Dhanbarr (hollow log memorial pole) 2004
Wood with natural pigments / 312 x 20cm (diam.) / Purchased 2005. Queensland Art Gallery Foundation / Collection: Queensland Art Gallery

Baraltja 2005
Natural pigments on bark / 196.5 x 74.5cm / Purchased 2005. Queensland Art Gallery Foundation / Collection: Queensland Art Gallery

Mundukul (lightning serpent) 2005
Natural pigments on bark / 200 x 79.5cm / Purchased 2005. Queensland Art Gallery Foundation / Collection: Queensland Art Gallery

Source of fire 2005
Natural pigments on bark / 191 x 84cm / Purchased with funds provided by the Aboriginal Collection Benefactors' Group 2005 / Collection: Art Gallery of New South Wales, Sydney

Burrut'tji (lightning serpent) 2006
Natural pigments on bark / 247 x 82cm / Collection: Annandale Galleries, Sydney

Dhanbarr (hollow log memorial pole) 2006
Wood with natural pigments / 350 x 35cm (approx.) / Collection: Annandale Galleries, Sydney

Garrangali 2006
Natural pigments on bark / 277 x 75cm / Collection: Annandale Galleries, Sydney

NASREEN **MOHAMEDI**
INDIA 1937–90

Untitled c.1958–81
Gelatin silver photographs, ed. 7/10 / 23 sheets ranging from 20.8 x 38.2cm to 30.9 x 30.8cm

Untitled c.1978
Gelatin silver photographs, ed. 7/10 / Triptych: left sheet: 29.5 x 37.1cm; centre sheet: 30.5 x 37.6cm; right sheet: 30.2 x 38cm

Purchased 2004. The Queensland Government's Gallery of Modern Art Acquisitions Fund / Collection: Queensland Art Gallery

Untitled c.1980
Pencil and ink / 59.7 x 74.9cm / Private collection, Mumbai

Untitled c.1981
Watercolor, pencil and ink / 47.6 x 47.6cm / Collection: Deepak Talwar / Courtesy: Talwar Gallery, New York

Untitled c.1982
Pencil and ink / 56 x 72.1cm / Collection: Deepak Talwar / Courtesy: Talwar Gallery, New York

Untitled c.1987
Pencil and ink / 4 sheets: 27.9 x 35.6cm (each) / Collection: Deepak Talwar / Courtesy: Talwar Gallery, New York

TUẤN ANDREW **NGUYỄN**
VIETNAM B.1976

In collaboration with Hà Thúc Phú Nam, Link-Fish, Cá Sấu Yellow, Gil, Ngô Đồng and Jason Huang
Proposal for a Vietnamese landscape #1: Đoàn kết quyết thắng, khát khao hơn, Đinh (United and determined to triumph, thirst for more, Dinh) 2006
Proposal for a Vietnamese Landscape #2: Độc lập tự do, Gil, tóc luôn vào nếp (Independence and freedom, Gil, your hair back into place) 2006
Proposal for a Vietnamese Landscape #3: Link Sao, đẩy mạnh công nghiệp hoá, công nghệ mang tinh nhân bản (Link Sao, push industrialisation, human technology) 2006
Oil on canvas / 3 panels: 120 x 180cm (each) / Collection: The artist

In collaboration with Hà Thúc Phú Nam
Nhu cầu vẽ bậy (Spray it, don't say it) 2006
High-definition video, 15 minutes, colour, sound / Collection: The artist

DENNIS **NONA**
AUSTRALIA B.1973
KALA LAGAW YA PEOPLE

Sessere 2004
Hand-coloured linocut, ed. 3/45 / 112 x 200cm / Purchased 2005 / Collection: Queensland Art Gallery

Baidam 2006
Linocut, A.P. / 95 x 239cm / Purchased 2006. Queensland Art Gallery Foundation Grant / Collection: Queensland Art Gallery

Ara 2006
Linocut, A.P. / 90 x 240cm / Purchased
2006. Queensland Art Gallery Foundation
Grant / Collection: Queensland Art Gallery

Kerr kerr (mountain bush ginger) 2006
Linocut, ed. 5/45 / 112 x 67cm / Collection:
The artist / Courtesy: The Australian Art
Print Network, Sydney

Dangau Pui 2006
Linocut on paper / 111x75cm / Collection:
The artist

Mazzaru 2006
Linocut on paper / 111x54cm / Collection:
The artist

EKO **NUGROHO**
INDONESIA B.1977

I'm lost in my mind 2004
40 x 29cm

*We are celebrating our Independence
Day* 2004
42 x 46cm

Welcome back virus 2004
37 x 46cm

*What's different between you and the
President* 2004
39 x 31cm

Untitled (1) 2005
30.5cm (diam.) (irreg.)

Untitled (2) 2005
25.5cm (diam.) (irreg.)

Nobody 2005
29.5cm (diam.) (irreg.)

Blind me 2005
25 x 22cm (irreg.)

Is anybody still care? 2005
53.5cm (diam.) (irreg.)

Trust me 2005
30cm (diam.) (irreg.)

Free as a gun 2005
27.5 x 54.5cm (irreg.)

Turn left go ahead, turn right get save
2006
174 x 159cm (irreg.)

Trick me please 2006
181 x 153.5cm (irreg.)

Machine embroidered rayon thread on
a fabric backing / Purchased 2006 /
Collection: Queensland Art Gallery

It's all about the Destiny! Isn't it? 2006
Synthetic polymer paint on MDF board /
1384.5 x 1862.8cm / Site specific work
for APT5 / Courtesy: The artist and the
Queensland Art Gallery

TSUYOSHI **OZAWA**
JAPAN B.1965

From 'Vegetable weapon' series:

Korean style vegetable hotpot/Seoul
2001
Chapsui/Baguio, The Philippines 2001
Seafood hotpot/Beijing 2002
Salmon hotpot/Tokyo 2002
Vegetable vindaloo/Brisbane, Australia
2005
5 sheets: 157 x 114cm (each, approx.)

*Parippu (Lentil curry) from Sri
Lanka/New York* 2002
Giblets hotpot/Fukuoka 2002
Vegetable curry/Brisbane, Australia
2005
*Chicken and spinach risotto/Brisbane,
Australia* 2005
4 sheets: 114 x 157cm (each, approx.)

Type C photographs, ed. of 1 / Purchased
2005 with funds from John Potter and
Roz MacAllan through the Queensland Art
Gallery Foundation / Collection:
Queensland Art Gallery

New Nasubi Gallery, a collaborative
project by Tsuyoshi Ozawa with APT5
artists: Ai Weiwei / Khadim Ali / Gussie
R Bento / Beck Cole / Justine Cooper /
eX de Medici / Hong Hao / Jitish Kallat /
Kwon Ki-soo / Sutee Kunavichayanont /
Dinh Q Lê / Finau Mara / Mu Chen and
Shao Yinong / Dennis Nona / Eko
Nugroho / Tsuyoshi Ozawa / Stephen
Page / Paiman / John Pule / Qin Ga /
Nusra Latif Qureshi / Rashid Rana /
Sangeeta Sandrasegar / Michael
Stevenson / Sima Urale / Việt Linh /
Yang Zhenzhong / Yoo Seung-ho
28 wooden boxes with mixed media
33 x 19.6 x 14.2cm (each) / Collection:
Each participating artist

PACIFIC TEXTILES PROJECT

ALINE **AMARU**
TAHITI, FRENCH POLYNESIA B.1941

La Famille Pomare (The Pomare Family)
1991
Tifaifai, Pa'oti style quilt: commercial
cotton cloth and thread in appliqué and
embroidered technique / 231 x 238cm /
Purchased 2004. Queensland Art Gallery
Foundation Grant / Collection: Queensland
Art Gallery

GUSSIE R **BENTO**
HAWAI'I, UNITED STATES B.1932

*Na kalaunu a me na kāhili o Kamehameha
IV (The crown and the kāhili of
Kamehameha IV)* c.1980
Kapa kuiki quilt: commercial cotton cloth,
synthetic batting with hand appliqué
and contour quilting / 254 x 269.24cm /
Collection: The artist

TUNGANE **BROADBENT**
MANGAIA/RAROTONGA, COOK ISLANDS
 B.1940

Tairiiri (fan) 2005–06
Tivaevae, Manu style quilt: commercial
cotton cloth and thread in appliqué
technique / 260 x 225cm / Commissioned
2006 / Collection: Queensland Art Gallery

SUSANA **KAAFI**
TONGA/AUSTRALIA B.1920

Fala pati 1988
Mat: woven lau'akau (pandanus) and
commercial wool / 237 x 178.5cm (irreg.,
including fringes of 17.5cm and 9cm) /
Purchased 2004 / Collection: Queensland
Art Gallery

DEBORAH (KEPOLA) U **KAKALIA**
HAWAI'I, UNITED STATES 1915–2002

Lili'uokalani c.1993
Kapa kuiki quilt: commercial cotton cloth,
synthetic batting with hand appliqué
and contour quilting / 269.2 x 248.9 cm /
Gift of Deborah (Kepola) U Kakalia, 1996
Collection: Bishop Museum, Honolulu

SERUWAIA **KUDRUVI**
LAU ISLANDS, FIJI B.(C.)1950

Ibe vakabati 2005
Mat: woven voi voi (pandanus) and
commercial wool / 181.5 x 246.3cm /
Commissioned 2005 / Collection:
Queensland Art Gallery

FILITI LEYA **LEDUA**
FIJI B.1948

Ibe vakabati 2003
Mat: woven voi voi (pandanus) and
commercial wool / 238 x 347.5cm (irreg.,
including fringe of 12cm) / Purchased
2004 / Collection: Queensland Art Gallery

FINAU **MARA**
LAU ISLANDS, FIJI B.1950

I yara yara 2005–06
Baby mat: woven voi voi (pandanus) with
beach hibiscus and commercial wool /
100 x 140cm / Commissioned 2005 /
Collection: Queensland Art Gallery

TEKAUVAI TEARIKI **MONGA**
AITUTAKI/RAROTONGA, COOK ISLANDS
 1900–61

Etu popongi (Morning star) 1958
Tivaevae, Taorei style quilt: commercial
cotton cloth and thread in patchwork
technique / 232 x 219.5cm / Purchased
2006. Queensland Art Gallery Foundation /
Collection: Queensland Art Gallery

MARGO **MORGAN**
HAWAI'I, UNITED STATES B.1920

Naupaka 1977
Kapa kuiki quilt: commercial cotton cloth,
synthetic batting with hand appliqué and
contour quilting / 244 x 246cm /
Collection: The artist

LAUPULE **POUTASI**
SAMOA 1912–2004
TUSI **LUAFUTU**
SAMOA/AUSTRALIA B.1951

Fala su'i c.1984, reworked 2004
Mat: woven laufala (pandanus) and
commercial wool / 140.5 x 206.5cm (irreg.) /
Purchased 2004 / Collection: Queensland
Art Gallery

SUSIE **SUGI**
JAPAN/HAWAI'I, UNITED STATES B.1949

*Na kalaunu a me na kāhili (The crown
and the kāhili)* 2001
Kapa kuiki quilt: commercial cotton cloth,
synthetic batting with hand appliqué and
contour quilting / 230 x 152.4cm /
Collection: Poakalani & John Serrao,
Honolulu

EMMA **TAMARII**
MARQUESAS ISLANDS/TAHITI, FRENCH
 POLYNESIA B.1937

Tifaifai 2000
Marquesan style quilt: commercial cotton
cloth and thread in reverse appliqué
technique / 227 x 253cm / Purchased
2000. Queensland Art Gallery Foundation
Grant / Collection: Queensland Art Gallery

MARIE-THERESE **TAMARII**
MARQUESAS ISLANDS/TAHITI, FRENCH
 POLYNESIA B.1959

Couronne du Roi (The King's crown)
2003
Tifaifai quilt: commercial cotton cloth and
thread in appliqué and embroidered
technique / 280 x 240cm / Purchased
2006. Queensland Art Gallery Foundation /
Collection: Queensland Art Gallery

LEPETIA **TOA**
SAMOA

Fala su'i 2000
Mat: woven laufala (pandanus) and
commercial wool / 143 x 216cm /
Collection: Museum of New Zealand
Te Papa Tongarewa, Wellington

SIVAIMAUGA **VAAGI**
SAMOA B.1964

Fala su'i 2005
Mat: woven laufala (pandanus) and
commercial wool / 148.5 x 217.3cm (irreg.,
including fringes) / Purchased 2005.
Queensland Art Gallery Foundation /
Collection: Queensland Art Gallery

TAPAERU **WILLIAMS**
COOK ISLANDS/NEW ZEALAND B.(C.)1935

Tivaevae 2003
Taorei style quilt: commercial cotton cloth
and thread in patchwork technique /
286 x 259cm / Purchased 2003. The
Queensland Government's Gallery of
Modern Art Acquisitions Fund / Collection:
Queensland Art Gallery

REPEKA **YALI**
LAU ISLANDS, FIJI B.1942

Ibe vakabati 2005
Mat: woven voi voi (pandanus) and
commercial wool / 178.7 x 272.7cm /
Commissioned 2005 / Collection:
Queensland Art Gallery

ARTIST UNIDENTIFIED
SAMOA

Fala su'i c.1980–85
Mat: woven laufala (pandanus) and
commercial wool / 128 x 224cm (irreg.,
including fringe) / Purchased 2005 /
Collection: Queensland Art Gallery

ARTIST UNIDENTIFIED
LAU ISLANDS, FIJI

Ibe vakabati c.2001
Mat: woven voi voi (pandanus) and
commercial wool / 185.5 x 210.5cm /
Purchased 2005 / Collection: Queensland
Art Gallery

STEPHEN **PAGE**
AUSTRALIA B.1965
NUNUKUL/MUNALDJALI/YUGAMBEH PEOPLE

Kin 2006
Devised/Director: Stephen Page /
Composer: David Page / Design: Peter
England / Lighting design: Glenn Hughes /
Stage manager: Kylie Mitchell / Cast: Isieli
Jarden, Ryan Jarden, Josiah Page, Samson
Page, Sean Page, Hunter Page-Lochard,
Curtis Walsh-Jarden / Cinematographer:
Douglas Watkin

The Kin Story 2006
Mini DV, 30 minutes (approx.), colour,
sound / Cinematographer/Editor: Douglas
Watkin / Composer: David Page /
Courtesy: Douglas Watkin, Stephen Page,
David Page and the Queensland Art
Gallery

PAIMAN
MALAYSIA B.1970

From 'The Code' series 2005:

Azalina Othman 1
Chandra Muzzafar 1
Code 22 — Azalina Othman
Daim Zainuddin 1
Kerk Kim Hock
Lim Kit Siang
Muhammad Taib 1
Muhammad Taib 3
Musa Hitam
Tun Salleh Abas
Ungku Aziz
Chin Peng
Idris Jusoh
Kamaruddin Meranun
Watercolour and ink

Eric Chia
Hassan Merican
Marina Mahathir
Muhammad Taib 2
Watercolour, silver leaf, synthetic polymer
paint and ink

Nazri Aziz
Rahim Noor
Syed Ahmad Jamal
Tun Abdul Razak
Tunku Abdul Rahman
Ink

Nik Aziz
Pahamin Rejab
Rahim Tamby Chik
Rashid Maidin
Sharir Samad
Tengku Mahalel
Watercolour, synthetic polymer paint
and ink

Samy Vellu
Watercolour, collage and ink

Subramaniam
Watercolour, synthetic polymer paint,
collage and ink

Code 14 — Raja Aziz Addruse
Synthetic polymer paint, graphite and ink
on canvas

Code 21 — Najib Tun Razak
Watercolour, graphite and ink

3M
Watercolour, graphite, collage and ink

Code 54
Synthetic polymer paint and ink on
canvas

Code 58
Watercolour, gouache and ink

Mahathir Mohamad
Synthetic polymer paint, silver leaf and ink

37 sheets ranging from 11 x 76cm to 79 x
62cm / Purchased 2006 / Collection:
Queensland Art Gallery

MICHAEL **PAREKOWHAI**
NEW ZEALAND B.1968

The indefinite article 1990
Synthetic polymer paint on wood /
5 components: 250 x 500 x 200cm (installed) /
Jim Barr and Mary Barr loan collection /
Collection: Dunedin Public Art Gallery

*Acts (10: 34–38) 'He went about doing
good'* 1993
Synthetic polymer paint on wood /
Dimensions variable / Purchased 1993 /
Collection: Auckland Art Gallery Toi o Tāmaki

Acts II 1994
Wood with enamel paint / 3 components:
284 x 90 x 40cm (each) / Purchased
2004. The Queensland Government's
Gallery of Modern Art Acquisitions Fund /
Collection: Queensland Art Gallery

Kiss the baby goodbye 1994
Powder coated steel / 2 components:
360 x 460cm (overall) / Chartwell
Collection / Collection: Auckland Art
Gallery Toi o Tāmaki

The story of a New Zealand river 2001
Paua, capiz, lacquer and wood on a
concert grand piano / 101.5 x 158 x
272.5cm / The Auckland Triennial
Collection on loan from the Thanksgiving
Foundation, 2001 / Collection: Auckland
Art Gallery Toi o Tāmaki

From 'The consolation of philosophy —
Piko nei te matenga' series 2001:
Le Quesnoy
Boulogne
Carais
Type C photographs, ed. of 8 / 3 sheets:
155 x 125cm (each)

What's the time Mr Woolf 2005
Type C photograph, marker pen, ed. 5/5 /
100 x 100cm

Purchased 2006. Queensland Art Gallery
Foundation / Collection: Queensland Art
Gallery

JOHN **PULE**
NIUE/NEW ZEALAND B.1962

*Halahala (The pathway is clear for the
child to be born)* 1992
Oil on canvas / 247 x 176.5cm
(unstretched)

Untitled 1998
Oil on canvas / 246.4 x 225.7cm
(unstretched)

Gift of the artist 2005 / Collection:
Queensland Art Gallery

Lagaki (To lift) (series) 2000–05
Ink, oil stick, pencil and pastel / 15 sheets:
76.3 x 56.4cm (each, approx.)

Tukulagi tukumuitea (Forever and ever)
2005
Oil on canvas / Triptych: 199.9 x 199.9cm
(each panel)

Purchased 2005. The Queensland
Government's Gallery of Modern Art
Acquisitions Fund / Collection:
Queensland Art Gallery

*Kulukakina (after experiencing
something miraculous, withdraw)* 2004
Oil and ink on canvas / 200 x 180cm /
Purchased 2004. The Queensland
Government's Gallery of Modern Art
Acquisitions Fund / Collection:
Queensland Art Gallery

NUSRA LATIF **QURESHI**
PAKISTAN/AUSTRALIA B.1973

Backdrops II 2001
Gouache, synthetic polymer paint and
gold leaf on wasli paper / 20.5 x 15.4cm

Conversations II 2001
Gouache and gold leaf on wasli paper /
14.7 x 14.9cm

Afterthoughts 2001
Gouache and silver leaf on wasli paper /
19.5 x 14.3cm

Justified behavioural sketch 2002
Gouache and ink on wasli paper /
21 x 14.7cm

Gardens of desire II 2002
Gouache on wasli paper / 21 x 14.8cm

The Kenneth and Yasuko Myer Collection
of Contemporary Asian Art. Purchased
2003 with funds from Michael Simcha
Baevski through the Queensland Art
Gallery Foundation / Collection:
Queensland Art Gallery

Silent spaces 1 2005
Gouache, paper, synthetic polymer paint
and wasli on illustration board / Diptych:
40 x 30cm (each panel) / Purchased
2005. The Queensland Government's
Gallery of Modern Art Acquisitions Fund /
Collection: Queensland Art Gallery

A garden of fruit trees 2006
A simple garden layout 2006
A set of serviceable shapes 2006
Gouache on wasli paper / 34 x 26cm

Some exotic flower beds 2006
The right adjustments — I 2006
Gouache and silver on wasli paper /
34 x 26cm

Precious strings of pearls 2006
Gouache, ink and graphite on wasli paper /
34 x 26cm

My sister in the garden of wonders
2006
Synthetic polymer paint and gouache
on wasli on illustration board / Diptych:
40 x 29cm (each panel)

Purchased 2006 / Collection: Queensland
Art Gallery

RASHID **RANA**
PAKISTAN B.1968

Ommatidia I / Hrithik Roshan 2004
Type C photograph, ed. 12/20 /
85.1 x 76.2cm

Ommatidia II / Salman Khan 2004
Type C photograph, ed. 12/20 /
78.74 x 76.2cm

Ommatidia III / Shah Rukh Khan 2004
Type C photograph, ed. 12/20 /
76.2 x 83.82cm

All eyes skyward during the annual parade 2004
Type C photograph, ed. 5/5 /
250.4 x 609.6cm

Off shore accounts — II 2006
Type C photograph, ed. 1/5 /
199.4 x 373.4cm

Collection: The artist

SANGEETA **SANDRASEGAR**
AUSTRALIA B.1977

Untitled no. 1, 22, 26, 27, 33, 34 (from 'Goddess of flowers' series) 2003
Paper, beads and glitter / 6 pieces: 29.5 x 42cm (each, irreg., approx.) / Purchased 2004. Queensland Art Gallery Foundation Grant / Collection: Queensland Art Gallery

Untitled 2006
Paper, beads and gitter / 400 components: installation and dimensions variable / Collection: The artist / Courtesy: Mori Art Gallery, Sydney

KUMAR **SHAHANI**
INDIA B.1940

Fire in the Belly 1973
16mm, 18 minutes, b. & w., mono, India, English / Director: Kumar Shahani / Producer: Films Division, Government of India / Print source/Rights: National Film Archive, India

The Wave (Tarang) 1984
35mm, 171 minutes, colour, mono, Hindi (English subtitles) / Director: Kumar Shahani / Producer: Ravi Malik / Story: Roshan Shahani / Script: Kumar Shahani, Roshan Shahani / Cinematography: KK Mahajan / Editor: Ashok Tiyagi / Art direction: CS Bhatti, Bansi Chandragupta / Sound: Hitendra Ghosh, R Kaushik, Narinder Singh / Music: Vanraj Bhatia / Cast: Amol Palekar, Smita Patil, Shreeram Lagoo, Girish Karnad / Production company: National Film Development Corporation / Print source/Rights: National Film Archive, India

The Khayal Saga (Khayal Gatha) 1988
35mm, 103 minutes, colour, mono, India, Hindi and Urdu (English subtitles) / Director/Script: Kumar Shahani / Producer: Maydhya Pradesh Film Development Corporation / Dialogue: Ashmaki Acharya, Kama Swaroop / Cinematography: KK Mahajan / Editor: Paresh Kamdar / Art direction: Anoop Singh / Sound: Vikram Joglekar, AM Padmanabhan / Music research and co-ordination: Roshan Shahani / Cast: Mangal Dhillon, Rajat Kapoor, Mita Vasisht / Production company: Bombay Cinematograph / Print source: Queensland Art Gallery / Rights: Kumar Shahani / Purchased 2006. The Queensland Government's Gallery of Modern Art Acquisitions Fund / Collection: Queensland Art Gallery

Kasba 1990
35mm, 115 minutes, colour, mono, India, Hindi, Urdu, and Punjabi (English subtitles) / Director: Kumar Shahani / Producer: National Film Development Corporation, India / Executive producer: Ravi Malik / Story: Anton Chekhov / Adaptation: Bhisham Sahni / Script: Farida Mehta, Kumar Shahani / Dialogue: Gulzar / Cinematography: KK Mahajan / Editor: Paresh Kamdar / Art direction: Nitish Roy, Nitin Desai / Sound: Vikram Joglekar / Music: Vanraj Bhatia / Cast: Mita Vasisht, Navjot Harsra, KK Raina, Manohar Singh, Shatrughan Sinha / Production company: Doordarshan, National Film Development Corporation / Print source: Queensland Art Gallery Collection / Rights: National Film Development Corporation / Purchased 2006. The Queensland Government's Gallery of Modern Art Acquisitions Fund / Collection: Queensland Art Gallery

Immanence (Bhavantarana) 1991
35mm, 65 minutes, colour, mono, India, Oriya and Sanskrit (English intertitles and subtitles) / Director: Kumar Shahani / Producer: Roshan Shahani / Script: Fareeda Mehta, Kumar Shahani / Cinematography: Alok Upadhyay / Editor: Paresh Kamdar / Sound: Namita Nayak / Music: Bhubaneshwar Mishra, Hari Prasad Chaurasia / Cast: Kelucharan Mohapatra, Sanjukta Panigrihi, Rajat Kapoor, Ramchandra Parihar / Production company: Bombay Cinematograph / Print source: Queensland Art Gallery Collection / Rights: Ministry of External Affairs, India / Purchased 2006. The Queensland Government's Gallery of Modern Art Acquisitions Fund / Collection: Queensland Art Gallery

Four Chapters (Char Adhyay) 1997
35mm, 110 minutes, colour, mono, India, Hindi (English subtitles) / Director/Script: Kumar Shahani / Producer: National Film Development Corporation / Script consultant: Rimli Bhattacharya / Cinematography: KK Mahajan / Editor: Sujata Narula / Art direction: Nitish Roy / Sound: Narinder Singh, Namita Nayak, AM Padmanabhan / Music: Vanraj Bhatia / Cast: Nandini Ghosal, Sumanto Chattopadya, Kaushik Gopal, Shibhu, Sruti Yusufi, Ramchandra Parihar / Production co-ordinator: Rimli Bhattacharyal Production company: National Film Development Corporation / Print source/Rights: National Film Archive, India

The Bamboo Flute (Birah Bharyo Ghar Aangan Kone) 2000
35mm, 84 minutes, colour, mono, India, Hindi and Tamil (English subtitles) / Director/Script: Kumar Shahani / Executive producer and music research: Roshan Shahani / Cinematography: KK Mahajan, Subroto Maullick / Editor: Lalitha Krishna / Sound: AM Padmanabhan / Musicians: Pandit Hariprasad Chaurasia, Pandit Jal Balaporia, Rupak Kulkarni / Archival music: Annapurna Devi, (on surbahar), T Viswanathan, Dr N Ramani, TR Mahalingam (flautists) / Cast: Anandi Ramachandran, Sidharth Srinivasan, Abid Ali, Abha Dubey, Pandiram / Production company: Bombay Cinematograph / Print source: Queensland Art Gallery Collection / Rights: Ministry of External Affairs, India / Purchased 2006. The Queensland Government's Gallery of Modern Art Acquisitions Fund / Collection: Queensland Art Gallery

TALVIN **SINGH**
UNITED KINGDOM/INDIA B.1970

Tablatronic 2006
'The 5th Asia–Pacific Triennial of Contemporary Art', Queensland Art Gallery

MICHAEL **STEVENSON**
NEW ZEALAND/GERMANY B.1964

From 'Argonauts of the Timor Sea' 2004:

Timor Sea crossed on raft
Pastel on paper / 30.8 x 10.5cm

Frame saw
Wood, metal, string and bamboo / 86 x 114 x 8cm (irreg.)

Rute migrasi lama
Synthetic polymer paint on canvas with maple rods and string / 191 x 168 x 2.3cm (including rods)

Ocean currents, Australia
Synthetic polymer paint on canvas with maple rods and string / 250 x 220 x 1.8cm (including rods)

Das gift
Meranti wood, silk and nails / 23.8 x 15 x 4.5cm

Ekspedisi Kon-Tiki
Letterpress on paper in coconut wood frame, ed. 1/20 / 27.8 x 18.9cm

The gift
Gelatin silver photograph, ed. 1/15 / 50.5 x 60.5cm

Purchased 2004. The Queensland Government's Gallery of Modern Art Acquisitions Fund / Collection: Queensland Art Gallery

Making for Sheppey 2004
Mini DV, 23 minutes, colour, sound / Director of photography: Sean Reynard / Filmed with the 2nd Whitstable Sea Scout troop on Whitstable beach, Kent, United Kingdom, October 2004 / Collection: The artist

The gift 2004–06
Aluminium, wood, rope, bamboo, synthetic polymer paint, World War Two parachute and National Geographic magazines / 400 x 600 x 300cm (installed, approx.) / Collection: The artist / Courtesy: Darren Knight Gallery, Sydney

MASAMI **TERAOKA**
JAPAN/UNITED STATES B.1936

McDonald's Hamburgers Invading Japan/Chochin-me 1982
36 colour screenprint on Arches 88 paper, ed. 41/91 / 54.3 x 36.5cm / Purchased 2005. The Queensland Government's Gallery of Modern Art Acquisitions Fund / Collection: Queensland Art Gallery

Wave Series/Tattooed Woman at Makapuu Beach 1984
Watercolour / 50.8 x 73.7cm / Collection: Brian Pawlowski, USA

Wave Series/Turtle Island 1984–86
Watercolour / 2 panel screen: 76.2 x 396.2cm (overall) / Private collection, Los Angeles

Samurai Jogger 1986
Watercolour on paper, mounted on wood / Six panel screen: 196.9 x 595.6cm (installed) / Gift of Cray Research Inc. with additional funds from Walker Art Center, 1986/1994 / Collection: Walker Art Center, Minneapolis

American Kabuki/Oishiiwa 1986
Watercolour on paper, mounted as a four-panel folding screen / 196.85 x 393.7cm / Museum purchase, American Art Trust Fund, Brian Pawlowski and Aki Ueno Fund / Collection: Fine Arts Museums of San Francisco

AIDS Series/Black Ships and Geisha 1987
Watercolour / 76.2 x 144.8cm / Private collection, Honolulu

AIDS Series/Geisha in Bath 1988
Watercolour on canvas / 274.3 x 205.7cm / Collection: The artist / Courtesy: Catharine Clark Gallery, San Francisco

Hanauma Bay Series/Snorkel Woman and Climbing Octopus 1988
Watercolour / 195.6 x 54.3cm / Collection: Dick Spencer and Shawn Gould, USA

Sunset Beach 1989
Watercolour and sumi on canvas / 205.7 x 269.2cm / Private collection, San Francisco

YUKEN **TERUYA**
JAPAN/UNITED STATES B.1973

Notice — Forest 2005
Paper / 5 components: 9.3 x 15 x 27.5cm; 9.3 x 15 x 28.3cm; 9.2 x 15 x 28cm; 10.3 x 16.8 x 33cm; 9.2 x 15.2 x 28.2cm / Collection: Ota Fine Arts, Tokyo

Notice — Forest 2005
Paper / 6 components: 7.9 x 13 x 24cm; 9 x 14.9 x 27.3cm; 11.4 x 17.6 x 32.5cm; 9.5 x 15.1 x 27.9cm; 8.1 x 12.2 x 24.3cm; 12.2 x 17.8 x 28.1cm / Collection: Obayashi Collection, Tokyo / Courtesy: Ota Fine Arts, Tokyo

Notice — Forest 2005
Paper / 2 components: 10.5 x 14.9 x 27.8cm; 8 x 18 x 31.3cm / Collection: Studio Guenzani, Milan / Courtesy: Ota Fine Arts, Tokyo

Notice — Forest 2006
Paper / 5 components: 11.7 x 23.9 x 34.9cm; 9.9 x 21.8 x 28.8; 10.5 x 19.5 x 26.5cm; 11.7 x 23.9 x 34.9cm (approx.); 11.7 x 23.9 x 34.9cm (approx.) / Collection: The artist

SIMA **URALE**
SAMOA/NEW ZEALAND B.1969

O Tamaiti 1996
35mm, 15 minutes, b. & w., stereo, New Zealand, Samoan (English subtitles) / Director/Script: Sima Urale / Producer: Carol J Paewai / Cinematography: Rewa Harre / Editor: Annie Collins / Art direction: Bridey Farrell / Sound: Ray Beentjes / Music: George Nepia / Cast: Harry Wendt, Therese Louise Fatu, Charles Faamausili, Tom Andrews, Julio Joseph Mel / Production company: Paewai Productions / Print source: Queensland Art Gallery / Rights: New Zealand Film Commission / Purchased 2004. Queensland Art Gallery Foundation Grant / Collection: Queensland Art Gallery

Velvet Dreams 1997
Digital Betacam, 47 minutes, colour, stereo, New Zealand, English / Director: Sima Urale / Producers: Vincent Burke, Clifton May / Cinematography: Leon Narbey / Cast: Joy Vaele, Lisa Taouma, Nina-Kaye Tane Tinorau, Ruth Awina Forsyth, John Pule / Production company: Top Shelf Productions / Print source/Rights: Alliance Atlantis

Still Life 2001
35mm, 11 minutes, colour, stereo, New Zealand, English / Director/Script: Sima Urale / Producer: Anna Rasmussen / Cinematography: Rewa Harre / Editor: Eric de Beus / Art direction: Kirsty Cameron / Sound: Dick Reade / Cast: John Harcox, June Bishop / Production company: Niu Movies Limited / Print source: Queensland Art Gallery / Rights: New Zealand Film Commission / The James C Sourris Collection. Purchased 2005 with funds from James C Sourris through the Queensland Art Gallery Foundation / Collection: Queensland Art Gallery

Hip Hop New Zealand 2003
Digital Betacam, 45 minutes, colour, stereo, New Zealand, English / Director: Sima Urale / Producer: Sonali Amarasingham-Christie / Cinematography: Rewa Harre / Editor: Eric de Beus / Sound: Phil Donovan, Pete Brebner / Music: DLT, Def Squad, Tha Feelstyle, Brotha D & Cru, P-Money featuring Scribe / Cast: Time Bandits, King Kapisi, Captain imon Star, KOS 163, MC OJ & Rythm Slave, DJ Raw, and Tha Feelstyle / Production company: Screentime Communicado / Print source/Rights: Screentime Communicado

VIỆT LINH
VIETNAM B.1952

Travelling Circus (Gánh Xiếc Rong) 1988
35mm, 80 minutes, b. & w., mono, Vietnam, Vietnamese (English subtitles) / Director: Việt Linh / Producer: Tran Khai Hoang / Script: Pham Thuy Nhan / Cinematography: Dinh Anh Dung / Editor: Thien Huong / Art direction: Pham Nguyen Can / Music: Hoang Hiep / Cast: The Anh, Thai Ngan, Bac Son, Viet Minh / Production company/Rights: Giai Phong Film Studio / Print source: Discovery Communication / Screening format: Digital Betacam

Devil's Mark (Dấu Ấn Của Quỷ) 1992
35mm, 90 minutes, colour, mono, Vietnam, Vietnamese (Japanese & English subtitles) / Director: Việt Linh / Producer: Duong Minh Hoang / Script: Pham Thuy Nhan / Cinematography: Doan Quoc / Editor: Thien Huong / Art direction: Pham Hong Phong / Sound: Quang Dao / Music: Phu Quang / Cast: Don Duong, Ngoc Hiep, Le Cung Bac / Production company/Rights: Giai Phong Film Studio / Print source: Fukuoka City Public Library Film Archive

Collective Flat (Chung Cư) 1999
35mm, 90 minutes, colour, mono, Vietnam/France, Vietnamese (Japanese & English subtitles) / Director: Việt Linh / Producer: Duong Minh Hoang / Script: Việt Linh from the short story The Building by Nguyễn Hồ / Cinematography: Hai Bao / Editor: Thien Huong / Art direction: Pham Hong Phong / Sound: Le Ngu Nghia / Music: Phu Quang / Cast: Mai Thanh, Hong Anh, Don Duong, Minh Trang, Quyen Linh, Kim Xuan / Production company: Giai Phong Films Studio, Le Bureau / Print source: Fukuoka City Public Library Film Archive / Rights: Giai Phong Film Studio

Me Thao, Once upon a Time (Mê Thảo, Thời Vang Bóng) 2002
35mm, 107 minutes, colour, stereo, Vietnam, Vietnamese (English subtitles) / Director: Việt Linh / Producer: Duong Minh Hoang / Script: Pham Thuy Nhan, Việt Linh, Serge Le Peron / Cinematography: Pham Hoang Nam / Editors: Cam Van, Thuy Chung / Art direction: Pham Hong Phong / Sound: Hoang Anh, Trong Tung, Minh Khana, Dang Khoa / Music: Van Dung / Cast: Dung Nhi, Don Duong, Minh Trang, Thuy Nga, Hong Chuong / Production company: Giai Phong Film Studio, Les Films d'ici / Print source: Golden Valley Entertainment / Rights: Giai Phong Film Studio

GORDON **WALTERS**
NEW ZEALAND 1919–95

Blue on Yellow 1967
Synthetic polymer paint on canvas / 182.5 x 136.5cm / Collection: Jennifer Gibbs Trust, Auckland

Kahukura 1968
PVA and synthetic polymer paint on canvas / 114 x 152cm / Collection: Victoria University of Wellington, New Zealand

Rongotai 1970
PVA and synthetic polymer paint on canvas / 152 x 115cm

Black Centre 1971
Synthetic polymer paint on canvas / 152.4 x 152.4cm

Genealogy 5 1971
Synthetic polymer paint on canvas / 152.3 x 152.3cm

Collection: Jennifer Gibbs Trust, Auckland

Maheno 1981
Synthetic polymer paint on canvas / 153 x 115cm / Purchased 1982 / Collection: Auckland Art Gallery Toi o Tāmaki

Untitled 1995
Synthetic polymer paint on canvas / 152 x 114cm / Collection: Gordon Walters Estate / Courtesy: Sue Crockford Gallery, Auckland

APICHATPONG **WEERASETHAKUL**
THAILAND B.1970

0016643225059 1994
16mm, 5 minutes, colour, stereo, Thailand, Thai (English subtitles) / Director/Script/Cinematography/Editor: Apichatpong Weerasethakul / Rights: Apichatpong Weerasethakul / Screening format: Betacam SP

Like the Relentless Fury of the Pounding Waves 1995
16mm and video, 30 minutes, b. & w., stereo, Thailand, Thai (English subtitles) / Director/Script/Cinematography: Apichatpong Weerasethakul / Cast: Piyaporn Tananupappisal, Juthamanee Tananupappisal, Noppadol Tungsakul, Tawin Jaidee, Chatsakkarin Pahukul / Print source: Kick the Machine / Rights: Apichatpong Weerasethakul / Screening format: Betacam SP

thirdworld 1997
Digital video, 17 minutes, colour, stereo, Thailand, Thai (English subtitles) / Director/Cinematography/Editor: Apichatpong Weerasethakul / Sound: Paisit Phanpruksachat, Adhinan Adulayasis / Cast: Chumnan Boonyaputhipong, Paisit Phanpruksachat, Apichatpong Weerasethakul, Nappaporn Konkirati / Production company: 9/6 Cinemafactory / Print source: Kick the Machine / Rights: Apichatpong Weerasethakul / Screening format: Betacam SP

Mysterious Object at Noon (Dokfa nai meuman) 2000
16mm, 85 minutes, b. & w., Dolby SR, Thailand, Thai, (English subtitles) / Director/Script: Apichatpong Weerasethakul / Producers: Gridthiya Gaweewong, Mingmongkol Sonakul, Apichatpong Weerasethakul / Cinematography: Gridthiya Gaweewong, Apichatpong Weerasethakul / Editor: Mingmongkol Sonakul / Sound: Paisit Phanprucksachat / Cast: Duangla Hiransri, Kongkeirt Komsiri, Saisiri Xoomsai, Somsri Pinyopol, To Hanudomlapr / Production company: 9/6 Cinemafactory / Print source: Kick the Machine / Rights: Apichatpong Weerasethakul / Screening format: 35mm

Haunted Houses (Thai Version) 2001
Digital video, 60 minutes, colour, stereo, Thailand, Thai (English subtitles) / Director/Cinematography: Apichatpong Weerasethakul / Sound: Soontara Pinwisai / Production company: Kick the Machine, La-Ong Dao Company Limited / Print source: Kick the Machine / Rights: Apichatpong Weerasethakul / Screening format: Betacam SP

Blissfully Yours (Sud Sanaeha) 2002
35mm, 122 minutes, colour, Dolby SRD, Thailand, Thai and Burmese (English subtitles) / Director/Script: Apichatpong Weerasethakul / Producers: Eric Chan, Charles de Meaux / Cinematography: Sayombhu Mukdeeprom / Editor: Lee Chatametikool / Art direction: Akekarat Homlaor, Arthit Mahasri / Sound: Teekadet Vucharadhanin, Lee Chatametikook / Cast: Kanokprn Tongaram, Min Oo, Jenjira Jansuda / Production company: La-Ong Dao Company Let, Kick the Machine / Print source: Kick the Machine / Rights: Apichatpong Weerasethakul

Nokia Short 2003
Digital Betacam, 2 minutes, colour, stereo, Thailand, Thai (English subtitles) / Director/Script/Cinematography: Apichatpong Weerasethakul / Music: Masato Hatanaka / Production company: Kick the Machine / Print source/Rights: Apichatpong Weerasethakul / Screening format: Betacam SP

This and a Million More Lights 2003
Digital video, 1 minute, colour, silent / Director/Cinematography: Apichatpong Weerasethakul / Print source: Apichatpong Weerasethakul / Screening format: Betacam SP

The Adventure of Iron Pussy (Hua Jai Tor Ra Nong) 2003
Digital video, 90 minutes, colour, stereo, Thailand, Thai (English Subtitles) / Directors/Script: Apichatpong Weerasethakul, Michael Shaowanasai / Producers: Peyanan Chantraklom, Pheeraya Prommachat / Cinematography: Surachet Thongme / Editor: Panu Tatwisetwong / Art direction: Akekarat Homlaor / Music: Animal Farm / Cast: Michael Shawanasai, Krissada Terrence, Darunee Kritboonyalai, Jutharat Attakorn, Varin Sachdev / Production company: GMM Grammy and Apichatpong Weerasethakul / Print source/Rights: GMM Grammy / Screening format: Betacam SP

Tropical Malady (Sud Pralad) 2004
35mm, 118 minutes, colour, Dolby SRD, Thailand, Thai, (English subtitles) / Director/Script: Apichatpong Weerasethakul / Producer: Charles de Meaux / Cinematography: Jarin Pengpanitch, Vichit Tanapanitch, Jean-Louis Vialard / Editor: Lee Chatametikool, Jacopo Quadri / Art direction: Akekarat Homlaor / Sound: Akritchalerm Kalayanamitr / Music: Nutcha Weeranukul, Gandhi Anantagant, Rung, Jay / Cast: Banlop Lomnoi, Sakda Kaewbuadee / Production company: Anna Sanders Films, TIFA, Thoke+Moebius, Downtown Pictures, Kick the Machine / Print source/Rights: Celluloid Dreams

Ghost of Asia 2005
Betacam, 9:15 minutes, colour, stereo, Thailand/France, Thai (English subtitles) / Directors: Apichatpong Weerasethakul, Christelle Lheureux / Producers: Cité Siam, Alliance Française (Bangkok), French Embassy (Bangkok)l Script: Jantrakansorn Sukkrajang, Sakda Poka, Nantawat Poonpeum / Cast: Sakda Kaewbuadee, Decha Woongor / Music: Gandhr Anantagant / Production company/Print source: Kick the Machine / Rights: Apichatpong Weerasethakul / Screening format: Betacam SP.

Worldly Desires 2005
Betacam SP, 40 minutes, colour, stereo, Thailand/South Korea, Thai language, (English subtitles) / Director: Apichatpong Weerasethakul, Pimpaka Towira / Producer: Apichatpong Weerasethakul / Script: Sompot Chidgasornpongse / Cinematography: Sayombhu Nukdeeprom, Sivaroj Kongsakul / Editor: Apichatpong Weerasethakul, Sompot Chidgasornpongse / Art direction: Akekarat Honlaor / Production company/Print source: Kick the Machine / Rights: Apichatpong Weerasethakul

Syndromes and a Century (Sang Sattawat) 2006
35mm, 104 minutes, colour, Dolby SRD, Thailand, Thai, (English Subtitles) / Director/Producer/Script: Apichatpong Weerasethakul / Producers: Pantham Thongsang, Charles de Meaux / Cinematography: Sayombhu Mukdeeprom / Editor: Lee Chatametikool / Music: Kantee Anantagant / Sound: Akritchalerm Kalayanamitr, Shimizu Koichi / Cast: Nantarat Sawaddikul, Jaruchai Iamaram Nu Nimsomboon, Sophon Pukanok, Jenjira Pongpas / Art direction: Akekarat Homlaor / Production company: Kick the Machine, New Crowned Hope, Anna Sanders Films, BackUp Films, TIFA / Print source: Fortissimo Films

YANG FUDONG
CHINA B.1971

An Estranged Paradise (Mohsheng Tiantang) 1997–2002
35mm, 76 minutes, b. & w., stereo, China, Mandarin (English subtitles) / Director/Producer/Script: Yang Fudong / Cinematography: Wang Yi, Liu Tao / Editor: Zhang Zhenran / Music: Jin Wang, Band, Shui Ji-Die / Cast: Zheng Chun Zi, Zheng Hong, Qi Wei, Shen XiaoYan / Print source: ShanghART Gallery / Rights: Yang Fudong / Screening format: Digital Betacam

City light (Chengshi zhiguang) 2000
Mini DV, 6:40 minutes, colour, stereo, ed. 3/10 / The James C Sourris Collection. Purchased 2003 with funds from James C Sourris through the Queensland Art Gallery Foundation / Collection: Queensland Art Gallery

Backyard — Hey! Sun is Rising (Hou Fang — Hei, Tian Liang Le) 2001
35mm, 13 minutes, b. & w., stereo, China, no dialogue / Director: Yang Fudong / Cinematography: Xie Bin, Hu Hun, Wang Zhaodun / Editor: Tang Li Ke, Lin Feng / Music: Zhou Qing / Cast: Gu Lei, Gao Ming, Lu Chun Sheng, Wu Jian Xi / Print source: ShanghART Gallery / Screening format: Digital Betacam

Jiaer's livestock 2002–05
10-channel video installation, 35mm, 18 minutes, colour, sound, suitcases and clothing / Collection: The artist / Courtesy: ShanghART Gallery, Shanghai

YANG ZHENZHONG
CHINA B.1968

922 rice corns 2000
Betacam SP, 8 minutes, colour, sound, ed. 7/10 / Purchased 2005. Queensland Art Gallery Foundation / Collection: Queensland Art Gallery

I will die (Shanghai version) 2001
Betacam SP, 20 minutes, colour, sound (Mandarin language, English subtitles) / The Kenneth and Yasuko Myer Collection of Contemporary Asian Art. Purchased 2006 with funds from Michael Simcha Baevski through the Queensland Art Gallery Foundation / Collection: Queensland Art Gallery

Light and easy 2002
Type C photograph on paper, ed. 8/10 / 120 x 181.7cm

Light and easy no. 5, 9, 15, 16, 17, 24 2002
Type C photographs, ed. 8/10 / 6 sheets: 120 x 79.3cm (each, approx.)

Purchased 2005. Queensland Art Gallery Foundation / Collection: Queensland Art Gallery

YOO SEUNG-HO
KOREA B.1973

Oh! Darling 2005–06
Ink on paper / 226.3 x 181.8cm

Eoheung — Once upon a time 2006
Ink on paper / 231.5 x 140cm

Plush, plush 2006
Ink on paper / 231.5 x 135cm

yodeleheeyoo! 2006
Ink on paper / 231.5 x 135cm

yodeleheeyoo! 2006
Ink on paper / 229 x 183cm

Collection: The artist / Courtesy: One and J Gallery, Seoul

KIDS' APT

KHADIM ALI
PAKISTAN B.1978

The Bamiyan drawing project 2006
Paper and pencil / 57 drawings: dimensions variable / Courtesy: The artist and the Queensland Art Gallery

JUSTINE COOPER
AUSTRALIA/UNITED STATES B.1968

The call of the wild 2006
Computer interactive / Dimensions variable / Courtesy: The artist and the Queensland Art Gallery / The artist would like to acknowledge Tammy Brennan's and Mazen Murad's assistance with the sound recordings for this interactive

EX DE MEDICI
AUSTRALIA B.1959

Tattoo shop 2006
Temporary tattoos, plywood, glass, frosted film, carpet, vinyl, MDF board, mirror, synthetic polymer paint and fabric / DVD, 3 minutes, colour, sound / CD: Peter and the Wolf, Op. 67, by Sergei Prokofiev, 24:15 minutes / Courtesy: The artist and the Queensland Art Gallery

BHARTI KHER
UNITED KINGDOM/INDIA B.1969

Nothing is ordinary 2006
Bindi, cardboard and mirror / Dimensions variable / Courtesy: The artist and the Queensland Art Gallery

SUTEE KUNAVICHAYANONT
THAILAND B.1965

Classroom upside down 2006
Wood, wallpaper, paper and crayons / 6 desks: 75 x 61 x 39cm (each); 24 stools: 20 x 27 x 27cm (each) / Courtesy: The artist and the Queensland Art Gallery

KWON KI-SOO
KOREA B.1972

Run, run, run 2005 — special edition for APT5
Foam / Dimensions variable / Courtesy: The artist and the Queensland Art Gallery

DENNIS NONA
AUSTRALIA B.1973
KALA LAGAW YA PEOPLE

Gitalai (mud crab) and the witch 2006
Digital images, plastic and wood / Dimensions variable / Courtesy: The artist and the Queensland Art Gallery

EKO NUGROHO
INDONESIA B.1977

What do you want? 2006
Synthetic polymer paint on MDF board / 605 x 517cm / With thanks to Shailer Park State High School, Logan: Simone Filippow, Michelle Hopper, Catherine Middleton, Jade Pregelj; Woodridge State High School, Logan: Jenny Coventry, Christina Hall, Jeannie Macnamara, Gemma White; Cleveland District State High School, Redland: Jesse Garrett, Stephanie Hendy, Nicole Henderson, Sarah Parsons, Sarah Tuomi

Trick me please! 2006
Postcards, felt tip pens / Dimensions variable / Courtesy: The artist and the Queensland Art Gallery

TSUYOSHI OZAWA
JAPAN B.1965

Everyone likes someone as you like someone 2006
Japanese futons, plywood, timber, steel, postcards and coloured pencils / 240 x 900cm (diam.) / Courtesy: The artist and the Queensland Art Gallery

JOHN PULE
NIUE/NEW ZEALAND B.1962

Drawing words 2006
Paper, pencils, plywood, synthetic polymer paint and fabric

Drawing words 2006
Mini DV, 4:26 minutes, colour, sound / John Pule reading from his novel *The Shark that Ate the Sun*, published by Penguin, Middlesex, 1992. Filmed by Sangeeta Singh, assisted by Kelepi Koroi at the Video Unit, the University of the South Pacific Media Centre, Suva, Fiji

Courtesy: The artist and the Queensland Art Gallery

NUSRA LATIF QURESHI
PAKISTAN/AUSTRALIA B.1973

Enchanted spaces 2006
Paper, water-based markers, glass, synthetic polymer paint, backlit film, plywood, fluorescent tubes, aluminium and fabric / Dimensions variable / Courtesy: The artist and the Queensland Art Gallery

TALVIN SINGH
UNITED KINGDOM/INDIA B.1970

I am Talvin Singh 2006
Touchscreens, foam, carpet, plywood, MDF board and synthetic polymer paint / Dimensions variable / Courtesy: The artist and the Queensland Art Gallery

YANG ZHENZHONG
CHINA B.1968

Light and easy (Brisbane) 2006
Digital image, touch screen, video camera, LCD Screen, plywood, MDF board and synthetic polymer paint / Dimensions variable / Courtesy: The artist and the Queensland Art Gallery

The Gallery would like to acknowledge the Brisbane City Council's assistance with this project.

ARTIST BIOGRAPHIES

AI WEIWEI
B.1957, BEIJING, CHINA
Lives and works in Beijing

SELECTED SOLO EXHIBITIONS
2004 Caermersklooster, Gent, Belgium
Kunsthalle Bern, Switzerland
Robert Miller Gallery, New York, USA
2003 Gallery Urs Meile, Lucerne, Switzerland
1988 'Old Shoes — Safe Sex', Art Waves Gallery, New York, USA
1982 Asian Foundation, San Francisco, USA

SELECTED GROUP EXHIBITIONS
2006 Biennale of Sydney, Australia
'Serge Spitzer / Ai Wei Wei', Museum for Modern Art, Frankfurt, Germany
2005 Second Guangzhou Triennial, China
'Mahjong', Kunstmuseum, Bern, Switzerland
'Dreaming of the Dragon's Nation: Contemporary Art from China', Irish Museum of Modern Art, Dublin, Ireland

'Chinese Art Invasion', Ethan Cohen Fine Arts, New York, USA
2004 'Regeneration: Contemporary Chinese Art from China and the US', Samek Gallery, New York; touring USA until 2006
'Between Past and Future: New Photography and Video from China', International Center of Photography and the Asia Society, New York, and other venues, USA; UK; Germany
'On the Edge: Contemporary Chinese Photography and Video', Ethan Cohen Fine Arts, New York, USA
2003 'Junction: Architectural Experiment of Chinese Contemporary Art', Lianyang Architecture Art Museum, Shanghai, China
2002 First Guangzhou Triennial, China
2001 'Take Part: Contemporary Chinese Art' and 'Take Part II: Contemporary Chinese Art', Gallery Urs Meile, Lucerne, Switzerland
2000 'Fuck Off', Eastlink Gallery, Shanghai, China

'New Chinese Photography: Contemporary Photography and Performance Art', Ethan Cohen Fine Arts, New York, USA
1999 48th Venice Biennale, Italy
1998 'Double Kitsch: Painters from China', Max Protetch Gallery, New York, USA
1997 'A Point of Contact: Korean, Chinese, Japanese Contemporary Art', Taegu Art & Cultural Hall, Taegu, Korea
1995 'Configura 2 — Dialog der Kulturen', Erfurt, Germany

QUALIFICATIONS, GRANTS & AWARDS
1997 Founder China Art Archives & Warehouse, Beijing, China
1981 Studies at Parsons School of Design and Art Student's League, New York, USA
1978 Studies at the Beijing Film Institute, China
-81

COLLECTIONS
Queensland Art Gallery, Brisbane, Australia

KHADIM ALI
B.1978, QUETTA, PAKISTAN
Lives and works in Quetta

SELECTED SOLO EXHIBITIONS
2005 'Qaeeda-e-Riyazi' (Math Book), Chawkandi Art Gallery, Karachi, Pakistan
2004 'Jashn-e-Gull-e-Surkh' (The Celebration of Red Tulips), Chawkandi Art Gallery, Karachi, Pakistan

SELECTED GROUP EXHIBITIONS
2006 'Lila/Play: Contemporary Miniatures & New Art from South Asia', Span Galleries, Melbourne, Australia
'Winds of Artist in Residence 2006', Fukuoka Asian Art Museum, Japan
2004 'Contemporary Miniature Paintings from Pakistan', Fukuoka Asian Art Museum, Japan

QUALIFICATIONS, GRANTS & AWARDS
2006 Residency, Fukuoka Asian Art Museum, Japan
2005 Haji Sharif Prize, National College of Arts, Lahore, Pakistan
2003 BFA, National College of Arts, Lahore, Pakistan
2000 Short courses in mural painting and
−03 calligraphy from Tehran University
Merit Scholarship National College of Arts, Lahore, Pakistan

COLLECTIONS
Fukuoka Asian Art Museum, Japan
Iran Culture Centre, Quetta, Pakistan
Mohatta Palace Museum, Karachi, Pakistan
Queensland Art Gallery, Brisbane, Australia

JACKIE CHAN
B.1954, HONG KONG
Lives and works in Hong Kong

SELECTED FILMOGRAPHY
2006 *Rob-B-Hood*
2005 *The Myth* (executive producer/action choreographer)
2004 *The Huadu Chronicles: Blade of the Rose*
New Police Story (action choreography)
2003 *Around the World in 80 Days* (executive producer/action choreographer)
The Twin Effect
The Medallion (executive producer)
Shanghai Knights (executive producer/action chorographer)
2002 *The Tuxedo*
2001 *Rush Hour 2*
Accidental Spy (producer/action choreographer)
2000 *Shanghai Noon* (producer/action choreographer)
1999 *Gorgeous* (producer/writer)
Rush Hour (action choreographer)
1998 *Who Am I?* (co-director/writer/action choreographer)
1997 *Mr Nice Guy*
1996 *Police Story IV: First Strike* (action choreographer)
1995 *Thunderbolt* (action choreographer)
1994 *Rumble in the Bronx* (action choreographer)
Drunken Master II (co-director/action choreographer)
1993 *Crime Story* (uncredited director/action choreographer)
City Hunter
1992 *Police Story III: Supercop* (executive producer)
1991 *Twin Dragons* (action choreographer)
Island of Fire
1990 *Armour of God II* (director/producer/writer/action choreographer)
1989 *Miracles* (director/writer/action choreographer)
1988 *Police Story II* (director/writer/action choreographer)
1987 *Dragons Forever*
Project A Part II (director/writer/action choreographer)
1986 *Armour of God* (director/writer/action choreographer)
1985 *Police Story* (director/writer/action choreographer)
Heart of Dragon
The Protector
Twinkle, Twinkle, Lucky Stars
My Lucky Stars
1984 *Wheels on Meals*
Project A (director/writer/action choreographer)
1983 *Cannonball Run II*
Winners and Sinners
1982 *Dragon Lord* (director/writer/action choreographer)
1980 *Cannonball Run*
Battle Creek Brawl
The Young Master (director/writer/action choreographer)
Fearless Hyena II

1979 *Fearless Hyena*
 (director/writer/action
 choreographer)
1978 *Drunken Master*
 Snake in the Eagle's Shadow
 (based on story by Jackie Chan)
 Dragon Fist (action choreographer)
 Magnificent Bodyguards (action
 choreographer)
 Half a Loaf of Kung Fu (action
 choreographer)
 Snake and Crane Arts of Shaolin
 (action choreographer)
1977 *To Kill with Intrigue*
 Killer Meteors (action
 choreographer)
1976 *Shaolin Wooden Men* (action
 choreographer)
 New Fist of Fury
 Hand of Death
1975 *All in the Family*
1973 *Not Scared to Die* (action
 choreographer)
1972 *Hapkido*
 Police Woman
1971 *The Heroine* (action choreographer)
 The Little Tiger of Canton
 Fist of Fury
1966 *Come Drink with Me*
1964 *The Story of Qui Xiang Lin*
1963 *The Love Eternal*
1961 *Big and Little Wong Tin-Bar*

AWARDS & SCREENINGS
2005 Professional Achievement Award,
 Hong Kong Film Awards
 Best Actor, Hong Kong Film Awards
 Special Jury Prize, Asia–Pacific Film
 Festival
2004 Best Action Choreography, Golden
 Horse Film Festival, Taiwan
2002 Innovator Award, American
 Choreography Awards
 Taurus Honorary Award, World Stunt
 Awards
2001 Grand Prix Special des Ameriques,
 Montreal World Film Festival
2000 Award for Excellence in International
 Cinema, Indian Film Academy

BECK **COLE**
B.1975, ADELAIDE, AUSTRALIA
WARRAMUNGU/LURITJA PEOPLE
Lives and works in Sydney and
 Alice Springs, Australia

FILMOGRAPHY
2005 *The Lore of Love* (documentary)
 Plains Empty (short)
2004 *Wirriya Small Boy* (documentary)
2002 *Flat* (short)
2001 *The Good Fight* (documentary)
 Creepy Crawleys (documentary)
1999 *Missing in Alice* (documentary)

AWARDS & SCREENINGS
2005 *Plains Empty*, Sundance Film
 Festival
2004 *Wirriya Small Boy*, Best Australian
 Film, Sydney WOW Film Festival
2004 *Flat*, Sundance Film Festival
2003 *Flat*, Edinburgh Film Festival

JUSTINE **COOPER**
B.1968, SYDNEY, AUSTRALIA
Lives and works in New York, USA

SELECTED SOLO EXHIBITIONS
2006 'Justine Cooper', National Academy
 of Sciences, Washington DC, USA
2005 'Saved By Science', Kashya
 Hildebrand Gallery, Chelsea, USA
 'Justine Cooper: RAPT I and II', Visual
 Arts Gallery, University of
 Alabama, Birmingham, USA
2003 'Excite/Moist', Julie Saul Gallery,
 New York, USA
1998 'RAPT II', Centre for Contemporary
 Photography, Melbourne,
 Australia
 'Cell', Gallery 19, Sydney, Australia

SELECTED GROUP EXHIBITIONS
2006 'In the Line of Flight', Millennium Art
 Museum, Beijing, China
 International Center of Photography,
 New York, USA
 'Strange Attractors: Charm between
 Art and Science', Zendai Museum
 of Modern Art, Shanghai, China
2005 'Your Sky', Gigantic ArtSpace,
 New York, USA
 Second Beijing International New
 Media Arts Exhibition, China
 Millennium Museum, Beijing, China
2004 'The Nature Machine: Contemporary
 Art, Nature + Technology',
 Queensland Art Gallery, Brisbane,
 Australia
2003 'Transfigure', Australian Centre for the
 Moving Image, Melbourne,
 Australia
 'How Human, Life in the Post
 Genome Era', International Center
 of Photography, New York, USA
 'Science Fictions', Earl Lu Gallery,
 Singapore Art Museum,
 Singapore
 'Another Planet', Robert Beck
 Memorial Cinema, New York, and
 other venues, USA
 'oZone', Centre Pompidou, Paris,
 France
2002 'Moist. Multimedia Art Asia–Pacific',
 Millennium Monument, Beijing,
 China
 'Other Views', QCA Gallery, Griffith
 University Queensland College of
 Art, Brisbane, Australia
 Adelaide Biennial of Australian Art,
 Australia
 'Medicine as Metaphor', NTT
 InterCommunication Center,
 Tokyo, Japan
 'World Views', New Museum of
 Contemporary Art, New York, USA
2000 Third Gwangju Biennale, Korea
1999 'The Liquid Medium: Video Works
 from the Queensland Art Gallery
 Collection', Queensland Art
 Gallery, Brisbane, Australia

COMMISSIONS
2004 'TULP: The Body Public' (visual
 director) performance/installation
 with ELISION Ensemble and
 composer John Rodgers, Art
 Gallery of New South Wales,
 Sydney, Australia
2003 The Imaginary Opera Project,
 Ensemble Offspring, Sydney
 Conservatorium of Music,
 Australia

 'Lady from the Sea' video
 animations (Ibsen), Wax Factory
 Production, New York, USA
2001 Video commission: 'Steel Fracture',
 Director Gail Kelly, Australian
 Technology Park + Performance
 Space, Sydney, Australia

QUALIFICATIONS, GRANTS & AWARDS
2004 Australia Council for the Arts New
–06 Media Arts Fellowship
2003 Australian Network for Art and
–04 Technology (ANAT) Deep
 Immersion: Scientific Serendipity
 grant for artist-in-residency at
 the Museum of Natural History,
 New York, USA
 'SOS (Sounds of silence)' Joint
 winner, Inaugural HARRIES Award
 (National Digital Art Award),
 Australia
2003 Greenwall Foundation Grant, USA
2002 Artist-in-Residence, Multimedia Art
 Asia–Pacific, Central Academy of
 Fine Art, New Media Department,
 Beijing, China
 Artist-In-Residence, Santa Fe Art
 Institute, New Mexico, USA
2001 Artist-in-Residence, Bellevue Art
 Museum, Washington, USA
 'World Views', the Lower Manhattan
 Cultural Council's Artist-in-
 Residence Program at the World
 Trade Center, New York, USA
1998 'RAPT', First Prize, National Digital Art
 Awards, Australia
 Master of Visual Arts in Electronic
 Art, Sydney College of the Arts
1990 Bachelor of Science, Syracuse
 University, New York, USA

COLLECTIONS
Australian Centre for the Moving Image,
 Melbourne, Australia
Griffith Artworks, Brisbane, Australia
Metropolitan Museum of Art, New York,
 USA
Monash University, Melbourne, Australia
Powerhouse Museum, Sydney, Australia
Queensland Art Gallery, Brisbane,
 Australia

EX **DE MEDICI**
B.1959, RIVERINA REGION, AUSTRALIA
Lives and works in Canberra, Australia

SELECTED SOLO EXHIBITIONS
2005 'Charm School', Boutwell Draper
 Gallery, Sydney, Australia
2004 'eX de Medici @ MPRG', Mornington
 Peninsula Regional Gallery,
 Mornington, Australia
 'Masters and Slaves', Boutwell
 Draper Gallery, Sydney, Australia
 'Gals with Guns', Helen Maxwell
 Gallery, Canberra, Australia
2003 'Soft Steel', Heidi Museum of
 Modern Art, Melbourne, Australia
2001 'Sp', Helen Maxwell Gallery,
 Canberra, Australia

SELECTED GROUP EXHIBITIONS
2006 'Social Capital', Canberra
 Contemporary Art Space,
 Australia
 'High Tide: New Currents in Art from
 Australia and New Zealand',
 Zachęta National Gallery of Art,
 Warsaw, Poland

 'Who Cares?', Boutwell Draper
 Gallery, Sydney, Australia
2005 'Moist: Australian Watercolours',
 National Gallery of Australia,
 Canberra, Australia
 'Future Tense: Security and Human
 Rights', DELL Gallery @ QCA,
 Griffith University, Brisbane,
 Australia
 'This & Other Worlds Contemporary
 Australian Drawing', Ian Potter
 Centre, National Gallery of
 Victoria, Melbourne, Australia
2004 '2004: The Year in Art', SH Ervin
 Gallery, Sydney, Australia
 'Making Portraits', National Portrait
 Gallery, Canberra, Australia
2002 'Dobell Prize for Drawing', Art Gallery
 of New South Wales, Sydney,
 Australia
 'National Works on Paper',
 Mornington Peninsula Regional
 Gallery, Mornington, Australia
2001 'So You Wanna Be a Rock Star',
 National Portrait Gallery,
 Canberra, Australia
2000 'The Car in Australian Art and
 Culture', Heidi Museum of Modern
 Art, Melbourne, Australia
1996 Adelaide Biennial of Australian Art,
 Australia

QUALIFICATIONS, GRANTS & AWARDS
2003 Artist Fellow, CSIRO Entomology
–04 (Taxonomy), Black Mountain
 Facility, Canberra, Australia
2002 National Works on Paper Prize,
 Mornington Peninsula Regional
 Gallery, Mornington, Australia
2001 Residency, Dunedin Public Art
 Gallery, New Zealand
2000 Residency, CSIRO Entomology
–02 Division, Canberra, Australia
1998 Residency, University of Tasmania,
 Hobart, Australia
1997 Residency, Trongate Studios,
 Glasgow, Scotland

COLLECTIONS
Australian High Commission, Beijing, China
Australian National Insect Collection,
 CSIRO, Canberra, Australia
Canberra Museum and Gallery, Canberra,
 Australia
Griffith University Gallery, Brisbane,
 Australia
Monash University Gallery, Melbourne,
 Australia
Mornington Peninsula Regional Gallery,
 Mornington, Australia
National Gallery of Australia, Canberra,
 Australia
National Portrait Gallery, Canberra,
 Australia
Queensland Art Gallery, Brisbane,
 Australia

JITISH **KALLAT**
B.1974, MUMBAI, INDIA
Lives and works in Mumbai

SELECTED SOLO EXHIBITIONS
2006 'Rickshawpolis-2', Spazio Piazza
 Sempione, Milan Italy
2005 'Rickshawpolis-1', Nature Morte,
 New Delhi, India
 'Panic Acid', Bodhi Art, Singapore
 'Humiliation Tax', Gallery Chemould,
 Mumbai, India

2004 'The Lie of the Land', Walsh Gallery, Chicago, USA

'FAQ', Art Rotterdam, the Netherlands

2002 'First Information Report', Bose Pacia Modern, New York, USA

2001 'Milk Route', India Habitat Centre, New Delhi, India

'General Essential', Sakshi Gallery, Bangalore, India

2000 'Ibid.', Gallery Chemould, Mumbai, India

1999 'Private limited-I', Bose Pacia Modern, New York, USA

'Private limited-II', Apparao Gallery, Chennai, India

1998 'Apostrophe', India Habitat Centre, New Delhi, India

1997 'PTO', Gallery Chemould and Prithvi Gallery, Mumbai, India

SELECTED GROUP EXHIBITIONS

2006 Sixth Gwangju Biennale, Korea

2005 'Indian Summer', École Nationale Supérieure des Beaux-Arts, Paris, France

'The Artist Lives and Works in Baroda/Bombay/Calcutta/Mysore/Rotterdam/Trivandrum', House of World Cultures, Berlin, Germany

First Pocheon Asian Art Triennale, Korea

2004 'Summer Show', Bose Pacia Gallery, New York, USA

2003 'SubTerrain: Artists Dig the Contemporary', House of World Cultures, Berlin, Germany

'Pictorial Transformations', National Art Gallery, Kuala Lumpur, Malaysia

'Crossing Generations: DiVerge' National Gallery of Modern Art, Mumbai, India

'Indians+Cowboys', Gallery 4A, Sydney, Australia

2002 'Under Construction', the Japan Foundation Asia Center, Tokyo, Japan

'Clicking into Place', Sakshi Gallery, Mumbai, India

2001 'Century City', Tate Modern, London, UK

'Indian Painting', Art Gallery of New South Wales, Sydney, Australia

2000 Seventh Havana Biennial, Cuba

1999 First Fukuoka Asian Art Triennale, Japan

1998 'Multimedia Art of the 90's', CIMA Gallery, Kolkata, India

'Jehangir Nicholson Collection', National Gallery of Modern Art, Mumbai, India

1997 '50 Years of Art in Mumbai', National Gallery of Modern Art, Mumbai, India

QUALIFICATIONS, GRANTS & AWARDS

1996 Fellow at the Sir JJ School of Art,
–97 Mumbai, India

1990 BFA (Painting), Sir JJ School of Art,
–96 Mumbai, India

ANISH **KAPOOR**

B.1954, MUMBAI, INDIA

Lives and works in London, United Kingdom

SELECTED SOLO EXHIBITIONS

2006 Regen Projects, Los Angeles, USA

Centro de Arte Contemporánec, Malãga, Spain

2005 'Japanese Mirrors', SCAI The Bathhouse, Tokyo, Japan

2004 'Whiteout', Barbara Gladstone Gallery, New York, USA

Grand Hornu, Musée des Arts Contemporains, Hornu, Belgium

2003 'My Red Homeland', Kunsthaus Bregenz, Austria

'Anish Kapoor: Painting', Lisson Gallery, London, UK

2002 The Unilever Series — 'Anish Kapoor: Marsyas', Tate Modern, London, UK

2000 'Taratantara', BALTIC, Centre for Contemporary Art, Gateshead, UK; Piazza del Plebiscito, Naples, Italy

'Blood', Lisson Gallery, London, UK

Regen Projects, Los Angeles, USA

1999 'Anish Kapoor: Recent Works', SCAI The Bathhouse, Tokyo, Japan

1998 Hayward Gallery, London, UK

capcMusée d'Art Contemporain, Bordeaux, France

1995 Fondazione Prada, Milan, Italy

1990 'Drawings', Tate Gallery, London, UK

SELECTED GROUP EXHIBITIONS

2005 'God is Great', Lisson Gallery, London, UK; Italy

'Raised Awareness', Tate Modern, London, UK

'Collection Eté-Automne 2005', capcMusée d'Art Contemporain, Bordeaux, France

'Centre of Gravity', Istanbul Modern, Istanbul, Turkey

2004 'Art in New Spaces', Walker Art Gallery, Liverpool, UK

2003 'Happiness: A Survival Guide for Art and Life', Mori Art Museum, Tokyo, Japan

2002 'No Object, No Subject, No Matter . . .', Irish Museum of Modern Art, Dublin, Ireland

2001 'Artcité: Quand Montréal Devient Musée', Musée d'Art Contemporain de Montréal, Canada

2000 Fifth Lyon Biennale, France

Third Shanghai Biennale, China

'Between Cinema and a Hard Place', Tate Modern, London, UK

'Half Dust', Irish Museum of Modern Art, Dublin, Ireland

1998 'At the Edge of the World', Centro Galego de Arte Contemporánea, Santiago de Compostela, Spain

1996 23rd São Paulo Biennale, Brazil

1995 The Fourth Istanbul Biennale, Turkey

SELECTED COMMISSIONS

2006 *Sky Mirror*, Rockefeller Center, New York, USA

2005 Unity Sculpture, British Memorial Garden, Hanover Square, New York, USA

Cloud gate, Millennium Park, Chicago, USA

2002 *Marsyas* (third in 'The Unilever Series' of commissions), Turbine Hall, Tate Modern, London, UK

Taratantara, BALTIC, The Centre for Contemporary Art, Gateshead, UK

2001 *Sky Mirror*, Nottingham Playhouse, UK

2000 *Parabolic Waters*, Millennium Dome, New Sculpture Project, London, UK

QUALIFICATIONS, GRANTS & AWARDS

1991 Turner Prize

1990 Premio Duemila Prize, 44th Venice Biennale

1982 Artist-in-Residence, Walker Art Gallery, Liverpool, UK

1977 Chelsea School of Art, London, UK
–78

1973 Hornsey College of Art, London, UK
–77

SELECTED COLLECTIONS

Auckland Art Gallery Toi o Tāmaki, New Zealand

Carnegie Museum of Art, Pittsburg, USA

Fine Art Museum of San Francisco, USA

Hara Museum of Contemporary Art, Tokyo, Japan

Heide Museum of Modern Art, Melbourne, Australia

Hirshhorn Museum and Sculpture Garden, Washington DC, USA

Leeum, Samsung Museum of Art, Seoul, Korea

Moderna Museet, Stockholm, Sweden

Museo National Centro de Arte Reina Sofia, Madrid, Spain

Museum of Modern Art, New York, USA

Queensland Art Gallery, Brisbane, Australia

Rijksmuseum Kroller-Muller, Otterlo, the Netherlands

Stedelijk Museum, Amsterdam, the Netherlands

Tate Gallery, London, UK

Walker Art Museum and Sculpture Garden, Minneapolis, USA

BHARTI **KHER**

B.1969, LONDON, UNITED KINGDOM

Lives and works in New Delhi, India

SELECTED SOLO EXHIBITIONS

2006 'Do Not Meddle in the Affairs of Dragons, because You Are Crunchy and Taste Good with Ketchup', Gallery 88 and Ske Gallery, Mumbai, India

2004 'Quasi-, Mim-, Ne-, Near-, Semi-, -ish, -like', Gallery Ske, Bangalore, India

'Hungry Dogs Eat Dirty Pudding', Nature Morte, New Delhi, India

2000 'The Private Softness of Skin', Bose
–01 Pacia Modern, New York, USA; Gallery Chemould, Mumbai, India

1999 'Telling Tails', New Delhi, India; Galerie FIA (Foundation for Indian Artists), Amsterdam, the Netherlands

1997 Galerie FIA, Amsterdam, the Netherlands

1995 Art Heritage, New Delhi, India

SELECTED GROUP EXHIBITIONS

2006 'Inside Out', Nature Morte, New Delhi, India

'Made by Indians', Galerie Enrico Navarra, Art on the Beach, St Tropez, France

2005 'Indian Summer', l'Ecole des Beaux Arts, Paris, France

'Summer', Nature Morte, New Delhi, India

2004 'Contemporary Art from India', Thomas Erben Gallery, New York, USA

'Vanitas Vanitatum', Sakshi Gallery, Mumbai, India

2003 'Crossing Generations: DiVerge', National Gallery of Modern Art, Mumbai, India

'Bad Taste', Apparao Gallery, Apeejay New Media Centre, New Delhi, India

2002 'Under Construction', Tokyo Opera City Art Gallery, and other venues, Japan

'Creative Space', Sakshi Gallery, New Delhi, India

'Playgrounds & Toys, ART for the World', University of Geneva, Switzerland; India

'Cutting Edge Contemporary', National Gallery of Modern Art, Mumbai, and other venues, India

'Sidewinder', CIMA Gallery, Kolkata, and other venues, India

2001 'Art on the Move', a Sahmat project in five venues in New Delhi, India

2000 'Open Circle Exhibition', Lakeeren Art Gallery, Mumbai, India

'Of, Based on, or Obtained by (Tradition)', Nature Morte, New Delhi, India

1999 'Embarkation's', Sakshi Gallery, Mumbai, India

'Icons of the Millenium', Lakeeren Art Gallery, Mumbai, India

1998 'Cryptograms', Lakeeren Art Gallery, Mumbai, India

1996 'Of Women Icons/Stars/Feasts', Eicher Gallery, New Delhi, India

1995 'Postcards for Gandhi', a Sahmat exhibition in five cities in India

QUALIFICATIONS, GRANTS & AWARDS

2004 French Government Residency, Paris, France

2003 The Sanskriti Award, India

2002 Khoj Residency, New Delhi, India

1988 Foundation Course in Art & Design
–91 Newcastle Polytechnic, BA Honours, Fine Art, Painting, Newcastle upon Tyne, UK

SUTEE **KUNAVICHAYANONT**

B.1965, BANGKOK, THAILAND

Lives and works in Bangkok

SELECTED SOLO EXHIBITIONS

2005 'Stereotyped Thailand', 100 Tonson Gallery, Bangkok, Thailand

2001 'Inflatable Nostalgia', Atelier Frank & Lee, Singapore

'Siamese Twins', Thai Art Foundation, Amsterdam, the Netherlands

'Elephant', Optica, Montreal, Canada

'Baby Elephant', Musashino Art University, Tokyo, Japan

2000 '4 Days, Elephant Breath Donation and History Class', Art Centre, Silpakorn University, Bangkok, Thailand

1999 'Burden of Joy', Bangkok University Art Gallery, Bangkok, Thailand

1998 'Rain Drops — Pig's Shit Running', TADU Contemporary Art, Bangkok, Thailand

1997 'The Myth of an Asian Tiger', Galerie Gauche, Ecole Nationale Superieure des Beaux-Arts, Paris, France

1995 'The White Elephants of Siam', the Art Gallery of the Faculty of Painting, Sculpture and Graphic Arts, Silpakorn University, Bangkok, Thailand

SELECTED GROUP EXHIBITIONS

2006 'Temporary Art Museum Soi Sabai',
Pla Dib, Bangkok, Thailand

2002 Second Fukuoka Asian Art Triennale,
Japan

2001 'Bangkok Meets Cologne, Cologne
Meets Bangkok', Art Centre,
Silpakorn University, Bangkok,
Thailand; Germany

'Thin Skin: The Fickle Nature of
Bubbles, Spheres, and Inflatable
Structure', AXA Gallery, New York,
and other venues, USA

'Art, Religion, Faith, Vision', The Art
Center, Chulalongkorn University,
Bangkok, Thailand

'Within', Art in General, New York,
USA

'Next Move, Contemporary Art from
Thailand', Earl Lu Gallery, LASALLE-
SIA College of the Arts, Singapore

'Tiger's Eye: Assorted Asian Tigers',
Proud Camden, London, UK

'Identities Versus Globalisation',
Chiang Mai Art Museum, and
other venues, Thailand; Germany

'Neo-Nationalism', The Art Center,
Chulalongkorn University,
Bangkok, Thailand

'Keep your Distance', National Art
Gallery, Kuala Lumpur, Malaysia;
China; Japan; France

'History & Memory', The Art Center,
Chulalongkorn University, and
other venues, Thailand

2000 'Thai Contemporary Art 2000', Art
Centre, Silpakorn University,
Bangkok, Thailand

'Keep Your Distance', Tadu
Contemporary Arts, Bangkok,
Thailand; Singapore

'The Glocal Scents of Thailand',
Edsvik konst och kultur,
Sollentuna, Sweden

1999 '26th Century, Self Examination by
Cobalt Blue Group', National
Gallery, Bangkok, Thailand

Liverpool Biennial, UK

'10 Asian Artists in Residence',
Mattress Factory, Pittsburgh, USA

1998 'Bangkok Art Project 1998', Bangkok,
–99 Thailand

1998 'Report from the Forest 1998',
National Gallery, Bangkok,
Thailand

1997 'Contemporary Fine Arts Exhibition',
Hanoi Fine Arts Institute and Hue
College of Arts, Vietnam

'Thai Vision I', California Polytechnic
State University, USA

1996 'Into the Next Decade', Tadu
Contemporary Art, Bangkok,
Thailand

1995 'Long Table and Stairway to Heaven',
Installation and Performance with
Paradix K, Kitaza, Kyoto, Japan

QUALIFICATIONS, GRANTS & AWARDS

2000 Residency, Mattress Factory,
Pittsburgh, USA

1992 Master of Visual Arts, Sydney
–93 College of the Arts, University of
Sydney, Australia

1985 BFA (Graphic Arts), Faculty of
–89 Painting, Sculpture and Graphic
Arts, Silpakorn University,
Bangkok, Thailand

COLLECTIONS

Fukuoka Asian Art Museum, Japan
LASALLE-SIA College of the Arts,
Singapore
Singapore Art Museum, Singapore
Thai Farmers Bank PCL, Bangkok, Thailand

KWON KI-SOO
B.1972, YOUNG-JU, KOREA
Lives and works in Seoul, Korea

SELECTED SOLO EXHIBITIONS

2005 'Kwon Ki Soo: Animation', Paik Hae
Young Gallery, Seoul, Korea

2004 'A Red Fountain', Gallery Fish, Seoul,
Korea

1998 'The Show 1998', Kwanhoon Gallery,
Seoul, Korea

SELECTED GROUP EXHIBITIONS

2006 'Fiction@Love', MOCA Shanghai,
China

'Joyful Art Travel', Gwangju Museum
of Art, Korea

2005 'The Family', Insaartcenter, Seoul,
Korea

'Traveling Art Museum 2005',
National Museum of
Contemporary Art, Seoul, Korea

'The Elegance of Silence', Mori Art
Museum, Tokyo, Japan

'Mam Screen', Mori Building Screen,
Tokyo, Japan

'Rainbow Sherbet', Gallery Skape,
Seoul, Korea

2004 'Traveling Art Museum', National
Museum of Contemporary Art,
Seoul, Korea

'What Happens between Art and
Popular Culture', National
Museum of Contemporary Art,
Seoul, Korea

'Fiction. Love-Ultra New Vision in
Contemporary Art', Museum of
Contemporary Art, Taipei, Taiwan

2003 'Prince & Princess', Gallery Hyundai,
Seoul, Korea

'Comics in Art, Art in Comics', Ewha
Women's University Museum,
Seoul, Korea

'Charity—Present', Ssamzie Space
Gallery, Seoul, Korea

2002 'Flow: New Tendencies in Korean Art
— Paradise Among Us', Korean
Culture and Arts Foundation,
Seoul, Korea

1999 'Ho-Bu-Ho-Hyong', ArtSonje Center,
Seoul, Korea

1998 'Filter: Come Out of the Forest', Insa
Gallery, Seoul, Korea

'Drawing and Painting', Dukwon
Gallery, Seoul, Korea

1996 'The 15th Grand Art Exhibition of
Korea', National Museum of
Contemporary Art, Kwachun,
Korea

QUALIFICATIONS, GRANTS & AWARDS

2003 Jerusalem Center for Visual Arts,
Jerusalem, Israel

1998 MFA Hongik University, Seoul, Korea
1996 BFA Hongik University, Seoul, Korea

COLLECTIONS

National Museum of Contemporary Art,
Seoul, Korea

DINH Q LÊ
B.1968, HA-TIEN, VIETNAM
Lives and works in Ho Chi Minh City,
Vietnam

SELECTED SOLO EXHIBITIONS

2006 'Dinh Q Lê', Shoshana Wayne
Gallery, Santa Monica, USA

'Tapestries', PPOW, New York, USA

2005 'A Higher Plane', Asia Society,
New York, USA

'Vietnam: Destination for the New
Millennium, The Art of Dinh Q Lê',
Asia Society, New York, USA

2004 'Homecoming: New Works by Dinh
Q Lê', University of California Art
Museum, Santa Barbara, USA

'Photoweavings', 10 Chancery Lane
Gallery, Hong Kong

'From Vietnam to Hollywood', PPOW,
New York, USA

2003 Shoshana Wayne Gallery, Santa
Monica, USA

'Qua Ben Nuoc Xua' (Collaboration
with Sue Hadju), Mai Gallery,
Ho Chi Minh City, Vietnam

2001 'The Texture of Memory', PPOW,
New York, USA

2000 'Persistence of Memory', Elizabeth
–01 Leach Gallery, Portland;
Shoshana Wayne Gallery,
Santa Monica, USA

1999 'Lotusland', Shoshana Wayne
Gallery, Santa Monica, USA

1998 'The Headless Buddha', Los Angeles
Center for Photographic Studies,
and other venues, USA

'Cambodia: Splendour and
Darkness', PPOW, New York,
and other venues, USA

SELECTED GROUP EXHIBITIONS

2006 Sixth Gwangju Biennale, Korea

First Singapore Biennale, Singapore

'Infinite Painting: Contemporary
Painting and Global Realism', Villa
Manin Centre for Contemporary
Art, Codroipo, Italy

2005 'Image War: Contesting Images of
Political Conflict', The City
University of New York, USA

'Permanent Vestiges: Drawings from
the American–Vietnam War',
Drawing Center, New York, USA

'Stages of Memory: The Vietnam
War', Museum of Contemporary
Photography, Chicago, USA

'Collection Remixed', Bronx Museum
of the Arts, New York, USA

'Universal Experience: Art, Life, and
the Tourist's Eye', Museum of
Contemporary Art, Chicago, USA

2004 'Identities vs Globalisation?', National
Gallery, Bangkok, Thailand

'21', PPOW, New York, USA

2003 50th Venice Biennale, Italy

'Red, Yellow and Blue', The Goethe
Institute, Hanoi, Vietnam

'Commodification of Buddhism',
Bronx Museum of the Arts, New
York, USA

'Only Skin Deep', International Center
for Photography, New York, USA

2001 'Made in California', Los Angeles
County Museum of Art, USA

'Indochina: The Art of War', Luckman
Fine Arts Gallery, California State
University, Los Angeles, USA

1999 'Slow Release: The Rich Mix
Exhibition', Bishopsgate
Goodyard, London, UK

1998 'Histories (Re)membered',
PaineWeber Art Gallery,
New York, USA

1996 'A Labour of Love', The New
Museum of Contemporary Art,
New York, USA

QUALIFICATIONS, GRANTS & AWARDS

2000 Light Work Artist-in-Residence
Program, Syracuse, New York, USA

1994 National Endowment for the Arts,
–95 Fellowship in Photography, USA

1993 Travel Pilot Grant, Arts International
and the National Endowment for
the Arts, USA

1992 Artist-in-Residence, Asian-American
Arts Centre, New York, USA

1990 MFA, Photography and Related
–92 Media, The School of Visual Arts,
New York, USA

1984 BA, Fine Arts, University of California,
–89 Santa Barbara, USA

COLLECTIONS

Bronx Museum of the Arts, New York, USA
Ford Foundation, USA
JP Morgan Chase, USA
Los Angeles County Museum of Art, USA
Museum of Modern Art, New York, USA
Queensland Art Gallery, Brisbane,
Australia
The Rothschild Foundation, USA
San Francisco Museum of Modern Art, USA

LONG MARCH PROJECT

On 28 June 2002, the Long March Project
departed from Beijing and, starting from
Ruijin, Jiangxi province, began the 'Long
March: A Walking Visual Display'.

[The project's] aim . . . is to take both
contemporary Chinese and
international art to a sector of the
Chinese public that has rarely, perhaps
never, been exposed to such work . . .
Specifically, we will bring art to the
people who live along the route of Mao
Zedong's Long March. Mao's march
symbolised the deliverance of the
Communist ideal to the Chinese
proletariat. It is with this symbolism in
mind that we now choose to march
contemporary art out to China's
peripheral population.

The curatorial team and two camera
crews will travel for a five-month period
along the route of the Long March,
documenting the journey and
compiling an archive of the experience.
Along the way, local and international
artists will join in at different venues to
participate in the project by creating
and/or showing their art works. There
will be 20 events taking place in
specific locations, each chosen to
represent a certain historical, political,
geographical and/or artistic context.
Every event will include an exhibition
and a forum for debate. In these
exhibition venues, original artwork will
be shown, but secondary sources
such as slides, videos and exhibition
catalogues will also be displayed.
Following the exhibition we will hold
discussions with invited artists,
curators, critics and the local public.
— Lu Jie, Initiator and Chief Curator of
the Long March Project

The Long March Project began with Lu Jie and a team of volunteers staging local art exhibitions along the route of the march. International artists were also invited to participate in various stages of the march and to exhibit their work alongside the rural artists. News of the Long March Project spread outside of China, attracting more and more artists from China and abroad to be a part of the project.

The project was planned to take place in China over five months, culminating in a series of exhibitions documenting the event and showcasing particular participating artists, in China and internationally. However the project has now been running for four years and shows no sign of ending.

INTERNATIONAL VENUES

2005 Third Fukuoka Asian Art Triennale, Japan
Yokohama International Triennale of Contemporary Art, Japan
Second Prague International Biennale of Contemporary Art, Czech Republic

2004 Taipei Biennale, Taiwan
Fifth Shanghai Biennale, China
'Le Moine et le Demon: Contemporary Chinese Art', Museum of Contemporary Art, Lyon, France
'Light as Fuck! Shanghai Assemblage 2000–2004', National Museum of Contemporary Art, Oslo, Norway

2003 Long March Foundation sponsors 'Yang Jiechang: Lohkchat', Centre A, Vancouver, Canada
'The Long March: A Walking Visual Display', Ethan Cohen Fine Arts, New York, USA
'Power of the Public Realm', 25000 Cultural Transmission Center, Beijing, China

Lu Jie and Qiu Zhijie have organised forums and given keynotes addressing the key goals of the Long March Project with the following international institutions:

2004 Home and Away Symposium, Centre A, Vancouver, Canada
Beijing-London Creative Entrepreneurs Bilateral Dialogue, Institute of Contemporary Art, London, UK
Association for Asian Studies (AAS) Annual Conference, New York, USA

2003 The College Art Association Annual Conference, New York, USA
Second Echigo-Tsumari Art Triennial, Japan
Hot & Spicy, Mori Art Museum, Tokyo, Japan

HONG HAO

B.1965, BEIJING, CHINA
Lives and works in Beijing

SELECTED SOLO EXHIBITIONS

2002 'Scenes from the Metropolis', Courtyard Gallery, Beijing, China
'Suspended Disbelief', Art Beatus Gallery, Vancouver, Canada

1999 'Hidden Scriptures: Exhibition of Works by Hong Hao' CVASAN International Art Foundation, Amersterdam, the Netherlands

SELECTED GROUP EXHIBITIONS

2006 'On the Edge: Contemporary Chinese Artists Encounter the West', Davis Museum and Cultural Center, Wellesley College, USA

2005 Guangzhou International Photography Biennale, Guangdong Museum of Art, Guangzhou, China

2004 'Between Past and Future', International Center of Photography, New York, USA

2003 'Zooming into Focus: Chinese Contemporary Photography and Video from the Haudenschild Collection', San Diego State University, and other venues, USA; China

2002 First Guangzhou Triennial, China

2001 First Chengdu Biennale, China

2000 Third Shanghai Biennale, China
'Big Torino 2000', Torino, Italy

1999 'Beijing in London', Institute of Contemporary Art, London, UK
Biennale d'Issy, France

1998 'Inside Out: New Chinese Art', Asia Society; PS1 Contemporary Art Center, New York, USA

QUALIFICATIONS, GRANTS & AWARDS

BFA, Printmaking Department, Central Academy of Fine Arts, Beijing, China

COLLECTIONS

Boston Museum of Fine Arts, USA
British Museum, London, UK
China National Museum of Fine Arts, Beijing, China
Fukuoka Asian Art Museum, Japan
Guangdong Museum of Art, China
Hong Kong Museum of Fine Arts, Hong Kong
Khoan and Ashmolean Collection, Oxford, UK
Museum of Modern Art, New York, USA
National Gallery of Canada, Ottawa, Canada
New York City Public Library, USA
NUS Museum, National University of Singapore
Queensland Art Gallery, Brisbane, Australia
Shanghai Art Museum, China

LI TIANBING

B.1933, MAKENG VILLAGE, FUJIAN PROVINCE, CHINA
Lives and works in Makeng village

SELECTED SOLO EXHIBITIONS

2005 'Comrade', 25000 Cultural Transmission Center, Beijing, China

SELECTED GROUP EXHIBITIONS

2005 Second Prague International Biennale of Contemporary Art, Czech Republic

2004 Fifth Shanghai Biennale, China
Beijing International Art Expo; International Exhibition Center, Beijing, China

2003 'Power of the Public Realm', 25000 Cultural Transmission Center, Beijing, China

2002 'The Long March: A Walking Visual Display', former Soviet Post and Telecommunication Ministry, Ruijin, Guangxi province, China

LIU JIEQIONG

B.1967, YANCHUAN COUNTY, SHAANXI PROVINCE, CHINA
Lives and works in Yanchuan county

SELECTED GROUP EXHIBITIONS

2004 'The Great Survey of Papercuttings in Yanchuan County', in the Taipei Biennale, Taiwan, and the Fifth Shanghai Biennale, China
'Yanchuan Papercutting Survey', 25000 Cultural Transmission Center, Beijing, China

COLLECTIONS

Queensland Art Gallery, Brisbane, Australia

MU CHEN AND SHAO YINONG

Before 2000, Shao Yinong and Mu Chen worked as individual artists. Since 2000, they have been working as one creative team. This is the CV of their joint work.

MU CHEN

B.1970, LIAONING PROVINCE, CHINA
Lives and works in Beijing, China

SHAO YINONG

B.1961, XINING, QINGHAI PROVINCE, CHINA
Lives and works in Beijing, China

SELECTED SOLO EXHIBITIONS

2004 'Shaoyinong & Muchen Photography Exhibition', Chinese Contemporary, London, UK

2003 'Shaoyinong & Muchen Photography Exhibition', Goedhuis Contemporary, New York, USA; Rencontres de la Photographie, Arles, France

2002 'Family Register', Courtyard Gallery, Beijing, China

SELECTED GROUP EXHIBITIONS

2003 'Alors la Chine?', Centre Pompidou, Paris, France

2002 'History of Time: Pingyao International Photography Exhibition', Pingyao, China
Taipei Biennale, Taiwan
'Paris–Peking', Espace Cardin, Paris, France
'Money and Value: The Last Taboo', Biel, Switzerland

2001 'Chinese Plan: Rotate 360', Paragold International Art Centre, Shanghai, China
'Virtual Future', Guangdong Art Museum, Guangzhou, China
'Pingyao International Photography Exhibition', Pingyao, China

QUALIFICATIONS, GRANTS & AWARDS

1995 Mu Chen graduated from People's University of China, Photojournalism, MA

1982 Shao Yinong graduated from Qinghai Normal University

COLLECTIONS

Queensland Art Gallery, Brisbane, Australia

QIN GA

B.1971, INNER MONGOLIA, CHINA
Lives and works in Beijing, China

SELECTED SOLO EXHIBITIONS

2005 'The Miniature Long March 2002–2005', Long March Space, Beijing, China

SELECTED GROUP EXHIBITIONS

2006 'Biennale Cuvee', OK Centrum, Linz, Austria

2005 Second Prague International Biennale of Contemporary Art, Czech Republic

2004 'Le Moine et le Demon: Contemporary Chinese Art', Museum of Contemporary Art, Lyon, France
'Light as Fuck! Shanghai Assemblage 2000–2004', National Museum of Contemporary Art, Olso, Norway
'Designed in France, Made in China', Espace Paul Ricard, Paris, France

2003 'Drifting: A Contemporary Art Exhibition', Post Modern City, Beijing, China

2002 'The Long March: A Walking Visual Display', various sites throughout China

2001 'Dreaming to Country', Shanxi province, China

2000 'Fuck Off', Eastlink Gallery, Shanghai, China
'Documentary Show of Chinese Avant-garde Art in the 1990s', Fukuoka Asian Art Museum, Japan
Fifth Lyon Biennale, France
'Invitational Exhibition of Contemporary Chinese Sculpture', Qingdao Sculpture Museum, China
'Obsession with Harm', Sculpture Institute of the Central Academy of Fine Arts, Beijing, China

1999 'Post-sense Sensibility: Alien Bodies and Delusion', Beijing, China

1995 'Hiroshima '95', International Conference Center, Hiroshima, Japan

QUALIFICATIONS, GRANTS & AWARDS

2004 MFA, Sculpture Department, Central Academy of Fine Arts, Beijing, China

1997 BFA, Sculpture Department, Central Academy of Fine Arts, Beijing, China

SHEN XIAOMIN

B.1972, FUJIAN PROVINCE, CHINA
Lives and works in Beijing, China

FILMOGRAPHY

2002 *Love 368g*
2001 *Village Cameraman and his Son*
2000 *Eulogy of Longjiang River*
1999 *Performance*
1998 *Walking and Singing*

SELECTED GROUP EXHIBITIONS

2006 'Long March Yan'an Project', Yan'an, Shaanxi Province, China

2005 Second Prague International
 Biennale of Contemporary Art,
 Czech Republic

2002 'The Long March: A Walking Visual
 Display', various sites throughout
 China

2001 'Cities on the Move: First Chinese
 Independent Video Exhibition',
 Beijing, China

 'Chinese Fine Arts Academy New
 Media Festival', Hangzhou, China

WANG WENHAI

B.1950, HENAN PROVINCE, CHINA
Lives and works in Yan'an, Shaanxi
 province, China

SELECTED GROUP EXHIBITIONS

2005 Second Prague International
 Biennale of Contemporary Art,
 Czech Republic

2004 'Le Moine et le Demon:
 Contemporary Chinese Art',
 Museum of Contemporary Art,
 Lyon, France

2004 'Beijing International Art Expo',
 International Exhibition Center,
 Beijing, China

2003 'Power of the Public Realm', 25000
 Cultural Transmission Center,
 Beijing, China

ZHOU XIAOHU

B.1960, CHANGZHOU, JIANGSU PROVINCE,
 CHINA
Lives and works in Changzhou

SELECTED SOLO EXHIBITIONS

2002 'Zhou Xiaohu's Photography',
 Moscow Central House of Artists,
 Russia

1989 'Optional Works Show', Sichuan
 Academy of Fine Arts, Chongqing,
 China

SELECTED GROUP EXHIBITIONS

2006 'Building Code Violations', Long
 March Space, Beijing, China

2005 'City_Net Asia 2005', Seoul
 Museum of Art, Seoul, Korea

 'Mahjong: Contemporary Chinese Art
 from the Sigg Collection',
 Kunstmuseum, Bern, Switzerland

 'Living in Interesting Times: A Decade
 of New Chinese Photography',
 Open Museum of Photography,
 Tel Hai, Israel

 'Shanghai Surprise', Space for
 Contemporary Art, Munich,
 Germany

 'Pseudo Hacker's Art in Parallel
 Zone', Museum of Contemporary
 Art Taipei, Taiwan

2004 First Seville International Biennale of
 Contemporary Art, Spain

 'Between Past and Future: New
 Photography and Video from
 China', International Center of
 Photography, New York and
 Smart Museum of Art, Chicago,
 USA

 'Le Moine et le Demon:
 Contemporary Chinese Art',
 Museum of Contemporary Art,
 Lyon, France

 'Light as Fuck! Shanghai
 Assemblage 2000–2004',
 National Museum of
 Contemporary Art Oslo, Norway

'China Now', Museum of Modern Art,
 New York, USA

'Out the Window: Spaces of
 Distraction', The Japan
 Foundation Forum, Tokyo, Japan

2003 'New Zone-Chinese Art', Zachęta
 National Gallery of Art, Warsaw,
 Poland

'A Strange Heaven: Contemporary
 Chinese Photography',
 Rudolfinum Art Museum, Prague,
 Czech Republic

'Second Hand Reality', Today Art
 Museum, Beijing, China

'56th Locarno International Film
 Festival', Video Installation Show,
 Ticino, Switzerland

'The 36th Houston International Film
 Festival', Houston, USA

'Aubes', Reveries Au Bord de Victor
 Hugo, Maison de Victor Hugo,
 Paris, France

2002 'Video Art from Asia', Nikolaj
 Contemporary Art Center,
 Copenhagen, Denmark

'The Long March: A Walking Visual
 Display', various sites throughout
 China

First Guangzhou Triennial, China

'Golden Autumn', Zagreb National
 Museum, Zagreb, Croatia

'Contemporary Art from China',
 Kuppersmuhle Museum, Duisburg,
 Germany

2001 First Chengdu Biennale, China

'Up-rising', Hong Kong Outer Space
 Museum, Hong Kong

'China Rushes', Hamburger Bahnhof
 National Museum, Berlin

'Non-linear Narrative', Gallery of
 National Academy of Fine Arts,
 Hangzhou, China

'Excess', Multimedia Art Asia–Pacific
 Festival, Powerhouse, Brisbane,
 Australia

'Third Bangkok Experimental Film
 Festival', Bangkok, Thailand

2000 Third Shanghai Biennale, China

1989 'Optional Works Show', Sichuan
 Academy of Fine Arts, Chongqing,
 China

DJAMBAWA MARAWILI

B.1953, EASTERN ARNHEM LAND, AUSTRALIA
MADARRPA PEOPLE
Lives and works in Yilpara, Australia

SELECTED SOLO EXHIBITIONS

2005 'Djambawa Marawill: Source of Fire
 2003–2005', Annandale Galleries,
 Sydney, Australia

1997 'Djambawa', William Mora Gallery,
 Melbourne, Australia

SELECTED GROUP EXHIBITIONS

2006 Biennale of Sydney, Australia

2004 Biennale of Sydney, Australia

 'White/Light', Queensland Art Gallery,
 Brisbane, Australia

 'Blak Insights: Contemporary
 Indigenous Art', Queensland Art
 Gallery, Brisbane, Australia

2003 'Buwayak: Invisibility', Annandale
 Galleries, Sydney, Australia

1999 'Saltwater Country — Bark Paintings
 from Yirrkala. A National Tour
 recognising Indigenous Sea
 Rights', Drill Hall Gallery, Canberra,
 and other venues, Australia

1996 'Big Bark', Annandale Galleries,
 Sydney, Australia

1995 'Miny'tji Buku Larrngay, Paintings
 from the East', National Gallery of
 Victoria, Melbourne, Australia

QUALIFICATIONS, GRANTS & AWARDS

1996 Telstra National Aboriginal and Torres
 Strait Islander Art Award for Bark
 Painting

COLLECTIONS

Art Gallery of New South Wales, Sydney,
 Australia

Art Gallery of South Australia, Adelaide,
 Australia

Art Gallery of Western Australia, Perth,
 Australia

Crafts Museum, New Delhi, India

Kelvingrove Art Gallery and Museum,
 Glasgow, Scotland

JW Kluge Collection, Virginia, USA

Colin & Liz Laverty Collection, Sydney,
 Australia

National Gallery of Australia, Canberra,
 Australia

National Gallery of Victoria, Melbourne,
 Australia

National Maritime Museum, Sydney,
 Australia

Queensland Art Gallery, Brisbane,
 Australia

Kerry Stokes Collection, Perth, Australia

Sydney Opera House Collection, Australia

NASREEN MOHAMEDI

1937–90, KARACHI, INDIA
Lived and worked in Mumbai and Delhi,
 India

SELECTED SOLO EXHIBITIONS

2005 'Lines among Lines', The Drawing
 Room, New York, USA

 Gallery Nature Morte, New Delhi,
 India

 'Photoworks from the 1960s and
 '70s', Talwar Gallery, New York, USA

2000 Retrospective, Jehangir Art Gallery,
 Bombay, India

1999 Jehangir Art Gallery, Mumbai, India

1991 Jehangir Art Gallery, Bombay, India

SELECTED GROUP EXHIBITONS

2003 'Crossing Generations: DiVerge',
 National Gallery of Modern Art,
 Mumbai, India

 'The Last Picture Show: Artists Using
 Photography, 1960–1982', Walker
 Art Center, Mineapplis; and other
 venues, USA; Spain; Switzerland

2000 'Drawing Space', INIVA, London, UK

1998 'Aparanta: Approaching the Infinite',
 Gallery Lakeeren, Mumbai, India

1997 'Out of India: Contemporary Art of
 the South Asian Diaspora',
 Queens Museum of Art, New
 York, USA

1994 'Drawing '94', Gallery Espace,
 New Delhi, India

COLLECTIONS

National Gallery of Modern Art, New Delhi,
 India

Queensland Art Gallery, Brisbane,
 Australia

Rukaya Dossal, Mumbai, India

XAL Praxis, Mumbai, India

TUẤN ANDREW NGUYỄN

B.1976, HO CHI MINH CITY, VIETNAM
Lives and works in Ho Chi Minh City

SELECTED GROUP EXHIBITIONS

2005 'The 4th Bangkok Experimental Film
 Festival', Bangkok, Thailand

 'US Asean Film Festival', Falls
 Church, USA

 'AFM American Film Market', Santa
 Monica, USA

 '18th Annual Singapore International
 Film Festival', Singapore

 'Short Shorts Film Festival Asia',
 Tokyo, Japan

2004 'In Place of Place', One Night Gallery,
 Los Angeles, USA

 'E-flux video rental project', e-flux,
 New York, USA

 'There's No Place Like Place', One
 Night Gallery, Tel Aviv, Israel

 'Supersonic', The Windtunnel,
 Pasadena, USA

 'While Dodging Fake Bullets in the
 Dark', Voz Alta Projects, San
 Diego, USA

 'Los Angeles Asian Pacific Film &
 Video Festival', Director's Guild of
 America, Los Angeles, USA

 'Trying to Kill Me by Accident',
 California Institute of the Arts,
 Valencia, USA

2003 'Vietnamese International Film
 Festival', University of California
 Art Gallery, Irvine, USA

 'Mine', Lombard-Freid Fine Arts,
 New York, USA

 Re:fresh, hip-hop symposium,
 California Institute of the Arts,
 Valencia, USA

2002 'Platforms', California Institute of the
 Arts, Valencia, USA

 '7th Annual Chicago Asian American
 Film Festival', Gene Siskel Film
 Center, Chicago, USA

2001 'T-10', 21 Grand Gallery, Oakland, USA

2000 'Exquisite Corpse', online
 collaborative digital art exhibition,
 www.loudcricket.com

 '5th Annual Chicago Asian American
 Film Festival', The School of the
 Art Institute of Chicago, USA

1999 'Los Angeles Asian Pacific Film &
 Video Festival', Director's Guild of
 America, Los Angeles, USA

 'Centered on the Center', Huntington
 Beach Museum of Art,
 Huntington Beach, USA

1998 'En Route: Constructing Home',
 73 Freeway, Irvine, USA

 'Regression and Seasickness:
 Dripping Seawater and Seeing
 Home/Beginning Departure', MAB
 Space, Irvine, USA

 'Uneven Eyes and Eyeliner', Visual
 Communications Center,
 Los Angeles, USA

 'Artifacts', University of California Art
 Gallery, Irvine, USA

 'Third Annual Asian American Art
 Exhibition', Huntington Beach
 Museum of Art, Huntington
 Beach, USA

QUALIFICATIONS, GRANTS & AWARDS

2004 MFA, California Institute of the Arts,
 Valencia, USA

2002 CalArts Scholarship, California
 Institute of the Arts, Valencia,
 USA

1999 Artsbridge Scholarship
 Bachelor of Arts, Studio Art (with
 Minor in Digital Arts), University of
 California, Irvine, USA
 Dean's Honor List, University of
 California, Irvine, USA

DENNIS **NONA**
B.1973, BADU ISLAND, AUSTRALIA
KALA LAGAW YA PEOPLE
Lives and works in Brisbane, Australia

SELECTED SOLO EXHIBITIONS
2005 'Sesserae: The Works of Dennis
 Nona', DELL Gallery @ QCA,
 Griffith University, Brisbane,
 Australia

SELECTED GROUP EXHIBITIONS
2004 'Fragments', Little Stanley Street
 Gallery, Brisbane, Australia
2003 '19th Telstra National Aboriginal &
 Torres Strait Islander Art Award',
 Museum and Art Gallery of the
 Northern Territory, Darwin,
 Australia
 Centre Jean-Marie Tjibaou, Nouméa,
 New Caledonia
 'Dream Traces', Brighton University,
 Brighton, UK
 'Beneath the Monsoon: Visions
 North of Capricorn', Artspace,
 Mackay, and other venues,
 Australia
2002 'Paipa: Windward', National Museum
 of Australia, Canberra, Australia
 Adam Art Gallery Te Pātaka Tci,
 Wellington, New Zealand
2001 'Gelam Ngzu Kazi: Gelam My Son',
 Australian Museum, Sydney,
 Australia
 Tandanya National Aboriginal
 Cultural Institute, Adelaide,
 Australia
2000 '16th Telstra National Aboriginal &
 Torres Strait Islander Art Award',
 Museum and Art Gallery of the
 Northern Territory, Darwin,
 Australia
1998 'Ilan Pasin (this is our way): Torres
–2001 Strait Art', Cairns Regional Gallery,
 and other venues, Australia
1998 'The Art of Place: The 4th National
 Indigenous Heritage Art Award',
 Old Parliament House, Canberra,
 and touring Australia
1995 Fireworks Gallery, Brisbane, Australia
 'Same But Different', Aborigina &
 Islander Students at the
 Australian National University
 School of Art Gallery, Canberra,
 Australia

COLLECTIONS
Art Gallery of South Australia, Adelade,
 Australia
Brighton University, Brighton, UK
Cairns Regional Art Gallery, Australia
Cambridge University Museum, UK
Gold Coast City Art Gallery,
 Surfers Paradise, Australia
National Gallery of Australia, Canberra,
 Australia
National Maritime Museum, Sydney
 Australia
Perc Tucker Regional Gallery, Townsville,
 Australia
Queensland Art Gallery, Brisbane,
 Australia

Queensland University of Technology Art
 Collection, Brisbane, Australia
University of Wollongong Art Collection,
 Australia
Victoria & Albert Museum, London, UK

EKO **NUGROHO**
B.1977, YOGYAKARTA, INDONESIA
Lives and works in Yogyakarta

SELECTED SOLO EXHIBITIONS
2004 'Welcome Back Mayo'nnaise',
 Cemeti Art House , Yogyakarta,
 Indonesia
 'Jauh di Mata Dekat di Hati', Fukuoka
 Asian Art Museum, Japan
2003 'Fight Me', Via-Via Cafe, Yogyakarta,
 Indonesia
2002 'Like a Chimney', Cemeti Art House,
 Yogyakarta, Indonesia
2001 'Indonesia vs Televisi', Pum'n Yang
 Art Shop, Yogyakarta, Indonesia
2000 'Sendiri', Pasundan University,
 Universitas Pendidikan Indonesia,
 Institut Teknologi Bandung,
 Indonesia
 'Herk', Apotik Komik Gallery,
 Yogyakarta, Indonesia
1999 'Pameran Tunggal Bersama'
 (collective solo exhibition), Institut
 Seni Indonesia, Yogyakarta,
 Indonesia

SELECTED GROUP EXHIBITIONS
2005 'Politics of Fun', House of World
 Cultures, Berlin, Germany
 'OK Video: Jakarta Video Festival
 2005 — Sub/version', Indonesian
 National Gallery, Jakarta,
 Indonesia
 'Have We Met?', Japan Foundation
 Forum, Tokyo, Japan
 '3 Young Contemporaries', Valentine
 Willie Fine Art, Kuala Lumpur,
 Malaysia
2004 'Reformasi: Contemporary
 Indonesian Artists Post 1998',
 Sculpture Square, Singapore
 'Urban Art Poster', Cemeti Art House,
 Yogyakarta, Indonesia
2003 Seventh Yogyakarta Biennale,
 Indonesia
 'Melbourne Connection Asia
 (September/October)', City Tram
 Stops, Melbourne, Australia
 'Worms Festival 5: House', Plastique
 Kinetic Worms, Singapore
 'OK Video: Jakarta Video Festival
 2003', Indonesian National
 Gallery, Jakarta, Indonesia
 'Read', Cemeti Art House,
 Yogyakarta, Indonesia
2002 '3030', Edwin Gallery, Jakarta,
 Indonesia
2001 'Kabinet Komik Indie' (Indie Comics
 Exhibition), Gelaran Budaya,
 Yogyakarta, Indonesia
2000 'Dies natalis', Institut Seni Indonesia,
 Yogyakarta, Indonesia
 'Yogyakarta Art Festival XIII',
 Indonesia
1999 'Young Visual Artists 2000', Purna
 Budaya, Yogyakarta, Indonesia
1998 'Lepas 97', Purna Budaya,
 Yogyakarta, Indonesia
1997 'Lepas 97', Institut Seni Indonesia,
 Yogyakarta, Indonesia
1996 'Yogyakarta Art Festival IX',
 Indonesia

SOLO PUBLISHING
COMIC BOOKS
2004 *The Konyol*
2002 *Hope*
2001 *Sertifikat untuk Indonesia
 (Certificate for Indonesia)*
 Viva Macho
 Terbang (Flying)
 Untitled
2000 *Hancur di pagi Buta (Ruined at
 Dawn)*
 *Panggil saja aku Togel (Just Call
 Me Togel)*
 *Assalamualiaikum (Peace Be with
 You/Greetings)*
 Herk
1999 *Unwanted*
1998 *Komik Kondom (Condom Comic)*
 Komik Korek (Match Comic)
 Kuman (Germ)
 Komik 43, 1 % 5 -0,7 x 1/2'
1997 *Bukan Komik (Not Comic)*
 The WC (The Lavatory)

COLLABORATIVE PUBLISHING
COMIC BOOKS
2005 *Daging Tumbuh*, vol.10, 'No deal
 foundation'
2004 *Daging Tumbuh*, vol.9, 'Ditampar
 pabrik kulit'
 Daging Tumbuh, vol.8, 'Jangan ada
 ganteng diantara kita'
2003 *Daging Tumbuh*, vol.7, 'Invasi Ganda
 Minyak Tanah'
 Daging Tumbuh, vol.6, 'Tendangan
 Maut Nanas Muda'
2002 *Daging Tumbuh*, vol.5, 'Merobohkan
 Kalenjar Hari Libur'
 Daging Tumbuh, vol.4, 'Sirkus'
2001 *Menggergaji Es Jeruk (Slicing
 Orange Icicle with a See-Saw)*
 Daging Tumbuh, vol.3
 Compilation with colleagues from
 YAKKUM, Yogyakarta
 Compilation with SD Kanisius
 Gayam elementary
 schoolchildren, Yogyakarta,
 Indonesia
2000 *Daging Tumbuh*, vol.2, 'Presiden vs
 Komik'
 Daging Tumbuh, vol.1, 'Segar
 Narcis*
1998 *Kuman Core*

ANIMATIONS
2005 *Dark Disco*
2004 *The Breeders*
 Let Me Love Me
2002 *Bercerobong (Chimney-ing)*
 Memakan (Eating)

COLLECTIONS
Queensland Art Gallery, Brisbane,
 Australia

TSUYOSHI **OZAWA**
B.1965, TOKYO, JAPAN
Lives and works in Tokyo

SELECTED SOLO EXHIBITIONS
2005 'Koropokkuru Talk to You', Galerie
 Yvon Lambert, Paris, France
2004 'Answer with Yes and No!', Mori Art
 Museum, Tokyo, Japan
 'One Man Group Show 2: Yontaro
 Okamoto, Gotaro Okamoto,
 Rokutaro Okamoto, Tsuyoshi
 Ozawa', Ota Fine Arts, Tokyo,
 Japan

1998 'One Man Group Show: Ichitaro
 Okamoto, Nitaro Okamoto,
 Santaro Okamoto, Tsuyoshi
 Ozawa', Ota Fine Arts, Tokyo,
 Japan

SELECTED GROUP EXHIBITIONS
2006 'GUANGDONGTOKYO: Tsuyoshi
 Ozawa + Chen Shaoxiong', Ota
 Fine Arts, Tokyo, Japan
2005 Second Guangzhou Triennial, China
2004 'Adaptive Behaviour', New Museum
 of Contemporary Art, New York,
 USA
 'Swedish Hearts', Moderna Museet,
 Stockholm, Sweden
2003 Eighth Istanbul Biennale, Turkey
 'How Latitudes Become Forms: Art
 in a Global Age', Walker Art
 Center, Minneapolis, USA
 50th Venice Biennale, Italy
 Second Echigo-Tsumari Art Triennial,
 Japan
2002 'Under Construction: New
 Dimensions of Asian Art', Tokyo
 Opera City Art Gallery, Japan
 Fourth Gwangju Biennale, Korea
2001 Second Berlin Biennale, Germany
 'Public Offerings', Museum of
 Contemporary Art, Los Angeles,
 USA
 Yokohama International Triennale of
 Contemporary Art, Japan
2000 'My Home is Yours/Your Home is
 Mine', Rodin Gallery, Seoul, Korea
 'Rendez-vous', Collection Lambert en
 Avignon, Avignon, France
 'Musueum City Fukuoka 2000 [Art
 Out]', Former Gokusho
 Elementary School, Fukuoka,
 Japan
1999 First Fukuoka Asian Art Triennale,
 Japan
 'Modest Radicalism: MOT ANNUAL
 1999', Museum of Contemporary
 Art, Tokyo, Japan
1998 Taipei Biennale, Taiwan
1997 'Cities on the Move', Secession,
 Vienna, Austria; CAPC, Musee d'
 Art Contemporain, Bordeaux,
 France; USA; Denmark; UK

QUALIFICATIONS, GRANTS & AWARDS
1991 Postgraduate studies, mural painting,
 Tokyo National University of Fine
 Arts and Music, Japan

COLLECTIONS
Collection Lambert, Avignon, France
Fukuoka Asian Art Museum, Japan
Hiroshima City Museum of Contemporary
 Art, Japan
The Japan Foundation
Museum of Contemporary Art, Tokyo,
 Japan
Museum of Modern Art, Shiga, Japan
Queensland Art Gallery, Brisbane,
 Australia
Toyota Municipal Museum of Art, Aichi,
 Japan
Watarium, The Watari Museum of
 Contemporary Art, Tokyo, Japan

PACIFIC TEXTILES PROJECT

ALINE **AMARU**
B.1941, TAHITI, FRENCH POLYNESIA
Aline Amaru began creating *tifaifai* when she was 17. She exhibits regularly in Papeete, Tahiti, and her work was chosen to represent Tahiti at the Ninth Pacific Arts Festival in Palau in 2004.

GUSSIE R **BENTO**
B.1932, HAWAI'I, USA
Gussie R Bento was taught the art of *kapa kuiki* by her grandmother. She studied at the University of Hawai'i and worked as a teacher and museum curator at the Kamehameha School for girls. Her work has been shown in Hawai'i, the United States and Japan.

TUNGANE **BROADBENT**
B.1940, MANGAIA/RAROTONGA, COOK ISLANDS
Tungane Broadbent migrated to New Zealand in 1970 and returned to Rarotonga, Cook Islands in 2001 where she is a part-time school teacher. Her quilts have been exhibited in the Cook Islands, New Zealand and France.

SUSANA **KAAFI**
B.1920, TONGA/AUSTRALIA
Susana Kaafi migrated from Tonga to Australia in 1991 and lives in Sydney. Over a decade ago Kaafi initiated a women's group that produce tapa cloth and quilts. Kaafi has exhibited in Australia.

DEBORAH (KEPOLA) U **KAKALIA**
1915–2002, HAWAI'I, USA
Deborah U Kakalia was a highly esteemed quilter in Hawai'i, creating many of her own designs. She began making *kapa kuiki* in her forties. Kakalia published the first instruction book for *kapa kuiki* patterns in 1976. Her work has been collected by the Bishop Museum, Hawai'i and continues to be shown in exhibitions in Hawai'i and Japan.

SERUWAIA **KUDRUVI**
B.(C.)1950, LAU ISLANDS, FIJI
Seruwaia Kudruvi left Vatoa, Lau Islands at a young age and now lives on the main island of Fiji. She exhibits annually at the Eastern and National Craft Fairs. Her work is held in the collection of the Fiji Arts Council.

FILITI LEYA **LEDUA**
B.1948, LAU ISLANDS, FIJI
Filiti Leya Ledua comes from Lakeba in the Lau group of islands and now lives in Suva, Fiji. Ledua makes work specifically for ceremonial occasions. In most of her work, whether it is weaving or *masi* (tapa), she includes the names of the people she is celebrating.

TUSI **LUAFUTU**
B.1951, SAMOA/AUSTRALIA
Tusi Luafutu moved from Auckland, New Zealand, to Brisbane in 1991. She forms part of the Tofa Mamao women and elders' community group in Riverview, Brisbane, who create screenprinted material from carved woodblocks.

FINAU **MARA**
B.1950, LAU ISLANDS, FIJI
Finau Mara credits her mother as the source of her many unique patterns. Mara is represented in the collection of the Fiji Arts Council and has had a solo exhibition at the Fiji Museum, Suva in 1998. She has exhibited in Japan and Taiwan and has also represented Fiji at various arts festivals, including the Ninth Pacific Arts Festival, Palau, in 2004.

TEKAUVAI TEARIKI **MONGA**
1900–61, AITUTAKI/RAROTONGA, COOK ISLANDS
Tekauvai Teariki Monga was a respected *tivaevae* maker and teacher. Her husband's ancestors came from French Polynesia and influenced Monga's designs. Her work has been shown in the Cook Islands and New Zealand.

MARGO **MORGAN**
B.1920, HAWAI'I, USA
Margo Morgan is a third generation Hawaiian and is the first quilter in her family. She learnt to make *kapa kuiki* in 1949 with the help of a Hawaiian friend. Her work has been shown in Hawai'i, the United States and Japan.

LAUPULE **POUTASI**
1912–2004, SAMOA
Laupule Poutasi was an active member of the women's art making groups in the villages of Fagali'i and Solosolo. She wove mats and made *fala su'i* for special occasions and as a form of exchange and gift.

SUSIE **SUGI**
B.1949, JAPAN/HAWAI'I, USA
Susie Sugi came to Hawai'i from Japan in 1988. Originally a patchwork quilt-maker, she studied the art of *kapa kuiki* with well known artists such as Deborah (Kepola) U Kakalia.

EMMA **TAMARII**
B.1937, MARQUESAS ISLANDS/TAHITI, FRENCH POLYNESIA
Emma Tamarii was born on Ua Huka, Marquesas Islands. In 1962, she moved with her family to Tahiti where she learnt the art of making *tifaifai*. She exhibits regularly in Papeete, Tahiti, and has also shown work in Japan and the Cook Islands.

MARIE-THERESE **TAMARII**
B.1959, MARQUESAS ISLANDS/TAHITI, FRENCH POLYNESIA
Although not a professional textile artist like her mother Emma Tamarii, Marie-Therese often collaborates with her and is known for her skilled embroidery.

LEPETIA **TOA**
SAMOA
Lepetia Toa is from the village of Moata'a, where weavers are well known for making *fala su'i*. Toa produces these mats as part of the Samoa Women in Business scheme, which is aimed at encouraging villagers to generate income and create a sustainable village economy.

SIVAIMAUGA **VAAGI**
B.1964, SAMOA
Sivaimauga Vaagi learnt the technique of stitching *fala su'i* from her mother at the age of eight. Formerly a school teacher, she now tutors weaving and stitching to the younger women of her village Moata'a.

TAPAERU **WILLIAMS**
COOK ISLANDS/NEW ZEALAND B.(C.)1935
Tapaeru Williams was born in the Cook Islands and now lives in South Auckland, New Zealand.

REPEKA **YALI**
B.1942, LAU ISLANDS, FIJI
Repeka Yali now lives on the main island of Fiji and has had her work commissioned by the Fijian Department of Culture and Heritage. Her work is held in the collection of the Fiji Arts Council.

STEPHEN **PAGE**

B.1965, BRISBANE, AUSTRALIA
NUNUKUL/MUNALDJALI/YUGAMBEH PEOPLE
Lives and works in Sydney, Australia

PROFESSIONAL CAREER
2006 Choreographer, *Gathering*, The Australian Ballet
2005 Choreographer, *Mimic*, Bangarra Dance Theatre
Choreographer, *Boomerang*, Bangarra Dance Theatre
Director, *Page 8*, toured Australia and United Kindom
2004 Artistic Director, Adelaide Festival of Arts
Artistic Director, *Unaipon*, Bangarra Dance Theatre
Co-choreographer, *Clan*, Bangarra Dance Theatre
2003 Artistic Director, *Bush*, Bangarra Dance Theatre
Artistic Director, *The Dreaming*, Bangarra Dance Theatre
2002 Artistic Director, *Walkabout*, Bangarra Dance Theatre
Choreographer, *Totem*, The Australian Ballet
2001 Choreographer and Artistic Director, *Corroboree*, Bangarra Dance Theatre
2000 Director Indigenous Segments, Opening and Closing Ceremonies, Sydney Olympic Games
Creator, *Tubowgule*, Opening Ceremony, Sydney Olympic Arts Festival
Choreographer and Artistic Director, *Skin*, Bangarra Dance Theatre
1998 Choreographer and Artistic Director, *Fish*, Bangarra Dance Theatre
1997 Choreographer, *Rites*, Bangarra Dance Theatre and The Australian Ballet
1996 Choreographer, *Alchemy*, The Australian Ballet
Choreographer, Flag Handover Ceremony, Atlanta Olympics
1995 Artistic Director, *Ochres*, Bangarra Dance Theatre
1993 Choreographer and Director, *Black River*, Bangarra Dance Theatre
1991 Appointed Artistic Director, Bangarra Dance Theatre

AWARDS
2003 Sidney Myer Performing Arts Awards, Individual Winner
2002 Matilda Award for Contribution to the Arts in Queensland
2001 Helpmann Award, Best Choreography for *Corroboree*
2000 Helpmann Award, Best New Australian Work & Best Dance Work for *Skin*
1997 Green Room Award, Melbourne, for *Rites*
1993 Grand Prix Opera Screen '93, Paris, for *Black River*

PAIMAN

B.1970, MELACCA, MALAYSIA
Lives and works in Seri Manjung, Perak, Malaysia

SELECTED SOLO EXHIBITIONS
1996 'Issue: Now and Then', Galeriwan, Kuala Lumpur, Malaysia
'The Independent Day', Creative Centre, National Art Gallery, Kuala Lumpur, Malaysia

SELECTED GROUP EXHIBITIONS
2006 'Print in Malaysia', National Art Gallery, Kuala Lumpur, Malaysia
2005 'Lightweight Heavyweight', Maya Gallery, Kuala Lumpur, Malaysia
National Art Gallery, Kuala Lumpur, Malaysia
'Narrative Strains', Galeri Petronas, KLCC, Kuala Lumpur, Malaysia
2004 'Aiskirim Malaysia' (Malaysia Edition), Galeri Adiwarna, Universiti Sains Malaysia, Pulau Pinang, Malaysia
2003 'Wahana', National Art Gallery, Kuala Lumpur, Malaysia
'Young Contemporaries', National Art Gallery, Kuala Lumpur, Malaysia
'Philip Morris Art Awards', National Art Gallery, Kuala Lumpur, Malaysia
2002 'Off Wall, Off Pedestals', Akal di Ulu, Ulu Langat, Selangor, Malaysia
2001 'Face the Act', Galeri Petronas, KLCC, Kuala Lumpur, Malaysia
2000 '7: Seven', Corner House Gallery, Manchester, UK
1999 'Kembara Tenggara', Creative Gallery, National Art Gallery, Kuala Lumpur, Malaysia
First Fukuoka Asian Art Triennale, Japan
'Blind Date', Righton Gallery, Manchester Metropolitan University, Manchester, UK; USA
1998 'Apa? Apa? Kenapa?', Artis Pro Activ, Kuala Lumpur, Malaysia
'GEMA: Resonance — An Art Exhibition of Malaysian Contemporary Art', Manes Gallery, Prague, Czech Republic
1997 'Malaysian Drawing', National Art Gallery, Kuala Lumpur, Malaysia
1996 'Young Contemporaries', National Art
–97 Gallery, Kuala Lumpur, Malaysia
1995 'Philip Morris Art Awards', National
–97 Art Gallery, Kuala Lumpur, Malaysia

QUALIFICATIONS, GRANTS & AWARDS
2005 Artist Residency, Galeri Petronas, KLCC, Kuala Lumpur, Malaysia

2002 Major Award, The Young
Contemporary, National Art
Gallery, Kuala Lumpur, Malaysia
1999 Artist Residency, Fukuoka Asian Art
Museum, Japan

COLLECTIONS

Fukuoka Asian Art Museum, Japan
National Art Gallery, Kuala Lumpur,
Malaysia
Queensland Art Gallery, Brisbane,
Australia

MICHAEL **PAREKOWHAI**
B.1968, PORIRUA, NEW ZEALAND
NGA-ARIKI, NGATI WHAKARONGO
Lives and works in Auckland, New Zealand

SELECTED SOLO EXHIBITIONS

2006 'Eerst me fiets (First my bicycle)',
Roslyn Oxley9 Gallery, Sydney,
Australia
2005 'Rainbow Servant Dreaming', Roslyn
Oxley9 Gallery, Sydney, Australia
'Driving Mr Albert', Michael Lett
Gallery, Auckland, New Zealand
2004 'Michael Parekowhai: The
Consolation of Philosophy — Piko
nei te matenga', Govett-Brewster
Art Gallery, New Plymouth, New
Zealand
'Selected Works 1989–1994', Michael
Lett Gallery, Auckland, New
Zealand
2003 'Kapa Haka', Michael Lett Gallery,
Auckland, New Zealand
2002 'All There Is', Gow Langsford Gallery,
Auckland; Jonathan Smart
Gallery, Christchurch, New
Zealand
2001 'Michael Parekowhai: The
Consolation of Philosophy —
Piko nei te matenga', Gow
Langsford Gallery, Auckland,
New Zealand; Australia
2000 'The Beverly Hills Gun Club', Gow
Langsford Gallery, Auckland, New
Zealand
'The Beverly Hills Gun Club / True
Action Adventures of the
Twentieth Century', Jonathan
Smart Gallery, Christchurch, New
Zealand
1999 'Patriot: Ten Guitars', Artspace,
–2001 Auckland, and other venues,
New Zealand; Andy Warhol
Museum, Pittsburgh, USA
1999 'Kitset Cultures', Djamu Gallery,
Sydney, Australia
1998 'Recent Paintings', Jonathan Smart
Gallery, Christchurch,
New Zealand
1997 'Recent Paintings', Gow Langsford
Gallery, Auckland, New Zealand
'Recent Paintings', City Gallery
Wellington Te Whare Toi,
Wellington, New Zealand

SELECTED GROUP EXHIBITIONS

2006 'High Tide: New Currents in Art from
Australia and New Zealand',
Zachęta National Gallery of Art,
Warsaw, Poland
2004 'Paradise Now? Contemporary Art
from the Pacific', Asia Society,
New York, USA
Fifth Gwangju Biennale, Korea
26th São Paulo Biennale, Brazil

2003 'Extended Play: Art Remixing Music',
Govett-Brewster Art Gallery,
New Plymouth, New Zealand
'Nine Lives: The 2003 Chartwell
Exhibition', Auckland Art Gallery
Toi o Tāmaki, Auckland, New
Zealand
'Traffic', Australian Centre for
Photography, Sydney, Australia
'Indians & Cowboys', Gallery 4A,
Sydney; Canberra Contemporary
Art Space, Canberra, Australia
2002 Biennale of Sydney, Australia
'Scape: Art & Industry Urban Arts
Biennial 02', Christchurch,
New Zealand
2001 First Auckland Triennial, New Zealand
'Techno Maori', City Gallery
Wellington Te Whare Toi,
Wellington, New Zealand
'Purangiaho: Seeing Clearly',
Auckland Art Gallery Toi o Tāmaki,
New Zealand
2000 'Flight Patterns', Museum of
Contemporary Art, Los Angeles,
USA
Nouméa Biennale, New Caledonia
1999 Third Asia–Pacific Triennial of
Contemporary Art, Brisbane,
Australia
First Fukuoka Asian Art Triennale,
Japan
1998 'The Dream Collectors: 100 Years of
Art in New Zealand', Museum of
New Zealand Te Papa Tongarewa,
Wellington; Auckland Art Gallery
Toi o Tāmaki, Auckland,
New Zealand
1996 'The World Over/De Wereld Bollen:
Art in the Age of Globalisation',
City Gallery Wellington Te Whare
Toi, New Zealand; Stedelijk
Museum, Amsterdam, the
Netherlands
1995 'Cultural Safety: Contemporary Art
from New Zealand', Waikato
Museum of Art and History
Te Whare Taonga o Waikato,
Hamilton, and other venues,
New Zealand; Germany

QUALIFICATIONS, GRANTS & AWARDS

2001 Arts Foundation of New Zealand
Laureate Award

COLLECTIONS

Arario Museum, Cheonan, Seoul, Korea
Art Gallery of New South Wales, Sydney,
Australia
Auckland Art Gallery Toi o Tāmaki,
New Zealand
Dunedin Public Art Gallery, New Zealand
Govett-Brewster Art Gallery,
New Plymouth, New Zealand
The Jim Barr and Mary Barr Collection,
Wellington, New Zealand
Musee du Quai Branly, Paris, France
Museum of New Zealand Te Papa
Tongarewa, Wellington, New Zealand
Queensland Art Gallery, Brisbane,
Australia
Saatchi & Saatchi Collection, Wellington,
New Zealand

JOHN **PULE**
B.1962, NIUE
Lives and works in Auckland, New Zealand

SELECTED SOLO EXHIBITIONS

2005 'John Pule', Galerie Römerapotheke,
Zurich, Switzerland
2004 'Niniko Lalolagi: Dazzling Worlds',
Gow Langsford Gallery, Auckland,
New Zealand
2003 'Recent Painting', Gow Langsford
Gallery, Sydney, Australia
'The Wind Reminds Me How
Palpable and Mythical My Life
Was Becoming', Bartley Nees
Gallery, Wellington, New Zealand
'New Lithographs and Etchings',
Paper Graphica Gallery,
Christchurch, New Zealand
2002 'I Had a Mind as Invisible as Light',
Gow Langsford Gallery, Auckland,
New Zealand
2001 'A Sequence of Lyrics Dedicated to
the Birth of a Lighthouse', Bartley
Nees Gallery, Wellington, New
Zealand
2000 'Fakaue Kia Koe Maui Pomare
(Thanks to you Maui Pomare)',
Gow Langsford Gallery, Auckland,
New Zealand
'People Get Ready', Auckland Art
Gallery Toi o Tāmaki, Auckland,
New Zealand
1999 New Works Studio, Wellington,
New Zealand
1998 'Savage Island', Djamu Gallery,
–99 Sydney, Australia
1998 Gow Langsford Gallery, Auckland,
New Zealand
1996 Gow Langsford Gallery , Auckland,
New Zealand
1995 'Malika', New Works Gallery,
Wellington, New Zealand

SELECTED GROUP EXHIBITIONS

2006 'Tribute', Auckland Art Gallery
Toi o Tāmaki, New Zealand
2005 'Te Moana Nui a Kiwa', Auckland Art
Gallery Toi o Tāmaki, New
Zealand
Jonathan Smart Gallery,
Christchurch, New Zealand
'Frieze', Gow Langsford Gallery,
Auckland, New Zealand
'Future Tense: Security and Human
Rights', DELL Gallery @ QCA,
Griffith University, Brisbane,
Australia
2004 'Paradise Now!', Asia Society,
New York, USA
'South Pacific Arts Festival', Palau
1998 'Wake Naima, Creating Together',
Centre Jean-Marie Tjibaou,
Nouméa, New Caledonia
1996 Second Asia–Pacific Triennial of
Contemporary Art, Brisbane,
Australia
'Seventh Festival of the South
Pacific', Samoa
'Re-imaging the Pacific', Australian
National University, Canberra,
Australia
1995 First Gwangju Biennale, Korea
Johannesburg Biennale, South Africa
'Bottled Ocean: Contemporary
Polynesian Artists', Auckland Art
Gallery Toi o Tāmaki, New Zealand

SELECTED PERFORMANCE & POETRY

2005 *Strata*, Auckland University
Poet's Corner on 'Artsville' (director,
Ian Mune)
2003 *Honouring Words 2003* Australia,
Indigenous writers tour
1998 *Ocean & Others Symposium*,
Museum of Sydney, Sydney
1998 *Raw Fishes*, The Physics Room,
Christchurch
1998 *The Bond of Time*, 2nd edition,
PWF, University of the South
Pacific
1996 *Re-imaging the Pacific*, Australia
National University, Canberra
1995 *The Post Colonial Body*, University
of Waikato
Bodies in Question Symposium,
University of Auckland
Interdigitate, Herald Theatre,
Aotea Centre

QUALIFICATIONS, GRANTS & AWARDS

2005 Roemerapotheke Art Residency,
Basel, Switzerland
2004 Laureate Award, Arts Foundation of
New Zealand
2003 Artist-in-Residence, Cultural
Museum, Rarotonga, Cook Islands
2002 Distinguished-Visiting Writer to
Department of English at
University of Hawai'i at Manoa,
Honolulu, USA
2000 Writer-in-Residence, Auckland
University (English Department),
New Zealand
1998 Artist-in-Residence, Oceania Centre
for Arts and Culture, University of
the South Pacific, Suva, Fiji
Artist-in-Residence, University of
Canterbury, Christchurch, New
Zealand
1997 Pacific Writers Fellow, University of
the South Pacific, Suva, Fiji
1996 Writer-in-Residence Fellowship,
University of Waikato, Hamilton,
New Zealand

COLLECTIONS

Auckland Art Gallery Toi o Tāmaki,
New Zealand
Auckland University, New Zealand
Fletcher Trust Challenge, Auckland,
New Zealand
Government of Niue
Manukau City Council, Auckland,
New Zealand
National Museum of Scotland, Edinburgh,
Scotland
Queensland Art Gallery, Brisbane,
Australia
Robert McDougall Art Gallery,
Christchurch, New Zealand
Museum of New Zealand Te Papa
Tongarewa, Wellington, New Zealand
Victoria University of Wellington Art
Collection, Wellington, New Zealand
Wallace Trust Collection, Auckland,
New Zealand
Wellington High Court, New Zealand

NUSRA LATIF **QURESHI**
B.1973, LAHORE, PAKISTAN
Lives and works in Melbourne, Australia

SELECTED SOLO EXHIBITIONS
2005 'Acts of Compliance', Studio Glass
 Gallery, London, UK
 'Intentions of Memory', Joshua
 McClelland Print Room,
 Melbourne, Australia
2004 'Exotic Bodies', Counihan Gallery,
 Melbourne, Australia
 'The Way I Remember Them', Smith
 College Museum of Art,
 Northampton, USA
2002 'Postcolonial Representation', Joshua
 McClelland Print Room,
 Melbourne, Australia
 'Altered Perceptions', Artholes
 Gallery, Melbourne, Australia
1999 Rohtas Gallery, Islamabad, Pakistan

SELECTED GROUP EXHIBITIONS
2006 'Common Destination', The Drawing
 Center, New York, USA
 'Beyond the Page', Manchester Art
 Gallery and Asia House, London,
 UK
 Croweaters Gallery, Lahore, Pakistan
 'Meeting Place Keeping Place',
 George Adams Gallery, The Arts
 Centre, Melbourne, Australia
 'Lila/Play: Contemporary Miniatures
 and New Art from South Asia',
 Span Galleries, Melbourne,
 Australia
 'Karkhana: A Contemporary
 Collaboration', Asian Art Museum,
 San Francisco, USA
2005 'A Thousand and One Days: The Art
 of Pakistani Women Miniaturists',
 Honolulu Academy of Arts,
 Hawai'i, USA
 'Karkhana: A Contemporary
 Collaboration', Aldrich
 Contemporary Art Museum,
 Ridgefield, USA
 Gallery Barry Keldoulis, Sydney,
 Australia
 'Beyond Borders: Art of Pakistan',
 National Gallery of Modern Art,
 Mumbai, India
 'Nusra Latif Qureshi and Naveen
 Haider', Canvas Art Gallery,
 Karachi, Pakistan
 'Rapt: AustralAsia Zero Five',
 Sherman Galleries, Sydney, Australia
2004 'Miniatures', Queensland Art Gallery,
 Brisbane, Australia
 'Contemporary Miniature Paintings
 from Pakistan', Fukuoka Asian Art
 Museum, Fukuoka, Japan
2003 'Contemporary Miniatures: India and
 Pakistan', Fine Art Resource,
 Berlin, Germany
 'Specifications of Desire', Janice
 Oresman Gallery, Smith College,
 Northampton, USA
2002 'Women's Salon', Counihan Gallery,
 Melbourne, Australia
 'Uraan', Amin Gulgee Gallery, Karachi,
 Pakistan
 'Interrogating Diversity', Betty Rymer
 Gallery, Art Institute of Chicago,
 USA; Pakistan; Australia
2001 'Khoj', Sakshi Gallery, New Delhi, India
 'Manoeuvring Miniatures:
 Contemporary Art from Pakistan',
 International Arts Centre, New
 Delhi and Sakshi Gallery, Mumbai,
 India

2000 'Miniature Painting at National
 College of Arts', Gallery NCA,
 Lahore, Pakistan
 'Pakistan, Another Vision', Brunei
 Gallery, London, and other
 venues, UK
1999 Rohtas Gallery, Islamabad, Pakistan
1997 Chawkandi Art Gallery, Karachi,
 Pakistan
 'Lahore Colours', Alhamra Art
 Galleries, Lahore, Pakistan
 'Contemporary Miniature Painting',
 Lahore Museum, Pakistan
 'Patterning: Artists from Australia +
 Pakistan', Asialink, Melbourne,
 Australia; Pakistan

QUALIFICATIONS, GRANTS & AWARDS
2006 New Work Grant, Australia Council
2005 Darebin La Trobe Acquisitive Art
 Prize for Emerging Artist
 Ian Potter Cultural Trust Travel Grant
 International Programs Grant, Arts
 Victoria
2004 Australia Council Kultour Grant for
 2005
2003 UNESCO residency at the 18th
 Street Arts Complex, Santa
 Monica, USA
2002 MFA, Victorian College of the Arts,
 University of Melbourne, Australia
1995 BFA, National College of Arts, Lahore,
 Pakistan

COLLECTIONS
Art Omi International Arts Center,
 New York, USA
Fukuoka Asian Art Museum, Japan
Honolulu Academy of Arts, Hawai'i, USA
Landfall Press, Chicago, USA
Moreland City Council, Melbourne,
 Australia
National Gallery of Victoria, Melbourne,
 Australia
Queensland Art Gallery, Brisbane,
 Australia
Smith College Museum of Art,
 Northampton, USA
The Victorian College of the Arts
 Collection, Melbourne, Australia

RASHID **RANA**
B.1968, LAHORE, PAKISTAN
Lives and works in Lahore

SELECTED SOLO EXHIBITIONS
2005 Philips Contemporary, Mumbai, India
2004 'Identical Views', VM Art Gallery,
 Karachi, Pakistan; India
2000 Rohtas Gallery, Islamabad, Pakistan

SELECTED GROUP EXHIBITIONS
2006 First Singapore Biennale, Singapore
2005 'Subodh Gupta, Rashid Rana & LN
 Tallur', Bose Pacia, New York, USA
 Third Fukuoka Asian Art Triennale,
 Japan
 'Across the Borders: Art from
 Pakistan', National Gallery of
 Modern Art, Mumbai, India
 'Mirror Worlds: Contemporary Video
 from Asia', Australian Centre for
 Photography, Sydney; Brisbane,
 Australia
2004 'Along the X Axis: Video Art from
 India and Pakistan', Apeejay
 Gallery, New Delhi, India
 Tenth Asian Art Biennale,
 Bangladesh

2003 Ninth Cairo International Biennale,
 Egypt
2002 'Painting over the Lines: Five
 Contemporary Artists from
 Pakistan', York Quay Gallery,
 Toronto, Canada; USA

QUALIFICATIONS, GRANTS & AWARDS
2003 Artist-in-Residence, Gasworks,
 London, UK

SANGEETA **SANDRASEGAR**
B.1977, BRISBANE, AUSTRALIA
Lives and works in Melbourne, Australia,
 and London, United Kingdom

SELECTED SOLO EXHIBITIONS
2006 'The Shadow of Murder Lay upon
 My Sleep . . .', Murray White
 Room, Melbourne, Australia
 'There is No Light . . .', Johnston
 Gallery, Perth, Australia
2004 'Peculiar to . . .', Mori Gallery, Sydney,
 Australia
2003 'Goddess of Flowers', Mori Gallery,
 Sydney, and other venues,
 Australia
2002 'That Happened Which Did Happen',
 Mori Gallery, Sydney, Australia
2001 'Room to Frieze', Mori Gallery,
 Sydney, and other venues,
 Australia
 'Lady White Snake', Lord Mori
 Gallery, Los Angeles, USA
2000 'Floating Worlds', Mori Gallery,
 Sydney, Australia
 'Shadows in the Lights', City Lights
 Inc., Melbourne, Australia

SELECTED GROUP EXHIBITIONS
2006 'Meeting Place, Keeping Place',
 George Adams Gallery Art Centre,
 Melbourne, Australia
 'Light and Shade', 24HR Art, Darwin,
 Australia
 'Lila/Play: Contemporary Miniatures
 and New Art from South Asia',
 Span Galleries, Melbourne,
 Australia
2005 'Asian Traffic', Gallery 4A, Sydney;
 Singapore; China
 'Christmas Show — 5 Artists', Mori
 Gallery, Sydney, Australia
2004 'Savvy: New Australian Art',
 Queensland University of
 Technology Art Museum,
 Brisbane, Australia
 'Primavera', Museum of
 Contemporary Art, Sydney,
 Australia
 'Miniatures', Queensland Art Gallery,
 Brisbane, Australia
 'Heavenly Creatures', Heidi Museum
 of Modern Art, Melbourne,
 Australia
 Second Auckland Triennial,
 New Zealand
 'Home/Ground: Scape Biennial,
 2004', Christchurch, New Zealand
2003 'Papercuts', Monash University
 Faculty Gallery, Melbourne,
 Australia
 'Tale Chaser', Gallery 4A, Sydney,
 Australia
 'A Third Place', SOFA Gallery,
 Christchurch, New Zealand
2002 'National Works on Paper Award',
 Mornington Peninsula Regional
 Gallery, Mornington, Australia

2000 'Techno Tots', Mori Gallery, Sydney,
 Australia
1999 'Adventures in Lip Lop Lap Land',
 Motorworks Gallery, Melbourne,
 Australia

QUALIFICATIONS, GRANTS & AWARDS
2005 Australia Council, Skills and Arts
 Development Individuals Grant
 Collex MCA Primavera Acquisitive
 Art Award
2000 PhD, Victorian College of the Arts,
–04 Melbourne, Australia
2003 Australia Council Milan
 Studio/Residency, Italy
2001 The Lucato Peace Prize, Victorian
 College of the Arts, Melbourne,
 Australia
2000 Freedman Foundation Traveling
 Scholarship for Emerging Artists
1999 Graduate Diploma in Visual Art,
 Victorian College of the Arts
 Post Graduate Prize — joint,
 Response to Derrida Exhibition,
 Victorian College of the Arts
1996 BFA (Painting), Victorian College of
–98 the Arts, Melbourne, Australia

COLLECTIONS
Queensland Art Gallery, Brisbane,
 Australia

KUMAR **SHAHANI**
B.1940, LARKANA, SIND (NOW PAKISTAN)
Lives and works in Mumbai, India

FILMOGRAPHY
2000 *The Bamboo Flute (Birah Bharyo
 Ghar Aangan Kone)*
1997 *Char Adhyay*
1991 *Bhavantarana (Immanence)*
1990 *Kasba*
1989 *A Ship Aground* (short)
1988 *Khayal Gatha (The Khayal Saga)*
1987 *Var Var Vari* (short)
1984 *Tarang*
1976 *Our Universe* (short)
1973 *Fire in the Belly*
1972 *Maya Darpan*
1971 *Object* (short)
1970 *Rails for the World* (short)
1969 *A Certain Childhood* (short)
1967 *Manmad Passenger* (short)
1966 *The Glass Pane* (short)

AWARDS & SCREENINGS
1991 Filmfare Award (Best Film)
1990 Filmfare Award (Best Film)
 FIPRESCI Award (International Film
 Festival, Rotterdam)
1988 Prince Claus Award
1972 Filmfare Award (Best Film)

COLLECTIONS
Queensland Art Gallery, Brisbane,
 Australia

TALVIN **SINGH**
B.1970, LONDON, UNITED KINGDOM
Lives and works in London, UK, and
New Delhi, India

SOLO RECORDINGS
2001 *Ha*, Universal Island Records
1998 *OK*, Island Records

COLLABORATIVE RECORDINGS & REMIXES
2004 *Songs for the Inner World*, Naïve
(with Sangat)
2002 *Vira*, Navras Records (with flautist
Rakesh Chaurasia)
Tala Matrix, Palm Pictures (with
Tabla Beat Science)
2001 *Remixsingh OK*, Island Records, UK
2000 *Back to Mine*, DMC World
Master Musicians of Jajouka,
Philips
Randall & Hopkirk (Deceased) —
Original soundtrack, Island Records,
UK
1997 *Star Rise — Nusrat Fateh Ali Khan
and Michael Brook: Remixed*,
Real World Records
*Anokha: Sounds of the Asian
Underground*, Island Records, UK
1995 *Calcutta Cyber Café: Drum +
Space*, Omni Records

AWARDS
1999 Mercury Music Prize, for *OK*

MICHAEL **STEVENSON**
B.1964, INGLEWOOD, NEW ZEALAND
Lives and works in Berlin, Germany

SELECTED SOLO EXHIBITIONS
2006 'Tropical Economies', Capp Street
Project, Wattis Institute of
Contemporary Arts, CCA, San
Francisco, USA
2005 'Art of the Eighties and Seventies',
Stadliches Museum Abteiberg,
Monchengladbach, Germany
'Making for Sheppey', Lismore
Regional Gallery, Lismore, Australia
'The Gift: The Form and Reason for
Exchange in Archaic Societies',
Neuer Aachener Kunstverein,
Aachen, Germany
'The Smiles Are Not Smiles', Vilma
Gold, London, UK
'Die Aufteilung Michael Stevenson',
ceremony, Neuer Aachener
Kunstverein, Aachen, Germany
2004 'Argonauts of the Timor Sea'
(in association with the Two20
Collection and the NAK, Aachen,
Germany), Darren Knight Gallery,
Sydney, Australia
'Keim', (with Cornelia Schmidt-Bleek)
Galerie Kamm, Berlin, Germany
'Rakit', Herbert Read Gallery, Kent
Institute of Art & Design,
Canterbury, UK
2003 50th Venice Biennale, Italy
'International Studio Programme',
Künstlerhaus Galleries,
Künstlerhaus Bethanien, Berlin,
Germany
'This is the Hand', Hamish McKay
Gallery, Wellington, New Zealand
2002 'To Our German Friend', Vilma Gold,
London, UK

2001 'Immendorff in Wellington', Hamish
McKay Gallery, Wellington,
New Zealand
2000 'Call Me Immendorff', Gallerie
–01 Kapinos, Berlin, Germany
2000 'Separated at Birth/Daily Practice',
Lombard/Freid Fine Arts, New
York, USA
1999 'Slave Pianos', Lovers, Melbourne;
Darren Knight Gallery, Sydney,
Australia*
'Slave Pianos!! Emancipate the
Dissonance!', Lombard/Freid Fine
Arts, New York, USA*
1998 'The Gift of Critical Insight',
Lombard/Freid Fine Arts, New
York, USA
1997 'Let Those Who Ride Decide', The
Physics Room, Christchurch,
New Zealand
1996 'Screen Options', Australian Centre
for Photography, Sydney,
Australia
1995 Hamish McKay Gallery, Wellington,
New Zealand
Darren Knight Gallery, Melbourne,
Australia
Teststrip, Auckland, New Zealand

SELECTED GROUP EXHIBITIONS
2006 Kunstbank (with Iris Kettner), Berlin,
Germany
2005 'Small World Big Town:
Contemporary Art from Te Papa',
City Gallery Wellington Te Whare
Toi, Wellington, New Zealand
'Saltuna', Rooseum, Malmo, Sweden
'Monuments for the USA', Wattis
Institute of Contemporary Arts,
CCA, San Francisco, and other
venues, USA
2004 'Berlin North', Hamburger Bahnhof,
Berlin, Germany
'Kurzdavordanach', Photography
Collection, SK Stiftung Kultur,
Cologne, Germany
2003 'Home Sweet Home: Works from the
Peter Fay Collection', National
Gallery of Australia touring
exhibition, Canberra, Australia
'Nine Lives', Chartwell exhibition,
Auckland Art Gallery Toi o Tāmaki,
Auckland, New Zealand
2002 Biennale of Sydney, Australia
'Prophets of Doom', Kunsthalle
Baden-Baden, Germany
'The Walters Prize', Auckland Art
Gallery Toi o Tāmaki, Auckland,
New Zealand
'Profiler', Kunstlerhaus Bethanien,
Berlin, Germany; Govett-Brewster
Art Gallery, New Plymouth,
New Zealand
2001 'Audit', Casino Luxembourg — Forum
d'art Contemporain, Luxembourg
'The Broccoli Maestro' and 'The
Strange Voyage of Bas Jan Ader',
Chamber Operas by Slave
Pianos, Neuer Aachener
Kunstverein, Aachen and
Malkasten, Dusseldorf, Germany*
'Superman in Bed', Kunst Der
Gegenwart und Fotografie
Sammlung Shürmann, Museum
am Ostwall Dortmund, Germany
2000 'Slave Pianos Internationale Biennale
2000: Songs of Life', Royal
Melbourne Institute of
Technology Gallery, and other
venues, Melbourne, Australia*

'Genealogy' (with Steven Brower),
Govett-Brewster Art Gallery,
New Plymouth, New Zealand
'Non-Objective Brass', Slave Pianos
with the Burley Griffin Brass
Band, National Galley of Australia,
Canberra, Australia*
'Circles ∞ 3', Zentrum fur Kunst und
Medientechnologie, Karlsruhe,
Germany
'Slave Pianos', Fourth Sergey
Kuryokhin Festival, Leningrad
Palace of Youth, St Petersburg,
Russia*
'Rent', Overgaden, Copenhagen,
Denmark
1999 'What Your Children Should Know
about Conceptualism', (with
Danius Kesminas), Neuer
Aachener Kunstverein and
Brandenburgischer Kunstverein,
Potsdam, Germany
'Toi, Toi, Toi, Three Generations of
Artists' (with Danius Kesminas),
Museum Fridericianum, Kassel
1998 'Ground Control', Lombard-Freid Fine
Arts, New York, USA
'Entropy at Home', Neue Gallerie,
Ludwig Museum, Aachen,
Germany
1997 'Pre Millennial' (with Ronnie van
–99 Hout); Contemporary Art Centre
of South Australia, Adelaide, and
other venues, Australia; New
Zealand
1997 'Seppelt Contemporary Art Award
–98 1997', Museum of Contemporary
Art, Sydney, Australia
1997 'Selections Fall '97', The Drawing
Centre, New York, USA
'Power, Corruption and Lies', Institute
of Modern Art, Brisbane, Australia
'Multiplication: The Multiple Object in
Art', Monash University Gallery,
Melbourne, Australia
1996 Adelaide Biennial of Australian Art,
Australia
1995 'Hangover', Waikato Museum of Art
–96 and History Te Whare Taonga o
Waikato, Hamilton, and other
venues, New Zealand
1995 'A Very Peculiar Practice', City
Gallery Wellington Te Whare Toi,
Wellington, New Zealand

* 'Slave Pianos' is a collaborative art and
music project with Michael Stevenson,
Danius Kesminas, Neil Kelly and Rohan
Drape

QUALIFICATIONS, GRANTS & AWARDS
2002 Künstlerhaus Bethanien Studio
Residency, Creative New Zealand,
Arts Council of New Zealand Toi
Aotearoa
1999 Greene Street Studio, New York,
USA, Australia Council for the Arts
1995 Fellowship grant, Creative New
Zealand, Arts Council of
New Zealand Toi Aotearoa
1991 Research grant, Queen Elizabeth II,
Arts Council of New Zealand Toi
Aotearoa
1990 Queen Elizabeth II, Arts Council of
New Zealand Toi Aotearoa

COLLECTIONS
Art Gallery of New South Wales, Sydney,
Australia
Art Gallery of South Australia, Adelaide,
Australia

Art Gallery of Western Australia, Perth,
Australia
Auckland Art Gallery Toi o Tāmaki,
New Zealand
Chartwell Collection, Auckland,
New Zealand
Dunedin Public Art Gallery, New Zealand
Govett-Brewster Art Gallery,
New Plymouth, New Zealand
Manawatu Art Gallery Te Manawa,
Palmerston North, New Zealand
Museum of New Zealand Te Papa
Tongarewa, Wellington, New Zealand
National Gallery of Australia, Canberra,
Australia
Queensland Art Gallery, Brisbane,
Australia

MASAMI **TERAOKA**
B.1936, ONOMICHI, JAPAN
Lives and works in Hawai'i, USA

SELECTED SOLO EXHIBITIONS
2006 'Masami Teraoka: Cloisters Workout',
Catharine Clark Gallery, San
Francisco, USA
'Rebels and Renegades', Jordan
Schnitzer Museum of Art,
University of Oregon, Eugene,
USA
2004 'Perils and Pleasures: Tales from
Masami Teraoka, 1976–2003',
Carleton College Art Gallery,
Northfield, USA
'Masami Teraoka: Early Works', Sarah
Lee Artworks & Projects, Santa
Monica, USA
'Masami Teraoka: New Work',
McKinney Avenue Contemporary,
Dallas, USA
'Works on Paper', Carleton College,
Northfield, USA
2003 'US Inquisition', Catharine Clark
Gallery, San Francisco, USA
2002 'Works on Paper 1972–2002',
Catharine Clark Gallery, San
Francisco, USA
2000 'Tower of Babel', Pamela Auchincloss
Gallery, New York, and other
venues, USA
1999 'Masami Teraoka: Web of
Confession', University of Oregon
Museum of Art, Eugene, USA
1998 'Masami Teraoka: From Tradition to
Technology — The Floating World
Comes of Age', Mitaka City
Gallery of Art, Japan; USA
1997 'Paintings by Masami Teraoka', Asian
Art Museum, San Francisco, USA
1996 'Paintings by Masami Teraoka',
Arthur M Sackler Gallery,
Smithsonian Institution,
Washington DC, USA
1995 Hui No'eau Visual Arts Center, Maui,
USA

SELECTED GROUP EXHIBITIONS
2006 'Conflict and Art', Iris & B Gerald
Cantor Center for Visual Arts,
Stanford, USA
'Otis LA Nine Decades of Los
Angeles Art', Los Angeles
Municipal Art Gallery, Los
Angeles, USA
'Reconstructing Memories',
University of Hawai'i Art Gallery,
Honolulu, USA
'Reflections of Beauty: Women from
Japan's Floating World', Pacific
Asia Museum, Pasadena, USA

'Visual Politics: The Art of Engagement', San Jose Museum of Art, San Jose, and other venues, USA
2005 'Art and Interiors', TAMA Gallery, New York, USA
'Bodyworks', de Young Museum, San Francisco, USA
'No Name Fever: HIV/AIDS in the Age of Globalization', Museum of World Culture, Göteborg, Sweden
'Here Comes the Bogey-Man', Chelsea Art Museum, New York, USA
'Selected Works from the Collection', Gallery of Modern Art, Glasgow, Scotland
2004 'Finesse', Catharine Clark Gallery, San Francisco, USA
'This and That at the Mac, 9-11', McKinney Avenue Contemporary, Dallas, USA
2003 'Annual Nikakai', Tokyo Metropolitan Art Museum, Tokyo, Japan
'Asian Galleries: A New Light on Asian Art', Art Gallery of New South Wales, Sydney, Australia
'Gyroscope', Hirshhorn Museum and Sculpture Garden, Washington DC, USA
2001 Fifth Biennial of Hawai'i Artists, Honolulu, USA
2000 'Made in California', Los Angeles County Museum of Art, Los Angeles, USA
1996 The Glasgow Museum, Glasgow, Scotland
1995 San Francisco Museum of Modern Art, San Francisco, USA
Walker Art Center, Minneapolis, USA

COLLECTIONS
de Young Museum, San Francisco, USA
Los Angeles County Museum of Art, USA
Metropolitan Museum of Art, New York, USA
National Gallery of Australia, Canberra, Australia
Queensland Art Gallery, Brisbane, Australia
San Francisco Fine Arts Museum, USA
Smithsonian Institute, Washington DC, USA
Walker Art Center, Minneapolis, USA

YUKEN **TERUYA**
B.1973, OKINAWA, JAPAN
Lives and works in New York, USA

SELECTED SOLO EXHIBITIONS
2006 'Waterborne Islands', Asahi Art Collaboration, Sumida Riverside Hall Gallery, Tokyo, Japan
2005 'Yuken Teruya: 'Notice Forest', Kunstverein, Wiesbaden, Germany
'Forest Inc.', Josee Bienvenu Gallery, New York, USA
2004 'Yuken Teruya: 'Notice Forest', Diverse Works Art Space, Houston, USA
'Yuken Teruya: Paperbags and New Works', Voges and Partner Gallery, Frankfurt, Germany
2003 'Yuken Teruya', Murata and Friends Gallery, Berlin, Germany
Elizabeth Leach Gallery, Portland, USA
2002 Shoshana Wayne Gallery, Santa Monica, USA

'Yuken Teruya: Arboretum', KS Art, New York, USA
'Yuken Teruya: 2002 Aldrich Emerging Artist Award Recipient', The Aldrich Museum of Contemporary Arts, Ridgefield, USA

SELECTED GROUP EXHIBITIONS
2006 Twelfth Asian Art Biennale, Bangladesh
'Rapt!', Object Galley, Sydney; Gertrude Contemporary Art Space, Melbourne, Australia
2005 'Material Matter', Cornell University, New York, USA
'Which Way the Tomorrow Is?', Ota Fine Arts, Tokyo, Japan
'Greater New York', PS1, Contemporary Art Center, New York, USA
Yokohama International Triennale of Contemporary Art, Japan
2004 'Dessins et des autres', Galerie Anne De Villepoix, Paris, France; Belgium
Fuchu Biennale, Tokyo, Japan
'Refrain; Korean, Balkan, Okinawa', Total Museum of Contemporary Art, Seoul, Korea
2003 'Internal Excess: Selections Fall 2003', The Drawing Center, New York, USA
2002 'VOCA: Vision of Contemporary Artists', Ueno Royal Museum, Tokyo, Japan
'Model World', The Aldrich Museum of Contemporary Arts, Ridgefield, USA
2001 'Young Horses', The Jam Factory, London, UK

QUALIFICATIONS, GRANTS & AWARDS
2005 New York Foundation for the Arts fellowship — Lily Auchincloss Fellow
2002 Vision of Contemporary Artists, Tokyo, Japan
Emerging Artist Award, The Aldrich Museum of Contemporary Arts, Ridgefield, USA
2001 Skowhegan School of Painting and Sculpture Fellowship, Skowhegan, USA
MFA, School of Visual Arts, New York, USA
1999 Post Baccalaureate, Maryland Institute College of Art
1996 BFA, Tama Art University, Tokyo, Japan

COLLECTIONS
Altoids Collection, New Museum, New York, USA
Charles Saatchi Collection, London, UK
Hoffman Collection, Berlin, Germany
Museum of Modern Art, New York, USA
Norton Collection, New York, USA
Sakima Art Museum, Okinawa, Japan
Solomon R Guggenheim Museum, New York, USA
Twigg Smith Collection, Hawai'i, USA

.

SIMA **URALE**
B.1969, SAVAI'I, SAMOA
Lives and works in Wellington, New Zealand

FILMOGRAPHY
2003 *Hip Hop New Zealand* (documentary)
2001 *Still Life* (short)
2000 *Reverse Resistance* (music video for King Kapisi)
Ko Wai Ka Hua (music video for Toni Huata)
1999 *Better than Change* (music video for Dallas)
1997 *Velvet Dreams* (documentary)
Sub-Cranium Feeling (music video for King Kapisi)
1996 *O Tamaiti* (short)
1994 *Burning Moths* (short)

SELECTED GROUP EXHIBITIONS
2004 'How We Live', Queensland Art Gallery, Brisbane, Australia

AWARDS
2004 Fulbright–Creative New Zealand Pacific Writers Residency at the University of Hawai'i, USA
2001 *Still Life*, Best Short Film, Montreal Film Festival, Canada
1997 *Velvet Dreams*, Best Documentary, Yorkton Film Festival, Canada
1997 *Sub-cranium Feeling* Best Music Video at the BFM, Mai Time and Flying Fish Awards
1996 *O Tamaiti*, Silver Lion, Best Short Film, Venice Film Festival, Italy
1996 *O Tamaiti*, Best Short Film, New Zealand Film Awards

COLLECTIONS
Queensland Art Gallery, Brisbane, Australia

VIỆT LINH
B.1952, HO CHI MINH CITY, VIETNAM
Lives and works in Ho Chi Minh City

FILMOGRAPHY
2002 *Me Thao, Once upon a Time (Mê Thảo, Thời Vang Bóng)*
1999 *Collective Flat (Chung Cư)*
1992 *Devil's Mark (Dấu Ấn Của Quỷ)*
1989 *A Stolen Life (Một Chộc Đời Bị Dánh Cắp)*
1988 *Travelling Circus (Gánh Xiếc Rong)*
1987 *Judgement Needs a Judge (Phiên Tòa Cần Chánh Án)*
1986 *Where Peace Reigns, the Birds Sing (Nơi Bình Yên Chim Hót)*

AWARDS
Me Thao, Once upon a Time (Mê Thảo, Thời Vang Bóng)
2003 Golden Rosa Camuna Award, 21st Bergamo Film Meeting, Italy
2003 Second Prize, Bourse International Promotion, Francophonie Agence
2002 Semaine du Film de Femmes, Tokyo International Film Festival

Collective Flat (Chung Cư)
2000 Silver Screen Award, Singapore International Film Festival (Nominated)
1999 ACCT Promotional Award for a Southern Film, Namur International Film Festival, Belgium

1999 Special Jury Prize, Vietnamese Film Festival
1999 Golden Bayard Award, Namur International Film Festival (Nominated)
1999 Golden St. George, Moscow International Film Festival (Nominated)

Devil's Mark (Dấu Ấn Của Quỷ)
1993 Special Jury Prize, Vietnamese Film Festival
1993 Direction Award, 38th Asia–Pacific Film Festival, Japan
1992 Special Prize, 38th Asia–Pacific Film Festival, Japan

Travelling Circus (Gánh Xiếc Rong)
1993 Special Mention, Laon International Film Festival for Young People, France
1992 Distribution Help Award, Fribourg International Film Festival, Switzerland
1992 Grand Prix, Fribourg International Film Festival, Switzerland
1991 Best Film, Madrid's Women Film Festival, Spain
1991 Audience Award, Uppsala International Film Festival, Sweden
1991 Public Prize for Film for Children, Uppsala International Film Festival, Sweden
1991 Special Mention, UNICEF Jury, Berlin International Film Festival
1991 Best Film, Vietnamese Film Festival
1991 Best Director, Vietnamese Film Festival

Judgement Needs a Judge (Phiên Tòa Cần Chánh Án)
1988 Special Jury Prize, Vietnamese Film Festival

GORDON **WALTERS**
1919–95, WELLINGTON, NEW ZEALAND
Lived and worked in Christchurch, New Zealand

SELECTED SOLO EXHIBITIONS
1994 'Parallel Lines: Gordon Walters in Context', Auckland Art Gallery Toi o Tāmaki, Auckland, New Zealand
1983 'Gordon Walters: A Retrospective Exhibition', Auckland Art Gallery Toi o Tāmaki, Auckland, and touring New Zealand

SELECTED GROUP EXHIBITIONS
2004 'Representation and Reaction: Modernism and the New Zealand Landscape Tradition, 1956–1977', Auckland Art Gallery Toi o Tāmaki, Auckland, New Zealand
'Gordon Walters: Prints and Design', Adam Art Gallery Te Pātaka Toi, Wellington, New Zealand
2003 'Past Presents', Museum of New Zealand Te Papa Tongarewa, Wellington, New Zealand
2000 John Leech: Gow Langsford Gallery, Auckland, New Zealand
'Parihaka: The Art of Passive Resistance', City Gallery Wellington Te Whare Toi, Wellington, New Zealand
1999 'Home & Away', Auckland Art Gallery Toi o Tāmaki, Auckland, New Zealand

'Manufacturing Meaning: The Victoria University of Wellington Art Collection in Context', Adam Art Gallery Te Pātaka Toi, Wellington, New Zealand

1998 'The Dream Collectors: 100 Years of Art in New Zealand', Museum of New Zealand Te Papa Tongarewa, Wellington, and other venues, New Zealand

SELECTED COLLECTIONS

Auckland Art Gallery Toi o Tāmaki, New Zealand

Jennifer Gibbs Trust, New Zealand

Museum of New Zealand Te Papa Tongarewa, Wellington, New Zealand

APICHATPONG WEERASETHAKUL

B.1970, BANGKOK, THAILAND
Lives and works in Bangkok

FILMOGRAPHY

2006 *Syndromes and a Century (Sang Sattawat)*
The Anthem (short)
Luminous People (short)

2005 *Ghost of Asia* (short)
Worldly Desires (short)

2004 *Tropical Malady (Sud Pralad)*

2003 *The Adventure of Iron Pussy (Huajai Toranong)* (co-directed with Michael Shaowanasai)
This and a million more lights (short)
Nokia Short (short)

2002 *Blissfully Yours (Sud Sanaeha)*
Second Love in Hong Kong (collaboration with Christelle Lheureux)

2001 *Haunted Houses (Thai Version)*

2000 *Boys at Noon* (short)
Mysterious Object at Noon (Dogfar Nai Meu Marn) (documentary)

1999 *Malee and the Boy* (short)
Windows (short)

1997 *thirdworld* (short)

1995 *Like the Relentless Fury of the Pounding Waves* (short)

1994 *0116643225059* (short)

AWARDS & SCREENINGS

Syndromes and a Century (Sang Sattawat)

2006 In competition, Venice Film Festival

Tropical Malady (Sud Pralad)

2005 Best Film, The International Gay & Lesbian Film Festival, Turin, Italy
Special Jury Prize, The International Gay & Lesbian Film Festival, Turin, Italy
Special Jury Prize, Singapore International Film Festival, Singapore
Special Jury Prize, Indianapolis International Film Festival, USA

2004 Prix du Jury, Cannes Film Festival, France
Age d'Or Prize, Cinédécouvertes, Belgium
Grand Prize, Tokyo Filmex, Japan
Critics Award, São Paulo International Film Festival, Brazil

Blissfully Yours (Sud Sanaeha)

2004 Best International Film Award, Images Festival, Canada

2003 The Circle of Dutch Film Critics (KNF) Award, Rotterdam International Film Festival
The International Critics Award (FIPRESCI Prize), Buenos Aires Film Festival
Silver Screen Award: Young Cinema Award, Singapore International Film Festival

2002 Le Prix Un Certain Regard, Cannes Film Festival, France
Golden Alexander Award, Best Film, Thessaloniki Film Festival, Greece
Grand Prize, Tokyo Filmex, Japan

Mysterious Object at Noon (Dogfar Nai Meu Marn)

2001 Runner Up Award, Yamagata International Documentary Film Festival, Japan
NETPAC Special Mention Prize, Yamagata International Documentary Film Festival
Grand Prix, Woosuk Award, JeonJu International Film Festival, Korea

2000 Special Citation, 'Dragons & Tigers', Vancouver International Film Festival, Canada

SELECTED GROUP EXHIBITIONS

2006 'Faith', Liverpool Biennial, UK
'Waterfall', Cinematic Art Gallery, Vila do Conde, Portugal, Spain
'Grey Flags', Sculpture Center, New York, USA

2005 T1-Turin Triennial Threemuseums, Turin, Italy
KunstenFESTIVALdesArts, Brussels, Belgium

2004 Taipei Biennial, Taiwan
'SENI Singapore 2004: Art and the Contemporary', Singapore Art Museum
Busan Biennale, Korea
'Videotraffic', ArtSonje, Seoul, Korea

2003 'Under Construction: New Dimensions of Asian Art', Tokyo Opera City Art Gallery, Japan

2001 Seventh Istanbul Biennale, Turkey

YANG FUDONG

B.1971, BEIJING, CHINA
Lives and works in Shanghai, China

FILMOGRAPHY

2006 *Seven Intellectuals in Bamboo Forest (Zhu Lin Qi Xian), Part 3* (short)

2004 *Seven Intellectuals in Bamboo Forest (Zhu Lin Qi Xian), Part 2* (short)

2003 *Seven Intellectuals in Bamboo Forest (Zhu Lin Qi Xian), Part 1* (short)
Liu Lan (short)

2002 *An Estranged Paradise (Mo Sheng Tian Tang)*

2001 *Backyard — Hey! Sun is Rising (Hou Fang, Hei, Tian Liang Le)* (short)

SELECTED SOLO EXHIBITIONS

2005 'Yang Fudong', Castello di Rivoli, Rivoli, Italy
'Don't Worry, It Will be Better . . .' Kunsthalle Wien, Vienna, Austria

Marian Goodman Gallery, Paris, France
'Yang Fudong', Stedelijk Museum, Amsterdam, the Netherlands

2004 '5 Films', The Renaissance Society, University of Chicago, USA
'Recent Works', Roy and Etna Disney Cal Arts Theater, Los Angeles, USA
Marian Goodman Gallery, Paris, France
'Breeze', Galerie Judin Belot, Zurich, Switzerland
'Drei Filme', Gesellschaft für Aktuelle Kunst, Bremen, Germany
Galleria Raucci Santamaria, Naples, Italy
Sketch Gallery, London, UK

2003 '"Seven Intellectuals in Bamboo Forest" and Selected Works on Video', The Moore Space, Miami, Florida, USA

SELECTED GROUP EXHIBITIONS

2005 Sharjah International Biennale 7, United Arab Emirates
Third Fukuoka Asian Art Triennale, Japan
'The Wall: Reshaping Contemporary Chinese Art', Albright-Knox Art Gallery & University and Buffalo Art Galleries, Buffalo, USA; China
'Follow Me! Contemporary Chinese Art at the Threshold of the Millennium', Mori Art Museum, Tokyo, Japan
'Le Invasioni Barbariche', Galleria Continua, San Gimignano, Italy
First Moscow Biennale of Contemporary Art, Russia
'Shanghai Constructions', Shanghai Gallery of Art, Shanghai, China

2004 'Past in Reverse: Contemporary Art of East Asia', San Diego Museum of Art, San Diego, USA
'Camera', National Museum of Contemporary Art, Bucharest, Romania
'Dreaming of the Dragon's Nation: Contemporary Art from China', Irish Museum of Modern Art, Dublin, Ireland
Taipei Biennale, Taiwan
Fifth Shanghai Biennale, China
'Time Zones: Recent Film and Video', Tate Modern, London, UK
'Carnegie International', Carnegie Museum of Art, Pittsburgh, USA
'Encounters in the 21st Century: Polyphony — Emerging Resonances', 21st Century Museum of Contemporary Art, Kanazawa, Japan
'3', Schirn Kunsthalle, Frankfurt, Germany
Liverpool Biennial, UK
'Light as Fuck! Shanghai Assemblage 2000–2004', National Museum of Contemporary Art, Oslo, Norway
'Slow Rushes', SMC.CAC Contemporary Art Centre, Vilnius, Lithuania
Busan Biennale, Korea
'The Logbook: An Art-Project about Communication and Cultural Exchange', Long March Foundation, Beijing, China

'Le Moine et le Démon: Contemporary Chinese Art', Museum of Contemporary Art, Lyon, France
Biennial of Contemporary African Art, Dakar, Senegal
'Between Past and Future: New Photography and Video from China', International Center of Photography; Asia Society, New York, and other venues, USA; Germany
'China Now', MoMA Film at the Gramercy Theatre, New York, USA
'Out the Window: Spaces of Distraction', The Japan Foundation Forum, Asia Center, Tokyo, Japan

2003 'Happiness: A Survival Guide for Art and Life', Mori Art Museum, Tokyo, Japan
'Avicon (Asia Videoart Conference Tokyo)', Videoart Center Tokyo, Japan
'Alternative Modernity: An Exhibition of Chinese Contemporary Art', Beijing X-Ray Art Center, Beijing, China
'Zooming into Focus: Chinese Contemporary Photography and Video from the Haudenschild Collection', San Diego State University, and other venues, USA; China
'New Zone Chinese Art', Zachęta National Gallery of Art, Warsaw, Poland
'Cine casi Cine 2003', Museo Nacional Centro de Arte Reina Sofia, Madrid, Spain
Prague Biennale 1, Czech Republic
50th Venice Biennale, Italy
'Alors la Chine?', Centre Pompidou, Paris, France

2002 Fourth Shanghai Biennale, China
First Guangzhou Triennial, China
'Paris–Pekin', Espace Pierre Cardin, Paris, France
'Documenta 11', Kassel, Germany

2001 First Valencia Biennial, Spain
'Living in Time: Contemporary Artists form China', Hamburger Bahnhof, Berlin, Germany
Yokohama International Triennale of Contemporary Art, Japan
Seventh Istanbul Biennale, Turkey
'ARCO, Asian Party, Global Game', Madrid, Spain

2000 'Useful Life', Temporary Space, Shanghai, China
'Uncooperative Approach, (Fuck Off)', Eastlink, Shanghai, China
'Presence and Place', Multimedia Art Asia–Pacific Festival, Powerhouse, Brisbane, Australia

1999 'CityZoom', Hanover Film Festival, Germany
'Post-sense Sensibility: Alien Bodies & Delusion', Shao Yao Ju, Beijing, China

QUALIFICATIONS, GRANTS & AWARDS

1995 Graduated from China Academy of Fine Arts, Hangzhou

COLLECTIONS

Museum of Modern Art, New York, USA
Queensland Art Gallery, Brisbane, Australia

YANG ZHENZHONG

B.1968, XIASHAN, GUANGDONG
PROVINCE, CHINA
Lives and works in Shanghai, China

SELECTED SOLO EXHIBITIONS

2002 'Light as Fuck', Bizart, Shanghai,
China
2001 'I Will Die', Brussels, Belgium
1998 'Jiangnan: Yang Zhenzhong', Access
Gallery, Vancouver, Canada

SELECTED GROUP EXHIBITIONS

2005 'Follow Me! Contemporary Chinese
Art at the Threshold of the
Millennium', Mori Art Museum,
Tokyo, Japan
'Biennale! Artist Film and Video',
temporarycontemporary, London,
UK
2004 'China Now', MoMA film at the
Gramercy Theatre, New York, USA
'Chine: Generation Video', Maison
Européene de la Photographie,
Paris, France
'The Logbook: An Art-Project about
Communication and Cultural
Exchange', Long March
Foundation, Beijing, China
'Between Past and Future: New
Photography and Video from
China', International Center of
Photography; Asia Society,
New York, and other venues,
USA; Germany
'Light as Fuck! Shanghai
Assemblage 2000–2004',
National Museum of Art, Oslo,
Norway
'Concrete Horizons: Contemporary
Art from China', Adam Art Gallery
Te Pātaka Toi, Wellington,
New Zealand
'At the Still Point of the Turning
World', Foundation for Art and
Creative Technology Centre,
Liverpool, UK
2003 Prague Biennale 1, Czech Republic
'Under Construction: New
Dimensions of Asian Art', Tokyo
Opera City Art Gallery, Tokyo,
Japan
'OK Video: Jakarta Video Festival
2003', Jakarta, Indonesia
'City_Net Asia 2003', Seoul
Museum of Art, Seoul, Korea
'Zooming into Focus: Chinese
Contemporary Photography and
Video from the Haudenschild
Collection', San Diego State
University, and other venues,
USA; China
'The Skyline at Work', New York, USA
Second Echigo-Tsumari Art Triennial,
Japan
'Alors la Chine?', Centre Pompidou,
Paris, France
50th Venice Biennale, Italy
2002 'Under Construction: New
Dimensions of Asian Art', The
Japan Foundation Asia Centre;
Tokyo Opera City Art Gallery,
Tokyo, Japan
First Guangzhou Triennial, China
Fourth Shanghai Biennale, China
Fourth Gwangju Biennale, Korea
'Art in General', 4th Annual Video
Marathon, New York, USA
2001 First Valencia Biennial, Spain
2000 'BIG Torino 2000', Torino, Italy

1997 'Chinese Video and Photography',
Max Protetch Gallery, New York,
USA
'Contemporary Photo Art from
China', NBK, Berlin, and other
venues, Germany; USA
'Demonstration of Video Art '97',
The Central Academy of Fine Arts
Gallery, Beijing, China
1996 'Phonema and Image: '96 Video Art',
Hangzhou, China

QUALIFICATIONS, GRANTS & AWARDS

1990 Graduated from the Fashion Design
Department of the Zhejiang
Institute of Silk Textile
1993 Studied in the Oil Painting
Department of the Zhejiang
Academy of Fine Arts

COLLECTIONS

Queensland Art Gallery, Brisbane,
Australia

YOO SEUNG-HO

B.1973, SUHCHEON, CHOONGNAM
PROVINCE, KOREA
Lives and works in Seoul, Korea

SELECTED SOLO EXHIBITIONS

2005 'Echowords', One and J Gallery,
Seoul, Korea
2003 'Echowords', Gallery Doll, Seoul,
Korea
'Echowords', Moran Gallery, Seoul,
Korea
2000 'Echowords', Seo-Nam Art Center,
Seoul, Korea
1999 'Hee Hee Hee', Gallery Jo, Seoul,
Korea

SELECTED GROUP EXHIBITIONS

2005 'First Peak (Young Artists from
Korea)', Entenhalle (Blaue Ente
Restaurant), Zürich, Switzerland
'The Elegance of Silence', Mori Art
Museum, Tokyo, Japan
'Sounding Around the 38N:
Contemporary Art from North
and South Korea', Canvas
International Art Gallery,
Amstelveen, Netherlands
'Nano in Young Artist, LOOP',
Ssamzie Gallery, Seoul, Korea
'Looking Both Ways: Three Artists
from Korea', Bard College,
New York, USA
2004 'Officina Asia', Galleria d'Arte
Moderna, Bologna, Italy
'Art Chicago 2004', Chicago, USA
'CIGE2004' China International
Gallery Exposition, Beijing, China
'The Idiots', Project Space Sarubia-
Dabang, Seoul, Korea
2003 'Tric', Dongduck Art Gallery, Seoul,
Korea
'Art and Playing', Hangaram Art
Museum of Seoul Arts Center,
Seoul, Korea
'New Frontier Exhibition', Daegu
Culture and Arts Center, Daegu,
Korea
'Comics in Art, Art in Comics', Ewha
Women's University Museum,
Seoul, Korea
2002 Fourth Gwangju Biennale, Korea
'Image, Text, Typo', Pusan Municipal
Museum of Art, Pusan, Korea

'BABEL2002', National Museum of
Contemporary Art, Kwachon,
Korea
'Living Furniture', supplement space
STONE & WATER, Anyang, Korea
'Self Portrait', Gallery Wooduk, Seoul,
Korea
2001 '2D to 3D', Cho-Sun Gallery, Seoul,
Korea
'Ssamzie Site-specific: Crossing
Parallels Between', Ssamzie
Space Gallery, Seoul, Korea; USA
'Photographs & Contemorary Art',
Seoul Auction, Seoul, Korea
'Get Scattered', Korean Culture and
Art Center, Seoul, Korea
2000 'Currents in Korean Contemporary
Art', Taipei Fine Arts Museum,
Taiwan; Hong Kong
'Young Korean Artists Exhibition
2000: Towards the New
Millennium', National Museum of
Contemporary Art, Kwachon,
Korea
'Line & Dot', Hyundai Art Center
Gallery, Woolsan, Korea
1999 'The State of 1990s Korean
Contemporary Art', Allen Kim
Murphy Gallery, Seoul, Korea
'Beyond Landscape', ArtSonje
Center, Seoul, Korea
'A Relay', Artist Kang Aeran Studio,
Seoul, Korea
1998 'Cross Point', Ye-Mek Gallery, Seoul,
Korea
'Kongsan Art Festival', Dong-Ah
Gallery, Seoul, Korea

QUALIFICATIONS, GRANTS & AWARDS

2003 The 22nd Suk Nam Arts Prize, Seoul,
Korea
1999 BFA, Han-Sung University, Seoul,
Korea
1998 Excellency Reward at the Fifth
Kongsan Art Festival, Seoul, Korea

SPONSORS

FOUNDING SUPPORTER

QUEENSLAND GOVERNMENT
The Honourable Peter Beattie, MP,
 Premier of Queensland
The Honourable Rod Welford, MP,
 Minister for Education and Training and
 Minister for the Arts

PRINCIPAL SPONSORS

Visual Arts and Craft Strategy / An
 initiative of the Australian, State and
 Territory Governments
Australian International Cultural Foundation

MAJOR SPONSORS

Accor Hotels and Resorts
Adshel
Australia Council for the Arts / APT5 is
 assisted by the Australian Government
 through the Australia Council, its arts
 and funding advisory body
Brisbane City Council
Brisbane Marketing
The Courier-Mail
Fosters Group
Network Ten
Sidney Myer Fund
Singapore Airlines

SUPPORTING SPONSORS

Australia–China Council, Department of
 Foreign Affairs and Trade
Australia–India Council, Department of
 Foreign Affairs and Trade
Australia Indonesia Institute, Department
 of Foreign Affairs and Trade
Australia–Malaysia Institute, Department
 of Foreign Affairs and Trade
British Council
Caxton Street Catering
Crayola
Creative New Zealand Toi Aotearoa
Department of Foreign Affairs and Trade
HarrisonNess
Japan Foundation
Ministry of Culture and Office of
 Contemporary Art and Culture, Thailand
ourbrisbane.com
Tourism Queensland

ACKNOWLEDGMENTS

The Chair, the Board of Trustees, the Director and staff of the Queensland Art Gallery
wish to thank the many Australian and international artists, curators, galleries, academics,
arts professionals and government representatives who have generously given their
expertise and knowledge and have offered continuing support for the Asia–Pacific
Triennials of Contemporary Art. Special thanks are also given to the authors who have
contributed to this catalogue.

ARTISTS

The Queensland Art Gallery wishes to
thank the artists in APT5.

LENDERS

The Gallery is grateful to the many lenders
to the exhibition:

PUBLIC INSTITUTIONS

Art Gallery of New South Wales, Sydney,
 Australia
Art Gallery of South Australia, Adelaide,
 Australia
Auckland Art Gallery Toi o Tāmaki,
 Auckland, New Zealand
Bishop Museum, Honolulu, Hawai'i, USA
Centre de Documentation du Cinéma
 Chinois, Paris, France
China Film Archive, Beijing, China
Chinese Taipei Film Archive, Taipei, Taiwan
Chartwell Trust, Auckland Art Gallery
 Toi o Tāmaki, Auckland, New Zealand
Dunedin Public Art Gallery, Dunedin,
 New Zealand
Fukuoka City Public Library Film Archive,
 Fukuoka, Japan
Hong Kong Film Archive, Hong Kong
National Film Center, The National
 Museum of Modern Art, Tokyo, Japan
MH de Young Memorial Museum, Fine
 Arts Museum of San Francisco,
 San Francisco, USA
Mornington Peninsula Regional Gallery,
 Mornington, Australia
National Gallery of Australia, Canberra,
 Australia
National Film Archive of India, Pune, India
New Zealand Film Commission, Wellington,
 New Zealand
Museum of New Zealand Te Papa
 Tongarewa, Wellington, New Zealand
Victoria University of Wellington Art
 Collection, Adam Art Gallery Te Pātaka
 Toi, Wellington, New Zealand
Walker Art Center, Minneapolis, USA

PRIVATE LENDERS

Jim Barr and Mary Barr, Wellington,
 New Zealand
Arani and Shumita Bose, New York, USA
Jennifer Gibbs Trust, Auckland,
 New Zealand
Brian Pawlowski, USA
Obayashi Collection, Tokyo, Japan
Ota Fine Arts, Tokyo, Japan
Poakalani and John Serrao, Honolulu,
 Hawai'i, USA
Dick Spencer and Shawn Gould, USA
Deepak Talwar, New York, USA
Gordon Walters Estate, Auckland,
 New Zealand
Studio Guenzani, Milan, Italy
and other private collectors who wish to
 remain anonymous

THE QUEENSLAND ART GALLERY WISHES TO THANK THE POETS, PERFORMERS AND ARTISTS IN THE APT5 PERFORMANCE PROGRAM

Angus Rabbitt and the Travelling Aboriginal
 Band
Aurukun community
Bounty 75
Briscoe Sisters
Cornelius
Deadly Aunties
Dennis Nona and the Badu Island dancers

Djambawa Marawili and the Yirrkala
 dancers
Feleti and JP
Indigenous Intrudaz
John Pule
Ladi6
The Last Kinection
Nunukul Yuggera Dancers
REV MC
Sam Watson
Scribe
Sean Choolburra
Seraphim
Shakaya
Sia Figiel
Sista Native
Toni Janke
Troy 'n' Trevelyn and the Tribe
Tusiata Avia
Wagga Dance Company
Yelangi Preschool

THE QUEENSLAND ART GALLERY WISHES TO THANK THE FOLLOWING INSTITUTIONS AND INDIVIDUALS FOR THEIR VALUED ASSISTANCE

100 Tonson Gallery, Bangkok, Thailand;
A little blah blah, Ho Chi Minh City,
Vietnam: Motoko Uda; Alternative Space
Pool, Seoul, Korea: Park Chang-young;
American Museum of Natural History,
New York, USA: Mark Katzman; Annandale
Galleries, Sydney, Australia: Bill & Anne
Gregory; Art Beatus Limited, Hong Kong:
Richard Yiu; Art Vietnam Gallery, Hanoi,
Vietnam: Suzanne Lecht; Dennis Ascalon,
Bacolod, Philippines; Asia Art Archive,
Hong Kong: Claire Hsu, Angela Seng &
Phoebe Wong; Auckland Art Gallery Toi
o Tāmaki, Auckland, New Zealand: Ron
Brownson; Auckland Museum, Auckland,
New Zealand: Roger Neich & Pandora
Fulimalo Pereira; The Australian Art Print
Network, Sydney, Australia: Michael
Kershaw; Australia Council for the Arts:
Jennifer Bott, CEO, Billy Crawford & Anna
Waldmann; Australian Embassy, Bangkok,
Thailand: HE Mr William Paterson PSM,
Australian Ambassador to the Kingdom
of Thailand, & Piyarat Suksiri; Australian
Embassy, Beijing, China: Dr Alan Thomas,
Australian Ambassador to China & Daniel
Sanderson; Australian Embassy, Hanoi,
Vietnam: HE Mr Bill Tweddell, Australian
Ambassador to the Socialist Republic of
Vietnam, Damien Coke, Andrea Faulkner
& Nguyen Thi Thanh An; Australian
Embassy, Seoul, Korea: Mr Geoff Tooth,
Minister and Deputy Head of Mission to
the Republic of Korea, & Moonsun Choi;
Australian Embassy, Manila, Philippines:
Australian Ambassador to the Republic of
the Philippines, HE Mr Tony Hely, Elizabeth
Reymundo & Kerryn Tagle; Australian High
Commission, Suva, Fiji: Ms Jennifer
Rawson, High Commissioner to Fiji,
& Dennis Rounds; Australian High
Commission, New Delhi, India: Mr John
McCarthy, AO, High Commissioner to India,
John Fisher & Asha Lele Das; Australian
High Commission, Kuala Lumpur, Malaysia:
Mr James Wise, High Commissioner to
Malaysia, Lauren Bain & Rahel Joseph;
Australian High Commission to Pakistan:
Ms Zorica McCarthy, Australian High
Commissioner to Pakistan; Australian High
Commission, Singapore: Mr Miles Kupa,
High Commissioner to Singapore,

Charlene Lim; Australian High Commission, Colombo, Sri Lanka; Dr Greg French, High Commissioner to Sri Lanka; Michael Simcha Baevski, Brisbane, Australia; Geoffrey Bawa Trust, Colombo, Sri Lanka; Bishop Museum, Honolulu, Hawai'i, USA: Maile T Drake & Betty Kam; Bose Pacia Gallery, New York, USA: Anita Sharma; Boutwell Draper Gallery, Sydney, Australia: James Draper & Susan Boutwell; Buku Larrnggay Mulka Art Centre and Museum, Yirrkala, Australia: Will Stubbs; Ingrid Cameron, Brisbane, Australia; Susan Caulfield-Leclercq, Queensland University of Technology, Brisbane, Australia; Cemeti Art House, Yogjakarta, Indonesia: Nindityo Adipurnomo & Mella Jaarsma; Chamber of Commerce, Avarua, Rarotonga, Cook Islands: Donye Numa; China Art Archives and Warehouse, Beijing, China: Beatrice Leanza & Hans van Dijk; Michelle Christie, Coochiemudlo Island, Australia; Catharine Clark Gallery, San Francisco, USA: Catharine Clark & Andrea Antonaccio; Cleveland District State High School, Redland, Australia: Jesse Garrett, Stephanie Hendy, Nicole Henderson, Sarah Parsons & Sarah Tuomi; Cook Islands Association of Non-Governmental Organisations, Rarotonga, Cook Islands: Vereara Maeva-Taripo; Cook Island Tivaevae Association, Rarotonga, Cook Islands: Dawn Baudinet, Andrea Eimke & Te Tika Mataiapo (Dorice Reid); CPS, Manchester, UK: Trevor Jones; Sue Crockford Gallery, Auckland, New Zealand: Sue Crockford & Isha Welsh; Joselina Cruz, Manila, Philippines; Department of Culture and Heritage, Suva, Fiji: Honourable Nanise Nagusuca, Assistant Minister for Culture and Heritage; Department of Culture and Heritage, Fiji Arts Council, Suva, Fiji: Tulia Seduadua & Adi Niqa R Tuvuki; Development Cooperation, AusAID, Apia, Samoa: Fiona Tofilau-Tofa; Earl Lu Gallery, La Salle-SIA College of the Arts, Singapore: Eugene Tan; Celestine Doyle, Marketing & Communications Advisor, Brisbane, Australia; Edition Haere Po No Tahiti, Papeete, Tahiti: Denise & Robert Koenig; Brenda Fajardo, Manila, Philippines; Gordon Walters Estate, Auckland, New Zealand: the late Margaret Orbell and the Walters family; Tuna Fielakepa, Langafonua, Nuku'alofa, Tonga; Fiji Arts Council, Suva, Fiji: Michael Dennis; Patrick Flores, University of the Philippines, Manila, Philippines; Galeri Seni Maya, Kuala Lumpur, Malaysia: Rafizah Abdul Rahman; Galerie Urs Meile, Luzern, Switzerland; Gallery Chemould, Mumbai, India: Shireen Gandhy; Gallery Quynh, Ho Chi Minh City, Vietnam: Quynh Pham; Gallery SKE, Bangalore, India: Sunitha Kumar Emmart & Aruna Keshav; Gao Yuan, Beijing, China; Gridthiya Gaweewong, Chiang Mai University, Chiang Mai, Thailand; Marian Goodman Gallery, New York, USA and Paris, France: Nalani Gourd, Honolulu, Hawai'i, USA; Gow Langsford Gallery, Auckland, New Zealand: John Gow and staff; Tara Gower, Brisbane, Australia; Spencer and Jan Grammer, Brisbane, Australia; Graphic Art Mount, Sydney, Australia; Hanart TZ Gallery, Hong Kong: Chang Tsong-zung; Professor Salima Hashmi, Lahore, Pakistan; Hawaiian Quilt Research Project, Honolulu, Hawai'i, USA: Laurie Woodard; Julie Hayes, Brisbane, Australia; Lynda Hess, Honolulu,

Hawai'i, USA; Hyungwoo Lee, Seoul, Korea; Professor Jyotindra Jain, Jawaharlal Nehru University, New Delhi, India; Kapoor Studio, London, UK: Peter Berwick & Zoe Morley; Geeta Kapoor & Vivan Sundaram, New Delhi, India; Ani Katu, Esther Katu & Mareta Matamua, Aitutaki, Rarotonga, Cook Islands; Karen K Kosasa, Department of American Studies, University of Hawai'i at Mānoa, Honolulu, Hawai'i, USA; Darren Knight Gallery, Sydney, Australia: Darren Knight; LEEUM Samsung Museum of Art, Seoul, Korea: Soyeon Ahn; Michael Lett Gallery, Auckland, New Zealand: Michael Lett; Lisson Gallery, London, UK: Michelle D'Souza & Rowena Paget; Long March Project, Beijing, China: Lu Jie & David Tung; Tran Luong, Hanoi, Vietnam; MADD Gallery, Apia, Samoa: Momoe Von Reiche; Nalini Malani, Mumbai, India; Galerie Mirchandani + Steinruecke, Mumbai, India: Usha Mirchandani & Ranjana Steinruecke; Mission Houses Museum, Honolulu, Hawai'i, USA: Margo Vitarelli; Mori Gallery, Sydney, Australia; Mr Rupert Myer, AM, Chairman, Contemporary Visual Arts and Craft Inquiry; Museum of New Zealand Te Papa Tongarewa, Wellington, New Zealand: Sean Mallon; Muzium dan Galeri Seni, Universiti Sains Malaysia, Penang, Malaysia: Hasnul J Saidon; National Art Gallery Malaysia Balai Seni Lukis Negara, Kuala Lumpur, Malaysia: Puan Zanita Anuar; National Commission for Culture and the Arts, Manila, Philippines: Emilie V Tiongco; National Gallery of Victoria, Melbourne, Australia: Kelly Gellatly; National Museum of Korea, Seoul, Korea: Choi Eung Chon; Nature Morte, New Delhi, India: Peter Nagy; Novamedia Ltd., Melbourne, Australia: Antoanetta Ivanova; Numthong Gallery: Numthong Sae-Tang; Karen Flores Ocampo, Manila, Philippines; Oceania Centre for Arts and Culture, The University of the South Pacific, Suva, Fiji: Epeli Hau'ofa; One and J Gallery, Seoul, Korea: Wonjae Park, Patrick Lee & Jaeho Jung; Ota Fine Arts, Tokyo, Japan: Hidenori Ota, Yoriko Tsuruta and Yoshiko Kogi; Fumi Ozawa, Tokyo, Japan; Paik Hae Young Gallery, Seoul, Korea: Lim Sung Yon; Parasol Unit Foundation for Contemporary Art, London, UK: Peter Turner & Ziba de Weck; Manu Park, Busan Biennale 2006, Busan, Korea; Marian Pastor Roces, Manila, Philippines; Sharmini Pereira, Colombo, Sri Lanka; PKM Gallery, Seoul, Korea: Shi-ne Oh; Dr Apinan Poshyananda, Director General, Office of Contemporary Art and Culture, Ministry of Culture, Bangkok, Thailand; John Potter and Roz MacAllan, Brisbane, Australia; Profolab, New Delhi, India; Queensland Government Trade and Investment Office — China, Shanghai, China: Zhang Zijian, Commissioner; Rumah Air Panas, Kuala Lumpur, Malaysia; Sakshi Gallery, Mumbai, India: Geetha Mehra; TK Sabapathy, Singapore; Shailer Park State High School, Logan, Australia: Simone Filippow, Michelle Hopper, Catherine Middleton & Jade Pregelj; Shanghai Art Museum, Shanghai, China: Li Xu; ShanghART Gallery, Shanghai, China: Lorenz Helbling, Chen Yan, Laura Zhou & Helen Zhu; Thamotharampillai Shanaathanan, Jaffna, Sri Lanka; Shoshana Wayne Gallery, Los Angeles, USA: Shoshana Wayne; Judy Freya Sibayan, Manila, Philippines; Ahmad Mashadi, Singapore Art Museum, Singapore; Pooja Sood, New Delhi, India;

SSamzie Space, Seoul, Korea: Kim Hong Hee & Hyunjin Shin; The Substation, Singapore: Lee Weng Choy; Dr Habiba Surabi, Governor of Bamiyan, Bamiyan, Afghanistan; Tadu Contemporary Art, Bangkok, Thailand: Luckana Kunavichayanont; Talwar Gallery, New York, USA: Deepak Talwar; Adam Teraoka, Los Angeles, USA; Theertha International Artists' Collective, Colombo, Sri Lanka; Tifaifai of Polynesia, Papra Pk, Tahiti; Valentine Willie Fine Art, Kuala Lumpur, Malaysia: Rachel Ng & Beverly Yong; Vibhavi Academy of Fine Arts, Colombo, Sri Lanka: Chandragupta Thenuwara; Marie-Helene Villierme, Papeete, Tahiti; Women and Development Centre, Prime Minister's Office, Nuku'alofa, Tonga: Lilika Fusimalohi; Paul Willett, Principal Advisor, Strategic Implementation Branch, Department of Education, Training and the Arts, Queensland Government, Brisbane, Australia; Women in Business, Apia, Samoa: Adimaimalaga Tafunai; Annie Wong Art Foundation, Hong Kong, and Vancouver, Canada: Dr Annie Wong; Wong Hoy Cheong, Kuala Lumpur, Malaysia: Woodridge State School, Logan, Australia: Jenny Coventry, Christina Hall, Jeannie Macnamara & Gemma White; Zhang Jinsong, Beijing, China.

INDIVIDUAL PROJECT SUPPORT

CINEMA

100 Meter Films, Tokyo, Japan: Shohei Shiozaki; Adlabs Films Ltd, Mumbai, India: Krishnand Shetty & Raghu Moolya; Alliance Atlantis Communications, Sydney, Australia: Irene Read; Alliance Française, Brisbane, Australia: Jérôme Richalot; Asia Television Limited, Hong Kong: Janet Lee; Blackfella Films, Sydney, Australia: Darren Dale & Rachel Perkins; Frank Bren, Melbourne, Australia; British Film Institute, London, UK: Nina Harding; Cathay-Keris Films, Singapore: Oi Leng Lui; Celestial Pictures, Hong Kong: Shirley Chung; Celluloid Dreams, Paris, France: Audrey Krief; Central Australian Aboriginal Media Association, Alice Springs, Australia: Lisa Stefanoff; Centre de Documentation du Cinéma Chinois, Paris, France: Marie-Claire Quiquemelle; China Film Archive, Beijing, China: Chen Jingliang, Mr Liu Dong & Yangrong Tan; Chinese Taipei Film Archive, Taiwan: Teresa Huang, Grace Kao & Winston Lee; Maura Edmond, Melbourne, Australia; Film Depot, Sydney, Australia: Kath Shelper; Fiesta Entertainment Ltd., Mumbai, India: Anirvan Ghose; First Distributor, Hong Kong: Wong Hoi; Force Entertainment, Melbourne, Australia: Selina Chong & Simone Ubaldi; Fortissimo Films, Amsterdam, the Netherlands: Marit Ligthart; Fortune Star Entertainment, Hong Kong: Apple Chiu; Dendy Films, Sydney, Australia: Jason Hernandez; Films Around The World, Inc., New York, USA: Alexander Kogan; French Embassy, Canberra: HE Mr François Descoueyte, Ambassador of France to Australia; French Consulate-General, Sydney: Jean-Jacques Garnier, Valérie Isbled & Sidney Peyroles; Fukuoka City Public Library Film Archive, Fukuoka, Japan: David Kalischer & Yoshiyuki Yahiro; Giai Phong Film Studio, Ho Chi Minh City, Vietnam: Lê Đức Tiến; Golden Scene Company Ltd, Hong Kong: Athena Tsui; Golden Valley Entertainment, San José,

USA: Bui Truong; Griffith University, Brisbane, Australia: Mary Farquhar; Taro Goto, Los Angeles, USA; Paul Hankinson, Berlin, Germany; Hanoi Cinémathèque, Hanoi, Vietnam: Gerald Herman; High Commission of India in Australia, Canberra: Mr P.P. Shukla, High Commissioner, & NG Vasanth Kumar, First Secretary; Hong Kong Arts Centre, Hong Kong: Grace Cheng; Hong Kong Film Archive, Hong Kong: Angela Tong, Head, Mabel Ho & Sam Ho; Hong Kong Film & Video Award, Hong Kong: Agnes Chan & Teresa Kwong; Jackie Chan Group: Willie Chan, Solon So & Peco Ng; Keita Kurosaka, Tokyo, Japan; Kick the Machine, Bangkok, Thailand; Kihachiro Kawamoto, Tokyo, Japan; Kong Chiao Film Company, Hong Kong; Lai Shek, Hong Kong; Las Palmas de Gran Canaria International Film Festival, Canary Islands, Spain: Claudio Utrera; Los Angeles Film Festival, Los Angeles, USA: Doug Jones; Laleen Jayamanne, University of Sydney, Sydney, Australia; KK Mahajan, Mumbai, India; Fareeda Mehta, Mumbai, India; Ministry of External Affairs, New Delhi, India: Navtej Singh Sarna & JK Sharma; Mistral Film, Tokyo, Japan: Akira Mizuyoshi; National Film & Sound Archive, a division of the Australian Film Commission, Australia: Meg Labrum & Paolo Cherchi Usai, Canberra, & David Noakes, Sydney; National Film Archive of India, Pune, India: KS Sashidharan; National Film Development Corporation Ltd, Mumbai, India: Nina Lath Gupta, P Sathyanarayanan, Mukesh Seghal & SD Pai; National Film Centre, The National Museum of Modern Art, Tokyo, Japan: Akira Tochigi; New Zealand Film Commission, Wellington: Kate Kennedy & Hayley Weston; Ng Chi-wang, Hong Kong; Nguyễn Minh Trang, Singapore; Plane: Bibliothèque de Cinéma, Osaka, Japan: Yoshio Yasui; Prasad Film Laboratories, Chennai, India: A Sarat Kumar & S Sivaraman; Prasad Film and TV Academy, Chennai, India: Mr Hariharan; RAQs Media Collective, New Delhi, India: Shuddhabrata Sengupta; Royal Netherlands Embassy, New Delhi, India: Mr. Eric Franciscus Charles Niehe, Ambassador, & Ila Singh; Screentime, Auckland, New Zealand: Sharon Bolderson; Nadine Seligmann, Uchte, Germany; Rewati Shahani, London, UK; Roshan Shahani, Mumbai, India; ShanghART Gallery, Shanghai, China: Lorenz Helbling, Chen Yan, Laura Zhou & Helen Zhu; Michael Shaowanasai, Bangkok, Thailand; Sil-Metropole Organisation, Hong Kong: Mr Chiu; Sipka Media, Brisbane, Australia: Mark Sipka; Sojitz Corporation, Tokyo, Japan: Akane Yokoyama; Sony Pictures, Sydney, Australia: Michael Atkins; Thai Independent Filmmakers Association, Bangkok, Thailand: Pimolthip Yeesuntes; Tomoyasu Murata Company, Tokyo, Japan: Tomoyasu Murata; Transmit, Wellington, New Zealand: Sarah Hunter; Twentieth Century Fox Film Distribution, Sydney, Australia: David Townsend; Vietnamese Cinema Department, Hanoi, Vietnam: Đỗ Duy Ảnh & Nguyễn Phúc Thành; Vietnamese Film Institute, Hanoi, Vietnam: Trần Nghĩa Hà & Dr Hoàng Như Yến; Media Resource Centre, Adelaide, Australia: Mike Walsh; Warner Music, Auckland, New Zealand: Ashley Page; Warner Bros. Pictures, Los Angeles, USA: David Read; Lucas A Wisniewski, Brisbane,

Australia; Yamamura Animation Inc., Tokyo, Japan: Koji Yamamura; Tim Youngs, Hong Kong; Yuu Takehisa, Tokyo, Japan.

APT5 PERFORMANCE PROGRAM
3-D Corporation, Tokyo, Japan: Riki Domen; Creative New Zealand, Wellington, New Zealand: Anton Carter; CRS Music Management, Auckland, New Zealand: Teresa Patterson; Naomi Flatt, London, UK; The Harbour Agency, Sydney, Australia: Brett Murrihy; Musgrave Park Cultura Centre, Brisbane, Australia; Jonathon Parsons, Riverfestival, Brisbane, Australia; Queensland Performing Arts Centre, Brisbane Australia: John Kotzas; Taboo Management, Los Angeles, USA: Blaine Kaplan; United Sound, Zurich, Switzerland: Vinod Gadher.

Kin: Devised and directed by Stephen Page; Composer: David Page; Designer: Peter England; Lighting designer: Glenn Hughes; Stage manager: Kylie Mitchel; Cast: Isieli Jarden, Ryan Jarden, Josiah Page, Samson Page, Sean Page, Hunter Page-Lochard, Curtis Walsh-Jarden; Cinematographer: Douglas Watkin. Special thanks to Geraldine Jarden; Grant Jarden; Tamika Walker; Frances Page; Megan Page; Roy & Doreen Page, and the Page family; Shane Paulson and the Munurjali Elders; Cheryl Walsh; *The Kin Story* crew: Cameron Kennedy, Lachlan Lacey, Craig McAnulty and Linton Vivian.

QUEENSLAND ART GALLERY STAFF

PROJECT DEVELOPMENT & DIRECTION
Doug Hall, AM, Director
Lynne Seear, Assistant Director,
 Curatorial & Collection Development
Andrew Clark, Assistant Director,
 Public Programs

CURATORIAL TEAM
Doug Hall, AM, Director
Lynne Seear, Assistant Director,
 Curatorial & Collection Development
Andrew Clark, Assistant Director,
 Public Programs
Suhanya Raffel, Head of Asian,
 Pacific & International Art
Julie Ewington, Head of Australian Art
Kathryn Weir, Head of Cinema
Maud Page, Curator, Contemporary
 Pacific Art
Sarah Tiffin, Curator, Historical Asian Art
Don Heron, Head of Exhibitions & Display

CURATORIAL PROJECT OFFICER
Zoe Butt, Assistant Curator, Contemporary
 Asian Art

Since the inception of the Asia–Pacific Triennial project in 1993, Queensland Art Gallery staff have contributed in outstanding ways to the Triennial's success and have offered consistently high levels of support, innovation, energy, diligence and professionalism to bring each of these major events to fruition. This support is most gratefully acknowledged by the Board of Trustees and Director. The following staff are especially thanked for their leadership and contributions towards the presentation of APT5.

KIDS APT
Andrew Clark, Assistant Director,
 Public Programs
 Tony Albert, Exhibitions Project Officer
 & Indigenous Trainee Coordinator
 Helen Bovey, Program Officer
 (Visitor Services)
 Tamsin Cull, Programs & Audience
 Development Officer (Children's Art
 Centre)
 Angela Goddard, Program Officer
 (Regional Services)
 Lynda Griffin, Assistant Exhibition
 Designer
 Don Heron, Head of Exhibitions &
 Display
 Fiona Lee, Designer
 Kelly Nichols, Projects & Events
 Coordinator
 Michael O'Sullivan, Senior Exhibition
 Designer
 Maud Page, Curator, Contemporary
 Pacific Art
 Suhanya Raffel, Head of Asian, Pacific
 & International Art
 Aidan Robertson, Web & Multimedia
 Designer
 Kate Ryan, Curatorial Interactive &
 Program Development Officer
 Julie Walsh, Program Officer (Education
 & Children's Art Centre)

APT5 PERFORMANCE PROGRAM
Andrew Clark, Assistant Director,
 Public Programs
 Tony Albert, Exhibitions Project Officer
 & Indigenous Trainee Coordinator
 Nicholas Chambers, Assistant Curator,
 Contemporary International Art
 Don Heron, Head of Exhibitions &
 Display
 Bruce McLean, Associate Curator,
 Indigenous Australian Art
 Kelly Nichols, Projects & Events
 Coordinator
 Michael O'Sullivan, Senior Exhibition
 Designer
 Maud Page, Curator, Contemporary
 Pacific Art
 Miranda Wallace, Managerial
 Researcher
 Julie Walsh, Program Officer (Education
 & Children's Art Centre)

ASIA, PACIFIC & INTERNATIONAL ART
Suhanya Raffel, Head of Asian, Pacific &
 International Art
 David Burnett, Curator, International Art
 Zoe Butt, Assistant Curator,
 Contemporary Asian Art
 Nicholas Chambers, Assistant Curator,
 Contemporary International Art
 Abigail Fitzgibbons, Research Assistant
 Ruth McDougall, Curatorial Assistant
 Maud Page, Curator, Contemporary
 Pacific Art
 Sarah Tiffin, Curator, Historical Asian Art
 Robyn Ziebell, Project Officer, Australian
 Centre of Asia–Pacific Art

AUSTRALIAN & INDIGENOUS ART
Julie Ewington, Head of Australian Art
 Joan Collins, Indigenous Liaison &
 Administration Officer
 Michael Hawker, Curatorial Assistant,
 Contemporary Australian Art
 Bruce McLean, Associate Curator,
 Indigenous Australian Art
 Diane Moon, Curator, Indigenous
 Fibre Art

Chantelle Woods, Project Officer,
 Indigenous Australian Art (till Sep.
 2006)

CINEMA
Kathryn Weir, Head of Cinema
 Jose Da Silva, Curatorial Assistant, Film
 Rosie Hays, Curatorial Assistant,
 Cinema Acquisitions & Programming
 Rachel O'Reilly, Curatorial Assistant,
 Video & New Media

CONSERVATION
Anne Carter, Head of Conservation
Amanda Pagliarino, Acting Head
 of Conservation
 Mervyn Brehmer, Conservation
 Workshop Coordinator
 Damian Buckley, Conservation
 Technician (Mount cutting)
 Nicholas Cosgrove, Conservation
 Assistant
 Belinda Gourley, Conservator (Works
 on paper)
 Samantha Shellard, Conservator
 (Works on paper)
 Mandy Smith, Senior Conservation
 Technician
 Lyn Streader, Conservation Technician
 Liz Wild, Conservator (Sculpture)

DIRECTORATE
Heather Kelly, Executive Assistant

DESIGN, WEB & MULTIMEDIA
Elliott Murray, Head of Design, Web &
 Multimedia
Chris Starr, Senior Designer
 Madeline Hoy, Designer
 Fiona Lee, Designer
 Angelina Martinez, Designer
 Aidan Robertson, Web & Multimedia
 Designer
 Ryan Taylor, Web & Multimedia
 Designer
 Ben Wickes, Audio Visual Project
 Officer

EDUCATION
Kate Ravenswood, Head of Access,
 Education & Regional Services
 Helen Bovey, Program Officer (Visitor
 Services)
 Tamsin Cull, Programs & Audience
 Development Officer (Children's Art
 Centre)
 Lizzy Dixon, Project Officer (Education
 & Public Programs)
 Angela Goddard, Program Officer
 (Regional Services)
 Donna McColm, Acting Program Officer
 (Education & Public Programs)
 Fiona McFadyen, Project Officer
 (Children's Art Centre & Youth)
 Melina Mallos, Curriculum & Education
 Programs Officer
 Sarah Stratton, Program Officer
 (Education & Public Programs)
 Julie Walsh, Program Officer (Education
 & Children's Art Centre)

EXHIBITION DESIGN & INSTALLATION
Don Heron, Head of Exhibitions & Display
Michael O'Sullivan, Senior Exhibition
 Designer
 Tony Albert, Exhibitions Project Officer
 & Indigenous Trainee Coordinator
 Nick Ashby, Installation Officer
 Neville Barker, Artisan
 Peter Barker, Installation Officer
 (Carpenter)

Noel Bigalla, Gallery Painter
Patrick D'Arcy, Installation Officer
 (Carpenter)
Andrea Fisher, Exhibitions Project
 Officer
John Francia, Project Officer, APT
Lynda Griffin, Assistant Exhibition
 Designer
Carolyne Jackson, Assistant Exhibition
 Designer
John Marshall, Artisan
Judith Vink, Apprentice Wood Machinist
 (till September 2006)
Sharyn Watson, Installation Assistant
Warren Watson, Installation
 Co-ordinator
Philip Wilson, Installation Officer
 (Electrician)

INFORMATION & PUBLISHING SERVICES
Judy Gunning, Head of Information &
 Publishing Services
Cathy Pemble-Smith, Senior Librarian
Ian Were, Senior Editor
 Julie Bond, Collection Information
 Systems Coordinator
 Patrice Burke, Library Technician
 Mathew Fletcher, Digital Imaging
 Assistant
 Amanda Gardner, Librarian (GoMA
 Projects)
 Melinda Goopy, Support Officer,
 Collection Information Systems
 Eric Meredith, Publications Assistant
 Fiona Mowat, Collection Information
 Systems Officer
 Kylie Timmins, Publications Assistant
 Kerri Ullrich, Publications Assistant
 Jacklyn Young, Librarian (Collections)

MANAGEMENT & OPERATIONS
Alan Wilson, Assistant Director,
 Management & Operations
Graeme Archibald, Head of Protection
 & Services
Allan Brand, Head of Technology
Colin Diachkoff, Head of Financial
 Services
Linda Mehan, Head of Retail &
 Commercial Services
 Peter Beiers, Senior Bookbuyer, Gallery
 Store
 Izabella Chabrowska, Assistant
 Manager, Gallery Store

MANAGERIAL RESEARCH
Alison Lee, Head of Managerial Research
Sarah Stutchbury, Senior Managerial
 Researcher
 Yan Lee, Project Assistant, Managerial
 Research
 Emma Mühlberger, Research Assistant
 Miranda Wallace, Managerial
 Researcher

MARKETING & COMMUNICATIONS
Shirley Powell, Head of Marketing &
 Communications
 Amelia Gundelach, Media Coordinator
 Helen Gunner, Advertising &
 Promotions Officer
 Kelly Nichols, Projects & Events
 Coordinator
 Helen Jones, Communications
 Assistant
 Simone Kelaart, Marketing Officer
 (Projects & Events)
 Dana Mam, Marketing Assistant
 Hayley Owen, Projects & Events Officer

REGISTRATION

Andrew Dudley, Head of Registration

Tiffany Noyce, Registrar (GoMA)

Pam Bailey, Assistant Registrar (GoMA)

Kia Hing Fay, Assistant Registrar (QAG)

Catherine Henderson, Registration Assistant

Philip Lawless, Assistant Registrar (Collection Storage)

Martin Smith, Loan Coordinator/Curatorial Assistant, Government Buildings

Krystle Sutherland, Documentation Assistant, Registration

SPONSORSHIP

Anna Marsden, Head of Development

Michelle James, Development Officer

Dominique Jones, Grants Officer

Liz Watson, Membership Officer

VOLUNTEERS

The Gallery wishes to especially thank the many volunteers who have given their time and expertise to assist with the realisation of the APT5 project.

COPYRIGHT & REPRODUCTIONS

PHOTOGRAPHIC CREDITS

Photography of art works and installations for APT5, and works in the Queensland Art Gallery Collection by Ray Fulton and Natasha Harth, Photographers, except where otherwise credited.

All other photography credited as known.

THE VISUAL ARTS AND CRAFT STRATEGY

AUSTRALIAN
INTERNATIONAL
CULTURAL
FOUNDATION

A 709.5074943 A832

Asia-Pacific Triennial of
Contemporary Art (5th : 2006
The 5th Asia-Pacific
Triennial of Contemporary
Art
Central Fine Arts CIRC
09/07

Dedicated to a better Brisbane

SIDNEY MYER FUND

SINGAPORE
AIRLINES

A STAR ALLIANCE MEMBER

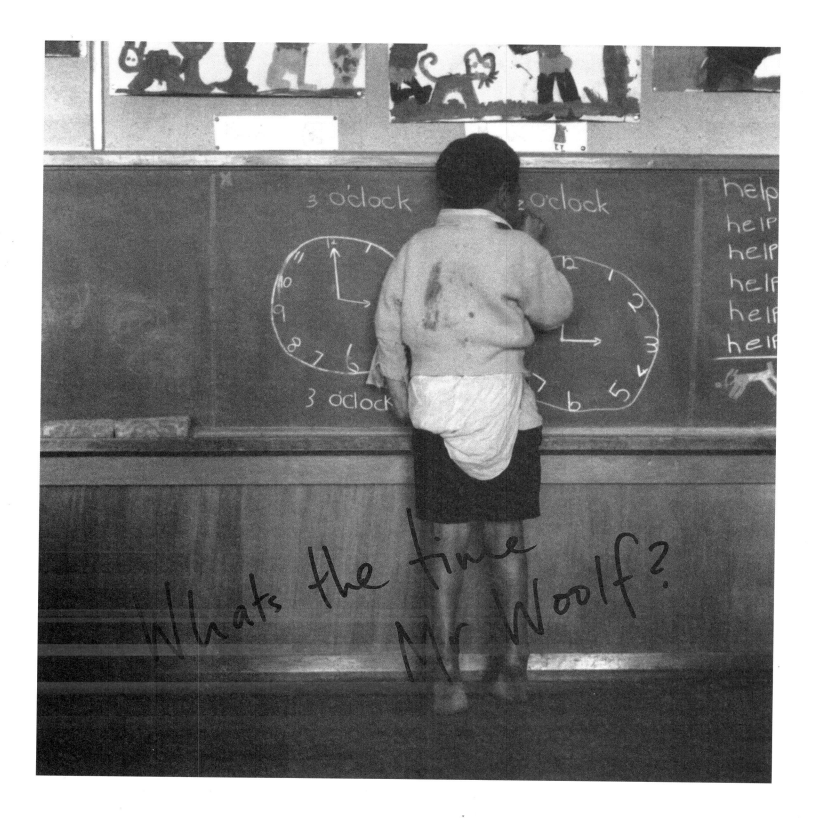